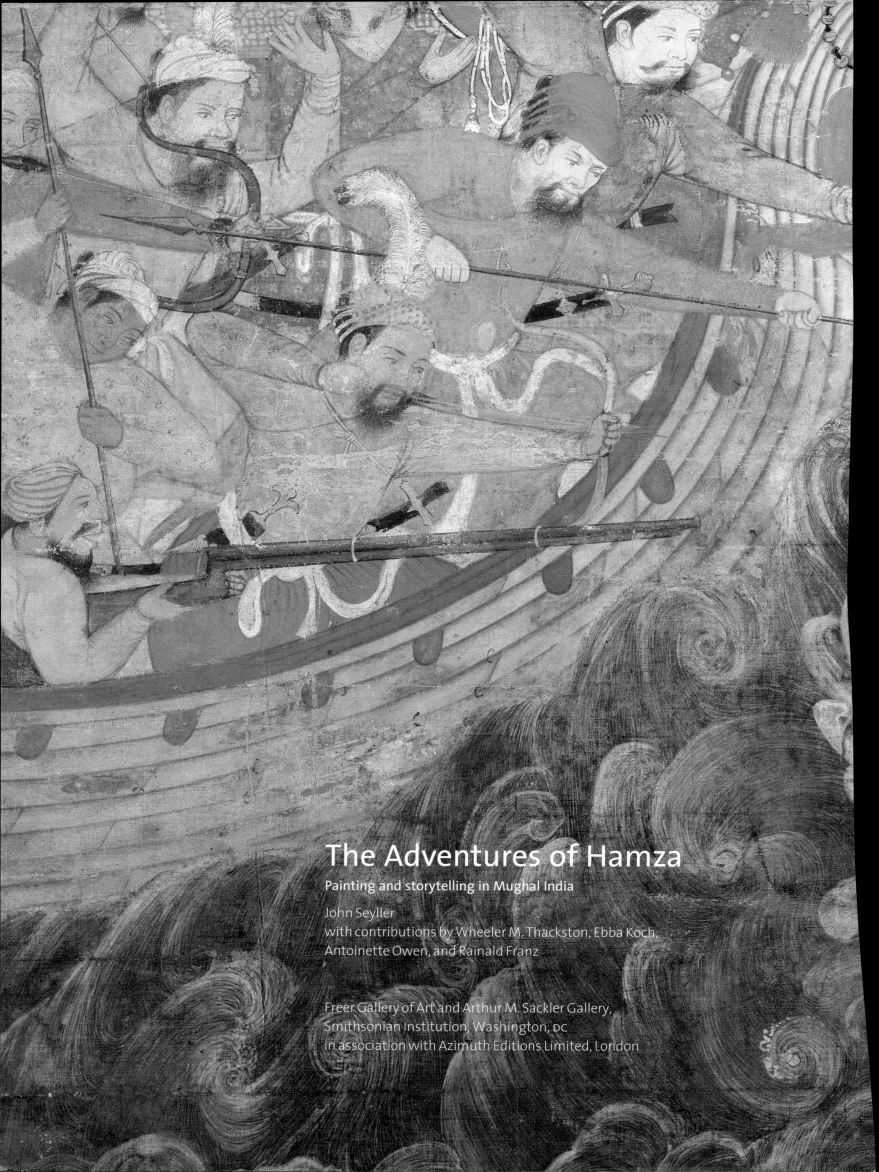

The Adventures of Hamza

Painting and storytelling in Mughal India

John Seyller
with contributions by Wheeler M. Thackston, Ebba Koch,
Antoinette Owen, and Rainald Franz

Freer Gallery of Art and Arthur M. Sackler Gallery,
Smithsonian Institution, Washington, DC
in association with Azimuth Editions Limited, London

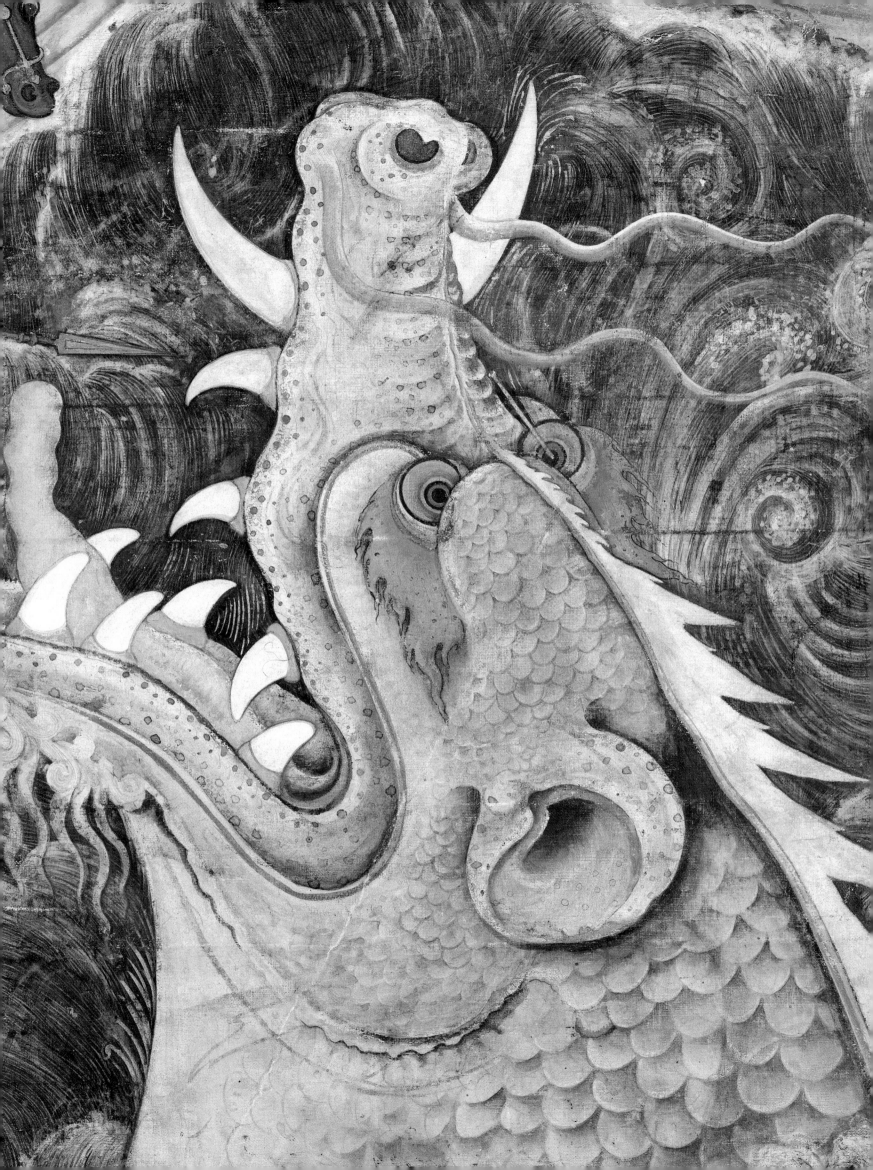

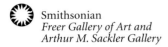
Smithsonian
Freer Gallery of Art and
Arthur M. Sackler Gallery

The cover and pp.6–7 show details from *Zumurrud Shah
flees with his army to Antali by flying through the air on
urns sent by sorcerers* (cat.57)
The frontispiece shows a detail from *A leviathan attacks
Hamza and his men* (cat.27)

Published on the occasion of the exhibition
The Adventures of Hamza
organized by the Arthur M. Sackler Gallery,
Smithsonian Institution, Washington, DC

This exhibition is made possible by generous grants
from Juliet and Lee Folger/The Folger Fund and The Starr
Foundation. Additional funding is provided by the Friends
of the Freer and Sackler Galleries and the Else Sackler Public
Affairs Endowment of the Arthur M. Sackler Gallery. This
exhibition is supported by an indemnity from the Federal
Council on the Arts and the Humanities.

Published by the
Freer Gallery of Art and Arthur M. Sackler Gallery,
Smithsonian Institution, Washington, DC
in association with
Azimuth Editions Limited, London

Distributed in the United Kingdom by
Thames & Hudson Limited
181A High Holborn, London WC1V 7QX
Tel. (020) 7845 5000 Fax. (020) 7845 5050

Available in the United States through
D.A.P./Distributed Art Publishers
155 Sixth Avenue, 2nd Floor, New York, NY 10013
Tel. (212) 627 1999 Fax. (212) 627 9484

© Smithsonian Institution 2002

British Library Cataloguing in Publication Data
A catalogue record for this book is available from
the British Library.

Library of Congress Cataloging in Publication Data
Data applied for

ISBN 1 898592 22 5

Produced by Azimuth Editions Limited
Unit 2A, The Works, Colville Road, London W3 8BL
Designed by Anikst Associates
Reproduced and printed by PJ Print, London
Bound by Skyline, Dorking, Surrey

CONTENTS

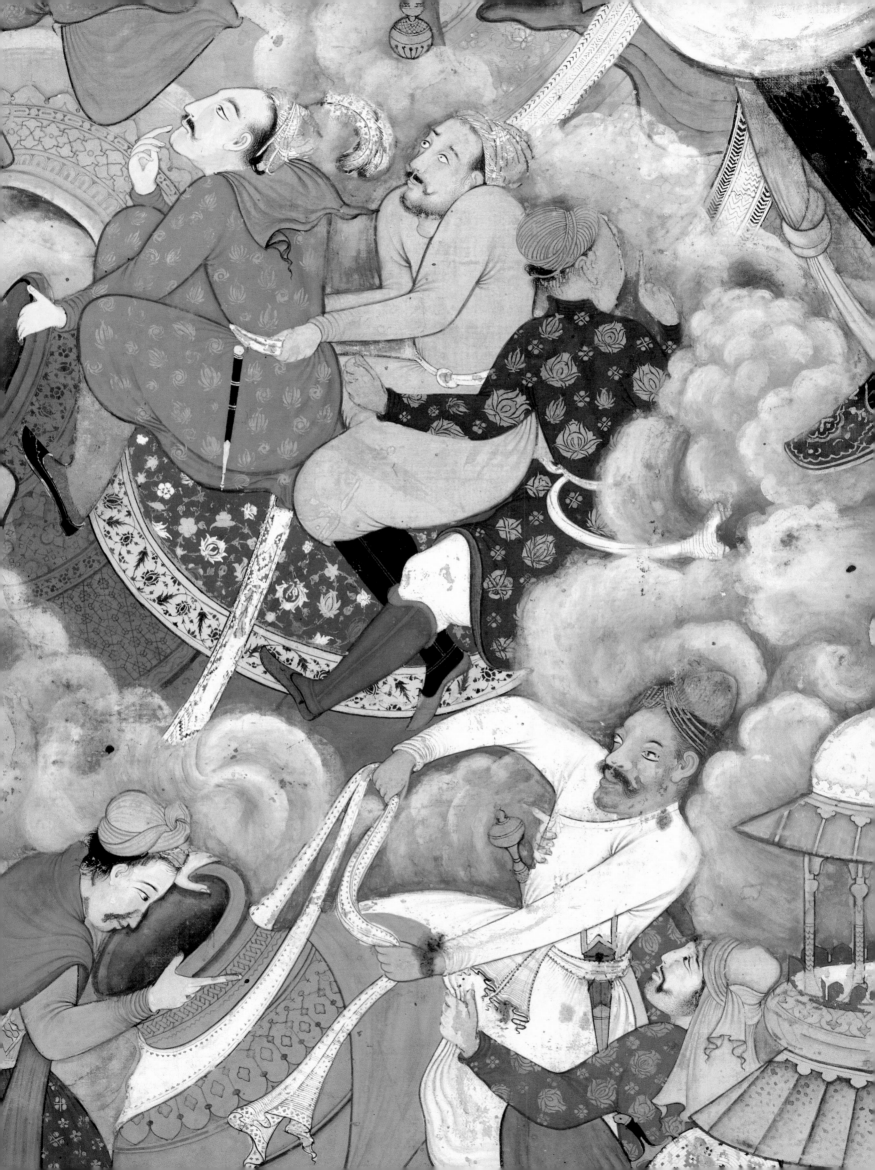

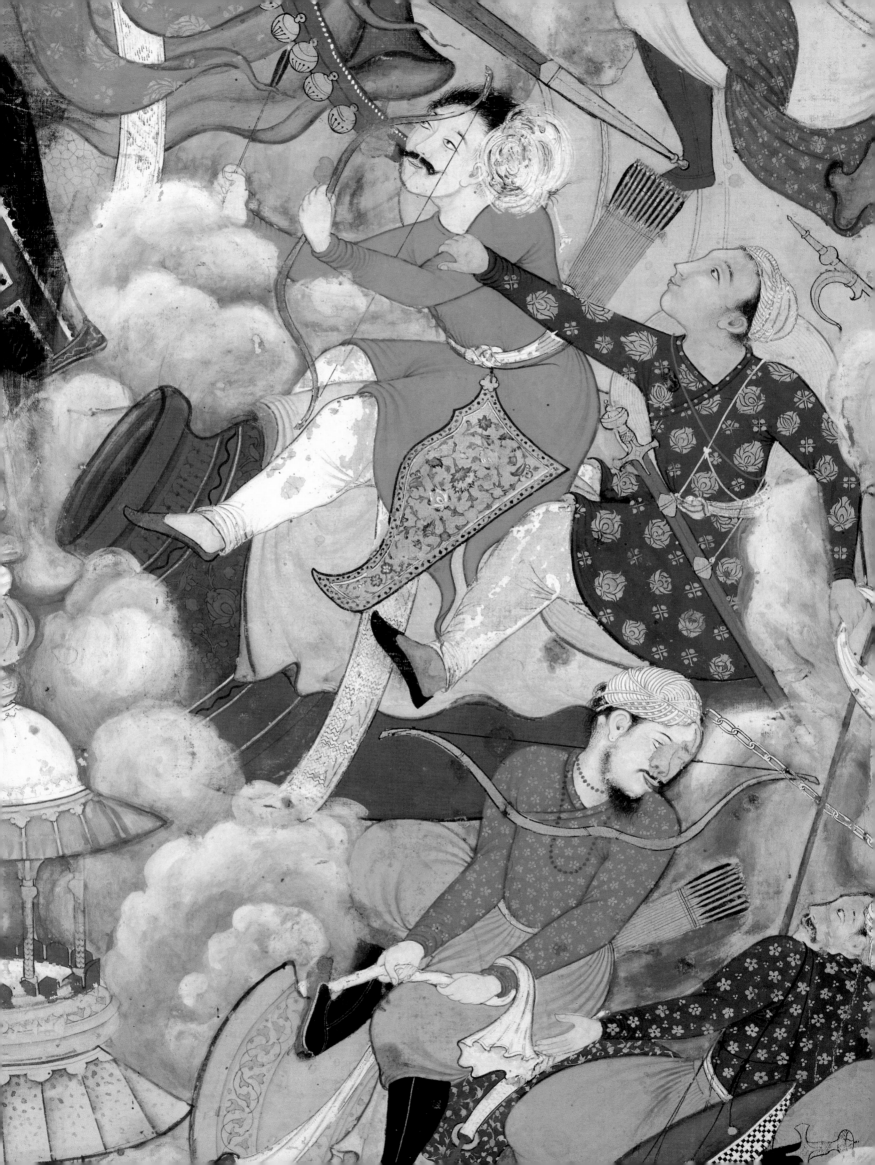

The *Hamzanama* ('Adventures of Hamza') tells the fabulous exploits of its eponymous hero, Hamza, the uncle of the Prophet Muhammad. The tales, replete with monsters and giants, heroes and villains, appear to have originated in Iran and spread from there to regions as widespread as Anatolia and Indonesia, where they were often recited in popular gatherings, even into the twentieth century. The *Hamzanama* found, however, a monumental expression in what was one of the grandest manu-script commissions of all time. Produced in the mid-sixteenth century for the Mughal ruler of India, the Emperor Akbar, while he was still in his teens, the *Hamzanama* comprised a remarkable total of 1,400 images, each of huge size. The scale of the undertaking is even more impressive as the paintings were among the earliest products of a fledgling imperial studio which harnessed the talents of Indian artists to that of emigrés from Iran. Above all the large paintings projected the narrative vigor of the stories, and captured the immediacy of the oral presentations they were intended to accompany.

For a manuscript of such acknowledged importance, it is surprising that this is the first exten-sive study of its pages since the long out-of-date publication by Heinrich Glück in 1925, and the exhibition it accompanies the first to bring together many of the finest and best-preserved examples of the approximately two hundred extant *Hamzanama* pages.

In this catalogue, the entries for individual paintings are intended to help viewers follow the crea-tive logic of several known painters' narrative and compositional choices and explore the nuances of their working methods. A series of essays establishes the political and artistic context of this remarkable commission, reconstructs its overall organization, and analyzes the multi-layered physical structure of the painted folios. The exhibition, too, is designed to evoke the flavor of some of the *Hamzanama*'s colorful tales by means of translation, description and performance.

Begun nearly a decade ago, this project is the culmination of the commitment and efforts of an international group of collaborators to whom the Freer Gallery of Art and Arthur M. Sackler Gallery owe tremendous gratitude. Milo C. Beach, former Director of the Freer and Sackler galleries, played a pivotal role in the genesis and evolution of the project; we are indebted to him. His boundless enthusiasm for Mughal painting and intense pursuit of scholarly excellence gave a shape and direction to the project that shines through in this presentation.

Thomas W. Lentz, the galleries' former Deputy Director and current Director of the International Art Museums Division, Smithsonian Institution, administered the early phases of the project with foresight and sensitivity; through his efforts the primary team was brought together, the initial studies of the paintings for exhibition were organized, and the groundwork for this project was laid.

The galleries are especially grateful to the MAK–Austrian Museum of Applied Arts/Contemporary Art, Vienna. No serious exhibition or study of the *Hamzanama* could be accomplished without its participation. The late Dr. Hanna Egger, former Deputy Director, championed the project through its early development; we regret that she is unable to see the fruit of her labor. Dr. Peter Noever, Director, was supportive from the project's inception and committed considerable MAK resources toward its completion, including the generous loan of twenty-eight pages from its collection. In the Library and Graphics Collection, Dr. Rainald Franz, Curator, contributed an essay to this catalogue and lent his administrative and curatorial expertise, while Kathrin Pokorny-Nagel, Department Head, continues to contribute ongoing administrative support to the exhibition. Manfred Trummer and Beate Murr, assisted by Anka Schäning, executed the conservation of the paintings.

Because of the rarity of extant *Hamzanama* pages, we owe deep gratitude to all of the lenders to the exhibition. Their generosity in making their paintings available for travel enables the rich presentation

offered at each of the exhibition venues; elsewhere in this volume they are acknowledged individually.

Professor John Seyller admirably rose to the dual demands of author and curator. His work here and in his many other publications provides the most thorough understanding of the development of Mughal painting to date, and many of his conclusions have forced reconsideration of long-accepted assumptions and enlivened the debate.

Dr. Ebba Koch enriched this book with her discussion of the cultural climate of Akbar's court and his patronage of the arts, while Dr. Wheeler Thackston contributed expertise even beyond his remarkable translations of the *Hamzanama* texts contained in this volume.

At the galleries, Massumeh Farhad, Associate Curator of Islamic Art, coordinated the presentation of the exhibition and provided invaluable curatorial expertise to both the catalogue and installation. Debra Diamond, Assistant Curator of South and Southeast Asian Art, contributed curatorial oversight in the early phase of installation planning. Through their considerable talents, Dennis Kois, Head of Design and Production, and Rebecca Lepkowski, Graphic Designer, brought both elegance and vitality to the installation and its didactic materials. Lynne Shaner, Head of Publications, edited the didactic text with utmost care and provided helpful counsel on the catalogue production. Rebecca Gregson, Associate Registrar, coordinated the myriad registrarial details of a complex exhibition. The rich educational programs complementing the presentation were conceptualized and administered by Ray Williams, Head of Education, and Joanna Pecore, Exhibitions Liaison. But perhaps no one person at the galleries worked longer or more diligently to make this exhibition and catalogue a reality than Cheryl Sobas, Exhibitions Coordinator, who from beginning to end brought a keen sense of creativity, analysis, and disciplined planning to a host of challenges, ranging from complex negotiations with lenders and venues to the securing of photography and permissions for the catalogue.

This catalogue admirably conveys the spirit and dynamism of the paintings, and we are grateful to the team at Azimuth Editions for producing a book that so effortlessly marries the popular and the scholarly. Special thanks are due to Julian Raby and Alison Effeny who structured and edited the volume, and to Misha Anikst for his work on the design; and to Lorna Raby at PJ Print for the exquisite color reproductions and print.

The support and cooperation of the staff of the other exhibition venues is gratefully acknowledged, in particular: at the Brooklyn Museum of Art, its Director Arnold Lehman, Amy Poster, Curator of Asian Art, and Senior Conservator of Paper, Antoinette Owen, who played a critical early role in the project by conducting the initial conservation survey of the Vienna pages, by providing treatment proposals and generously sharing her expertise with the MAK staff; at the Royal Academy of Arts, London, Professor Phillip King, President, Sir Philip Dowson, former President, Emeline Max, Head of Exhibitions Organization, and Isabel Carlisle, Deputy Exhibitions Secretary; and at the Museum Rietberg Zürich Dr. Albert Lütz, Director, and Dr. Eberhard Fischer, Senior Director.

We are deeply indebted to Lee and Juliet Folger/The Folger Fund. Lee Folger provided early and immediate financial support for the catalogue and additional support for the installation, his natural enthusiasm for the project having been augmented by recent travels in Central Asia and Iran. The Starr Foundation provided a generous grant, with additional funding provided by the Friends of the Freer and Sackler Galleries. We are also grateful for the grant of an indemnity by the Federal Council on the Arts and the Humanities.

Vidya Dehejia
Acting Director

ACKNOWLEDGMENTS

The idea for this exhibition was born as a result of a conversation I had a decade ago with Dr. Milo Cleveland Beach, a valued colleague who has a similar passion for Indian painting. I am deeply indebted to him for agreeing to commit the prestige and resources of the Freer Gallery of Art and the Arthur M. Sackler Gallery to this undertaking at a very early stage, and for deftly guiding the project to fruition. Dr. Thomas Lentz, formerly Deputy Director of the Freer Gallery of Art and the Arthur M. Sackler Gallery, threw himself wholeheartedly into the project early on and spent countless weeks courting potential venues and negotiating loan arrangements with crucial institutions. I am profoundly grateful to him for his encouragement and effectiveness. Once the exhibition was scheduled, I was introduced to Cheryl Sobas, Exhibitions Coordinator at the Freer and Sackler galleries, who cheerfully shouldered much of the extra institutional burden that comes with having a guest curator, and kept the arrangements for both the catalogue and exhibition on pace with aplomb and good humor. I will long be beholden to her for remarkable efforts.

The catalogue and exhibition have benefited enormously from the contributions of several other authors, experts all in their respective fields. Dr. Wheeler Thackston has provided masterful translations of the relevant text pages of the manuscript, including many in less than pristine condition; he also patiently read and discussed with me a number of other difficult inscriptions. Dr. Ebba Koch not only contributed a fascinating study of Mughal culture under Akbar, but also greatly facilitated matters in Vienna. There, Rainald Franz of the MAK–Austrian Museum of Applied Arts/Contemporary Art kindly agreed to write on the history of his institution's acquisition and interest in the *Hamzanama* paintings. Through her tireless examination of *Hamzanama* folios in collections in the United States and Europe, Antoinette Owen became a leading authority on the technical aspects of the manuscript.

I must express my thanks to many individuals who provided assistance on matters large and small. In Washington, I am grateful to Jim Smith and Rocky Korr for making available for study over the years the *Hamzanama* paintings at the Freer and Sackler galleries, and to Dr. Massumeh Farhad and Dr. Debra Diamond for attending to a host of exhibition-related matters. In New York, Amy Poster of the Brooklyn Museum of Art, who has long been a most enthusiastic supporter of my research on the *Hamzanama*, cultivated support for this exhibition. At the Metropolitan Museum of Art, Dr. Stefano Carboni, Dr. Navina Haidar, Marie Lukens Swietochowski, and Daniel Walker all provided valuable help at one point or another. My thanks also go to Subhash Kapoor and Navin Kumar.

Elsewhere in the United States, I owe a debt of appreciation to Abolala Soudavar, Art and History Trust; Dr. Joan Cummins, Museum of Fine Arts, Boston; Dr. James Cuno and Mary McWilliams of the Harvard University Art Museums, Cambridge, and Julia Bailey, formerly of that institution; Dr. Glenn Markoe, Cincinnati Art Museum, and Ellen Avril, formerly at the museum; Dr. Stanislaw Czuma, The Cleveland Museum of Art; Dr. Stephen Markel, Los Angeles County Museum of Art; Dr. Darielle Mason, Philadelphia Museum of Art; and Dr. William Jay Rathbun, Seattle Art Museum. I am fortunate to be able to rely on Dr. Catherine Benkaim and Dr. Ellen Smart as colleagues willing to share their vast knowledge of Indian painting.

In London, I wish to express my gratitude to Dr. Ebadollah Bahari, Edmund and Richard De Unger, Sven Gahlin, Sir Howard Hodgkin, Dr. Linda Leach, and Indar Pasricha. Dr. Ernst Grube and Dr. Eleanor Sims generously made available to me their entire file of *Hamzanama* material. Other professional kindnesses have been extended to me by Dr. Henry Ginsburg, Jeremiah P. Losty, and Muhammad Isa Waley of The British Library; Dr. Sheila Canby, The British Museum; Rosemary Seton, School of Oriental and African Studies, University of London; Marcus Fraser, formerly at Sotheby's; Francesca Galloway; and John Guy, Dr. Deborah Swallow, Susan Stronge, and Mike Wheeler of the Victoria and Albert Museum. Elsewhere in Great Britain, I have been given access to exceptional material and resources by David Scrase, The Fitzwilliam Museum, Cambridge University; and by Dr. Andrew Topsfield, Ashmolean Museum, and Adrian Roberts, Bodleian Library, University of Oxford.

In Paris, I am grateful to Francis Richard of the Bibliothèque nationale; Maria Van Berge-Gerbaud, Fondation Custodia; Amina Okada, Musée Guimet; and A.M. Kevorkian. Kjeld von Folsach of the David Collection, Copenhagen, Dr. Michael Ryan and Dr. Elaine Wright of the Chester Beatty Library, Dublin, and Dr. Anna Contadini, formerly of that institution, and the late Hannah Egger at the MAK, Vienna, all went beyond the call of duty in making their paintings available for study and loan. Dr. Karin Rührdanz provided valuable information about the *Falnama* and the *Hamzanama* paintings formerly in German collections. Sheikh Nasser al-Sabah and Katie Marsh took time away from their own busy exhibition planning to respond to our loan request. Dr. B.N. Goswamy and Dr. Sharon Littlefield provided useful documentation of some paintings in Indian collections.

I gratefully acknowledge the private collectors who agreed to lend their works but wish to remain anonymous.

The National Endowment for the Humanities and the University of Vermont provided much-needed financial support for my research on this topic.

My wife, Anna, read over the nightly rushes of the catalogue, and helped keep track of mountains of paperwork. Her encouragement and patience have sustained me over the years of involvement with this project.

JS

I wish to thank the numerous conservators involved in exchanging information on the folios: Mag. Anka Schäning, private conservator, Vienna; Mag. Beate Murr and Mag. Manfred Trummer, MAK, Vienna; Mike Wheeler, Pauline Webber and Anna Hillcoat Imanishi, Victoria and Albert Museum, London; and Carolyn Tomkiewicz, Brooklyn Museum of Art, for her German–English translations.

AO

INTRODUCTION

John Seyller

The *Hamzanama* ('Story of Hamza') is, literally and figuratively, a fabulous book, one that has enthralled many different audiences since its creation in sixteenth-century India. Its appeal is direct and immediate, and requires no schooling in the refined conventions of the more customary literary and artistic fare of the Mughal court. Unlike the standard classics of Persian poetry, whose virtue lay in subtleties of metaphor and rhyme, or Mughal dynastic histories, which blend prosaic fact with high-flown propaganda, the *Hamzanama* is a popular collection of action-filled stories that recount in straightforward, vernacular language the exploits of legendary heroes. Born of the tradition of Persian oral literature that regaled predominantly illiterate audiences around nomadic campfires and in urban coffee-houses, the fantastic tales of the *Hamzanama* so captured the imagination of the young Mughal emperor Akbar (r. 1556–1605) that he recited them personally, and commissioned his fledgling painting workshop to make its first major project a spectacular illustrated copy of the text. The *Hamzanama* is by far the most ambitious of all manuscripts illustrated at the Mughal court, absolutely dwarfing contemporary projects in both size and scope. Whereas most illustrated manuscripts can easily fit in one's hand and include only a dozen or so images, the *Hamzanama* originally comprised 1,400 folios more than two feet high, each painted in a manner that combines passages of unprecedented boldness with others of fine detail. By its scope, size, and execution, then, the *Hamzanama* lends itself to two very different kinds of viewing experience: one, as part of a public recitation dramatized serially by a professional storyteller, the other as the focus of a more intimate perusal of its illustrations.

THE LEGEND OF HAMZA

The tales of Hamza form one of the oldest and most popular romances of the Persian world. Said to have been commissioned originally by one Hamza ibn Abdullah Khareji (d. 828–29), the *Hamzanama*'s basic outline is thought to have been established in Iran even earlier than Firdawsi's celebrated tenth-century epic, the *Shahnama* ('Book of Kings'), with which it shares some anecdotes and verses.[1] Unlike the *Shahnama*, however, the Hamza romance remained largely within the oral tradition. As it was told and retold over the centuries, it became known in many different versions, in many different languages, including Arabic, Urdu, Turkish, Georgian, and even Malay.[2] Even when one particular version happened to be copied out, it never became codified. Thus, there is no standard text to which one can turn to trace the loosely organized narrative, which takes many an unpredictable turn, and is enhanced with optional episodes. The number of sections, for example, varies even among the Persian versions of the *Hamzanama*, ranging from sixty-nine to eighty-two.[3] This narrative elasticity does much to keep oral performances fresh and vibrant, but it greatly complicates the reconstruction of the *Hamzanama* manuscript that is the focus of this book. Similarly, although every effort has been made to coax the present selection of illustrations into a number of coherent story lines, circumstances compel some episodes to stand practically alone. In these cases, our expectation of a sustained narrative development should yield to the spirit of the romance tradition, which prizes a good yarn above all, no matter how it fits into the overall narrative scheme.

Like other popular Persian romances, the Hamza legend has a historical figure at its core. In this case, it is Hamza ibn Abdul-Muttalib, the paternal uncle of the Prophet Muhammad and purportedly his 'milk brother,' having been suckled by the same nursemaid. Hamza, who was born in Arabia about 569, initially rejected Muhammad's teachings, but converted to Islam about 615. He thereupon became one of the faith's most stalwart champions, and figured prominently in the

glorious victory of Badr in 624. In 625, he died at the battle of Uhud, when an Abyssinian named Wahshi struck him down while he was engaged with another opponent. Hamza's extraordinary valor and the ignominious defiling of his corpse have burnished his memory in the popular imagination as both hero and martyr. The Hamza legend also features the nearly contemporary figures of the Sassanian ruler Anoshirvan (r. 531–579) and his minister Buzurjmihr. This nominally locates at least some of the collections of stories in the sixth and seventh centuries. But anachronisms abound, and some parts of the story are colored by the penchant for the fantastic developed in medieval Islam. Many of these picaresque interpolations seem to have been inspired by another figure named Hamza, one Hamza ibn Abdullah, who lived in the region of Sistan in Iran in the late eighth and early ninth centuries and who led the struggle against the caliph Harun al-Rashid (r. 786–809).[4] Although this second Hamza was much less orthodox in his religious orientation, he did venture further afield. Over time, then, the two Hamza figures appear to have been conflated into an idealized and Persianized combination of righteous bravery and piety. The Hamza romance, therefore, is neither a biography of a single historical individual nor an account of the spread of Islam, but a collection of wildly entertaining stories something in the order of *The Thousand and One Nights* or the lore of Robin Hood.

The *Hamzanama* is, above all, a tale of heroes, foremost of whom is Hamza himself. Persian heroes are typically handsome, courageous, chivalrous, strong, and proud, but their list of virtues really stops there.[5] They are not particularly intelligent and almost never pause for any sort of philosophical reflection, so other characters are introduced to complement the king or champion: the vizier offers him wise counsel, and an *ayyar*, a kind of resourceful spy, faithfully does whatever dirty work is necessary. The *ayyar* is usually delegated to baffle, torment, or execute enemies, sullying tasks a hero personally avoids as much as possible. When a hero is compelled by duty to take the life of an opponent, he does so only after giving him ample opportunity to submit and convert. The same complementary pairing of personalities occurs among the women whom a hero encounters. Princesses are inevitably beautiful and virtuous, and are the objects of fleeting but honorable romantic attachment (Hamza, for example, marries a Greek princess), but the women who participate in the most dangerous activities are usually their clever handmaidens (see cat.60, 61, and 66). Similarly, a hero's primary opponents are often kings or princes in their own right, complete with their own ministers and *ayyar*s. Naturally, they are not nearly as capable or handsome as the heroes; indeed, they tend to be artless in thought and oversized in physique. Sometimes defeated brawny opponents become a hero's staunchest allies, as is the case with Landhaur, an imposing Moor from Ceylon (Sri Lanka) who is carried away by a demon (cat.25), and Umar Ma'dikarb, who displays the heft and sturdiness of Friar Tuck (cat.40).

Most characters assume sobriquets or names that reveal their nature.[6] This standard device, which announces the figure's basic identity to the audience, is used for major and minor characters alike. Hence, Hamza is often referred to as Sahib-Qiran ('Lord of the Auspicious Conjunction'), while the archfiend Zumurrud Shah occasionally has 'the Wayward' or 'the Lost' appended to his name. One of Hamza's offspring, Prince Badi'uzzaman ('Wonder of the Age,' cat.42), has his glorious fate writ in his very name, whereas typically fearsome adversaries, Marku' Boar-Tooth (cat.41) and Ra'im Khun-Asham ('Ra'im Blood-Drinker,' cat.39), have their reprehensible behaviors indelibly tagged by theirs. A friendly *ayyar* goes by an epithet that highlights his speed or stealthiness, such as Songhur Balkhi ('Falcon of Balkh,' cat.58, 64) or Sabukpay ('Fleet of Foot,' cat.58); conversely, a hostile *ayyar*'s

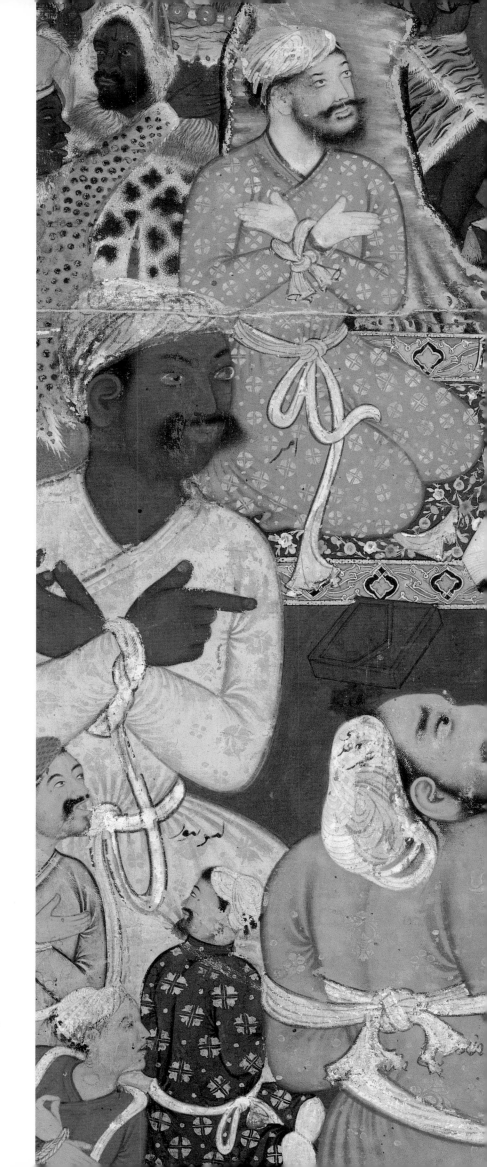

Detail of CAT 53

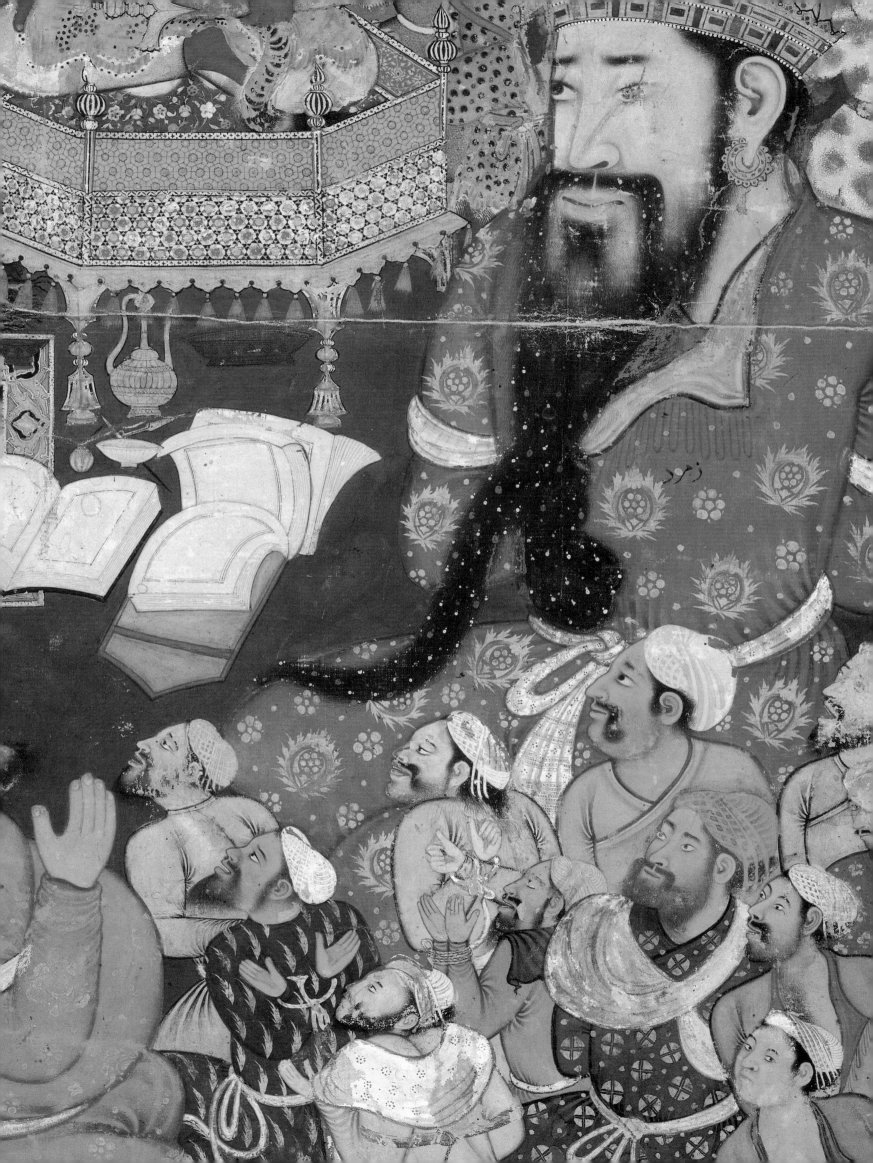

seditious nature or deviant appearance is conveyed by a nickname such as Shahrashob ('Disturber of the City,' cat.30, 34) or Kajdast ('Crooked Hand,' cat.66). Women are always lauded for their beauty and grace, whether they trade upon their royal station or streetwise wiles. Accordingly, an opposing princess-turned-heroine bears the appellation Malak Mah ('Angel Moon,' cat.63), while even a hardened female operative is elevated by the moniker of Khosh-Khiram ('One Who Walks Elegantly,' cat.66).

The collection of Hamza stories begins, as these popular romances generally do, with a short section describing events that set the stage for the appearance of the central hero. In this case, the place is Ctesiphon in Iraq, and the initial protagonist is Buzurjmihr, a child of humble parentage who displays both a remarkable ability to decipher ancient scripts and great acumen in political affairs (see fig.13).[7] By luck and calculated design, Buzurjmihr displaces the current vizier, and attaches himself first to the reigning king, Qubad, and then to his successor, Anoshirvan. Nonetheless, a bitter rivalry has been seeded, for the widow of the wicked dead vizier bears a son she names Bakhtak Bakhtyar, and he in turn becomes a lifelong nemesis of both Hamza and Buzurjmihr. The latter soon relates a vision to Anoshirvan that a child still in embryo in Arabia will eventually bring about his downfall; Anoshirvan responds in Herod-like fashion, dispatching Buzurjmihr to Arabia with an order to kill all pregnant women. Emerging unscathed by this terrible threat are Hamza and Umar Umayya, who is destined to be Hamza's faithful companion.

Unlike most Persian heroes, Hamza is not born to royalty, but is nonetheless of high birth, the son of the chief of Mecca. An auspicious horoscope prophesies an illustrious future for him. Hamza shows an early aversion to idol-worship, and with the aid of a supernatural instructor, develops a precocious mastery of various martial arts. He soon puts these skills to good use, defeating upstart warriors in individual combat, preventing the Yemeni army from interdicting tribute to Anoshirvan, and defending Mecca from predatory – but not religious – foes. Anoshirvan learns of these sundry exploits, and invites Hamza to his court, where he promises him his daughter Mihr-Nigar in marriage. The girl is thrilled at this match, for she has long yearned for Hamza, and has had one soulful but chaste evening with him.

First, however, Anoshirvan sends Hamza to Ceylon to fend off a threat from Landhaur, and thence onto Greece, where Bakhtak Bakhtyar has insidiously poisoned the kings against him. Hamza, of course, proves his mettle in these and other tests, but his marriage to Mihr-Nigar is forestalled by the treacherous Gostaham, who arranges her nuptials with another. Hamza is seriously wounded in battle with Zubin, Mihr-Nigar's prospective groom, but recovers to ally himself with some fairies, supernatural creatures engaged in their own struggle against elephant-eared demons known as the Qaf, on the promise of the fairies' assistance against his opponents. Hamza prevails again, and is rewarded with some legendary weapons, a three-eyed horse produced by the union of a demon and a fairy, and the hand of a fairy named Asma, with whom he has a daughter. Though life among the fairies presents untold pleasures and challenges, it does not slake Hamza's desire for Mihr-Nigar, to whom he vows to return. True to his word, he does so in Tangiers, albeit after eighteen long years, and eventually Hamza and Mihr-Nigar are married. Such a long interlude among the fairies seems capricious at first, but it is hardly so, for it was all prophesied for Hamza upon his birth.

While Hamza and his allies navigate various shoals of courtly intrigue, they also wage a pro-longed war against infidels. Although the ostensible goal of these conflicts is to eradicate idolatry and convert opponents to Islam, the latter is usually related with little fanfare at the end of the

episode. Champions often proclaim their faith in God as they take to the battlefield, and sometimes reproach unbelievers for failing to grasp that the Muslims' past military success is *prima facie* evidence of the righteousness of their cause. However standard and overt this proselytizing is in the formal triumphant speeches in the text, surprisingly few religious references are admitted into the illustrations of the *Hamzanama* manuscript. The most explicit is a painting in which idols fall to the ground and sea creatures churn the sea in delight at the birth of the Prophet (cat.22). Another work shows Hamza returning home to greet his father at Mecca, a holy city identified visually by the Ka'ba.

Having vanquished adversaries and tracked down long-lost loves in their own region, Persian heroes roam about, often undertaking long voyages to foreign lands to find new sources of adventure. To judge from the many paintings in which seafaring ships appear, the favorite means of travel was by ocean, to destinations as far-flung as Greece, the Caucasus, India, Ceylon, and Abyssinia. Although Hamza in fact never left the Arabian peninsula, in legend he arrives at an endless series of strange lands, a staple feature of entertainment in popular romances.[8] In these exotic locales, which are often described as islands, Hamza and his companions come across many a marvelous creature, such as witches, demons, and dragons. They frequently manhandle their adversaries, of course, but sometimes they are able to convert them simply with intimidating displays of their physical prowess, whether unleashing a deafening roar or singlehandedly hoisting an elephant overhead (cat.52). Even heroes falter occasionally, however, so many a story is devoted to imprisonment, both feigned and real. Sometimes a hero's friends liberate their imprisoned comrade from purportedly inescapable fortresses or dungeons by conventional means, such as a tunnel; at other times, they do so with the aid of magic formulas hidden in the most unlikely places, such as among the feathers of a slain bird. There is magic aplenty in this world of heroes. It regularly produces miraculous escapes from tight spots by heroes and their enemies, whether in the form of sudden flight on thousands of magical flying urns (cat.57), or that of *deus ex machina*: a helping hand reaching down from the clouds to save a rascal from the clutches of his foes (cat.69). In short, the strange, occasionally bizarre nature of the stories often begs the audience to suspend disbelief, an act few listeners are inclined to resist.

Despite its widespread popularity throughout the Islamic world and particularly in India, the *Hamzanama* is presently known only in two manuscripts made in the subcontinent. One, with 189 paintings, was produced in the mid-fifteenth century in one of the Muslim kingdoms of northern India.[9] Nothing about this earlier manuscript predicts the narrative choices and astounding visual impact of the magnificent copy commissioned by Akbar a century later. Zumurrud Shah, for example, is conspicuously absent from the Sultanate manuscript, but figures prominently in the Mughal one. The small illustrations of the fifteenth-century work are simply conceived and executed, with a few rudimentary figures crowding out almost all other elements in each composition. Similarly, when shortly after the completion of the *Hamzanama* project Akbar ordered an illustrated copy of a very comparable popular romance, the *Darabnama* ('Story of Darab'), he did not call upon the imperial Mughal workshop to create anything beyond the ordinary, either in the size of the manuscript or in the technical quality of its illustrations.[10] Hence, it seems apparent that while the performance tradition of this type of text raised the possibility of a large-scale manuscript format, it was the exceptionally auspicious conjunction of a dynamic and visionary patron and the very recent assembly of talent from the furthest reaches of the rapidly expanding Mughal empire that occasioned this monumental work.

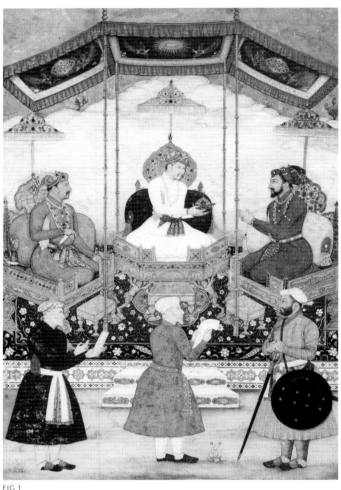

FIG 1 FIG 2

The first six rulers of the Mughal dynasty – the 'Great Mughals' as they were known in the West – were all fascinating and singularly gifted individuals, and among them Akbar (1542–1605) has been regarded as the most outstanding, even by thinkers who are critical of the notion of kingship and its impact on society (fig.1).[1] More has been written on Akbar's reign than on any other period of Mughal history; only the interest devoted to his great-grandson Awrangzeb (1618–1707), the last of the Great Mughals, who is seen as his negative counterpart and under whom the empire began to disintegrate, comes close. Akbar has become such a popular subject of research and has been studied from so many different angles not only because of his personality and dynastic context but also because his reign covered perhaps one of the most dynamic periods in Indian history, a time of profound social, intellectual and religious transition. Students of Mughal India have increasingly become interested in the manner in which Akbar dealt with these developments and was influenced by them. In India it is felt that his own influence reaches into our times; he has been considered a founding father of the Indian nation, a unifier who brought large parts of the subcontinent together under a single government. Akbar's tolerant stance toward all religions, striving in particular to reconcile his Hindu and Muslim subjects, has lost none of its exemplary appeal, especially today, in times of increasing communal tension.

Fig.1
*Dynastic group portrait of
Akbar between his son
Jahangir and his grandson
Shah Jahan, to whom he
transfers the Timurid crown*
From the Minto album.
Painted by Bichitr. Mughal,
1630–31. 29.77 x 20.5 cm.
Chester Beatty Library,
Dublin. MS.7, no.19.

Fig.2
*Dynastic group portrait of
Timur between Humayun
and Babur, to whom he
hands his imperial crown*
From the Minto Album.
Painted by Govardhan.
Mughal, *circa* 1630.
38 x 27 cm. Victoria &
Albert Museum, London,
I.M.8-1925.

Fig.3
*The capture of Sultan
Bayezid I of Turkey*
Mughal, *circa* 1680.
39.3 x 23.8 cm. The British
Library, London, Oriental
and India Office
Collections, Johnson
Album 1, no.2.

Akbar has not failed to capture the imagination of the West. In eighteenth-century Europe, when the 'Great Mughal' had become a synonym for oriental absolutism, Akbar even appeared in opera; he lent his name to a tyrant king in *Zemira*, composed by Pasquale Anfossi after a libretto by Gaetano Sertor and staged in Venice in 1782. At the end of the twentieth century, Akbar became known to a wider Western public mainly through the arts patronized by him, which were featured in several general exhibitions on Mughal art.[2]

AKBAR'S ANTECEDENTS

When Akbar came to the throne in 1556 at the age of thirteen, there was little to foretell that by the end of his reign in 1605 the Mughal empire would extend from Kabul to the Deccan and from the Arabian Sea to the Gulf of Bengal, and that the Mughal *padshah* or *badshah* (commonly translated as 'emperor') would have become the third player in the 'triumvirate of giants of South and Southwest Asia, the Great Turk [the Ottomans], the Great Sufi [the Safavids], and the Great Mughal.'[3] Indeed, Akbar's reign began inauspiciously: his father Humayun (1508–1556) had famously died from a fall down the stairs of his library, having only recently returned to Delhi from exile in Iran to wrest back from his rival Sher Shah Sur the Mughal dominions in India which had been conquered by his father Babur (fig.2).

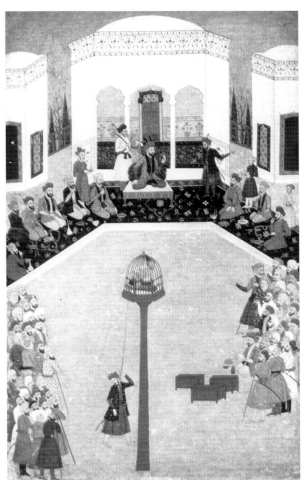

FIG 3

After moving from Samarkand via Kabul into India, Babur (1483–1530) had vanquished the Delhi sultanate in 1526, with the *Zafarnama* literally in his hands. In that work, completed in 1424–25, the historian Sharafuddin Ali Yazdi had described and extolled the conquests of Timur, Babur's famous ancestor, who had taken Delhi in 1398. Timur, or Tamerlane as he was known in the West, had brought large parts of Asia, from Samarkand to Anatolia, under his sway in a neo-Mongolian drive of conquest. Living up to his Latin nickname, *Orientis terror*, he had won himself the favor of Europe at the battle of Ankara in 1402 by defeating Sultan Yıldırim Bayezid so devastatingly that the Ottomans were kept from taking Constantinople for another fifty years. The Mughals always felt superior to the Ottomans because of the humiliation of Bayezid, whom Timur had captured and, so the historical rumor goes, taken in a cage on his way back to Samarkand (fig.3), using him as a step when mounting his horse.[4] The Ottomans could not improve their reputation in Mughal eyes even when they claimed, wrongly of course, to have conquered Vienna, as the Turkish admiral Sidi Ali Reis did when a shipwreck brought him to the court of Humayun in 1554.[5]

The Mughals were at all times more closely engaged with the Safavids, the descendants of the Sufi shaykh Safiuddin and the third Muslim superpower in Asia, not only because they were their immediate neighbors but also because as shahs of Iran they were the heirs of the ancient kings of Persia, the Achaemenids and Sassanians, who had long since been accepted by Islam as model rulers and exemplary kings. Persian was the language of the Muslim courts of Asia, and Persianate culture formed the life of the ruling elite at those courts and in the cities.

As the latest of the three superpowers to emerge, and as an elite minority ruling over a vast territory of peoples of different creeds and cultures, the Mughals were particularly driven to legitimate themselves, and they relied above all on their impeccable Turko-Mongolian lineage. Babur's claim to the title and status of *padshah* was bolstered by the fact that he descended not only from Timur but also, on his mother's side, from the even greater pan-Asian force, Chingiz Khan, who in turn had inspired Timur. The attitude of the Mughals toward Chingiz was ambivalent: on the one hand, they were proud of their Chingizid blood; on the other, they preferred to be associated with the more recent and more refined Timurids. For the people of India, however, they remained 'the Mongols' (*Muggula, Mugala*);[6] the Europeans followed suit and gave them the dynastic title Grao Mogor, Groote Mogul, Grand Moghol, or Grossmogul.

Timur's sons and successors had established a splendid courtly culture of Persianate orientation centered first at Samarkand and then, toward the end of the fifteenth century, at Herat in present-day Afghanistan; it was reflected by smaller Timurid principalities like that of Farghana, where Babur was born. But this background does not explain Babur's astonishing career as an adventurer and ruler, nor how he became the author of the *Baburnama* (probably begun around 1494), an outstanding autobiography at any time, but in particular for a Central Asian prince of the sixteenth century. He comments with candor and in almost Proustian detail on wide-ranging subjects, from his youthful infatuation with a boy in his encampment to his peregrinations and campaigns in Central Asia and India to the flora and fauna of newly conquered Hindustan.[7] Babur's matter-of-fact, rational approach seems to have laid the foundation for Akbar's thinking, in which reason was the driving force, and it remained a characteristic of the Mughal dynasty in general, at least until Awrangzeb.

In Hindustan, as the Mughals called northern India, Babur overthrew the Lodi dynasty (1451–1526), the last rulers of the Delhi sultanate which had shrunk throughout the fifteenth century while regional sultans asserted themselves. Especially in areas far from Delhi, such as Bengal and

Kashmir (which was always a place apart), the sultans had presented themselves as rulers in Indian terms and had interacted with the local societies and cultures.[8]

The Mughal horizon widened further with Humayun's exile in Iran, where he took refuge with Shah Tahmasp in 1544. This involuntary sojourn intensified the Mughals' contact with Persian culture and inspired the distinctly eccentric Humayun to further enrich the Mughal myth of kingship, which he had begun to develop in India, with borrowings from ancient Persian concepts. It seems that his intentions were widely known: Mulla Abdul-Qadir Badauni tells us that when Humayun was in Mashhad in 1544, a pilgrim whispered in his ear ' "So! you are again laying claim to omnipotence!" This was a reference to the circumstance that Humayun used generally in Bangala [Bengal] to cast a veil over his crown, and when he removed it the people used to say, Light has shined forth.'[9]

Thus Humayun associated himself with Indian and Iranian practices of sun-rulership and with the old Iranian concept of the divine effulgence of the king, none of which was forgotten in Islamic times. The learned theologian, poet and moralist Davani, for instance, who visited Persepolis in 1476 with Sultan Khalil, the son of the Turkman ruler Uzun Hasan, claims that the mythical Persian king Jamshed, after having constructed Persepolis

> had caused a golden throne, studded with shining jewels, to be placed on the columns ... and sat on it in state. At sunrise he ordered the throne to be turned towards the Sun, and the eyes of the onlookers were dazzled by the brilliancy. Saying that they beheld two suns, one in the sky and the other on earth, they knelt down ... and thenceforth he was surnamed Jamshid, his name being Jam and shid meaning 'Sun'.[10]

The concept of divinely illumined kingship was to become a leading idea in the Mughal myth of rulership. Back in India, Humayun must have thought of the legendary carpets and throne of the Sassanian Khusraws when he designed a large cosmological carpet of concentric rings on which his court had to sit according to origin and rank, with the emperor 'like the Sun' in the center.[11]

AKBAR AS UNIVERSAL RULER

Realizing that the concept of divinely illumined kingship was also part of Indian tradition, Akbar elaborated on Humayun's associations between the ruler and the sun; he appeared at sunrise like a traditional Indian king or a Hindu deity for public viewing (*darshan*) and his subjects prostrated themselves before him. He even went so far as to pray to the sun, as his heavenly counterpart (fig.4).[12] Jahangir (1569–1627) and Shah Jahan (1592–1666) were to develop further the idea of Mughal sun-rulership, which was abolished by the orthodox Awrangzeb because he disapproved of it as un-Islamic. It is possible that these ideas reached the court of Louis XIV and inspired him to formulate his own version, which provided the myth of European absolutism.

Such multicultural concepts held a special attraction for the Mughals in their attempt to legitimate themselves as *padshah*s of a highly diverse empire: the very status of a ruler might work as a unifying factor equally if not more important than his religion or cultural background. In India, Muslim rulers had long since been integrated into the social order of the Hindus; they were treated on the same terms as Indian kings, even as mythological heroes or gods. This phenomenon can be observed particularly in Bengal from the early fifteenth century onward,[13] and in Kashmir at about the same time. The historian Shrivara Pandita, who completed the section of the *Rajatarangini* written by Jonaraja, compares Sultan Zaynulabidin (Shri Jainollabhadina, r. 1420–70) with Indra

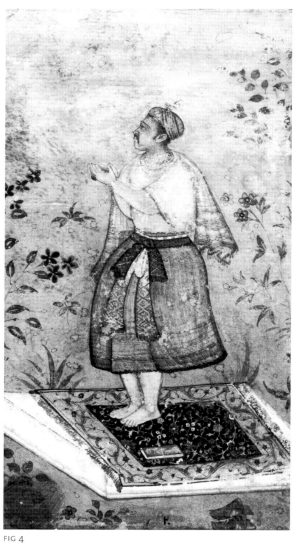

FIG 4 FIG 5

and celebrates him as 'an incarnation of Vishnu.'[14] In the sixteenth-century Sanskrit work *Bhanuchandra-charita*, 'Sahi Srimad-Akabbara (Akbar)' is projected as Rama.[15] From the disapproving Badauni we learn that his emperor lent an open ear to such associations:

> Brahmans collected another set of one thousand and one names of 'His Majesty the Sun,' and told the Emperor that he was an incarnation, like Ram, Krishna, and other infidel kings.[16]

The Mughal myth of kingship acquired a distinct Sufi dimension when Akbar was declared the Perfect Man (*insan al-kamil*) who establishes Universal Peace (*sulh-i kul*) between Muslims and Hindus.[17] From one who sought the blessings and support of Sufi saints, of Shaykh Salim Chishti of Fatehpur Sikri and of Shaykh Mu'inuddin Chishti of Ajmer, Akbar became a spiritual authority in his own right. Thus the old dichotomy between the power of Sufi saints and the worldly authority of the sultans was resolved in the imperial person of Akbar. To this end his alter ego, friend, advisor, biographer, and (as Richard Eaton has put it) principal ideologue, Abu'l-Fazl (1551–1602) idealized even the historical Akbar in a neoplatonic construct: every one of his apparent actions underlies

Fig.4
*The Emperor Akbar
praying toward the sun*
Mughal, *circa* 1590.
11.5 × 6.5 cm. Keir
Collection, London.

Fig.5
Portrait of Akbar
Mughal, perhaps early
17th century. 13.3 × 13 cm.
The British Library, London,
Oriental and India Office
Collections, Add. Or. 1039.

a true spiritual meaning. This gives his *Akbarnama* (1589–95), despite its aim of historical authenticity, a mystical and mythical dimension.

Akbar not only associated himself with historical, mythical and spiritual kingship to strengthen his own authority as a ruler, but also widened this frame of reference and sought access to the contemporary family of rulers of the world. He states this explicitly in a letter, still little studied, which he wrote in 1582 to King Philip II of Spain, whom he tried to win over to an alliance against the Ottomans:

> we are, with the whole power of our mind, earnestly striving to establish and strengthen the bonds of love, harmony and union among the population, but above all with the exalted tribe [*ta'ifa*, here better 'family'] of princes [sultans], who enjoy the noblest of distinctions in consequence of a greater (share of the) divine favour, and especially with that illustrious representative of dominion, recipient of divine illumination and propagator of the Christian religion, who needs not to be praised or made known [i.e. Philip]; (and this decision is) on account of our propinquity, the claims whereof are well established among mighty potentates, and acknowledged to be the chief condition for amicable relations.[18]

But Akbar did not come to the family of kings as a humble supplicant. In a letter of 1594 to Shah Abbas, he admonished the Iranian ruler for his intolerance in religious matters, and he expressed the opinion that his own stance toward different religions and cultures gave him the right to rule above them all:

> as it has been our disposition from the beginning of our attaining discretion to this day not to pay attention to differences of religion and variety of manners and to regard the tribes of mankind as the servants of God, we have endeavoured to regulate mankind in general.[19]

Akbar implied that he was superior to rulers like Philip II or Shah Abbas, because they accepted only one religion and acted merely within one culture while his tolerance gave him the moral authority to take care of all mankind. Thus he was a true universal king.

AKBAR'S RELIGIOUS POLICIES

On the political level, Akbar unified large parts of India in several military campaigns, bringing Malwa (conquered 1562), the Rajput states (1561–69), Gujarat (1573), Bengal (1576), Kashmir (1586), and Khandesh (1601) under Mughal rule and securing the northwestern frontier by recapturing Kabul and Qandahar (1595). At the same time, the emperor (fig.5) and Abu'l-Fazl sought to consolidate the political unification by a policy of cultural reconciliation. Religion was a main issue in this project.

Akbar had a deep personal interest in spirituality, which he tried to reconcile with Mughal rationalism. He first identified with Islam, with Sunni orthodoxy, but, frustrated by the diverging opinions of the *ulama*, he established in 1575 the *Ibadatkhana* ('House of Worship'), where an increasing range of religions was discussed, with Shiites, Hindus, Parsis, Jains, and Christians all participating.[20] But Akbar wanted to explore beyond the interpretations of the preachers and decided to have the source books of different religions translated into Persian, the language of the Mughal court and empire. He established a translation bureau (*maktab khana*) for which every talent was recruited, even such unwilling ones as Badauni, who had entered court service at the end of April 1574 and who, when ordered by Akbar to translate Sanskrit texts, hoped that God would allow that 'the translation of atheism is not atheism.'[21]

Akbar went even further in his search for the true religion, natural to all men, and in the late

1570s started a Kaspar Hauserian experiment. He had children brought up in a secluded house with nurses who were not allowed to talk to them, to find out whether they would speak on their own and in what language, and 'what religion and sect these infants would incline to, and above all what creed they would repeat.'[22] The project failed tragically when 'after three or four years they all turned out dumb' – some of the children even died. This experiment bespeaks the Mughal empirical approach (which was to take a turn toward natural history in Akbar's son, Jahangir) but it also has a long tradition among kings and appeared at different times in different cultures.[23]

In 1578, Akbar's comparative religious studies acquired a new dimension; he asked the viceroy of Goa 'for two learned priests who should bring with them the chief books of the Law and the Gospel'; in 1580, the first Jesuit mission reached the Mughal court, bringing along the latest and most prestigious edition of the Bible then available in Europe, the Royal Polyglot Bible, which had been sponsored by Philip II of Spain and published by Christophe Plantin in Antwerp between 1568 and 1572. The Jesuit fathers joined the religious 'think tank' at Akbar's court in the misguided hope of converting him to Christianity; they misunderstood Akbar's pre-Enlightenment interests because these did not fit into their mono-religious thinking (fig.6).[24]

Eventually Akbar accepted all religions, perceiving reason as their common truth, as he tells us in his own words in his letter to Philip II:

> As most men are fettered by bonds of tradition, and by imitating the ways followed by their fathers, ancestors, relatives and acquaintances, everyone continues, without investigating the arguments and reasons, to follow the religion in which he was born and educated, thus excluding himself from the possibility of ascertaining the truth, which is the noblest aim of the human intellect. Therefore we associate at convenient seasons with learned men of all religions, thus deriving profit from their exquisite discourses and exalted aspirations.[25]

One would like to know how Akbar's ideas were received at the court of the Most Catholic King Philip II, the promoter of the Spanish Inquisition. Even Akbar knew the king as a 'life giver to the Christian laws (*muhyi-yi marasim-i 'Isawi*)' and the Jesuits – with whom he discussed an embassy that would take the letter to Philip – would have informed him about the uncompromising attitude of the Spanish Habsburgs toward other religions during the *reconquista* of Spain. Philip's father, Emperor Charles V, had allowed an entire cathedral to be built right in the middle of the eighth-to-tenth-century Great Mosque of Cordoba, as a visible sign that Spain had been wrested from the Muslims. Akbar would have been better understood by thinkers like Lord Herbert of Cherbury (1583–1648), the father of English deism and a contemporary of Descartes. Lord Herbert commended a 'natural' religion, demanded and established by reason common to all men, and capable of finding universal acceptance.

The Polyglot Bible that the Jesuits had brought to the Mughal court had been created out of an interest similar to the one that had driven Akbar to ask for it, namely to obtain an authentic and reliable text, but the two rulers' ultimate motivations were, of course, different. The Polyglot Bible was to be the one and final Catholic answer to the host of translations into vernacular languages with which Protestant reformers had flooded Europe. Plantin himself had a vested interest in publishing the Bible because he hoped thus to free himself from accusations of heresy. The publisher was a member of the Family of Love, one of the sects which had come into being in the spiritual climate heralded by the proclamations of Luther and Calvin; their creed held up universal love

Fig.6
The Jesuits Rudolf Aquaviva and Antonio Monserrate at Akbar's court
From an imperial copy of the *Akbarnama*.
Painted by Nar Singh.
Mughal, 1597. 28 × 20 cm.
Chester Beatty Library, Dublin. ms.3, f.263b.

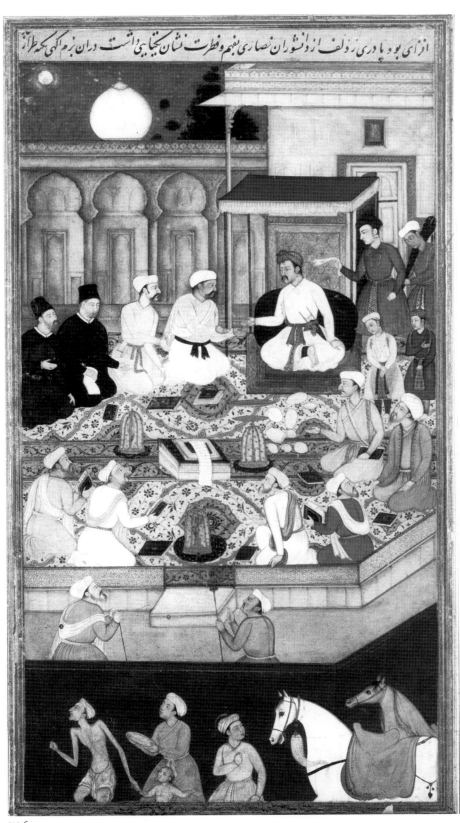

FIG 6

or charity as the supreme doctrine and dismissed all religions and religious establishments as superfluous.[26]

A kindred spirit reigned at the Mughal court, which was deeply influenced by the ideas of the great Spanish Sufi thinker Ibn al-Arabi (d. 1240), who wrote:

My heart has become capable of all forms.
It is a meadow for gazelles and monastery for Christian monks.
A temple for idols and the pilgrim's Kaba.
The table of the Law and the book of Koran.
I profess the religion of Love, and whatever direction
Its steed may take, Love is my religion and my faith.[27]

An inscription composed by Abu'l-Fazl for a temple at Kashmir reflects these thoughts:

O God, in every house I see people that seek you, and in every language I hear spoken, people talk about you.
Infidelity [*kufr*] and Islam walk on your way and say, 'He is one, without companion.'
If it be a mosque, people remember you with holy calls, and if it be a church [*kalisa*], they ring the bell out of desire for you.
Oh the arrow of your love – the heart of the lovers is its target ...
Sometimes I withdraw to a monastery [*dair*], and sometimes I stay in a mosque, but it is you whom I search from house to house.
Your servants have no dealings with either infidelity or Islam; for neither of them has access behind the curtain of the submission to you.
Infidelity to the unbeliever, and religion to the orthodox,
The smell of the rose petal belongs to the heart of the perfume-seller.
This house was erected for the purpose of binding together the hearts of the Unitarians of Hindustan, and especially the worshippers of the Deity in the region of Kashmir,
By order of the Lord of the throne and the crown, the lamp of creation, Shah Akbar ...
He who looks at this building with insincerity and destroys it should first demolish his own place of worship; for if we look at the heart, we must bear with all men, but if we look to the external [lit. water and clay], [we find] everything proper to be destroyed.[28]

This questioning of established religions and institutions at the Mughal court did not represent an isolated elite moment; it reflected ideas widespread in sixteenth-century Indian society, propagated by Sufi orders and *bhakti* sects. Eugenia Vanina has tried to draw a parallel between these movements and the sects which came into being in Europe during the Reformation, and to explain their differences and points of connection.[29] One difference is certain: in sixteenth-century Europe these ideas never rose to an imperial level.

HISTORIOGRAPHY

Akbar's search for truth and the authentic text also determined the particularly intense phase in Muslim history writing that he sponsored. This was dominated by Abu'l-Fazl's great history of his own reign, the *Akbarnama*. An essential source of inspiration was the Chingizid and Timurid tradition of historiography, at the beginning of which stood the monumental Il-Khanid Mongol

world history of Rashiduddin Fazlullah entitled *Jami'uttawarikh*, 'one of the greatest achieve-ments of historical research of all time.' Ata Malik's history of Chingiz Khan, the *Tarikh-i Jahangusha*, completed in 1260, was also well known at the Mughal court. Sharafuddin Ali Yazdi's history of Timur which had served Babur as a guide to conquering Hindustan, the *Zafarnama*, was highly influential. From India, there was the historiography of the sultans of Delhi, which had had its best moment under the Tughluqs in the fourteenth century, and the famous *Rajatarangini*, the Sanskrit history of the kings of Kashmir, which was written by the Kashmiri Brahman Kalhana in 1148–49 and continued by several authors until some years after the annexation of Kashmir by Akbar in 1586. Akbar recognized this as an outstanding historical work full of important notions about Indian kingship and had it translated by several scholars, including the ever-reluctant Badauni.[30]

The purpose of the close collaboration between Akbar and Abu'l-Fazl was to relate universal history to Akbar, to document his lineage, and to establish him as an exemplary historical truth. The *Tarikh-i Alfi* was compiled on the emperor's order from 1585 onward as a comprehensive his-tory of the Muslim world, from the death of the Prophet to Akbar's time, commemorating the first millennium of Islam. The history of the house of Timur was put together in the *Tarikh-i Khandan-i Timuriyya* (*circa* 1584–86) and Babur's memoirs were translated by Abdurrahim Khankhanan from Turkish into Persian (1589). The basis for the *Akbarnama* was the day-to-day documentation of the Record Office, established by the emperor in 1573–74, but members of the imperial house-hold were also ordered to put on paper what they remembered about the early days of the dynasty. Akbar's old aunt Gulbadan Begam wrote about Akbar's father in her *Humayun-nama* (1591–92). Humayun's ewer-bearer Jawhar Aftabchi came forth with his *Tazkirat ul-Waqi'at* (1586–87) and Bayezid Bayat, who served both Humayun and Akbar, was made to dictate his memoirs, *Tazkira-i Humayun wa Akbar* (1591), to a clerk of Abu'l-Fazl's while supervising the royal kitchen. Although Turkish was their native tongue, these two writers had to submit their accounts in Persian.

THE DOMINANT LANGUAGE

This emphasis on Persian was new in India. Akbar was the first among the Muslim rulers of Hindustan to declare formally that Persian was to be the language of administration at all levels. Here, the Mughals differed from the earlier sultans of India who had shown greater involvement with Indian languages. In the pre-Mughal period Hindavi had been used as a semi-official language by the Lodis and Surs,[31] and in Kashmir, the enlightened Sultan Zaynulabidin had studied Sanskrit in order to understand the *Gita Govinda* and to read the Vedas himself.[32] Akbar's insistence on Persian sheds a new light on his tolerance and translation policy. While he abstained from imposing a dominant religion on India, he imposed instead a non-Indian language, which, as Muzaffar Alam has suggested, became the main instrument of Mughal inculturation and domi-nance of Hindustan and even 'acquired a kind of religious sanctity for the Muslims.'[33] Only those who spoke and read Persian could participate in the Mughal system and through the medium of Persian the diverse Indian cultures and religions were brought into the imperial fold. This system-atic appropriation is comparable to the large-scale translations into Arabic undertaken by the Abbasids in the ninth and tenth centuries AD, through which knowledge of the ancient world came into the House of Islam.

ARCHITECTURE

Akbar's efforts at religious and cultural reconciliation, in particular between his Hindu and Muslim subjects, have been used to explain the arts created for him, especially architecture. Akbar built more and on a larger scale than any Indian ruler before him. We owe to his patronage the great Mughal fortress palaces of Agra (1564–1570s) and Lahore (completed 1580), the suburban residence Fatehpur Sikri with its monumental mosque (1571–85), and Humayun's tomb at Delhi (1562–71), to name just the most outstanding architectural achievements of his reign. It is, however, not quite clear to what extent Akbar was personally interested in architecture; Abu'l-Fazl has remarkably little to say about it, and Antonio Monserrate, chronicler of the first Jesuit mission to the court of Akbar, refers to it only as an occasion for Akbar to demonstrate his physical prowess, when he mingled with his builders and carried blocks of stones.[34] The official Akbari view on architecture can be obtained from Muhammad Arif Qandahari, another historian, who claimed that Akbar designed parts of Fatehpur Sikri, and who represented the architecture of his emperor as a testimony to his rule:

> a good name for kings is [achieved by means] of lofty buildings That is to say the standard of the measure of men is assessed by the worth of [their] building (*imarat*) and from their high-mindedness is estimated the state of their house.
> ... Whosoever saw the spacious expanse of that place [*makan*] and the arrangement of ornament [*nuzhat*] of that edifice [*bunyan*] [the Agra fort (fig.8)] found the affairs of the kingdom and means of authority in full accord with this order and the high and low, in consonance with allegiance and obedience.[35]

These statements justify the interpretation of Akbar's architecture as a 'lithic expression' of his policies.[36] But art historians have too easily drawn an equation between the forms of Akbar's architecture and his *Weltanschauung*. A common practice, which goes back to British notions of the nineteenth century, is to describe arches and vaults as 'Muslim' and brackets and beams as 'Hindu,' and their common use in one building as an expression of Akbar's tolerance.

Abu'l-Fazl saw the use of Indian forms rather in regional terms; he tells us that the buildings of the Red Fort of Agra 'were built in the beautiful styles of Gujarat and Bengal.'[37] Gujarat in particular had, as no other region of India, absorbed older local forms in its Muslim architecture. Thus the Gujarati building types and forms adopted in Akbari architecture could be read as 'Hindu,' if one wanted to disregard their historical development. A particularly telling example comes from the so-called Astrologer's Seat at Fatehpur Sikri (fig.9). Its prominent caterpillar (*ilika-valana*) brackets are a characteristic element of the architecture of Gujarat and thus they have caused this pavilion to be cited frequently as evidence of the direct imitation of Gujarati Hindu or Jain religious architecture. But the structure has a much closer forerunner in an Islamic building in Gujarat, the *mukabbar* kiosk in the courtyard of the Jami' Masjid in Cambay, constructed in 1325 (fig.7). This means that in the Astrologer's Seat Akbar's builders were making reference to what they considered a transculturally successful regional style of India. Another Indian style which was highly influential on Akbari architecture was the ornamental sandstone tradition of the early Delhi sultanate. It had gone out of fashion during the fourteenth and fifteenth centuries in Delhi but continued uninterrupted in provincial centers like Bayana or Kannauj, creating an architectural heritage from which early Mughal buildings could draw inspiration.[38]

We may want to regard Akbari architecture as a testimony of his rule, but it seems more likely

FIG 7

Fig.7
Mukabbar kiosk in the courtyard of the Jami' Masjid, Cambay, Gujarat, completed in 1325.

Fig.8
Agra fort, 1564–1570s.

Fig.9
The so-called Astrologer's Seat at Fatehpur Sikri, 1571–76.

that its intention was to bring 'the regional' on to a supra-regional, imperial level. Selected styles and forms from Hindustan were merged with the building principles and forms of Timurid Central Asia. These components were given new emphasis by magnified proportions, by a new approach to structural logic, reflected in décor and detail, and, at least in the heartland of Mughal building activities at Delhi, Agra, and Fatehpur Sikri, by the unifying medium of red sandstone, which had a high symbolic value. Red had been the color of kings since ancient times and was also used exclusively for imperial Mughal tents. In India, old shastric texts, such as the *Vishnudharmottara* (probably eighth century), recommended red stones for the buildings of the *kshatriya*s, the warrior and kingly caste, and white for brahmins, the priestly caste. By adopting red sandstone as their preferred building material and by highlighting it with white marble, the Mughals revived a practice of the early sultans of Delhi and associated themselves architecturally with those they considered their counterparts, the uppermost ranks in the Indian social hierarchy. Since red sandstone had royal

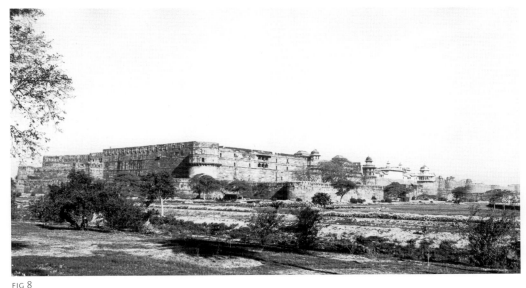

FIG 8

FIG 9

properties in both the Muslim and Hindu traditions, it worked, if we may make this cross-disciplinary comparison, even better than the Persian language as a unifying, appropriating element.

PAINTING

Humayun's stay in Iran had a decisive impact on the formation of Mughal painting. By the time he was to leave the court of Shah Tahmasp in 1544, his host had repudiated the interest in painting of his youth, and thus Humayun was able to bring back to India some of the outstanding masters who had worked on the Shah's great illustrated manuscript, the *Shahnama-i Shahi*, which had been completed in the late 1530s. Often known as the Houghton *Shahnama* after the twentieth-century collector, but now more fittingly referred to as the Shah Tahmasp *Shahnama*, it is considered by many art historians to be the greatest masterpiece of Persian painting (see cat.2). The Iranian painters Mir Sayyid Ali and Abdul-Samad joined Humayun in 1549 in Kabul, where he resided before his return to Hindustan. Later, under Akbar, they became the leading masters of the Mughal court atelier in which a large number of artists created a specific Mughal style, bringing together Persian, Central Asian, Indian, and European painting traditions.[39]

Abu'l-Fazl discusses Akbar's patronage of painting in more detail than his architecture and draws attention to the personal interest the emperor took in this art. Abdul-Samad himself instructed the young Akbar in drawing,[40] and later, as emperor, Akbar supervised the work of his painters on a regular basis. He also spoke repeatedly in defense of painting, which, in contrast to architecture, was a controversial art. Abu'l-Fazl's reports reflect the ambivalent attitude of Akbar's court to painting, and even he cannot free himself entirely from the traditional bias of Muslim treatises on calligraphy and painting when he gives preference to the written word. In an intriguing argument he begins in almost post-modern terms anticipating Saussure's notions of 'sign,' 'signifier,' and 'signified,' continues on a neoplatonic, post-Tridentine note in conceding that painting, especially European naturalism, may serve as a means to recognize a higher truth, and ends with the superiority of writing:

> A picture [*surat*] leads to the form it represents [*khodawand-i khwud*, lit. 'its own master'] and this [leads] to the meaning [*ma'ni*] just as the shape of a line [*paikar-i khati*] leads one to letters [*harf*] and words [*lafz*] and from there the sense [*mafhum*] can be found out. Although in general they make pictures [*taswir*] of material appearances [*ashbah-i kauni*], the European masters [*karbardazan-i firang*] express with rare forms [*ba-shigirf suratha*] many meanings of the creation [*basa ma'ani khalqi*] and [thus] they lead those who see only the outside of things [*zahirnigahan*] to the place of real truth [*haqiqatzar*]. However, lines [*khat*, writing, calligraphy] provide us with the experiences of the ancients and thus become a means to intellectual progress.[41]

Painting was most acceptable when it appeared in connection with the word and thus illustrated books were traditionally the preferred context for painting in Islamic culture. The rich production of books at Akbar's court went hand in hand with their illustration, and producing 'miniatures' for manuscripts was the main occupation of Akbar's court atelier. We also have evidence of figural wall-painting, which made its appearance in Islamic societies over the centuries under 'image friendly' patrons. Akbari wall-paintings are preserved in Maryam's House at Fatehpur Sikri, and we learn that great miniaturists of Akbar's court atelier practiced this art, even in non-imperial buildings. Abdul-Samad, who eventually became the second director of the *Hamzanama* project, painted 'with his own blessed hand [*ba dast-i mubarak-i khud*]' the private apartment [*khilwat khana*] of the house of Khan-i A'zam Mirza Aziz Koka (d. 1624) situated inside the Agra fort.[42]

In Akbar's painting studio artists from different regions of India worked together, and Abu'l-Fazl takes pains to point out the excellence of the Indian masters. The *Hamzanama* project dominated the studio's early years, and in its production we observe the trend toward merging various painting traditions, Persianate, Central Asian, regional Indian, and European to produce what was, for a book, a format on a monumental 'imperial' scale, a development comparable to that seen in architecture.

Besides the *Hamzanama*, Akbar's artists produced paintings for the main works of the imperial scriptorium, illustrating several texts more than once. The focus was first on stories and romance, the *Tutinama* (*circa* 1565–70), *Duwal Rani wa Khizr Khan* (1568), and *Darabnama* (*circa* 1577–80); then on historical works, the *Tarikh-i Khandan-i Timuriyya* (*circa* 1584–86), *Baburnama* (1589), *Akbarnama* (1596–97), and the *Chingiznama* (1596); and then on translations of works of Sanskrit literature, the *Mahabharata* (*Razmnama*, 1584–86), *Harivamsa* (*circa* 1585), and *Ramayana* (1588–91), to name only the principal projects. At all times special interest was taken in the Persian classics, the *Gulistan*, the *Khamsa* of Nizami, and the *Anwar-i Suhayli*. The last of these belongs to a

genre known as the 'Mirror of Princes,' which consisted of political theories, often expressed by fables with a didactic content. The *Anwar-i Suhayli* was illustrated several times – in 1570, *circa* 1575, and 1596–97 – and was rendered by Abu'l-Fazl into simplified Persian prose as the *Iyar-i Danish* and illustrated *circa* 1594. This book of animal tales, which in Arabic is known under the title *Kalila wa Dimna*, had an astonishing history. It goes back to an Indian source, the *Panchatantra*, and became an unparalleled international success as a guide to wise and correct behavior, especially that of rulers.[43]

AKBAR AND THE HAMZANAMA

It remains to try to place Akbar's patronage of the *Hamzanama* within the intellectual and artistic climate of his court, whose activities were intended to establish Akbar as a universal ruler through political and cultural integration on all possible levels in a complex interaction between the regional and supra-regional.

His involvement with the fictional story of Hamza demonstrates the young Akbar's personal interest in the fantastic and ahistorical, which stands in contrast to the emphasis on reason and search for historical truth of his mature years. He thought differently from Babur, for whom the *Hamzanama* served as an example of literature he disliked, 'contrary to good taste and sound reason.'[44] Even Abu'l-Fazl, in his preface to the translation of the *Mahabharata*, warns his readers about the fantastic and fictitious aspects of this work.[45] Badauni for once was of the same opinion as Abu'l-Fazl when he compared the *Hamzanama* ironically with the *Ramayana*:

> Hence it is evident that these events are not true at all, and are nothing but pure invention, and simple imagination, like the *Shahnamah*, and the stories of Amir Hamzah, or else it must have happened in the time of the dominion of the beasts and the jinns – but God alone knows the truth of the matter.[46]

Akbar's openness toward the less rational aspects of life also manifested itself in his actions, when as a young man he hunted obsessively and risked his life by jumping on the back of an elephant gone wild, or when he allowed Abu'l-Fazl to record for posterity in the *Akbarnama* that he fell in a trance (or an epileptic fit) in the forest during a hunt in 1578.

Akbar also made his court a haven for poets, and Mughal poetry came to its real flowering during his reign. Akbar was the patron of Ghazali Mashhadi (d. 1572–73) and Fayzi (d. 1595–96), poets, who, despite being attached to the court, wrote in their own right and not as humble court servants, as did the later eulogists of Shah Jahan; Akbar's commander-in-chief Abdurrahim Khankhanan patronized the great Urfi from Shiraz (d. 1590) and Naziri (d. 1612/13). It was only at the end of Akbar's reign that Abu'l-Fazl could report on a triumphant note: 'As the foundation of poetry has been placed on fancy and fiction, H.M. pays less regard to it.'[47] Abu'l-Fazl did not see that in engaging 'fancy and fiction' Akbar proved himself more of a universal man than Abu'l-Fazl had ever conceived him to be.

John Seyller

With every known volume of the Mughal *Hamzanama* manuscript broken up, and the opportunity to view more than two or three pages at one time now a rarity, it is easy to lose sight of the original scale and function of this remarkable work. We can, however, reconstruct the way in which the *Hamzanama* was organized and used by the Mughals by gleaning information from scattered literary references and the long-overlooked physical evidence of folio construction and size, folio numbers, inspection notes and seal marks on the paintings themselves.

LITERARY REFERENCES TO THE *HAMZANAMA*

The limited set of contemporary literary references to the *Hamzanama* agree on most aspects of the manuscript: its physical size, the number of paintings per volume, the key artists employed, and the rate of production. But these same sources contradict each other on a few important points, notably the number of volumes and the dates of production, and have thereby provoked some longstanding scholarly disagreements. To resolve these discrepancies, one must assess the authority of each writer, and measure the accuracy of his statements against the facts that can be verified now.

The earliest reference to the *Hamzanama*, or *Qissa-i Amir Hamza* ('Story of Amir Hamza') as it is always known in contemporary texts, is the *Nafais al-Maasir* ('Riches of Glorious Traditions'), a commentary on poetry and a compendium of biographies of poets written by Mir Ala al-Dawla Qazwini. The author belonged to a distinguished family of scholars. His father, Mir Yahya Hasani Sayfi, was an eminent court historian for Bahram Mirza, the brother of Shah Tahmasp, but was imprisoned in his old age because his enemies impugned him for being a Sunni; his elder brother, Mir Abdul-Latif, seeing the harsh new religious climate in Iran, fled to India at Humayun's invitation. By the time he reached India, the young and unlettered Akbar had acceded to the throne and, receiving Mir Abdul-Latif with honors, quickly accepted him as his tutor and confidant.[1]

Mir Ala al-Dawla himself, who is recorded as being in Qazwin in AH 971 (AD 1563–64), made his move to India shortly before AH 973 (AD 1565–66), when he commenced the *Nafais*. The autograph copy of the text uses chronograms to give the dates of inception, AH 973 (AD 1565–66), and completion, AH 979 (AD 1571–72).[2] An eight-folio addendum to the manuscript, written on different paper but apparently in the same hand, recounts the events of a campaign in Gujarat that transpired after the completion date, that is, AH 980 to 11 Muharram 981 (AD 1572–15 May 1573). A concluding section of forty-six folios offers a hagiographical tribute to Akbar. On the final folio (335a), below the chronogram and a separate numerical date of AH 979, is a three-line note written in Arabic; it states that 'Niẓām b. Aḥmad Dihlawī wrote some sections of the book on 8 Rabiʿ II 980 [18 August 1572] in the city of Ajmer.'[3] On the opposite side of the final folio is a note indicating that the book was presented to Akbar for his approval, which, it is postulated, must have been before the emperor left Ajmer for Gujarat on 22 Rabiʿ II (1 September 1572).[4] Thus, it appears that the text in the main portion of the manuscript was written between AH 973 and AH 979 (29 July 1565–25 May 1571), and that the section by Nizam b. Ahmad Dihlawi and the author's marginal notes throughout the manuscript were penned later, that is, between AH 980 and AH 981 (14 May 1572–22 April 1574).

These admittedly involved chronological details are important because Mir Ala al-Dawla makes two crucial series of remarks about the *Hamzanama* in a biographical entry on the painter Mir Sayyid Ali, who also wrote poetry under the *nom de plume* of Judaʾi. The first, which appears in the body of the text, is as follows:

It is now seven years that the Mīr has been busy in the royal bureau of books (*kitāb khāna-i ʿālī*), as commanded by His Majesty (*ḥaẓrat-i aʿlā*) in the decoration and painting of the large compositions (*taṣwīr-i majālis*) of the story of Amīr Ḥamza (*qiṣṣa-i amīr ḥamza*), and strives to finish that wondrous book which is one of the astonishing novelties that His Majesty has conceived of. Verily it is a book the like of which no connoisseur has seen since the azure sheets of the heavens were decorated with brilliant stars, nor has the hand of destiny inscribed such a book on the tablet of the imagination since the discs of the celestial sphere gained beauty and glamour with the appearance of the moon and the sun. His Majesty has conceived of this wondrous book on the following lines. The amazing descriptions and the strange events of that story are being drawn on the sheets for illustrations in minuscule detail and not the subtlest requirement of the art of painting goes unfulfilled. That story will be completed in twelve volumes, each volume consisting of one hundred leaves (*waraq*); each leaf being one 'yard' (*zarʿ*) by one 'yard,' containing two large compositions (*majlis-i taṣwīr*). Opposite each illustration, the events and incidents relative to it, put into contemporary language, have been written down in a delightful style. The composition of these tales, which are full of delight and whet your fancy, is being accomplished by Khwāja ʿAṭāullāh, the master prose stylist (*munshī*) from Qazwin. Although, during the aforesaid period, thirty painters, equal to Mānī and Bizhād, have constantly been devoted to the task, no more than four volumes have been completed. One can imagine just from that its grandeur and perfection. May God bring their work to completion under the sublime and majestic shade.[5]

A marginal note beside this entry (datable, as we have seen, to between May 1572 and April 1574) provides further information:

At present, the Mīr having obtained permission to go on Ḥaj, the task of preparing the aforementioned book has been assigned to the matchless master Khwāja ʿAbd al-Ṣamad, the painter from Shiraz; the Khwāja has greatly endeavoured to bring the work to completion and has also notably reduced the expenditure.[6]

In sum, these statements, written while the *Hamzanama* project was still under way, indicate that the manuscript was ordered by Akbar; that it would eventually consist of twelve volumes of one hundred folios each, with each folio containing two paintings, presumably one to a side; that the accompanying stories were composed by Khwaja Ataullah; that these scenes were being realized by thirty painters; that in seven years of labor only four volumes were completed; and that Mir Sayyid Ali, having obtained permission to undertake the pilgrimage to Mecca, was ultimately replaced as supervisor by Abdul-Samad.

A second comprehensive account of the *Hamzanama* is provided by Muhammad Arif Qandahari in a text known alternatively in two incomplete and corrupt copies as the *Tarikh-i Akbari* ('History of Akbar') or *Tarikh-i Qandahari* ('History of Qandahari').[7] Muhammad Arif was less intimately involved with Akbar; indeed, for much of his career he was attached to Muzaffar Khan, a prominent noble who spent most of his time in Bihar and Bengal until his death in AH 988 (AD 1580). Most of the work was written by AH 986 (AD 1578–79), as established by the last date mentioned in one copy of the text and the present tense used for events of that year, but upon Muzaffar Khan's demise, Muhammad Arif made some changes and rededicated the text to the emperor. Muhammad Arif draws upon his predecessor's work, as was customary for most historians of the time, but supplies some new details about the *Hamzanama*:

The emperor is a designer of marvels since he has ordered that of the story of Amīr Ḥamza (*qiṣṣa-i amīr ḥamza*), which has 360 tales, each tale should be illustrated with large compositions (*majālis*). Close to one hundred matchless painters (*muṣawwir*), gilders (*muẕahhib*), illuminators (*naqqāsh*), and binders (*mujallid*) are working on that book. The size (*qatʿ*) of that book is one 'meter' and a half (*yak gaz-o-nīm-i sharʿī*); its paper is imbued with colours; its borders have floral designs (*jul-kārī*); and between two sheets of paper a sheet of <u>*chautār*</u> cloth has been placed to make it more permanent. All the pages are illustrated and gilded. It has been ordered that *munshīs* possessing unique eloquence and a sweet tongue should narrate the entire story in measured and rhythmic prose and that mercury-paced fine calligraphers should put it down in the book. In spite of this, in every two years, one volume is prepared; and on each volume close to one million *tanka-i-siyāh* are spent.[8]

From Muhammad Arif, then, we learn that the *Hamzanama* contained 360 stories; that almost one hundred artists of various specializations were set to work on the project; that the paper was colored; that the borders were decorated with floral designs; that a layer of coarse cloth was inserted between two sheets of paper to strengthen each folio; that multiple narrators composed the stories; that it took two years to complete one volume; and that the total expenditure for each volume was about one million *tanka-i-siyah*.

The last two points require further explanation. First, although Muhammad Arif wrote after Mir Ala al-Dawla, he maintained the latter's estimation that the volumes were being produced slowly, that is, at the rate of one volume every two years, a statement that Mir Ala al-Dawla himself had emended in his marginal note. Moreover, in the later of the two copies of Muhammad Arif's text, this line is crossed out, as if in recognition that it was no longer true.[9] Second, Muhammad Arif's estimate of the cost of producing a volume is instructive, though again it probably should be revised in light of Mir Ala al-Dawla's remark that Abdul-Samad had reduced the production cost of a *Hamzanama* volume. With one million *tanka-i-siyah* equivalent to 50,000 rupees and one hundred folios in each *Hamzanama* volume, the cost of each folio – including material and labor for text, illustration, and borders – averages 500 rupees. In some respects, this lofty estimate is not surprising for a book of this size and exalted reputation, yet it far exceeds the valuations assigned to all individual Mughal paintings, which are typically 5–20 rupees for paintings approximately one-eighth to one-quarter the size of *Hamzanama* illustrations, and easily outstrips even the costliest of Mughal manuscripts of any period.[10] This latter comparison is particularly noteworthy because the *Hamzanama* lacks the one feature that determines almost every high valuation: truly fine writing by a well-regarded calligrapher.

Abu'l-Fazl, historian and advisor to Akbar, refers to the *Hamzanama* twice in his chronicles of Akbar's reign. In the *Akbarnama*, the official court history of Akbar's lineage and reign begun in 1589, he mentions that the emperor relaxed to the stories after capturing wild elephants in the thick forests near Narwar in 1564.

Next morning when the world-warming sun had sate on the throne of the horizons, H. M. the <u>Sh</u>āhin<u>sh</u>āh with the desired prey in his net and the cup of success at his lip sate on that auspicious throne and graciously ordered his courtiers to be seated. Then for the sake of delight and pleasure he listened for some time to Darbār <u>Kh</u>ān's recital of the story of Amīr Ḥamza.[11]

In the *Aʾin-i Akbari* ('Annals of Akbar'), a voluminous description of the various institutions of Akbar's reign completed in 1598, Abu'l-Fazl includes the *Hamzanama* in his discussion of the art of painting:

As this art has gained in status more and more masterpieces were prepared. Persian books of both prose and poetry were decorated and a great many large and beautiful compositions (*majlis*) were painted. The story of Ḥamza (*qiṣṣa-i amīr ḥamza*), put into twelve volumes, has been illustrated (*rang-āmez kardand*), and magic making masters have painted fourteen hundred astonishing pictures of as many incidents (*mauzī'*).[12]

Thus, writing approximately a quarter-century after Mir Ala al-Dawla, but with all the resources of the imperial archives at his disposal, Abu'l-Fazl concurs with the former's tally of twelve volumes, but confuses the situation by adding that there were 1,400 illustrations in all. This formulation departs from the two earlier accounts, each of which had one hundred folios per volume.

Abu'l-Fazl's contemporary and rival, Badauni, wrote *Muntakhab'uttawarikh* ('Selected Chronicles'), an unofficial and often critical account of Akbar's reign. In one section dated to the end of AH 990 (AD 1582), Badauni describes with some distaste Akbar's decision to have a famous Hindu religious text, the *Mahabharata*, translated into Persian. He prefaces the emperor's rationale for doing so – to have felicitous and spiritually important works made accessible in his name – with these remarks:

When he had had the Shahnāmah, and the story of Amīr Ḥamza, in seventeen volumes transcribed in fifteen years, and had spent much gold in illuminating it, he also heard the story of Abū Muslim, and the Jāmi'-il-Ḥikāvāt, repeated, and it suddenly came into his mind that most of these books were nothing but poetry and fiction; but that, since they were first related in a lucky hour, and when their star was in the act of passing over the sky, they obtained great fame.[13]

Elsewhere, in a biographical account of Juda'i (Mir Sayyid Ali), he describes the *Hamzanama* in this way:

The story of Amīr Ḥamza in sixteen volumes was illuminated and completed under his supervision. Each volume of it fills a box, and each page of it measures a yard wide by a yard long, and on each page is a picture.[14]

Badauni, then, augments the earlier computation of twelve volumes to sixteen and even seventeen volumes. That he not only deviates from the total given by Mir Ala al-Dawla and Abu'l-Fazl, but also provides two different numbers in his own chronicle, suggests that he is not an entirely reliable source for the precise details of the project, with which he was apparently little concerned.[15] Indeed, Badauni provides many fewer details than the other authors do. Aside from mentioning that the paintings were a yard square, a description matching early ones, he makes but three points. The first is that the *Hamzanama* was completed under the supervision of Mir Sayyid Ali, something completely at odds with Mir Ala al-Dawla's detailed marginal remark that Mir Sayyid Ali was replaced as supervisor by Abdul-Samad. The second is that each volume filled a box, an observation that may be a clue as to how the volumes were organized and stored (for which, see below). But it is Badauni's third point – that the *Hamzanama* was transcribed over fifteen years – that has emerged as the most crucial of all, for it factors in every estimation of the absolute dates of production.

A seventeenth-century author, Qati'i, does not offer a full physical description of the *Hamzanama* in his *Majma' al-Shu'ara Jahangirshahi* ('The Poets of Jahangir'). His essentially biographical remarks, however, contain three pertinent points about the *Hamzanama*. According to Qati'i, the calligrapher Mir Husayn al-Husayni (also known as Mir Kalang)[16] 'worked together with Mir Dauri

and Hafiz Muhammad Amin to "write the story of Hamza which I [Qati'i] had made and finished and brought into bound volumes, and they displayed their fine writing."[17] As Annemarie Schimmel notes, this statement by the elderly Qati'i contradicts Mir Ala al-Dawla's claim that Khwaja Ataullah, a fellow native of Qazwin, composed the *Hamzanama*. It also names three of the calligraphers who actually copied out the text of the manuscript, and describes the volumes as 'bound.'

The final Mughal literary comment on the *Hamzanama* is by Shah Nawaz Khan, the author of the *Maasir al-Umara* ('The Feats of the Commanders'), a biographical compendium of Mughal nobles begun in 1742 and completed in about 1780. In the entry for Darbar Khan, the Iranian-born professional storyteller associated earlier with the *Hamzanama*, Shah Nawaz Khan relates with some distress that Darbar Khan and Akbar regarded each other with such affection that the storyteller asked to be buried like a dog at the emperor's feet, a wish that Akbar granted by having a domed tomb built for him. He continues:

> Though Akbar did not possess fully the arts of reading and writing, yet he occasionally composed verses, and was versed in history; especially he was well acquainted with the history of India. He was very fond of the story of Amīr Ḥamza which contained 360 tales. So much so that he in the female apartments used to recite them like a storyteller. He had the wonderful incidents of that story illustrated from beginning to end of the book and set up in twelve volumes.
>
> Each volume contained one hundred folios, and each folio was a cubit (*zirā*) long. Each folio contained two pictures and at the front of each picture there was a description delightfully written by Khwāja ʿAṭā Ullah Munshī of Qazwīn. Fifty painters of Bihzād-like pencil were engaged, at first under the superintendence of the Nādiru-l-mulk Humāyūnshāhī Saiyid ʿAlī Judāī of Tabriz, and afterwards under the superintendence of Khwāja ʿAbdu-s-Ṣamad of Shiraz. No one has seen such another gem nor was there anything equal to it in the establishment of any king. At present the book is in the Imperial Library.[18]

Writing from a vantage point nearly two hundred years removed from the *Hamzanama* project, Shah Nawaz Khan had no possibility of independent information, and relied most heavily on Mir Ala al-Dawla's account. Accordingly, he reiterates the earlier author's formulation of twelve volumes of one hundred folios each, with two paintings per folio. He increases the number of painters involved in the project from thirty to fifty, an emendation recorded already in one copy of the *Nafais al-Maasir*.[19] He does, however, add one valuable tidbit of information, that is, that the *Hamzanama* was still in the imperial library. As one scholar has noted, this implies that the *Hamzanama* was not seized by the Iranian king Nadir Shah when he sacked Delhi in 1739.[20]

This point is complicated by a Persian source, *Nama-yi Alam-Ara-yi Nadiri* written by Muhammad Kazim, who specifically mentions the *Hamzanama* and the magnificent Kuh-i Nur diamond as the most prized possessions acquired in the campaign in Delhi. A recent scholarly study summarizes the relevant passages of this Persian source in this way:

> And there is some new physical data, such as 'each folio measured 1½ × ¾ royal cubits, and was set in pasteboard [*muqavvā*].' Above all, we get some notion of the value placed on the Tales [*Hamzanama*], when we read that with the volumes packed on two camels for shipment to Iran, the Emperor sent his Grand Vazir with a special plea for their return. The conqueror was welcome to all his treasures, but he begged to be spared the loss of this book. The Shah was gracious in his reply: 'Ask but the return of all your treasures, and they are yours – but not the Amir Hamzeh!'[21]

Given the complexity of the project, it is not surprising that these various literary sources provide descriptions of the making of the *Hamzanama* that differ in details. These details can, however, be corroborated, qualified or contradicted by the physical evidence of the surviving folios. The folios also carry evidence crucial to the dating of the project, which is a topic the literary sources do not address explicitly.

THE PHYSICAL EVIDENCE OF THE *HAMZANAMA*

All the literary sources agree that the *Hamzanama* folios were large, with all authors but Muhammad Kazim using a single measurement (1 yard, or 1 ½ *zar'*, i.e., meters) for both height and width, thereby implying that the folios were square or nearly so. Even the largest of the surviving folios (cat.38), measuring 88.8 by 73 centimeters, falls well short of these absolute dimensions, and only folios that obviously have been cut down from their original size approximate a square. Thus, it appears that either the dimensions cited by various authors were intended only to convey extraordinarily large size without pretense of exactness, or that the borders have been substantially reduced from their original form. As Antoinette Owen demonstrates in her essay (pp.281–2), the margins – which were themselves covered with colored paper – are attached to the main support of the folio in an unexpectedly complex way, and all show signs of having been trimmed. This alteration probably explains the absence of the floral borders mentioned by Mir Ala al-Dawla, and perhaps even his description of the paper of the *Hamzanama* as being colored. It is more likely that this latter description refers to the paper on which the text is written. Most folios, of course, have text on the reverse written on cream-colored paper decorated with flakes of gold, but several folios ostensibly from the early volumes of the manuscript have panels of text written on strips of blue or pale-green paper placed above and below the painting.[22] Likewise, although Mir Ala al-Dawla's remark that there were two paintings to a folio is generally dismissed as a simple error, it may well have some basis in fact. At least one *Hamzanama* folio has a painting on each side, and several others (e.g., cat.19) have nothing but plain paper on their reverse.[23] In light of the laminate structure of the folio described by Owen, this may be the result of the cloth-backed sheet of paper on which the following text was written having been stripped away from the painted sheet. A more likely explanation, however, is that some of these folios once had a second painting on their reverse, and that a dealer separated the addorsed paintings in order to maximize his opportunity for commercial gain. In short, Mir Ala al-Dawla's remarks often seem to be informed by an awareness of the *Hamzanama* in its early phase, a point implied by the contemporaneity of his statements: 'It is now seven years that the Mīr has been busy ...' and 'the story will be completed in twelve volumes.'

One standard observation about the *Hamzanama* in the literary sources is that each of its volumes had a hundred illustrations. This is corroborated by a series of numbers written in black immediately below most illustrations and in red above the penultimate line of text on the reverse. These numbers do not follow the traditional manner of foliation, that is, with each folio bearing a single numeral, and the numerals arranged in consecutive order. Instead, a given painting and the text on the preceding folio bear identical numbers. For example, one folio (cat.30) has a painting numbered '3' and the following text numbered '4'; the painting on the next folio in the manuscript (cat.31) is numbered '4' and the text on that folio is numbered '5.' Thus, the true unit of the manuscript was not a single folio, but the painted scene and its accompanying text, which appear on two separate folios.

No folio bears a numeral above 100, but several numerals – 2, 6, 10, 14, 15, 23, 26, 68, 74 – appear on as many as three separate folios. This confirms that each volume was foliated separately from one to one hundred. The sole occurrence of the latter, in the MAK–Museum of Applied Arts/Contemporary Art, Vienna (B.I. 8770/18), has the number 100 written in red on the central *dev*'s right leg; on the reverse, where on an earlier folio a page of text would normally follow, there is a blank field impressed with three seals. This suggests that this was indeed the last folio of the set, which consisted, as Mir Ala al-Dawla claimed, of 100 folios. Conversely, two folios (MAK, B.I. 8770/1 and 8770/20) commence with a blank field on which seals are impressed and inspection notes are written, and follow with a page of text that is apparently the beginning of a new volume (figs 11 and 12).

Thus far, then, Mir Ala al-Dawla has been proven reliable on nearly every count. This pattern changes, however, with the number of volumes, which Mir Ala al-Dawla had claimed would be twelve, a projected total later repeated as the factual end result by Abu'l-Fazl and others. Among the many inscriptions on the aforementioned initial pages are two inspection notes that begin, respectively, 'eleventh volume' (fig.11b) and 'thirteenth volume' (fig.12a). These notes, therefore, provide unequivocal evidence that there were, in fact, at least thirteen volumes in the manuscript. Acknowledging this evidence, and following the reconstruction put forward in 1925 by Heinrich Glück, most scholars have accepted Abu'l-Fazl's statement that there were 1,400 pictures, and, excusing as an error his contradictory one that there were just twelve volumes, have concluded that there were actually fourteen, each with a hundred folios.

Although the issue of the absolute dates of the *Hamzanama* project is not addressed as such by any of the contemporary Mughal chroniclers, it has vexed modern art historians for almost a half-century. Some have entertained the possibility that the project commenced during the reign of Humayun, but most scholars concur that Mir Ala al-Dawla's mention of 'His Majesty' (*ḥaẓrat-i a'lā*) can only refer to the reigning sovereign, Akbar. Hence, the earliest possible inception date of the project is February 1556, the date of Akbar's accession. Beyond this, however, great controversy ensues, fueled often by unabashed speculation about when the young emperor's level of maturity, state of mind, or success in military and political matters might have made the project most likely. One position, developed in the 1960s and argued forcefully thereafter by Karl Khandalavala and his followers, posits a chronological framework of 1567–82; another, formulated about ten years later by Pramod Chandra, uses literary evidence far more judiciously to propose dates *circa* 1562–77.[24] Khandalavala, for example, takes without any justification whatsoever Badauni's mention of 1582 as the *terminus ad quem* of the *Hamzanama*, and by subtracting fifteen years from that date, arrives at a starting date of 1567. But at the heart of each of these two positions is the date of the *Nafais al-Maasir*, and more specifically the date from which the seven years taken to produce the first four volumes should be reckoned. If one uses literary sources alone, there is little hope of determining this point with the kind of precision that most scholars now seek.

Fortunately, new evidence found on the manuscript itself helps to clarify the issue of the *Hamzanama*'s chronology. In 1993, this author recognized that a number on one illustration (cat.24), previously misread by Glück as '672' and understood by him to be an unprecedented three-digit painting number (i.e., the seventy-second painting of volume 6), should actually be read as '972.'[25] Written beside the flaming tripod in the lower center of the painting, this number 972 did not seem to be a painting number, for there was already one ('74') in the usual position in the border below the painting; moreover, written just below the three-digit number was another number

Fig.10
Detail of the date '972'
written on cat.24.

('6'; fig.10). The number 972 therefore appeared to me to be something else altogether: a date in the Hijra calendar corresponding to August 1564–July 1565. It might be objected that the putative date appears without the word 'year' (*sana*), customarily written directly below nearly all numerical dates; indeed, one scholar has recently proclaimed that a date on such an elaborate manuscript appearing in any form but a proper monumental inscription is utterly implausible.[26] In my opinion, however, this position places excessive faith in the applicability of orthodox practice in Persian manuscripts to workshop customs in Mughal India, and ignores the unparalleled amount of informal documentation written directly on the painting fields of all sorts of imperial manuscripts.[27]

The number 6 written nearby, ignored altogether by Glück, must be nothing other than a volume number. It is, in fact, one of six known examples of the volume number being written on the painting field immediately below a painting number.[28] In this case, the appearance of a volume

FIG 10

number on a dated painting proves exceptionally important, for it provides exactly the firm point of reference that literary sources do not. If we accept Mir Ala al-Dawla's statement that only four volumes were completed in the first seven years of the *Hamzanama* project, and count backward from this secure date of 1564–65, we arrive at an inception date of no later than mid-1558. Given that this dated painting appears well into volume 6, when according to Mir Ala al-Dawla the rate of production accelerated, we should push back the starting date slightly further, to late 1556 or, as seems more likely, AH 965 (October 1557–October 1558).[29] This latter date tallies reasonably well with the earliest possible one calculated seven years from the stated commencement of the *Nafais* in AH 973 (1565–66), that is, AH 966 (October 1558–October 1559). Thus, we conclude that the *Hamzanama* project was begun about a year and a half after Akbar acceded to the throne, and continued for fifteen years until AH 980 (AD 1572–73), the probable date of Mir Ala al-Dawla's

marginal comment about Mir Sayyid Ali being replaced by Abdul-Samad as supervisor.

In light of the unusual placement and form of this date, an intriguing series of three black marks on another painting (cat.28) merits consideration as another fortunate instance of painterly graffiti. Under magnification, the tiny marks, which are written obliquely beside the rightmost bear in the foreground, seem to be too deliberate to be accidental effects; indeed, they resemble the numbers 975, albeit somewhat malformed and generously spaced ones.[30] If this reading is correct, the three numbers very probably represent the Hijra date corresponding to 1567–68. Given that the seven volumes (7–14) were produced in the years between 1565–66 and 1572–73, we can calculate an approximate production time of twelve months per volume. By this reckoning, cat.28, dated AH 975 (AD 1567–68), or three years after a painting late in volume 6 (cat.24), would fall in volume 9 or volume 10. By extension, volume 11 – the volume to which most extant paintings belong – would have been executed throughout 1569 and 1570.

It is surprisingly difficult to determine the narrative order of the *Hamzanama*'s many stories and thus to reconstruct the position of most surviving folios in the original manuscript. The text itself offers little help in this regard, for unlike such classical Persian texts as the *Bustan* and *Gulistan* of Sa'di, the *Hamzanama* does not divide its narrative into discrete and individually numbered stories. One cannot even depend absolutely on apparent chronological progression, for one illustration of

Fig.11
Inspection seals and inscriptions on the final folio of volume 11. MAK–Austrian Museum of Applied Arts/ Contemporary Art, Vienna, B.I. 8770/1.

Fig.11a
Detail of inspection inscriptions in Fig.11: 'God is almighty. On the date of 14 Zi'l-Hijja year 30 [7 October 1656]. On the date of the first of Shahriwar year one [13 August 1606] transferred to Mulla Abdul-Ghaffur the courtier. Inspected on 3 Mihr the Ilahi month, year 34 [equivalent to] 14 Zi'l-Hijja [13 September 1589].

FIG 11

FIG 11a

FIG 11b

the events occurring at the birth of the Prophet Muhammad (cat.22), who shared his childhood with Hamza, seems unrelated stylistically to other paintings associated with the four early volumes. Sometimes, however, one can use narrative elements in combination with inscriptional evidence to assign a given painting to a particular volume. Occasionally, this placement has significant ramifications for the manuscript as a whole. Cat.24, for example, illustrates the murder of Hamza's son Qubad. A profusely illustrated mid-fifteenth-century *Hamzanama* manuscript produced in northern India (see p.17) forgoes the scene of the murder itself in favor of one illustrating Hamza's wife Mihr-Nigar mourning her dead son.[31] Three folios later, another small painting features Umar searching for Hamza at the grave of Mihr-Nigar, who has evidently relinquished her life in grief. In one of the rare coincidences of the two manuscripts' illustrations, the Mughal manuscript illustrates Umar beholding the corpse of Mihr-Nigar.[32] The narrative and physical proximity of the mourning scene to the one of Qubad's murder indicate that this painting of Umar's discovery of Mihr-Nigar's body must also belong to volume 6. Yet this folio has two lines of text written on paper affixed above the illustration, a feature thought to be present only on folios from volumes 1–4, that is, before the physical structure and format of the folios assumed their most commonly found form. Thus, there does not seem to have been a sharp break in the format at the end of the first seven years of production, as is commonly assumed.

THE USE OF THE *HAMZANAMA*

The format and size of the *Hamzanama* suggest how the manuscript was used at the Mughal court. The text, written on cream-colored paper flecked with gold, has one feature strikingly atypical of Mughal manuscripts. Each page of text has nineteen lines. For the most part, these lines are written in a respectable manner, with proper spacing between individual words and lines, the latter the result, it seems, of lines scored into the paper to guide the calligrapher. Yet a number of folios show noticeable compression in the last line or two, and sometimes have additional passages – occasionally as much as a full line – crowded below the final regular line and even wrapped around its left end. This decidedly ungainly effect must have been driven by narrative concerns, for it is completely at odds with the highly codified aesthetics of Islamic writing, which, no matter the proficiency of the individual calligrapher, always mandated a harmonious rhythm of spaces between individual letters and words as well as among separate lines of text. This situation is compounded by the fact that the story on each page of text never continues uninterrupted onto the following page, but only resumes in summary after a new introductory phrase. Thus, it is clear that each folio – or to be more precise, each unit of text and image on consecutive folios – was effectively a separate entity within the manuscript, and superseded usual manuscript-wide considerations.

As we have seen, the designers of the *Hamzanama* arrived at the distinctive format of a full-page painting backed by a full page of text only after the project had been underway for at least seven years. They may have understood that the separate production of text pages and paintings would be more efficient and thus less costly, as Antoinette Owen suggests, or recognized that they could augment the already large size of the painting field if they abandoned the small panels or strips of text on the painted side of the folio. It is, however, most likely that the change in format was precipitated by the gradual realization that the more traditional manuscript format – that is, with text above and below the painting – was ill-suited to the actual function of the *Hamzanama* folios: to support or enhance the recitation of Hamza's adventures at court. By contrast, the later

arrangement, in which text and illustration were physically separate, must have had obvious practical advantages. A professional storyteller such as Darbar Khan could read aloud the colorful narratives from one page of text while an assistant of sorts could hold up the painting for all to see, and another point out the relevant details in the accompanying illustration. As with great music or poetry, no two performances of the tales of Amir Hamza would have been the same, for it is almost certain that the renowned storytellers at court did not read verbatim the rather tersely described actions related in the text. Instead, they must have referred to them only as a narrative guideline, embellishing certain characters and situations as they pleased, a point confirmed by the wide variation in narrative coverage among the many different copies of the text.

Yet these entertaining public performances cannot have been the only way in which the *Hamzanama* paintings were used. Although many Mughal sources discuss the number of discrete volumes, only Qati'i mentions that the volumes were bound; this observation is presently unsupported by physical evidence, such as a wider outer margin, indicating that the folios were originally bound.[33] This was probably a pragmatic decision, for a binding would have made public recitations and displays impractical and handling the gathered folios an unwieldy, even onerous experience. Once more, it seems that we should take Mir Ala al-Dawla at his word, and accept his statement that each set of a hundred folios was stored in a box, perhaps protected by something approximating an oversize portfolio.

Even unbound, the painted folios are so large that a seated individual would be hard-pressed to see them well as he held them in his hands; in the case of royal viewers, this inconvenience must have been mitigated by servants who physically handled the paintings. Nonetheless, the artists seem to have designed and executed the paintings with an intimate viewing distance in mind. Mir Ala al-Dawla notes with pride the minuscule detail in which the illustrations are rendered, and lauds them as examples of the most sophisticated kind of painting. These comments are borne out by the formal observations in the individual entries that follow in the catalogue, many of which dwell on subtle visual passages measuring no more than a centimeter or two across. Thus, in most formal respects, the *Hamzanama* illustrations are simply enlarged versions of contemporary Mughal painting. In fact, the only concession the painters really made to situations in which audience members would be seated several meters away from the illustrations is that they featured more large-scale, organizing forms than do other Mughal paintings of the period.

Scattered across the otherwise plain side of the initial folios of volumes 11 and 13 are a series of notes and seals that record the date of inspection and document the transfer of the volumes from the custody of one imperial librarian to another (figs 11a, 12b). Such notes, which are found on the fly-leaves of most manuscripts that once belonged to the imperial library, are exceedingly formulaic in nature. They usually contain a precise date and month, chosen from either the traditional Islamic calendar or the Ilahi calendar used by Akbar, a regnal year, and the names of one or two librarians. By correlating these dates to the named librarians, we can chart the times at which the manuscript was brought out for official inspection over the course of a century.

It is clear that these official library inspections do not denote actual royal viewings. Nevertheless, an analysis of thousands of such notes demonstrates that the most precious manuscripts were inspected most frequently, sometimes as often as once a year.[34] Despite the *Hamzanama*'s contemporary renown, however, the manuscript was inspected relatively infrequently. Because the record of inspection shows that for the most part volumes 11 and 13 were inspected in tandem,

FIG 12a

Fig.12
Inspection seals and inscriptions on the final folio of volume 13. MAK–Austrian Museum of Applied Arts/ Contemporary Art, Vienna, B.I. 8770/20.

Fig.12a
Detail of inspection inscription in Fig.12: 'Thirteenth volume. On the seventeenth of the month of Shawwal year 5 [23 December 1610] transferred from Muzaffaruddin to Mu'inuddin.'

Fig.12b
Detail of inspection inscriptions in Fig.12: 'Inspected on 3 Mihr the Ilahi month,

FIG 12

FIG 12b

year 34 [equivalent to]
14 Zi'l-Hijja [13 September
1589]. Inspected on the date
of the 20th of the month of
the Ilahi month Amurdad
year 7 [31 July 1612].
Thirteenth volume.
Inspected on 15 Zi'l-Qa'da
year 49 [29 February 1705].
[Certified by] the slave
Abdullah. It happened
that on the date of
27 Zi'l-Hijja year 9
[20 June 1666] transferred
from Rafi'ullah to Ala al-Din
Seals of Amanat Khan
Shah Jahani year 5,
1042 [1632-33], Qabil Khan,
khanazada-yi Alamgir
Padshah 1097 [1685-86].'

one can reasonably assume that a single librarian would normally have been able to account for the presence of all fourteen volumes over a day or two.[35] The earliest documented inspection occurs only on 3 Mihr, the equivalent of 14 Zi'l-Qa'da, of year 34 of Akbar's reign, a date corresponding to 13 September 1589. Although this date is too late to shed any light on the date of the manuscript itself, the gap between it and the probable completion of the manuscript in 1572 should be seen more as a reflection of the developing custom of recorded inspections than as an indication of the infrequent use of the volumes. Later, however, the situation changes. Against the backdrop of increasingly regular inspections of manuscripts during the reigns of Jahangir (1605–1627) and Shah Jahan (1628–1658), the meager number of notices garnered by the *Hamzanama* throughout the seventeenth century – the early years of Jahangir's reign seeing the greatest number of inspections and Awrangzeb's reign (1658–1707) the fewest – strongly suggests that imperial enthusiasm for these kinds of tales and paintings had waned significantly since the dawn of Akbar's reign. In many ways, this relative disfavor comes as no surprise, for the later emperors and their courts differed from Akbar as much in character as in aesthetic taste, with physical vigor and cultural ebullience gradually giving way to more cerebral and calculated manners and more conspicuously refined styles.

THE *HAMZANAMA* MANUSCRIPT AND EARLY MUGHAL PAINTING

John Seyller

In many ways, the *Hamzanama* is the key to all early Mughal painting. The sheer scale of the project made it a kind of crucible of workshop organization. The imperial order to produce a huge, multi-volume manuscript required the painting workshop to establish the mechanisms to ensure a steady supply of sheets of paper of unprecedented size, to have accomplished storytellers compose and competent calligraphers copy out hundreds of sheets of text on separate pieces of decorated paper, and to assemble the text and illustrations in a timely and permanent manner. All these activities were, however, relatively routine tasks familiar to any painting workshop, including the royal Safavid atelier in which Mir Sayyid Ali and Abdul-Samad had been junior members before they came to India. Yet nothing in the experience of these two Iranian-born artists could have prepared them for the far more formidable task of recruiting and retraining a large number of Indian artists, whose hereditary skills emphasized qualities quite unlike the linear forms, fine execution and finished surfaces featured in Iranian art (see cat.1).

An examination of other early Mughal works, both those sponsored by Humayun at Kabul and Delhi and by Akbar in the first years of his long reign, makes clear the galvanizing role that the *Hamzanama* played in the development of the Mughal style. The few paintings commissioned by Humayun in the first half of the 1550s (cat.5–7) are essentially akin to contemporary Safavid works; indeed, apart from a slight increase in the suggestion of volume, the most noticeable difference is one of clothing fashion, as figures are shown wearing a turban type invented by Humayun or a *jama*, a distinctive tunic-like garment worn only in India. This is to be expected, for these small-scale works are either ascribed or attributed to the six known Iranian artists present at Humayun's two courts, where they presumably worked on paintings individually.[1]

Although Mughal painting can be said to mirror generally the personality and taste of the reigning emperor, the specific timing of discernible shifts in style bears a more tenuous relationship to the patron. There was, for example, little change in Mughal painting in the immediate aftermath of Akbar's accession in 1556, as can be seen in a painting ostensibly dated to the first year of his reign (cat.9) or another made about five years later (cat.8a). One might argue that Akbar was still too young to possess or display a pronounced personal taste, or too weak politically during the regency of Bayram Khan to impose it on his painters, but such an argument merely tailors the description of political conditions to fit a hypothetical model of patronage. To my mind, a more persuasive line of thinking abandons the assumption that painters responded to their patron in every aspect of their craft, and sees the art of painting in more pragmatic terms. In cat.8a, for example, Mir Sayyid Ali builds upon his personal repertoire of forms, characterizing an elderly figure only slightly more naturalistically than he had another greybeard depicted when he worked for Shah Tahmasp (cat.3), or a youthful figure made when he painted under the aegis of Humayun (cat.5). These three works together present a more coherent picture of Mir Sayyid Ali's gradual personal development as an artist than of the momentous artistic philosophies of three different patrons.

Opportunities for individual artists to demonstrate such subtle and personal growth were limited or obscured by the massive scale of the *Hamzanama* project, which crowded out all others until the mid-1560s and necessitated a high degree of collaboration among artists. To meet the greatly increased demand for paintings, the workshop expanded from fewer than a dozen artists to over thirty. Akbar might have followed his father's lead and stocked his workshop with still more Iranian-born artists, who, in the mid-sixteenth century, were ever in search of more stable and lucrative employment; instead, to judge from the many Indian names mentioned in contemporary

Fig.13
Khwaja Buzurjmihr takes leave of his aged mother to go out in the world and seek redress for his family's adversity
From the *Hamzanama* manuscript. Mughal, *circa* 1560. 66.3 × 47 cm. Arthur M. Sackler Gallery, Smithsonian Institution; Purchase – Smithsonian Institution Trust Funds, Smithsonian Collection Acquisition Program, and Dr. Arthur M. Sackler, S1986.398.

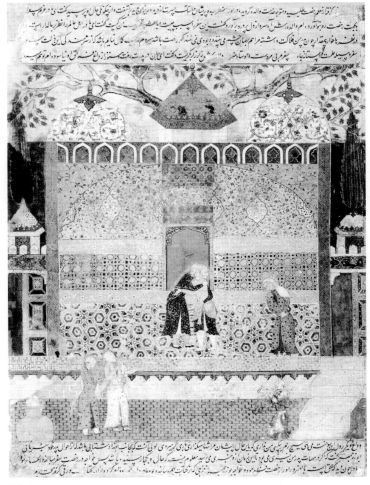

FIG 13

literary sources and actual ascriptions, he directed his master painters to seek out local Indian talent.

Despite the gradual influx of artists unfamiliar with the norms of Iranian painting, the first few volumes of the *Hamzanama* are dominated by Safavid pictorial conventions. In a work dating to *circa* 1560, for example, the artist conceives the palace as an absolutely flat backdrop, with every architectural form but the staircase in the lower right set parallel to the surface of the painting (fig.13). Unlike Mir Sayyid Ali (cat.3) and Abdul-Samad (cat.2), this anonymous artist, whose style suggests training in the Shirazi idiom, delineates his forms so tentatively that the wide chamber becomes little more than a series of symmetrical forms and dainty patterns, including typically Iranian filigree on the back wall and spandrels. And while most major domes in later *Hamzanama* paintings are covered with bold, occasionally flamboyant tiled patterns (for example, cat.20), a feature that gives them an assertive, if not always fully three-dimensional presence, this artist overlays the pair of white domes with a large Persianate scrollwork design, effectively placing them on the same plane as the adjacent foliage and sky. The relentless compositional symmetry, maintained in the matched set of half-open doorways and cypress trees and even in the central position of the small-scale protagonists, underscores the generally conservative nature of this early *Hamzanama* effort.

By the middle volumes of the project, which date to about 1565, all this changes. In one illustration

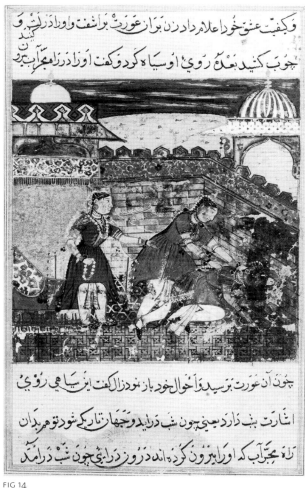

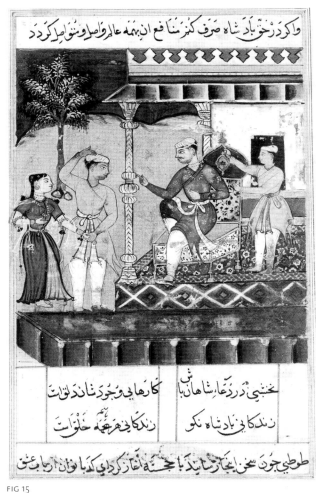

FIG 14 FIG 15

from volume 7 (cat.26), the architecture is still beset with patterns, most strikingly in the long, flower-filled cartouches along the top of the ramparts and the gleaming, diamond-shaped machicolations below them, and more typically in the tilework running the height of the bastions. Nevertheless, the fortress displays the Mughal artist's growing concern with volume and space. The gate towers, for example, are rendered as hexagonal forms visibly projecting on either side of the drawbridge. Likewise, the large covered chamber in the upper center is shown obliquely, so that it intrudes conspicuously into the courtyard before it and encloses a sleeping figure. The landscape, too, diverges noticeably from Safavid models. Although it continues to feature the pastel-colored outcrops ubiquitous in Iranian painting, it has replaced their abstract, sinuous curves with knobby, space-defining earthen forms. Within a matter of a few years, these forms are still more loosely painted and more vigorously outlined. Finally, this artist, like many of his peers, begins to incorporate details from the Indian environment he observes all around him: roots sprouting from tree limbs and snaking unremittingly toward the ground, a brushwood fence ringing a modest cluster of huts, and villagers slumbering on rope-strung cots.

By the time the last few volumes of the *Hamzanama* were finished, in the years around 1570, the birth of a distinct style was complete. Recently fashioned Mughal architectural forms – deep

FIG 15a

sandstone eaves, extravagantly knotted brackets, and coiling foliate bases and capitals – crop up in a representative illustration from volume 11 (cat.64). The cast of characters takes a decidedly local turn, so that swarthy complexions and native Indian clothing styles, from four-pointed *jama*s to loincloths and dhotis, appear here and become more commonplace throughout the manuscript. Beyond this, the figures strike animated poses and have recognizable expressions absolutely unknown in either Iranian or pre-Mughal Indian painting. Artists improvise a host of new compositions and descriptive effects, experimenting with the possibilities of suggesting deep vistas, depicting figures directly from behind or nearly so, and rendering the volume of limbs and garments with ever greater acuity. This painting demonstrates that the palette has also metamorphosed, with the unmodulated, pastel colors of Iranian art now constituting only part of a palette more varied in hue and tone; standard colors such as bright orange or red are supplemented by greenish black in the upper right, the deep brown of the low courtyard wall, and the shaded blue of the central figure's lower garment. Many of these features were loosely inspired by European works of art, examples of which had begun to trickle into the imperial court as gifts from solicitous missionaries and ambassadors. Such foreign material was known elsewhere in the Islamic world, but never before had it been received so eagerly and adapted so creatively as it was at the Mughal court.

Thus, in no more than a decade, Mughal artists forged a new and distinctive style. Writing in the *A'in-i Akbari* some thirty years later, Abu'l-Fazl lauds the formulation and later refinement of Mughal painting as marvelous accomplishments, on a par with the achievements of a legendary Iranian master and wondrous European artists, and beyond anything India had ever known. He discusses painting in terms of absolute quality, both in material and expressiveness, and never as a calculated vehicle of cultural fusion. In typical fashion, Abu'l-Fazl credits Akbar as being the catalyst for every positive development in painting.

> Drawing the likeness (*shabīh*) of anything is called *taṣwīr* (painting, pictorializing). Since it is an excellent source, both of study and entertainment, His Majesty, from the time he came to an awareness of such things [i.e., his childhood] has taken a deep interest in painting and sought its spread and development. Consequently this magical art has gained in beauty. A very large number of painters has been set to work. Each week the several *dārogha*s [superintendents] and *bitikchī*s [clerks] submit before the king the work done by each artist, and His Majesty gives a reward and increases the monthly salaries according to the excellence displayed. His Majesty has looked deeply into the matter of raw materials and set a high value on the quality of production (*paidā'ī*). As a result, colouring has gained a new beauty (*rang-āmezī ḥusn-i dīgar pazīraft*), and finish a new clarity (*ṣafāḥā rā ābrū-i tāza padīd shud*). Such excellent artists have assembled here that a fine match has been created to the world-renowned unique art of Bihzād and the magic making of the Europeans (*ahl-i farang*). Delicacy of work (*nāzukī-i kār*), clarity of line (*safā'ī-i nuqūsh*), and boldness of execution (*ṣabāt-i dast*, lit., stability of the hand), as well as other fine qualities have reached perfection, and inanimate objects appear to have come alive. More than one hundred persons have reached the status of a master and gained fame; and they are numerous who are near to reaching that state or are half-way there. What can I say of India! People had not even conceived of such glories; indeed, few nations of the world display them (such glories).[2]

These remarks also relate the manner in which painters had their works presented and remunerated,

as well as the formal criteria by which paintings were judged. These qualities are considerably more varied and sophisticated that the sheer miniaturism praised so often, and can readily be discerned in many *Hamzanama* illustrations.

Abu'l-Fazl continues with some invaluable biographical information about the foremost artists of the atelier.

Among the forerunners on this high road of knowledge (*āgahī*) is Mīr Sayyid 'Alī of Tabriz. He had learnt a little from his father. When he obtained the honour to serve His Majesty and thus gained in knowledge, he became renowned in his profession and bountiful in good fortune. Next there is Khwāja 'Abd al-Ṣamad, the *shīrīn qalam* (lit., sweet pen/brush) of Shiraz. Though he knew this art before he joined the royal service, the transmuting glance (*iksīr-i bīnish*) of the king has raised him to a more sublime level and his images have gained a depth of spirit. Under his tutelage many novices have become masters. Then there was Daswanta, the son of the palanquin-bearer (*kahār*), who was in the service of this workshop and, urged by a natural desire, used to draw images and designs on walls. One day the far-reaching glance of His Majesty fell on those things and, in its penetrating manner, discerned the spirit of a master working in them. Consequently, His Majesty entrusted him to the Khwāja. In just a short time he

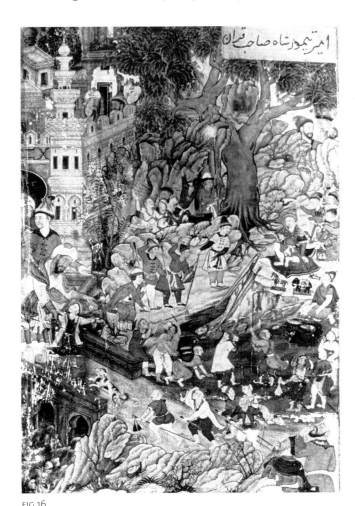

FIG 16

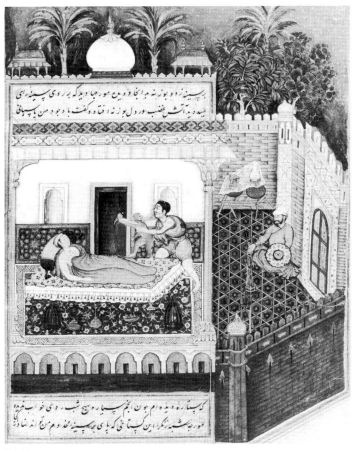

FIG 17

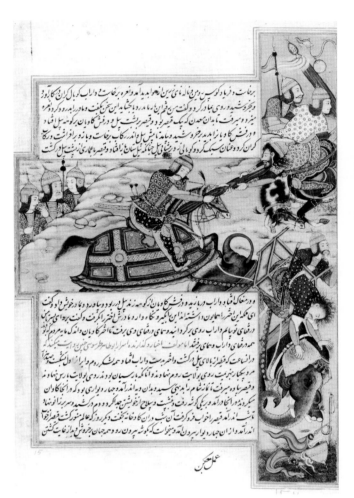

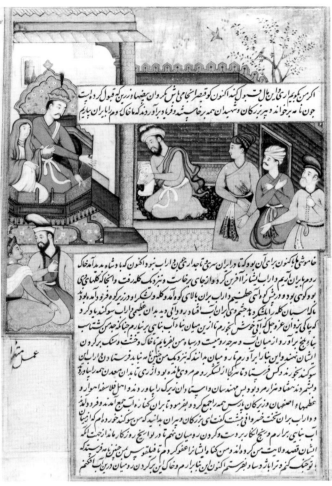

FIG 18

FIG 19

became matchless in his time and the most excellent (*sar-āmad-i rūzgār*), but the darkness of insanity enshrouded the brilliance of his mind and he died, a suicide. He has left several masterpieces. In designing (*ṭarrāḥī*), painting faces (*chihra kushā'ī*), colouring (*rang-āmezī*), portrait painting (*mānind nigārī*), and other aspects of this art, Basāwan has come to be uniquely excellent. Many perspicacious connoisseurs give him preference over Daswanta.[3]

Here, too, Abu'l-Fazl describes the emperor as being responsible for the change in style that came over Mir Sayyid Ali and Abdul-Samad, described as gaining 'a depth of spirit,' and for the discovery of Dasavanta's hitherto unrecognized talent. The chronicler predictably cites Akbar's tutelage as the reason for Dasavanta's excellence, but attributes the artist's suicide to insanity. The terse comparison of Dasavanta and Basavana implies that at least some members of the court routinely examined paintings with an eye to the identity of their makers and exercised some critical judgment of their work (see cat.8a, 8b).

Using literary references to the Safavid atelier and the abundant documentation of the practices of the Mughal studio from about 1577 on, scholars have surmised that in each case one master was put in nominal charge of the library and atelier, and probably assigned given projects or even individual manuscript illustrations to certain teams of artists; it is widely assumed that since Mir

Sayyid Ali was director of the *Hamzanama* project, he was also the overall director of the atelier.[4] Once the initial allocation of work was made, the designated project supervisor chose the subject of the individual illustration, conceivably – but not probably – in consultation with the patron. In Mughal India, this information was conveyed to the artists assigned to execute the painting either through direct oral communication or by brief notes written on the painting field; in the latter instance, the artists were supposed to paint over the notes as they did their work, but occasionally failed to do so.[5] In most manuscripts, the painting was a collaborative effort, usually with the more senior or talented artist designing the composition, and the more junior one doing most of the actual coloring or painting.[6] In many cases, however, the designer also supplied prominent passages, such as the central figures, a habit documented sporadically in some extended ascriptions and discerned frequently in individual paintings in which there is an obvious shift in style.

Available documentation indicates that many Mughal artists, including several of those featured in this selection of *Hamzanama* paintings, had careers lasting on average about thirty years.[7] Occasionally, a painter's career could extend well beyond this, as is demonstrated by two paintings in the exhibition (cat.2, 18) that bracket the sixty-five-year career of Abdul-Samad. Most artists developed distinctive idiosyncrasies over the course of their careers and consistently used most of them in their work. These are often what must seem to be very minor details: certain facial types and hair fashions, preferences for particular colors or degrees of tonal contrast, the means of suggesting corporeality, and the structure of rock formations. Scholars learn to recognize these subtle distinguishing differences, and try to gauge each artist's creative latitude.

Only one *Hamzanama* painting bears anything resembling an ascription. Near the bottom of a much-restored painting in the Fondation Custodia, Paris, the name Ali is written in white.[8] While it is tempting to take this as an indication that Mir Sayyid Ali personally executed at least part of this work, the atypically abbreviated name and the unusual placement of the ascription make it extremely unlikely. A few individual paintings and manuscript illustrations from the 1550s and 1560s bear ascriptions to individual artists (for example, cat.7, 8a, 10, and 11), but it seems that this information did not become a regular feature of the documentation on Mughal manuscripts until the late 1570s, when it first appears on the *Darabnama* (see below). The unprecedented effort to record officially the names of the individual artists responsible for each painting coincided with elaborate workshop procedures instituted to impose a certain standard of quality on every part of a given manuscript. In most cases, this standard seems to have been determined primarily not by the type of literature (historical, poetical, religious) represented by the text of the manuscript, but by a prior decision to produce a physically sumptuous, ordinary, or even lackluster book, much as a modern publisher might do. To ensure that an especially high level of quality would be maintained, for example, a supervisor might select a certain kind of paper, a particularly accomplished calligrapher, and a group of elite painters and illuminators, and offer them a lenient schedule by which they were expected to complete their work. Thus, to identify and understand the creative choices made by a particular artist working on the *Hamzanama* or another contemporary manuscript, we must measure them against the backdrop of both the unique characteristics of a given project and the stage of development of Mughal painting.

The manuscript that overlaps the *Hamzanama* most significantly is the Cleveland *Tutinama*, dated *circa* 1565–70. To judge from the approximately one dozen ascriptions written informally in the lateral margins of illustrated folios, the small paintings were done by artists working individually.

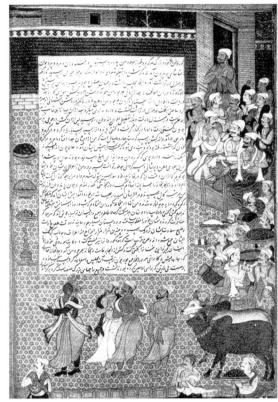

FIG 20

Fig.20
Krishna arrives in Duryodhana's court as a mediator
Folio from a *Razmnama* manuscript. Designed and painted by Jagana. Mughal, *circa* 1584. Size unknown. Maharaja Sawai Man Singh II Museum, Jaipur, A.G.1729. 20 (after Banerjee 1978, fig.244).

Fig.21
Bahram Gur demonstrates his hunting prowess to Fitna
From a *Khamsa* of Nizami manuscript, f.184b. Ascribed to Mah Muhammad. Mughal, *circa* 1585–90. 8.2 × 6.3 cm. Keir Collection, London.

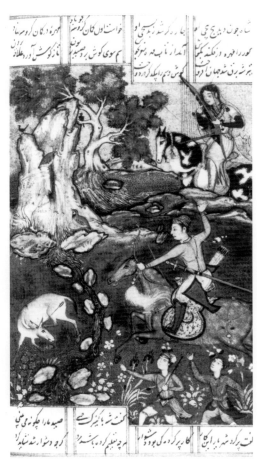

FIG 21

Several of these ascribed paintings afford a clear glimpse of the very beginning of the careers of some well-known artists, notably Dasavanta and Basavana (cat.10, 11). Our understanding of the style of the manuscript is complicated by the fact that Mughal artists painted over many illustrations rendered in an earlier Sultanate style.[9] In some cases, the new paintings are in a wholly Mughal style, and point directly to the attribution of contemporary works in the *Hamzanama* (for example, cat.33, 66). Conversely, some other ascribed paintings in the *Tutinama* (figs 14 and 15) show vestiges of the underlying illustrations. In these instances, we must differentiate the facial features peculiar to an individual Mughal artist from the compositional and surface effects created by the underlying *Chandayana*-style illustrations;[10] only then can we use them as the basis for further attributions.

Dasavanta's two very painterly illustrations in the *Tutinama* lead directly to the attribution of a few paintings in the *Hamzanama* and indirectly to a good number more. These newly attributed works are a major addition to this master's known oeuvre, which had been limited to a few drawings, a single, jointly painted illustration in the Khuda Bakhsh Library *Tarikh-i Khandan-i Timuriyya* (fig.16), and a series of collaborative efforts in the long-inaccessible manuscript of the *Razmnama* in Jaipur, the last project in which he participated before his death.[11] The *Hamzanama* paintings (for example, cat.59, 64), in turn, allow us to recognize Dasavanta's handiwork in another contemporary manuscript, the *Anwar-i Suhayli* of 1570, in the School of Oriental and African Studies, University of London (fig.17). Here, then, working alone on an ambitious illustration in a high-quality manuscript, Dasavanta employs many forms seen in his works in the *Hamzanama* – an arcade below an open chamber, a blazing torch, a bold tilework pattern, brushy foliage, heavily modeled clothing, and an intensely focused facial expression featuring an eye with a large, dark pupil. The subject of the illustration calls for a night-time scene with a limited number of figures, and the original layout of the manuscript compels him to incorporate the text panels above and below into the architecture forming the core of the expanded painting field, but otherwise Dasavanta's work in this illustration is stylistically indistinguishable from his *Hamzanama* contributions.

The profusely illustrated *Darabnama* in the British Library, dated *circa* 1577–80, which rises above an average level of quality only occasionally, is the first Mughal manuscript to have formal ascriptions written below nearly all its illustrations.[12] Because the manuscript postdates the *Hamzanama* by less than a decade and its medium-sized miniatures were apparently made by artists operating individually, the manuscript is one of the most useful sources of visual documentation of the artists involved in the *Hamzanama*. On the basis of these illustrations (figs 18 and 19), artists such as Jagana and Mithra, the latter little known from contributions to subsequent manuscripts, can be readily associated with distinctive figure and facial types that appear throughout the *Hamzanama* (for example, cat.68). Similarly, the large, jointly produced illustrations in the Jaipur *Razmnama* of 1584–86 flesh out the work of these same artists and demonstrate the consistency of their personal styles; in a few examples a single artist, Jagana, was charged with both the design and the execution of a painting, making it a particularly valuable touchstone of his work (fig.20). Finally, there is Mah Muhammad. A minuscule ascription in the corner of one painting (cat.14) reveals Mah Muhammad's inclination to work in an elegant and somewhat Persianate style. As we trace certain forms from this work to a very different kind of scene (cat.15), and match them to others found in a solo painting in a tiny copy of the *Khamsa* of Nizami (fig.21), we discover that this hitherto obscure artist played an unexpectedly prominent role in the *Hamzanama*, a masterpiece whose legacy is both its grand vision and collaborative realization.

Basavana

FIG 22

Fig.22
Ascribed to Basavana (active *circa* 1565–98)
*Shahpur, who helped Tahrusiyya search
for Darab, tells her that all the slaves have
been sold* (detail)
Mughal, *circa* 1577–80. *Darabnama*,
British Library, Or. 4615, f.34a.
See also cat.8b, 10, 11, 20, 27, 30, 32, 33, 35,
66, 68, 76, 80, 81, and 82.

Fig.23
Attributed to Lalu (active *circa* 1565–85)
*The old man eats of the fruit of the Tree
of Life, but drops dead* (detail)
Mughal, *circa* 1565–70. *Tutinama*,
Cleveland Museum of Art, 62.279.78.a,
f.78a.
See also cat.41.

Fig.24
Attributed to Dasavanta
(active *circa* 1565–84)
*The parrot cautions her young on the
danger of playing with foxes* (detail)
Mughal, *circa* 1565–70. *Tutinama*,
Cleveland Museum of Art, 62.279.32.a,
f.32a.
See also cat.25, 31, 36, 42, 44, 45, 47, 53, 54,
58, 59, 63, 64, 69, 71, 73, 79, 83, and 86.

Fig.25
Ascribed to Kesava Kalan (Kesava Dasa)
*The water maiden's husband, insane with
jealousy because of her love for Mihrasb,
tears their children's bodies apart in front
of her* (detail)
Mughal, *circa* 1577–80. *Darabnama*,
British Library, Or. 4615, f.46a.

Fig.26
Ascribed to Kesava Dasa
(active *circa* 1565–96)
Elephant and rider (detail)
Mughal, *circa* 1585. Rijksmuseum,
Amsterdam, MAK 521.
See also cat.28, 29, 48, 52, 55, 56, 60, 61,
77, 78, and 85.

Lalu

FIG 23

Dasavanta

FIG 24

Kesava Dasa

FIG 25

FIG 26

Madhava Khurd

FIG 27

Shravana

FIG 29

Mahesa

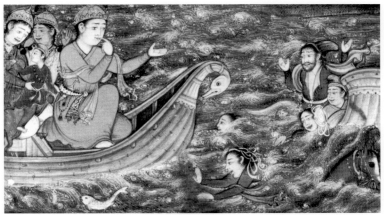

FIG 30

Tara

FIG 28

Fig.27
Ascribed to Madhava Khurd
*Darab unties Humay's bonds after he
defeated Kuh Asa and his men* (detail)
Mughal, *circa* 1577–80. *Darabnama*,
British Library, Or. 4615, f.101a.
See also cat.38, 40, 57, 59, 62, 72, and 79.

Fig.28
Designed by Basavana, painted by
Tara Kalan (active *circa* 1565–96)
*Akbar watches a fight between two
bands of* sanyasis *at Thaneswar, Ambola,
Punjab* (detail)
Mughal, *circa* 1586–87. *Akbarnama*,
Victoria & Albert Museum, I.S. 2-1896
61/117.
See also cat.82, 83, and 85.

Fig.29
Ascribed to Shravana
(active *circa* 1565–1600)
*Shapur returns to his house to find
it ransacked* (detail)
Mughal, *circa* 1577–80. *Darabnama*,
British Library, Or. 4615, f.37a.
See also cat.23–25, 27, 30, 36, 42, 43, 45,
47, 51, 53, 57, 65, 69, 70, 71, 72, 74, 77, 79,
82, 83, and 84.

Fig.30
Ascribed to Mahesa
(active *circa* 1565–99)
*Darab and his son watch one of the boats
accompanying them being wrecked off
the Arabian coast near
Mt. Uman* (detail)
Mughal, *circa* 1577–80. *Darabnama*,
British Library, Or. 4615, f.90b.
See also cat.22, 26, 39, 43, 46, 49, 52, 65,
70, and 71.

CAT 1

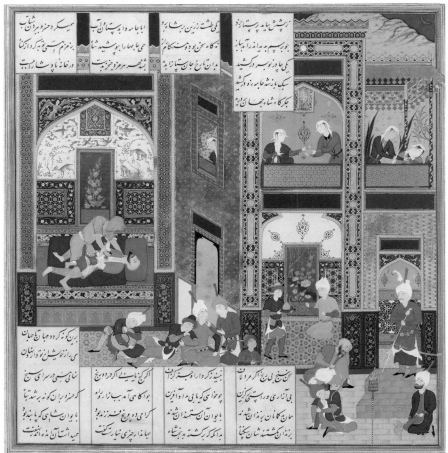

CAT 2

1 KRISHNA DEFEATS TRINAVARTA, THE WHIRLWIND DEMON

Page from a dispersed
Bhagavata Purana series
India, possibly Mathura region,
circa 1525–40
18.4 × 23.9 cm.
Freer Gallery of Art,
Smithsonian Institution,
Washington, DC; Purchase
F1987.4

Published: Michell 2000, fig.7;
Seyller 1999, fig. 1; Beach 1992,
pl.B.

This striking painting belongs to the earliest known illustrated series of the *Bhagavata Purana*, a devotional text which celebrates the wondrous events of the life of Krishna, a popular incarnation of the god Vishnu. Here Krishna is shown defeating Trinavarta, one of many demons dispatched to kill him. Assuming the form of a violent whirlwind, Trinavarta sweeps the child Krishna up into his vortex even as he blinds all those around him with great gales of dust. But Krishna prevails, as he inevitably does, by choking the formless demon and smashing his lifeless body to the ground.

Krishna, whose youth and divinity are indicated by his short stature and blue color, is shown twice: once at the apex of the demonic funnel and again before his relieved mother, presumably in the aftermath of this cataclysmic struggle. The use of repeated figures to relate sequential events in a continuous narrative is a device found throughout this series and indigenous Indian painting generally.

The widely dispersed *Bhagavata Purana* series is regarded as a landmark of pre-Mughal Indian painting for the sheer number and variety of its illustrations. Its provenance and date are still a matter of some controversy, but most scholars agree that the series was made in northern India, perhaps in Rajasthan or the vicinity of Mathura, about 1530. Elements of the tradition it represents, the so-called Chaurapanchasika style, appear in several *Hamzanama* paintings, and thus establish the persistence of this general style in the 1560s.

One of its principal characteristics is a highly compartmentalized composition, often organized primarily by schematic architectural and arboreal forms and arbitrary fields of color. The concern for overall design overshadows an interest in fine draftsmanship. Paint, while normally applied carefully, as in the elaborate patterns on the women's skirts, is sometimes allowed to flow freely, a tendency seen vividly here in the vibrant strands of color in the whirlwind. Above all, it is the female figure type that lives on in early Mughal painting. The Indian aesthetic taste for images of women endowed with rhythmic gestures, voluptuous proportions, angular facial features, and a large, leaf-shaped eye apparently captured the fancy of a number of Mughal artists, for they happily introduced such sensuous local beauties into paintings with few other overtly Indian passages.

2 THE ASSASSINATION OF CHOSROËS PARVEZ

Folio 742b from the
Shah Tahmasp *Shahnama*
Attributed to Abdul-Samad
Iran, Safavid dynasty, *circa* 1535
Painting 28.4 × 27.3 cm,
folio 47 × 31 cm.
The Metropolitan Museum
of Art, New York,
Gift of Arthur A. Houghton, Jr.,
1970 (70.301.75)

Published: Dickson & Welch
1981, pl.260; Welch 1979, no.39;
Welch 1972, pp.184–87.

Like so many others grown fond of power, the Sassanian king Chosroës Parvez loses sight of justice and drifts slowly into tyrannical behavior. Eventually, the supporters of Prince Shiruya depose him and place him under house arrest. They prevail upon Shiruya to dispatch him once and for all; Shiruya reluctantly pays off a thoroughly uncouth man, Mihr-Hurmuzd, to carry out the reprehensible deed. The assassin catches Chosroës attended by a single page. The former king, trying to forestall his impending fate, orders the page to bring some articles to be used in prayer services, but the naive youth does exactly as he is told and returns without seeking out guards who could save his master. Chosroës solemnly says his prayers, all the time knowing that death is now inevitable. Once he has finished, the assassin leaps on him and steals the life from his body.

This work is the sole painting attributed to Abdul-Samad in the Shah Tahmasp *Shahnama*, the most ambitious and magnificent of all Safavid manuscripts.[1] It embodies Abdul-Samad's early style, of which the technical precision and somewhat formulaic nature were to undergo a marked change soon after he began to work for Humayun and Akbar. Here, for example, his figures are relatively expressionless, no matter whether they are gripped by sleep or an assassin's hand. Similarly, for his architecture Abdul-Samad favors brilliant surface pattern over spatial definition; indeed, the only passages that lack intricate patterns are those that have been left unfinished, namely, the seven uninscribed blue panels over the doorway, window, and chambers, and the shockingly stark blue, green, and red forms behind the murderer and his victim.[2] The open-faced, planar construction and densely patterned surfaces contrast with those of courtyards seen throughout the *Hamzanama*, which habitually have space-enclosing outer walls and gateways, occasional respites from patterns, and generally larger figures.

1. The attribution to Abdul-Samad is made by Welch (1972, p.184).
2. Mihr-Hurmuzd's face and arms also remain unfinished.

3 A SCHOOL SCENE

Amid the bustle of schoolboy activities, a school-master beats a pupil for presuming to occupy his place during a temporary absence, a transgression implied by the verses written in the cartouches of the carpet on which the master sits.[1] Such punishment must be routine, for only the adult standing behind the master casts an eye in its direction. The students busy themselves with their lessons and chores, which include boiling rags to make pulp, kneading it to make paper, dyeing and drying individual sheets, and burnishing a sized and trimmed folio. Elsewhere, a princely figure holds up an inscribed book, a pupil squats to wash his hands, and a muezzin calls the faithful to prayer from the rooftop.[2]

Mir Sayyid Ali accommodates these varied but stock activities in a brilliantly compartmentalized composition. He uses complementary colors and patterns, for example, to balance the two equally sized portions of the courtyard, and a bifurcated landscape and tall plane tree to answer the colors and shapes of the formal architectural screen and dome.

This painting, thought by many scholars to be a detached page from a royal Safavid copy of the *Khamsa* of Nizami,[3] has emerged as a key document in Mir Sayyid Ali's oeuvre. It not only bears the painter's signature, written in a minute hand on a sheet of paper held by a student dressed in purple,[4] but also provides a virtual checklist of his most distinctive forms and devices. Among these are figures in whom the whites of the eyes are visible around tiny pupils, a pronounced taste for meticulously rendered patterns, and the appearance of thematically related verses on books and carpets.

1. The verses by the poet Hafiz are transliterated and translated by Melikian-Chirvani (1998, p.44): 'You cannot rest excessively in the place of great ones / Unless you have prepared the paraphernalia of greatness / If you leave your lot in the Lord's care Hafez / [You shall often lead the good life with the good fortune given by the Lord.]' Very similar imagery occurs in a Bukharan manuscript of *Shah wa Darvish* of Hilali dated AH 972 (AD 1564–65) in the Keir Collection.
2. According to Melikian-Chirvani (1988, p.44), the inscription reads: 'I saw a beauty to whom the master gave a pitcher [of wine] at a time of penury – He looked at her/his face and forgot what he meant to do.'
3. British Library Or. 2265, dated 1539–43.
4. Though read and noted earlier, the signature was first published in Melikian-Chirvani 1998, p.40, and fig.10.

Signed by Sayyid Ali
Iran, Safavid dynasty,
circa 1540
Painting 27 × 15.1 cm,
folio 37.2 × 23.9 cm.
Arthur M. Sackler Gallery,
Smithsonian Institution,
Washington, DC; Purchase –
Smithsonian Unrestricted Trust
Funds, Smithsonian Collection
Acquisition Program, and
Dr. Arthur M. Sackler S1986.221

Published: Grabar & Natif 2001,
fig.23; Seyller 1999, fig.2;
Melikian-Chirvani 1998, figs 9–12;
Beach 1992, fig.8; Lowry, Beach,
Marefat & Thackston 1988,
no.412; Lowry & Nemazee 1988,
no.30; Lowry 1987, p.50; Binyon,
Wilkinson & Gray 1933, pl.CIII-A.

4 THE ANGEL OF DEATH ATTACKS SHADDAD AS HE DISMOUNTS IN THE GARDEN OF IRAM

Few series of paintings in the Islamic world can match the *Hamzanama* illustrations in sheer size. One prominent exception is a dispersed *Falnama* manuscript, the most sumptuous copy of a text allegedly composed by the Shia Imam Ja'far al-Sadiq and used for divinations. This manuscript was made for the Safavid ruler Shah Tahmasp shortly after 1550, just a few years before Akbar's painting workshop undertook the *Hamzanama* project. This *Falnama* is much smaller in scope – only about thirty paintings are known – but it is closely related to the *Hamzanama* in overall structure and figure scale. The book was organized so that a full-page painting was followed by a page of text describing the omen, a relationship between text and image reversed in the *Hamzanama*.[1]

This scene, which appears in several later copies of the *Falnama*, depicts a demonic creature attacking King Shaddad. Unlike cat.19, this is not a demonstration of valor in the face of adversity, but of the ruinous consequences of hubris. Shaddad, it seems, became obsessed with the idea of creating a garden so splendid that it would rival Paradise itself. Once this garden of Iram is complete, Shaddad arrives on his horse and starts to dismount. No sooner does he set one foot on the ground than God dispatches the angel of death to smite him with a club, thereby exacting swift and fatal retribution for his vain and impudent challenge to divine supremacy in all matters.[2]

The painting illustrates this portentous subject with marvelous directness. Hurtling through the air and seizing Shaddad by the throat is the angel of death, rendered here as a spotted *dev*-like creature, albeit without the customary horns, tails, and claws. He breathes fire, something no ordinary *dev* can do, and brandishes a club ablaze with the wrath of God. Behind him is the blasphemous garden, filled with trees laden with sweet-tasting fruits and inhabited by wondrous half-human birds. Shaddad, his mounted companions, and the figures taking refuge in the tower are all conceived as large-scale and absolutely flat forms, and are all variations of a distinctive facial type associated with Aqa Mirak, to whom this entire series has been attributed.[3]

1. Milstein, Rührdanz & Schmitz 1999, p.60. Barbara Schmitz believes that the manuscript was originally bound.
2. I am indebted to Karin Rührdanz for information about the subject of this scene.
3. Stuart Cary Welch in Falk 1985, pp.94–99.

Folio from a *Falnama*
manuscript
Attributed to Aqa Mirak
Iran, Safavid dynasty,
circa 1550–55
Painting 59 × 44.8 cm,
folio 59.3 × 44.8 cm.
Arthur M. Sackler Gallery,
Smithsonian Institution,
Washington, DC; Purchase –
Smithsonian Unrestricted Trust
Funds, Smithsonian Collection
Acquisition Program, and
Dr. Arthur M. Sackler S1986.252a

Published: Lowry, Beach,
Marefat & Thackston 1988,
no.170; Lowry & Nemazee, pl.30.

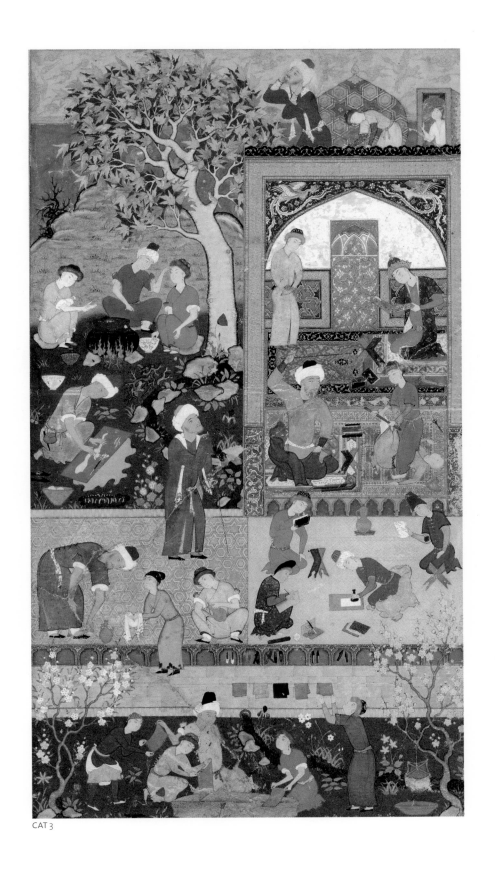

CAT 3

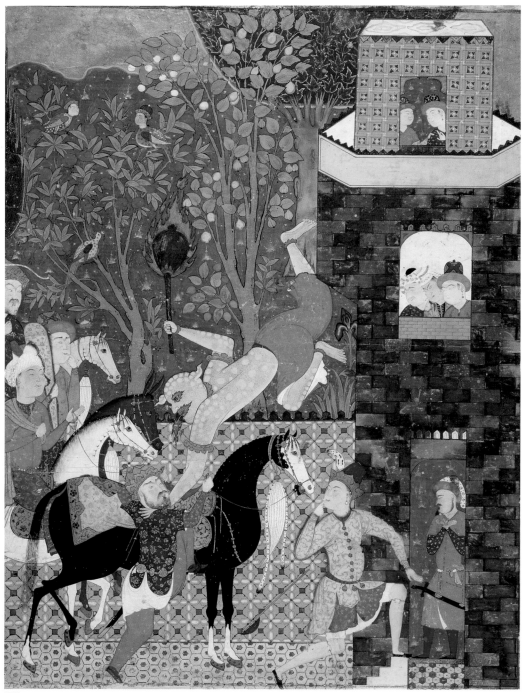

CAT 4

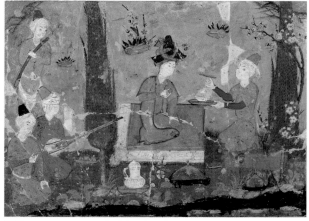

CAT 5

5 BAHRAM GUR PREPARES FOR A FEAST

Folio 169a from a *Khamsa*
of Nizami (detail)
Attributed to Mir Sayyid Ali
Afghanistan, Kabul, Mughal
dynasty, *circa* 1551–53
Painting 9.5 × 11.3 cm,
folio 25 × 17 cm.
Bibliothèque nationale
de France, Paris,
Ms. Smith-Lesouëf 216

Published: Richard 1997, no.101;
Richard 1994, pl.VIII.

Not in exhibition

This damaged copy of a classic Persian poetical text is one of the rarest works of all early Mughal painting. Although its colophon is missing, several features of this manuscript establish that it was made in Kabul, where Humayun set up court in November 1545, when he first wrested control of the city from his brother and rival, Kamran; notwithstanding a few temporary lapses in control, Humayun maintained Kabul as his base of power until November 1554, when he began the campaign to retake his former territories in India. The *Khamsa*'s ten illustrations generally display an accomplished Persian style, although to judge from certain details of costume, one realized by several different artists. One illustration is ascribed to Mawlana Darvish Muhammad, a painter named by the chronicler Bayezid Bayat as one of a small coterie of artists in Humayun's service but whose work is otherwise undocumented. Other illustrations – especially this one – may be associated plausibly with Mir Sayyid Ali, who, together with Abdul-Samad, began to work for Humayun soon after September 1549.[1]

In two illustrations, an enthroned figure wears a conical hat with a square base, a distinctive type of headgear purportedly invented by Humayun. The first of these, the figure of Nawfal in the painting on folio 112a, has been given the visage of Humayun, whose features and pointed beard are recognizable from a painting dated AH 960 (AD 1553) in the Gulshan Album, the much-studied *Princes of the House of Timur*, and later dynastic portraits.[2] The second is the figure of Bahram Gur shown here. Rather than appearing as a mature ruler, as he normally does, Bahram has a decidedly boyish face and body; in fact, the figure strongly resembles the young prince Akbar, who was born in 1542 and is portrayed in a very similar manner in the aforementioned Gulshan Album painting, when he would have been nine years old. Thus, it seems that two artists flattered their patron and his son by using the time-honored visual conceit of incorporating their likenesses in illustrations of a literary text.

One specific feature of this painting suggests the hand of Mir Sayyid Ali. The carpet on which Bahram is seated is shown folded into quarters, and has verses, largely illegible but tentatively identified as by the poet Hafiz, written in red in cartouches along its border. This device recurs in much of Mir Sayyid Ali's work, notably cat.3 and 7.

1. This date is provided by Abu'l-Fazl, *Akbar Nama*, 1, p.252. Melikian-Chirvani (1998, p.31) argues that these two artists were actually received by Humayun in Shawwal 959 (September–October 1552). He asserts that this date must be more accurate because Bayezid claims to cite it from a letter sent by Humayun to the ruler of Kashghar and shown to him by Abdul-Samad in 1590–91. Canby (1998, n.3), however, lends credence to the 1549 date by noting that Abdul-Samad was captured by Kamran for several months in AH 957 (AD 1550–51), but returned to Humayun by AH 958 (AD 1551).

2. The *Khamsa* folio is reproduced in Richard 1994, pl.VII. The Gulshan Album painting by Abdul-Samad is published widely, most recently in Elgood 1994, fig.8. The British Museum painting known as *Princes of the House of Timur* is published extensively in Canby 1994.

6a A VIZIER DELIVERS THE PETITION OF MIR MUSAWWIR TO HUMAYUN

This much is certain: a dark-skinned, bespectacled man wearing an Indian-style *jama* and turban holds a scroll with a long inscription; this petition mentions the aged Mir Musawwir, alludes to his son (Mir Sayyid Ali), and addresses His Majesty. Beyond this, a lively controversy breaks out, with some scholars accepting the identification of the sitter as Mir Musawwir and asserting that the artist is his son, and others forging new interpretations that contend that either Mir Musawwir is portraying himself or a third party presenting his petition.[1] As will be seen, the determination of the precise circumstances under which this painting was made affects our understanding of painting during the reign of Humayun.

So proficient a painter was Mir Musawwir that Humayun was happy to solicit his services, offering to send Tahmasp the great sum of a thousand *tuman*s if he would release the artist.[2] Humayun could reasonably expect a positive response, for as the Safavid chronicler Budaq-i Munshi-yi Qazwini wrote, the painter was already in disgrace. Budaq then follows up with this statement: 'It is thus that the Mīr's son, who had become better than his father, went earlier to India, and the father followed him there.'[3] In this light, the contents of the scroll's inscription become perfectly intelligible:

> Petition from the old and long time slave, Mīr Muṣavvir: It is a great honour to report that it has been a while since this slave's son (i.e. Mīr Sayyid ʿAlī] has entered the services of Your Majesty. It is hoped that he will become the subject of munificence. [As for me], I am hopeful to start my journey soon and join Your Majesty's services. God willing, the shadow of your radiance [shall protect us forever].[4]

Because Mir Musawwir acknowledges that Mir Sayyid Ali had joined Humayun some time earlier, the pictorial petition must postdate late 1549 by at least several years; because the artist addresses Humayun, it must predate January 1556 by at least a few months, for there is some evidence that Mir Musawwir did, in fact, work briefly for Humayun.5

Melikian-Chirvani's recent alternative interpretation of the painting as a self-portrait of Mir Musawwir falters on several points. First, the subject's dark skin is a conventional indication of an Indian identity, and was not used for persons of Iranian birth. Second, it does not explain why the figure wears Indian dress and how the curling scroll shows signs of exposure to European art – something that, by Melikian's own account, was not known in Iran or Kabul at the time – if Mir Musawwir were yet to reach Humayun's court, as the inscription clearly states.[6] The most likely scenario, therefore, is that Mir Sayyid Ali, whose name is ascribed in the lower margin, composed the text of this address on his father's behalf. Being a clever artist, he then incorporated this written petition into a skillful yet humble visual one, perhaps even arranging for the painting to be delivered to Humayun by the very advisor depicted therein. This scenario also means that the painting retreats in date from the 1560s, when the *Hamzanama* project was well under way, to the final year of Humayun's reign, when the fledgling Mughal atelier was still being organized and its production was limited to a handful of paintings.

1. The extensive publication history of this painting is reviewed critically by Melikian-Chirvani (1998, pp.39–40, and n.31–33); and Soudavar 1999, pp.50–51, and n.18–25. I had not absorbed these new arguments at the time my own recent publication of this painting (Seyller 2000) went to press.
2. A Shah Tahmasp *Shahnama* illustration (f.516b) signed by Mir Musawwir and dated AH 934 (AD 1527–28) is reproduced in Welch (1972, p.169).
3. Budaq-i Munshi-yi Qazwini, *Javahir al-akhbar*, a manuscript copied in 1576, as cited in Soudavar 1999, p.50.
4. Soudavar 1999, p.50.
5. Welch attributes to Mir Musawwir two paintings in the Lalbhai Collection *Khamsa* of Nizami, which, by most scholars' reckoning, is the only known manuscript other than the Bibliothèque nationale *Khamsa* of Nizami (cat.5) to have been made for Humayun; Chandra 1976, pp.189–90.
6. Melikian-Chirvani 1998, pp.38–40.

Ascribed to Mir Sayyid Ali
India, Mughal dynasty,
circa 1555
12 × 11.1 cm.
Musée des arts asiatiques-Guimet, Paris No. 3619, IB.

Published: Seyller 2000, fig.10; Soudavar 1999, pl.xvd; Melikian-Chirvani 1998, fig.8; Elgood 1994, fig.5; Verma 1994, pl.XLII; Okada 1992, fig.68; Pal 1991, p.viii, fig. 1; Okada 1989, no.25; Dickson & Welch 1981, fig.245; Welch 1979, no.81; Stchoukine 1929, pl.IIa.

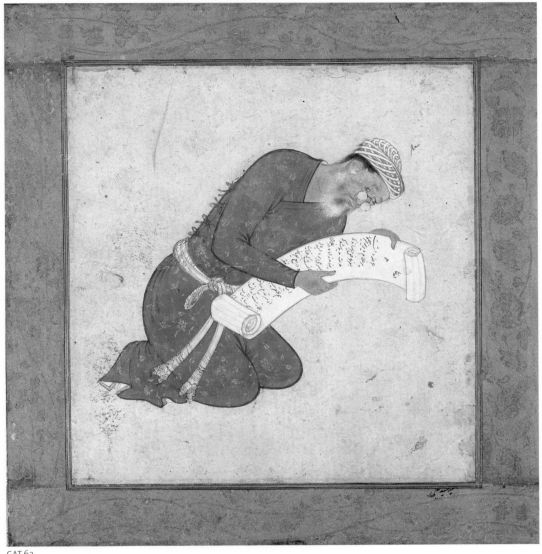

CAT 6a

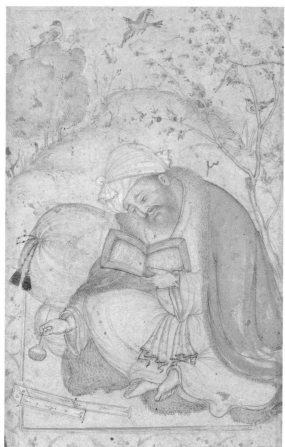

CAT 6b

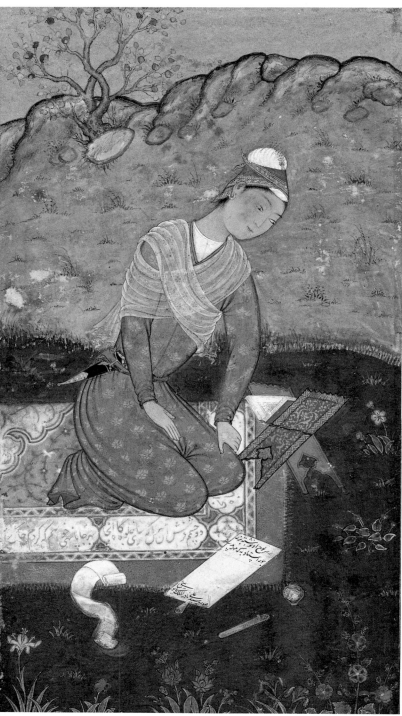

CAT 7

6b A SCHOLAR WRITING

Ascribed to Lala
India, Mughal dynasty,
circa 1590–1600
12 × 6.4 cm.
Musée des arts asiatiques-
Guimet, Paris 3619, 1c

Published: Verma 1998, fig.12;
Okada 1989, no.44; Stchoukine
1929, no.51.

The compiler of this album page wittily juxtaposed the older image of an aged petitioner (cat.6a) with this portly scholar. The former leans forward solicitously and holds a scroll addressed to a superior, while the latter, a self-contained mound of a man, hunches over a weighty tome and takes up his pen for his own satisfaction. Apart from presenting a contrast in character, the two paintings demonstrate the fundamental change that Mughal painting underwent in the second half of the sixteenth century. Mir Sayyid Ali's elegant petitioner remains essentially a flattened form, an effect accentuated by the supplicant's implausibly torqued pose, solidly colored *jama*, and smooth contours, as well as by his isolation against an abstract ground. By comparison, Lala, whole name is ascribed in the lower border, dwells upon his scholar's sheer bulk. The artist envelops his figure's broad body with a heavy fur-lined cloak rendered with a halting line, a streaky wash, and a real interest in texture, and encircles his three-dimensional hands and feet with generous sleeves and folds. Once he extended the figure's general amplitude with two plump, lightly tinted bolsters, Lala's interest seems to have flagged. For the setting, he musters only two sketchy segments of a carpet border, a slender tree daubed with undefined blossoms, and the faint suggestion of an arching hill.

Lala, an accomplished and prolific artist, often resorts to this half-colored manner, which was particularly in vogue in the 1590s. His figure style is easily recognized in the scholar's narrow eyes, knitted brow, and taut facial lines, which combine to lend many of his characters a somewhat weary and distracted expression even when it is not entirely appropriate to their station or action. By contrast, the figure's remarkably full hands and feet are hardly in keeping with this artist's work. Although Mughal artists occasionally applied light washes of white paint to correct or refine their forms as they worked, it is quite possible that the whitened passages on the hands and feet are signs that these darkly outlined features were enhanced when the painting was mounted not long after it was made. It seems that at this time, too, some other parts of the painting – notably the lines along the scholar's left shoulder, the lower edge of the book, and the bottom of the sash – were strengthened, and the lines of the robe were carried into the right margin.

7 SELF-PORTRAIT

Signed by Sayyid Ali
India, Mughal dynasty,
1555–56
Painting 19.1 × 10.5 cm,
folio 31.6 × 20 cm.
Los Angeles County
Museum of Art,
Bequest of Edwin Binney, 3rd,
M.90.141.1.

Published: Melikian-Chirvani
1998, fig.1; Elgood 1994, fig.6; Pal
1993, no.45; Okada 1992, fig.69;
Welch 1990, fig.13; Brand &
Lowry 1985a, no.6; Dickson &
Welch 1981, fig.248; Welch 1979,
no.74; Chandra 1976, pl.64;
Welch 1973, no.52; Binney 1973,
no.10; Grube 1968, no.90.

This exquisite portrait is a landmark of early Mughal painting. Its youthful subject initially seems ordinary, for sixteenth-century Iranian painting abounds with such images. Its importance stems from the information supplied by two formal inscriptions placed in the composition. Lying between a scroll and a pen and inkwell, implements that collectively suggest that the figure had done the writing himself, is a tablet inscribed above: 'At the top of the writing tablet, it is written in gold: "The master's tyranny is better than the father's kindness."'[1] The inscription below reads: 'Sayyid Ali, the rarity of the realm of Humayun Shah, painted this.' By virtue of its location and phrasing, this second inscription must be understood as a signature, still an exceedingly rare indication of authorship at this point in the history of Iranian painting.[2] Moreover, the epithet Mir Sayyid Ali uses implies that Humayun was the reigning emperor. The logical inference, therefore, is that Mir Sayyid Ali completed the painting for Humayun before that ill-fated ruler fell to his death on 28 January 1556. To judge by the sitter's Indian dress and the style of the painting, which displays greater figural volume and a more spatially advanced setting than work executed at Kabul in the early 1550s (for example, cat.5), this portrait was probably done not long after Humayun and his artists had reached Delhi in August 1555.[3] In short, it serves as the benchmark for Mughal painting on the eve of Akbar's accession and the inception of the *Hamzanama* project.[4]

While most authors have taken the subject to be generic, one has recently proposed that this painting is actually a second self-portrait of Mir Sayyid Ali,[5] an interpretation supported by the probable meaning of the first inscription, which plausibly alludes to the artist's training by his father, Mir Musawwir.

1. Melikian-Chirvani 1998, pp.36–37. This reading varies significantly from that offered by Martin Dickson in Dickson & Welch 1981, 1, pp.190–91: 'On the frontispiece of his mind he has written, "Better a forceful master than a father over kind."'
2. It omits the title Mir, which would never be used when referring to oneself.
3. In his generally convincing argument for this date, Melikian-Chirvani (1998, p.38) cites the European-inspired form of the scroll, which, he believes, was never known in Kabul.
4. Due to an editorial oversight, a painting in the Bellak Collection was erroneously attributed to Mir Sayyid Ali in Mason 2001, no.13.
5. Melikian-Chirvani 1998, pp.34–37.

8a SEATED SCHOLAR

In both theme and form, this image of a middle-aged scholar seated pensively before a bookstand complements the scene of astrologers mounted beside it (cat.8b). A man again stares at a book, apparently now without any of the urgent expectation that it will yield simple answers to immediate predicaments. The assorted writing implements and carrying cases make their way into this world, too, but pale before a lectern and a pile of cushions, as if the reader has settled in for a prolonged session of pondering more difficult texts.

The two drawings also represent very different points along the spectrum of Mughal naturalism. This drawing, ascribed to Mir Sayyid Ali in the lower margin, has many glimmers of naturalism, from the position of the head cradled wearily in one hand to the sense of weight conveyed by the left arm stiffened for support. Despite these touches, the drawing is still dominated by a rhythmic, even calligraphic line, manifested most obviously in the great curves of the legs and right arm, as well as in those of the sashes and *jama* folds covering the feet. And when the artist wishes to render the folds of the delicately colored shawl where it is thrown over the scholar's shoulders, he does so with utterly schematic

forms. By contrast, in Basavana's work some twenty years later (cat.8b), these same features become pliant and irregular, with attention directed more to the substance of a form than to its shape or outline. Both drawings were much admired by the Mughals themselves. In the case of this contemplative scholar, this high regard is indicated by the word *awwal* ('first class') written faintly in the lower right corner.

The dearth of documentation of Mir Sayyid Ali's work in India makes it difficult to date this drawing with any certainty. It compares reasonably closely in style to cat.7, but the greater facial expressiveness suggests a slightly later date, probably during the years when Mir Sayyid Ali faced the burden of directing the enormous *Hamzanama* project.

Ascribed to Mir Sayyid Ali
India, Mughal dynasty,
circa 1560–65
14 × 9.5 cm.
Musée des arts asiatiques-Guimet, Paris EO 3577 B

Published: Seyller 2000, fig.9; Melikian-Chirvani 1998, fig.17; Okada 1992, fig.70; Okada 1989, no.27; Zebrowski 1983, no.18.

8b PRINCE AND ASTROLOGERS

What does the future hold for us? As prince and pauper alike have pondered this age-old question, they have often enlisted the aid of astrologers, who assure their clients that their individual fates can be discerned in the alignment and movement of the celestial bodies. European travelers attest that the practice of consulting astrologers to glimpse the future was wildly popular in Mughal India. At the royal level, this observation is borne out in most illustrated historical manuscripts, for almost every scene celebrating the birth of a royal scion includes a passage in which astrologers chart his horoscope.

This drawing depicts a young prince seeking answers to more immediate quandaries. Seated in a palatial chamber festooned with heavy swags and attended by a page, a sword-bearer, two attendants, and a pet monkey, the plumed figure waits intently for the leader of a motley troupe of astrologers to make his prediction. This venerable soothsayer surely will not disappoint. Having gathered some arcane charts and instruments—a scroll presumably containing lists of cryptic omens, an inkwell, a pen, and an hourglass – he now points with all gravity at a rotating ring dangling from a short chain. A young assistant consults a book, probably a copy of the

Diwan of Hafiz or the Koran, while a more senior colleague becomes so anxious that he raises not one, but four fingers to his mouth.

A fragmentary ascription to Basavana in the lower right corner confirms an attribution of this compelling scene to Basavana, the most perceptive student of human nature in all of sixteenth-century Indian painting. The prince and his puckered-mouthed pages are less strongly characterized than we normally expect of Basavana, perhaps because the artist recognized that their tender age and lost profiles made for too clean a slate for his usual humanizing traits. By contrast, his assorted soothsayers could hardly be quirkier or more interesting in countenance. Whatever their expression, all the figures are rendered with marvelous volume, achieved largely by means of soft contours and carefully observed texture and shading.

Despite these many fine features, this drawing was rated as second class in quality, as is indicated by the numeral 2 written below the central figure and again directly above the ascription. The anonymous evaluator singled out the chained monkey as still less accomplished, and inscribed a number 3 (third class) immediately beside it.

Ascribed to Basavana
India, Mughal dynasty,
circa 1585–90
14.9 × 11.7 cm.
Musée des arts asiatiques-Guimet, Paris EO 3577 A

Published: Melikian-Chirvani 1998, fig.7 (detail); Okada 1989, no.29.

CAT 8a

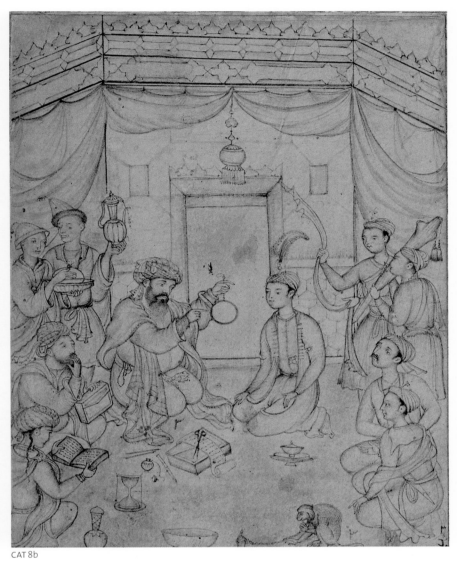

CAT 8b

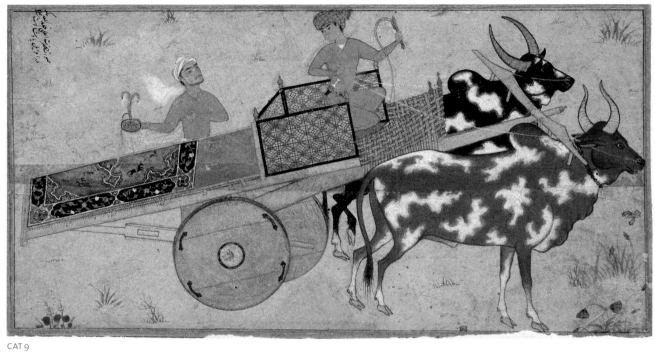

CAT 9

9 AKBAR DRIVES A BULLOCK CART

Attributed to Abdul-Samad
India, Mughal dynasty,
dated [96]4, AD 1556–57
Painting 8.9 × 17 cm,
folio 9.2 × 17.6 cm.
Private collection

From the outset, it is apparent that this hitherto unpublished scene is very early in date. The figure style is still exceedingly Persianate, and the bullocks and the cart they draw are crisp forms set against an almost entirely plain ground. The subject is, at first, a bit enigmatic: a handsome, richly turbaned youth with a golden-handled whip in hand driving a team of piebald bullocks. The vehicle he guides appears to be a utilitarian one, for it features large, solid wheels, a long, flat platform extending well beyond the wheel base, and a driving or sitting area surrounded on three sides by an intricate wooden screen, but otherwise left open. Much of the platform is covered with a fine pictorial carpet, depicted as though folded in half, with a scene of a mounted figure hunting deer in each quadrant. Behind it stands a slender, dark-skinned figure, who holds a plumed object with an oval base in his hand even as he looks toward the driver.

The overall impression of royalty is corroborated by the inscription oriented vertically in the upper left; it reads, 'Portrait of His exalted God-abiding Majesty at the beginning of royalty, year [-]4.'[1] This, then, is Akbar shortly after his accession in February 1556, an interpretation supported by the royal driver's obvious youth. But why is Akbar shown driving an empty bullock cart? The answer may lie in the elusive year noted at the end of the inscription, which becomes somewhat unclear as it runs across the thin black border and possibly also under the adjacent gold band. If the word beneath the numerals is *sana* ('year'), as would be customary, then enough of that word is cut off or obscured to allow for a second and third digit to the left of the clearly written number 4. The most logical date would be AH 964 (November 1556–October 1557), in fact, the beginning of Akbar's reign.[2] If, however, the mark to the immediate left of the black line is no number at all, then the year stands at [regnal year] 4, or March 1559–March 1560. The appeal of this reading is that the image suddenly acquires a specific rationale, that is, to commemorate the presentation to Akbar of a bunch of fine bullocks, described as 'unequalled and fit for the royal hunting equipage,' by Shaykh Muhammad Ghaws in exactly that year.[3] One serious objection to this tidy

coincidence is that dates formulated in regnal years were not used until after AH 992 (AD 1584), when they were applied retroactively in historical texts. Thus, if it is a regnal year, it would follow that the inscription was added well after the painting was made, a scenario that would accord well with the retrospective quality of the phrase 'at the beginning of royalty' (i.e., his reign).

Whatever its exact date, this painting of a bullock cart designed and outfitted for transporting cheetahs to the hunt may safely be attributed to Abdul-Samad.[4] The dark hair, slanted eyebrows, pointed chin, and slender, compact body of Akbar strongly resemble those of the young prince and many of the courtiers in Abdul-Samad's famous treehouse painting of 1553 in the Gulshan Album, as well as some of the original attendants in *Princes of the House of Timur*.[5]

1. The Persian reads '*sūrat-i haẓrat a'lā, khalladā 'llahu mulkahu, dar avāyil-i pādishāhat sana [-]4.*' I am indebted to Wheeler Thackston for his thoughtful exposition of the substance and date of this inscription.

2. The digit beside the 4 is overwritten with the numeral 2 with an abnormally small upper element, but there is evidence of the bowl of the number 6 beneath and to the left of this overwritten number.

3. *Akbar Nama*, 2, pp.133–34. One might also note the existence of a similar old-style painting by Abu'l-Hasan of *circa* 1605–10 showing a young Akbar being driven in a canopied vehicle drawn by two bullocks; the painting, whose location is unknown, is reproduced in Mehta 1926, opposite p.64.

4. For comparable carts shown carrying cheetahs, see Sen 1984, pls 10 and 39, and Arnold & Wilkinson 1936, pl.25.

5. For reproductions of these paintings, see cat.5, n.2.

10 THE MONKEY IS SLAIN SO THAT HIS BLOOD CAN BE USED TO CURE THE AILING PRINCE HE HAS BITTEN

The earliest painting ascribed to Basavana is this illustration from the *Tutinama*, a collection of colorful stories recounted by a parrot to his mistress Khojasta night after night to keep her from straying during her husband's long absence. This painting is the third of five illustrations accompanying the story of the fifth night, which tells of the misfortune that arises inevitably when creatures of dissimilar natures associate with one another. In this case, despite the protestations of his own kind, a monkey skilled in chess befriends a prince. One day, the monkey makes a rude gesture during a chess match and deeply embarrasses the prince before his friends. The annoyed prince whacks the monkey with a chesspiece, and the monkey retaliates by biting him on the hand. Soon the prince falls direly ill. When it seems that the prince is at death's door and no ordinary medicine can save him, a doctor recommends that the offending monkey be killed and his blood applied to the infected wound.

Basavana juxtaposes the bedridden prince with the fatal bloodletting required for the proposed remedy. The sallow prince, who wears a vacant expression and an odd, European-inspired head covering, weakly lets his arm hang down to allow an attendant to take his flagging pulse. Basavana demonstrates his early receptiveness to European art in the subtle modeling of the prince's sheets, which cling to the patient like a shroud, and in the more conspicuously voluminous rendering of the upswept bedchamber curtains. In this painting, this three-dimensional quality is still absent from his figures' clothing, which differs from other work in this manuscript only in the unusual brown used for the executioner's *jama*. The figures' faces, however, are marked already by Basavana's distinctive soft features, a quality created by the tiny overlapping strokes used to define both the eye and eyebrows as well as the fuzzy facial hair. Together with the black-streaked sky and the brushy foliage of one tree, these are the first hints of Basavana's longstanding interest in the expressive possibilities of painterly effects.

Folio 33b from a *Tutinama* manuscript
Ascribed to Basavana
India, Mughal dynasty, *circa* 1565–70
Painting 17 × 11.2 cm, folio 20.3 × 14 cm.
The Cleveland Museum of Art, Gift of Mrs. A Dean Perry, 1962.279.33.b

Published: Okada 1992, fig.73; Simsar 1978, pl.7; Chandra & Ehnbom 1976, no.56, pl.13.

11 THE HUNTER SELLS THE MOTHER PARROT TO THE KING OF KAMARUPA

Basavana's second ascribed painting in the *Tutinama* comes near the end of the fifth night's story. A mother parrot, who earlier had told her nestlings the cautionary tale of the chess-playing monkey, now finds that they have not heeded her and have continued to consort with some foxes. When a wildcat devours the baby foxes, the mother fox blames the parrot family and plots retribution. The fledglings are eventually caught in a hunter's net, but save themselves by feigning death as their mother had instructed them so that the hunter discards them. The mother parrot, who is taken in their place, persuades the hunter that she is more valuable alive than dead, for she is well-versed in the medical arts and can cure any disease. The hunter agrees and sells her to the king, who is afflicted by leprosy. Under the parrot's care, the king's leprosy begins to abate, but when she tricks him into freeing her from her cage, she flies off and leaves the cure half-done. With this conclusion, the parrot relating the tale to his mistress assuages her by advising that she should hasten now lest her own love affair be left similarly undone. Alas, as usual the parrot's story has gone on so long that dawn has come, and the would-be unfaithful woman must wait another day before she can slip out to consummate her affair.

This painting demonstrates Basavana's unsurpassed ability to render mass and texture. The hunter's tunic is not a flat color overlaid with schematic suggestions of folds at the waist and cuffs; rather, it is a pale blue that the artist has lightened in some parts and darkened in others to convey a sense of rounded form. Similarly, Basavana uses paint and crosshatching so subtly that the hunter's scarf changes imperceptibly from white to grey, and reads convincingly as a roughly woven fabric.

Like other artists who contributed to the *Tutinama*, Basavana incorporates some elements of the underlying Chandayana-style painting into his updated version of the scene. He keeps some of the ornamental passages, such as the white cornice, the floral valance, and the stepped gold band overhead. Conversely, he paints over many other parts, including the framing columns and the kiosks above, and obscures the pavilion's original interior with a thick layer of gold. One telltale sign of the original composition is the three swords extending into the text area; these have no rationale in the present scene, and must have belonged to a different set of courtiers.

Folio 36b from a *Tutinama* manuscript
Ascribed to Basavana
India, Mughal dynasty, *circa* 1565–70
Painting 10.1 × 10.5 cm, folio 20.3 × 14 cm.
The Cleveland Museum of Art, Gift of Mrs. A Dean Perry, 1962.279.36.b

Published: Brend 1999, fig.4; Verma 1994, pl.IV; Okada 1991, fig.1; Schimmel & Welch 1983, fig.5; Verma 1978, pl.II; Beach 1976, fig.2; Lee & Chandra 1963, fig.34; Welch 1963, no.3A.

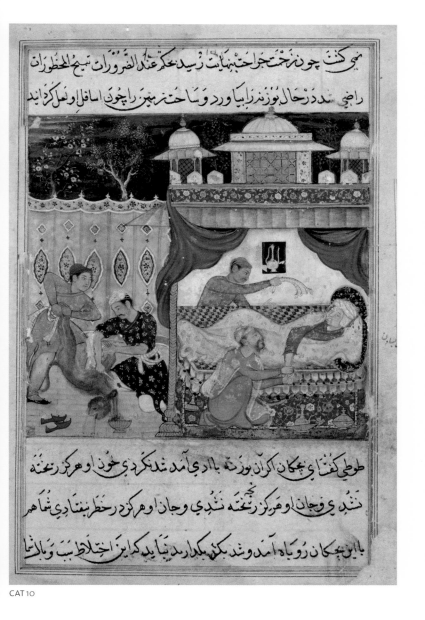

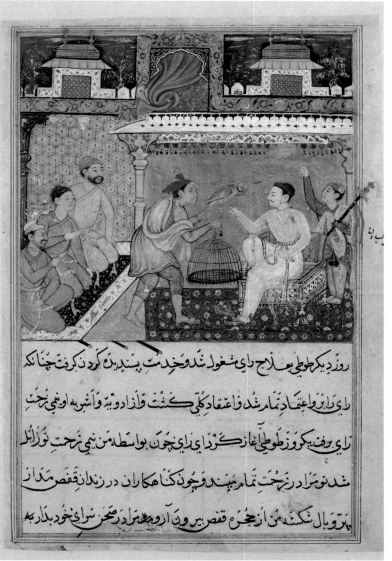

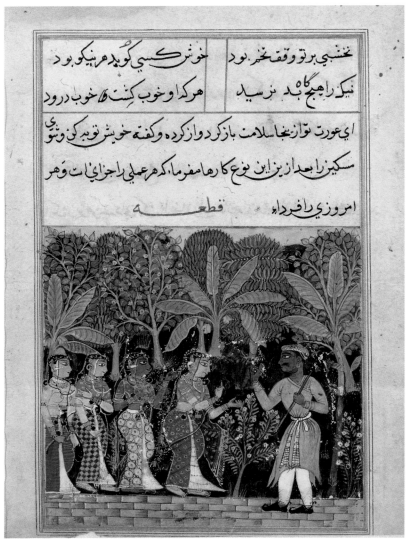

بخشی بر تو وقف نخیر بود خوش کسی کوبد مر نیکو بود

نیک را هیج گاه بد نرسید هر که او خوب کشت او خوب درود

ای عورت توان بخاسلامت باز کرد و از کرده خویشتر توبه کنی و تو

سکین را بعد از این این نوع کار ها مفرما که هر عملی را جزائی است و هر

امروزی را فرداه قطعه

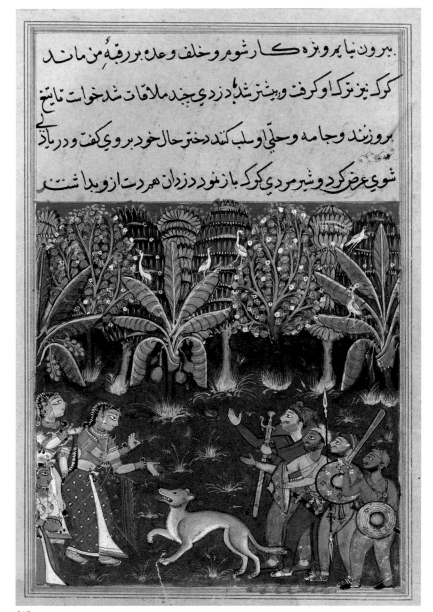

ببروند بنا بر وعده کار شوم و خلف وعده برورقه من ماند

کرک بوزک او کرف و بیشتر شند دزدی چند ملاقات شد خواست نایند

بروند و جامه و حلی او سلب کند دختر حال خود برو کف و دریائی

شوی عرض کرد و شبر مردی کرک با زمود دزدان هر دست از و بدا شت

CAT 12

CAT 13

12 THE MERCHANT'S DAUGHTER ENCOUNTERS A WOLF AND A THIEF ON HER WAY TO FULFILL HER VOW TO THE GARDENER

Folio 99b from a *Tutinama*
manuscript
India, Mughal dynasty,
circa 1565–70
Painting 11.1 × 10.2 cm,
folio 20.3 × 14 cm.
The Cleveland Museum of Art,
Gift of Mrs. A Dean Perry,
1962.279.99.b

Published: Simsar 1978, pl.18;
Chandra & Ehnbom 1976,
no.52, pl.10.

On the twelfth night, the parrot counsels his mistress to discern the real character of her paramour before she commits herself to an affair. As with most stories in this profusely illustrated manuscript, one illustration is dedicated to the parrot addressing Khojasta, another to the framing story, and several more to the encapsulated tale. This painting represents the last phase. A merchant's daughter comes across a perfect flower in a garden. She asks the gardener if she may have it, but he replies that it is priceless, and can be had on only one condition: that she give herself to him on her wedding night before she consummates her marriage with her husband. The woman promises to do so, and plucks the flower. On her wedding night, she persuades her husband to accept her arrangement by saying that an honorable person must keep her promises. On the way to her rendezvous, she encounters a wolf. The wolf looks at her with ravenous eyes, but she declares that he must not devour her until she fulfills her promise, for otherwise she would be dishonored. Next, she is intercepted by a thief, but she dissuades him, too, from waylaying her by pointing out that he should not cause her to violate the vow that her husband and the wolf have already allowed her to honor.

When, in the following illustration (cat.13), the woman finally meets the gardener again, she proclaims that she is ready to abide by her promise. The gardener, however, has grown devout and wise, and declines to exact his carnal recompense, saying 'If I pick a rose from another's garden, others will covet my garden.'

This painting is one of a small group of *Tutinama* paintings made by artists trained in the indigenous Indian tradition represented by cat.1 and painted over a Chandayana-style illustration of *circa* 1540. The row of highly schematic trees is common to both older traditions, but here these are tempered by Mughal clumps of grass at the base of their trunks and the blue sky painted over the original gold one. In a gesture to the emerging Mughal style, the artist has rounded slightly the faces of the merchant's daughter and her companions, and has applied a thin coat of paint to the thieves to give them a semblance of volume. This layering of paint often results in a somewhat murky surface, as it does here.

13 THE MERCHANT'S DAUGHTER ARRIVES TO FULFILL HER PROMISE TO THE GARDENER

Folio 100b from a *Tutinama*
manuscript
India, Mughal dynasty,
circa 1565–70
Painting 9.9 × 10.2 cm,
folio 20.3 × 14 cm.
The Cleveland Museum of Art,
Gift of Mrs. A Dean Perry,
1962.279.100.b

Published: Beach 1992, fig.13;
Beach 1987, fig.5; Verma 1978,
pl.III; Krishna 1973, fig.4; Lee &
Chandra 1963, fig.25; Welch
1963, no.3B.

The final illustration of the story of the twelfth night shows the merchant's daughter prepared to make good on her promise to surrender her virginity to the gardener in payment for the perfect blossom she had coveted. The gardener, identified by the spade resting on his shoulder, raises his hand in address and tells the woman to return home and never burden her husband again with such affairs again.

Like most Mughal painters, this artist does not insist on absolute consistency in a figure's costume or complexion in consecutive illustrations. In this case, however, he also arbitrarily increases the number of the daughter's companions from two to three, even though this required further changes to the underlying Chandayana-style scene. Examination of the painting under infra-red light reveals that the painter not only reworked three women and the gardener in face and dress, but also added the leftmost figure; this, in turn, compelled him to truncate the tree above her, which previously extended to the lower edge of the painting. To maintain compositional balance, he shortened the trunk of the rightmost tree by covering its lower half with grass and tile, an alteration visible even to the naked eye. He retains the foliage of the original screen of trees, but

now fronts it with three plantain trees. These more typically Indian plants crop up in several *Hamzanama* paintings, notably cat.59 and 76, where they are rendered in more muted tones and are usually set in much more naturalistic environments.

Few Chaurapanchasika-style features survive in such unalloyed fashion in the *Hamzanama*. This suggests that while a few artists trained in this older style were allowed to maintain it in their work on projects as modest as this *Tutinama* manuscript, new recruits to the imperial workshop were generally obliged to embrace the emerging Mughal style or to seek employment elsewhere.

14 AN *AYYAR* LEADS A ROYAL HORSE

The figure leading this dappled grey steed is no ordinary groom putting his master's horse through its paces. Battle-axe in hand and dagger tucked in belt, he is much too heavily armed for such mundane matters. Wiry and whippetlike, he is perfectly outfitted for speed and stealth. He is, in fact, an *ayyar*, a kind of spy shown skulking about in many a *Hamzanama* illustration, here brought out in the open for a solo performance. *Ayyar*s never ride, so the richly caparisoned horse must be that of a prince or amir.

The *ayyar*'s delicate features, the elegant linear rhythms of the horse, and the stone-strewn landscape have led some scholars to attribute this painting to Abdul-Samad.[1] In the lower right corner, however, is a minute ascription to Mah Muhammad, an artist heretofore little known in Mughal painting. His only other ascribed works – illustrations in the *Khamsa* of Nizami (fig.21) in the Keir Collection and the *Akbarnama* in the Victoria and Albert Museum – exhibit the same Persianate figure style, though in those slightly later paintings it is tinged by Mughal modeling.[2] The landscape of the Keir *Khamsa* illustration is stippled and less barren, but features discrete stones scattered beside a stream in much the same manner as they appear here.

The *Khamsa* painting, in turn, supports the attribution of several important early paintings to Mah Muhammad, most notably a much-published depiction of Prince Akbar hunting deer.[3] Spindly figures and some faces, such as that of the man by the stream and the doll-like ones elsewhere, recur in the *Khamsa* illustration. Jagged rocks with distinctive white internal highlights appear in both works, and in an illustration from the *Anwar-i Suhayli* of 1570, a painting that should be attributed to Mah Muhammad as well.[4] The combination of attenuated forms and a dark green ground streaked with loosely painted yellow tufts also connect Mah Muhammad with cat.15, and with a painting of a doe suckling its fawn.[5]

1. Canby 1998, p.16; Dickson & Welch 1981, p.199.
2. Victoria & Albert Museum, London, I.S.2-1896, no.50/117. This painting, which dates from the mid-1580s, is unpublished.
3. Fitzwilliam Museum, Cambridge, PD 72-1948, published in Beach 1987, frontispiece.
4. School of Oriental and African Studies, London, Ms.10102, f. 93b; Seyller 1986, fig.16.
5. San Diego Museum of Art, 1990:272; Beach 1987, fig.32.

Ascribed to Mah Muhammad
India, Mughal dynasty,
circa 1570–75
16.4 × 24.7 cm.
The Metropolitan Museum of Art, Fletcher Fund, 1925. (25.68.3)

Published: Canby 1998, fig.5; Kossak 1997, no.10; Schulz 1914, 1, pl.P.

15 BATTLE SCENE

This painting gives a good idea of how the *Hamzanama* might look if it were produced on a typical miniature scale. All the elements of a regular battle scene are here – the ranks of charging horsemen, the large ridge dividing the composition into discrete zones, and the fortified city. The visual effect, of course, is completely different; one easily takes in the composition in a single glance, and begins to regard the figures as so many antlike forms rather than as characters with their own stories to tell. At this scale, too, the precision of detail usually breaks down, and remains beyond the technical ability of many Mughal artists.

In this battle scene by Mah Muhammad, the elegance of his *ayyar* and horse (cat.14) has become daintiness, the former crispness of paint and color has grown soggy and muddled, victim of both miniaturism and the irregular painted surface below.[1] Mah Muhammad had considerable skills, but it took the perspicacious supervisors of the *Hamzanama* to recognize how best to make use of his talents.

Indeed, Mah Muhammad's work is evident in the *Hamzanama*, albeit not in any whole painting, nor even in any part involving primary figures, his weakest suit. Rather, he is assigned to paint architecture, where pattern and fantasy can compensate for sometimes faltering draftsmanship and a tenuous sense of pictorial space. Many fortresses, of course, have similar features; indeed, one *Hamzanama* illustration by another artist (cat.63) uses a gateway cut off again by a darkly outlined intrusive ridge and framed by nearly identical hexagonal towers. Yet Mah Muhammad's architectural ensembles are conspicuously more naive and boxy, and typically lack the rich detailing that sustains visual interest and gives substance to domes, courtyards, and defensive openings. These qualities are particularly pronounced in cat.26 and 55, both of which are also attributed to this artist.

1. This painting, like many in the group of early paintings divided between the British Museum and the Fitzwilliam Museum in 1948, was painted over an earlier image; the result is an unusually murky surface.

Attributed to Mah Muhammad
India, Mughal dynasty,
circa 1570–75
Painting 22.4 × 13.2 cm,
folio 28.8 × 18.9 cm.
The British Museum, London,
1948 10-9, 076

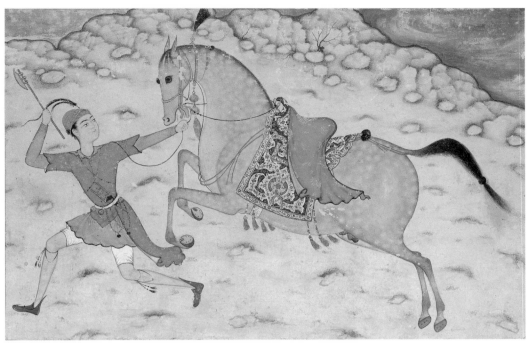

CAT 14

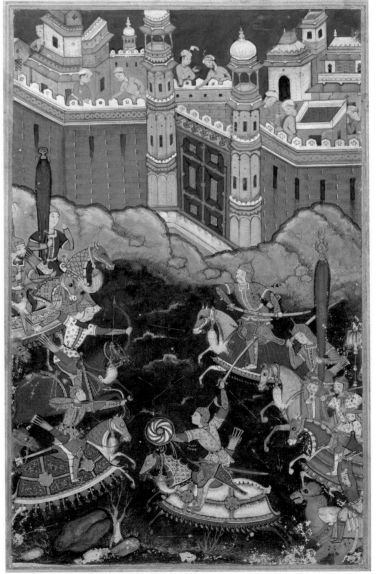

CAT 15

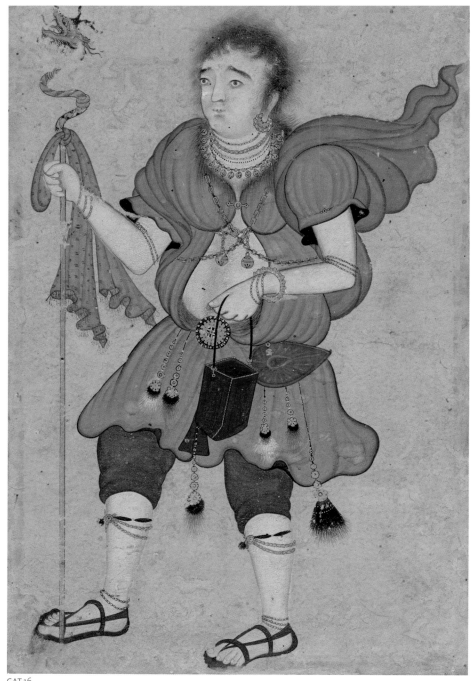

CAT 16

16 PILGRIM

Attributed to Mukunda
India, Mughal dynasty,
circa 1570–80
19 × 12.8 cm.
The British Museum, London,
1983 7-27-01

Published: Rogers 1993, fig.10;
Brand & Lowry 1985a, no.40;
Christie's, London, 13 June 1983,
lot 44.

From as early as 1561, when Akbar was still in his teens, he took an interest in spiritual seekers, both Muslim and Hindu. Abu'l-Fazl records that

> In his abundant carefulness he [Akbar] sought for truth among the dust-stained denizens of the field of irreflection – and most of the really great study it under this disguise – and consorted with every sort of wearers of patched garments such as *jogis, sanyāsīs* and *qalandar*s, and other solitary sitters in the dust, and insouciant recluses. From their outward ways and conversation he got at their real natures.[1]

This striding pilgrim is one of the earliest depictions of these captivating dervishes. The painting shows a fully colored figure trudging alone across an otherwise plain compositional field, a serpent-headed staff in one hand and a mendicant's bucket in the other. For one who has purportedly renounced worldly ways, the figure is ostentatiously festooned with golden earrings, necklaces, bracelets, chains, bells, and tassels. He wears a heavy fur-trimmed *jama* in a peculiar manner, closed at the breast by a golden clasp and left open below this to expose an ample belly. Although one author has proposed that the source of such subjects is albums compiled in Iran,[2] the bulky sleeves and fluttering shawl actually suggest a connection with European images, perhaps simply at the level of physical oddities.[3]

The pilgrim has an unusual countenance, with a plump face, tousled hair, rounded blue eyes, and a crinkly mouth. Many of these features reappear in another, albeit lightly colored, image of an ascetic with a pet sheep ascribed to Mukunda, and support an attribution to this artist.[4] The schematic modeling of the garments and the large, blockish, heavily outlined hand also recur in Mukunda's paintings in the 1595 *Khamsa* of Nizami in the British Library.[5] One damaged *Hamzanama* painting shows a giant named Sar Farangi wearing a *jama* open in the same fashion and exhibiting similarly thick limbs and hands.[6] This suggests that Mukunda, a prolific and highly regarded artist, was also involved in the *Hamzanama* project.

1. *A'in-i Akbari*, 3, p.236.
2. Rogers 1993, p.31.
3. See, for example, *Europeans Embracing* (Los Angeles County Museum of Art, M.83.105.20), published in Pal 1993, no.53, which also seems to be by Mukunda.
4. For this painting, now in a private collection, see London 1982, no.267.
5. Fols 184b and 318a; Brend 1995, figs 23, 42.
6. Victoria & Albert Museum, London, I.S. 2511-1883. See Reconstruction, no.32.

17 JAMSHED WRITING ON A ROCK

Jamshed, an ancient Iranian king credited in legend with the rock-cut marvels of Persepolis, is shown kneeling with pen and inkpot in hand as he prepares to inscribe a small unadorned rock face in the wilderness.[1] While this subject, which is described in the couplets above the painting, has few visual precedents, Jamshed was a staple exemplar of royal wisdom in Persian literature. It is possible that Abdul-Samad was asked to concoct a scene with Jamshed as a visual paean to Akbar's grandfather Babur, who refers to Jamshed's act in his memoirs.[2]

Abdul-Samad isolates a young Jamshed on one side of the composition, his golden raiment setting him off from the gloomy environment all about him. The rocks – one of Abdul-Samad's most distinctive features – display many of the contradictory impulses of his late style. Most of his peers would use the sharp, linear outlines that bind the rocks' flickering shapes to define a series of large, unified forms. In Abdul-Samad's work, however, those rocky forms dissolve into small nodules with muted striations and a stippled surface; only edges silhouetted against the sky or a distant background preserve the crispness of the landscapes of his Iranian heritage. Internal segmentations are thus paradoxically both geometric and soft, and never create the sense of volume that more painterly treatments do. This particular painting also exhibits a palette tempered heavily with a dark tonality, with bright, unmodulated color relegated to a few compact areas on the clothing of figures placed at the composition's periphery.

Abdul-Samad's penchant for precisely painted forms is well suited to the figure scale employed here; at this miniature size, the technically impressive amount of delicate detail in face and gesture more than compensates for its inhibited expression.

1. Soucek 1985, p.164. For the classical literary expression of this association, see Wickens 1974, p.30.
2. See *Baburnama*, p.135. Wheeler Thackston has suggested that the Timurid crown worn by Jamshed might serve to associate him with Babur (personal communication).

Page from the Album of Jahangir
Ascribed 'painted by Abdul-Samad *Shirin Qalam* in his great old age, dated [regnal] year 32, corresponding to 996 [AD 2 December 1587–9 March 1588]'
Painting without border decoration 33.3 × 20.8 cm, folio 42 × 26.5 cm.
Freer Gallery of Art, Smithsonian Institution, Washington, DC; Purchase F1963.4

Published: Beach 1994, p.26; Das 1994, fig.3; Rogers 1993, fig.11; Okada 1992, fig.61; Beach 1987, fig.44; Soucek 1985, p.166; Beach 1981, no.16d; Beach 1982, fig.5; Dickson & Welch 1981, fig.254.

18 TWO CAMELS FIGHTING

This painting, a close copy of an original composition by Bihzad, embodies the legacy of the Persian master whose work became the nominal standard of quality for Mughal painters from this time on.[1] Bihzad's painting had probably entered Mughal hands shortly before Abdul-Samad made this copy about 1599, for it was included in the majestic Gulshan Album being compiled at exactly this time. Abdul-Samad's version of the camel fight has been dated variously from 1570 to 1599, a chronological range that testifies to the overriding conservatism of his style. But in the dedicatory inscription above this painting, the artist effectively dates it by mentioning his age, which, at eighty-five, surpasses even the 'great old age' inscribed on his 1587–88 painting of Jamshed (cat.17):

> At the age of eighty-five, when his energies were sapped and his vision dimmed, the halting brush of this broken painter made this as a remembrance for his wise and ingenious son, Sharif Khan, who is fortunate enough to have been chosen for the blessing of the Merciful God. May his life be prolonged. Illustrated by Abdul-Samad.[2]

Abdul-Samad undoubtedly realized that his reprise of Bihzad's composition would inevitably be judged against the master's work. Reversing the composition, Abdul-Samad makes minor adjustments in the heads and legs of the fighting camels so that the balance of power shifts in favor of the beasts. The enraged camels now joust in earnest, and their unperturbed keepers make only a half-hearted attempt to control them with rope and stick. The Mughal artist dedicates a proportionately greater amount of the composition to the landscape, and frees the newly meandering horizon from the shape and rhythm of the camels' backs. The result is a scene more naturalistic in action and space, albeit without the compelling lateral tension of Bihzad's composition.

The earliest of the eight Mughal inspection notes and seals on the reverse dates from 1637.[3] The painting was given a Mughal valuation of Rs. 30, a high but not extravagant amount for an animal painting.

1. For Bihzad's painting, made about 1525, see Bahari 1997, fig.120.
2. As translated by Bahari (1997, p.216). This translation differs in one crucial detail from that put in Brand & Lowry 1985a, no.58, where the slightly damaged first two words are read as 'this master and shaykh' (*īn ustād wa shaykh*) rather than 'at the age of eighty-five' (*dar sinn-i hashtād wa panj*).
3. The seal is that of Abdul-Rahman, 'servant of Shah Jahan Padshah Ghazi, year 11.' Other Mughal documentation follows closely in date, and ends in the first year of Alamgir's reign (1658–59).

Ascribed to Abdul-Samad
India, Mughal dynasty, *circa* 1599
18.8 × 22.4 cm.
Private collection

Published: Lentz & Lowry 1989, fig.109; Fischer & Goswamy 1987, no.19; Brand & Lowry 1985a, no.58; Falk 1985, no.121; Soucek 1985, p.165.

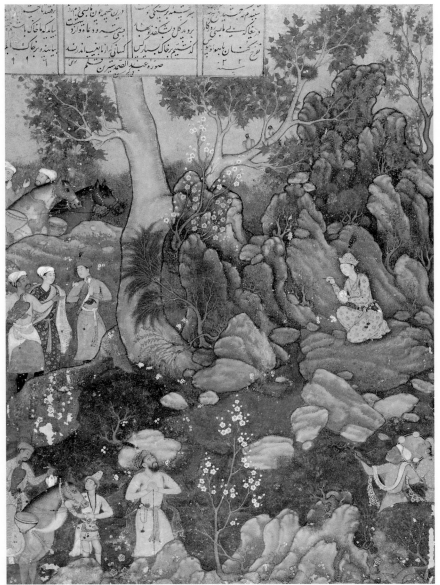

CAT 17

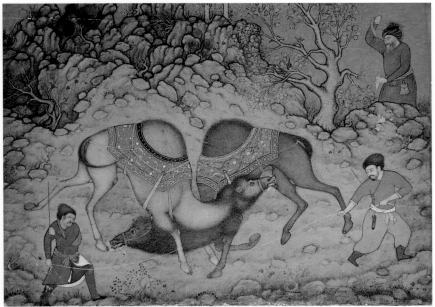

CAT 18

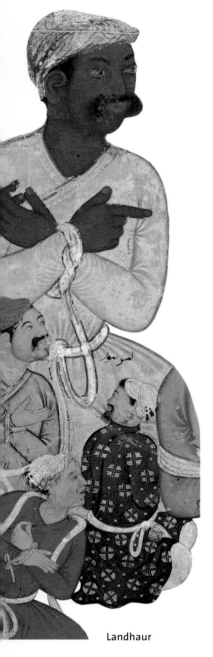

Landhaur

THE ARMY OF ISLAM

Afsar Banu
A princess with whom Prince Hamid
Ruby-Tunic falls in love

Alamshah Rumi
('the Greek') One of Amir Hamza's sons

Anoshirvan
Sassanian emperor of Iran,
Amir Hamza's father-in-law

Ashqar
Amir Hamza's three-eyed, winged
horse, born of a demon and a *peri*

Asma
A fairy who marries Amir Hamza
and helps him in his struggle

Ayjil
One of Amir Hamza's brothers

Baba Junayd
Arghus's jailer, now retired and
running a caravanserai

Badi'uzzaman
One of Amir Hamza's sons

Buzurjmihr, Khwaja
Anoshirvan's wise vizier

Hamid Ruby-Tunic, Prince
(La'l-Qaba) One of Amir Hamza's sons

Hamza
Son of Abdul-Muttalib, historically
the paternal uncle of the Prophet
Muhammad. He is the hero of the
Hamzanama, in which he is referred
to by his titles, Amir and Sahib-Qiran
('Lord of the Auspicious Conjunction')

Hurmuz
Anoshirvan's eldest son, the crown
prince of Sassanian Iran

Ibrahim, Prince
One of Amir Hamza's sons

Khosh-Khiram
Daughter of Malak Mah's nurse,
a female *ayyar*

Khusraw
Son of King Jamshed of Takaw

Khwarmah
A princess, daughter of the enemy
Malik Qimar and beloved of Prince
Ibrahim

Landhaur
Son of Sa'dan, the king of Ceylon, a
warrior companion of Amir Hamza

Mahiya
Maidservant of Sher Banu, who acts
as an *ayyar* for Prince Ibrahim

Malak Mah
Daughter of the enemy King Na'im
and the beloved of Prince Sa'id
Farrukh-Nizhad

Mihrdukht
Daughter of the enemy Malik Tayhur
and plucky wife of Prince Hamid

Mihr-Nigar
Anoshirvan's daughter, who marries
Amir Hamza and bears him Qubad

Misbah
A grocer who assists Amir Hamza's
ayyars

Muqbil
Amir Hamza's adoptive brother

Nu'man, Khwaja
One of Amir Hamza's *ayyars*

Qasim, Malik
('the quick-tempered') King of the
west, ally of Amir Hamza

Qubad
Son of Amir Hamza and Princess
Mihr-Nigar

Qubad
Son of Sa'd Padishah and Amir
Hamza's great-grandson

Sa'd Padishah
Amir Hamza's grandson

Sa'id Farrukh-Nizhad
A prince and ally of Amir Hamza

Sanawbar Banu
Sister of the enemy Tahmasp Anquil
who falls in love with Amir Hamza

Solomon
The biblical king who commanded
all creatures on the earth. The
'Solomonic court' refers to Amir
Hamza's court.

Songhur Balkhi
One of Umar's *ayyars*

Tul Mast
Son of Salsal the Zangi, one of Amir
Hamza's *ayyars*

Umar
Son of Umayya Zamiri, loyal comrade
of Amir Hamza and the greatest
ayyar of the age, often referred to as
Khwaja Umar and Baba Umar

Umar Ma'dikarb
A former opponent of Amir Hamza,
now a stalwart, sometimes comical,
warrior companion

Yazak the Cathayan
(i.e. from China) One of Umar's
companions

Zambur
One of Prince Ibrahim's *ayyars*

Mihrdukht

INFIDELS AND ENEMIES

Arghus, Malik
King of Takaw, ally of Zumurrud Shah

Bakhtak
Anoshirvan's evil vizier and counselor.
He is perpetually hostile to Hamza

Iraj Nawjavan, Malik
Leader of the Iranian fire-worshippers

Mahus
An enemy *ayyar*

Mazmahil
A surgeon from the sorcerer-held
city of Antali

Marzuq
King of the Franks (Europeans)

Nimrod
A Zoroastrian

Shahrashob
An enemy *ayyar* who abducts Amir
Hamza

Zarduhusht
Zoroaster, leader of Iranian infidels,
considered the foremost of sorcerers

Zumurrud Shah
(Gumrah, 'the Lost') King of the east,
a gigantic, perennial enemy of Amir
Hamza

Ashqar

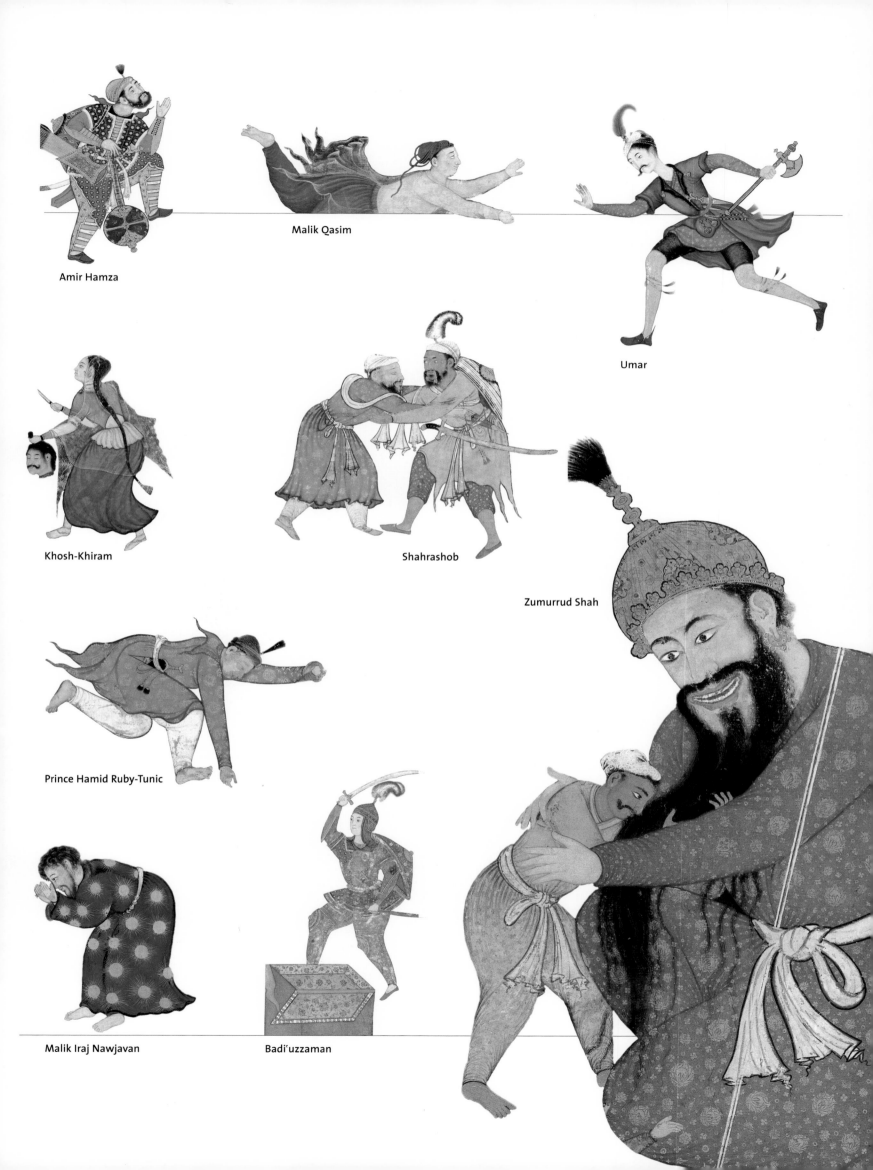

Amir Hamza

Malik Qasim

Umar

Khosh-Khiram

Shahrashob

Zumurrud Shah

Prince Hamid Ruby-Tunic

Malik Iraj Nawjavan

Badi'uzzaman

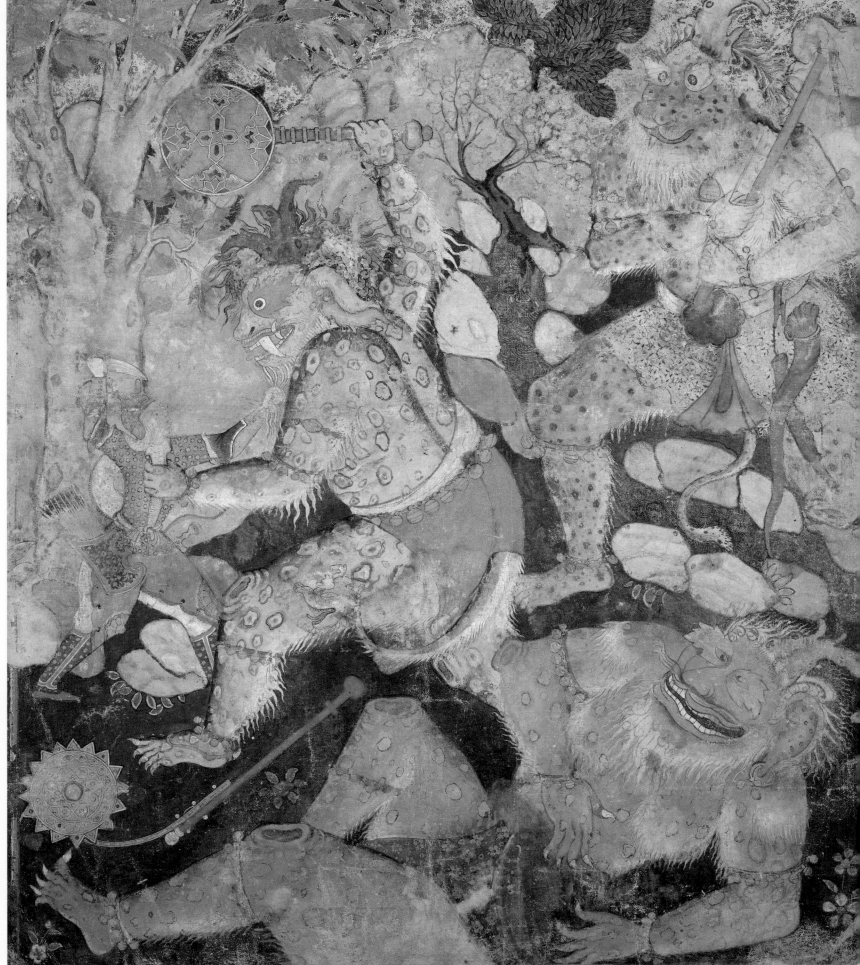

CAT 19

Unattributed

Volume and painting
number unknown
India, Mughal dynasty,
circa 1562
64 x 55.5 cm
Private collection
Published: Fischer &
Goswamy 1987,
no.7; Falk 1985, no.120.

Like genii or *peri*s, *dev*s (demons) figure in many tales in Islamic literature, and pose the same kind of other-worldly challenge to those who aspire to be heroes among men. Although they are essentially anthropomorphic, *dev*s are hideous in every respect, from their menacing fangs and antlerlike horns to their hairy, spotted bodies and wickedly sharp claws. Most wield weapons readily available in nature – clubs, boulders, and the like – but some manage to procure huge maces or daggers, and brandish them easily to demonstrate their prodigious strength. All heroes must confront these *dev*s at some time. Most often they dispatch them from this earth, but truly far-seeing ones such as King Solomon are able to harness their energy in tasks that benefit all.

These imposing *dev*s are still far from that rehabilitated state. They lumber through the landscape and threaten to pin the hero, probably the young Hamza, against a tree. One has drawn so near that he has part of Hamza's tunic in his grasp, and now prepares to pulverize the mortal with an enormous mace. But Hamza demonstrates his pluck by clutching his assailant's beard and stepping inside the arc of the mace swing so that he can bury his dagger in the *dev*'s chest. He seems to have mastered this maneuver, for he has already staggered the still larger *dev* in the foreground. That one now swoons, blood pouring from his disemboweled abdomen, his bladed mace lying abandoned at his feet. A third *dev* advances heedlessly across a stream, brandishing with both hands what remains of another type of *kistin* mace. (Attached by a chain to one end of the long handle is the mace's globular head, its once-golden surface now thoroughly effaced but its circular outline still clear at shoulder height.) A cudgel and horn hang from the sash tied about his waist and fastened with a large lobed buckle.

The artist embellishes these creatures with whimsical details. All *dev*s have shaggy breasts and limbs, but the one dying here has distinct tufts of hair sprouting like epaulets from his shoulders. His bluish counterpart is aided in the fray by his own dragon-headed tail, and the pinkish *dev* has no hope of shedding his comical appearance so long as he has mismatched eye-rims and a single fang issuing from the center of his lower lip. All three *dev*s wear breeches or skirts, and have developed knobby protuberances on their knees and elbows from crawling about on all fours.

This painting must belong to one of the early volumes of the *Hamzanama*. The folio has been stripped of the text on the reverse, a feature common to most extant paintings from the initial volumes. It also has a strongly Persianate style. The *dev*s, for example, are considerably flatter than the corresponding demon in cat.25, and read primarily as large two-dimensional shapes embedded in a carefully constructed compositional pattern. The ground is an unmodulated field of green interrupted only occasionally by a well-placed flower or two. Most old-fashioned of all are the remarkably flat and sharp-edged rocks tidily lining both sides of the narrow stream and lying by Hamza's legs. Such unnatural rocks, which resemble nothing so much as lithic shards, are found frequently in Safavid art, and almost never in early Mughal painting. They are the strongest indication that the painter had substantial training in the Safavid idiom.

There were, of course, very few painters in the Mughal workshop with such experience. Mir Sayyid Ali and Abdul-Samad both incorporated the kind of plane tree seen here in paintings made over their respective careers, but in every case the tree trunk has a smoother texture and more elegantly outlined contours. Hamza's face is abraded, but the eyes are clear enough to be distinguished from those in Mir Sayyid Ali's figures. Similarly, the sharp-edged geometric rocks, which recur along streams in several of Mir Sayyid Ali's paintings, including *A School Scene* (cat.3), are strung together with much less rhythm here.

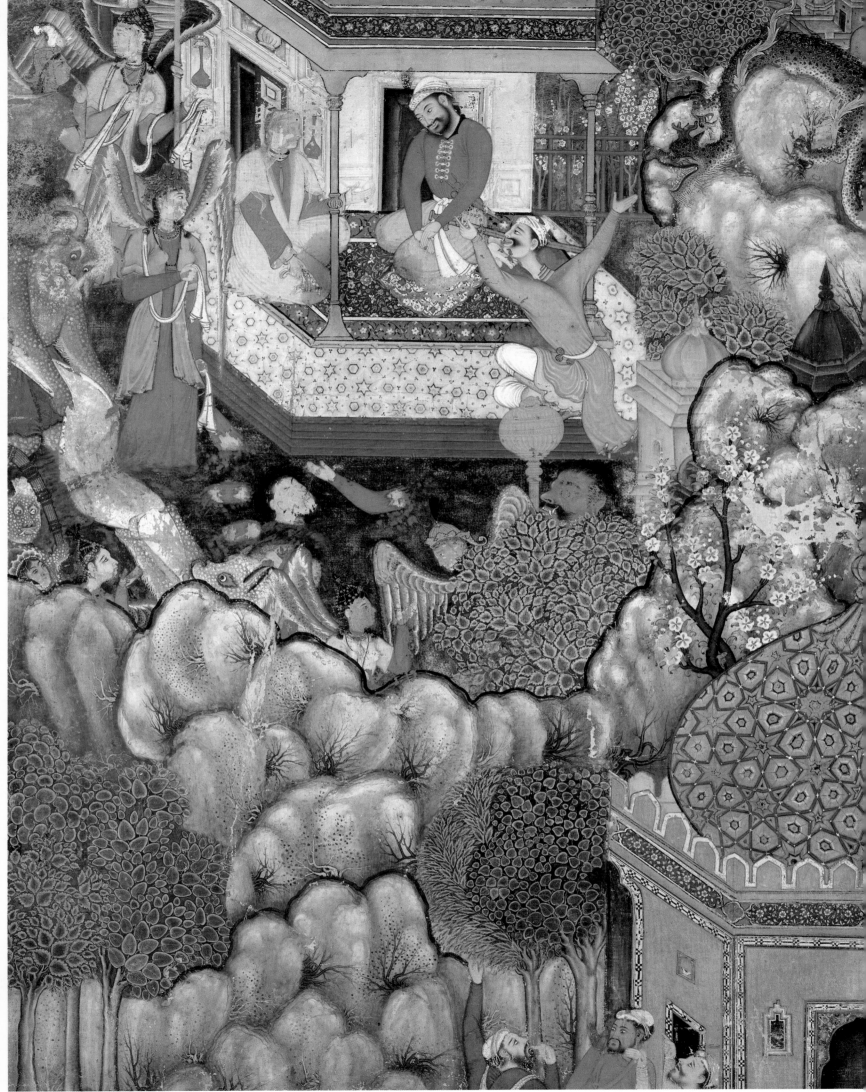

**Attributed to Jagana
and Basavana**

Volume unknown,
painting number 41,
text number 42
India, Mughal dynasty,
circa 1565
Painting 67.5 × 51.3 cm,
folio 73.8 × 57.9 cm
Caption cropped
Victoria & Albert Museum,
London, I.S. 1505-1883
Published: Stronge 2002,
pl.3, p.16; Beach 1987,
fig.43; Topsfield 1984, pl.6;
Hamza-nama, pl.3; Pinder-
Wilson *et al.* 1976, no.5;
Glück 1925, fig.8.

1. Reproduced in Seyller 1994,
figs 24–25.

One indication of the increasingly fantastic quality of the Hamza legend is the number of stories in which Hamza consorts with *peri*s (or fairies) and genii, supernatural beings who sometimes attend King Solomon. Normally, the relationship is a mutually beneficial one, with Hamza periodically assisting the fairies in their ongoing struggle against the *dev*s, and the fairies returning the favor by taking the Amir's side in battles against his mortal enemies. In this case, however, the relationship is put to the test by Hura the genie, who for unknown reasons arranges for a dragon to carry off Hamza's right-hand man Umar. Hamza sees this abduction and recognizes Hura's complicity in it, but says and does nothing. Hura, who is surprised by Hamza's passivity, asks him why he did nothing to stop the dragon. Hamza deftly replies by praising Hura and his lineage, and stating that he knows that they would never do anything bad. With this subtle reproach, he lets Hura know that he is fully aware that the genie had orchestrated the entire matter; the embarrassed Hura makes amends by arranging to have Umar and Ayjil brought back quickly and discreetly, and then orders his servants to prepare a great banquet in their honor.

This illustration appears at the point when the dragon is still waiting to pounce on Umar. Hamza sits politely before a male genie, presumably Hura, while his companion, Umar, gestures excitedly toward the lurking dragon. Other winged female *peri*s gather around the small pavilion. Two frothily spotted *dev*s – presumably the rehabilitated, sympathetic variety – tear asunder some unfortunate creature, in the process soaking the ground with blood and strewing it with the severed limbs and head of a human. A great rocky screen meanders around two small temples and cordons off a third, more resplendent one and some onlookers in the foreground.

Jagana, whose distinctive facial style is manifested in the large white eyes and the prickly hairs of Hamza's sculpted beard and Umar's mustache (see, for example, cat.35 and 50), casts Hamza as a demure figure who, despite the long golden sword he carries, sits with his head bowed slightly and his hands crossed gently on his lap. Umar, by contrast, is the picture of agitation, his neck craning nearly as far and as actively as his wildly gesticulating arms. Seated to the side of the pavilion and addressing the Amir is Hura, his face now too flaked to indicate gender, but his body lacking the small, high breasts seen on the accompanying fairies. The pavilion itself is decorated with the usual carpet and vessel-filled niches, but its oddly turned corner, truncated carpet, and the gleaming tiles of its wraparound platform demonstrate Jagana's penchant for bringing exuberance to his architectural forms. The foreground temple has a spectacularly patterned dome, crenellations outlined in white, and narrow inlaid bands set in a checkered pattern, all recalling architectural forms found in several other works attributed to this artist (cat.35, 61 and 74).

Although the *peri*s are peripheral to the composition and action, they still attract a fair amount of attention. Their large and flamboyantly colored wings surely contribute to this effect, but the faces that have survived intact are also noticeably more sensitively painted than those of the protagonists. Indeed, the *peri* whose face is framed by the body of the spotted red *dev* along the left edge of the painting has all the hallmarks of Basavana: almond-shaped eyes with small pupils, softly brushed features, and a subtly colored headdress. This attribution to Basavana, which can be extended to all the *peri*s in this painting, suggests that the contemporary *peri*s shown in a painting in the British Museum are also by this master.[1] Other features by Basavana here include the soft, painterly rocks studded with barren stumps, and the lively rendering of the dragon coiled around the outcrop in the upper right. The trees, conversely, are much too flatly conceived and blandly colored to be his work, and are almost certainly that of Jagana.

Hamza travels far and wide, compelling infidels everywhere to accept Islam. On one occasion, his conquests take him far to the west, where he encounters the Franks, the name by which Europeans were known in medieval Islam. Two paintings from volume 6 depict the believers' encounter with Marzuq, the Frankish king. The first (painting no.2) shows Khwaja Umar, who, having been captured by Marzuq, is secretly negotiating his freedom with his jailer, one Zangawa.[1] The second is this painting, numbered 34 beside the lowermost rock along the shore.

"When the ill-starred Marzuq fled from the fortress, the princes of the age, the champions, and the Sahib-Qiran killed many Farangis that night. The fire of battle blazed forth. The next day the Sahib-Qiran was informed. He entered the fortress and met his sons, warriors, and champions and showed great kindness to the warriors. ... q Farangi, Marzuq's nephew, fled to the sea with his household and family."

This illustration depicts several concurrent events in the capture and evacuation of the fortress. In the foreground, a number of oversized soldiers rush through the gateway while some smaller ones wait behind a low ridge. In the courtyard fronted by a confusing stack of towers, battlements, and walls, and bounded diagonally by a wall surmounted with large white crenellations, Hamza's forces behold the sprawling corpses of the last of the enemy holdouts. It is nighttime, and Hamza himself has not yet arrived, points established by the blazing torches and confirmed by the first few lines of the following text. Instead, this mop-up operation is being directed by the mountainous Umar Ma'dikarb, who stands closest to the enemy, the position always reserved for the allied leader. Disconsolate Frankish womenfolk witness the spectacle of defeat from a gallery above. In the adjacent courtyard, the systematic plunder of the fortress has already begun, as Hamza's men methodically remove and pass along chest after chest of booty. Meanwhile, Marzuq's forces flee with all they can. An armed soldier wearing a foreign hat ushers a group of Frankish women out a second gateway toward two waiting boats. Seated at the prow of the larger boat is Marzuq himself, wearing a foreign hat and a great sword and supervising the loading of his prized horse. The other boat, apparently reserved for royal women and their belongings, contains two women dressed in white *burqa*'s huddled between an enclosed litter and a chest of goods.

To feature all these separate activities simultaneously, the artist has employed an unusually busy and complicated composition. Walls banded with bright and assertive patterns zigzag across the center, and patterns of every type and color jostle for visual attention elsewhere. In some instances, such as the wall running diagonally along the shore, structural elements are downplayed in favor of decorative ones, so that the luminous floral band along the top of the ramparts actually dwarfs the wall proper. Figures often must squeeze into this world, as do, for example, the huge horse and two figures passing through the lower gate, or the eight figures filling the central courtyard. This conspicuous disparity in scale is a sure sign that one artist laid out and executed this mazelike environment, and another supplied the major figures.

Because every face in this work has been repainted, albeit with a finer and more careful hand than usual, the identity of the latter artist cannot be determined. The other artist, however, is certainly Mah Muhammad, who, in fact, used a similar composition and miniaturized scale in cat.60. This attribution is supported by many architectural features, most notably the tightly geometric towers and the honeycomb pattern on the red dado panel in the upper right. Other elements also connect this painting with cat.75, which is attributed to Mah Muhammad. These include the delicate whorls on the water, here reduced to a pattern of unprecedented density, a discretely colored strip of land along the water's edge, and widely scattered rocks overlaid with a single large white swirl.[2]

The text on the reverse has one exceptional feature: in addition to the usual nineteen lines, there are long panels of text written on blue paper applied to both lateral edges of the page.[3]

Attributed to Mah Muhammad

Volume 6, painting number 34, text number 35
India, Mughal dynasty, *circa* 1565
Painting 66.5 x 55 cm, folio 69.2 x 57.8 cm, The al-Sabah Collection, Dar al-Athar al-Islamiyyah, Kuwait National Museum, LNS 297 MS
Published: Grube 1971, color pl.49; Blochet 1930, pl.xxxi; Blochet 1928, pl.cLxxxviii.

1. Collection of Ramesh Kapoor. See below, Reconstruction, no.30. Two other illustrations, presumably from the same volume, also involve the Franks: Victoria & Albert Museum, I.S. 2516-1883 (painting number 5) and I.S. 2511-1883 (painting number 6); these are reproduced in the Reconstruction, nos 31 and 32, respectively.
2. Many of these forms also appear in Victoria & Albert Museum, I.S. 1517-1883 (see Reconstruction, no.150), which may also be attributed in part to Mah Muhammad.
3. This feature also appears on Victoria & Albert Museum, I.S. 1519-1883.

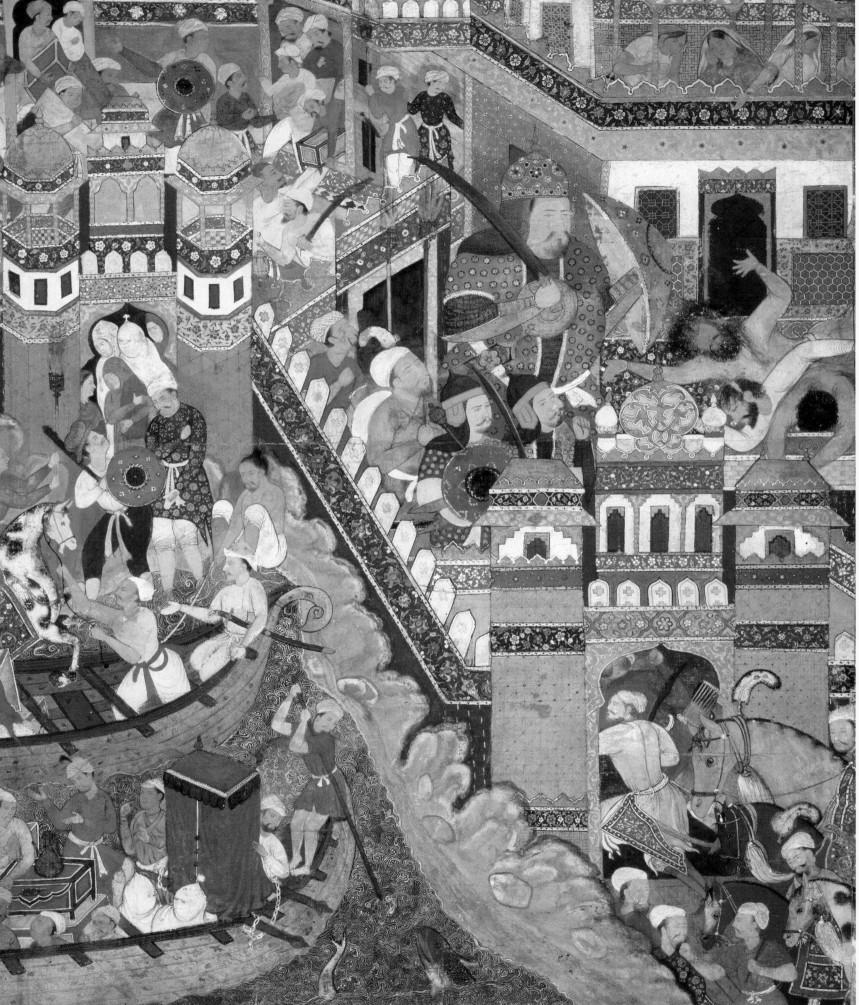

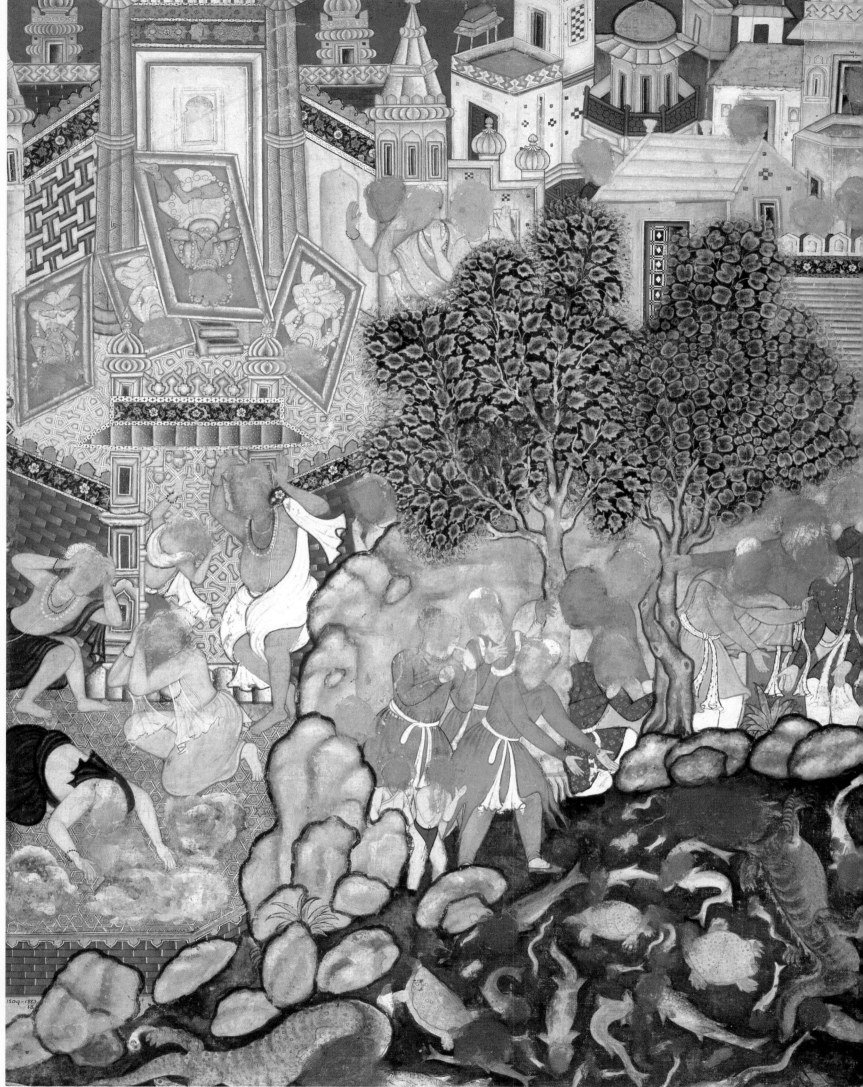

**Attributed to Mahesa
and Mukhlis**

Volume unknown,
painting number 96,
text number 97
India, Mughal dynasty,
circa 1565
66.5 × 51.3 cm
Caption: 'Idols are overturned
in the temple and the open
sea dries up on account of
the birth of His Holiness the
Prophet'
Victoria & Albert Museum,
London, I.S. 1509-1883
Published: Stronge 2002,
pl.15, p.31; *Hamza-nama*, pl.7;
Staude 1955a, fig.1; Clarke 1921,
pl.1.

1. The body types, angular
gestures, *jama* patterns,
and rocks link this work to
Mahesa's efforts in cat.26
and cat.49.

The triumph of Islam is a leitmotif of the Hamza legend. It is expressed in some stories in the use of the oath 'sun-worshippers,' and briefly at the conclusion of many others when an offending idolator converts or is punished for his recalcitrance. In one illustration in the Mughal manuscript, the rivalry among actual religions is given more attention when Hamza desecrates a Zoroastrian temple (cat.73). This painting, however, makes explicit the new order that the advent of Islam ushers into the world. The caption relates that the birth of the Prophet Muhammad in Mecca, the most sacred city of Islam, has astonishing repercussions: idols fall head over heels in a worship hall and the seabed rises and drains the sea. The text describing these and other events has vanished, and the following passages begin a separate tale featuring Hurmuz. They do, however, preface it with a few sentences describing Hamza's appointment of Hurmuz to Anoshirvan's throne, and Hamza's engagement and marriage to Mihr Guhartaj at Mecca. Thus, successive stories jump from an event from Hamza's childhood – the birth of his childhood companion Muhammad – to one of his early adulthood, suggesting that the geographical connection is paramount here. This example reminds us that the stories of the Hamza legend are often linked by elements other than chronological time, which has a much stronger grip on our own sense of events than it ever did in the realm of myth.

The composition is divided in two distinct parts, each apparently by a different artist. One part depicts a crowd of men gathered along the seashore. They point excitedly toward the disappearing water, where a veritable menagerie of aquatic creatures thrashes about on the muddy seabed. The first artist, Mahesa, makes it clear that this is no ordinary scene of the sea teeming with life; he depicts the entire bodies of the fish and marine animals – often belly up – rather than showing them half-hidden by water, and he forgoes all indications of waves and ripples.[1] This remarkable sight, then, is presented as a sign of a miraculous event, the geological equivalent of the irrevocable religious upheaval. As if the plight of these forlorn denizens of the sea were not bad enough already, an iconoclast later defaced their heads, as he did to most living creatures depicted in the other *Hamzanama* paintings acquired in nineteenth-century Kashmir.

The remainder of the painting, by Mukhlis, illustrates the self-destruction of the idols. Four large paintings of idols – all frontal, heavily garlanded, and seated in an Indian manner – have plummeted from their niches and are now inverted, a position that indicates their religious capitulation. The images lean against a large framed niche and the side walls of a tiled courtyard, a formulaic bit of architecture bearing only a meager resemblance to actual Indian temples. Two nearby worshippers react to this cataclysm with predictable distress; outside the front gate, which has a high threshold, as Indian temples normally do, five more devotees weep and wail at the sight of the rubble to which their gods have been reduced.

Mukhlis's hand is evident in the heavy, schematic folds of the idolators' garments as well as in many architectural details. The latter can be as subtle as the half-shaded bricks or as obvious as the exaggerated white highlights left on nearly every architectural member. The florid ornamentation of domes and neckings and the generally tipsy quality of the densely packed buildings are also characteristic of his work.

Missives bearing alarming news are featured prominently in the *Hamzanama*. In some cases, the letters or scrolls are intercepted by an *ayyar*, allowing for a hero's narrow escape or an unexpected turn of fortune; in other instances, they are delivered as intended and set off a more developed chain of events. This scene of two princes, Alamshah and Qubad, excitedly discussing the contents of a scroll falls into the latter category. The preceding text is missing, and the caption below is now partially damaged, but the text following the illustration suggests that it is the news contained in this scroll that spurs Alamshah to rush off to a city named Kharishna. Alamshah insists that he must undertake this journey alone, but he eventually allows Prince Sa'd and Luhrasp to accompany him. When he reaches Kharishna, where the Franks have laid waste to his former home, he rediscovers a secret tunnel dug precisely for such perilous circumstances, and there meets up with his cowering mother and distressed former servants.

To emphasize the drama induced by this disturbing letter, the artist isolates the two princes in the center of the crowded composition. One prince grasps the scroll and talks animatedly, his hand raised to head level. The other prince leans forward to grab his wrist, clearly with the intention of compelling him to relinquish the letter so that he may verify the news himself. Although Mughal artists often included real information on such painted letters (see, for example, cat.3, 6a, and 7), this artist was content to simulate text with a few lines of pseudo-writing.

As in the following painting (cat.24), a huge hexagonal canopy overtops the central action. Here, however, the artist has not shunted away to the perimeter the seemingly numerous supporting poles; instead, he staggers them in an experimental configuration that simultaneously obstructs the view of the two princes and flouts the standards of even Mughal visual logic.

If this environment has a few structural shortcomings, it compounds them with an anomaly in its brilliant decorative scheme. The princes sit on a narrow floral carpet with an exceptionally broad and exuberant foliate border, a feature that Shravana uses in most of his works in the manuscript. Beyond this central horizontal band of carpet is what appears to be a tiled hexagonal platform. This reading raises a problem of material. On the one hand, it would be wholly impractical to set up such a platform each time the court pitched its tents, as it obviously has done here. On the other, this kind of star pattern is found on no other carpet in the whole of the *Hamzanama*. Moreover, the same foliate border used for the central carpet runs around both the front and rear edges of this larger violet area, which it could not if the latter were truly a raised platform (see, for example, cat.77). We must conclude that this incongruity of pattern and material is the result of a rare miscommunication between artists working on different parts of a given painting.

From work elsewhere in the manuscript, we can surmise that Shravana contributed the canopy, carpet, and foliate borders, and a second artist, Banavari, supplied all the figures, the tiled surface, the surrounding tent, and the outcrop in the lower right. Although an iconoclast attempted to obscure all the faces, he applied the muddy paste too lightly or incompletely on some figures, and these survivors all have faces like those found in Banavari's other works. More telling are the slender, compact bodies and delicate *jama* patterns.[2] Banavari is accomplished in his own way, but he often overlooks refinements that Shravana never fails to make. In this scene, for example, Banavari constructs the tent so that the upright stays that are visible in the upper right fan out from the center of the painting, and the crisscrossing ones meet in haphazard fashion; in Shravana's hands (cat.24), these same elements are marshalled to the true vertical and form a powerful, regular pattern.

Attributed to Shravana and Banavari

Volume 6, painting number 50[1]
India, Mughal dynasty,
circa 1565
67.5 × 51.2 cm
Caption: 'Alamshah converses with Qubad about the affair...'
Fitzwilliam Museum, Cambridge, PD. 203-1948
Published: Beach 1987, pl.61.

1. The number 49 is written very faintly below the name of Qubad in the lower center margin.
2. See cat.48 for the identification of this artist.

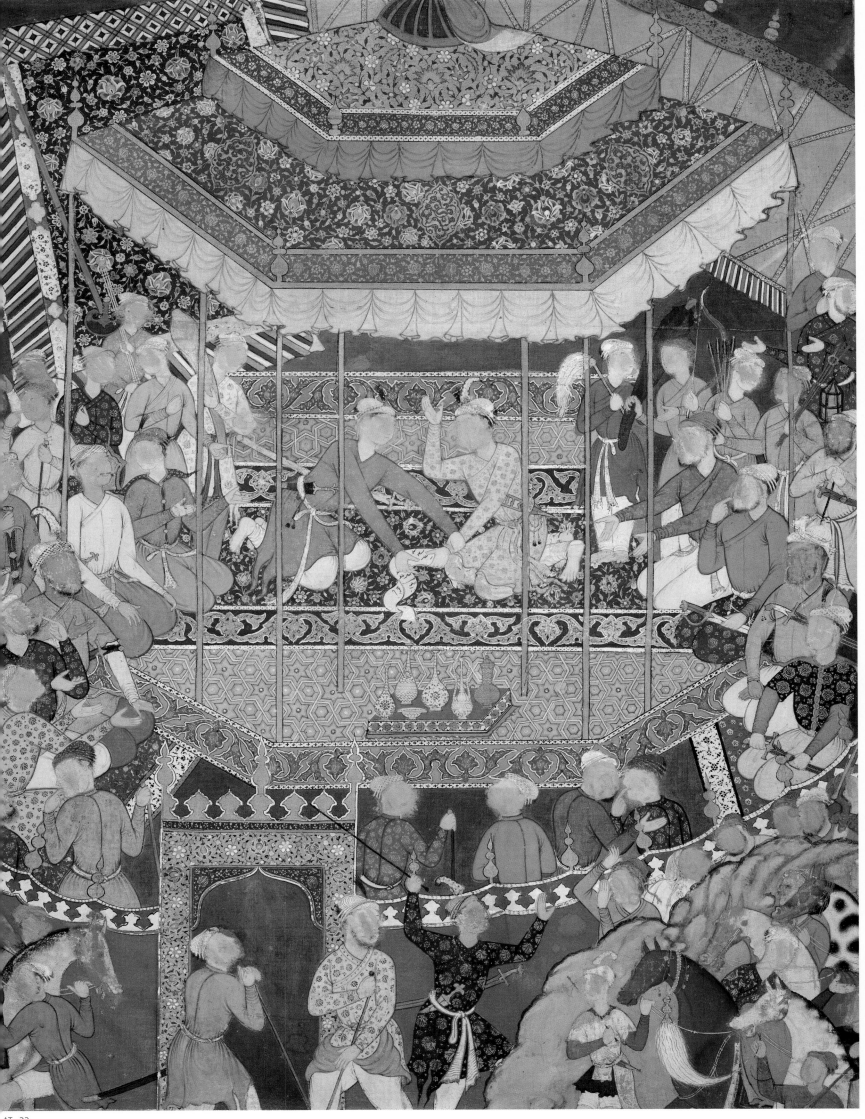

AT 23

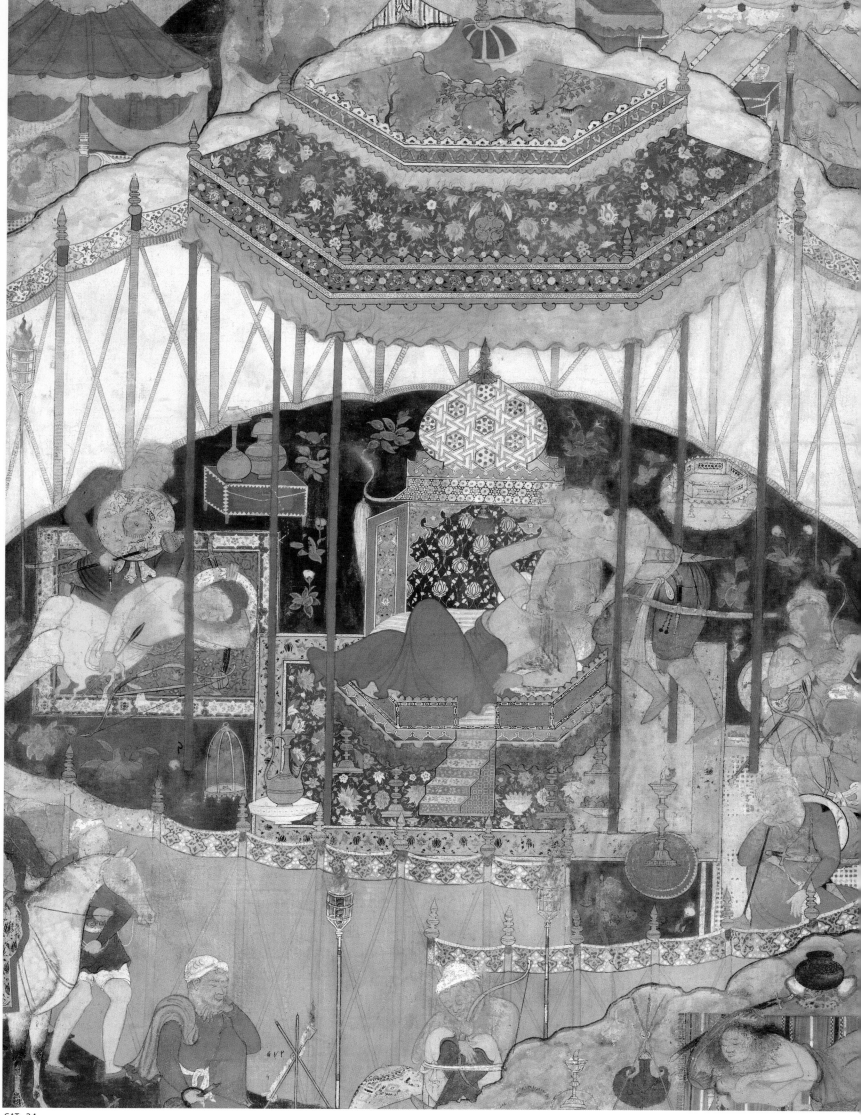

CAT 24

24 AN AYYAR MISUNDERSTANDS ANOSHIRVAN'S ORDER AND MURDERS QUBAD IN HIS SLEEP

Attributed to Shravana, dated
AH 972 (July 1564–July 1565)

Volume 6, painting number 74
India, Mughal dynasty
69.1 × 50.5 cm
Victoria & Albert Museum,
London, I.S. 1508-1883
Published: Stronge 2002,
pl.7, p.22 and details pl.8,
p.23; Walker 1997, fig.35
(detail); Seyller 1993, figs 1–2;
Hamzanama, pl.6; Glück 1925,
fig.11.

1. Seyller 1993, pp.502–505.

Life has few sorrows greater than the loss of one's child, particularly when one knows that it was both needless and preventable. Hamza, who takes pride in his steady nature, suffers this bitter tragedy as deeply as any in his life, and shows an emotional depth rarely intimated or fathomed.

How it all came to pass is somewhat unclear. The text that precedes this illustration is missing, and that following it is abraded in parts, but enough remains to deduce this: it begins when an *ayyar* named Rug-Ear hears Shah Anoshirvan – Hamza's father-in-law – speak of a certain handsome youth. Rug-Ear badly misconstrues his remarks, and, proceeding as if in a trance, murders the beautiful Prince Qubad, Hamza's second son, in his bed. Once his assassin's knife has caused the youth to roll up the carpet of existence, the *ayyar* is beset by a rush of contradictory impulses, thinking, on the one hand, of the acclaim he expects he will be given by Anoshirvan, and on the other, of the terrible end he has brought to a life in full blossom. Rug-Ear bundles up Qubad's severed head, and rides back to Anoshirvan's camp. When he deposits his bloody trophy at the feet of Bakhtak, Anoshirvan's minister, even that wicked one is dismayed. Anoshirvan, dumbstruck that this vile deed was committed purportedly at his instigation, is overcome with sorrow, and he dutifully sets out to inform Hamza. Meanwhile, Hamza has already had a premonition of his son's death:

"*From the fire in his heart came such a cry that fire fell into all people.*

In short, the Sahib-Qiran's camp was like doomsday, and the leaders, commanders, and princes garbed themselves in mourning for that sapling of the garden of martyrdom, putting on clothing as black as night."

Once the meaning of his dream is confirmed, his grief deepens to despair, a state expressed most poignantly when Hamza removes from his head the useless crown that, for all the glory it conferred, could do nothing to avert this cruel fate.

Shravana, who painted most, if not all, of this work, depicts the dastardly murder itself. Into a spacious tent compound, manned laxly by dozing sentries, slips Rug-Ear. His target sleeps peacefully on a hexagonal bed raised up and backed with thronelike features and sheltered by a sumptuous canopy. Rug-Ear creeps up and quickly draws his knife against Qubad's exposed throat; the prince, awakened by the pain of the first cut, jerks awake and makes a brief but futile effort to resist.

Shravana fleshes out this core action with many engaging details. He furnishes the prince's domain with an elaborate set of steps, an assortment of luxurious candlesticks, and an exquisite carpet. The throneback is wonderfully extravagant, both in the strikingly innovative pattern on its dome and the now-defaced dragon-headed finials that protrude from its sides. Overhead hovers a magnificent canopy, its golden top adorned with scenes of a dragon and other mythical creatures; around this runs the distinctive foliate design that recurs throughout Shravana's work. Further out in the compound is a red chest of armor; on it rest two golden vessels capped with what appear to be two inverted translucent jade drinking cups. Even the tent itself is made attractive by the attention the artist gives to the rhythm of upright and crisscrossing stays against the brilliant white cloth. Finally, a measure of human interest is provided by the guards. In most cases, they cradle their weapons, their constant companions, but one figure in the lower right corner has put duty aside for the night and allows his infant son to nestle against him.

In the lower center of this painting is the rarest of all documentation in the *Hamzanama*: a date. This one, which reads as 972 [Hijra], corresponding to AD 1564–65, is particularly valuable because it is accompanied by a volume number, 6. Together these numbers support a redating of the entire manuscript to *circa* 1557–72, five years earlier than had previously been thought.[1]

So brave and magnanimous is Hamza that he regularly transforms an inexorable foe into a staunch supporter. The Arab champion Umar Ma'dikarb, for example, is shown being vanquished by Hamza in one painting early in the manuscript, but converts to Islam and becomes Hamza's loyal lieutenant.[1] Landhaur, the gigantic figure depicted here, travels a more colorful road to Hamza's side. Soon after the premature death of his father, Sa'dan, the king of Ceylon (Sri Lanka), his mother dies of grief, and the infant Landhaur is forced to spend his first six years living at the gravesite. He is taken from there by his uncle, who sends him to an island inhabited by a herd of elephants, who adopt Landhaur as one of their own and sustain him with their milk. Hence, for the rest of his life Landhaur is rarely far from his elephant mount.

More strife ensues. Landhaur quarrels first with his uncle and later with his cousin. Eventually Umar is sent to his court to goad him into battle, and does so by stealing his crown. Finally, Landhaur encounters Hamza, who defeats him in a seventeen-day-long wrestling match and imprisons him. In the meantime his cousin converts to Islam, and prevails upon Hamza to release Landhaur from prison. A grateful Landhaur immediately converts to Islam and Hamza's cause.

This striking illustration has lost its text, both on the reverse and presumably in the blue area above the painting, but it shows the kind of peril that even a brief lapse in vigilance can bring.[2] A weary Landhaur has drifted off to sleep on a luxurious, if dangerously portable bed. Seeing this, a fearsome white *dev* seizes the opportunity to press his advantage and snatches Landhaur, bed and all, almost certainly to bear him to confinement or worse.

Dasavanta uses a figure scale well-suited to the struggle of titans. The *dev* bestrides nearly the entire composition, and carries effortlessly a low bed that now extends slightly beyond the lateral edges. Like most *dev*s, he has flaming eye-rims, fangs, horns, and spots. The artist also adds a few flourishes, girding the *dev* with a serpentine belt, and complementing the belled bracelets adorning the demon's arms and legs with a jangling bell on each of the two horns – odd apparel, it seems, for one engaged in stealthy abduction. Most of all, Dasavanta injects new life into this familiar creature by playing freely with paint, so that the *dev*'s spots seem simultaneously to hover above and lurk below his skin, and his mane and beard are both matted and scraggly. Dasavanta allows his collaborator, Shravana, to fill in the *dev*'s kilt with one of his precise floral patterns. Shravana does so with a pattern featuring a bright blue ribbonlike form, a pattern he applies elsewhere to canopies, carpets, and architectural bands. Dasavanta completes the form with a thick, modeled edge – something that Shravana never uses on his own.

The same blending of work occurs on the *dev*'s sleeping victim. Dasavanta is surely responsible for Landhaur's broadly conceived *jama* and the voluminous sheets, while Shravana supplies the bed's golden merlons, fine inlay, and brilliantly patterned pillow. Landhaur's flat and heavily painted features and hair have been repainted in modern times.

The landscape is simple, a prudent choice for a composition dominated by two huge forms. At the same time, its pink ground and regular pattern of tufts are throwbacks to a purely Persianate tradition, an effect continued in the schematic flamelike foliage along the left edge and the ornamental arrangement of yellow-tipped leaves on either side of the *dev*. The only overtly Mughal landscape feature is the small-lobed rocks with dark internal markings, a distinctive element used by Shravana in cat.51.

Attributed to Dasavanta and Shravana

Volume and painting number unknown
India, Mughal dynasty, *circa* 1565
59.3 × 45.2 cm
MAK–Austrian Museum of Applied Arts/ Contemporary Art, Vienna, B.I. 8770/19
Published: Egger 1974, pl.5; Egger 1969, pl.1; Glück 1925, pl.3.

1. Ashmolean Museum, Oxford, 1978.2596; Topsfield 1994, no.1.
2. The dimensions of the painting, together with the cropping of the horizon and the *dev*'s feet, indicate that the painting has been trimmed on at least two sides.

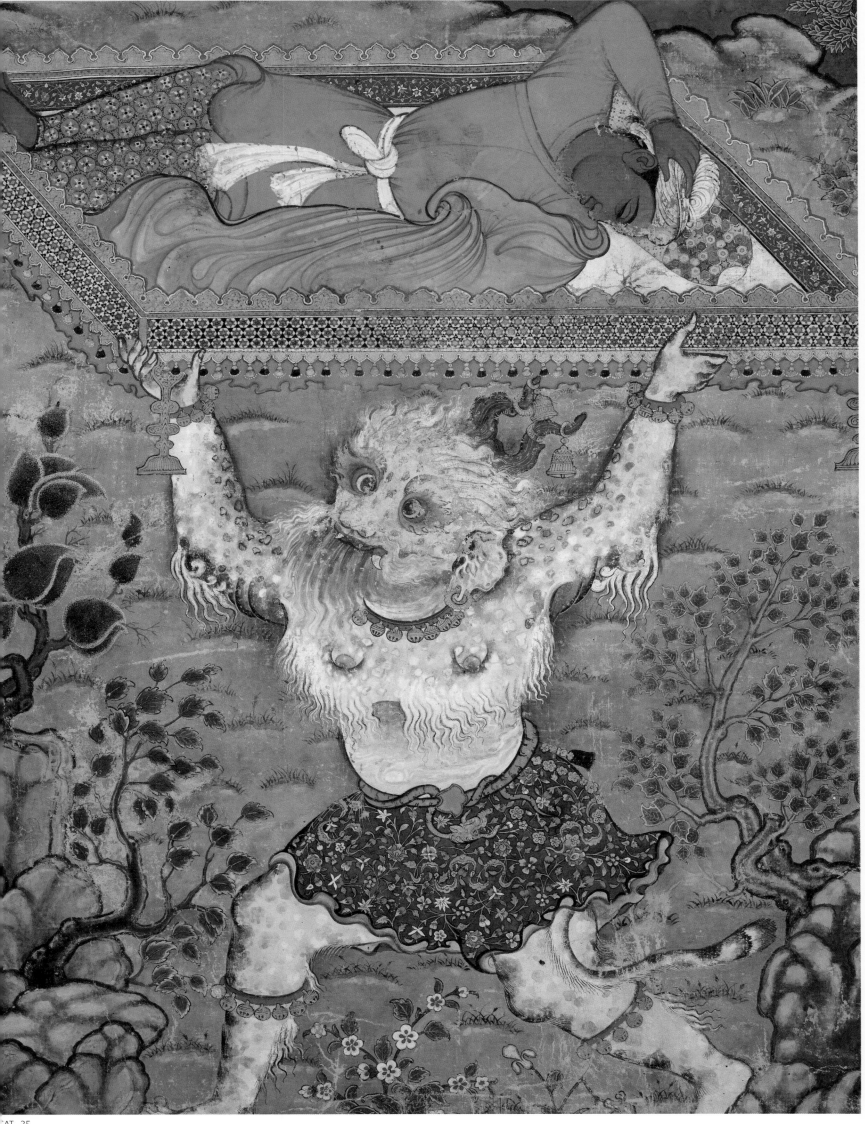

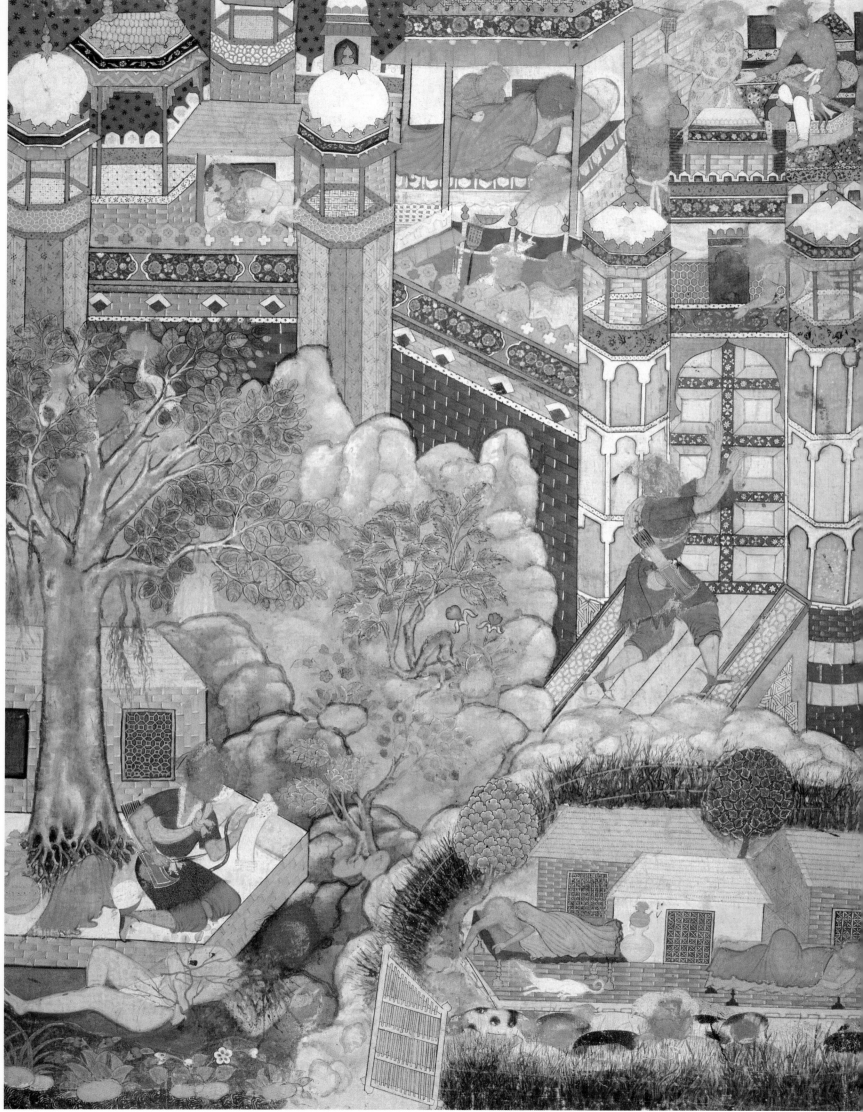

Attributed to Mahesa and Mah Muhammad

Volume 7, painting number 10, text number 10
India, Mughal dynasty, *circa* 1566
Painting 66.1 × 52 cm, folio 74 × 59.2 cm
Victoria & Albert Museum, London, I.S. 1520-1883
Published: Stronge 2002, pl.12, p.17; *Hamza-nama*, pl.18; Glück 1925, fig.30; Clarke 1921, pl.7.

1. *Hamzanama*, Victoria & Albert Museum, London, I.S. 1510-1883; *Anwar-i Suhayli*, School of Oriental and African Studies, University of London, MS.10102, f.174a; *Two Birds*, Gulshan Album, Gulistan Library, Tehran, no.1. The first painting is published in Egger 1978, pl.8, and below, Reconstruction, no.144; the second is published in Welch 1985, no.93a, where it is attributed to Basavana.
2. The body types, modeling, and palette are also in keeping with Mahesa's work.

The game that spies play is a ruthless one, with stakes as high as life itself. Hamza's spy Basu clearly wins this round. He waylays one of his counterparts, Namadposh ('Clad in Coarse Material'), and murders him not far from Acre Castle. Basu is on a mission to release Pahlavan Karb, and rightly surmises that Namadposh has information that will help him complete the rescue.

> "... when Basu cut off Namadposh's head and buried it in the ground, a letter fell from Namadposh's belongings. Basu read the letter, and when he learned the contents of the letter, he put on Namadposh's clothes and departed. Although Namadposh was tall, and Basu was short, nonetheless he got himself somehow to the gate of the Acre fortress in the middle of the night and cried out, 'Open the gate. I have come from Pahlavan Qaran.'
>
> 'Who are you?' asked the castellans.
>
> 'I am Namadposh the *ayyar*,' he said. When they heard that it was Namadposh, they opened the gate and let Basu in. They saw that he was not Namadposh, but he was wearing Namadposh's armor. Once again, to make certain, they asked him who he was.
>
> 'I am one of Namadposh's servants,' he said. 'Never mind who I am. Take me to Gurgana, and I'll tell him who I am.'"

He continues to weave this web of deceit when he is brought before Gurgana, telling him unverifiable stories that lead him to postpone Karb's execution for a few days. By good fortune, Gurgana orders him to guard the prisoner Karb lest some tricky *ayyar* try to rescue him, which, of course, is exactly what Basu himself has in mind.

This illustration is one of the few images in early Mughal painting to make use of continuous narration, an approach that allows a single figure to be depicted several times within one composition. Accordingly, Basu is shown once kneeling beside the ambushed Namadposh, and again outside the castle gate. There, Basu, whose stolen furry tunic is decidedly not too long, hails the guard, who leans out from his high watchtower to reply. In the upper right corner, the plumed and enthroned figure of Gurgana is given the news of the spy's arrival.

One element only marginally related to the story but prominent in the painting is the domestic compound in the lower right. Its nominal function is to establish the time of night – already clear from the torches blazing inside the fortress and the schematic dark-blue stars in the sky – but it also allows the artist to provide a glimpse of village life, where a watchdog barks at a passing stranger and a man dutifully tends his flock even as he dozes on a humble bed. A particularly unusual detail is the rough brushwood fence enclosing the cluster of huts; this ubiquitous feature of village India appears in only three other Mughal paintings of the period, all apparently the work of the same artist.[1]

Given the obliteration of all the faces, it is difficult to attribute most of the painting with any certainty. Nonetheless, several ancillary features suggest that the lower half of the scene was painted by Mahesa. The most telling of these are the insubstantial, pastel-colored outcrops that billow up like puffy clouds before the fortress; these resemble in many ways the ridges found in cat.46 and 49, both attributed to Mahesa.[2] The contours of the rocks in those works are strengthened with thick, darkly colored outlines, whereas the ones here conspicuously lack that feature. The outline appears to be a convention developed only once the *Hamzanama* project was well under way, for it is absent from all paintings belonging to the early volumes of the manuscript. In this respect, the numbers 7 and 10 inscribed on the wall of the hut to the right of stacked water jars take on added importance, for they are an informal record of the volume and painting number of this illustration, positioned less than halfway through the project.

The remainder of the painting was added by Mah Muhammad, an artist who supplied the architectural backdrops for many a scene. His trademark conventions are everywhere: the precariously stacked gate towers, the tiny, highly abstracted machicolations, and the boxy, slightly disjointed architectural forms. The inhabitants of his architectural creations rarely merit much interest, but the poignant scene of a mother tenderly cradling her child in the area above the tree is a welcome exception to this tendency.

Every seafarer can tell gripping stories of the awesome mysteries of the deep, when an unfathomable force or terrifying creature came so close to snuffing out his life that he vowed right then and there never to venture far from the safety of dry land. This spectacular leviathan, so enormous that an entire ship could disappear into its maw, is surely the stuff of such lore.

Without its caption and preceding text, the illustration has lost its original identification, but there are enough references in the following text that we can at least determine the destination toward which these heroes are sailing. The fourth line of the damaged text on the reverse of this painting introduces a physician named Muhandis, who attends King Ahras Saturn-Brow.[1] Ahras goes to investigate a formidable army that has somehow made its way to the shore of the island he rules. When he does, he meets Hamza, and the two swap stories about certain trees of legendary height and power. Eventually, Hamza urges Ahras to convert to Islam; Ahras agrees to do so only if Hamza can defeat him at wrestling, thereby tacitly acknowledging that spiritual righteousness normally manifests itself as physical superiority.[2] The result of the contest is therefore beyond doubt.

Before Hamza can even reach the kingdom of Ahras, however, he and his men must overcome the fearsome obstacle that looms before them. Their seafaring ships are so large that they fill more than half the composition, but still they are dwarfed by the huge monster suddenly rising up from the depths of the sea. The champions use every conceivable weapon to try to stave off the scaly beast. Hamza, dressed in orange and occupying the most prominent position in the centermost ship, has just let fly an arrow; in light of the Amir's legendary prowess and the arrow's trajectory, it must be this very arrow that has struck the enraged monster directly in the right eye. A prince to Hamza's left takes aim at the other eye, while Umar whirls his sling about and prepares to launch a paltry stone at the creature's snout. Other supporters attack with traditional weapons – spears, swords, maces, and tridents – but at least two men fire muskets and another tries out a newfangled crossbow.

Although every face has been reworked in a style drier and more precise than any known in this period, the repainting appears to follow the original underdrawing, leaving most figures – particularly those in the flanking ships – with the highly animated poses and expressions reminiscent of Shravana's figures in cat.51 and 69. Conversely, the brownish color of Umar's turban and the soft, voluminous treatment of those worn by Hamza and the prince indicate the hand of Basavana, as do the painterly forms of the two billowing sails. The construction details of the ships themselves also resemble those found in another of Basavana's works (cat.30). And with the possible exception of Dasavanta, it is difficult to imagine another artist conceiving such an inventive form as the long, leering wolfish prow of the central ship.

But even such captivating forms as the two animate prows pale before the living behemoth that confronts the heroes. Other paintings (cat.34 and 36) include roughly similar creatures, which are actually based upon a kind of Indian alligator known as a *ghariyal*.[3] This creature, however, is a type of indigenous Indian crocodile called a *siyahsar*, which, as Emperor Babur recorded in his memoirs, could grow as large as four or five yards and whose toothy snout was more than half a yard in length.[4] Both lizard-like creatures are depicted with rounded ears, streamers, and a spiny ridge, but the *siyahsar* is often shown with fangs projecting like horns from the front of the snout.[5] Indeed, Basavana himself features an identical *siyahsar* bearing down on Nuruddahr in cat.80. But in this case, Basavana, like many a fisherman, is unwilling to let even impressive facts get in the way of a good story, and exaggerates the scale with such relish that an already fierce sea creature becomes the whopper of all Mughal painting.

Attributed to Basavana and Shravana

Volume unknown, text number 69
India, Mughal dynasty, *circa* 1567
71 × 55.5 cm (detail on pp.2–3)
Private collection
Published: Christie's, New York, 3 October 1990, lot 28.

1. Although a vizier named Muhandis is mentioned in cat.62, the painting and text numbers of the preceding illustrations preclude an immediate connection with this one, and suggest that it does not belong to volume 11.
2. The Berlin manuscript (see above, p.17) contains an illustration (f.293b) in which Hamza wrestles the ruler of Shatar, which is probably the name of the island ruled by Ahras.
3. See f.394b of the British Library *Baburnama*, reproduced in Suleiman 1970, pl.73.
4. *Baburnama*, p.342.
5. Suleiman 1970, pl.72.

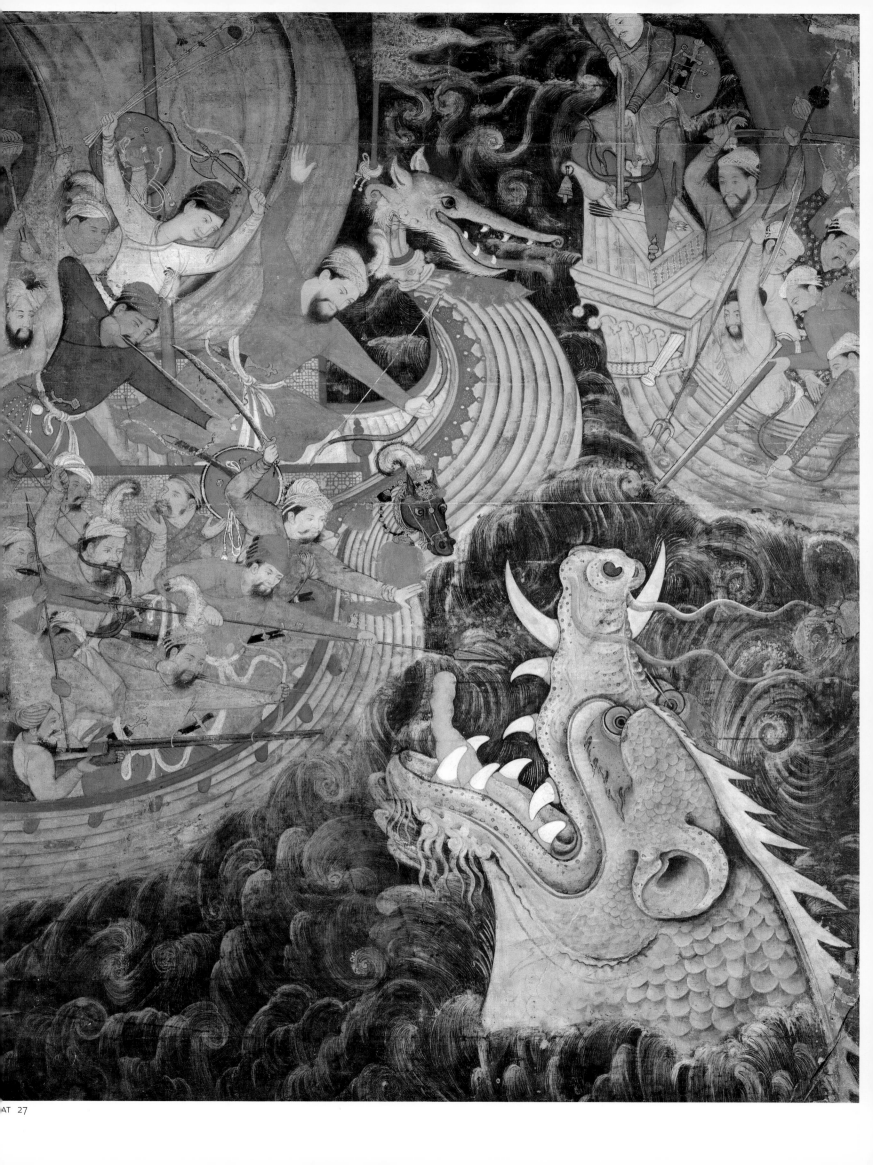

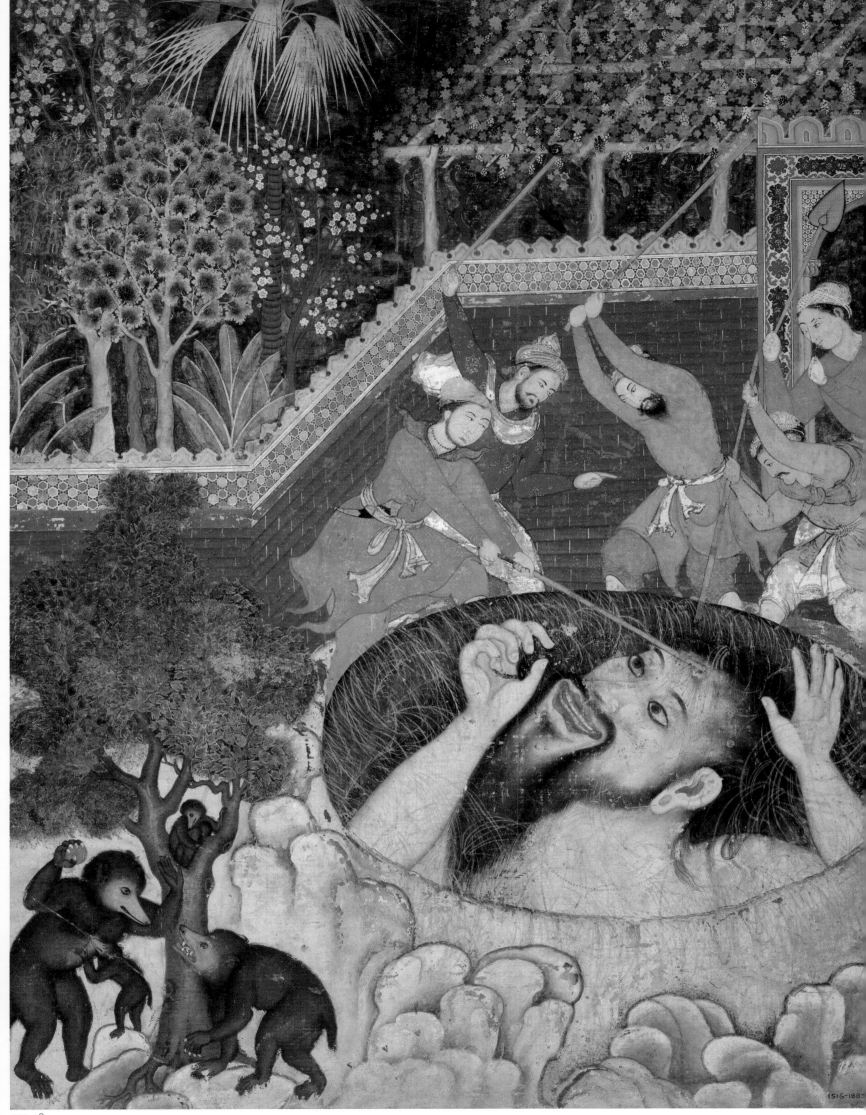

CAT 28

**Attributed to Kesava Dasa,
possibly dated AH 975
(July 1567–June 1568)**

Volume unknown, painting
number 15, text number 16
India, Mughal dynasty
68.9 × 54.7 cm
(detail on pp.102–103)
Victoria & Albert Museum,
London, I.S. 1516-1883
Published: Stronge 2002,
pl.21, p.35; *Hamza-nama*, pl.14;
Stchoukine 1929, pl.v; Glück
1925, fig.42; Clarke 1921, pl.12.

Zumurrud Shah, king of the east, suffers many adversities in his long struggle against Hamza, but none more abject than the punishment inflicted on him by a handful of ordinary gardeners. This illustration falls in the middle of a very entertaining story. We pick it up in the text that follows the painting:

"The narrator says that when Zumurrud Shah [was attacked by the men who] leapt from ambush and beat him senseless with sticks and clubs, he cried out, 'Friends, I am just a wayfarer. I entered this garden unknowingly. I have not yet touched anything that I should suffer such a fate.'

'Fellow,' they said, 'we thought that a bear was responsible for the ruination of our garden, but you are a desert ghoul that has come and wrecked this garden every day.'"

Zumurrud Shah, who is thoroughly perplexed by this thrashing, plaintively proclaims his innocence, and the gardeners grant him a temporary reprieve. Shaken and sullied, he crawls out of the pit, and declares that he is the lord of the east, the son of Lahut Shah. Taking such a grandiose identity to be an outrageous lie, the gardeners become irate and start to assail him with whips. A cowed Zumurrud Shah quickly disavows his claim, and, after being poked and prodded relentlessly, submits to being bound with chains and locked in a barn. There, his tribulations continue. When the gardeners' cattle return for the evening, they are none too pleased to find an intruder occupying their stalls. One cow tears at him with her horn, shredding his nose. Then, while Zumurrud Shah tries to salve his wound, another stops by and unloads a pile of dung on him!

Kesava Dasa illustrates this tale with great economy and wit. Once again, Zumurrud Shah dominates the composition by virtue of his enormous size, even though the artist cleverly conceals most of his huge bulk in the pit. Four angry gardeners assault the giant with sticks, as the text specifies, while the fifth wields a spade as a sign of their collective occupation. The object of their wrath has been stripped of his usual regal ornaments, and is now graced only by a pair of bloody welts. Beyond a zigzagging garden wall lies the source of the forbidden fruit; neatly trellised grapevines, a tall date palm, and assorted other vegetation. Finally, in the foreground, hidden from the gardeners by a spreading tree and rocky screen, are the guilty bears, not just one but a whole family, the female playfully withholding a piece of fruit from one cub while another looks on with amusement from the crook of the tree.

There are many indications that Kesava Dasa was responsible for most, if not all of this painting. Zumurrud Shah's face is the most obvious, its large eyes, grimacing expression, and wispy beard being enlarged versions of the features of the distressed *ayyar* in cat.55. Familiar, too, are the giant's hands, which have fine, elongated, and somewhat rubbery fingers. The trees and vegetation also show signs of being Kesava's handiwork. The bark of the tree sheltering the bears, for example, is rendered with the same distinctive contoured striations found on Umar's shorts in cat.55; similarly, the fine grasses ringing the pit appear in both cat.55 and 56. Even the rare date palm has a counterpart in the former work.

This illustration is marred slightly by the repainting of four of the five gardeners' faces, which have unburnished, greyish complexions and thinly drawn features.

One highly intriguing feature of this painting is a series of three black marks – apparently numbers – written obliquely beside the rightmost bear. These tiny numbers are somewhat malformed and generously spaced, but if they are what they seem, that is, the numbers 975, they probably represent a Hijra date corresponding to AD 1567–68. Like the other date in the manuscript (that of AH 972/AD 1564–65 on cat.24), this one is written and placed so informally that it should be regarded as the most fortunate kind of painterly graffiti.

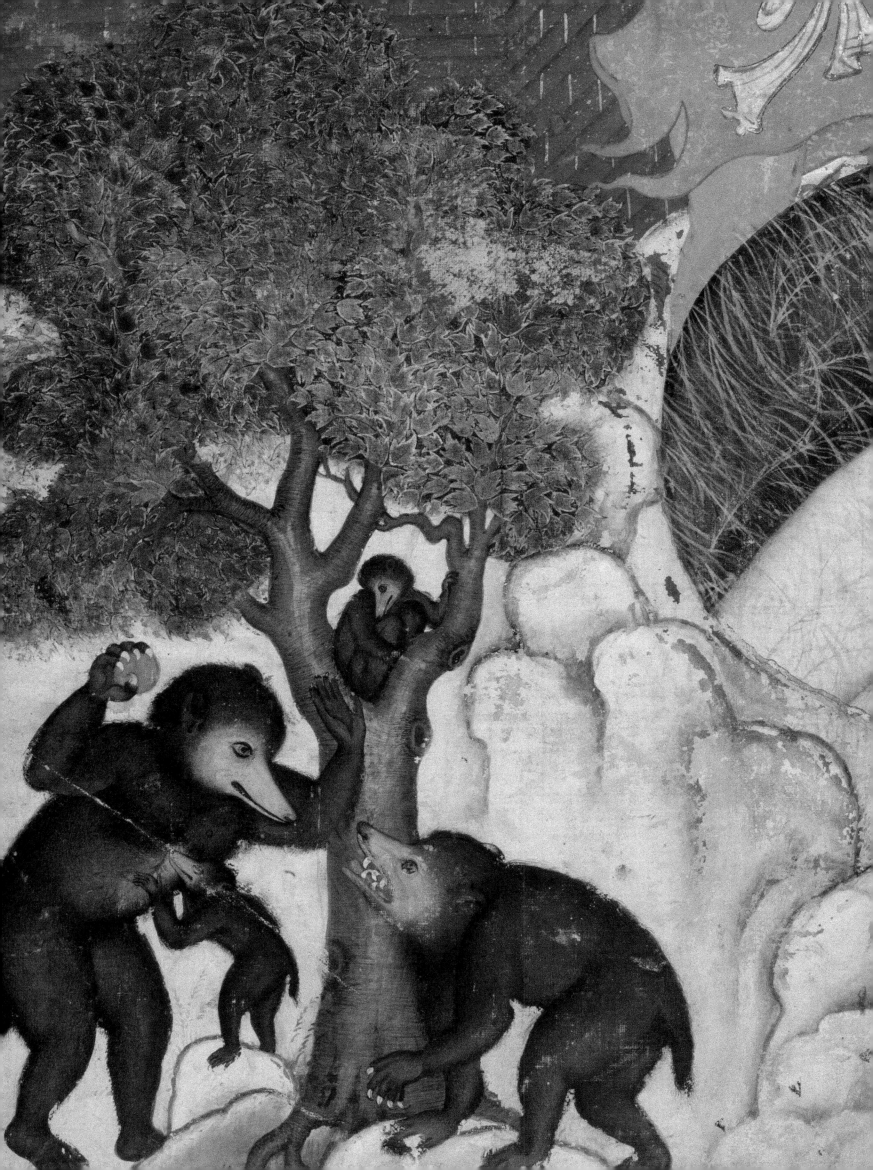

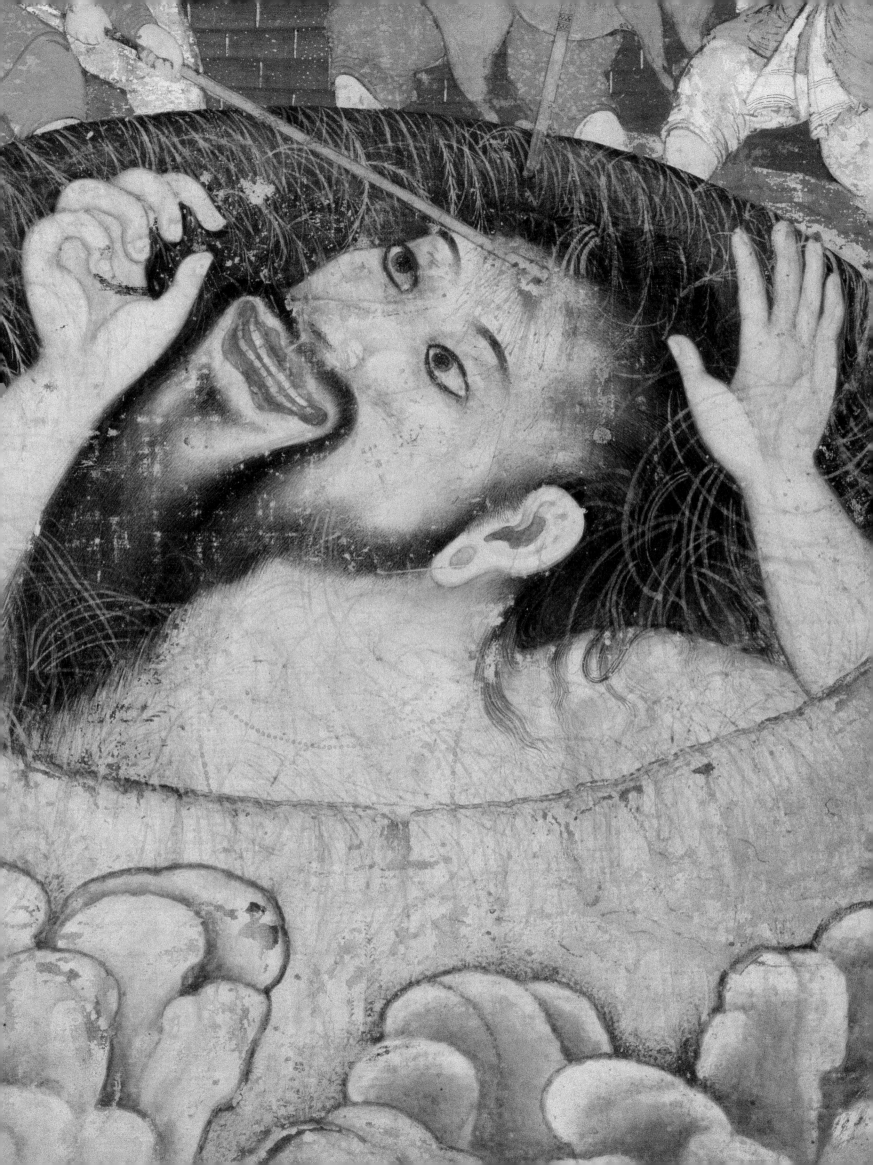

The subject of this dramatic painting is an elusive one, for neither the text that precedes this illustration nor its caption has survived. The following text is also of little use in this regard. It begins with a brief account of Zumurrud Shah's dispirited retreat to Mushtarisar, one that takes him through the dangerous Zaranqa Valley, where he meets up with an old ally, Ta'us Shah. A great ambush eventually ensues, and Qahir Qahraman – another of Zumurrud Shah's trusted confederates – is killed. All this is witnessed by Umar, who, in the concluding lines, hastens back to Hamza to tell him the news. Thus, there is no textual indication whatsoever that the figure shown dispatching this demoness is Hamza.[1] Moreover, although the hero sports three plumes in his turban, signifying his high station in life, he is much too young and active to be Hamza, who is normally depicted as bearded and stately.

Whatever his identity, the stout hero is making short work of the vile creature who has ventured out of a darkened cave in the center of a rocky landscape. She is dressed in ordinary woman's clothing, which clings enough at the bodice to reveal a sagging breast, a standard trait of crones and witches. Her predatory and savage nature is also conveyed by her tangled, wild hair. More overtly demonic are her flaming eye-rim, bony nose, bared teeth, and spiky tongue. Yet it is her hairy, wolfish ears that are featured most prominently, one being adorned with a tiny golden earring and the other, now somewhat abraded, being seized by her resolute opponent. The bloody slash mark across her back signals that he has already landed one devastating blow. Now, having yanked the demoness's head toward him, he raises his sword high and prepares to deliver the mortal strike to her neck. Seven unarmed onlookers scattered around the scene watch this spectacle with amazement.

This painting is surely by Kesava Dasa, one of the most eminent artists in the Mughal atelier. Signature features of his work are everywhere. Most obvious is the face of the demoness herself, which shows the same explicit expressiveness that Kesava uses for all his antagonists (see cat.55). Her dress, heavily modeled with broad, painterly strokes and edged with an undulating black line, also recalls Umar's cloak in the aforementioned painting. The rocks are again flattened and smooth, with dark contour lines binding their irregular oval shapes. Even the trees are familiar, both for their straight, lithe trunks and precise, vibrant foliage. So is the ground itself, divided abruptly into a dark foreground marked with greyish tufts, and a light, nearly plain middle zone.

By far the most distinctive feature of this painting is the sky. Most contemporary Mughal paintings limit the sky to the uppermost fifth of the composition, and render it as an expanse of blue streaked with white or gold, a convention adapted from European painting. Here, however, in the knotted, pinwheeling, flamelike clouds the artist has invoked a tradition with roots in Islamic painting as old as the fifteenth century, and an origin as distant as China. He is not content to superimpose this motif on an otherwise plain sky; instead, he uses it in concert with an extremely streaky ground, so that the electrifying energy of the clouds reverberates in the darkest and most jagged portions of the blue sky.

Attributed to Kesava Dasa

Volume unknown, painting number 9, text number 10
India, Mughal dynasty,
circa 1567
67 × 50.5 cm
Victoria & Albert Museum, London, I.S. 1513-1883
Published: Stronge 2002, pl.9, p.24; Guy & Swallow 1990, no.46; *Hamza-nama*, pl.11; Glück 1925, fig.9; Clarke 1921, pl.9.

1. In *Hamza-nama* the scene is identified as Hamza killing the demon Qamir while Umar watches. Umar, perhaps the most easily recognizable figure in the whole of the *Hamzanama*, is certainly absent.

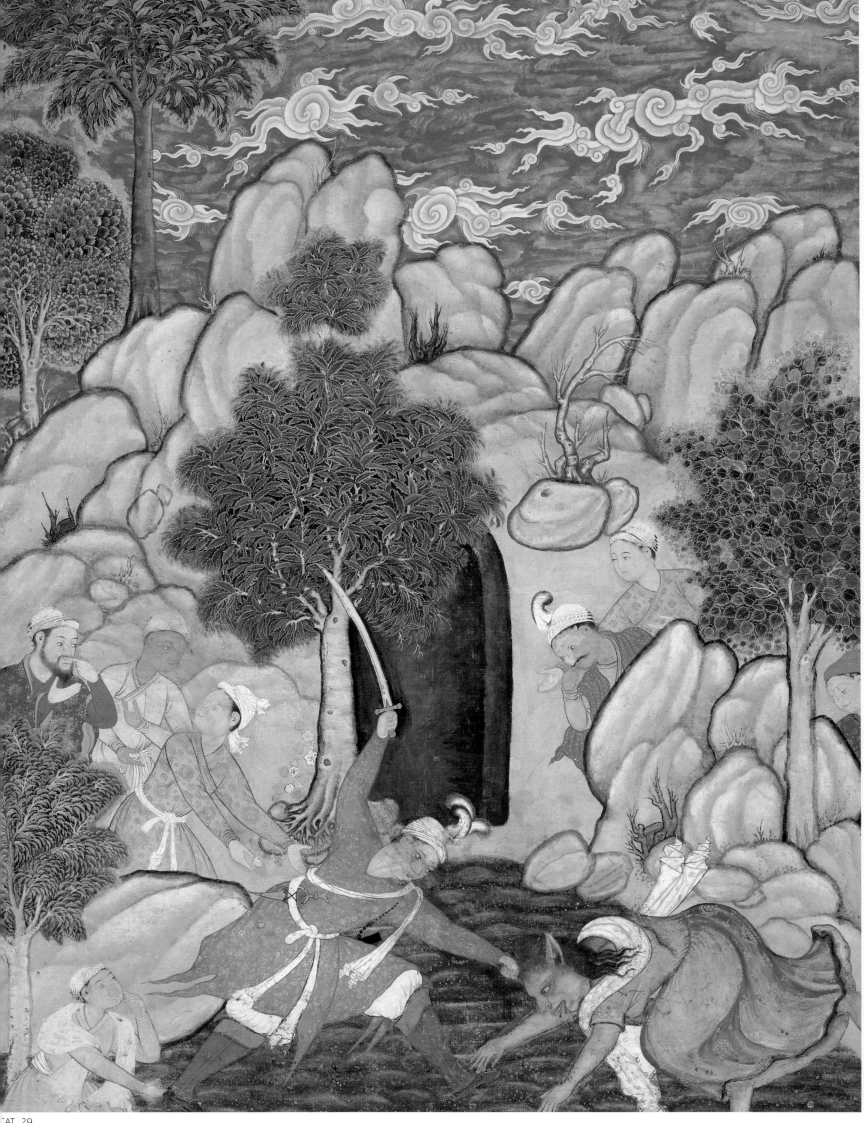

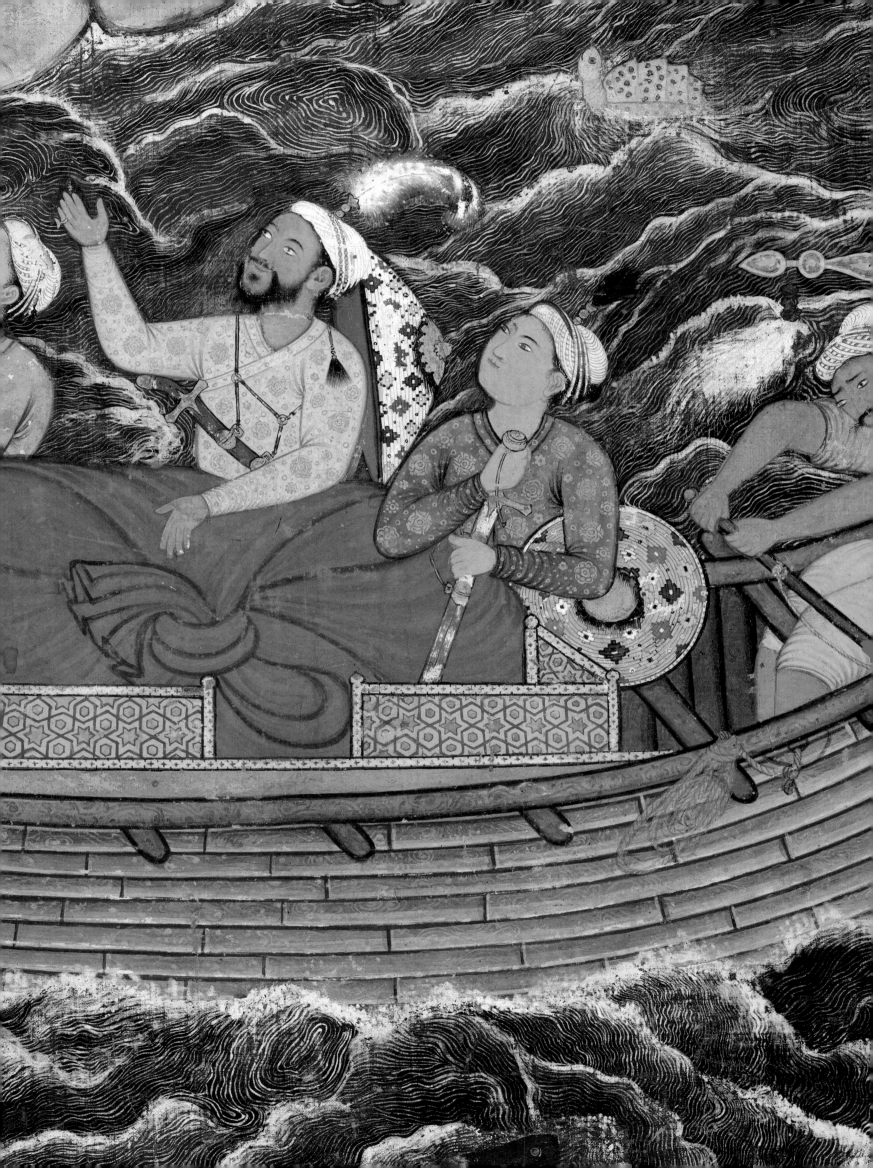

SHAHRASHOB ABDUCTS HAMZA, WHOSE COMPANIONS SEARCH FOR HIM IN TAKAW

CAT 30–33

This story is set in Sabayil, a city recently captured by Hamza and the place where he, Qasim, Badi'uzzaman, and Landhaur are all to be married. Some of the infidel inhabitants of Sabayil turn outlaw, including the spy Shahrashob, who sneaks back into the city in disguise and meets up with an opportunistic moneychanger named Mazhub. Shahrashob abducts Hamza by the shore, stows him heavily fettered in a boat, and flees to the east.

Umar comes across Hamza's horse, Ashqar, grazing in a spot where there is evidence of foul play. Seeing Mazhub loitering nearby, Umar accuses him of complicity in Hamza's disappearance, a charge Mazhub vociferously denies. The resourceful Umar has ways of extracting the truth, however, and frightens one of Mazhub's slaves into revealing that Shahrashob kidnapped Hamza, and that Mazhub, along with some roughnecks aptly named Nimrod, Larghay Chain-Chewer, and Sharit b. Beast-Chain, was indeed a willing accomplice. Umar orders Mazhub hanged for his deceit, hastily outfits a boat, and with Yazak the Cathayan sets sail in pursuit of Shahrashob and his captive.

Meanwhile, a different boat – manned by Hamza's brother Ayjil and son Alamshah, and Tul Mast – is sailing toward Sabayil. Despite the best efforts of the sailor Yunus, the boat is blown thoroughly off course, finally landing at Takaw, where Malik Arghus rules and Hamza's archenemy, Zumurrud Shah, is rumored to be afoot. Once the companions are in the town, Yunus makes his way to a caravanserai and asks for a room. The innkeeper, one Baba Junayd, begins to turn him away for want of space, but changes his mind when Yunus confides to him that his friends reek of money, and those who accommodate them will surely be perfumed by it. The travelers take a room over the gate, and Tul asks the proprietor to store some goods for a while. Next they need a money-changer, and are introduced to Khwaja Nu'man, a merchant who by chance has helped Hamza before and is known to Alamshah. He reveals his identity to Alamshah in private. Soon afterward, he shares his good news with Baba Junayd, who has his own complicated reasons to be gladdened by the presence of the Iranian heroes.

While waiting for news of Hamza, Ayjil, Alamshah, and Tul Mast go in disguise to see Mahlaj, a much-heralded champion, perform feats of great skill for Malik Arghus, the king of Takaw. He charges a camel weighed down with heavy bags of sand, impales it with his spear, and flings it over his shoulder. Next Mahlaj strikes a huge plane tree with such force that the tip of his spear passes completely through it and splits it. Another champion shows off his extraordinary facility with the bow, and like Mahlaj, boastfully calls out for someone to try to match him. Alamshah steps forward. Not only does he have the strength to draw the bow, he casually fires three arrows clean through the massive tree; he then breaks the bow in his hands and contemptuously casts it aside. Not to be outdone, Ayjil strolls over to the tree and extracts the spear with one mighty heave. He smashes the lance against the colossal rock with such force that it sinks into the ground with the spear embedded in it. At the sight of these astounding feats, a wave of admiration ripples through the crowd, but the presence of these formidable but unknown champions alarms Zumurrud Shah.

Detail of CAT 30

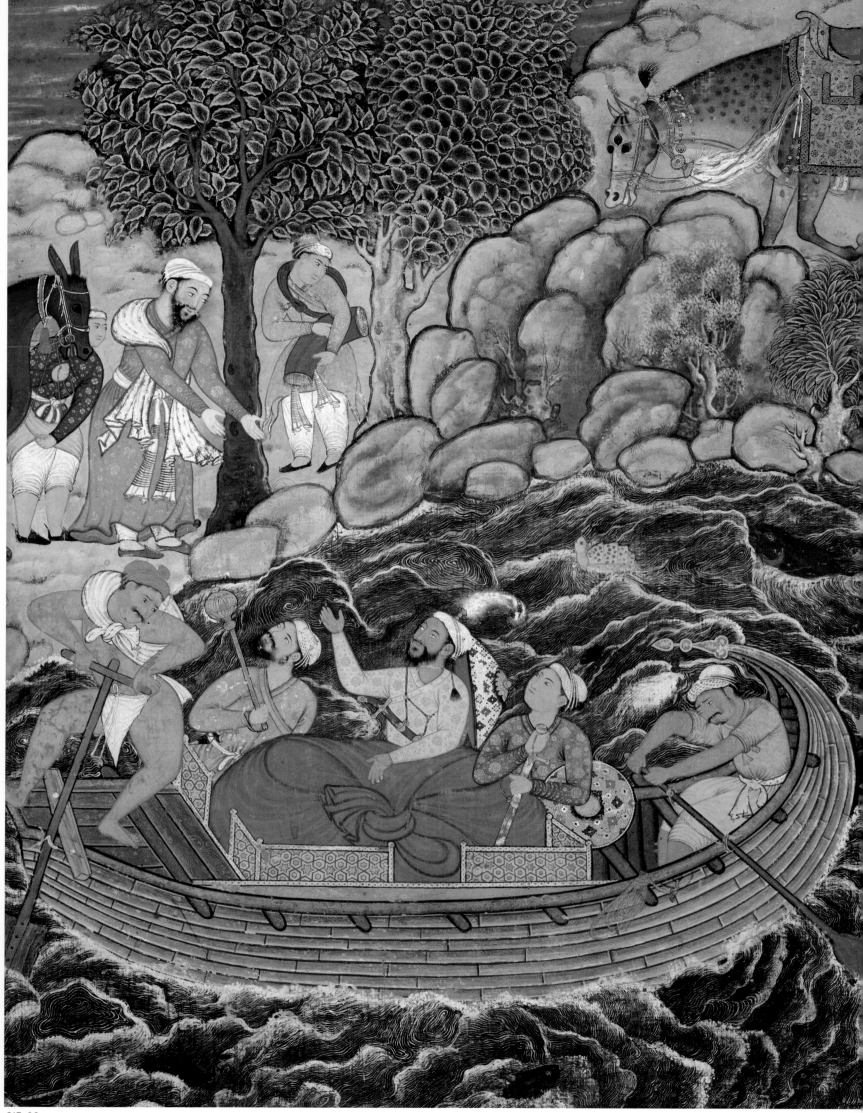

30 DURING HAMZA'S WEDDING TO THE DAUGHTER OF HIS FRIEND PRINCE UNUG, HAMZA IS ABDUCTED BY SHAHRASHOB AND STOWED IN A BOAT

Attributed to Basavana and Shravana

Volume 11, painting
number 3, text number 4
India, Mughal dynasty,
circa 1570
67.4 × 51.8 cm
(detail on pp.106–107)
Caption: 'Shahrashob seizes
the Amir and ... puts him in
a boat'
MAK–Austrian Museum of
Applied Arts / Contemporary
Art, Vienna, B.I. 8770/45
Published: Egger 1974, pl.13;
Egger 1969, pl.4; Betz 1965,
cover and pl. 8; Glück 1925, pl.7.

1. In fairness, it should be
said that Umar is one of those
figures, and is habitually
depicted with a whippetlike
body and face.

The first extant illustration of the eleventh volume of the *Hamzanama* has come to us without the benefit of the text that immediately precedes the painting, but the narrative on the first text page of the volume, the damaged caption, and the text on the reverse together provide a more than adequate account of the events that unfold in this scene: the kidnapping of Hamza by the infidel spy Shahrashob and his removal to the enemy kingdom of Takaw by boat.

Nearly half the painting is occupied by a large boat launched by two straining oarsmen. At its midsection, and indeed, the center of the composition, is a figure dressed in a brilliant yellow *jama* and a glowingly plumed turban, his left arm resting on an enormous red sack. By position and color, he is clearly the linchpin of the trio of armed men, and he alone actively gestures toward the shore. There, the largest and most brightly garbed of three men answers his beckon, while the flanking figures tend to a horse and camp paraphernalia.

In the context of the episode described in the caption, the key figures can be readily identified: Shahrashob bids farewell to his accomplice Mazhub as he steals away in his boat, and his bundled cargo is none other than Hamza. Finally, the dappled stallion pawing the ground in the upper right is recognized as no ordinary horse, but Hamza's steed Ashqar, a mount distinguished if not by his crimson coloring, then certainly by his magical third eye.

In most tellings of the story, this is surely how the narrator would use the illustration. But one can easily imagine that the painting could be adapted to other interpretations, so that the boatload of figures would be Umar's newly provisioned rescue vessel, and the figure on shore his ally Sa'd. It is even conceivable that this same image would be used to accompany both episodes, whether recited on one night or two. One point is that malefactors in these *Hamzanama* illustrations are rarely marked with an obviously villainous appearance, and even some major protagonists have few identifying visual attributes.[1] Another, further-reaching one is that the inexplicitness of most figures and settings in the manuscript is matched well with a collection of stories with a constant general storyline but an infinite number of episodic options.

Many elements in this painting recur throughout the *Hamzanama*. The rocks are rendered typically with dark but thin outlines and a slightly muddy pastel coloring. The trees vary mainly in the shape and color of their trunks and in the form of their yellow-tipped leaves. Most figures' faces are shown in three-quarter view and are easily categorized into a limited number of types. *Jama*s are uniformly colored, flat forms overlaid with medallions in gold, with schematic folds marking the cuffs, waist, and hem. This repertoire of forms is so standard that the work of an individual artist can be discerned only at a much subtler level. In this case, for example, the broad, tapering faces and tiny eyes signal the work of Shravana, as do the relatively large medallions on several figures' *jama*s.

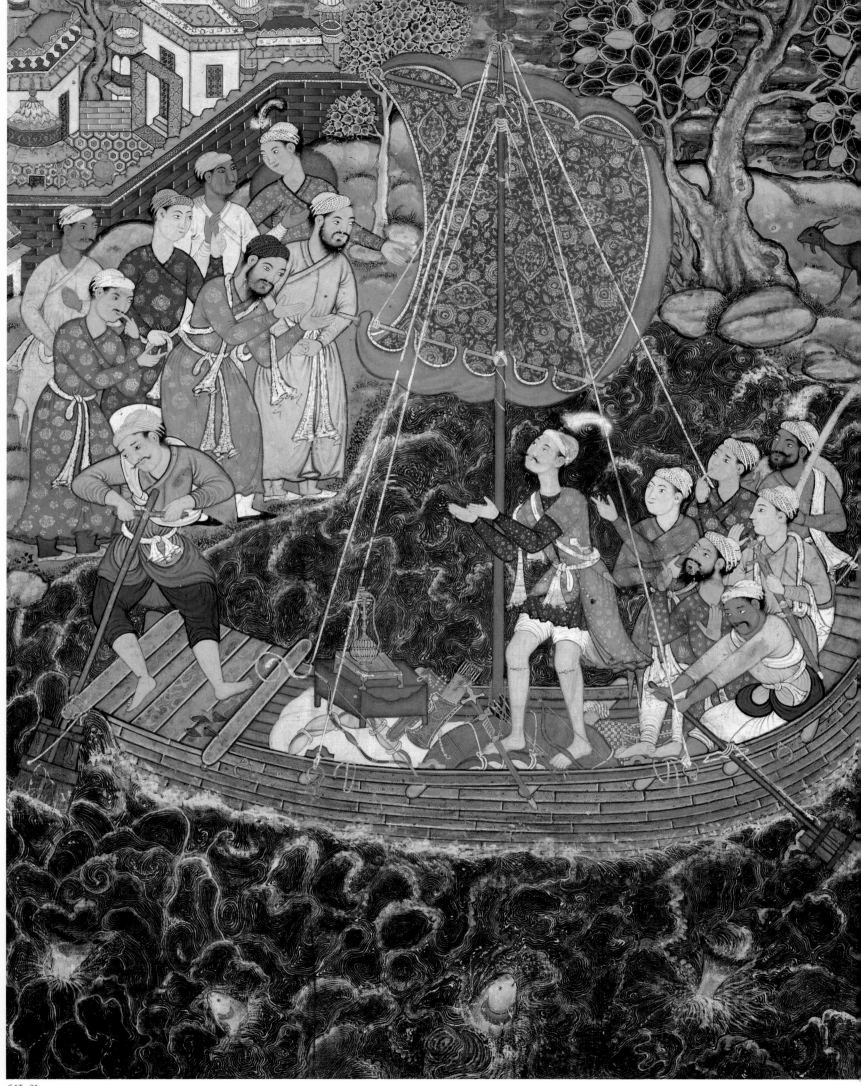

**Attributed to Dasavanta
and Banavari**

Volume 11, painting
number 4, text number 5
India, Mughal dynasty,
circa 1570
67.1 × 52 cm
Caption: 'Umar boards a ship
and goes on account of the
Amir and ...'
MAK–Austrian Museum of
Applied Arts/ Contemporary
Art, Vienna, B.I. 8770/47
Published: Egger 1974, pl.14;
Egger 1969, pl.5; Glück 1925,
pl.8.

Two short sentences at the very end of the preceding folio, describing Umar and Yazak the Cathayan as they begin their rescue mission, inspire this illustration:

"In short, he took ten slaves and six months' provisions, and he charged Sa'd, saying, 'Whenever news of the Amir arrives, arm yourself and come as quickly as possible.' Saying this, and bidding farewell to the kings and champions, he and Yazak the Cathayan got in a boat. The sails were trimmed, and they set out on the sea."

When the text on the reverse of this folio resumes with an account of a sea journey, one naturally assumes that it will be the next installment of Umar's escapades. Instead, the reading audience eventually surmises that the narrator has shifted abruptly to a new story, about another boat with a different crew, which is adjoined to the previous one because both involve sea travel. The remainder of the text recounts the second crew's adventures in the city of Takaw, which form the subject of the next painting.

The juxtaposition of two essentially similar images of a boat departing invites comparison of the nuances that the artist has added to a standard type of scene. Standing beside the bright mast and backed by an anxious crew, Umar uses a two-handed gesture of supplication to express his indebtedness to the 'kings and champions' gathered at the shore. Lest the focus on Umar be diminished, no one among those luminaries is singled out by dress or pose; rather, their collective presence before a city underscores the royal sponsorship of Umar's expedition, and lends it a propitiousness that the handful of nondescript figures seeing off Shahrashob in cat.30 can never bestow upon the spy. So, too, does the open display of the lavish fittings of Umar's vessel – from the golden ewer and mound of assorted weapons at his feet to the magnificent sail billowing directly above his head – contrast with the furtiveness implied by Shahrashob's rudely bound cargo. The distinction between meritorious and base action is extended even to so stock a Mughal figure as the boatman at each stern. Attired in regular clothing, Umar's pilot blends in easily with the figures behind him, and does not intervene between the *ayyar* and his well-wishers; Shahrashob's seafarer wears but a scanty loincloth, and stands out for it.

Much of the painting is given over to water, which here becomes an expressive element, as it does so often in this manuscript. Mughal painters had developed this irregular convention for water only within the decade, and they seemed eager to flaunt the mesmerizing power of its eddies and swirls whenever circumstances allowed. They intuitively recognized that its dark color and random visual texture provided relief from the flat patchwork of forms in dense figural groups. In this painting, Dasavanta exploits the spatial implications of this contrast in color and visual texture to particularly great effect, so that Umar, garbed in brilliant red and isolated against the dark churning sea, is made all the more prominent.

India teems with animals, a fact that Mughal artists rarely left out of their paintings. While the four fish exploding out of the sea add life and rhythm to its surface, the trio of goats grazing nonchalantly beside and behind the tree in the upper right are probably nothing more than an artist's fond recollection of the quiet sights of village life.

When Alamshah and his companions reach shore, they stash their boat, change into some local clothes, and slip into town.

"Yunus took them to an inn, which the comrades entered boldly and then sat in a corner. Yunus went to the aged innkeeper. When the old man saw him he asked him how he was. Yunus asked for a room in the inn. The old man said, 'People have taken over the inn. There is no room.'

'There is a group of nobles,' Yunus said. 'It would be worth your while to let them in.' He accepted and gave them a chamber over the gate."

The travelers decide to sell some of their valuables for cash, and to this end Yunus and Baba Junayd contact Khwaja Nuʿman, a wealthy merchant who many years earlier had aided Hamza and befriended Alamshah.

"By chance he had landed here and acquired untold wealth, for which he was well known in the city. Baba Junayd went to him and said, 'A group of merchants are selling gold and jewels.'

In short, he took Khwaja Nuʿman to the comrades' chamber, and when Nuʿman's eye lighted on Alamshah Nawjavan, he recognized him, but he said nothing, waiting for a better opportunity."

The illustration stages this encounter in the upper right of the composition, but prefaces it with the hubbub of a caravanserai where weary travelers and their animals settle down cheek by jowl for the night. Each vignette becomes an opportunity for narrator and painter to comment on the business of life. Some horses bury their heads in feedbags. A traveler dozes off beneath a makeshift tent, goods and weapons hard by his head and feet. A servant lays out a grainy banquet for two resting camels, while men behind him bustle about a pair of trunks. Other travelers converse before a dark gateway and staircase. Above, in the tight quarters where the red-clad Nuʿman meets Alamshah and his companions, the air is heavy with secret dealings. The architecture creates much of this climate, as dark brick walls encroach upon the unframed chamber from both ends. The figures, too, are close-packed in the chamber, and Tul assumes such gigantic proportions that he threatens to burst through the low parapet at even the slightest shift of his weight.[1] Two smaller figures on an adjacent corridor huddle together as a muezzin issues the evening call to prayer from a kiosk rooftop.

All this activity occurs within an unusual composition. Rather than employing the customary level view into an open-sided courtyard or an elevated view over the walls of a gated compound, the artist frames the scene with an uninterrupted low brick wall in the foreground and two contiguous eaves above. This construction fosters a sense of intimacy as the audience is permitted to peer down into the cloistered space from a nearby vantage point.

The innovative composition is the first sign of the handiwork of a master artist, but there are many other indications. Typically, they are concentrated on the key figures in the illustration. In this case, they include the gauzy rendering of the white scarf around Nuʿman's shoulder, the rounded contours of his *jama*, the exceptionally fine drawing of his feet, the rich brown color of Ayjil's turban, and the luminous modeling of Tul's scarlet *jama*. All these features point unmistakably to Basavana, the only Mughal artist able or inclined to draw and paint in this manner.[2] Similarly, the faces of all four named figures are strongly characterized, as Basavana's normally are; to realize the level of accomplishment here, one need only glance at the vapid expressions of the assistants to their left, surely the work of another painter, in all likelihood Banavari. But Basavana often expanded his role in collaborative work beyond the design and a few key features, and one can easily see his touch in the camels' lithe necks and bristly hair, the fluid modeling of the green sheet covering the slumbering figure, and the plumed figure in blue behind the camels. This figure's face bears a profound resemblance to the king in one of Basavana's ascribed paintings in the *Tutinama* (cat.11). Banavari, by contrast, seems to have a relatively restricted range of figures, best represented here by the two figures isolated against the blackened gate.

Attributed to Basavana and Banavari

Volume 11, painting number 5, text number 6
India, Mughal dynasty, *circa* 1570
67.6 × 51.8 cm
Caption: 'Ayjil, Alamshah, and Tul Zangi are recognized by Khwaja Nuʿman in the city of Takaw'
MAK–Austrian Museum of Applied Arts/ Contemporary Art, Vienna, B.I. 8770/41
Published: Egger 1974, pl.15; Egger 1969, pl.6; Glück 1925, pl.9.

1. One minor technical feature worth noting here is the faint label with Tul's name which is inscribed above his hand; this is a rare example in this project of a supervisory note left for the artist, probably to ensure that Tul, who is identified as a Zangi (Ethiopian) in the caption, would be given appropriately dark skin.
2. Many of these features are found, for example, in Basavana's ascribed work in the *Darabnama* in the British Library, London, f.34a; Welch 1978, pl.6. See fig.22 on p.52, above.

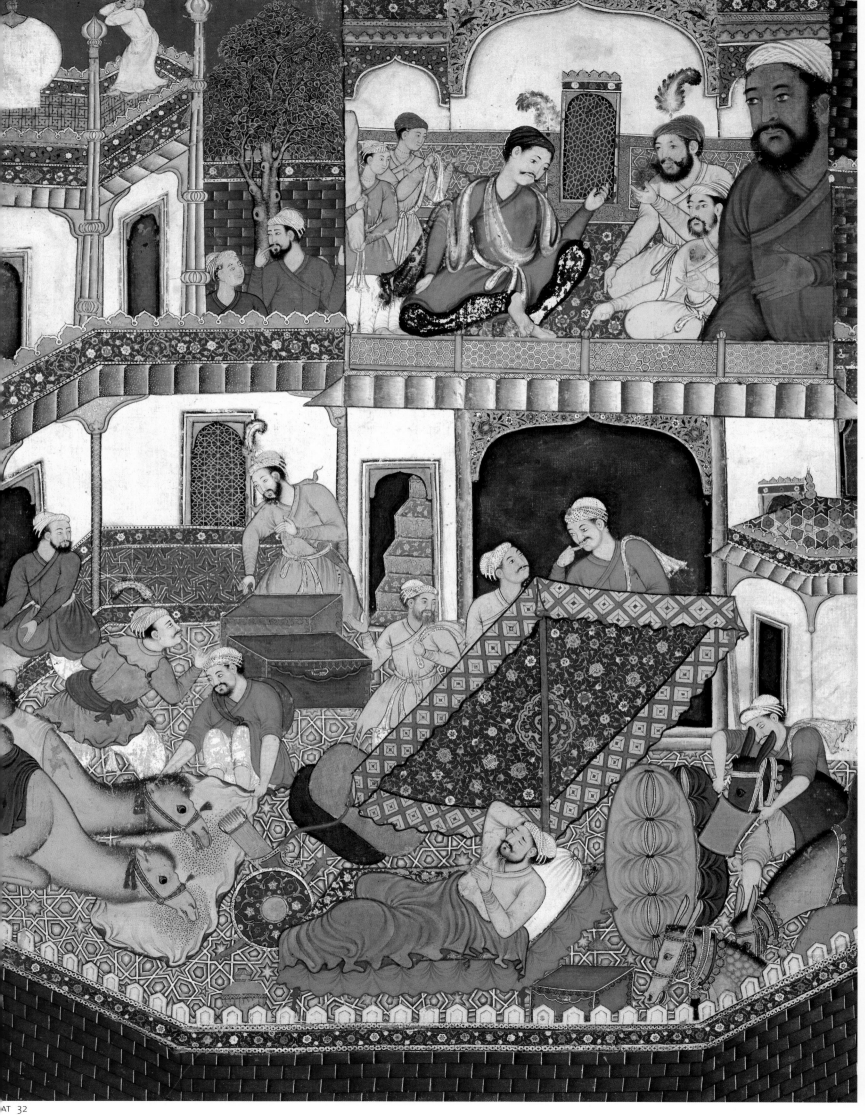

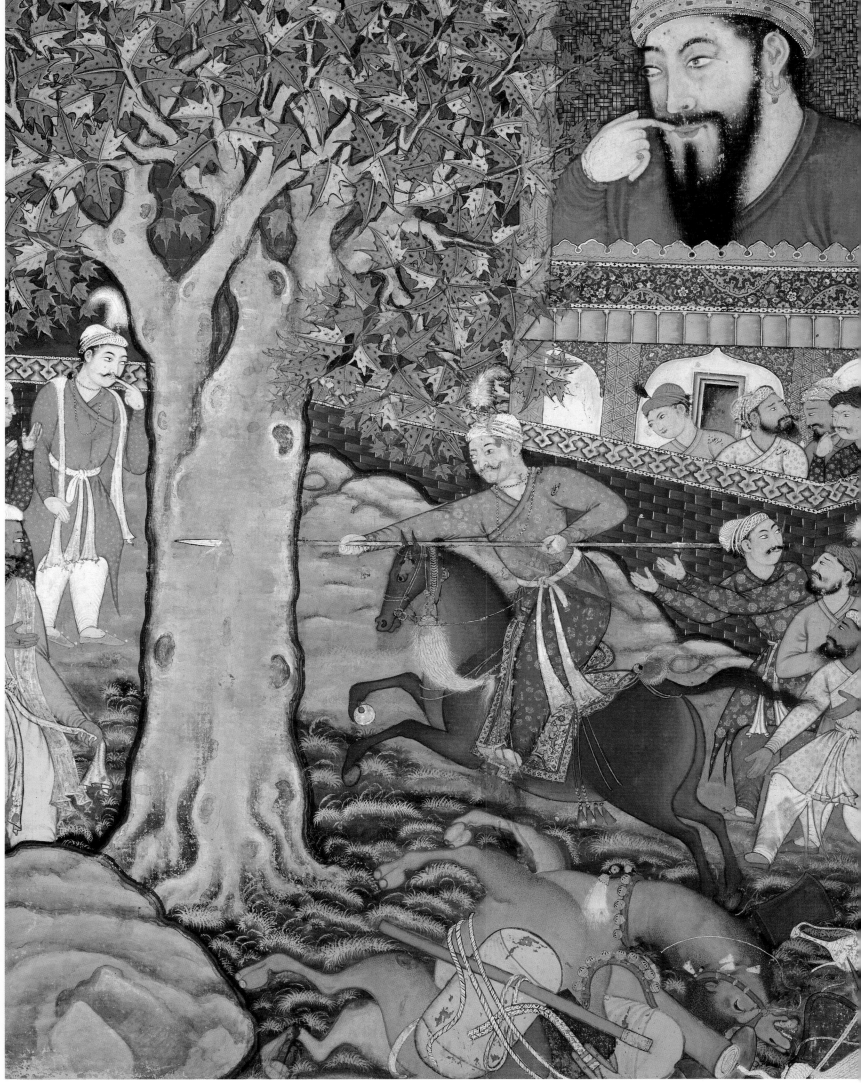

33 ZUMURRUD SHAH WITNESSES THE PROWESS OF MAHLAJ, WHO THRUSTS HIS SPEAR THROUGH A TREE

Attributed to Basavana and Jagana

Volume 11, painting number 6, text number 7
India, Mughal dynasty, *circa* 1570
67.3 × 52.1 cm
Caption: 'Mahlaj displays his skill before Zumurrud Shah and makes [his] spear pass through a tree'
MAK–Austrian Museum of Applied Arts/ Contemporary Art, Vienna, B.I. 8770/42
Published: Egger 1974, pl.16; Glück 1925, pl.10.

1. Both these figures and Mahlaj are identified by tiny labels written on their sleeves.
2. A particularly close comparison is the king in an illustration from a dispersed *Gulistan* of Sa'di dated 1596. The painting is reproduced in Pal 1993, no.57.
3. For the treehouse scene attributed to Basavana in the *Diwan of Anwari* of 1588, see Schimmel & Welch 1983, pl.2.

Word spreads of a festival at which various champions will perform feats of great skill for Malik Arghus, the king of Takaw, in his lovely spring garden. Ayjil, Alamshah, and Tul Mast, who take pride in their own strength and skill, are naturally interested in this spectacle, and make their way to the site in disguise.

"The name of the garden was Fayzabad. Two arrow shots away a pavilion had been erected, and there Zumurrud Shah, Hurmuz, and all their officers sat mounted while many people were standing. Opposite the pavilion was a huge tree, and at the base of the tree was a slab of stone weighing nearly three or four thousand *maund*s.

Mahlaj mounted a horse and began to exhibit his skill in spear-throwing. A camel stuffed with sand was brought, and Mahlaj charged it and planted his spear into its side in such a way that it passed straight through. Then he picked up the camel and its load and hurled it over his head. A cheer arose from the people. Next he speared the tree so hard that it split in two.

'My Lord,' said Mahlaj, 'if anyone can pull this spear out of the tree, he will have performed a real feat.' "

Recognizing the dramatic possibilities of the last lines of the text, the artist depicts the mounted Mahlaj in mid-stride as he plunges his lance into the tree. In the foreground is the sprawling corpse of the hapless camel, tongue lolling and blood trickling from its leg. The sandy ballast lashed to the camel's saddle was obviously no protection against Mahlaj's prodigious might; it has come undone and been cast aside along with a tent, a ewer, and a now useless feedbag. Zumurrud Shah, finger raised to his mouth in amazement, witnesses the spectacle from a viewing box designed for one giant alone; his host, Malik Arghus, the bearded figure in yellow, and Arghus's son, the plumed youth beside him, look on from ordinary positions below.[1] At the base of the tree, in the corner opposite Zumurrud Shah, is the 'slab of stone weighing nearly three or four thousand *maund*s.' Observing the events from an inconspicuous position between the tree and left edge of the painting are the three Iranian heroes. Tul has resumed normal proportions, no small trick of a disguise, and the plumed figure, either Ayjil or Alamshah, has shed the beard he wore in the previous illustration.

Mahlaj's extraordinary feat has inspired a painting of uncommon boldness. By his very size, Zumurrud Shah has an unsettling effect on any composition, one enhanced here by the juxtaposition of his huge head with the smaller and more decorative forms around him. The real visual attraction of the painting resides in the plane tree. It is more than simply big; it offers a compelling contrast between the painterly surface of its broad, greyish trunk and the precise forms of its colorfully bifurcated and speckled five-pointed leaves. The tree must have been considered sufficiently resplendent to represent a named garden, for the site is bereft of plantings other than the loosely rendered, long, yellow tufts of grass.

This work, too, contains some features that support an attribution to Basavana. Foremost among these is Zumurrud Shah's face, which has the narrowed, focused eyes, thin but hairy eyebrows, and sensitive modeling found in many figures by that artist.[2] Moreover, Zumurrud Shah's scarlet *jama* is practically identical to Tul's in the previous illustration. Similarly, the sprawling camel is consistent with Basavana's versions of these beasts in both form and texture. Basavana even reuses the plane tree, albeit on a much smaller scale, in a later composition.[3] In that instance, the trunk is very similar, but the leaves lack the flamboyant coloring seen here. The bright leaves, skeinlike tufts of grass, and treatment of most figures suggest that Basavana designed this *Hamzanama* painting, but left much of the detailing to a collaborator.

To judge from the strong resemblance of Mahlaj's face to those of several guards standing to the left of Hamza in cat.35, that collaborator was Jagana. Many of the figures here demonstrate his penchant for noticeably broad bodies, a trait seen again in cat.61. Both paintings also feature a wide architectural floral band with golden half-medallions; in this painting, that element appears immediately below Zumurrud Shah's box.

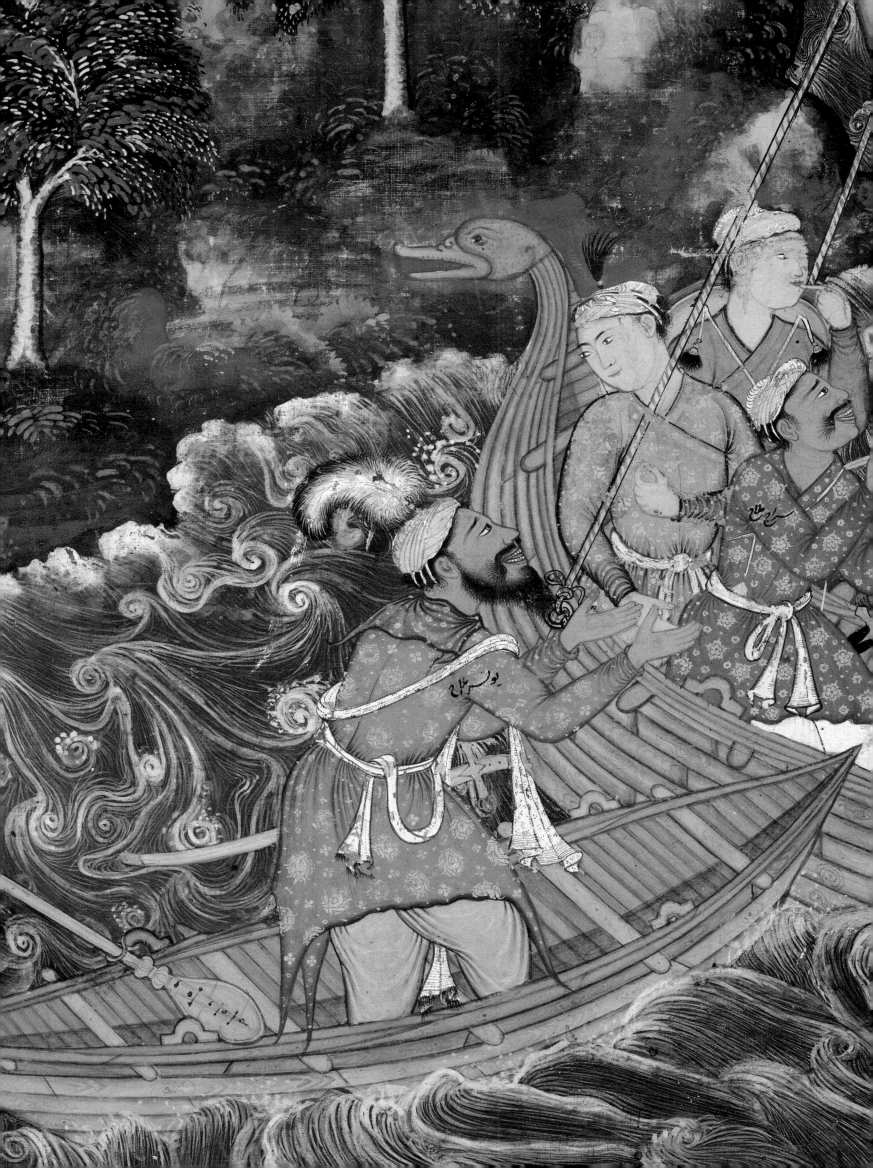

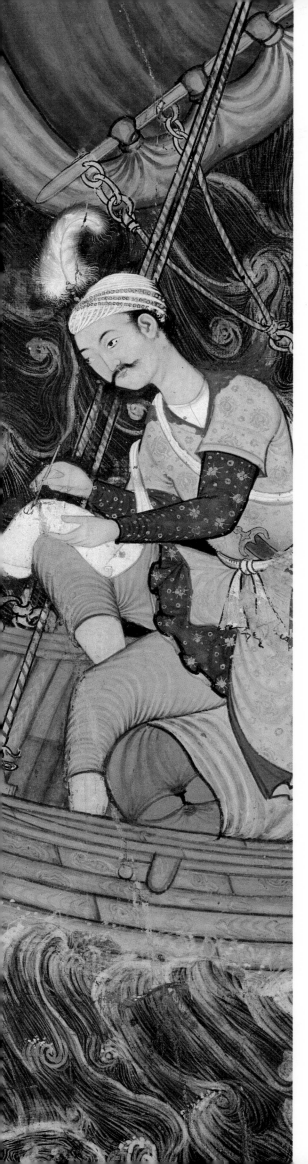

Detail of CAT 36

THE CAPTIVE HAMZA AND HIS ALLIES MEET UP IN TAKAW
CAT 34–37

Two of Malik Arghus's operatives, Khwaja Bakhtyar and Malik Kamyar, greet Shahrashob's three henchmen – Nimrod, Larghay Chain-Chewer, and Sharit b. Beast-Chain – at the water's edge, and are subsequently informed that Shahrashob holds the Amir captive. They relay the news to a delighted Arghus, who orders the drums sounded. Ayjil, Alamshah, and Tul Mast learn the cause of this morbid celebration, and vow to rescue Hamza at all cost.

Hamza is led on a chain to the court. Zumurrud Shah commands Hamza to prostrate himself, but Hamza defiantly proclaims that he will do so before God alone. Zumurrud Shah orders him killed, but is dissuaded by Arghus on the grounds that a public killing might provoke those Iranian champions who had just exhibited their awesome might. Zumurrud Shah agrees and orders Shahrashob to escort Hamza personally to prison, a place so daunting and dreadful that no escape is possible. By chance, the cortege passes by the caravanserai of Baba Junayd, where the Iranian champions continue to reside. Hearing the commotion, Tul looks out the window and sees the Amir, captive yet proud, but he and his companions can do nothing for the moment.

Shahrashob takes Hamza into the prison, and warns Tamat the jailkeeper not to let anyone else in; Tamat swears that no one other than his sons ever have or ever will enter, inadvertently disclosing how prison security could be breached. Hamza reminds everyone just how dangerous he is by kicking aside the enormous stone capping the dungeon. Once he is lowered into the dungeon, he meets a youth who has languished there for eighteen years and who tells him that he is Khusraw, son of Jamshed, the legitimate king of Takaw. Hamza promises the incredulous Khusraw that one day he will free him and install him on the throne that is rightfully his. This development links Khusraw's fate to Hamza's, and gives Baba Junayd, who long ago was ensnarled in the events leading to Khusraw's imprisonment, a stake in Hamza's liberation.

Meanwhile, Alamshah learns of Hamza's remarkable feat in prison, and excitedly plans to fight all of Takaw to spring him. Nu'man counsels prudence, and advises them to fetch Hamza's army first. Yunus, the sailor who had guided the trio to Takaw, volunteers to return to Sabayil to seek help. By a twist of fate, Umar, lost at sea for two months, is now sailing in exactly the opposite direction. Sarraj, the pilot of Umar's boat, climbs the mast to check his course and sees another boat approaching. As it draws near, Sarraj realizes that at the helm is none other than his brother, Yunus. The two brothers embrace, and Yunus tells Umar of Hamza's imprisonment. Yunus continues his mission to Sabayil, and Umar presses on toward Takaw. At last he espies a huge mountain and fort, where he will soon discover a new ally to aid him in the last leg of his quest.

When Umar lands, he is taken before Mikal Long-Bow, an old champion who expresses a wish to help Hamza even before he hears Umar's story. An informant arrives with news of Hamza and Khusraw in prison, and advises Umar to proceed to Takaw by boat. Umar is instructed to stay in the caravanserai, which is both close to the prison and run by Baba Junayd, a man who sympathizes with the prince's cause. Umar does as he is told. At Takaw, where he pretends to be a merchant, Umar is escorted by a customs official to the caravanserai of Baba Junayd, where he has his money and politeness hurled back in his face. Finally, a chagrined Nu'man personally offers Umar two rooms, and thus comes to know another of Hamza's friends.

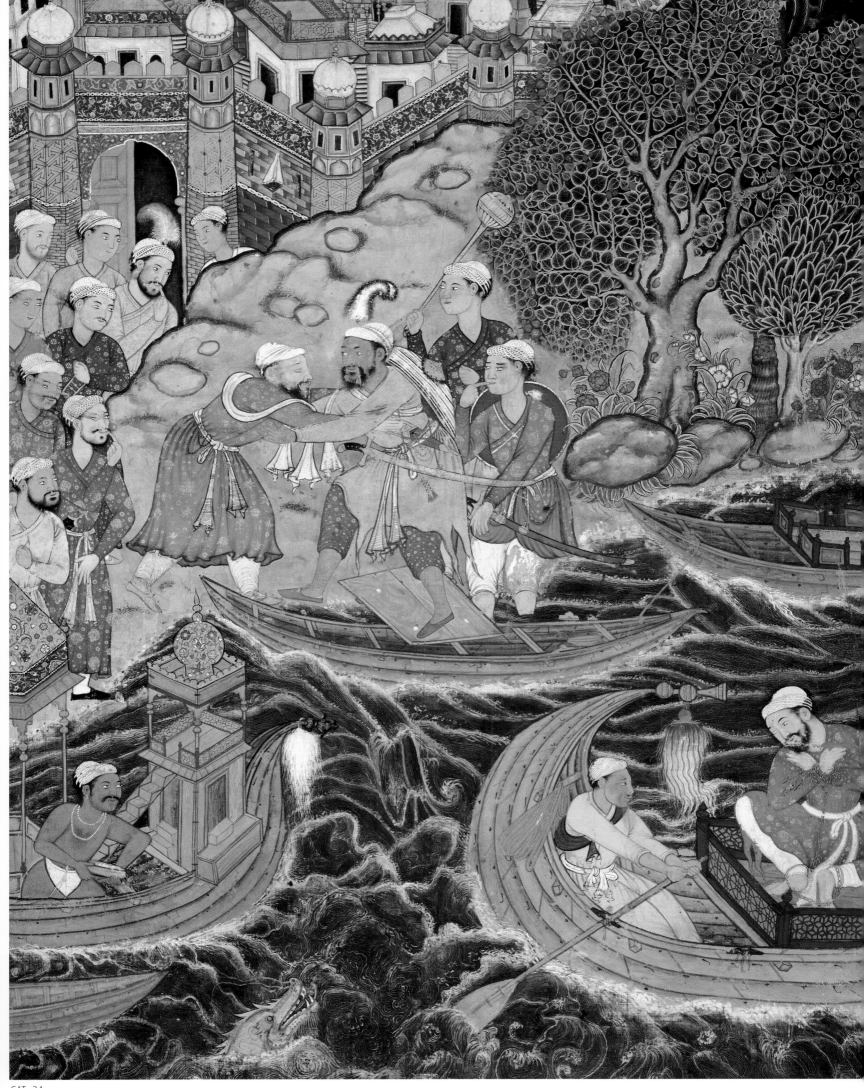

CAT 34

Attributed to Mukhlis

Volume 11, painting
number 8, text number 9
India, Mughal dynasty,
circa 1570
67.2 × 51.7 cm
MAK–Austrian Museum of
Applied Arts/ Contemporary
Art, Vienna, B.I. 8770/48
Published: Egger 1974, pl.17;
Egger 1969, pl.7; Glück 1925,
pl.11.

The sequence of illustrations is disrupted slightly by a lacuna of one folio, which in all likelihood was illustrated with one of the heroic exploits described above. Even without the ensuing page of text, the thread of the story is easy to pick up again as the separate tales of Alamshah and his companions and Shahrashob's abduction of Hamza finally converge on the outskirts of Takaw. This painting has lost its caption, but the subject is identified in the opening lines of the text that follows the illustration.

"When they met Khwaja Bakhtyar, Malik Kamyar, Nimrod, Larghay Chain-Chewer, and Sharit b. Beast-Chain and explained the Amir's situation to them, Bakhtak praised Shahrashob. Then they got out of the boat, mounted, and took the news to Malik Arghus. Bakhtak said, 'Malik Arghus, good news for you: Shahrashob Ayyar has the renowned Amir Hamza in chains and has brought him by sea with Nimrod, Larghay Chain-Chewer, and Sharit b. Beast-Chain.' The infidels rejoiced and ordered the drums of glad tidings to be sounded."

Meanwhile, Arghus and Zumurrud Shah rush to the shore to behold Shahrashob disembarking with a manacled Hamza.

The painting depicts Shahrashob and his men as they set foot on the beach at Takaw. Shahrashob's getaway boat has become a flotilla of skiffs, an artistic elaboration that allows the key figures to be spread across the composition. Wearing his shield on his back, a habit common among *ayyar*s, Shahrashob strides across a gangplank from the centermost boat to embrace one of Arghus's operatives, or possibly Arghus himself. Two henchmen behind Shahrashob, armed but less remarkable than their names, stand stoically in the water. A crowd of onlookers has gathered between the shore and the walls of Takaw. Still arriving in the largest of the boats is Hamza, his head downcast, his manacles plainly visible to all. Lest there be any confusion about the prisoner's identity, someone has written *Amir Kishwar Gir* ('Amir, the conqueror of provinces') on his sleeve. Balancing his boat is another one advancing from the left, its visual weight increased by an elaborate canopy and wooden baldachin. Likewise, a toothy sea monster, its glowing yellow scales now partly abraded, has been added to animate the sea and complement the size and position of the oar blade.

Mukhlis casts an attentive eye on the assorted boats, and particularly on their fittings. Essentially decorative elements such as the inlaid canopies and the hierarchically colored yaktails fluttering from the prows are outnumbered by meticulously described functional items including rope oarlocks, the bundle of mooring rope, and the cord yoking the two smaller skiffs.

This painting resembles another appearing slightly later in the volume (cat.38) in many respects. Most obvious is the distinctively elongated pattern of waves. Many of the facial types in the two paintings are exceedingly close, as are a number of architectural features and patterns.

The dastardly Shahrashob now furnishes his kind of spectacle: a shackled Hamza paraded from the shore to Malik Arghus's palace. When they arrive there, the furious Hamza sits down.

"Zumurrud Shah turned to the Amir and said, 'Come, prostrate yourself!'

The Amir said, 'You dog! I have prostrated to the Almighty who created the eighteen thousand worlds.'

In short, many words were exchanged between the Amir and Zumurrud Shah. In the end Zumurrud Shah ordered the Amir to be killed, but Dastur the vizier whispered in Arghus's ear, 'If Zumurrud Shah had any sense, he would not have lost his kingdom. This man is the leader of the whole army of Iran and Turan, and the champions of whom you have heard so much are in this man's service. Now, order this champion to be sent to prison so that we may see how battle-worthy his men are. Whenever you want to have him killed, it will be easy enough.'"

Shahrashob takes hold of Hamza's chains and, surrounded by a huge armed guard, leads the Amir through the city and past Baba Junayd's caravanserai, where his would-be rescuers see him.

"Tul Mast opened the window and saw Shahrashob holding the Amir's chain with three or four thousand men around the Amir holding naked swords to prevent the champions from making a rescue attempt. The Amir was walking like an enraged lion and a furious elephant. The champions sighed in despair, unable to help."

The prison to which Hamza is taken is a domed mountain with a deep dungeon capped by a mammoth stone.

"The circumference of the dome was a hundred and eighty cubits, and the thickness of the walls was forty cubits. Inside a pit had been dug, and on top of that was a stone that took four hundred men to lift by handles that had been attached to it. It took forty men to move the door to the dome, and when it was closed it made such a noise that everyone in the city could hear it."

The artist focuses on the human drama near the end of this account of Hamza's humiliation. Standing in relative isolation in the center of the composition is Hamza, head up, but hands shackled and suspended from another chain around his neck. He is tethered to two particularly sinister figures, Shahrashob in the lead and Bakhtak bringing up the rear. A throng of guards surround the prisoner, their swords and daggers brandished against any who would dare approach. They surge across a courtyard and through a city gate, and fan out in both directions. At every door and window of the caravanserai are astonished onlookers, purportedly including Hamza's friend, Tul Mast, though anyone who even remotely matches his previous description is absent.

Unlike the previous caravanserai scene, this painting draws its energy from subtle variations on a very restricted set of activities. Soldiers mill about, their turned heads directing attention every which way, and their upraised swords creating a staccato rhythm across the composition. From their tiny cubicles, the caravanserai-dwellers, heads bobbing as they gape, have much the same effect. A large portion of the paint on Hamza's face has flaked off, but that surface loss is compensated by the exquisite underdrawing.

The guards exhibit a very distinctive and coherent range of facial types. The eyes are typically very round and have remarkably bright whites. The mustaches are still more distinctive, thick and winglike in shape and bristly in texture, and often with upturned flaring ends. Indeed, some figures, notably the one directly behind Hamza or the guard dressed in red in the upper center, sport such impressive mustaches that they function as signature features. The recurrence of this combination of features throughout the illustration allows us to attribute most of the actual painting to Jagana, a major artist active in the late 1570s and 1580s, for he is named as both the designer and painter of two illustrations in the Jaipur *Razmnama* with an absolutely identical range of faces (see fig.20).[1] The irrefutable connection between this *Hamzanama* illustration and Jagana's work some fifteen years later demonstrates how little the basic elements of artists' personal styles in the Mughal atelier changed over time. Though Hamza's face is damaged, enough remains of his nose and eye to indicate that another well-documented artist, Basavana, supplied his face and torso.

Attributed to Jagana and Basavana

Volume 11, painting number 9, text number 10
India, Mughal dynasty, *circa* 1570
68.1 × 51.6 cm
(detail on pp.122–23)
MAK–Austrian Museum of Applied Arts/ Contemporary Art, Vienna, B.I. 8770/35
Published: Egger 1974, pl.18; Egger 1969, pl.8; Glück 1925, pl.12.

1. Maharaja Sawai Man Singh II Museum, Jaipur, AG 1729 and 1730; Hendley 1884, 4, pls 37–38; and Banerjee 1978, figs 243–44.

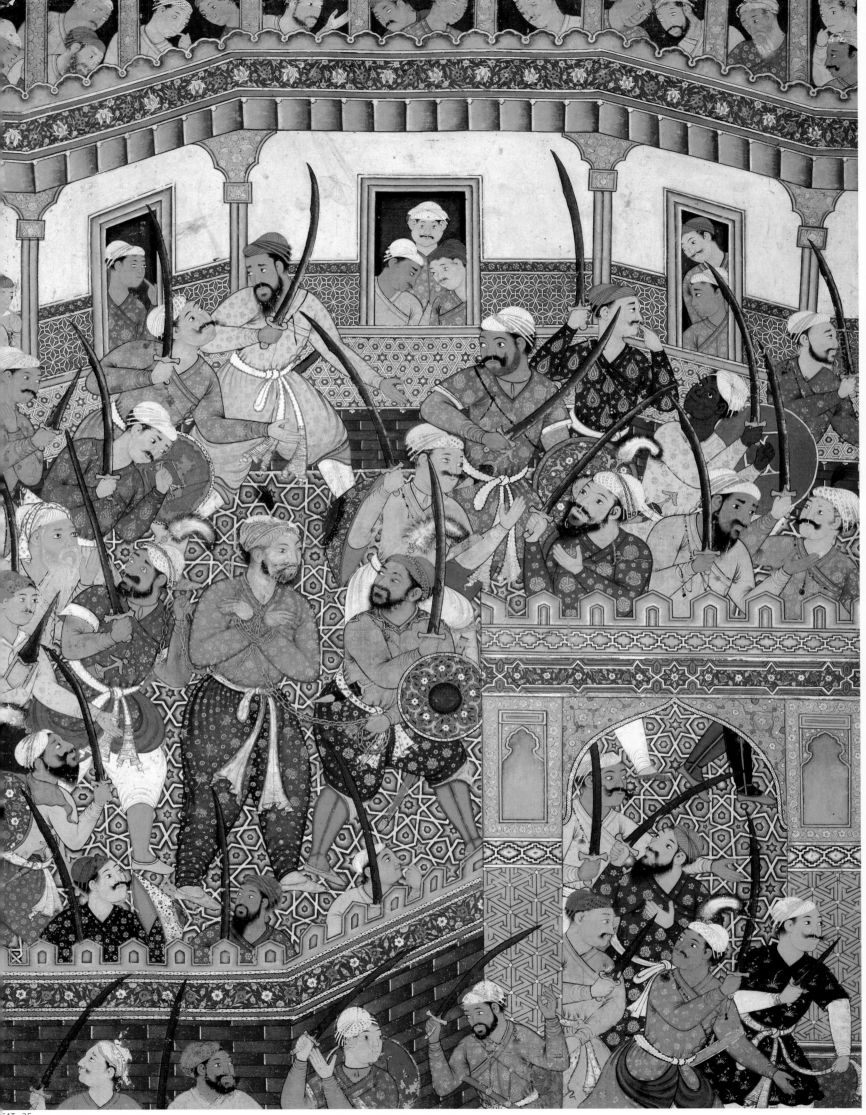

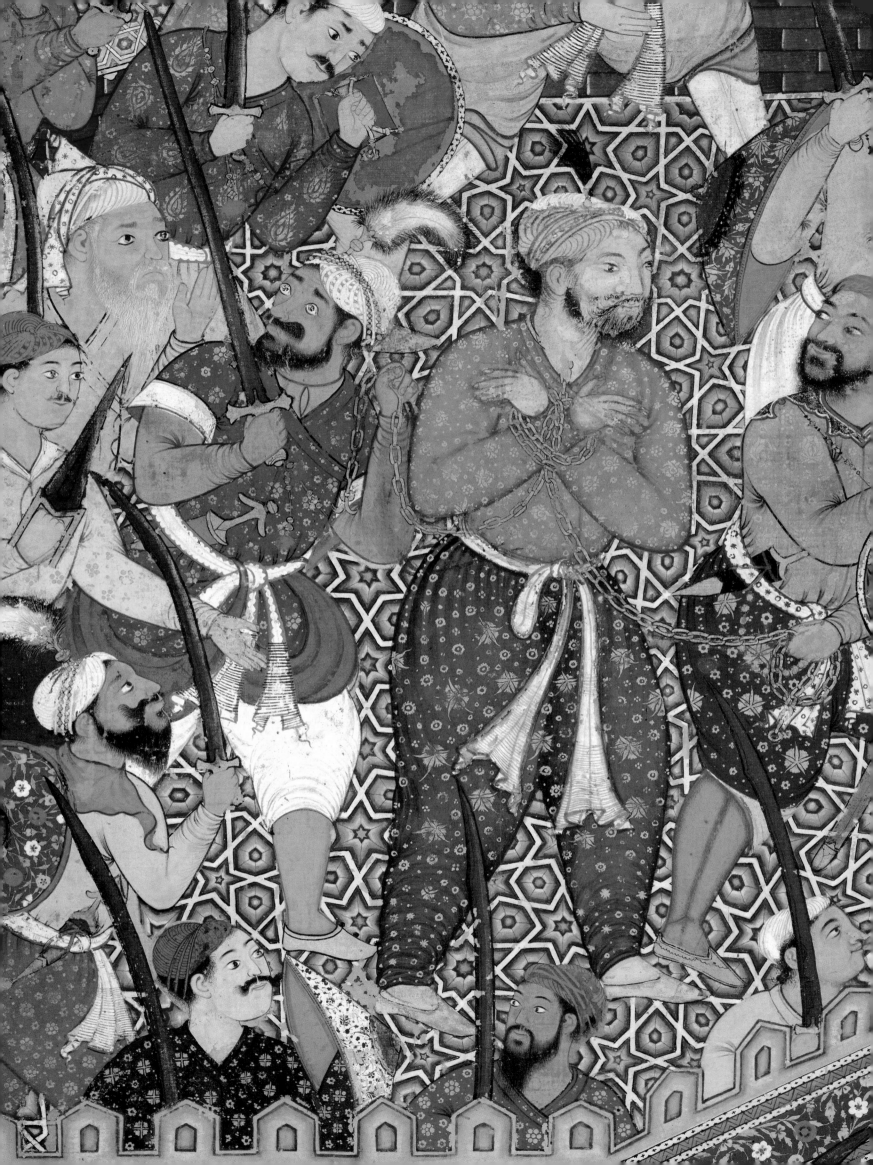

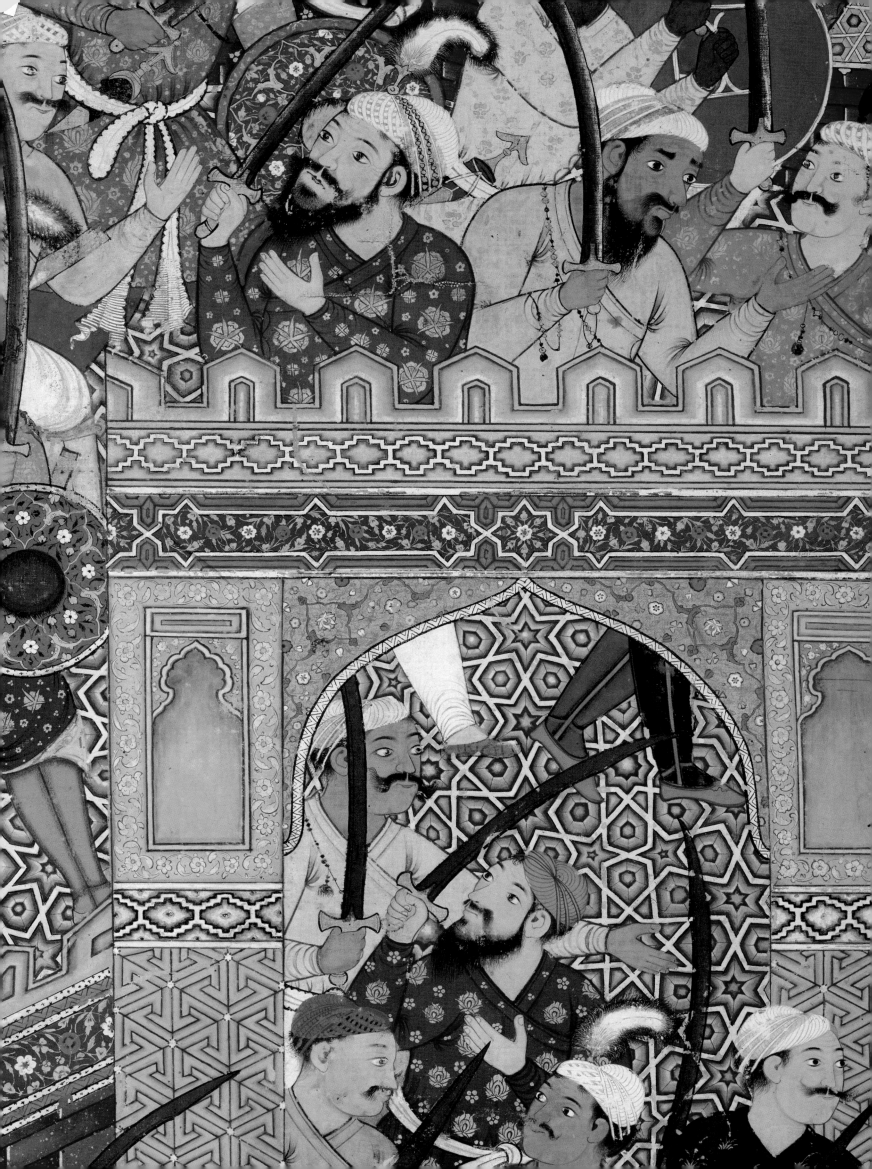

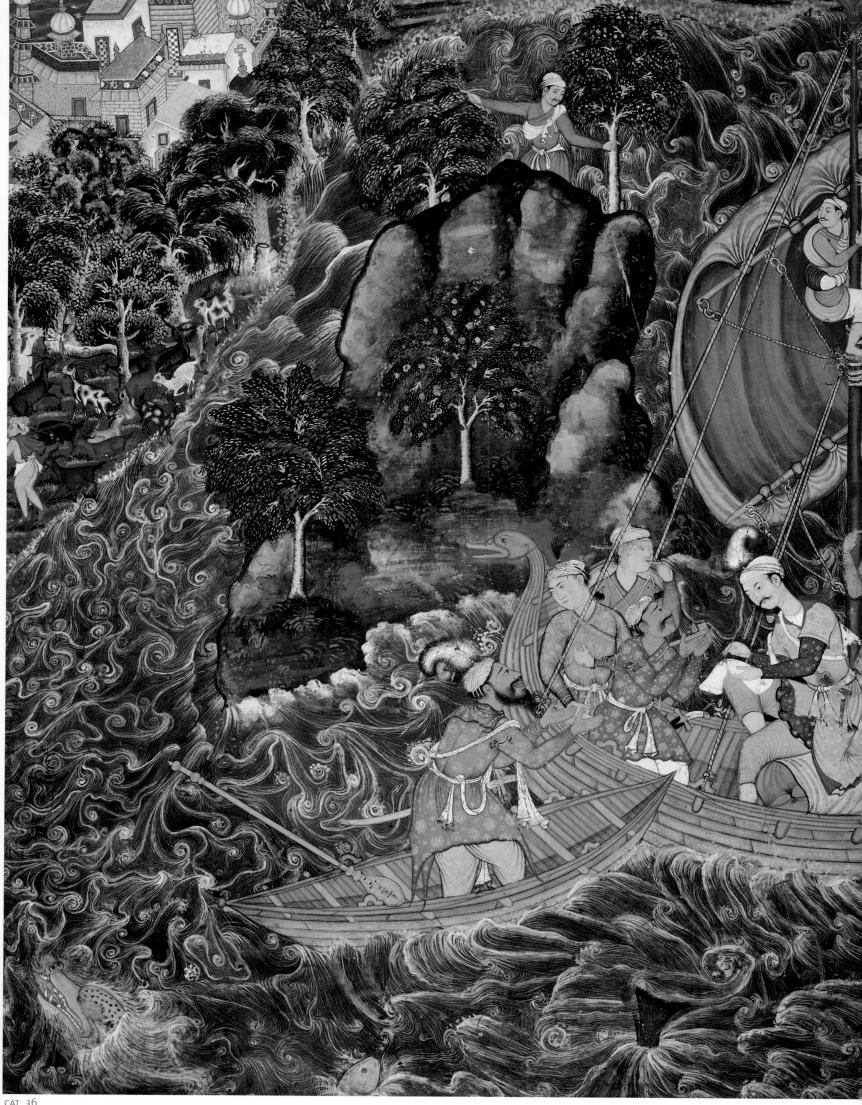

36 HAMZA'S FRIENDS SEND YUNUS THE SAILOR FOR HELP; HE MEETS UMAR, AND DIRECTS HIM TO TAKAW

Attributed to Dasavanta and Shravana

Volume 11, painting
number 10, text number 11
India, Mughal dynasty,
circa 1570
66.8 × 51.8 cm
(detail on pp.116–17)
MAK–Austrian Museum of
Applied Arts/ Contemporary
Art, Vienna, B.I. 8770/54
Published: Egger 1974, pl.19;
Egger 1969, pl.9; Archer 1960,
pl.18; Glück 1925, pl.13.

1. Cleveland Museum of Art,
62.279, ff.32a–b; Simsar 1978,
pls 5–6. The bearded figure
in yellow and the youth in
blue in f.32b of the *Tutinama*
have close counterparts
in the figures of Yunus and
the young crew members
See also fig.24 on p.52, above.

Three divergent narrative threads are woven together in the next installment of the text. The Iranian heroes vow to rescue Hamza from prison, but Khwaja Nu'man advises them to seek reinforcements first.

" 'Someone will have to be sent to the Amir's army,' said he.

'Who's to go?' they asked. Yunus the sailor agreed to go. Getting the boat out of the sand, he got in the boat and set sail in the direction of Sabayil.

As for Umar, Yazak, and Sarraj the sailor, they were lost for two months. One day Sarraj climbed up to the top of the mast and saw a ship with one man in it. When it got nearer, he saw that it was his own brother. The man recognized Yunus and came to Umar. Sarraj told his story, and Yunus recounted the story of the Amir. Umar rejoiced and sent him on his way while he himself proceeded until a huge mountain and fortress came into view. Umar rejoiced."

The artist illustrates the chance encounter of the two complementary rescue missions, an episode described briefly at the very end of the text on the preceding page. But rather than presenting a close-up view of the vessels and their inhabitants, as is done in the two embarkation scenes, he pulls back to depict the two boats on a vast sea. He sets Umar, the protagonist of the illustration, at the very edge of the composition, and aligns him with the two brothers, both of whom are labeled. Another sailor, perched on the makeshift crow's-nest of a mast so tall that he is only half the size of his shipmates, looks toward the huge mountain, the landmark mentioned in the text. Standing atop that mountain is an equally small figure gesturing toward a city in the far distance. Thus, the artist links in a great arc the separate actions of the episode – the two brothers meeting, Umar learning of Hamza's whereabouts and charting a new course, and the lookout's sighting of the mountain and fort.

The bulk of the composition is dedicated to topographical matters. The sea surges all around, often forming loose interlocking whorls but never falling into predictable patterns. The mountain rises up in great muscular lobes, its surface scumbled as if ground down by geological forces, its contours crevassed with broad, wet streaks of black paint. More striking still are the trees at the very center of the image. These are not the densely patterned, precisely painted trees seen in most of Mughal painting. They are expressionistic flurries – daubed with blue, flecked with yellow, shot through with eerily fractured branches. This painterly exuberance spreads across the straits, where a compact fortress is engulfed by a forest of equally splashy trees. This wild setting is the backdrop for a miniature and absolutely unrelated scene of a goatherd minding his goats. In this scene, too, the artist shows a lively touch: some goats amble about, one strains to reach the fresh growth above him, and two others rear to butt heads. The goatherd, crook in hand and a heavily modeled cloak about his shoulders, strides out of the composition.

Such a boldly designed and executed painting comes along but rarely, and is a testament to an extraordinary creative vision. Only Dasavanta consistently designed paintings of such compositional originality, and only he and Basavana ever used paint with the spontaneity seen here. A pair of paintings ascribed and attributed to Dasavanta in the *Tutinama* have both these qualities, as well as a matching set of figure types.[1]

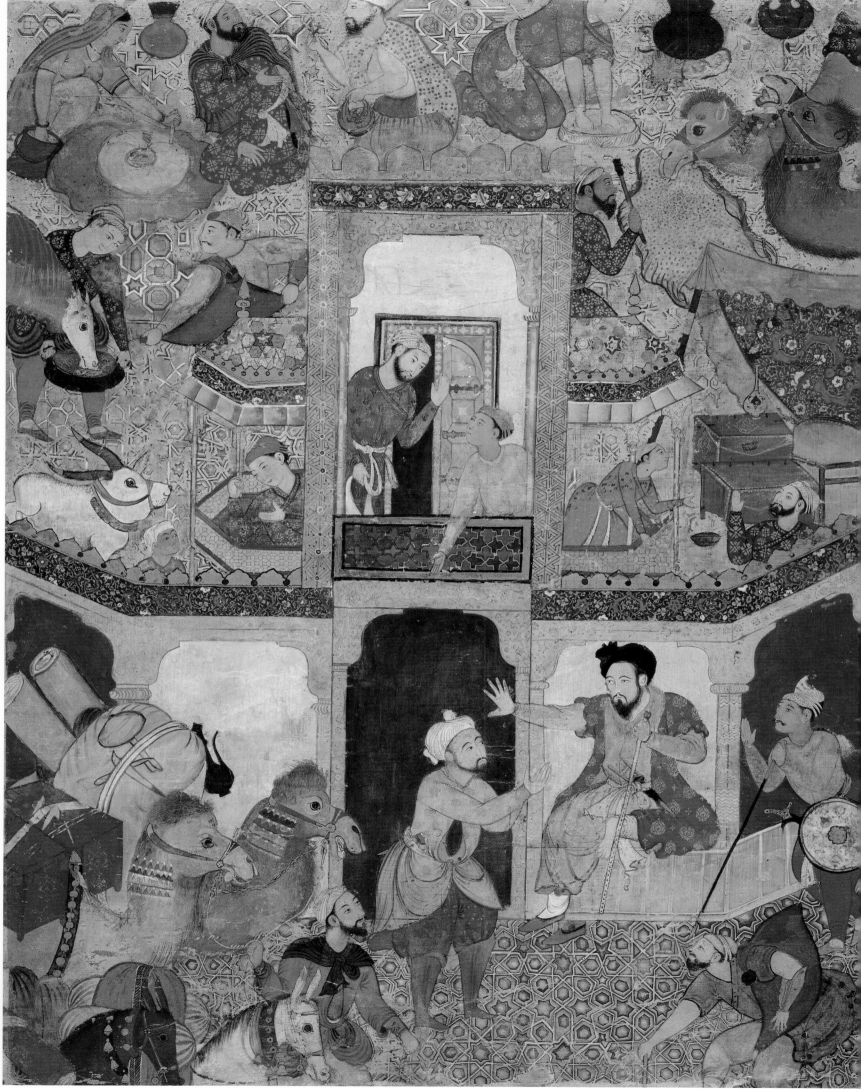

Unattributed

Volume 11, painting
number 11, text number 12
India, Mughal dynasty,
circa 1570
Painting 68.5 × 53 cm,
folio 70 × 54 cm
Freer Gallery of Art,
Smithsonian Institution,
Washington, DC;
Purchase F1981.11

1. MAK–Austrian Museum of
Applied Arts / Contemporary
Art, Vienna, B.I. 8770/60.
See Reconstruction, no.54.

Umar, disguised as a merchant, arrives at Takaw and asks for directions to the caravanserai of Baba Junayd; he
is accompanied there by a customs officer. They find the innkeeper seated on a girthing platform outside his
caravanserai. The officer makes the introductions:

"The customs man came and greeted him, saying, 'This is a good man. Give him a good place.'

'Fellow,' he cried out, 'am I a servant of the customs officer? How am I to find any room here?'

The customs servant said, 'Khwaja, we have spoken and heard. The rest is up to you.' This he said and
departed.

Umar came forward and said hello. Baba replied with a frown. Umar threw a handful of gold before
Baba and said, 'We have come out of love for you.'

'Am I a beautiful youth that you would come to see me?' replied Baba. 'I can do nothing for you. Pick up
your gold and go in peace, for there is no room.' Umar left the caravanserai, seeing that Baba Junayd was
in a bad mood.

Nu'man saw a merchant standing there with many well-laden animals, and Baba Junayd was being
rough with the merchant.

'Baba, what's wrong?' asked Nu'man.

'This man is looking for a place to stay,' he said, 'and I have no room. No matter how many times I tell
him, it doesn't do any good.'

Umar stood up. Nu'man saw him and bowed. [Nu'man] was ashamed and said, 'There is no reason to
be rude to people. Sir, I will give you a room.'"

The artist uses the occasion of an exchange of caustic banter to present two aspects of the caravanserai. On
a low platform outside his establishment sits Baba Junayd, one shoe kicked off and leg drawn up, surveying
with a jaded eye all that drifts by. He extends one hand, fingers splayed, near the face of a bearded man framed
by a blackened door. The identity of this figure whose entreaties are being rebuffed so adamantly is uncertain.
It may be Umar, the ostensible protagonist of the story, because he stands before a string of pack animals, a
detail mentioned specifically in the text. It is, however, more probably Khwaja Nu'man, whose bout with Baba
Junayd is recounted in the penultimate line of text, the most common location for the passage chosen for illus-
tration. Indeed, the portly figure looks more the prosperous merchant than Umar ever could, even in his best
disguise. In all likelihood Umar is actually the solicitous figure to the right, whose mustachioed face, lean body,
and shield are more in keeping with the *ayyar*'s persona.

But these figures tell only part of the story. Camels and horses heavily laden with trunks, carpets, and bun-
dles wait patiently opposite Baba Junayd, providing a sense of the caravanserai as a way station for all and
sundry as well as some relief from its statically composed and starkly detailed façade. From a chamber above
the gate, where not coincidentally Alamshah and his friends reside, two figures look down on the altercation.
At this level, demarcated by a densely decorated architectural band and a brightly colored balustrade, the inter-
nal world of the caravanserai comes into view. People go about their business – feeding animals, preparing
food, bargaining for goods – without pretense or drama, an effect created largely by the even, unhierarchical
distribution of figures and the lack of a potent architectural frame.

This illustration has suffered much surface abrasion, primarily in the tilework of the courtyard and in the
now thinly painted clothing, and the faces of the scene's most prominent figures have been repainted in a
dessicated style. Nonetheless, it is clear that even in its original condition the work was much more bland in
composition and execution than the earlier caravanserai scene (cat.32). Thus it is particularly surprising that
the composition is repeated almost exactly in the very next illustration, in which Shahrashob comes to inter-
rogate Baba Junayd about the Iranian troublemakers rumored to be staying in the caravanserai, and gets a
taste of Baba Junayd's gruff manners.[1]

This painting begins a sequence of eight consecutive illustrations that demonstrates the idiosyncratic nature of most narrative choices. Although the text of the preceding folio has not been located, it is clear that the scene depicted here is recounted in the second and third lines on the reverse of this painting. Ghazanfar, who presides over the fortress of Armanus, catches sight of Hamza and Umar as they reconnoiter the terrain around the bastion. Perched safely in a high tower and emboldened by wine, the insolent Ghazanfar begins to heap invective on the two strangers.

> "Umar cursed him in return, but the Amir said, 'If you are a man, come down and let us grapple to see who will win a match of courage.' This displeased Ghazanfar, and he immediately went down from the tower, and as he approached the Sahib-Qiran he aimed a blow with his sword at the Amir's head. As the sword was coming down the Amir stretched out his champion's hand and tightened his grip on the pommel of his sword, and as he attacked he drew his sword and said, 'Take this!' Ghazanfar raised his shield over his head. The Amir reached under the shield, grabbed his collar, and pulled him down to his knees. With his other hand the Amir reached for the dagger in his belt, lifted Ghazanfar from the ground, lifted him up, and then hurled him to the ground so hard that his vile body lay flat. The Amir then tied his hands and neck. Still Ghazanfar refused to give up and cursed repeatedly."

The wily Umar cuts out Ghazanfar's tongue and forces him to swap armor with Hamza. In this disguise, Hamza proceeds toward the fortress, loudly proclaiming that he, Ghazanfar, is returning with the defeated Hamza in tow. Once Ghazanfar's compatriots open the gates, Hamza reveals his true identity with a great shout, whereupon his army rushes in to vanquish Ghazanfar's allies, convert the city's inhabitants, and erect a mosque. Hamza's archrival, the giant Zumurrud Shah, flees the scene to fight another day.

Mukhlis, the designer of this painting, elects to depict the war of words rather than the ruse and its inevitable aftermath. Approaching from the right is Hamza, the very picture of valor as he sits astride a magnificently caparisoned horse, his spear raised proudly. Umar, ever Hamza's advance man, scurries before him, brandishing a battle-axe in one hand and a sling in the other. These postures leave no doubt about the figures' relative status. But Madhava, a portrait specialist asked to do these two figures, further reinforces Hamza's pre-eminence by isolating his head and torso against the churning waters around the fortress; conversely, he works with Mukhlis to relegate Umar to a subordinate role by placing him just within the confines of the strip of land before the moat. Both protagonists fix a cold stare on Ghazanfar, whose taunting demeanor is conveyed by his pointing finger and menacing mace. All three figures have clenched mouths, hardly the expression expected in a situation in which catcalls are being flung back and forth. But the Mughal penchant for visual description never really extended into the realm of nuanced facial expressions; instead, even the finest Mughal painters of this time were content to use the more easily visible and understandable language of gesture to establish the emotional complexion of their subjects. In this case they could certainly rely on the narrator to stand in for the protagonists and regale the audience with a series of well-chosen insults.

The real excitement of this painting comes not from the three central figures, but from the fortress itself, which crackles with tension. The sense of instability begins at its base, which is staggered at an impossibly acute angle and seems to hover above the frothy moat and foliage. It continues with the stronghold's ramparts, which, divided into abruptly dislocated sections and festooned with gaudily contrasting machicolations, are more like parts of a sliding puzzle than those of a defensive structure. And it culminates in the dizzying patchwork of brilliantly tiled pavilions and courtyards beyond the walls. The pavilion that frames Ghazanfar, for example, not only has a four-sided canopy rising incongruously from a six-sided base, it is also thrust forward so bizarrely by the kaleidoscopic patterns around it that Ghazanfar appears to levitate over the walls of his fortress. Mughal realism manifests itself sporadically; the drawbridge, for example, is rendered down to every detail of its hinges, clamps, and hooks. For the most part, however, the fortress is the stuff of architectural fantasy. Resting atop the insubstantial, mazelike tiles of the central tower block is a large pavilion, its heavy eaves supported precariously by just three slender brackets. Mukhlis further confounds the viewer's understanding of pictorial space by aligning the eaves with niche-filled uprights of exactly the same color, thereby constructing a strong, visually closed form that has no conceivable counterpart in reality. Finally, the painter ensures that there is no relief from the chock-a-block design by filling in virtually all the remaining space with pairs of flags and crowds of onlookers. The result is a composition abuzz with giddy agitation, a fitting backdrop for the impending confrontation between Ghazanfar and Hamza.

Attributed to Mukhlis
and Madhava Khurd

Volume 11, painting
number 19, text number 20
India, Mughal dynasty,
circa 1570
Painting 71.5 × 55.3 cm,
folio 88.8 × 73 cm
The Seattle Art Museum,
Gift of Dr. and Mrs. Richard
E. Fuller, 68.160
Published: Beach 1992, pl.c;
Heeramaneck 1984, pl.140;
Seattle 1973, no.36; Comstock
1925, p.356; Philadelphia 1924,
no.81.

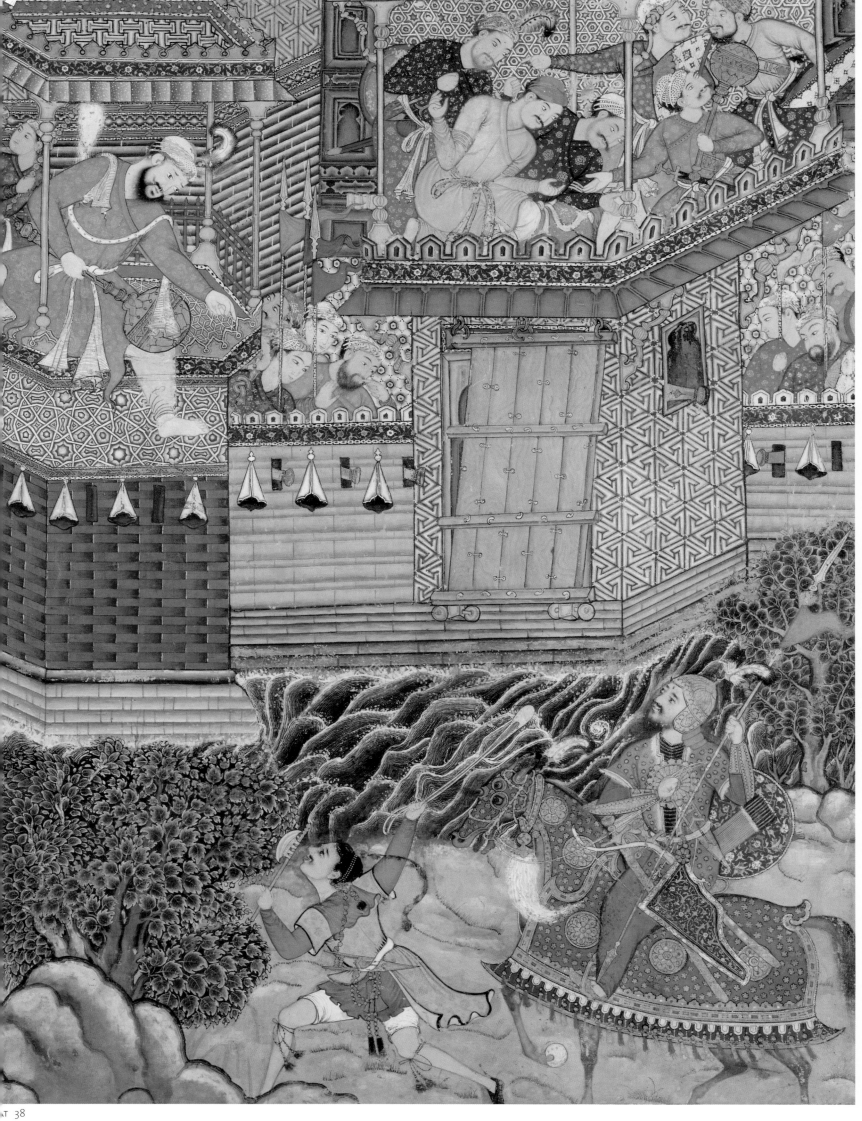

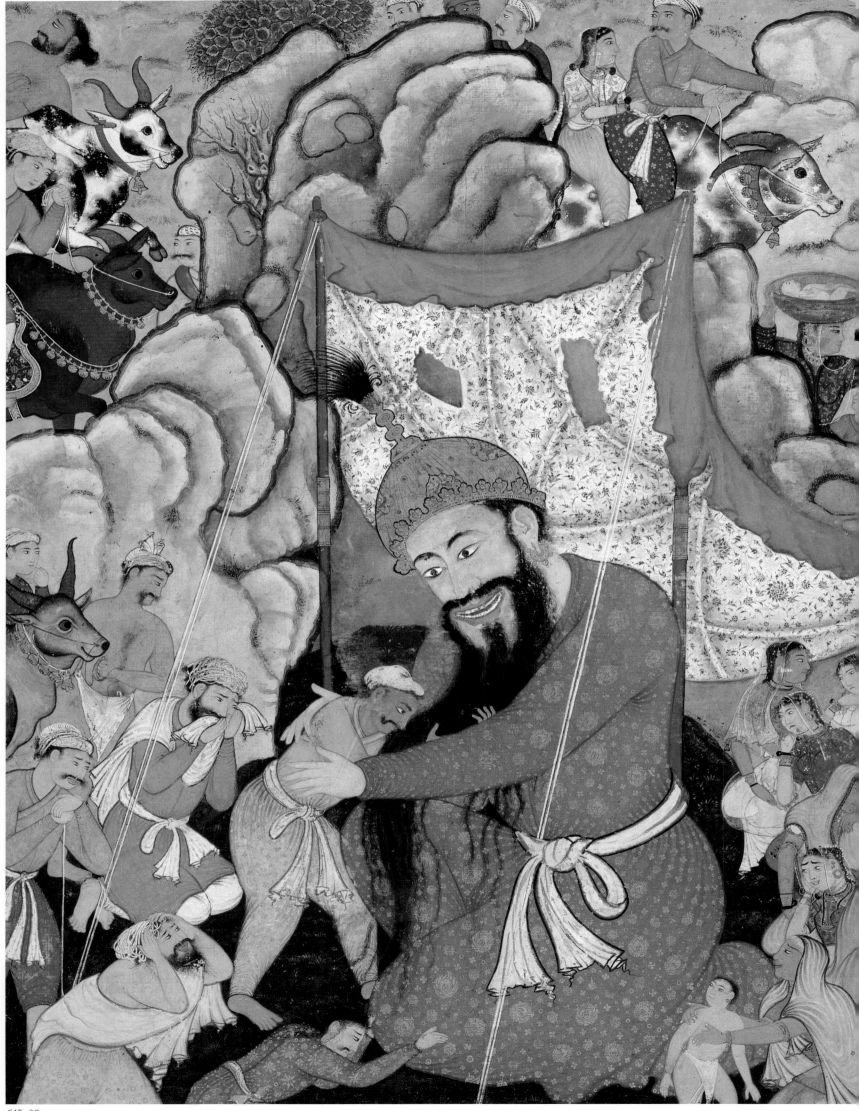

39 ZUMURRUD SHAH REACHES THE FOOT OF A HUGE MOUNTAIN AND IS JOINED BY RA'IM BLOOD-DRINKER AND YAQUT SHINING-RUBY

Attributed to Mahesa

Volume 11, painting
number 21, text number 22
India, Mughal dynasty,
circa 1570
Painting 67.9 × 51.1 cm,
folio 78.7 × 63.5 cm
Caption: 'Zumurrud Shah
arrives at the foot of the
mountain where he is found
by Ra'im Blood-Drinker and
Yaqut Shining-Ruby'
Brooklyn Museum of Art,
Museum Collection Fund,
24.48
Published: Poster *et al.* 1994,
no.23; Chandra 1989, fig.1.

The fast-paced and highly involved narrative described in the preceding text affords a raft of colorful and attractive illustrative choices: a young hero entombed alive, a romantic ploy that leads to the seizure of a fort, a series of individual battles, and the confiscation of Zumurrud Shah's treasury. This artist, Mahesa, bypasses all these to present instead the lamentable fate of Zumurrud Shah in the wake of this frenzied activity. Taking his cue from one short phrase in an episode described in the second and third lines of text on the reverse of this folio, he shows the giant resting in the shadow of a towering mountain, where he consoles a few key members of his distressed entourage and begins to plot his next course of action.

"When Zumurrud Shah the Lost came out alone from the battlefield and traveled until it was night, he was on the road that night. The next day too he was on the road. In brief, he traveled for eight days, and on the ninth day he came to the foot of a mountain that was so high it was level with the celestial sphere. He dismounted and spent that day beside a spring hunting meat. The next day Blood-Drinker and Shining Ruby arrived and joined Zumurrud Shah. On the third day the amirs all gathered, and nearly a hundred thousand men joined him ..."

Although Zumurrud Shah and the mountain are featured very prominently, the actions of his band of followers are relatively ambiguous, so much so that even though the painting's position in the manuscript was known, its subject was never identified properly. Recently, however, extensive conservation work has uncovered most of the original caption describing the scene, so that there can no longer be any doubt about the subject.

The giant dominates the painting by virtue of his central position, hulking orange mass, and toothy grimace. The guys of the canopy behind him frame four minions, each expressing his discomfiture in a different way: one prostrates himself, another tears at his turban, a third sinks to his knees and muffles his sobs in a shawl, and a fourth buries his head in the long tresses of Zumurrud Shah's beard. These male responses are complemented by the less ostentatious reactions of a gaggle of women huddled beneath the large canopy, its once pristine white surface and delicate pattern soiled and patched as a sign of the ignominy of defeat. Mahesa exploits the large canopy as an organizing compositional device, one simultaneously amplifying Zumurrud Shah's massive face and crown and concealing the base of the mountain, thereby accentuating the latter's billowing height. He subtly alters the mood of the scene with auxiliary features. Disregarding the surrounding passages of the text, which note the solitude of Zumurrud Shah's first day beside the mountain and describe a resurgent martial spirit thereafter, the artist nudges a stationary scene of solace into one of weary, ongoing retreat by filling the upper corners with villagers driving their livestock and a woman fleeing with her babe borne aloft in a basket.

Like many *Hamzanama* illustrations, this one was partially repainted at some point. Zumurrud Shah has undergone the most significant repair. His forehead has been slathered with a new layer of paint, as have his heavy jet-black beard, hands, and the thick sash about his waist. The figure paying homage to him has also received a new face. Most of this is not obvious from any distance over arm's length, but it becomes clear under both magnification and ultra-violet light. Only three of the ancillary figures were retouched at all, but happily this was done with a careful hand, so that their faces are entirely consistent with original ones.

THE SIEGE OF NOSHAD
CAT 40–44

Zumurrud Shah retreats to Noshad Fort, where he receives the homage of Anquil Demon-Nurturer and his countless legions. Zumurrud Shah still fears Hamza and is mollified only when Anquil offers to reinforce the defenses of the already treacherous rocky mountain pass leading to the city. His men dig a complicated series of channels that flood the narrow road and encircle the fort and two outposts with an untraversable moat.

Having located their enemy, Hamza's forces set up camp on the other side of the water but the defenders refuse to engage them. The next day, however, the enemy champion Marku' Boar-Tooth rides out to fight all challengers, killing or wounding each one. On the third day of fighting, suddenly and unexpectedly, he is defeated by a mysterious young knight whose identity is concealed by a veil. The champion chases down Marku''s frightened supporters and they jump into the sea. Only later does Hamza learn that the champion is a prince named Kayhan b. Rustam, who is kidnapped by Marku''s immediate allies by way of revenge.

Despite Kayhan's victory, the waters around Noshad continue to thwart Hamza's forces. A massive naval expedition is mounted, but is repulsed by a barrage of stones. Finally, other princes decide to take matters into their own hands. Hamza's son, Prince Badi'uzzaman, hides himself in a trunk and has it thrown into the sea; Malik Qasim immediately leaps into the sea and starts to swim after the trunk. By clinging to a tree, the latter saves himself and finds the source of the river in a garden, where he is discovered by a beautiful girl who immediately falls in love with him. Although she is the daughter of one of the fort's defenders, he tells her his mission and she becomes a Muslim.

The next day Qasim makes his way into the heart of the enemy lines. He responds to an insolent soldier by manhandling him before Surkhab, the commander of the garrison. Surkhab is duly impressed by this show of strength, but when he is told of Qasim's identity and how he came to Noshad, he is so overwhelmed by his resolve that he converts to Islam along with thousands of his men. Meanwhile, Badi'uzzaman has been washed ashore ready to do battle. He kills several opponents and converts hundreds of others. The exploits of these two princes bring about the surrender of the garrison to Hamza's forces, who are welcomed with much fanfare.

Detail of CAT 44

The text near the end of the preceding folio (cat.39) recounts the initial survey of the seemingly impregnable defenses at Noshad by Hamza's lieutenant Umar Ma'dikarb:

"... on the way was a river that was difficult to cross other than by a bridge, and on both sides of the river a tunnel had been dug. Water tumbled down from the top of the mountain, and it was so rocky that no one could traverse it. In olden times there had been no road through the rocks, but a road had been cut so that it was possible to go easily along the edge of the water. Facing this road a fortress had been built, and when the fortress was manned it was difficult to cross the water. Behind the fortress another gate had been constructed and another tunnel cut such that water from the moat of the fortress spilled into the tunnel and then entered a garden where buildings had been constructed. When the water left there it went to the skirt of a second fortress and then to the lands of Noshad. Anquil said, 'Be easy of mind. The road by which you have come cannot be traversed by all the armies of the world if we so choose.'"

The narrative ends abruptly with a night skirmish, and some messages being exchanged. Surprisingly, though the image represents the remarkable terrain described in considerable detail in the text on cat.39, the episode actually depicted corresponds to a few lines on the reverse of this painting. This moment is, as the caption informs us, when the *ayyar* Umar joins the stalwart Ma'di and Hamza himself in beholding the awesome site. Hamza masses his forces at the water's edge and sounds the battle drums in an effort to draw out the enemy, but to no avail. The drawbridge of the outpost remains raised, and the defenders refuse to engage Hamza and his men.

This painting is unique in the *Hamzanama* because it preserves a clue as to how Mughal artists really knew what to paint. The text of the *Hamzanama* is written in straightforward Persian and most Mughal artists were probably capable of reading the relevant passages, but they were never compelled to do so. Instead, they relied on oral instructions or cursory prescriptive notes written specifically for them by various supervisors or clerks involved in the project. Such notes are found on a number of sixteenth-century Mughal manuscripts, but this example is the very earliest known note in all of Mughal painting.[1] It reads: 'The Amir and Umar come before Umar Ma'dikarb at the edge of the sea. There should be a mountain on two sides. The water should cover the entire path. On the top of the mountain is another path blocked with stones.' The unpainted cloth beneath the inscription and the very language of the note – 'there should be'– make it clear that it was written before the execution of the painting, and was simply overlooked by the artists and marginator when they completed the painting.

Banavari, the designer of the painting, heeds his supervisor's recommendations. He places the three protagonists and an unidentified princely figure – perhaps Qasim – prominently in the foreground, and dutifully depicts a river encircling a promontory fortified with a pair of portals. A second artist, Mah Muhammad, has the larger of these portals stand oddly apart from any structure whatsoever, apparently construing it merely as the mechanism supporting the drawbridge. The moat is rather too narrow to cause much consternation, particularly for a figure as expansive as Ma'di, and Mah Muhammad's boyish defenders thronging the opposite shores seem more apprehensive than their thwarted attackers.

But these slightly illogical details would certainly have been forgiven by contemporary viewers, who had little expectation of a painting with a coherent sense of space. Yet this is precisely what the team of artists was trying to achieve by diminishing the scale of the figures as they receded into the distance. Such a concern with pictorial space was both novel and ambitious, but remained essentially peripheral to the narrative thrust of the painting. The real appeal of the illustration lay in the slyly comical presentation of the very different physical types in Hamza's small band of companions and the drumbeat of anticipation among the ranks of Anquil's soldiers. The surging forms and scumbled surfaces of the rocks in the foreground heighten the excitement of the scene and link the two halves of the composition.

A third artist, Madhava Khurd, painted Umar and Umar Ma'dikarb, and redid the face, hand, and cape of the prince. Madhava Khurd typically gives his figures larger and darker features and more naturalistically rendered hands; in contrast to Banavari, he rounds off his forms by applying rich, black lines to their contours, an effect seen most clearly here in the rotund shoulders and belly of Umar Ma'dikarb and in the hem of Umar's cloak.[2]

Attributed to Banavari,
Mah Muhammad, and
Madhava Khurd

Volume 11, painting number 22
India, Mughal dynasty,
circa 1570
67.8 × 51.9 cm
Caption: 'The Amir, Umar,
and Umar Ma'dikarb arrive at
the foot of the Noshad Pass'
MAK–Austrian Museum of
Applied Arts/ Contemporary
Art, Vienna, B.I. 8770/39
Published: Egger 1974, pl.24;
Egger 1969, pl.12; Staude
1955b, fig.31; Glück 1925, pl.18.

1. For a discussion of these notes, see Seyller 1987.
2. See, for example, his painting on f.27b of the *Darabnama*, which provides a particularly close comparison to the figure of Umar.

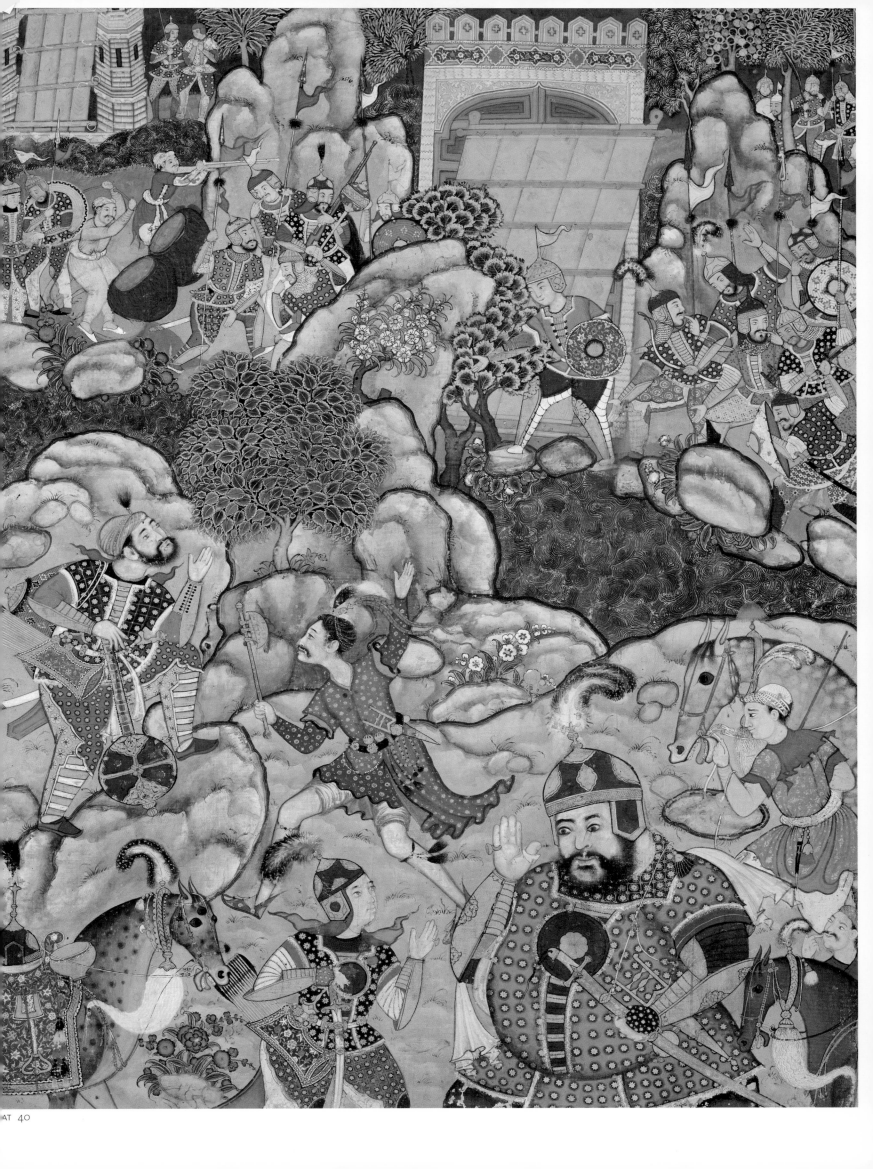

The enemy cannot resist the lure of Hamza's army forever. When day breaks, a fearsome champion named Marku᷾ Boar-Tooth orders the outpost's drawbridge lowered and rides forth onto the plain, brazenly calling for a challenger. One champion after another responds to the call, but each is thoroughly trounced in turn. With each triumph, Marku᷾ grows more impudent, cruelly taunting one wounded opponent as he retreats, 'God-worshipper, where are you going? Stay where you are. I'm coming!' In a righteous world, such blasphemy does not go unpunished for long:

"... then, without warning, by God's command and infinite grace, a young veiled hero stepped forth. Entering the field, he stood in that infidel's path. The treacherous guebre aimed a sword blow at the veiled youth's head, but the prince raised his shield, and as the sword came down, he grabbed the guebre's wrist. Try as he might, the guebre was unable to wrest his hand and sword from the youth's grasp. With one swift motion he pulled the sword from his hand and said, 'Take that!' The guebre raised his shield over his head, but the warrior struck him so hard across his middle that, despite all his armor, he was cut in two. All the guebre's men hurled themselves into the water and ran away."

The dramatic culmination of this sequence of events is narrated in a few lines of text near the very bottom on the preceding folio. Yet the writing does not end after the usual nineteen lines, but continues in two partial lines of text that are squeezed awkwardly into the narrow space below the last regular line. Surprisingly, these additional sentences describe a new phase of activity, beginning with the resentment that Marku᷾'s immediate allies harbor for Kayhan b. Rustam, who has been revealed as the veiled hero, and ending in the kidnapping of the youth by a spy in their employ.

"When Marku᷾ was killed, Surkhab and Zarnab became angry and wrote a letter to Anquil. At this point Nawroz Ayyar came from Anquil and said, 'Let me across the wall. Perhaps I can achieve something.'

Thus they did. By night he went to Kayhan's tent, rendered him unconscious, and stole him away."

That the text was extended in such an ungainly manner demonstrates the indifference accorded the physical layout of the text in this manuscript; that this narrative extension was unrelated to the subject of the ensuing illustration underscores the fluid nature of the relationship between text and illustration on consecutive folios.

Mukhlis presents a relatively comprehensive summary of the narrative. The young champion is positioned prominently, his veiled face practically at the center of the composition. Located to the left and slightly below him is Marku᷾, blood spewing from his innards and streaming over his dangling head. The artist casts this gory spectacle as the simple triumph of good over evil; whether by design or by accident, he omits Marku᷾'s fateful incapacitation, showing his sword plainly unencumbered and Kayhun without a shield. Likewise, he compresses the sequence of events so that three soldiers flounder in the sea while the veiled knight is still busy splitting Marku᷾ asunder. Other warriors mill about, their helmetless heads and gaping mouths leaving no doubt that the fight has gone out of them. The result is an image of a solitary champion wreaking havoc among a more numerous enemy.

The composition repeats the key features of the distinctive terrain of the Noshad Pass. One foe clambers across the drawbridge, which his compatriots hasten to raise; this detail simultaneously evokes Marku᷾'s sortie and funnels the chaotic action in the foreground back toward the outpost. The promontory is rendered in essentially the same manner, and is once more shown encircled by water and bracketed by a pair of outposts. In this case, however, the larger outpost abuts the edge of the painting, and the scale of the figures in the distance is reduced more gradually. The work is generally livelier than the preceding illustration. This effect is due in large part to the meandering flow of figures, but the particularly brilliant patterns of the caparisons and painterly treatment of the rocks also impart a vitality to the surface.

Mukhlis, who may have designed the painting, supplied all the figures up to the drawbridge. Although the coarse features of the fleeing soldiers function as attributes of their mean nature, Mukhlis habitually endows all his figures with wide-open eyes and expressive facial markings, and gives volume to their clothing with heavily conventionalized folds; all these elements also appear in cat.58. The prominent use of yellow and the garish bands of the caparisons are later repeated in another work (cat.62). A second artist, Lalu, who is known from five ascribed paintings and two attributed works in the *Tutinama*, seems to have provided the figures above the drawbridge and beyond.[1]

Attributed to Mukhlis and Lalu

Volume 11, painting number 23
India, Mughal dynasty,
circa 1570
67.5 × 51.8 cm
Caption: 'A veiled youth arrives and slays Marku᷾ Boar-Tooth'
MAK–Austrian Museum of Applied Arts / Contemporary Art, Vienna, B.I. 8770/37
Published: Egger 1974, pl.25; Egger 1969, pl.13; Glück 1925, pl.19.

1. Folios 71b, 75b, 81b, 83b, and 84b are ascribed to Lalu; folios 78a and 84a are attributed to him by Chandra. The figures of folio 78a (see fig.23) compare particularly closely to those above the drawbridge here.

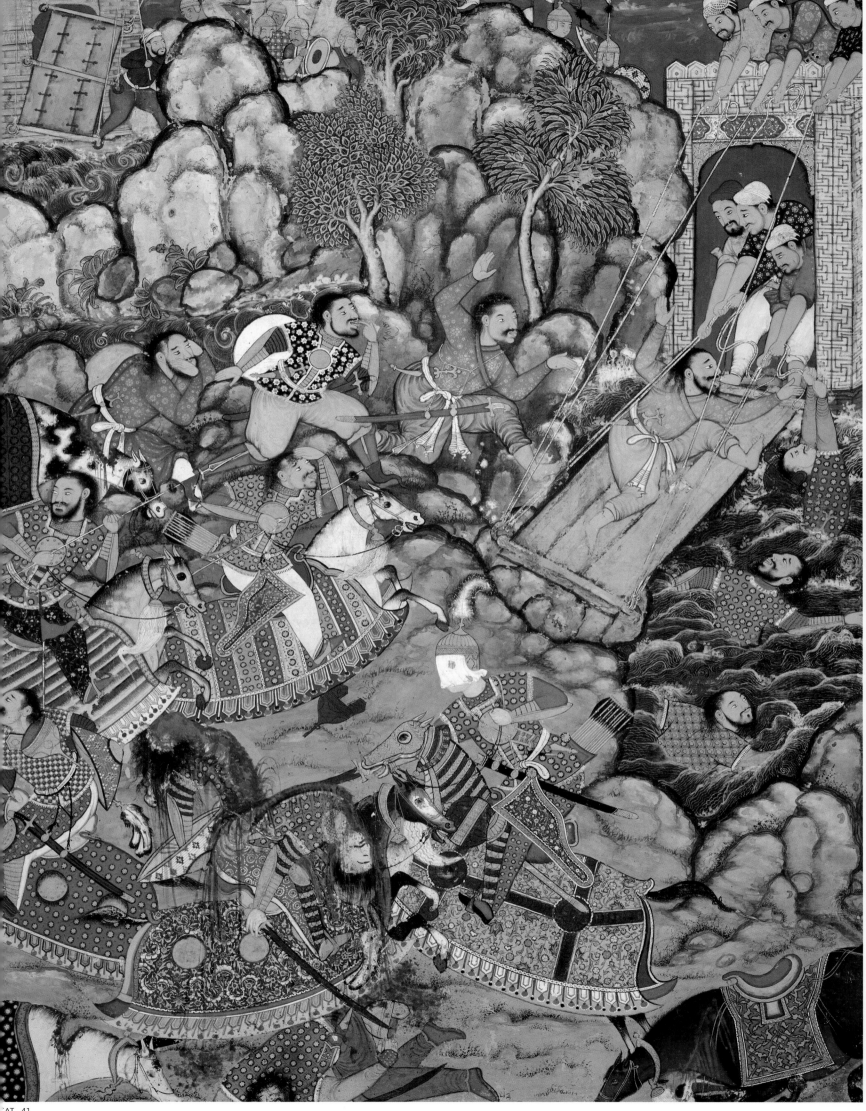

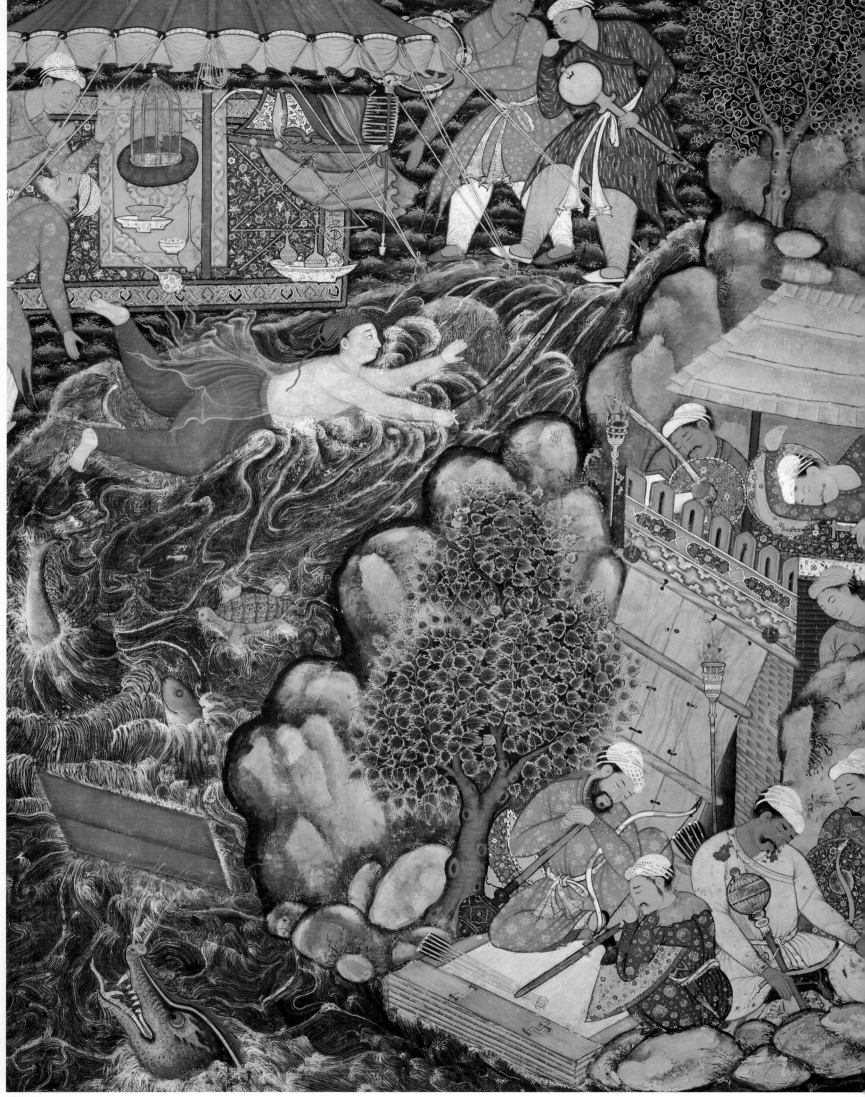

CAT 42

42 BADIʿUZZAMAN ENCASES HIMSELF IN A WATERTIGHT TRUNK AND HAS IT THROWN INTO THE SEA AROUND NOSHAD FORT; MALIK QASIM SWIMS AFTER IT AND REACHES ENEMY TERRITORY

Attributed to Dasavanta and Shravana

Volume 11, painting number 24
India, Mughal dynasty,
circa 1570
67.5 × 51.5 cm
(details on pp.140–41)
MAK–Austrian Museum of
Applied Arts/ Contemporary
Art, Vienna, B.I. 8770/50
Published: Egger 1974, pl.26;
Egger 1969, pl.14; Betz 1965,
pl.9; Glück 1925, pl.20.

1. Folio 67a, published in
Seyller 1992, fig.10.

Hamza's son, Prince Badiʿuzzaman, embarks on a clandestine mission, kept secret even from Hamza, to breach the waters surrounding Noshad Pass and ultimately direct the capture of the fort. He has himself encased in a watertight trunk and orders it thrown into the sea. Malik Qasim learns of this courageous action, and immediately matches it with one of his own. Forgoing even the rudimentary vessel launched by Badiʿuzzaman, he leaps into the sea and starts to swim after the trunk. The currents are so formidable that Qasim soon begins to flail and gasp for air. He catches hold of a tree bobbing on the waters; resourcefully using it as a makeshift kickboard, he propels himself toward the safety of a cove. He proceeds down a long submarine passageway. When he emerges, Qasim finds himself in an exquisite garden resounding with the laughter of beautiful maidens. He confides his plan to one especially comely maiden, and she converts to his cause and religion.

The artist selects an episode in the middle of this tale of peril and persuasion. As the wooden chest containing Badiʿuzzaman is swept uncontrollably downstream, Qasim thrashes about in the white water, seemingly buoyed by its foam. Danger abounds. A crocodilian monster menacingly approaches Badiʿ's trunk with teeth bared and plumes of water issuing from its snout. Qasim, whose trousers are the same bright red as the trunk, labors mightily against the current, an action the painter wittily mimicks with a sea tortoise paddling in the opposite direction. One peculiar detail is that Qasim swims with sword in hand, apparently a last-minute invention by the artist. Faintly visible on either side of the blade is a narrow, double-pronged brown form. To judge from its length – it extends just beyond the shore – and color, this pentimento is not a vestige of an earlier sword, as one would normally expect, but the tree to which Qasim is supposed to cling as he grows fatigued. The painter evidently decided to eschew this textually accurate detail in favor of a sword, an impractical attribute to be sure, but one more in keeping with Qasim's essential bravery.

The composition is an innovative one. By allocating more space to the waters around Noshad Pass and freeing them from their previously horizontal channels, the painter lends credibility to their daunting expanse and turbulence. Yet he intuitively understands that this story, like all *Hamzanama* tales, is still driven by figures, and he takes measures to ensure that they remain large enough to be easily readable. The primary beneficiary of this decision is Qasim, who seems practically within reach of the opposite shore as soon as he leaves his well-appointed tent. Likewise, the dozing guards at the familiar outpost of Noshad Pass become vulnerable precisely because they are so close and large. The artist often flaunts his visual acuity, describing such poignant features as their drowsy expressions and relaxed positions as well as such superfluous details as the damascened sword of the uppermost guard and the wood grain and string latch of the drawbridge.

The nocturnal scene of Qasim's camp is incidental to the action, but the nervous astonishment of his attendants at his dramatic escapade provides a telling contrast to the state of unwatchfulness below. Here again the artist supplies some attractive flourishes, ranging from the elaborate rigging of the stand holding Qasim's quiver and sheath to the flamboyantly streaky pattern on the mace-bearer's brown *jama*. The thick, wet, black contours of the rocks lining the sea are most unusual, and help provide a measure of distance between the two major features of the forbidding terrain.

Together with the very original composition, these stylistically divergent features point to a collaborative effort by two artists who are recognizable from their work in other *Hamzanama* paintings. The overall design and the details of the painterly rocks and Qasim's heavily modeled red pants are probably the work of Dasavanta. The remainder of the painting is by Shravana, an attribution supported most centrally by the strong resemblance of Qasim's face to a figure in a *Tutinama* illustration ascribed to him.[1] Likewise, the facial and figure style of the guards, and particularly the pronounced red highlighting on the yellow *jama* worn by one guard and on the lower garment of the mace-bearer in Qasim's camp, recur in another *Hamzanama* painting attributed to Shravana (cat.47).

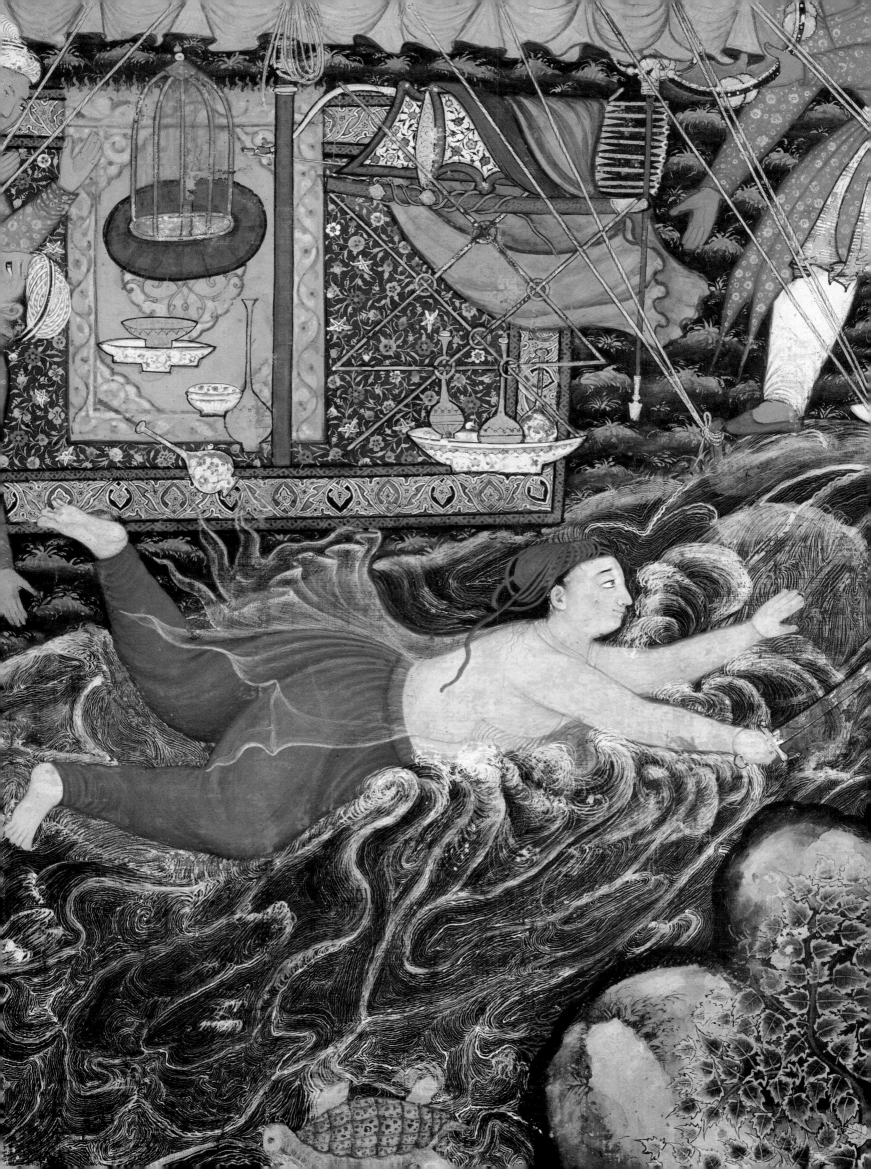

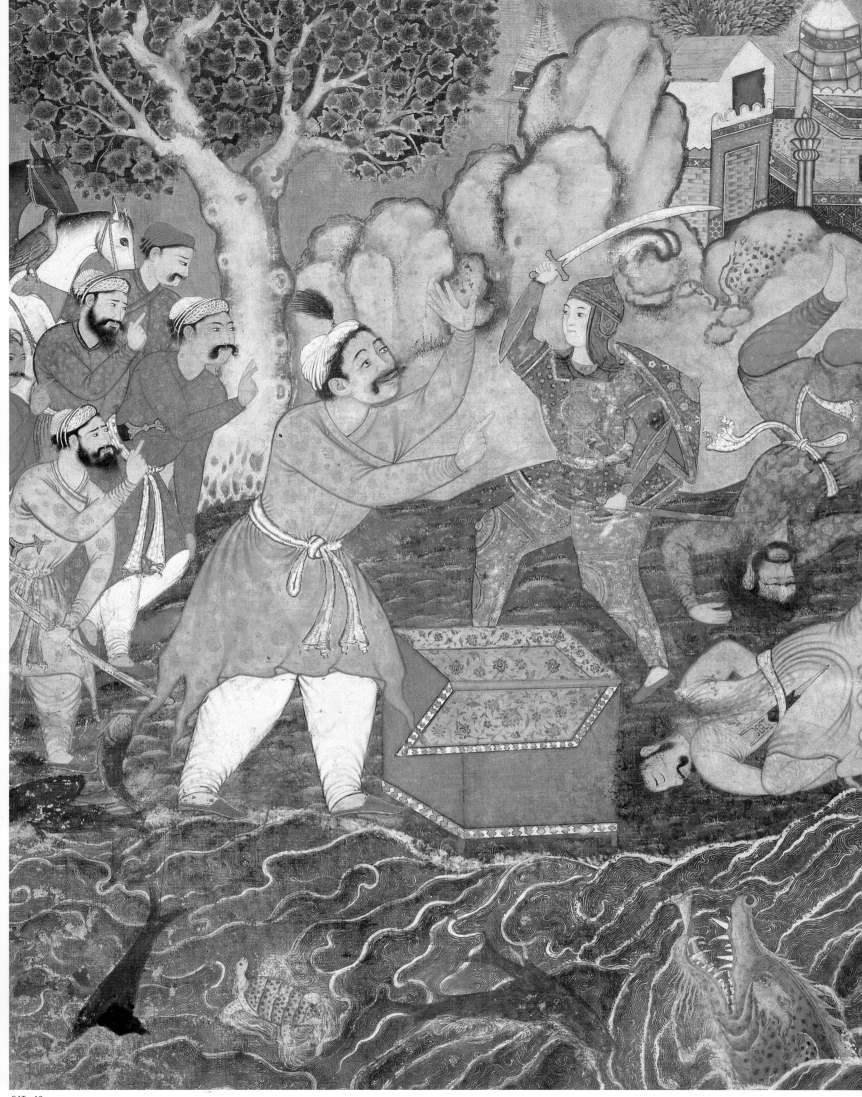

43 BADI'UZZAMAN EMERGES FROM THE TRUNK, SLAYS SOME OPPONENTS, AND CONVERTS ZARNAB

**Attributed to Mahesa
and Shravana**

Volume 11, painting
number 25, text number 26
India, Mughal dynasty,
circa 1570
Painting 67.2 × 51.1 cm,
folio 79.5 × 64 cm
Caption: 'Badi' emerges
from a trunk, kills many
[people], and makes a Muslim
of Zarnab'
Cincinnati Art Museum,
Gift of John W. Warrington,
1948.192
Published: *The Dictionary
of Art*, vol.15, fig.259;
Smart & Walker 1985, no.1;
Comstock 1925, p.350;
Culin 1924, frontispiece.

1. Smart & Walker 1985,
pp.14–15.

Meanwhile, Badi'uzzaman makes landfall in his own way. When the trunk containing him washes ashore, curious bystanders pry open its lid. Badi'uzzaman springs from his confinement and brandishes his sword, ready to kill or convert all in his path. He does not have to wait for long. A startled onlooker, one Khizrim, demands to know his name. Badi'uzzaman proclaims that he is Hamza's son.

"When he heard the name Badi'uzzaman, Malik Samaruq was startled and said, 'O Iranian, what are you saying?' And so saying, he aimed a sword blow at Badi'uzzaman's head, but Badi'uzzaman rushed forward, stretched forth his warrior's hand, and grabbed his wrist and the pommel of his sword. With one heroic movement he took the sword from his hand and said, 'Take that!' He raised his shield, but Badi' struck him in the head, and the sword went through his skull as though it were a ripe gourd and split him in two down to his belt. A groan came from that guebre as he fell. Just then his brother Kiaruq came and wielded his sword. The prince responded and dispatched him to hell too. There were three hundred men with him, and they all converted to Islam."

Now Zarnab hears the news of Badi'uzzaman's arrival and advances toward him. Badi'uzzaman's first local convert, Khizrim, urges Zarnab to join him in embracing Islam. Zarnab will have none of this, at least until he suffers defeat at the hand of Badi'uzzaman.

At this point, about halfway through the text on the previous page, the story switches pace and protagonist. The outpost falls unceremoniously to Badi'uzzaman's forces. Hamza learns of its capture, but is also apprised that Kayhun and Qasim are nowhere to be found. But even then Qasim is making his way toward the heart of the enemy's ranks and the triumphant conversion of Surkhab, the commander of the garrison.

From this spectrum of events the artist singles out Badi'uzzaman's defeat of Zarnab, his major adversary. Though more slightly built than his opponent, the young prince advances from the right – always the direction of power – and enjoys the advantage of higher ground. The painter extends this visual advantage by the calculated use of two compositional devices. The first is the placement of the red trunk that had borne Badi' across the sea and now lies before him. The trunk, a veritable perspectival conundrum, serves as Badi'uzzaman's defining attribute, of course, but it also boosts him up in the composition by occupying the space between him and the water's edge. The second device is the rocky outcrop behind the two figures. Mughal artists habitually use such features to screen distracting views into the distance. This painter follows suit, focusing attention on the figures by filling the background with a large undulating ridge, a schematic palace, and a spreading tree. But these elements are manipulated still further. It is surely by design that the outcrop fans outward to its greatest height and breadth directly behind Badi'uzzaman, physically aggrandizing him as it does. And while the rendering of rocks is often idiosyncratic, the pastel-colored, thinly outlined, and flat outcrops seen here were almost certainly given this form to provide an unobtrusive backdrop for the confrontation of Badi' and Zarnab.

The other elements in the painting play decidedly secondary roles. The two upended and bloodied figures are the two brothers Badi' slew before Zarnab appeared on the scene. They are also an unambiguous sign of the fate that awaits those who dare resist, and pave the way for the bloodless capitulation of Zarnab and his numerous compatriots. Although Badi'uzzaman's sword is raised against a weaponless Zarnab, the combat is undoubtedly over; the gesture merely indicates the immediate impetus for Zarnab to convert, a decision whose sincerity is signaled by his undisturbed plumed turban. Witnessing all this are a host of sea creatures, some glowering from a safe distance and others oddly floundering underfoot. The water itself is overlaid with a striking and apparently unique design of whitened serpentine crests.

The painting was formerly associated with Mahesa; this seems correct, for Mahesa appears to have been responsible for the composition and most of the figures.[1] It is likely that Shravana added Zarnab and the onlookers to his left.

With curious redundancy, the text preceding this illustration devotes nearly half a page to a more elaborate retelling of Qasim's arrival at the barrier. There, Qasim sees Malik Surkhab seated on a throne and boldly makes his presence known to him. A brawny bodyguard intervenes, but Qasim collars him and dashes his brains out. Another guard rushes forward. Qasim wards off his blow and slices him in half. Now that he has Surkhab's attention, he exclaims, 'What say you of that God who brought me to this barrier and of the victory I have achieved?' A duly impressed Surkhab professes his belief in that God.

After feting Qasim for days on end, Surkhab greets Amir Hamza himself. Hamza grants him a robe of honor, and Surkhab reciprocates with the key to the barrier. The remainder of the text relates how Umar Ma'dikarb and legions of soldiers triumphantly pass through the long-contested garrison, install themselves on the territory it guarded, and are joined by a host of illustrious kings and princes, including the world-conquering Amir.

"The next day the champions and heroes of the army of Islam set forth with thirty thousand of their relatives. When the overseer of the court had crossed, the next day the sultan of the western throne and Mundhir Shah of the Yemen crossed with two hundred thousand men. Behind them came Prince Nuruddahr and Malik Qasim's men. After them the kings of the east like Jamshed Golden-Quiver and Khwarshed Golden-Quiver crossed with two hundred thousand men. The next day Prince Badi'uzzaman's men and the princes of Mazandaran like Shah Shams and Shah Badr crossed with eighty thousand men. The next day Khwaja Umar's *ayyar*s crossed with their treasury and camp. The next day the Amir's ministers crossed with the ladies of the harem, and the next day Alexander's drum and the instruments of the royal band all crossed. The world-conquering Amir crossed with his renowned sons and army and camped on the other side of the barrier."

Despite the fact that the text describes Surkhab's submission to the Amir in the most summary manner, the artist chooses this episode as the subject of his illustration. He probably does so because it both epitomizes and personalizes the conquest of the Noshad Fort and reinforces Hamza's status as vanquisher of infidels, a role set aside during the many episodes in which Badi'uzzaman and Qasim occupied the limelight. With such general considerations in mind, the painter pays little heed to the specific details of the submission. Forgoing the exchange of the robe of honor and the key to the garrison, he expresses the idea of welcoming supplication with one novel feature and one standard gesture. As Surkhab is ushered before the bearded Hamza, he stands in the middle of a long red cloth unrolled by one of his retainers. The action, of course, is the medieval equivalent of the red carpet treatment, and is intended to grace Hamza's entry into the fort. Hamza magnanimously shares the cloth with his new subject, and permits him to touch his head to his foot, a servile gesture long a sign of respect in the Indian subcontinent.

Once more the key action transpires at the very center of the composition. Location, however, is not everything in this case, for nearly every other element in the painting contributes to the compositional focus on Surkhab and Hamza. Surkhab, for example, is dressed in a gleaming all-white *jama*, a color that contrasts sharply with the black of his turban and cape even as it adjoins Hamza's equally brilliant leggings. Onlookers also do their part, with a few in the foreground glancing and gesticulating toward the Amir and his humbled subject. On the whole, even the landscape cooperates, its primary ridges converging in a V-shaped configuration directly behind Surkhab's adjutant.

Some details are less obliging and draw attention only to themselves; the most notable of these are the puffy outcrops that billow up on either side of the barrier, the conspicuously shaded clustered colonnettes of the portal, and the regularly spaced, fuzzy tufts in the foreground. Another aspect of the collaboration involved in this project is revealed in the treatment of the various faces. Two members of the garrison rendered in three-quarter view are shown with their further eye projecting slightly beyond the shape of the face. This discreet feature is a holdover from pre-Mughal traditions, and dies out almost completely by the end of the *Hamzanama* project; most of the other soldiers have wide-set almond-shaped eyes, a facial type associated with Banavari (see cat.48). By contrast, the faces of Surkhab and Hamza are far more finely painted, and are almost certainly the work of Dasavanta, the master who designed the painting. Dasavanta favors large, dark facial features, particularly pupils, and is practically alone in his use of white as a real color.

**Attributed to Dasavanta
and Banavari**

Volume 11, painting
number 26
India, Mughal dynasty,
circa 1570
67.2 × 51.4 cm
(detail on pp.132–33)
Caption: 'Surkhab comes
out from the barrier and
places his head at the foot
of the Amir'
MAK–Austrian Museum of
Applied Arts/ Contemporary
Art, Vienna, B.I. 8770/34
Published: Egger 1974, pl.27;
Egger 1969, pl.15; Betz 1965,
pl.10; Glück 1925, pl.21.

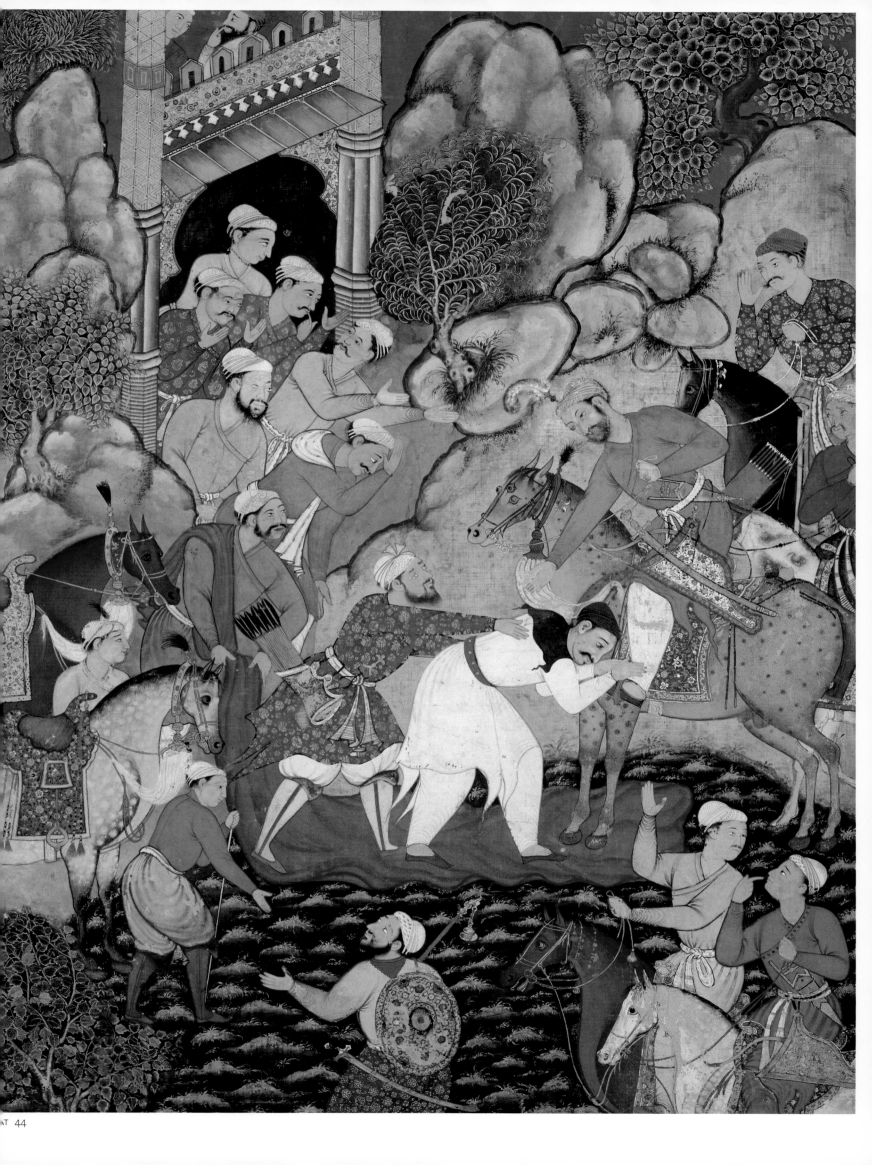

TAHMASP ANQUIL DOES BATTLE WITH HAMZA AND HIS MEN
CAT 45, 46

Aided by Umar, who uses trickery to enter the enemy fortress of Salija, Hamza's army defeats and converts to Islam all its inhabitants. Next, Hamza prepares to challenge the might of the Indian giant Tahmasp Anquil. One champion, Marzban, engages the giant in single combat but is overwhelmed by his opponent's size and strength. He has to be rescued from certain death by Umar, who once more puts to use the sling that he carries with him wherever he goes. The stone he flings hits Tahmasp on the temple, allowing Marzban to escape and fight another day. Tahmasp rebounds to terrorize the allies until Hamza himself takes the field.

Having inflicted serious wounds on Hamza and devastation among his champions, Tahmasp Anquil begins a new round of battle with the Amir's army. One champion after another falls before him. As the carnage mounts, the inhabitants of Mecca pray for deliverance from the Indian scourge. A champion named Satur launches a two-hundred-pound club at the giant, but the demon thwarts the attack by catching hold of the mace. More battles follow, and the number of martyrs reaches four hundred. Finally, Qasam al-Abbas rides out from Mecca. As he takes the field, he offers prayers to the Prophet and then snatches Tahmasp's weapon. The alarmed giant tries to ward off the coming blow with his shield, but Qasam al-Abbas lands it with such force that it smashes Tahmasp's head and shatters every bone in his body. The believers let out a great shout, the armies withdraw, and Hamza showers praise on Qasam al-Abbas.

Detail of CAT 45

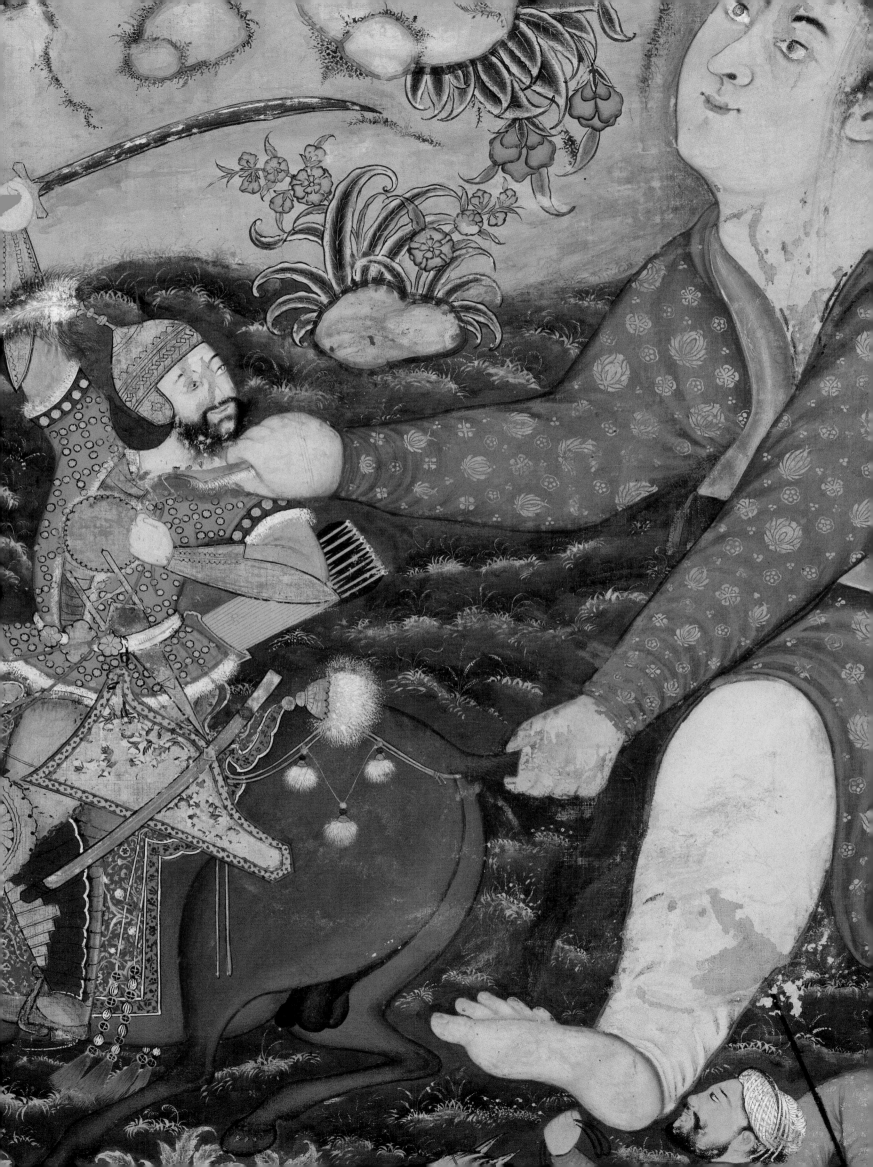

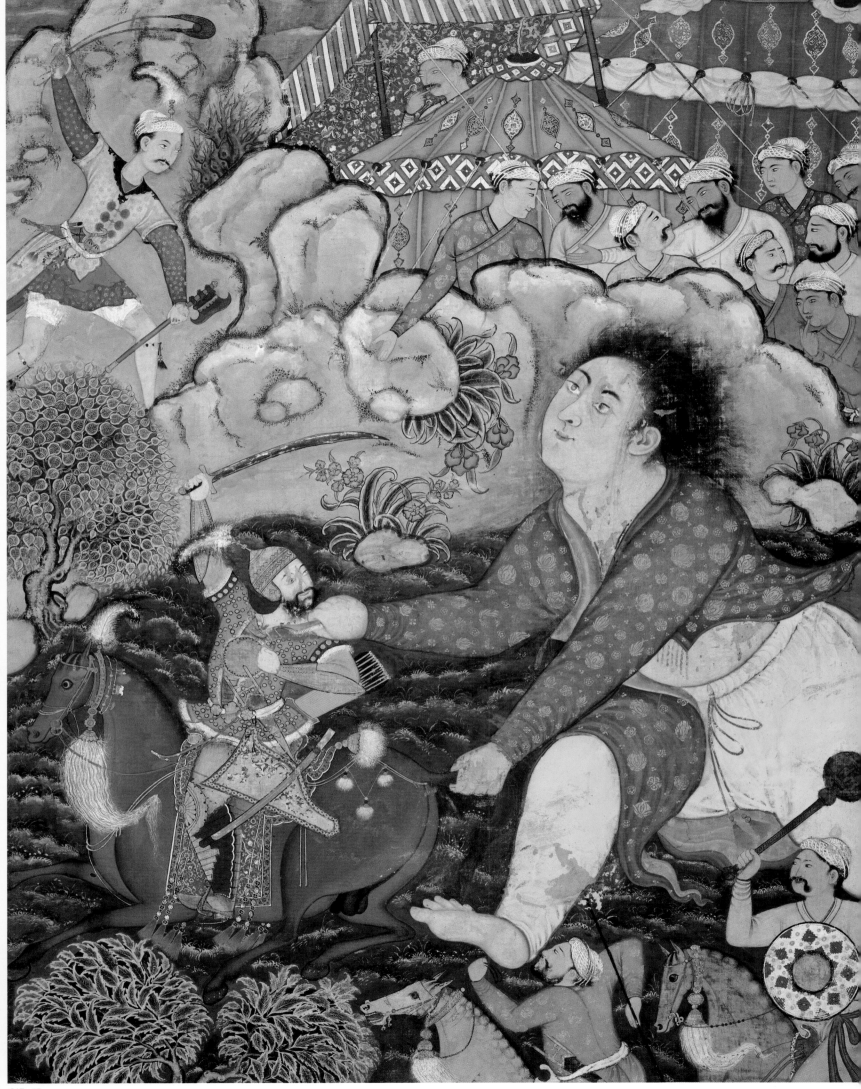

CAT 45

45 UMAR SLINGS A STONE AT THE GIANT TAHMASP, AND SAVES ONE OF HAMZA'S HEROES FROM HIS CLUTCHES

Attributed to Dasavanta and Shravana

Volume 11, painting
number 28, text number 29
India, Mughal dynasty,
circa 1570
66.3 × 51.8 cm
(detail on pp.146–47)
Caption: 'Tahmasp fights with
Marzban and Umar [flings]
a stone at Tahmasp's head'
MAK–Austrian Museum of
Applied Arts/ Contemporary
Art, Vienna, B.I. 8770/49
Published: Egger 1974, pl.28;
Glück 1925, pl.22.

With Hamza's permission, Umar sets out for Salija Fortress, where he hopes to free the kidnapped Kayhan b. Rustam. On the way, he meets an old woodcutter. Umar extracts some information from him, incapacitates him with some drugged fruit, and uses his identity to enter the fortress. That night, he creeps up on the sleeping guards, blows a knock-out drug up their noses, and rescues Prince Kayhan – all in a day's work. Thereupon Hamza's forces convert the entire garrison, and prepare for the coming showdown with Tahmasp Anquil. This event is forestalled, however, by the arrival of Ta'us Shah and his four hundred thousand men. Hamza dispatches some princes to intercept Ta'us Shah, but pointedly excludes Malik Qasim, known to have an impulsive nature, sending him instead to look for some chests of Hamza's armor that have accidentally fallen into the sea (see cat.48).

The end of this story coincides with a missing folio. The text on the reverse of this illustration introduces a new series of skirmishes. The most colorful of these involves the miraculous arrival of Ibrahim, Hamza's love-child with the princess of the fairies, from the heavens on a throne borne by demons. Hamza happily greets his offspring and enlists him in his cause.

This illustration now stands without benefit of its accompanying text. Nevertheless, its subject is easily understood both from the pithy caption and the straightforward action. Apparently Tahmasp is on the loose again, this time bearing down on a champion, Marzban by name, who has little hope of contesting the giant with either strength or guile. So overmatched is this hero, in fact, that Tahmasp has dispensed with his armor, weapons, and mount. Barefoot, he rumbles oafishly after Marzban, catching hold of his steed's tail with one hand and wrenching the champion's shoulder with the other. Two horsemen – one with his own shoulder turned inside out – join in the chase, but do nothing to abet either hunter or prey. Many more soldiers gape from the safety of a nearby ridge. Into this fray springs Umar. Like David before Goliath, he wields his sling with unerring accuracy. His projectile smites Tahmasp on the temple, causing the brute's head to recoil and his hair to stand on end.

Even before one parses this painting, there is a sense of dramatic excess that points unmistakably to Dasavanta. Tahmasp is not centered and static; he lunges from the side of the painting and paws the air. He is huge, of course, but this figure is far more dominant than his counterpart in the following illustration (cat.46) because he is modeled so marvelously and colored so extravagantly. Despite his wound, Tahmasp's face is stonily impassive, a metaphor Dasavanta encourages by placing a rock of equivalent size and shape almost directly before the giant's head. Yet his thick hair flies wildly, and his *jama* has burst open. Umar, his nettlesome opponent, stands resolutely in the opposite corner, wearing the same brilliant and streaked colors, albeit on a much reduced scale.

Dasavanta gives all three central characters his trademark features: large black pupils, a prominent nose, and a rosebud mouth. He displays an acute awareness of texture on objects ranging from the fluffy yaktail pompoms on Marzban's horse to the prickly stumps beside Umar. And he seems to revel in high color contrast, most obviously between the acidic yellow of Tahmasp's pants and the blackish-green ground, but also within individual forms, notably the flamelike foliage in the left foreground. The intensity of the painting abates only slightly in the passages contributed by Shravana, who provides the peripheral figures and ornate tents.

In a new round of battle, Tahmasp decimates Hamza's champions. When the earth is stained with the blood of four hundred martyrs, the hero Qasam al-Abbas rides out. He snatches Tahmasp's weapon and strikes him dead.

This illustration shows a youthful Qasam al-Abbas pitted against the titanic Tahmasp. Tahmasp is no stranger to the pictorial stage; he is, in fact, featured in no less than four of nine consecutive illustrations, a run finally brought to an end by his demise in this scene.[1] In his three earlier appearances – nearly all resulting in victory – Tahmasp thunders in from the right, twice riding across a composition with onlookers taking cover behind a similarly sloping horizon. Once Tahmasp simply seizes his opponent by the arm, but on the other two occasions he brandishes an enormous cleaverlike broadsword. Here, he has lost the advantage of direction, and pitches forward from the left. His vanquisher, Qasam al-Abbas, advances on a camel, an unusual mount which, together with the white cloth looped about his face, is meant to indicate his Arab origins. For once Tahmasp's opponent is able to counter his fearsome sword with a doomsday weapon of his own. With the colossal mace described in the text, Qasam al-Abbas smashes Tahmasp – not on the head, as is specified, but on the leg. This change was probably occasioned not because the artist was unaware of the textual account, which, after all, is very short and direct, but because he preferred to embed the huge mace within the form of Tahmasp's body and horse and thereby leave the giant's face intact. To set off the mace from Tahmasp's armor and his mount's caparison and to accentuate their physical collision, the artist runs one big golden stripe across its silver surface, a directional contrast strengthened accidentally by the blackened appearance that the silver has assumed over time.

This painting can be attributed to Mahesa. The most obvious connection is Tahmasp's face. This youthful facial type is large and smooth in shape, its flattened pursed mouth and rounded eyes combining to form a somewhat vacant expression. It appears in a number of works ascribed to Mahesa,[2] and recurs in the figure of Tahmasp in at least one other illustration in this series, thus suggesting that Mahesa designed and painted much of these other works as well.[3] Other elements are equally distinctive. Mahesa habitually uses an oversize polka-dot pattern for his studded tunics, as he does here on Tahmasp and previously on the figure of Ma'dikarb; even the markings of the two figures' helmets are identical. He renders many forms as large, flattened shapes, a tendency exemplified most clearly here in the discrete shapes of the two tunics and the caparison of Tahmasp's horse. Mahesa's landscape typically consists of puffy rock forms organized into large, broadly conceived arcs. His onlookers, with their boxy faces and thin features, represent some of his most typical figure types.

Attributed to Mahesa

Volume 11, painting number 36, text number 37
India, Mughal dynasty, *circa* 1570
Painting 68 × 52 cm, folio 78.7 × 64.8 cm
Caption: 'Qasam Abbas arrives on the battlefield and defeats Tahmasp with a mace blow'
Philadelphia Museum of Art: Gift (by exchange) of the Brooklyn Museum 1937-4-1
Published: *Orientations*, 17, no.2 (February 1986), p.57; Kramrisch 1986, no.8; Dim and 1948, p.6, fig.1.

1. MAK, Vienna, B.I. 8770/49 (cat.45), 8770/30, 8770/8 and this work; five of these illustrations have not been located.
2. British Library, London, *Darabnama*, ff.5a–b, and British Library, *Baburnama*, f.453a.
3. MAK, Vienna, B.I. 8770/30.

In the other painting (8770/8), Tahmasp's face has been entirely repainted.

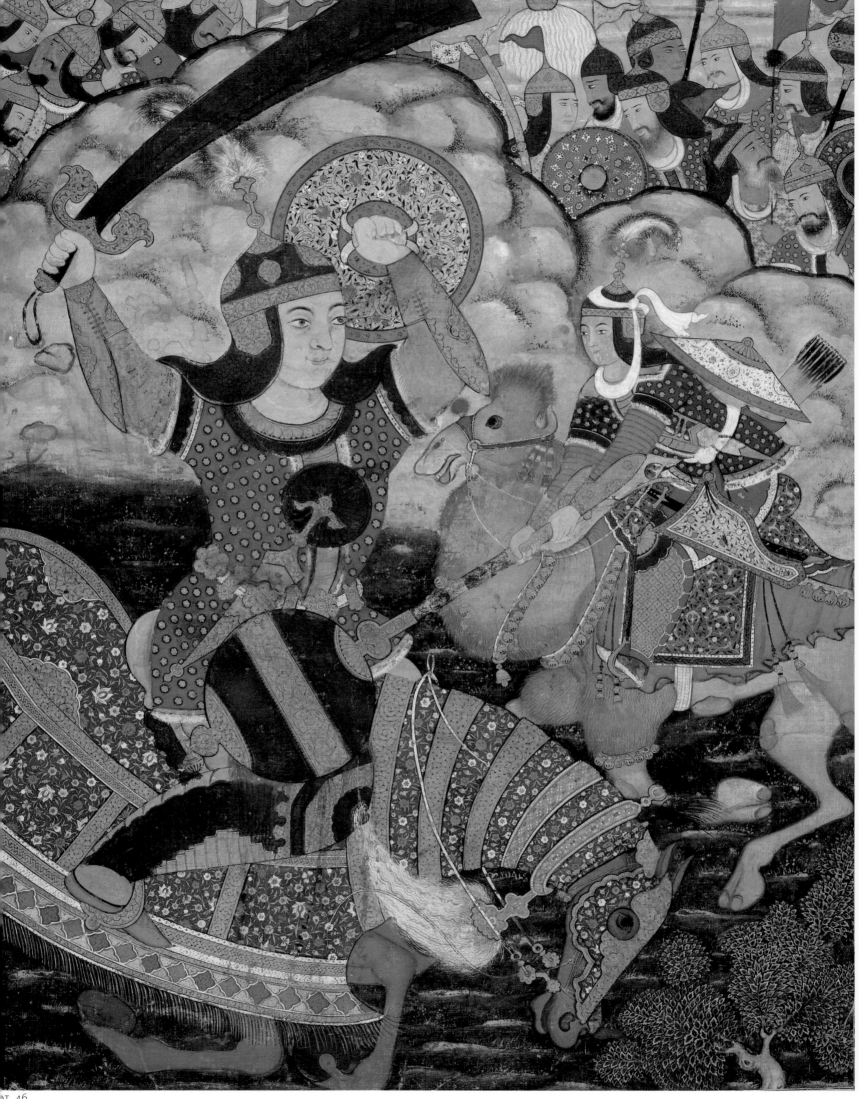

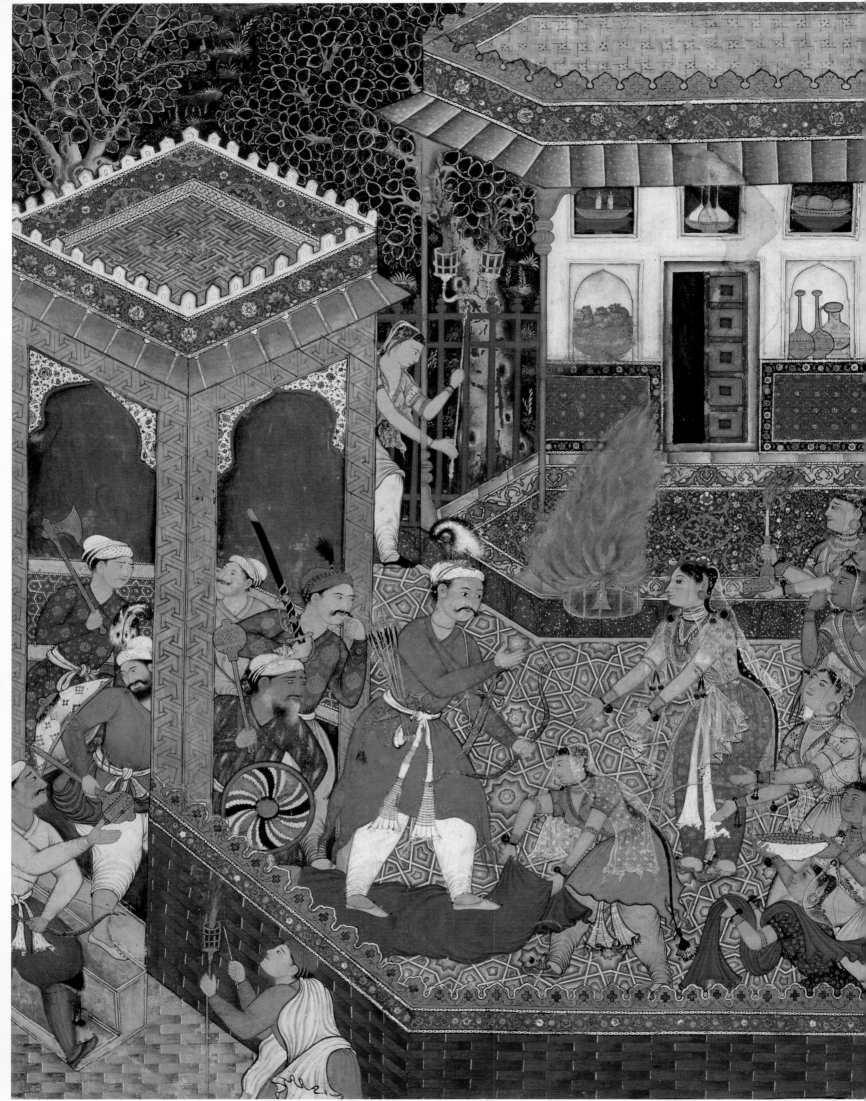

47 SANAWBAR BANU WELCOMES PRINCE QASIM AND THE CHAMPIONS OF IRAN AND TURAN

Attributed to Shravana and Dasavanta

Volume 11, painting
number 39, text number 40
India, Mughal dynasty,
circa 1570
Painting 67.6 × 51.5 cm,
folio 78.4 × 62.2 cm
Los Angeles County Museum
of Art, From the Nasli and
Alice Heeramaneck Collection,
Museum Associates Purchase,
M.78.9.1.
Published: Pal 1993, no.46;
Heeramaneck 1984, pl.141;
Pal 1982, pl.1.

1. On the other side of this
double-sided folio (f.67a) is a
painting ascribed to Shravana,
rendered in exactly the same
style. The paintings' profound
similarity and the workshop
habit of assigning multiple
paintings on a single folio
to one artist make for a defini-
tive attribution.
2. Folio 37a, published in
Titley 1983, p.196. See fig.29
on p.53, above.

The story lurches a bit now, as if often does, but Hamza continues to be done in by conniving spies and rescued just as often by his own resourceful *ayyar*s. In his latest escapade, Hamza is sprung from Noshad Fort by his two *ayyar*s, Yazak and Barakh Farangi, and together they exact bloody and material revenge on the vizier who sanctioned his imprisonment. Now comes one of the quiet interludes when Hamza or one of his heroes periodically enjoys the pleasure of fairer company.

Such is the case in this illustration, as Hamza's men are welcomed by Tahmasp's sister, a beauty named Sanawbar Banu. The circumstances of this rendezvous are unclear. Two text pages earlier, Umar and Hamza's men meet Sanawbar Banu in the aftermath of their looting of Noshad.

"She told him all about her love for the Amir, saying, 'Umar, that night, when I was struck by the arrow of love for the Sahib-Qiran, I came to the city and converted nearly four hundred people to Islam. Then, when I heard that the *ayyar*s of Iran had come to this city, it occurred to me that they had come to rescue the prisoners. Of course there would be guards at the prison gate. I came and found you like this.' She offered Umar a place to stay."

Umar accepts her offer, and leads his *ayyar*s to the safety of her house. With this the story breaks off, and after a gap of one folio, resumes on the reverse of this painting, which has lost its caption. On this page of text Sanawbar Banu is mentioned thrice: first when she is described as being eager to capture the *ayyar*s who do Hamza's bidding, again in lines 11–12, when she receives the champions at her house and gives them armor, and a third time when Hamza sends her a note. That Sanawbar Banu greets Hamza's champions more than midway through the text following the painting suggests that this is not the passage being illustrated. It is more likely that this action is merely congruent with the now-missing one, perhaps describing a return visit to her house. In any case, the somewhat contrary actions described above imply a certain opaqueness to her character, so that both Hamza and his foes solicit her assistance.

The artist adds many flourishes to a standard scene of greeting. One hero, probably Malik Qasim, leads his men into the courtyard. The troupe rush through an ornate, obliquely set, three-dimensional gateway, a detail that simultaneously allows the heavily armed followers to mass and to present their faces to the audience. One maidservant spreads a red cloth before the plumed figure, a gesture seen earlier in less domestic circumstances (cat.44) and one about to be repeated here. The central group is completed by Sanawbar Banu herself, who extends both hands in welcome. An inexplicably huge fire blazes from a single candlestick hovering beside the low platform, and flasks and fruit-laden bowls fill the niches of the pavilion wall.

But the feature that most sets this painting apart from other *Hamzanama* illustrations is the assortment of females, all of whom are clearly derived in both face and body from indigenous Indian types (see cat.1). Early Mughal paintings exhibit considerable variation in their adaptations of this square-headed, voluptuous type, particularly in the *Tutinama*, where one painting firmly attributed to Shravana provides an exact match to the woman holding a candle (see fig.14).[1] With this initial clue to the artist's identity, one can discern Shravana's handiwork throughout this painting. For example, the oblique arrangement of the architecture, unusual in Mughal painting of this period, occurs in one of Shravana's works in the British Library *Darabnama*.[2] That painting also features a narrow-eyed, bearded figure with a strong resemblance to the soldier holding the pinwheel shield, and several tilework patterns seen here. The male figures here have notably broad bodies dressed in flat *jama*s overlaid with large gold medallions; their faces, similarly wide and unmodeled, have thin eyes and wiry mustaches. The recurrence of these same elements in a painting four folios (and two extant paintings) later – in the MAK–Austrian Museum of Applied Arts/Contemporary Art, Vienna, B.I. 8770/27 – supports another attribution to Shravana, and bolsters the idea that artists often worked on nearly consecutive series of paintings in the *Hamzanama*.

Shravana seems to have completed nearly all of this painting. He left to his collaborator, Dasavanta, the faces of the two primary characters, the lead champion and Sanawbar Banu. The former is extremely close to Dasavanta's figure of Umar in cat.36, and the latter has a more elegant profile, a larger solid black pupil, and a more painterly surface than the other women in this scene. There is, in fact, physical evidence that Sanawbar Banu's face was inserted after the painting was virtually complete, for around the woman's brow and nose is a kind of painted corona that disrupts ever so slightly the carpet pattern behind the figure. This type of portrait-like insertion, commonplace in later Akbari painting, is not to be mistaken for repainting, which occurs here only on the right half of the central hero's face and on the entire face of the maidservant holding a double torch.

Having received armor from Sanawbar Banu, the champions split up, some staying in Noshad and others setting out to join up with Hamza. The latter contingent, headed by Malik Qasim, reaches the edge of the sea. A casket containing Hamza's armor had accidentally fallen into the water at that site, and Qasim, whose epithet is the quick-tempered bloodshedder, is now sent by Hamza to retrieve it.

"When the courageous Prince Malik Qasim reached the edge of the sea, he summoned all the sailors in the vicinity, gathered them together, and said, 'Go into the sea and bring out the chest of armor.' They entered the sea at Prince Malik Qasim's command and swam all through the water, but they could not locate the chest. Finally, they emerged and said, 'There is a demon called Aflagh hereabouts. If you summon him, he will come and get your chest out.'

Malik Qasim went, seized the demon, and brought him back. The demon went into the sea and brought out the chest. Putting the chest on the demon's head, Malik Qasim took it back to the Amir's camp."

This adventure, told in four lines at the end of the preceding text page, is summarized in one line at the beginning of the text on the reverse of this painting. This narrative pattern, one seen often in the manuscript, allows the narrator to remind the audience of where things stood at the conclusion of the previous session of recitation.

"When the king of the west, Malik Qasim the Quick-Tempered, placed the box of the Amir's weapons on the demon's head and brought it to the Sahib-Qiran, it was afternoon when he reached the Amir, and all the warriors cheered the prince."

This Mughal artist knows a good story when he sees one. He seizes upon the captivating image of a demon bearing a chest of weapons on its head, and makes it the largest, most central, and most extravagantly colored element in his painting. Such an arresting motif easily epitomizes both the illustration and the story, but it is how the artist fleshes out the scene that ultimately conveys something larger still, the very essence of visual storytelling in the *Hamzanama*. See this image and retell the story. Half-naked sailors dragooned to locate the submerged chest, a boat made available for the search, warriors with their weapons – arrows, a sword, and even a musket – prepared to press on to Hamza's camp, an *ayyar* agitated at the sight of the demon, and a figure prostrate in supplication to his master – all these elements are, or can be, part of the story. Physically conjoined but temporally incoherent, they embody a manner of visual storytelling known as the synoptic mode of narration. The sailors, for example, are shanghaied so that they can conduct the search; it makes no sense for them to remain bound after they have failed and the task has been assigned to the demon. Similarly, the demon does not arise from the sea with the chest on his head; Qasim puts it there, presumably after the demon has returned to dry land. Even the identity of the central figure in orange is in doubt. If he is Qasim, who is the figure prostrated before him? If he is the Amir, as the caption would have us believe, why is he shown young and beardless for the first time in the manuscript?[1] These questions beg a logical and precise sequencing absent from this painting and from the Hamza legend generally. What matters more is the complementary pairing of prince and demon, dignified and unrestrained behavior, civilized and uncouth men. What the audience is meant to take from this memorable and entertaining painting is the message of heroic and righteous action and its foil, no matter the order in which the imagery is considered and the story played out.

The artist responsible for much of the detailing of this compelling painting is Banavari, an artist known from his contributions to several contemporary manuscripts. As seen here in the three captive sailors and their fur-clad guard, Banavari's faces have one exceedingly unusual feature: their almond-shaped eyes have heavily painted whites outlined completely in black, and, like goggles, project slightly beyond both the plane and contour of faces seen in three-quarter view.[2] By contrast, the central figure has narrower and darker eyes, and much more ambitiously modeled clothing. In fact, in face, hands, and dress, he resembles the orange-clad figure on the mountaintop in cat.85, one of several figures in that painting attributed to Kesava Dasa. This, in turn, suggests the prostrate figure is also the work of Kesava Dasa, who probably designed the painting as well. The abrupt devision between the dark green ground and the purple area beyond, and the smooth, painterly tree trunk are also indications of Kesava Dasa's handiwork.

Attributed to Kesava Dasa and Banavari

Volume 11, painting number 40, text number 41
India, Mughal dynasty, *circa* 1570
Painting 67.5 × 52.5 cm, folio 79.1 × 63.3 cm
Caption: 'Arghan Dev brings the chest of armor to the Amir'
Brooklyn Museum of Art, Museum Collection Fund, 24.47
Published: Poster *et al.* 1994, no.22; Chandra 1989, fig.2; Pal 1983, M2; Glück 1925, fig.48.

1. Another minor discrepancy is the name of the demon, which is specified as Aflagh in the text, but given as Arghan in the caption.
2. See, for example, his ascribed works in the *Tutinama* (f. 50b, fig. 13), and in the Jaipur *Razmnama* (AG 1716, 1717, 1803, and 1804); these last four paintings are published in Hendley 1884, pls 26, 27, 104, and 105.

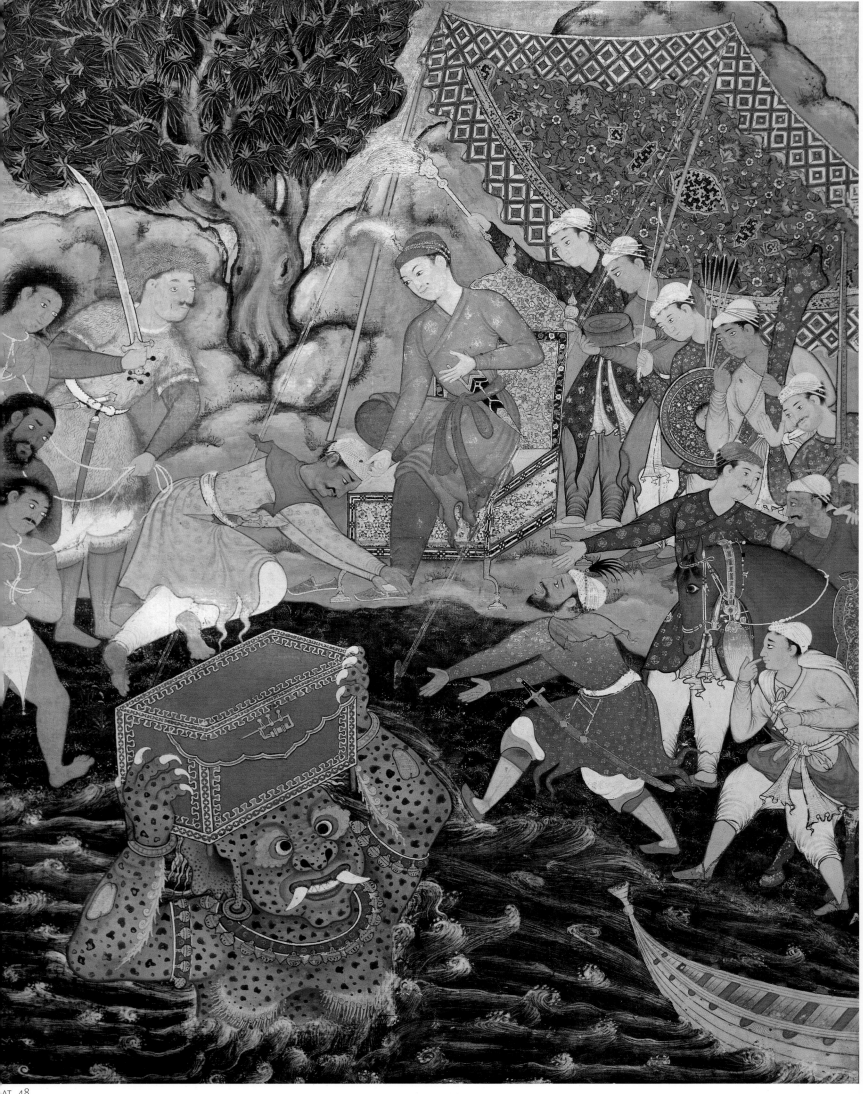

Hamza is told that the winter snows will block his travel through Shisan Pass, a place near Noshad, where a vast dam was built long ago by demons working at the command of King Solomon. The dam holds back the waters of a mountain valley and is plugged at the bottom by a huge brass ball on a chain. To lift the heavy plug and release the water into the desert below, it takes hundreds of men to wind the chain on a wheel at the top of the dam. Kayhur Dev, a descendant of the demon builder, now controls the dam.

When they reach the pass in the spring, Hamza and his men are confronted by the army assembled by Zumurrud Shah. Kayhur Dev rides out to attack them mounted on a rhinoceros and unseats the first hero to challenge him. Now Qasim rides forth, sword in hand. Kayhur strikes Qasim with his sword; Qasim retaliates with his own, missing Kayhur but severing the head of his rhinoceros. Kayhur grabs Qasim's horse, causing it to rear up violently and Qasim to leap to safety. Kayhur then tears Qasim's horse to pieces and begins to devour it. Without their steeds, both warriors retire for the night.

The next day a foe named Tayhur kills and wounds many of Hamza's heroes. The following day, Hamza girds himself for battle and joins his men in their assault. Tayhur attacks. Quickly, and with no elaboration whatsoever, Hamza subdues him and has him bound. Hamza offers him a chance to convert, and Tayhur accepts. The next day, Tayhur asks and receives permission to enlist his brother, too; once alone, he climbs up to the Shisan Pass, apparently renounces his conversion, and seizes control of the pass. Hamza's princes lead a charge to regain the pass, but are beaten back by a barrage of stones, and retire for the evening. Now Tayhur resorts to insidious environmental warfare. With his demonic strength, he cranks the wheel to dislodge the brass ball from its place at the base of the dam. A great torrent sweeps downhill and completely inundates Hamza's camp, drowning many there, including one noted champion named Hardam Devana.

Kayhur steals into Hamza's camp and beheads two champions as they sleep. When the murders are discovered in the morning, Hamza's *ayyar*s try to track the killer but without success. That night, Kayhur decapitates Prince Umar Gorzad. Umar continues the search with redoubled energy, and his scouting takes him to the Shisan dam, where he discovers a large band of infidel soldiers. Umar returns to camp and gets reinforcements, among them Qasim, Badi'uzzaman, Alamshah, Landhaur, and Tul Mast. Finally, a battle breaks out, and Alamshah, seeing Tayhur atop the dam, splits him asunder and cuts the chain holding up the huge ball.

Detail of CAT 49

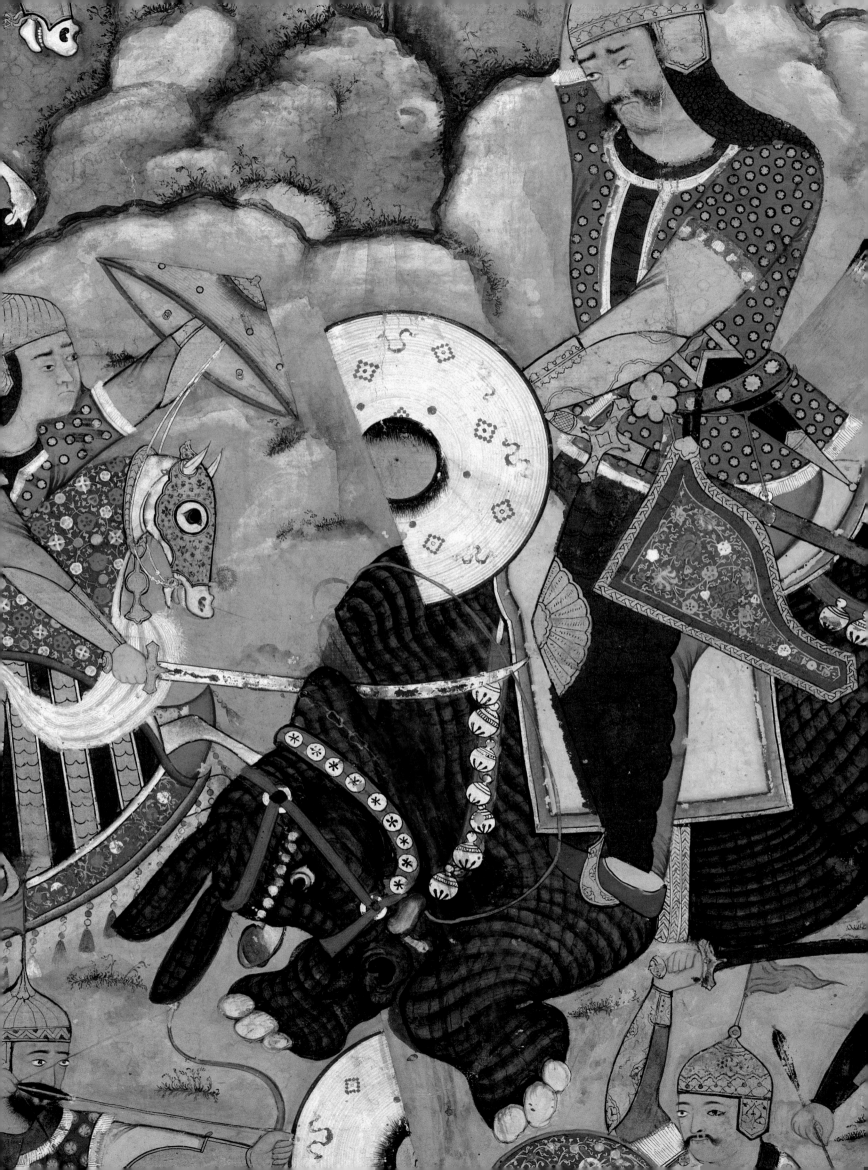

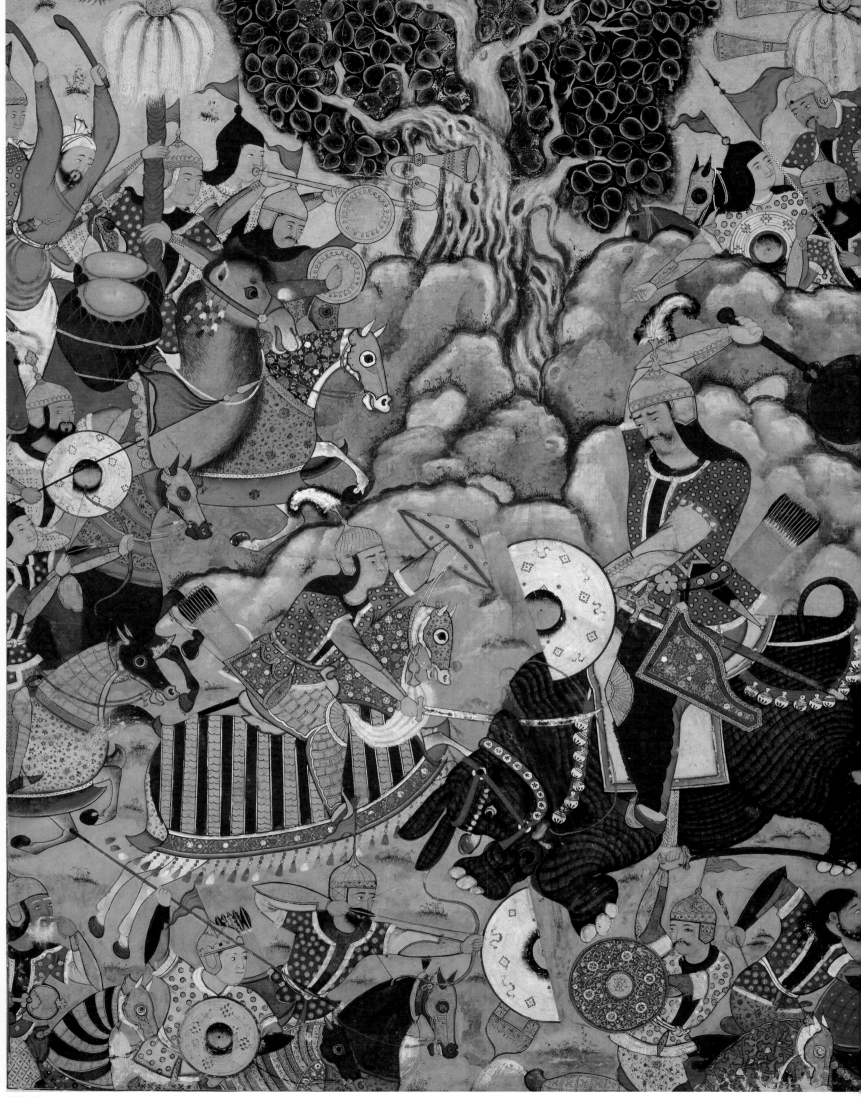

49 IN THE BATTLE FOR SHISAN PASS, PRINCE QASIM DUELS WITH THE GIANT KAYHUR, AND BEHEADS HIS RHINOCEROS

Attributed to Mahesa

Volume 11, painting
number 44, text number 45
India, Mughal dynasty,
circa 1570
67.4 × 50.8 cm
(detail on pp.156–57)
MAK–Austrian Museum of
Applied Arts/ Contemporary
Art, Vienna, B.I. 8770/52
Published: Egger 1974, pl.34;
Egger 1969, pl.21; Glück 1925,
pl.28

1. This youthful type is seen
in two ascribed paintings in
the *Darabnama*, ff.90a–b.
See fig.30 on p.53, above.

Here begins the story of a formidable place, the Shisan Pass, and the battle for control of the dam there, an engineering marvel that brings life or death. Hamza learns that in ancient times it was an inhospitable desert, but that it adjoined a mountainous valley watered by a large river. King Solomon, recognizing the possibilities of this terrain, ordered the host of demons at his command to build a dam in the valley so that water could be delivered to the desert below. One demon, Shisan Dev by name, took on this colossal task, and with the help of thousands of demons, completed it in five years. The dam is said to operate in this manner. At the bottom of the dam, half a league in breadth and four hundred cubits in height, is a hole dug by another demon, Aad Man-Eater. This hole is plugged by a huge brass ball fastened to a chain, and that chain is wound about a wheel at the top of the dam. So huge is that wheel and so heavy that ball that four hundred men are required to turn the crank to lift the plug. When they do, life-giving water pours from the reservoir onto the valley below. One of Shisan Dev's descendants, Kayhur Dev, maintains control of the dam to this day.

In the spring, Hamza and his men set out for this fabled and strategic place. When they arrive at the dam, they see a vast army assembled there at the instigation of Zumurrud Shah. The mighty Kayhur charges out on a war rhinoceros and unhorses the first champion sent to oppose him.

"Qasim came out. Both reached for their swords. Qasim took a blow from Kayhur and aimed a blow with his sword at him. Kayhur ducked, and the sword landed on the rhinoceros's neck, severing its head. Kayhur grabbed the leg of Qasim's horse, and anyone other than Qasim would have fallen from the horse. When Qasim saw this, he leapt from his horse. Kayhur tore the horse apart, put the horse's leg in his mouth, and started to chew it. The men on both sides stood still. When night fell they withdrew."

Now a war rhinoceros is no ordinary sight, even in the *Hamzanama*, and Mahesa takes full advantage of the beast's uniquely menacing form and color. A large Kayhur rumbles in from the right, his shield sliced in two, presumably by the blow that beheads the rhinoceros. As the left half of the shield falls to the ground, Mahesa keeps it exactly aligned with its mate so that the pair of brilliant white shapes bracket the dark and bloody neck of the enraged rhinoceros, the highpoint of the scene. Once again, the artist deviates from the text as he substitutes weapons at will, giving the brutish Kayhur a mace. Unlike his former battle scene (cat.46), which is dominated by a truly gargantuan figure, here Mahesa surrounds the featured combat with supporting warriors, some skirmishing in the foreground, and others sounding drums, trumpets, and cymbals in the rear. He uses a banyan tree to separate the opposing forces in the background, but positions it so that its trunk and sinewy roots also reinforce the compositional axis that passes through the rhinoceros's neck.

This painting fleshes out Mahesa's personal style. His faces continue to be his most easily recognizable feature, the youthful type represented by Qasim complemented here by a grizzled Kayhur with a fuzzy handlebar mustache.[1] His landscape repeats the pastel colors and rhythmically curved ridges of an earlier composition (cat.39), the latter on a scale in keeping with the medium-sized combatants. There is some continuity in motifs, such as the parasol-like yaktail standards, seen also in cat.46. Even the palette becomes familiar over time, as Mahesa consistently uses patches of red and yellow as visual accents.

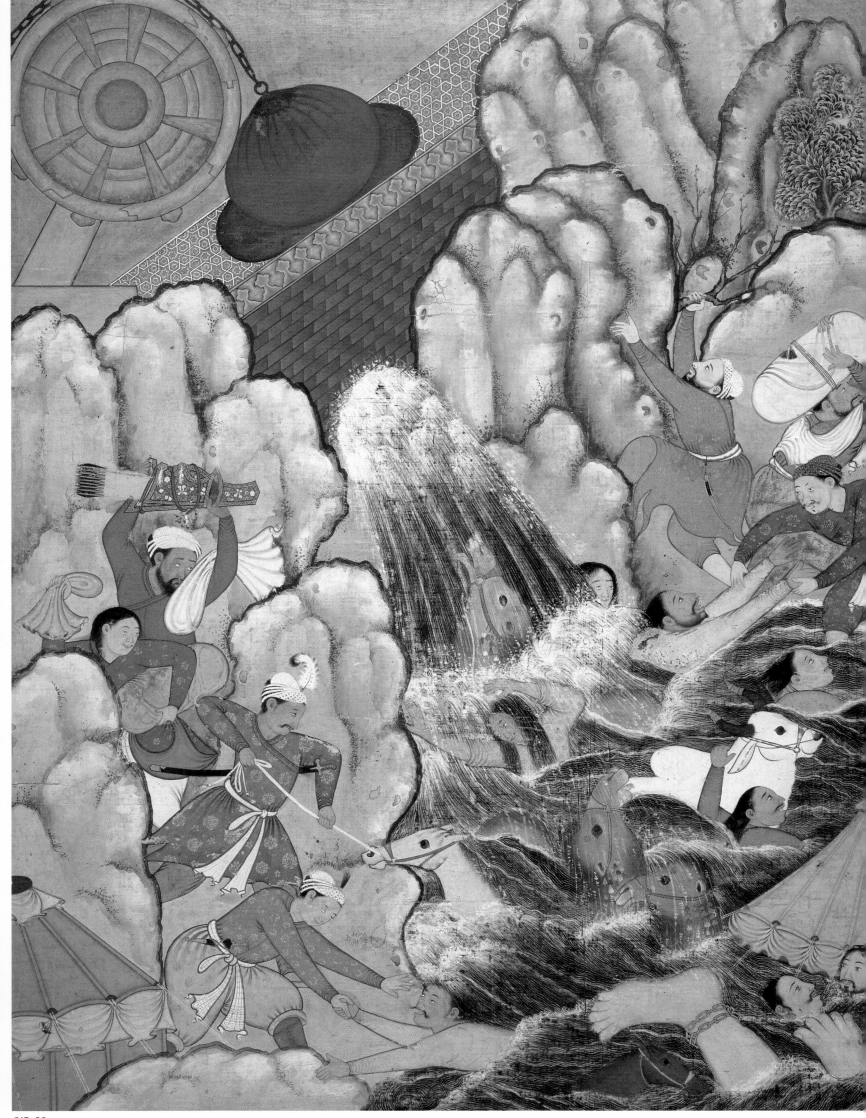

Attributed to Jagana

Volume 11, painting
number 45, text number 46
India, Mughal dynasty,
circa 1570
67.9 × 51.8 cm
Chester Beatty Library,
Dublin, 01.1
Published: Leach 1995,
no.1.202, color pl.11; Leach
1986, fig.10A; Arnold
& Wilkinson 1936, 2, pl.2.

The next day more battles ensue, with a foe named Tayhur inflicting many casualties on Hamza's forces. Many champions volunteer to face this enemy, but the following day, Hamza himself prepares to fight alongside them. Tayhur attacks, blaspheming all the way.

"When the wind swept the field clear of the dust, the two sides looked at each other until Tayhur, mounted on his steed, entered the field. After displaying his prowess, he headed for the lines of the army of Islam and shouted, 'God-worshippers, know that the god of the east has fated your death at my hands. Fare you well!' As he said this, from the army of Islam the world-conquering Amir halted on his steed and said, 'Come into the field of combat and show me your *ayyar*'s hat, for after me no one will come into the field.'

In short, the Amir spurred his horse into the arena and came opposite Tayhur. Through the grace of the Creator he sent that infidel from the field bound hands and neck, and he returned to Solomon's tent, where he took off the garb of battle and washed the dust and blood of the field from his hands. After that, he ordered a party given during which Tayhur was brought in and offered a chance to convert to Islam."

Tayhur agrees and is rewarded, but the next day, on a mission ostensibly to win over his brother, he reneges on his conversion, and seizes control of the pass once more.

"Tayhur turned the crank, and the rock rolled away from the mouth of the hole, and a deluge of water poured down so that all the ground was engulfed. Many men were lost. Of those of name, Hardam Devana was drowned. Such an uproar arose in the camp that the Amir imagined that soldiers had attacked the camp."

This dramatic illustration brings into play the earlier description of the Shisan dam and its ingenious floodgate. The narrow gorge across the pass has been sealed with a brick dam, edged in cut stone, and topped with ornamental tiles. Placed to one side is the colossal wooden crank used to raise and lower the circular brass plug. The artist shows the mammoth brown stopper exposed completely, with a dark oval space around it, to indicate that the waters have been unleashed deliberately. Curiously, however, he does not depict Tayhur, the culprit responsible for this catastrophe, probably to keep the focus on the dam mechanism and the deluge. To do this, he uses an extreme close-up view, so that the water gushing from the base of the dam occupies not only the center of the scene, but nearly a third of the entire composition. Nearly every detail speaks to the sheer fury of the waters. A camel strains to keep its head above water, a man grabs hold of a small tree to avoid being swept away, and others struggle to save kin and kine. Beside a half-submerged tent a giant bobs by. Only on the left does the situation seem less dire; there, one tent still stands, and one warrior has time to salvage his quiver. Everything, from people to rocks to the dam itself, is writ large.

The artist responsible for this tumultuous scene is Jagana. Many Mughal painters give their figures slightly projecting eyes, but Jagana makes his figures' eyes round and relatively small in proportion to their faces. He renders their features with a crispness often lacking in other artists' characters; this quality can be seen here, for example, in the neatly delineated mustaches and beards of the soldier holding his quiver aloft, or the figure below him leading a horse from the surging waters. Jagana shows no interest here in contemporary Mughal experiments with European-derived modeling. The faces and clothing of every figure are unabashedly flat, with modeling limited to the kind of minimal and formulaic convention seen at the gathers at the waist of the figure in the lower left. Similarly, the colors are absolutely unsullied by tonal shading, with the result that this scene of utter devastation is rendered with an oddly cheery palette.

After this straightforward episode, which is not summarized at the beginning of the following text page as is often the case, the story returns abruptly to Kayhur, now described as an *ayyar* rather than as a *dev*. He steals into Hamza's camp, and slipping by the dozing guards, beheads two champions.

"When it was night and the Amir Sahib-Qiran was contemplative, an alarm broke out in the camp of the army of Islam. Kayhur got his *ayyar*'s paraphernalia together and got himself across mountain and cliff to the army of Islam. As black night fell and the sky once again became a stage for the hosts of Ethiopia, the *ayyar* of the night vengefully cut off the head of the Bahram of the day."

The murders are discovered when morning comes, and an aggravated Hamza orders his *ayyar*s to try to track the killer. Their efforts are fruitless. That night, Kayhur exacts his bloody toll once more, this time decapitating Prince Umar Gorzad. Hamza directs an infuriated Umar to redouble the search.

"Finally, when he reached the barrier, he thought, 'One can get through this way.' When he was near the barrier, he saw that nearly two hundred fully armed men were standing with torches. Umar came and got seventy renowned champions of the Amir Sahib-Qiran like Qasim, Badi', Alamshah, Landhaur, Mâlik, and Tul Mast. When these came, battle broke out. Tayhur was on top of the barrier. Alamshah split him in two and ..."

With this act, the text on the preceding folio ends; when it resumes on the back of this painting, it mentions in the space of little more than one line Kayhur delivering the severed heads of his victims, his brother reporting the death of Tayhur, the seizing of the dam, the blocking of the water, and the severing of the chain. Thereafter, it recounts a new and prolonged round of battles.

Like the earlier double depiction of Baba Junayd's caravanserai (cat.37), this composition repeats virtually all the major elements of the preceding painting. The gorge and dam, the crank and ball, the torrent and its victims – all these recur in the second painting with negligible change. Indeed, the major difference between the imagery of the two illustrations resides in the inclusion of Alamshah, who scrambles up the rocks on the right, and Tayhur, who lies well out of striking distance of Alamshah but has already been sliced in two. Fewer souls flounder in the water, and conversely more figures have the physical luxury of gaping at Alamshah on one side and Tayhur's bloody corpse on the other. But the brass stopper remains raised and the torrent rages unabated.

The fundamental similarity of the two illustrations raises questions about how this particular pair of images would have been used in recitations. The two paintings could conceivably be viewed in close sequence, as the cause and remedy of a terrible disaster, without regard to the long digression that occurs between the two episodes at the dam. Yet if this had been the intention, the text could easily have been rearranged to accommodate this, with Tayhur's demise much preceding the unrelated series of assassinations carried out by Kayhur. Instead, it seems that the story was written down in its present arrangement precisely so that the same scene would be depicted twice, for in each case the subject illustrated is described at the very bottom of the text page.

Indeed, one wonders if these twinned images were a kind of informal competition between two artists, for despite their many compositional and narrative similarities, these works are surely by different hands. This artist, Shravana, pulls further away from the cataclysm, and generally uses a smaller scale. His figures are much more voluminous and hairy than Jagana's, and their *jama*s are decorated with the medallion patterns exhibited in his earlier works (cat.42 and 47). His rocks are also closely related to those in one earlier work (cat.42), with heavy shading applied around each rectangular facet within the larger outcrops; these more three-dimensional forms encroach upon the torrent both laterally and spatially, inadvertently diminishing its sweep and power.

Attributed to Shravana

Volume 11, painting number 46
India, Mughal dynasty,
circa 1570
Painting 69 × 52.2 cm,
folio 83.7 × 67 cm
Caption: 'Alamshah cuts
the chain of the wheel in
two [and blocks the water]'
The Cleveland Museum of Art,
Gift of George P. Bickford,
1976.74
Published: Cleveland 1998,
p.171; Lee 1994, color pl.18;
Leach 1986, no.10; Czuma 1975,
no.45; Welch 1973, no.53;
Blochet 1928, pl.189.

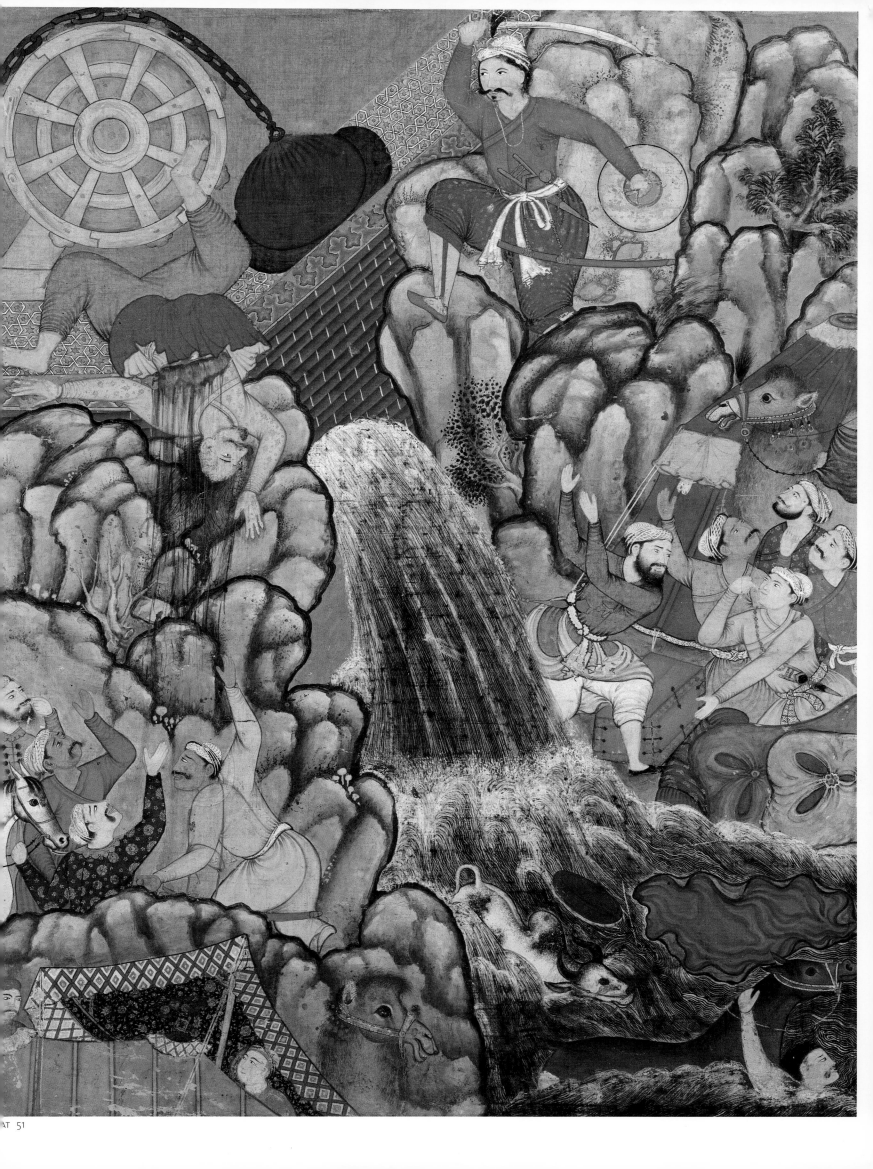

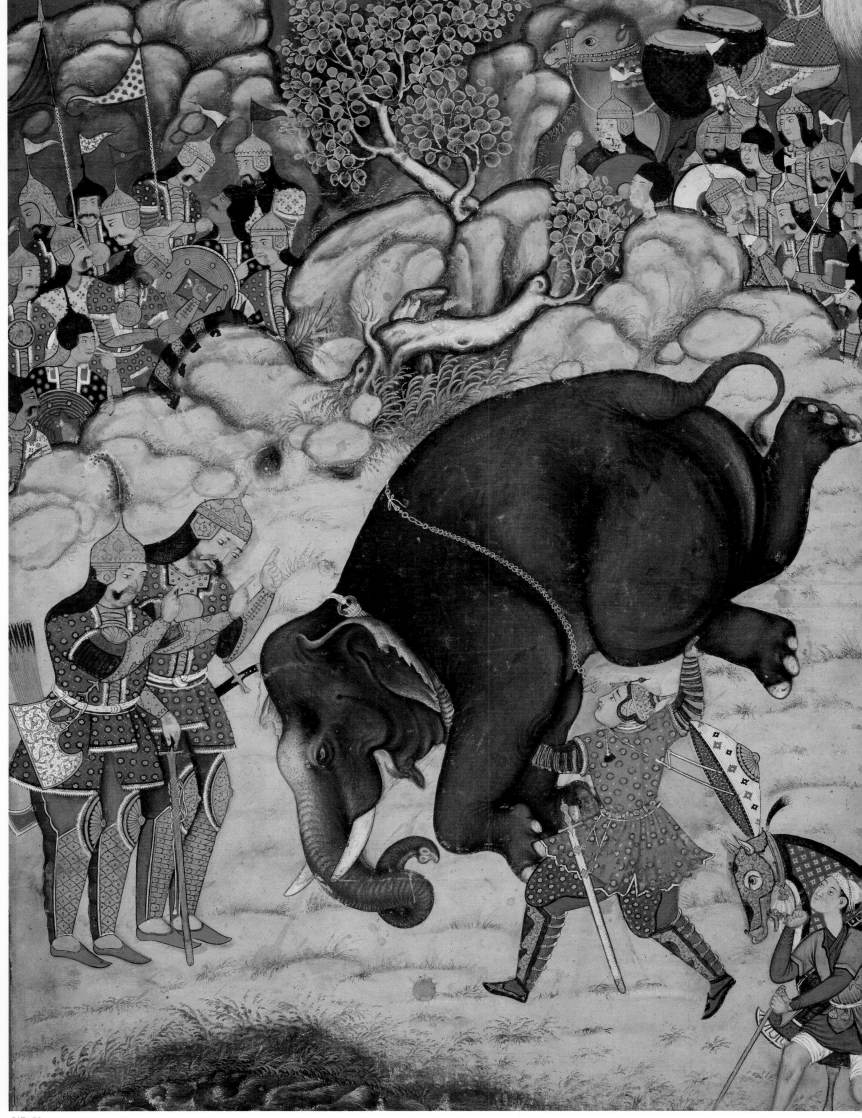

52 LIFTING AN ELEPHANT SINGLE-HANDED, FARRUKH-NIZHAD SO ASTONISHES TWO BROTHERS THAT THEY CONVERT TO ISLAM

**Attributed to Mahesa
and Kesava Dasa**

Volume 11, painting
number 47, text number 48
India, Mughal dynasty,
circa 1570
67.2 × 50.6 cm
Caption: 'Two brothers lift
an elephant on the field and
Farrukh-Nizhad goes and
lifts an elephant and converts
them to Islam'
MAK–Austrian Museum of
Applied Arts/ Contemporary
Art, Vienna, B.I. 8770/26
Published: Egger 1974, pl.35;
Egger 1969, pl.22; Glück 1925,
pl.29.

As the two armies vie for supremacy, Hamza seeks honor for the slain and retribution for the wicked. The ever capable Umar steals back the severed heads of the assassinated champions, and then, catching the fiendish Kayhur off guard, burns him with naphtha. Aad Man-Eater comes out for battle, and spurns Hamza's demand that he convert to Islam, an act that in this legend inevitably augurs imminent defeat or death. Princes, among them Hamza's sons Ibrahim and Badi'uzzaman, prove their mettle in a series of individual combats against the backdrop of vast legions and throbbing war drums.

It is not long before Aad gets his first comeuppance. Two of his warriors, brothers named Jang-Fil ('War-Elephant') and Sarab-Fil ('Mirage-Elephant'), swagger onto the battlefield.

"One brother took an elephant by its front two legs and the other brother held it by its back legs, and they hurled it into the field. After that they set out for the Amir's army, saying, 'O God-worshippers, can any of you perform such a feat on the field of battle?' Witnessing this feat, the soldiers were astonished. Suddenly a cavalier emerged from the army of Islam.

Not a horse but an eagle he spurred forth.

Not a blade but a crocodile he wielded.

And he entered the field and faced the two brothers, saying, 'What have you done? Two people, one elephant ...

what say you?'

'Let us see,' they replied.

Prince Sa'id Farrukh-Nizhad grabbed the elephant by the chain around its waist. As the two armies watched what was transpiring on the field of battle, that courageous one mentioned the name of the God of the world, seized the elephant and swung it around the field The drums of rejoicing were sounded in the army of Islam, but Sa'id Farrukh-Nizhad slammed the elephant down on the ground so hard that its body was crushed. The two brothers came forth and sincerely became Muslims at the hand of the prince."

Mahesa knows enough to let the fantastic action speak for itself. He fills the entire center of the composition with the elephant, tipping him forward just enough to alert the viewers that the creature appears here in extraordinary circumstances. Only after taking in this spectacle do we catch sight of the diminutive Farrukh-Nizhad as he performs the ultimate power lift. Mahesa disregards the textual specification that Farrukh-Nizhad grasp the chain girding the elephant, a decision he probably made to avoid the artistic problems of drawing the elephant at the angled view that this would necessarily entail. Directly opposite the elephant's head stand the two newly humbled brothers, whose broad faces and bulky, inflated bodies recall those of Mahesa's figure of the giant Tahmasp in cat.46. They express their astonishment and contrition with a well-established gesture of surprise, a gesture one brother doubles, apparently for emphasis.

The remaining elements echo the central forms and actions. The arc of the boulder-studded ridge and even the bend in the trunk of the central tree are designed to parallel the forms of the elephant and the brothers. Likewise, the small horse and groom and the pool of water are inserted to fill otherwise disturbingly vacant spaces in the foreground. The soldiers looking on from beyond the ridge provide the requisite battleground audience, but do not complete the composition in the usual way. Instead, a second billowing ridge and a buffer zone of blue-grey paint are added behind them. The result is a remarkably awkward solution to the corner, one never used again in painting of this period. In effect, Mahesa painted himself into the corner by predicating everything, particularly the left half of the ridge, on the brothers and the elephant.

Ironically, the centerpiece of the painting, the elephant itself, is not Mahesa's work. It is rather the creation of an artist with a profound interest in naturalism, as is evident in the elephant's subtly colored trunk, ragged ear, and thick, supple skin. These features, together with their rich, painterly surface, identify the collaborator as Kesava Dasa, who, in fact, made and signed a very similar elephant painting about a decade later (see fig.26). Kesava probably strengthened the contours of the original ridge and added the second layer of rocks. He also brought his naturalistic touch to a few minor elements as well, notably the heavily modeled trunk of the writhing tree, and the feathery grasses at its base and around the pool. He repeats these three features in three other works catalogued here (cat.55, 56, and 85).

At many times in many places, Umar and Zumurrud Shah are pitted against one another, each doing his wily best to outwit his foe and foil his designs. Here, Umar pulls off one of his more outrageous ploys. The preceding two pages have been lost, and so we know nothing of the details of his deceit. We can, however, surmise from both the painting and the following text that what is shown is an elaborately orchestrated spectacle involving Lakman, king of the Zangis, and a number of his followers. In the Hamza legend, Zangis (Ethiopians) are portrayed as exotic tribal people, so it would be a particularly humiliating experience for Zumurrud Shah to be held at their mercy.

The text that follows the painting supplies the aftermath of this ruse. Hamza rewards Umar for his action, accepts the homage of Lakman and grants that Zangi control of some distant territories, and takes the opportunity to chastise Zumurrud Shah.

"Zumurrud Shah the Lost and the black-faced infidels were summoned to be given advice, but no matter how much he stressed his points, it was of no use.

What profits advice to the black-hearted? An iron nail will not go into stone.

'If they had bound me by force of manliness and chivalry,' said Zumurrud Shah, 'the advice would have had an affect on my heart. But you, *ayyar*, bound me through trickery. All this talk is of no use.'

'Actually,' the Amir said, 'what Zumurrud Shah says is not untrue. Take the bonds from Zumurrud Shah's and the other infidels' hands and feet.' As ordered, the men rushed to release them, and the infidels were released and went to their homes."

The painting presents the culmination of Umar's ruse. Seated on a luxurious throne set beneath a large plane tree is a black-skinned, white-bearded figure, apparently Lakman, the Zangi king. Pressing close to him are his subjects, many clutching maces and other weapons, all garbed flamboyantly in the hides of tigers and leopards. Before the enthroned figure are many captives whose hands are bound with rope. Even under such circumstances Hamza is accorded the place of honor, and sits on a fine carpet before some open books and writing implements. Three other captives are recognizable by their distinctive physiques: Landhaur, the huge, black-skinned figure on the left; Umar Maʿdikarb, the roly-poly creature in orange; and Zumurrud Shah, the familiar bearded nemesis. Each of these figures, including the Amir, has a small label written on his *jama* or turban. This identifying device is important because one other figure is labeled as well: the enthroned king, who is named as Umar in an inscription between his body and right arm. If this means what it seems, then Umar, who often carries out his skulduggery in disguise, has really outdone himself.

The figures themselves are among the liveliest in the whole of the *Hamzanama*. The Zangis crane their necks and screw their faces into quizzical expressions; one particularly memorable figure distractedly sticks his arm completely through a knothole in the plane tree. Hamza is stoic, as usual, but most of the other captives squirm and squeal. And finally there is Zumurrud Shah, wearing jewels in his long beard and a perplexed expression on his face.

The masters who created this memorable scene are Shravana and Dasavanta. Shravana's genius is manifested most vividly here in his figures' highly animated expressions and original poses. See, for example, the assortment of characters with which he fills the lower right corner: a plump, docile figure with an oversized handlebar mustache; a toothy, weasely figure straining forward with his *jama* torn open; and a youth who turns outward to glance knowingly at the audience. He also supplied the fine inlay pattern of the throne and the foliate border of the carpet on which Hamza is seated.

Dasavanta, who probably conceived the scene as a whole, handles paint in a distinctive manner. In general, he is less fluid than Basavana, a difference evident when one compares the faces of Zumurrud Shah in this painting and in cat.33. Similarly, the trunk of the plane tree in Basavana's painting is loosely and convincingly modeled; this one is more decorative, its mottled markings seemingly pulled taut across a flat form in a manner seen later in Dasavanta's one ascribed painting in the *Tarikh-i Khandan-i Timuriyya* (see fig.16). Dasavanta often resorts to stippling, a technique used to great effect here in the Zangis' hats and cloaks. Conversely, in the center of the painting Shravana lays down a carpet of flat green, an effect rarely created by other artists.

Attributed to Dasavanta
and Shravana

Volume 11, painting
number 50, text number 51
India, Mughal dynasty,
circa 1570
67.8 × 51.1 cm
(detail on pp.14–15)
MAK–Austrian Museum of
Applied Arts/ Contemporary
Art, Vienna, B.I. 8770/6
Published: Beach 1987, fig.64;
Egger 1974, pl.36; Egger 1969,
pl.23; Staude 1955a, fig.4; Glück
1925, fig.27.

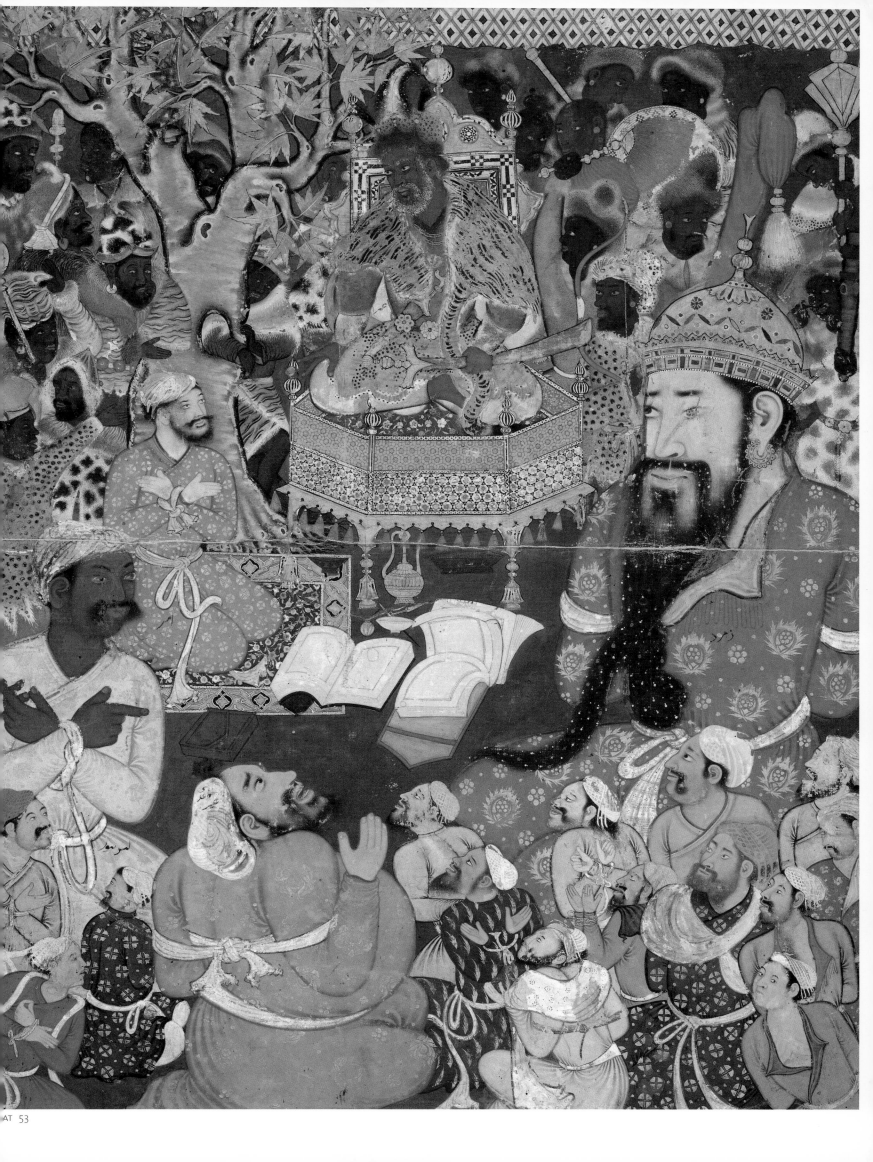

This illustration of an impromptu meeting between Misbah the grocer and the spy Parran has no obvious explanation now, for the text that once preceded it is missing and the text that follows alludes only to Parran in a very oblique manner. Nonetheless, a textual passage on an illustration five folios before this one relates Hamza's concern about the sudden disappearance of his son, Prince Ibrahim, as well as Umar's dispatch of Parran, one of Ibrahim's spies, to discover his whereabouts. Further remarks establish that an enemy *ayyar* named Firoz had kidnapped Prince Ibrahim from his bed and had taken him to the Mihratia Fortress. Malik Sadaj Kohi, Ibrahim's initial jailer, is eager to test the handsome youth's fabled strength, and so challenges him to a wrestling match, but makes Ibrahim swear that should he win, he would submit to imprisonment once more. The honorable Ibrahim agrees, and quickly displays his physical superiority. An alarmed Sadaj comes away from the match with a heightened appreciation of just how formidable his prisoner can be.

This illustration picks up the story when Parran reaches the city where he believes Ibrahim is being held. He somehow encounters Misbah the grocer, a believer in a city of infidels and something of a clandestine operative in his own right. The caption below the painting indicates that Misbah has brought Parran back to his own house, almost certainly to discuss plans to free Ibrahim from prison. Indeed, the text that follows describes the counter-measures Malik Qimar and his spies take to ensure that no one can possibly liberate Ibrahim. Misbah later becomes involved in the search for another of Hamza's allies, Malik Bahman (cat.58), and is finally rewarded for his devoted service by being made chief of police.

For a grocer, Misbah has quite an imposing presence. Even with his legs drawn up beneath him, the customary manner of sitting, he towers over his visitor and the servants ringing the courtyard. Parran, crouching before Misbah and speaking animatedly, looks every bit the seasoned spy: he wears a rakish fur cap on his head, a tigerskin cloak over his bare shoulders, a long horn across his back, and ample golden chains about his neck and ankles. Misbah's house shows no sign of his regular occupation; instead, it is crisscrossed with spy paraphernalia of every sort, from swords and shields to arrows and pelts. Most of the surrounding figures have already availed themselves of this stock, and one young follower worriedly clutches a musket, among the earliest depictions of this newfangled weapon in Mughal painting. By contrast, only two figures attend to the lavish platters and flasks set on and around the brilliant red cloth in the center of the courtyard.

Dasavanta's hand is seen in many parts of the painting. Most obvious are Misbah and Parran, the one given a voluminous *jama* and a deep black-green scarf with streaky gold highlights, the other characterized strongly and rendered in an adventurous back-turned view. As in cat.59 and cat.64 – both scenes involving spies – Dasavanta emphasizes the courtyard's crisp geometry by framing it with an absolutely flattened doorway and a wall comprised of repetitive niches, and by filling it with an exceptionally assertive octagonal tilework pattern. He continues this tendency to maximize contrast in the chamber itself, using a pure white wall both to silhouette the figures and to set off the ornamental display of weapons. The vibrant foliage of the tree in the upper right is also typical of his work.

The other figures are by Mithra, an artist who played a secondary role in a number of paintings in this volume. His figures have noticeably oval faces with large, dark features, and often assume strikingly apprehensive expressions. Several figures have had their faces partially or entirely repainted, most conspicuously Misbah and the soldier in white in the lower right.

Attributed to Dasavanta and Mithra

Volume 11, painting number 52, text number 53
India, Mughal dynasty, *circa* 1570
Painting 67.5 × 52.2 cm, folio 70.8 × 54.9 cm
Caption: 'Misbah the grocer, who was a Muslim, brings Parran *ayyar* into his own house'
The Metropolitan Museum of Art, Rogers Fund, 1924. (24.48.1)
Published: Kossak 1997, no.7; Welch 1987, no.102; Bowie 1970, no.124; Dimand 1948, fig.2.

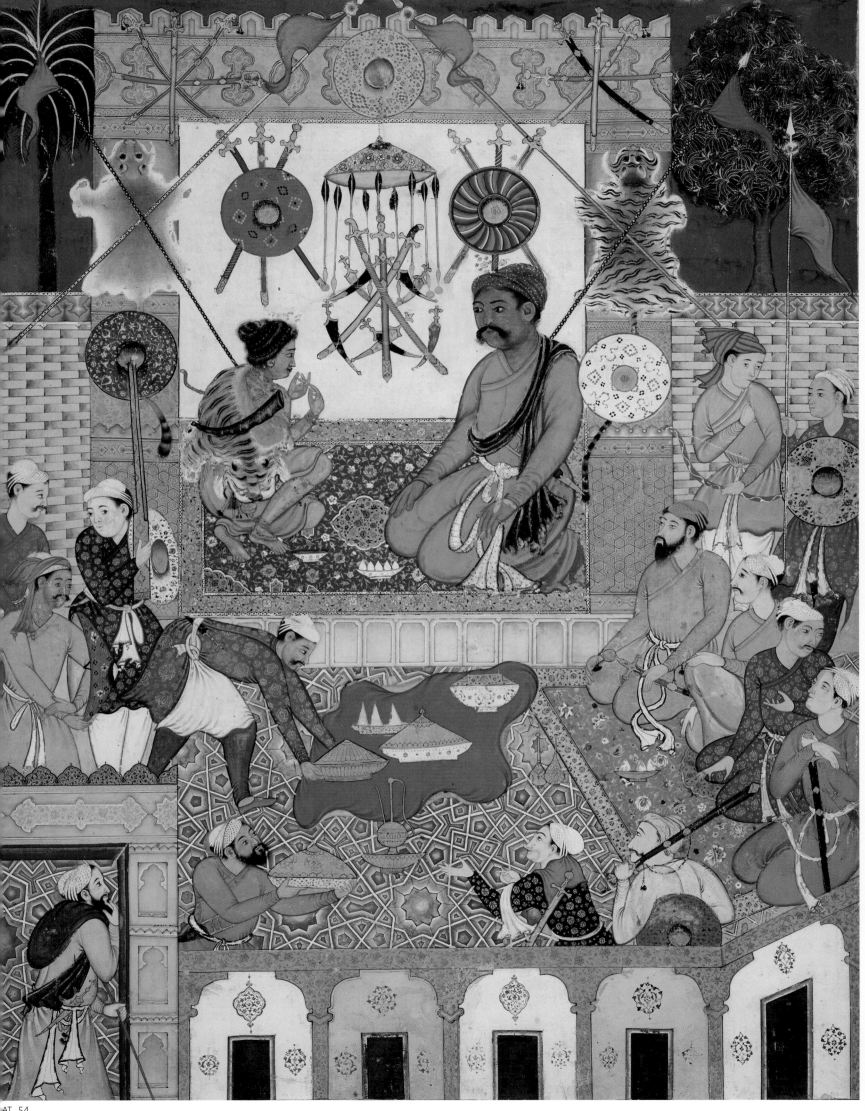

AT 54

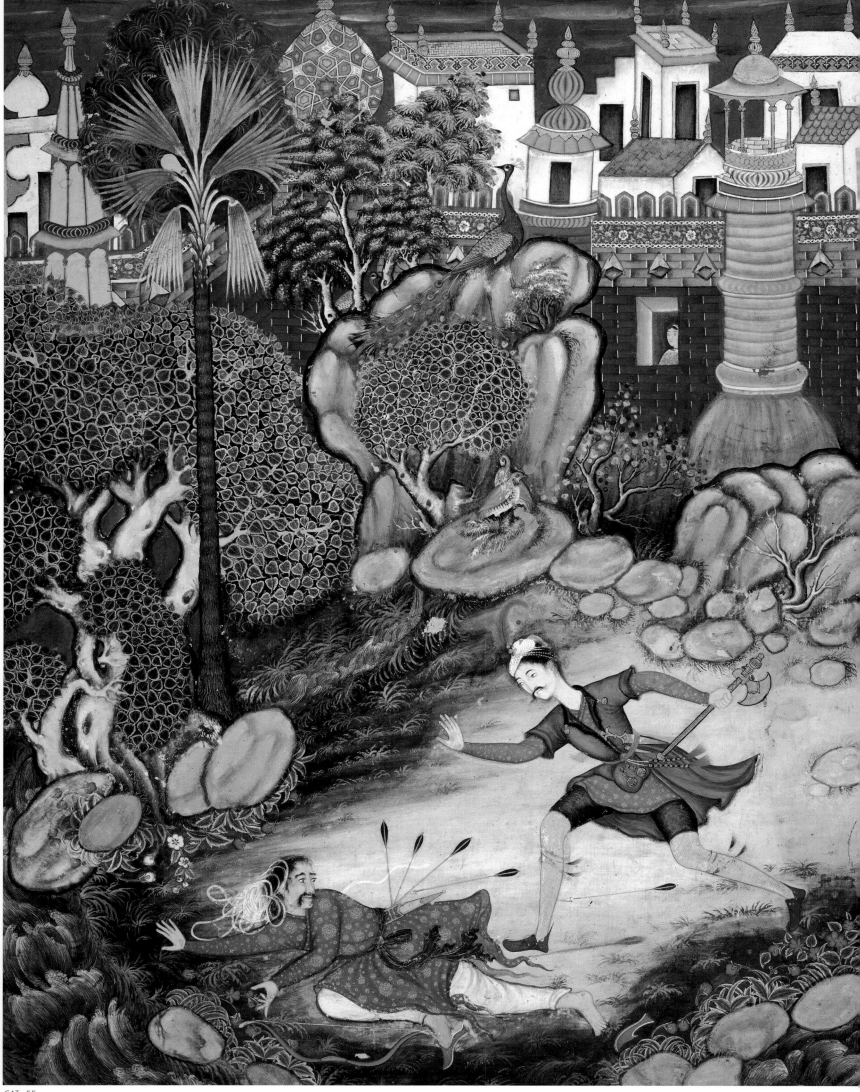

55 UMAR WALKS AROUND FULAD CASTLE, MEETS A FOOTSOLDIER AND KICKS HIM TO THE GROUND

Attributed to Kesava Dasa and Mah Muhammad

Volume 11, painting
number 55, text number 56
India, Mughal dynasty,
circa 1570
Painting 67.3 × 51.3 cm,
folio 73 × 56.5 cm
Caption: 'Umar walks around
the outside of Fulad Castle,
sees a footsoldier, and con-
cealing himself, gives him a
kick, and the footsoldier, who
was an *ayyar* of Fulad, falls'
The Metropolitan Museum of
Art, Rogers Fund, 1923. (23.264.2)
Published: Brand & Lowry
1985, no.11; Dimand 1948, fig.3.

1. See, for example, the
painting of St. Matthew the
Evangelist, signed by Kesava
and dated 1588, Bodleian
Library, Oxford, MS Douce
Or.a.1, f.41b; Topsfield 1994,
no.5 (color).

Now Umar demonstrates the other skill that his job requires. Sent out on a reconnaissance mission around Fulad Castle, Umar hears a stranger approaching. He hides until the armed footsoldier is before him and then ambushes him, knocking him to the ground with one powerful kick. Umar pounces on him, and sitting on his chest, threatens to kill him. The perturbed footsoldier, an *ayyar* named Haybat, pleads for mercy:

"'Khwaja Umar, don't kill me, for I will render you good service. I will show you the way into the castle.'

Khwaja Umar rejoiced and took the *ayyar* to the Amir. When the Sahib-Qiran asked him about himself, he said, 'O prince, if you mount I will show you the way.' The Amir Sahib-Qiran mounted with a group of champions with that *ayyar* in front. He led them to the foot of a mountain and showed them a tunnel."

Hamza immediately puts the *ayyar*'s information to good use. He proceeds down the tunnel that the *ayyar* revealed, and pops up in the middle of Fulad Castle, where he touches off a great commotion. The lord of the castle, Fulad Aad, learns from his vizier that the intruder is Hamza, a hero without equal, one for whom no task is too difficult. With this unstoppable figure in their midst and his followers at the gate, the vizier advises Fulad Aad to abandon the cause of Zumurrud Shah and to convert to Islam. This Fulad Aad does gladly. All the people of his domain convert as well.

The ambush itself, which must be the act described at the very end of the preceding page, is depicted with great flair and narrative economy. Umar, for whom weapons are normally superfluous, holds his battle-axe behind him as he scuttles across the brightest part of the composition in pursuit of his victim, whose escape is cut off by a stream. The unlucky *ayyar* sprawls helplessly before his attacker. He is clearly panic-stricken: his expression is anxious, his turban has come utterly undone, his shoe has fallen off, and his arrows lie beside him like so many porcupine quills shed in vain. In the background is Fulad Castle, where a lone woman watches from a window placed incongruously in the middle of its walls.

This dramatic scene is the work of Kesava Dasa. Kesava Dasa was particularly enamored of European-style modeling, an effect used selectively here, as it typically is throughout his work, to convey the deep, voluminous folds in Umar's fringed robe and the clinging, body-revealing quality of his running shorts. It is probably no coincidence that Kesava chooses to dress Umar in a deep blue, the color worn by many religious figures in European painting, and one that he employs often in his later work.[1] Both figures also have the long, narrow nose and tight, dark features that Kesava habitually favors in his facial types.

Much of the appeal of this painting stems from the luxuriant landscape, which belies the sinister mood of the episode. Some details, such as richly textured, whitened tree trunks, and the feathery, spiderlike tufts of grass, are familiar from Kesava's previous *Hamzanama* painting (cat.52). Others, such as the dark sward along the stream and the date palm tree, are new to his work. Still others come into view only after some-time. The brace of partridges resting in the very center of the painting, the peacock and peahen roosting dis-creetly above them – these bits of closely observed nature bring moments of vitality and joy to even the most violent of scenes.

The upper part of the painting appears to have been done by another artist. The castle is presented as a con-glomeration of boxy forms, a far cry from both the rich naturalism seen below and the spatially complicated cityscapes that Kesava designs in his later works. One notable departure from this formulaic quality is the bulbous base of the turret, rendered as a streaming thin wash quite unlike the even, opaque forms behind it. And when we realize that the patch of paint beside the base describes no form in nature, but only serves to blur the transition between the grove in which Umar fells his *ayyar* counterpart and the architecture of Fulad Castle, we see how two artists could cobble together their separate contributions to produce a painting of this size and complexity. The architecture has the same naive quality as Mah Muhammad's other efforts in this vein, and should be attributed to him.

The conversion of Fulad Aad sets in motion events that bring both death and deliverance to Hamza's family. As Hamza prepares to marry off one son at the newly converted city, he sends for Sanawbar Banu, who, because she is pregnant with his child, is to travel from Noshad by sea.

"She started out in a boat, but the heavens rumbled and an adverse wind arose. The whole sea became so stormy that the boat crashed against a cliff and sank. Sanawbar Banu got onto a raft, and her labor pains began. She brought forth a son on the raft. She had a jewel from the Amir on which his name was engraved. She bound the jewel to the infant's arm, wrapped him up in a piece of cloth, and died three days later. The child remained on the raft for two more days. The raft floated until it reached the island of Siquliya, where all the people were worshippers of water. Siqulshah was the king, and he possessed three thousand leagues of land. There were several wise men in attendance upon the throne, and he was a worshipper of water and did not obey Zumurrud Shah.

However, there was a fisherman in that city named Iskandar. It was his habit to go to the edge of the sea to fish from morning till evening, and thus he lived and passed his time. By chance, one day he was busy fishing when from a distance his gaze fell upon a raft. When he looked carefully he saw the raft coming into view, and there was something wrapped in cloth on it. At once he stripped, bound his loins, pronounced the name of the One God, jumped into the sea, and swam out. When he reached the raft, he took hold of the raft and swam back to the shore. When he opened the bundle, he saw that it was a crying babe. His heart melted. He kissed the child with love and affection, took it into his arms, and adopted it as his own child, giving it the name of his own father, Darab. Then he took it home and entrusted it to his wife. She was childless, but she was very desirous of having children, so she took the child in her arms, and at once milk flowed into her breasts. Thus she began to raise the child."

Kesava illustrates the poignant moment when Iskandar looks into the eyes of the helpless Darab. To enhance the drama, he shifts this moment backward in time so that the babe is still adrift on the waters. Likewise, he moves the encounter to the shallow waters just beyond the shore, a decision that allows him to include a heap of nets and baskets that identifies Iskandar as a fisherman. It also gives him an opportunity to show Iskandar wading rather than swimming, a pose that reveals nearly all of Iskandar's muscular body.

Because this concise group of forms occupies no more than a third of the painting, Kesava is free to fill the remainder of the scene with whatever pleases him. He begins by constructing a low screen of rocks and thick trees in an arc parallel to that of the shoreline. He staggers this screen a bit at a spot just above Iskandar, and uses that resulting bright space to introduce a highly developed genre scene: a shepherd lazily coaxing a motley flock home for the night, an ensemble preceded by some women doing daily chores. The city to which they all return is a gaudy architectural patchwork, an element absolutely irrelevant to the narrative, but an effective counterpoise to the relatively open and drab area of grass and water. And finally, there are the animals: two jackals nipping at each other, two partridges shrieking at intruders, and a lone chipmunk scurrying to safety.

Kesava again invokes his favorite effects and forms. Iskandar's body, for example, displays a subtle muscular articulation unknown in comparable figures, such as the scantily clad boatman in cat.30.[1] The infant is wrapped in heavily modeled swaddling, here made red to set it off from the dark raft and sea. The sea itself is studded with flotsam and aquatic life. The latter enlivens the waters, of course, but also adds to the young castaway's perils. Considerable care is exercised even in the most minor details. Kesava, for instance, originally included four ducks to the left of Iskandar's outstretched hand, but later painted them out because they diluted the encounter between Iskandar and Darab. The artist also indulges his keen interest in various textures, manifested most strikingly in the decayed surface of the blasted stump on the right, the coarse weave of the shepherd's cloak, and the raised stippling of the white sheep's wool.

Once more he lets another painter supply the architectural backdrop. This time, however, Kesava does not merely run his ponderous rocks over parts of the buildings and the people before them, he also interpolates an entirely new building: the finely detailed white temple in the upper left. He even dabbles in the sky, which changes from a flat blue to a streaky blue-black – a favorite color of his – at exactly that point.

Attributed to Kesava Dasa

Volume 11, painting number 56, text number 57
India, Mughal dynasty, *circa* 1570
Painting 68.5 × 52 cm
Caption: 'Iskandar finds a raft ... [and on it sees] Darab, Hamza's son'
Museum of Fine Arts, Boston, Horace G. Tucker Memorial Fund and Seth Augustus Fowle Fund, 24.129
Published: Boston 1982, no.165; Coomaraswamy 1930, p.16, pl.I; Comstock 1925, p.357.

1. An exceedingly similar figure appears in one of Kesava's ascribed paintings in the *Darabnama* (f.46a); Okada 1998, p.88, fig.4. See fig.25 on p.52, above.

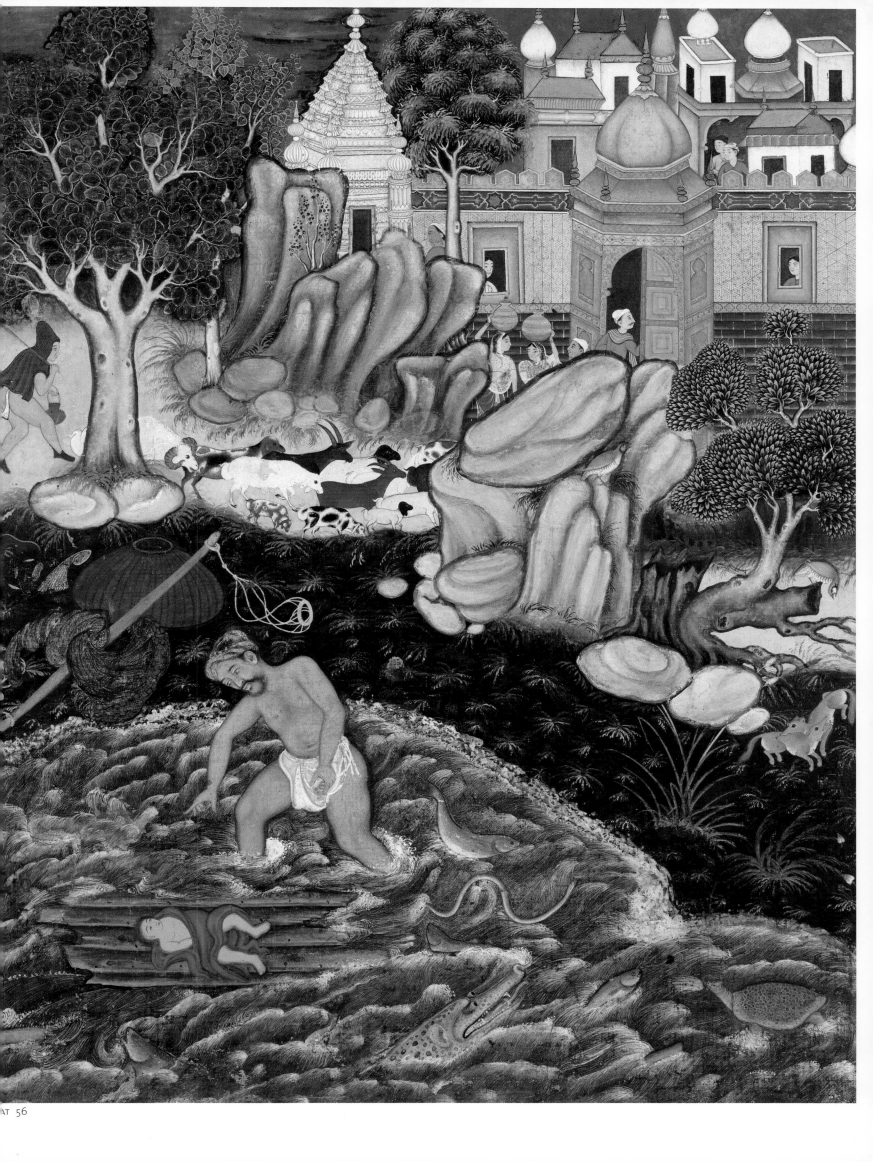

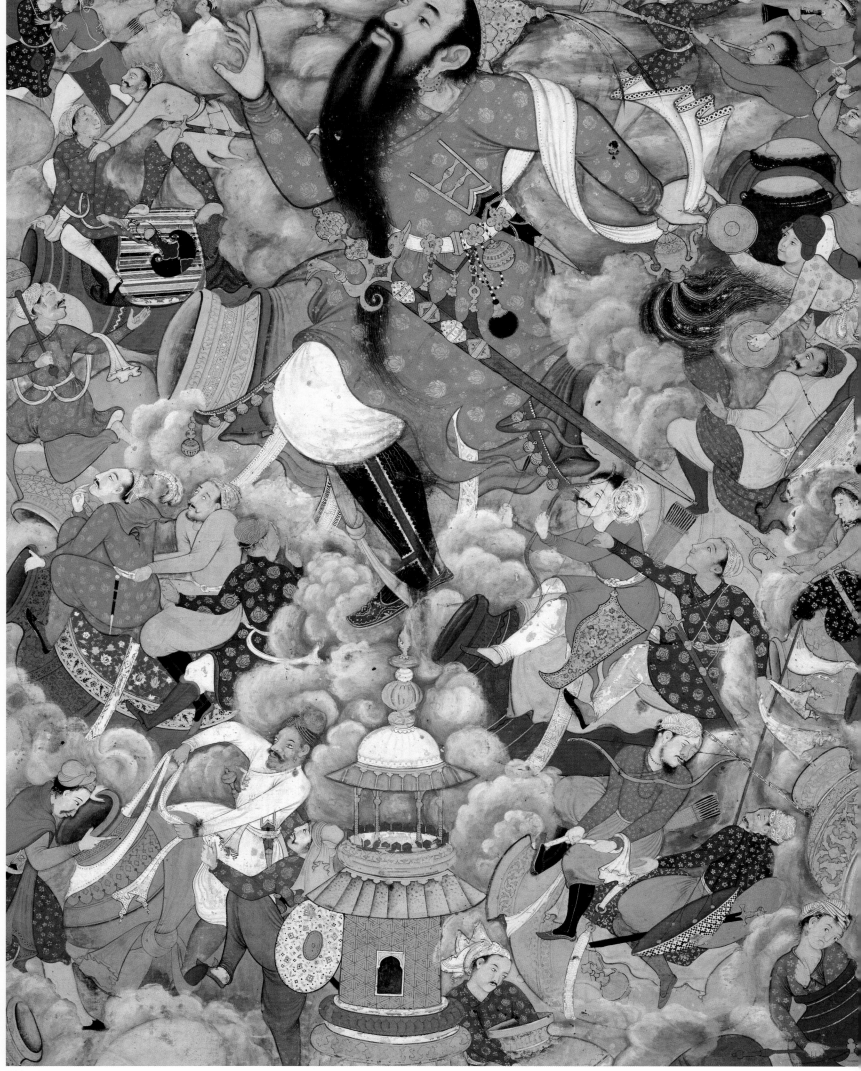

57 ZUMURRUD SHAH FLEES WITH HIS ARMY TO ANTALI BY FLYING THROUGH THE AIR ON URNS SENT BY SORCERERS

Attributed to Shravana and Madhava Khurd

Volume 11, painting number 58, text number 59 India, Mughal dynasty, *circa* 1570
67.1 × 52 cm (details on pp.6–7, 176–77)
Caption: 'Several thousand urns appear and all the soldiers of Zumurrud Shah sit on them'
MAK–Austrian Museum of Applied Arts/ Contemporary Art, Vienna, B.I. 8770/28
Published: Brend 1993, pl.xxxvii; Beach 1987, fig.40; Egger 1974, pl.38; Egger 1969, pl.24; Staude 1955b, fig.27; Glück 1925, pl.31.

1. This same arabesque, which has distinctive crab-like foliate forms, appears in cat.23, 42, 47, 67, and 74, as well as in MAK, Vienna, B.I. 8770/22 (Reconstruction, no.84); the last of these is a joint effort by Basavana and Shravana.
2. Compare his work in the *Darabnama*, especially ff.27a, 74a, and 101a (see fig.27 on p.53, above). In every case, he depicts a king with the same type of crown worn here by Zumurrud Shah. Folio 74a is published in Schimmel & Welch 1983, fig.6.

The story returns again to Zumurrud Shah, the resilient archfiend, who once more must flee before Hamza's might. He heads for Antali, a city ruled by Mâlik Zarduhusht (Zoroaster). Informed of Zumurrud Shah's intention to take refuge there, Mâlik Zarduhusht calls together in council hundreds of thousands of sorcerers. They know that while Zumurrud Shah professes the wrong religion, they have heard that Hamza accepts Islam as the only legitimate religion. Concluding that Hamza poses a greater threat to their power, they agree to welcome Zumurrud Shah to Antali and do everything possible to thwart Hamza. For sorcerers, of course, this involves incantations. To neutralize Hamza, no novice in the art of magic, they cast a spell upon him so that he can remember neither spells nor counter-spells, and then conjure up fantastic illusions to terrify his followers. Hamza is helpless until a sympathetic sorcerer appears before him and tells him that he must kill the sorcerer Iblis to break the spells' power. When Hamza does this, the tide of battle turns against the sorcerers.

Zumurrud Shah learns of these unexpected developments while still on his way to Antali, which the sorcerers have protected with a forcefield of spells.

"'How are we going to get past the talismans?' asked Zumurrud Shah.

'I will send someone and inform them of your approach,' he said. He made a bird of clay, wrote a letter, tied it to the bird's wing, worked his magic, and made it fly to Antali.

Two days later they saw that several jars had appeared. Zumurrud Shah and all his commanders, horsemen, and soldiers were sat on the jars, and off they flew into the sky toward Antali. The next day when the sun in the orient lit up the ancient world, several thousand jars appeared in the sky, and all of Zumurrud Shah the Wayward's horsemen and soldiers were sitting on the jars. The whole city of Antali was festively decorated, strange and fabulous shapes were made, and fine carpets were laid. Then, when Zumurrud Shah stopped at the gate to Mâlik Zarduhusht's house, sorcerers gathered all around Zumurrud Shah to welcome him and escort him into the palace, where a banquet was given in his honor."

What a spectacle! Pride of place in this unlikely airborne cavalcade is given to Zumurrud Shah, who soars so high that he flies over a tall tower and bursts out the top of the composition. Although the huge urn he bestrides has been outfitted with saddle and stirrups, Zumurrud Shah betrays his uneasiness by flailing his arms and opening his eyes wide in amazement. Nonetheless, he is the very picture of composure by comparison to his soldiers. One clings wild-eyed to makeshift reins even as one companion clambers aboard behind him and another peers into the vessel. A warrior in the upper left tentatively pioneers the sport of jug-walking. In the center right, still another rider performs a rodeo move as he tries to maintain control of his rambunctious red standard. And in the lower right corner, one particularly hapless rider has managed to get himself wedged into his urn, an act whose stupidity he acknowledges with a sheepish look.

Because this scene has so many wonderfully inventive expressions and details, one naturally thinks first of the most original Mughal painters, Dasavanta and Basavana, as its likely creator. Yet the painting is actually by Shravana, an artist whose earlier works in this catalogue (cat.42 and 47) are considerably tamer. Nevertheless, Shravana's hand is recognizable in many details: the brutish squared brow of the figure to the left of the tower, the focused eyes and tight mustaches, the *jamas*' patterns and selective modeling, the palette, and even the broad foliate pattern on the neck of the urn in the lower right.[1] Some credit for this fanciful scene must also go to the original author of this tale, for who could fail to be inspired by such outlandish whimsy?

Zumurrud Shah is executed in a markedly different style. His large, dark, and rounded features rival those of Basavana's figures in sensitivity, but the eyes are more languid, the lips fuller, and the beard wetter than the corresponding features of Basavana's Zumurrud Shah (cat.33). This figure is, in fact, by Madhava Khurd, an artist recognized as being so gifted in rendering faces that he was often called upon to add special faces to collaborative works.[2] Here, he supplies the entire figure of Zumurrud Shah as well as the thick, buoyant clouds, which, on the evidence of the forms they overlap, were apparently the last element to be painted.

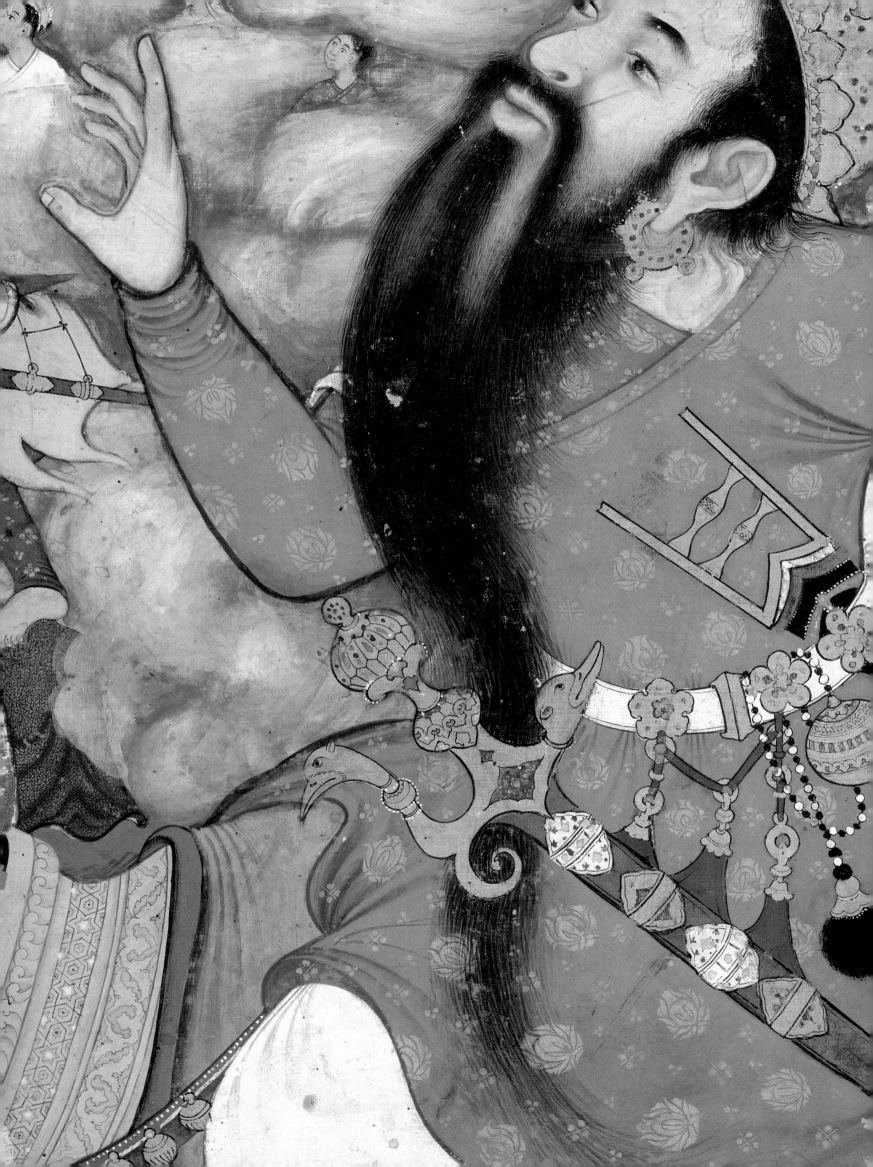

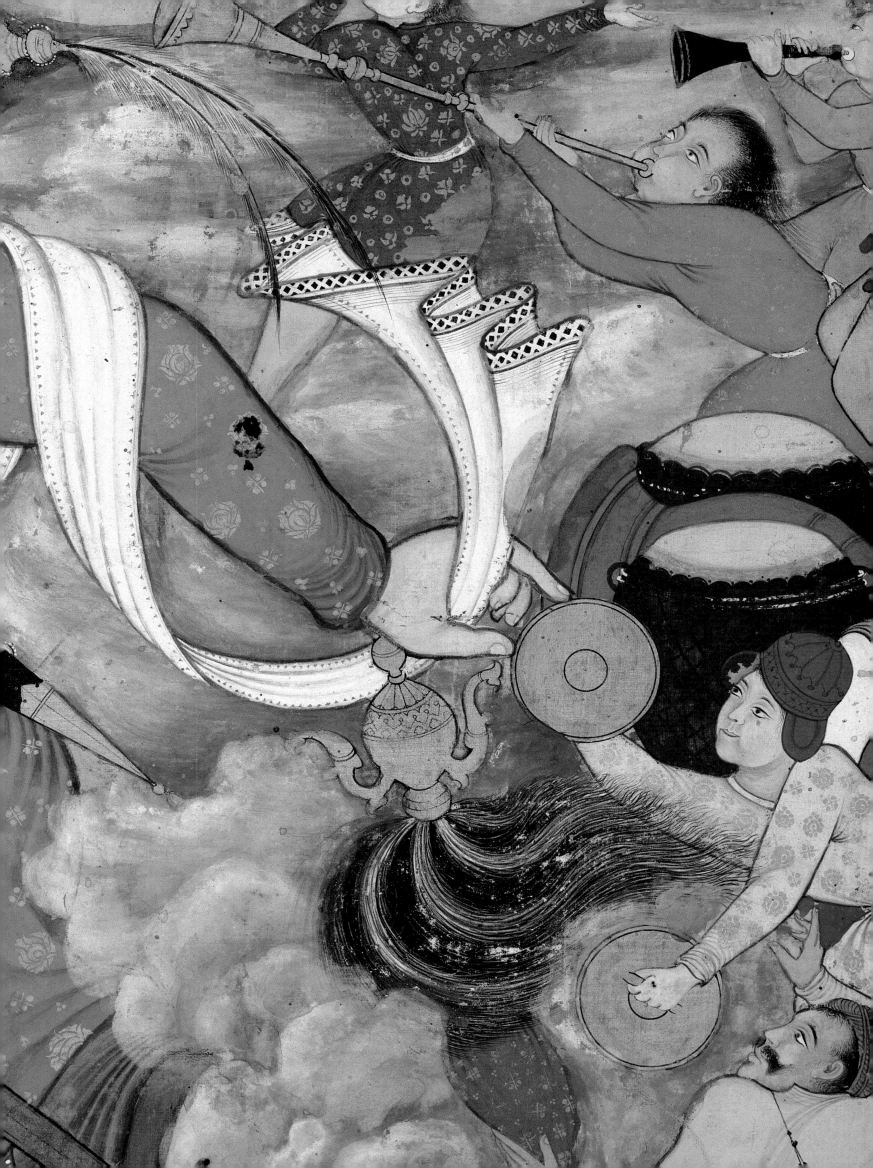

Malik Bahman, a former enemy who converted to Islam, is sent to negotiate the surrender of Qimar and his city. He, however, is swayed temporarily from his mission because he meets a beautiful maiden with whom he passes time in feast and dalliance. After Malik Bahman has been gone a while, rumors begin to circulate that he was among those killed in a recent battle. Hearing these rumors, Qimar plots to use them to his advantage, and deceptively proclaims that Malik Bahman is dead indeed, for he had ordered him killed for his reprehensible behavior while he was at Qimar's court. News of Malik Bahman's purported death spreads rapidly, causing consternation among Hamza's army, which is led by Sa'id Farrukh-Nizhad, he of elephantine strength (cat.52). Some of Hamza's informants in the city are asked to confirm Malik Bahman's death, but they cannot, and report that there is a suspicious lack of physical evidence. Qimar knows why this is, of course, and orders a night watchman named Setamsal to scour the city for Malik Bahman. Similarly, two of Hamza's spies, Songhur Balkhi and Sabukpay Eki, learn of the situation and resolve to find out the truth. That night they make their way to an unguarded section of the city walls. Using a rope to scale the tower, they creep into the city and slit the throats of the guards sleeping nearby. They do not get far, however, before they run into Setamsal's patrol. Songhur leaps to an adjoining rooftop and escapes, but his mate is not so fortunate. As he jumps, the edge of the roof gives way, and he falls into captivity. When the murdered guards are discovered, Sabukpay is taken to prison and put in the same cell as Prince Ibrahim, Hamza's son.

Dasavanta, the designer of this painting, takes a minor detail from a routine act of espionage – a spy clandestinely entering a city – and makes it the focus of the scene. He does this by isolating the rope-climbing spy against the only relatively plain area in the painting, and by giving him a shield with a loud pattern. More important, he lavishes attention on this figure, so that the spy wears a fiercely determined expression, his body hangs heavily, his feet catch hold of the rope in a practiced manner, and the rope responds to every straining limb. Only after we pause to admire this *ayyar*'s stealth and skill do we notice that his fellow spy is already among the sleeping sentinels, holding a severed head aloft as his first trophy and readying a sickle to continue his bloody harvest. The rest of the witless guard detail, their faces and bodies contorted in sleep, sprawl comically across the brightly tiled watchtower and courtyard.

Contrasting with this ruthless and cluttered environment is the tranquil and luxuriant stand of trees outside the fortress walls. The burgeoning vegetation, rendered with a vigorous but controlled brush, is clearly intended to be an expressive, if not narrative, part of the painting. The charming animals, from the pair of foxes to the monkeys grooming each other, to the parrots flitting among the trees, leaven the scene still further.

These two different environments were shaped by a complementary team of artists. Dasavanta laid out the composition and painted the two spies, who stand out from the other figures by style as well as by action. Dasavanta's hand is visible in the hairy, animated faces of both spies and in the daubed modeling of the lower one's blue garment.[1] He also contributed the marvelous trees and animals, some of which appear in a virtually identical style in his ascribed painting in the *Tutinama*.[2] The other painter, Mukhlis, supplied the guards and their slightly ungainly courtyard. Here, as elsewhere, Mukhlis attempts to model his figures' faces by superimposing faint wrinkles and folds of flesh on them. He models clothing with a similarly heavy-handed convention, an effect particularly conspicuous in the green *jama* of the recumbent sleeping guard.

Attributed to Dasavanta
and Mukhlis

Volume 11, painting
number 65, text number 66
India, Mughal dynasty,
circa 1570
67.6 × 51.1 cm
(detail on pp.180–81)
Caption: 'Songhur Balkhi and
Sabukpay Eki come [and] with
a lasso enter the fort of Qimar'
MAK–Austrian Museum of
Applied Arts/ Contemporary
Art, Vienna, B.I. 8770/25
Published: Welch 1978, pl.1;
Egger 1974, pl.40; Egger 1969,
pl.26; Staude 1955b, fig.29;
Glück 1925, pl.33.

1. The latter compares very
closely to the treatment of
the sail in cat.36.
2. See cat.36, n.1.

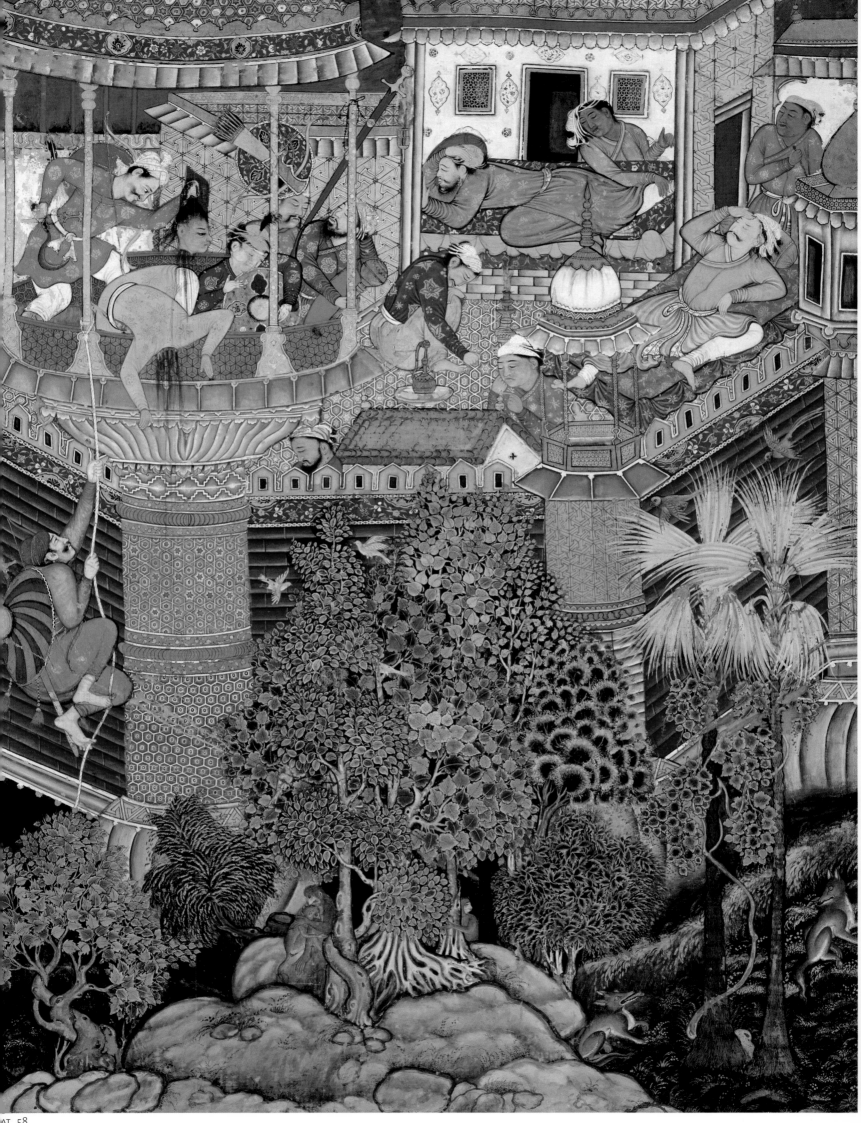

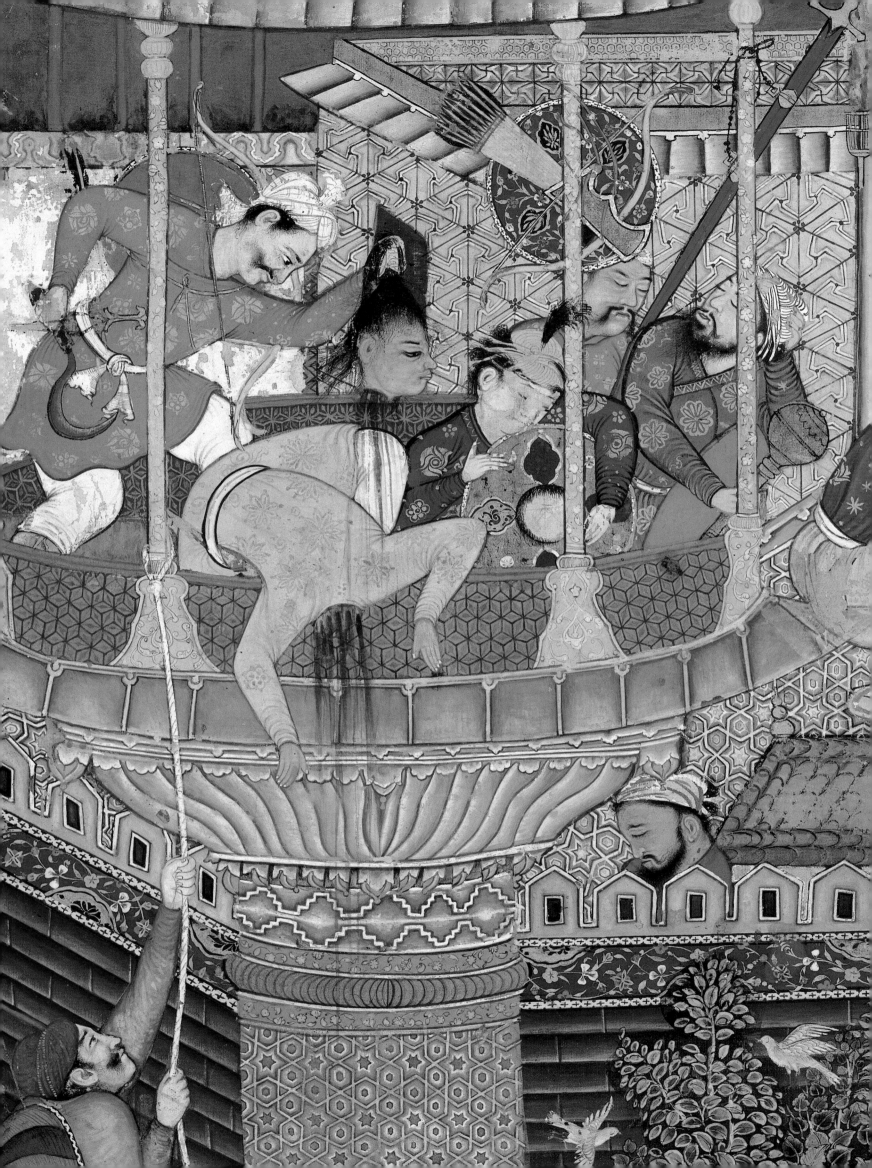

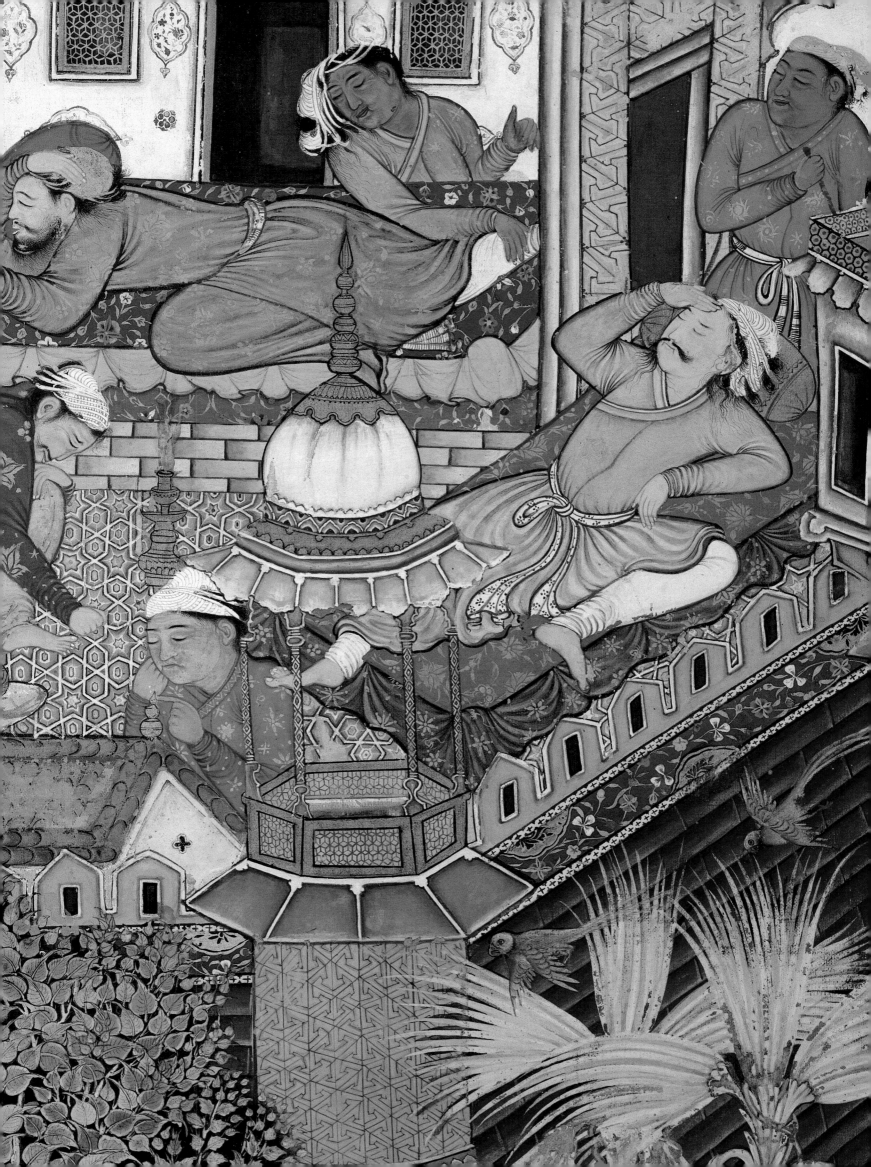

Detail of CAT 60

THE ABDUCTION AND LIBERATION OF KHWARMAH
CAT 59–61

The villain Qimar flees to Tawariq, whence he sends out his spy Mahus to discover the plans of the Muslim forces led by Sa'id Farrukh-Nizhad. Mahus learns that Qimar's former vizier, Khwaja Bihbud, wants to rejoin his master, and together they hatch a plot to release from prison Qalmas, Qimar's cousin, and kidnap Khwarmah, Qimar's daughter, who has fallen in love with Prince Ibrahim. Having achieved this, Mahus persuades Bihbud that the most effective way to smuggle Qalmas, Khwarmah, himself, and his wife out of the city is to conceal them all in chests. Mahus has the four large trunks loaded onto camels outside an inn, a sight that arouses the suspicion of Zambur, one of Hamza's spies. Because Zambur is alone, he is unable to compel the guards to divulge the contents of the questionable cargo, so he hastens to report the situation to Ibrahim. Ibrahim comes to investigate with a large number of soldiers, but they arrive too late: the caravan has departed already, and with it the cherished Khwarmah.

Khwarmah is held in Tawariq, and the allies ask Ibrahim's spy Zambur to find her. Sher Banu volunteers her maid Mahiya to accompany him. Posing as man and wife, riding two donkeys loaded with fruit, she and Zambur arrive in Tawariq and find the house of a female doctor, Ustad Khatun. Mahiya makes the doctor a present of the fruit she has brought, and persuades her to take her as a patient. By night Zambur discovers where Khwarmah is held, but is arrested by a group of guards led by one Gharrad. The guards are so drunk that they hang Zambur up by his feet before falling asleep. Mahiya finds them in this state, recognizes Zambur, and cuts him down. She then kills all the guards except Gharrad, whom she strings up in Zambur's place.

Mahiya now uses gentler means to get to Khwarmah. She charms Ustad Khatun into letting her accompany her on her rounds, which, Ustad Khatun brags, include tending to Khwarmah in the luxurious setting of Malik Na'im's harem. When the eunuchs and queen ask why Ustad Khatun has brought this new woman with her, she fobs them off with claims that the stranger is her sister or relative, and sometimes helps her with her work. As Mahiya enters Khwarmah's chamber with Ustad Khatun, Khwarmah recognizes her and gives her a knowing smile. She quickly makes an excuse to have Mahiya remain with her that night. Once they are alone, the two women update each other on Khwarmah's confinement and the plans for her rescue.

Meanwhile, Malik Na'im's son, Ghazanfar, is hopelessly in love with Khwarmah. Seeing his despair, his mother orders her spy Tarmas to drug Khwarmah, abduct her from Tawariq and take her to Khurramabad, where Ghazanfar can marry her. Once again Zambur and Mahiya set out to rescue her. Posing as a fortuneteller, Zambur tells Ghazanfar that his sister is so well-versed in magic that she can prepare a potion that will make Khwarmah love him. When Ghazanfar arranges for Khwarmah to meet Mahiya, the two women again collude, this time with the result that Ghazanfar is drugged and thrown into the sea, and Zambur and Mahiya smuggle Khwarmah out of Khurramabad. To escape, they must cross a desert, which blisters Khwarmah's feet. Zambur obtains a horse for her by murdering a sleeping enemy agent, on whom he discovers a letter authorizing the forced marriage between Ghazanfar and Khwarmah. Zambur ultimately leads the brave party to Ibrahim's camp, where the prince is blissfully reunited with his beloved.

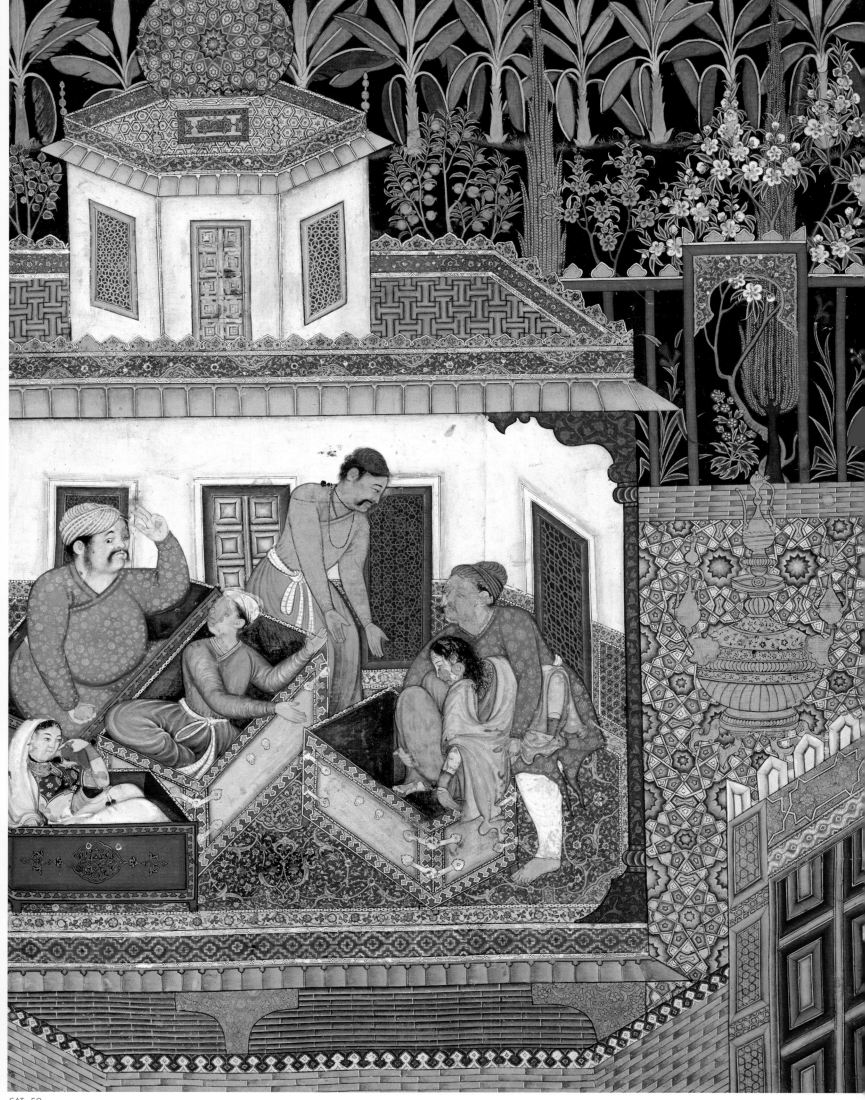

**Attributed to Dasavanta,
Jagana, and Madhava Khurd**

Volume 11, painting
number 66, text number 67
India, Mughal dynasty,
circa 1570
67.8 × 51.5 cm
Caption: 'Khwaja Bibhud
puts Qalmas and Khwarmah
in a trunk on the advice of
Mahus Ayyar'
MAK–Austrian Museum of
Applied Arts / Contemporary
Art, Vienna, B.I. 8770/33
Published: Egger 1974, pl.41;
Betz 1965, pl.11; Glück 1925,
pl.34.

The plot thickens now. Songhur Balkhi manages to free Sabukpay Eki and Prince Ibrahim from prison, an action that soon leads to the city's capture by the forces of Sa'id Farrukh-Nizhad and the flight of Qimar to Tawariq. The villainous Qimar dispatches his spy Mahus back to the city of Zibarjadnagar, where Ibrahim is now in charge. There, Mahus overhears Khwaja Bihbud, Qimar's former vizier, trying to devise a plan to rejoin and please his master. Mahus enters and proposes a daring plan to extract Qalmas, Qimar's cousin, from prison and to drug and kidnap Khwarmah, Qimar's daughter, who has taken up with Prince Ibrahim.

"After several days he arrived and released Qalmas, took him to Bihbud, and said, 'I'm going to bring Khwarmah.' He went. Khwarmah was in a garden asleep on a throne, so he went over the wall into the garden, rendered her unconscious and took her to Bihbud.

'O *ayyar*,' he said, 'in one night you have done something no one has ever done.'

'O *khwaja*,' he said, 'now one must go.'

'How should we go?' he asked.

'I will put you in a chest, the wife in another chest, Khwarmah in another chest, the cousin in another. Then I'll load the four chests and put those who are loyal to you in a certain caravanserai.'

Bihbud said, 'That's a good idea.' And they set out to execute that plan."

Dasavanta takes some license with the action described in the caption and last line of text. Four figures are already stashed in trunks, and two more stand beside them. Mahus, the mastermind of this operation, is presumably the central figure in violet exhorting Bihbud as he dumps the stupefied Khwarmah into the trunk on the right. The alert woman opposite is Bihbud's wife. The young figure in blue must be Qalmas, identified once as Qimar's cousin and another time as his nephew. The occupant of the fourth trunk, the heavyset figure in red, seems to be an interloper, for if Bihbud himself is to be among the stowaways, then one trunk should still be empty. Indeed, it appears that the artist did not trouble himself much with the headcount described in this somewhat confusing story, and simply filled the four trunks mentioned in the text with four figures, a solution more satisfactory on a visual level than on a strictly narrative one.

No matter who they are, the figures are characterized with remarkable acuity, particularly for a scene with little overt drama. Khwarmah's face, though damaged, is convincingly addled; her body, with one arm pulled uncomfortably back, is believably limp. Even her yellow robe is modeled with such fluidity that it seems to wrap about her like a shroud. On Qalmas, Dasavanta takes the modeling to still more compelling extremes, streaking the blue robe relentlessly with wet, white highlights in a manner later made famous by El Greco. No less engaging is the corpulent figure, who, already filling the trunk to capacity and still awaiting the lid, twists his mouth to the side in an expression conveying both apprehension and skepticism. This figure, however, is the work not of Dasavanta, but of the figure specialist Madhava Khurd. Here, again, the figure is outlined with a wet, black line; his eyes are more rounded than those of Dasavanta's figures ever are, and his left hand is noticeably plumper and more three-dimensional than any other figure's in the painting.

Dasavanta devotes the remainder of the scene to a courtyard and garden, two of the most common elements in Mughal painting. Dasavanta, however, infuses these standard features with uncommon boldness. He positions brackets and eaves below the chamber, for example, but the resulting visual rhythm of that foreground area is so exciting that the structural incongruity becomes a mere afterthought. He gives the tilework pattern such geometric and coloristic strength that it pulsates; indeed, it advances so much that the chamber appears to recede into it. Similarly, he makes a normally innocuous golden vessel swell to oversized dimensions and shake with a surfeit of energy. Likewise, the garden he creates is both orderly and vibrant, tied to the rest of the architecture by the framing red fence, and given emphatic regularity by the rank of plantain trees. For the ground, Dasavanta selects one of his favorite colors – a greenish black – to heighten the contrast with the bright flowers and beaded yellow buds of the cypress trees.

Some of the architectural details, notably the trilobed pattern and shaded brick of the front wall, the blue band along the roofline, and the dome of the rooftop kiosk, are the work of Jagana.

Once the allies know that Khwarmah is being held in Tawariq by Bihbud, they ask Ibrahim's *ayyar* Zambur to retrieve her. He is willing, but fears that the infidels will kill her if they know that he is near. Ibrahim suggests that they ask Sher Banu for her advice.

"She said to the person who had been sent, 'I don't know, but I have a woman in my service who has no equal in trickery and sneakiness. She says that if someone goes with her she will go into the city and get word of Khwarmah.'

... She said to summon Mahiya. 'Get two donkeys,' she said. 'Load one with fruit and the other with supplies.' Mahiya put her veil over her head and got on a donkey and set off with Zambur to Tawariq.

When they got there Zambur asked where to go. 'Take me around the city lane by lane,' she said. Suddenly a man appeared with a donkey on which sat a woman. The woman was wailing.

Mahiya said to Zambur, 'Ask what is wrong with her and where she is going.' He asked.

'I am Ustad Khatun,' she said, 'and I am a medicine woman.'

Mahiya went with her."

The designer of the painting sets the encounter of the two couples on a dusty byway of Tawariq. Mahiya and Zambur arrive from the right, their donkeys conspicuously laden with the provisions specified in the text. Mahiya looks back at her accomplice as she gestures toward the oncoming woman. That woman is a narrative device of sorts, for she inadvertently provides Mahiya with a cover and leads the *ayyar* couple to a safehouse. But she is also introduced to serve as Mahiya's personal foil. She, too, rides a donkey, but one driven by her actual husband. Unlike Ustad Khatun, who is both distressed and compassionate, Mahiya is all insincerity and subterfuge, the epitome of the female operative.

The designer elects to use an unusual composition, with the road angling precipitously through the town. This feature probably reinforces the fortuitous nature of the meeting, but it also poses insurmountable difficulties for the second member of the team of artists. The two couples are relatively large and solid, as the protagonists in these illustrations are wont to be. The framing buildings, however, are entirely different in scale and substance. They assume lilliputian dimensions, with whole rooftops and kiosks measuring little more than a donkey's pace. Their tiled surfaces tip and teeter in ramshackle fashion; the two steeply angled rooftops below Ustad Khatun, for example, cap no defined building, and the staircase before them leads nowhere. These qualities, of course, are not new to architectural representations in the *Hamzanama*, but they never appear in buildings placed so obtrusively in the foreground. This architectural confection is, in fact, the work of Mah Muhammad, whose contributions in other *Hamzanama* paintings are at a safe remove from the action.

The painter of the four protagonists, who presumably also blocked out the composition, is probably Kesava Dasa. The donkeys are lively and strongly modeled, and the bags of fruit borne by Zambur's animal are rendered with exceptional depth. More tellingly, the potted tree in the upper center, which so obviously stands out from the remainder of the painting that it must be his work as well, has the same dense structure, three-dimensional foliage, and feathery grasses about it as some of the vegetation in a slightly earlier joint work by Kesava Dasa and Mah Muhammad (cat.55). The major figures, who would normally confirm such an attribution, are of little use here, for three of the four have been almost entirely repainted.

Attributed to Kesava Dasa and Mah Muhammad

Volume 11, painting number 69, text number 70
India, Mughal dynasty, *circa* 1570
Painting 68 × 51.6 cm, folio 74 × 57.2 cm (detail on pp.182–83)
Caption: 'Zambur Ayyar leads Mahiya into the city mounted on a donkey'
The Metropolitan Museum of Art, Rogers Fund, 1923 (23.264.1)
Published: Dimand 1948, fig.4.

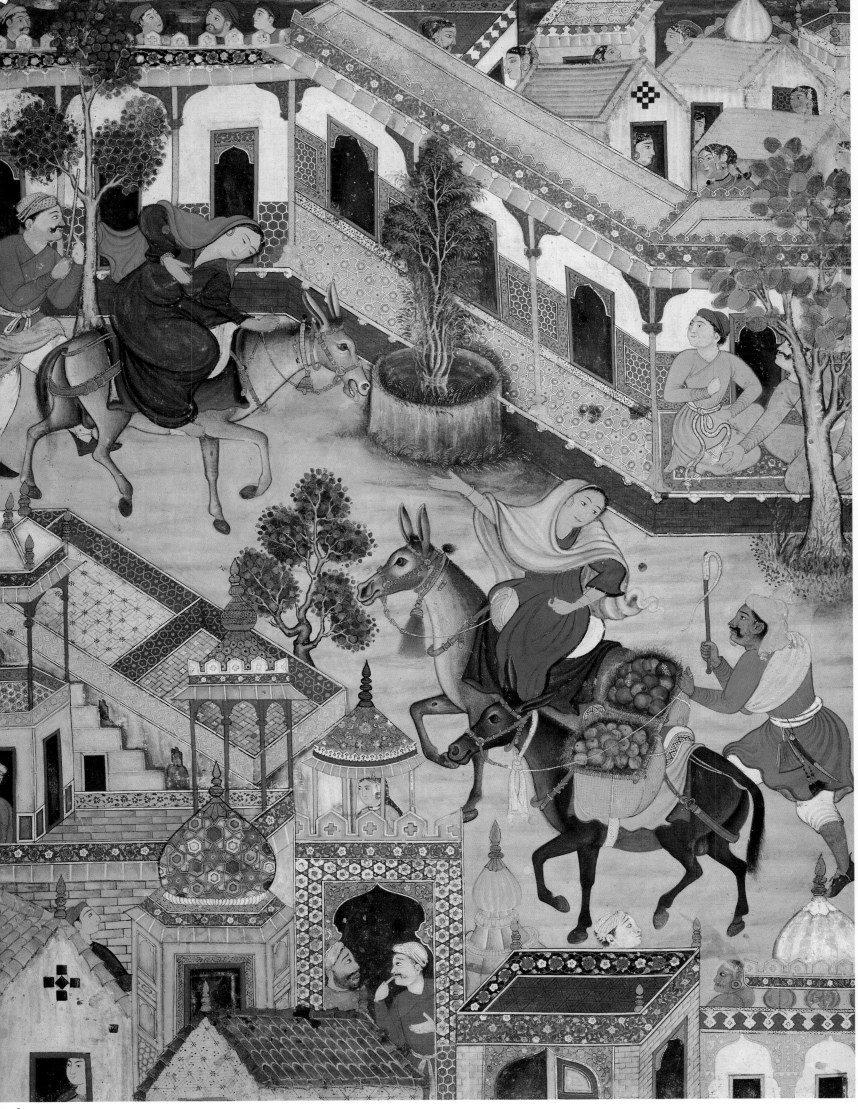

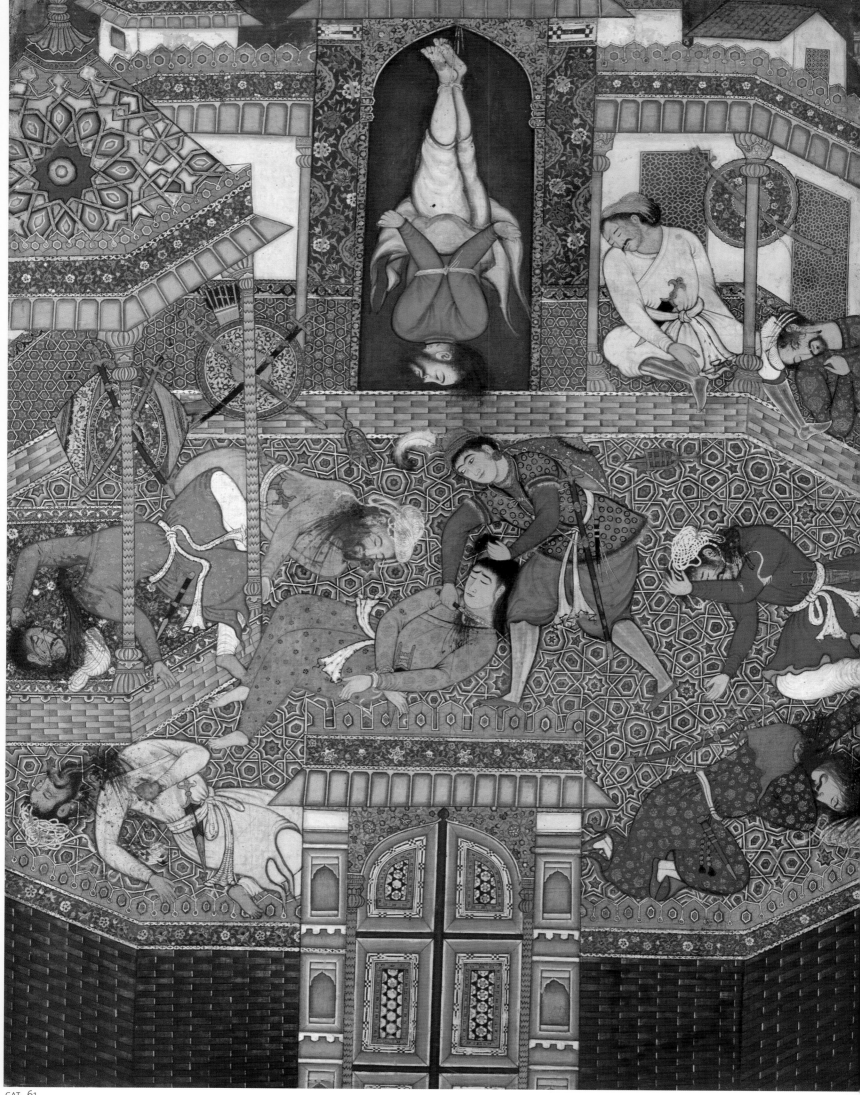

61 MAHIYA FREES ZAMBUR, BEHEADS HIS SLEEPING GUARDS, AND SUSPENDS GHARRAD IN HIS STEAD

**Attributed here to Jagana
and Kesava Dasa**

Volume 11, painting
number 70, text number 71
India, Mughal dynasty,
circa 1570
Painting 67.5 × 51.8 cm,
folio 77.6 × 62.5 cm
Caption: 'Mahiya cuts off
the heads of the guards, frees
Zambur and hangs Gharrad
upside down in his place'
Arthur M. Sackler Museum,
Harvard University Art
Museums, Francis H. Burr
Memorial Fund, 1941.292
Published: Harvard 1996,
p.143; Brand 1987, fig.7.1;
Schroeder 1941, p.110.

Once Mahiya reaches Ustad Khatun's house, she presents her with the fruit she has brought and cajoles her into treating her alleged depression. That night she urges Zambur to sneak out to try to discover Khwarmah's whereabouts. He does, but runs into a patrol headed by a guard named Gharrad. The guards seize Zambur and interrogate him. He persuades them that he is a simple stranger headed home, but they are so drunk that they boisterously string him up by his feet. They leave him hanging in this position while they succumb to sleep.

"As for Mahiya, she saw that it was late and she was waiting for Zambur to return. When a long time had passed she got upset. She put on her veil and boots and went outside the house, looking all through the marketplace until she came to that place. There she saw that someone was suspended upside down and a group of men had been drinking wine. The utensils of the party were scattered, and the participants were lying all over the place. She went forward and, recognizing Zambur, she set him free. Then she drew a knife from her belt and cut off the heads of all Gharrad's companions. She hung Gharrad up in Zambur's place and went back home with Zambur."

Jagana organizes this gruesome scene in a predictable but effective manner. Placing Mahiya, the heroine of the story, at the very center of the composition, he shows her actively slitting the throat of a guard. All but one of the sprawling figures have met the same fate at her hand. That figure, who must be Gharrad, has been spared because Mahiya has something special in mind for him. Hanging upside down in a blackened doorway directly above Mahiya and further aligned with the central gateway below is Zambur. Mahiya will soon avenge his humiliation by forcing his tormenter, Gharrad, to take his place.

While much of the preceding illustration (cat.60) suffers from a debilitating fussiness, this scene is invigorated by the sense of largeness that pervades virtually every element. The massacred guards, for example, are big, flat shapes placed strategically around the courtyard, their solidly colored *jamas* breaking up the expanse of patterned tilework behind them. Similarly, the hexagonal kiosk to the left expands powerfully into the courtyard, an effect enhanced by the huge starburst pattern of its tiled roof. Even the blue panels flanking Zambur have outsized half-medallions and flowers. All these features connect the painting with Jagana's earlier paintings in the volume (cat.35 and 50). Many of the tile patterns actually repeat those found in the former painting.

The obvious exceptions to this bright and basic style are the two crucial figures, Mahiya and Zambur. Mahiya's face, like that of her immediate victim, has been repainted. Nonetheless, the voluminous rendering of red sleeves and orange lower garment and even the fringe on her green tunic point to the hand of Kesava Dasa. This is corroborated by the hanging figure of Zambur, whose skillfully drawn face and feet and highly developed modeling strongly recall Kesava's figures in other paintings in this section of the manuscript (cat.55 and 56).

In the midst of all this conniving comes a very brief martial interlude. Malik Na'im's vizier, Muhandis, proposes to wreak havoc among Ibrahim's forces by releasing a fearsome Zangi from prison, where he is sent periodically for eating people. Na'im agrees, and sends out As the Zangi to carry the fight to the God-worshippers. The Zangi begins to decimate Ibrahim's men, but he soon runs into the formidable Ibrahim himself, who quickly tears him to pieces. With this hulking figure dispatched posthaste, the story returns to affairs of the heart, this time describing how Na'im's son Ghazanfar pines away for the captive Khwarmah.

The text provides no clue as to how Ibrahim kills As the Zangi. Left to his own devices, the painter Mukhlis simply invents a scene of grotesque carnage, with Ibrahim literally ripping the Zangi's arm completely away from his body. In this, he repeats a form he employed in an earlier scene (cat.41). He also constructs the composition in a similar manner, isolating Ibrahim and As the Zangi centrally and framing them with a congruent screen of rocks. In this case, however, he packs both sides of the composition with clusters of soldiers, who probably represent opposing armies, but are equally astonished at the slender Ibrahim's display of brute strength. Mukhlis shows some interest in varying his views of figures, as, for example, the drummer seen directly from the back, or the frontal figure slightly below him with a broad, squashed nose. Most of all, Mukhlis revels in pattern, typically making it so strong, so colorful, so relentless that it drowns out subtle volumetric and tactile effects.

Recognizing that Mukhlis was merely competent in faces, the supervisor assigned the faces and hands of the two key figures – Ibrahim and As the Zangi – to a figure specialist, Madhava Khurd. To discern Madhava's style is to admire it. The round-eyed Ibrahim, for example, bites his lip, as he wrenches the Zangi's arm from his body. Likewise, Madhava captures with inimitable nuance the Zangi's nappy hair, glazed eyes, and corncob teeth. Both hands are muscular and three-dimensional, qualities appreciated most fully when one compares the blockish hands or strandlike fingers of the soldiers to the right.

Mukhlis also supplies the architectural backdrop to the scene. His whimsical forms are familiar by now, but here they are more minuscule than ever, and collectively pitch precariously to the left. The artist resorts to somewhat forced transitional devices to integrate the two parts of the composition. On the left, for example, the ramparts end where the camel begins, but Mukhlis makes no effort to adjust the radically different scales he is using for forms set at approximately the same distance. In the center of the composition, Mukhlis obscures the entrance to the fort with a painterly ridge, one that billows so high, in fact, that it extends over much of one of his already completed soldiers.

Attributed to Mukhlis and Madhava Khurd

Volume 11, painting number 71, text number 72
India, Mughal dynasty, *circa* 1570
67.5 × 51.7 cm
Caption: 'Ibrahim tears at As the Zangi'
MAK–Austrian Museum of Applied Arts/ Contemporary Art, Vienna, B.I. 8770/21
Published: Egger 1974, pl.44; Egger 1969, pl.29; Glück 1925, pl.37.

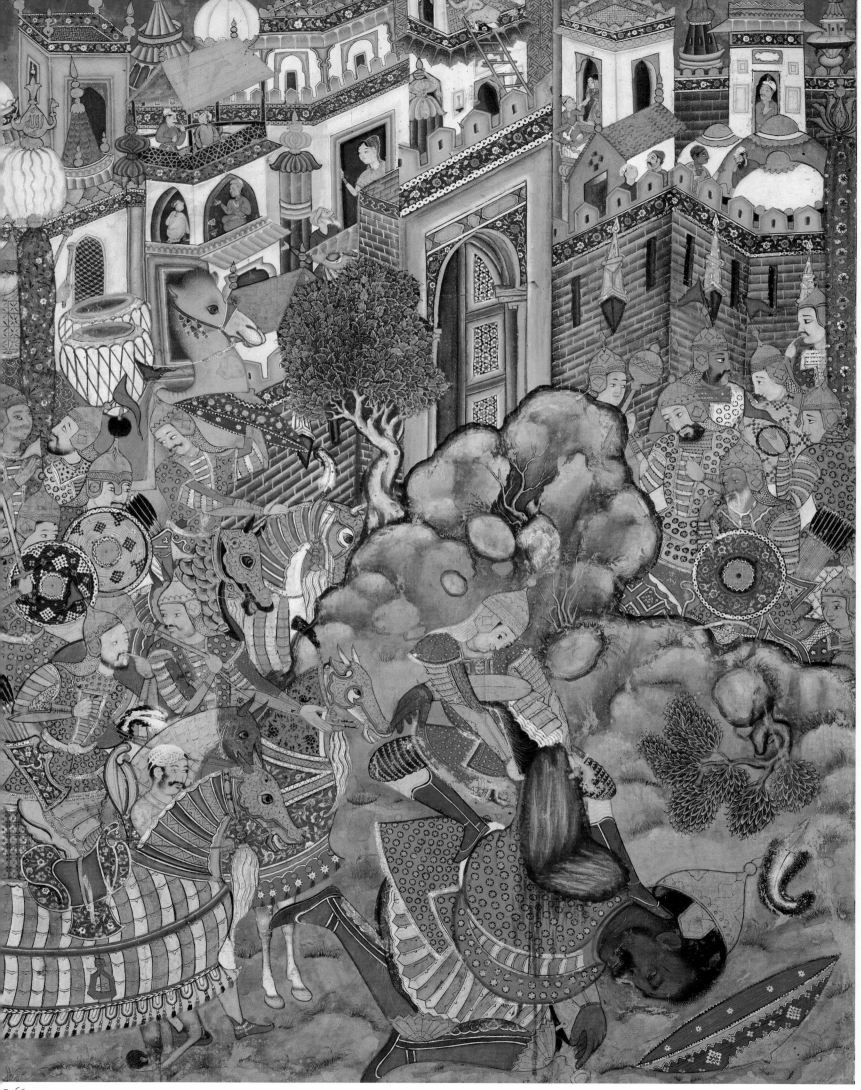

ALLIED SPIES SEEK OUT AND FREE PRINCE SA'ID FARRUKH-NIZHAD
CAT 63–65

A mere glimpse of the dashing Sa'id Farrukh-Nizhad causes Malak Mah, the daughter of King Na'im and Sarv Banu, to surrender her heart to him. She dons a warrior's armor and engages him for a time in battle, but he desists when he discovers that his opponent is a beautiful woman. The two retire from the field together; after a prolonged absence, Farrukh-Nizhad finally returns to his camp.

The enemy spy Mahlal abducts Farrukh-Nizhad, who is eventually transported to Aqiqnagar where Malik Taysun has him imprisoned. Malak Mah sets out to rescue her beloved and encounters Hamza's spies Songhur Balkhi and Lulu, who are on the same mission. This rescue party is joined by two more of Hamza's spies – Jaldak, and the woman Khosh-Khiram. In Aqiqnagar Malak Mah, lagging behind the others, is snatched from the street by an old hag – later revealed to have been a sorceress – and disappears before her companions have time to turn around.

During their explorations in the town, Songhur Balkhi and Lulu meet two merchants, actually followers of a famous local spy, Baba Bakhsha World-Traverser. He supports their cause and gives them information, but that night neither team of spies is able to break into the prison where Farrukh-Nizhad is being held. Finally, with the tacit approval of Sha'ban, a sympathetic wine-seller, they pour a knock-out drug into the drink served to the prison guards. Soon after, the *ayyar*s go to the prison, where the guards are thoroughly incapacitated. Then, as the text tersely recounts, the *ayyar*s cut off their heads, free Sa'id Farrukh-Nizhad, and smuggle him into Baba Bakhsha's establishment.

Detail of CAT 64

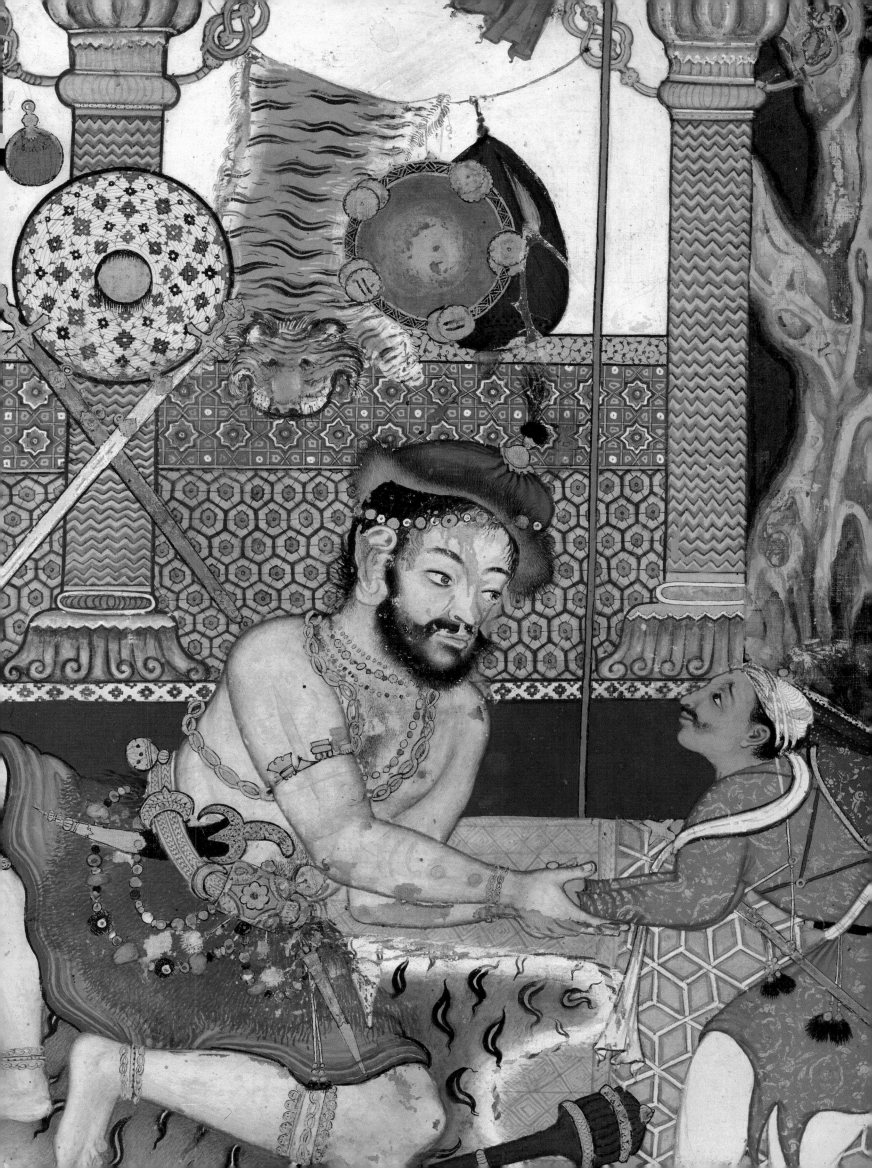

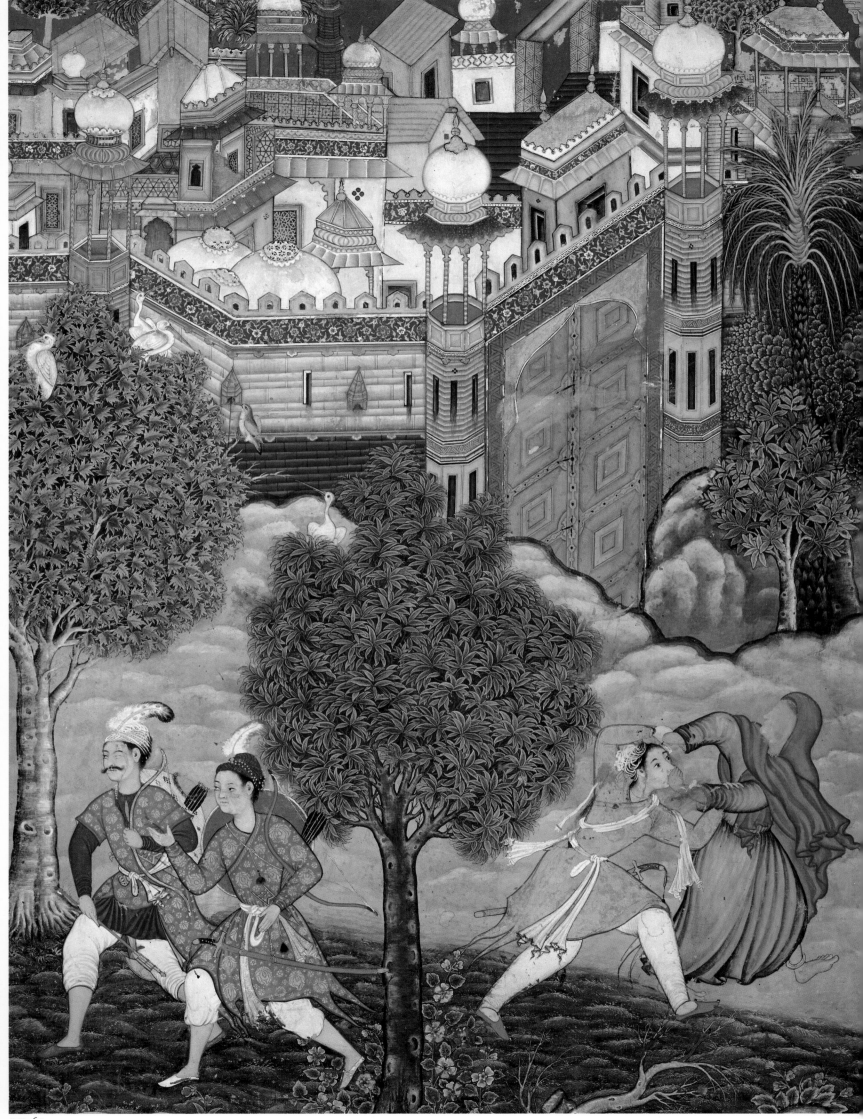

CAT 63

63 PRINCESS MALAK MAH JOINS HAMZA'S SPIES IN THE SEARCH FOR SA'ID FARRUKH-NIZHAD, BUT IS AMBUSHED BY A SORCERESS

Attributed to Dasavanta and Mukhlis

Volume 11, painting
number 73, text number 74
India, Mughal dynasty,
circa 1570
68 × 50.8 cm
(detail on pp.196–97)
MAK–Austrian Museum of
Applied Arts/ Contemporary
Art, Vienna, B.I. 8770/36
Published: Egger 1974, pl.46;
Egger 1969, pl.31; Glück 1925,
pl.39.

With one longstanding separation brought to a happy end, and a brief battle concluded in victory, the story returns to the tribulations of that other star-crossed couple, Sa'id Farrukh-Nizhad and Malak Mah. Sa'id Farrukh-Nizhad is transported to Aqiqnagar, where Malik Taysun orders him imprisoned again. Meanwhile, Hamza's spies – Songhur Balkhi, Lulu, Jaldak, and Khosh-Khiram – join Malak Mah in her search for the prince. As they reconnoiter the streets of Aqiqnagar, Malak Mah falls slightly behind. Her lingering soon has ruinous consequences. An old hag leaps out from behind a tree and snatches Malak Mah by the hair, clasping the other hand over her mouth so that she cannot call for help. The spies eventually turn around to check on Malak Mah, but she has vanished into thin air, the victim of a sorceress's wiles.

The drama of abduction – a sudden, usually violent change of circumstances – undoubtedly appealed to many Mughal artists, for it offers the bewitching combination of latent apprehension and blood-curdling terror. Dasavanta, however, never makes the latter too explicit, as Kesava Dasa does, for example, in the spy whom Umar accosts in cat.55. Instead, Dasavanta mutes the victim's expression, enticing the audience to imagine and vicariously experience the spine-tingling dread and rush of emotion for themselves. Here, he begins by shifting the kidnapping to an innocuous place beyond the city walls. He reduces the squad of spies from four to two, and shows both professional *ayyar*s, Songhur and Lulu, proceeding with grim-faced deliberation. A tree placed centrally at the very edge of the painting sequesters these two from Malak Mah, who becomes vulnerable to the hag's predations. The sorceress seizes Malak Mah, disguised as a young man but still clearly female, in the manner described by the text, yanking her hair and stifling her cry. She then drags her off in the opposite direction.

The figures bear all the hallmarks of Dasavanta's personal style. His *ayyar*s are closely related by facial type and amount of modeling to their counterpart Umar in cat.36. The alarmed Malak Mah is convincingly disheveled and wide-eyed, an expression particularly well-suited to Dasavanta's habit of making the pupils of his figures' eyes larger and more thickly painted than normal. The sorceress's gnarled features would normally be still more distinctive, but appear to have been obliterated, as often occurs in the manuscript; in fact, they were never finished, as the clear contours of her bony profile and the detectable underdrawing of her hair and eyes attest. Most distinctive of all is the hag's robe, a strident shade of green modeled emphatically with wet, painterly streaks. This effect is imitated by another painter, Mukhlis, in one of Dasavanta's collaborative efforts (cat.58), but in less adept hands becomes drier and more formulaic. As usual, Dasavanta makes the natural environment a vibrant and inviting one, with rustling trees and watchful birds.

Beyond the ridge and trees is the city of Aqiqnagar, which is the work of Mukhlis. Many of the forms replicate those found in cat.58. Beyond the outer walls is a thicket of domes and roofs, the former mushrooming from unseen courtyards, the latter tilting at every odd angle. The colorfully dense and still ensemble is a welcome change of pace from the open but disturbing action in the foreground.

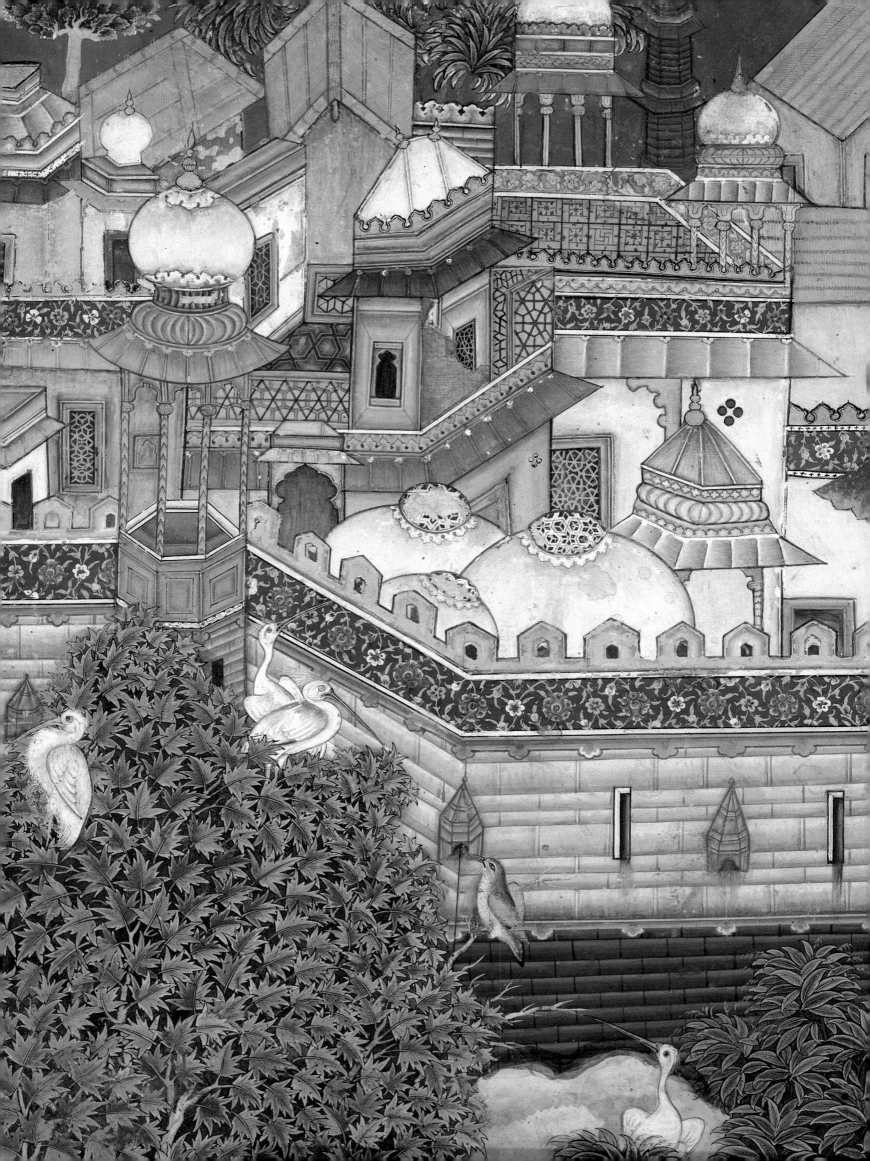

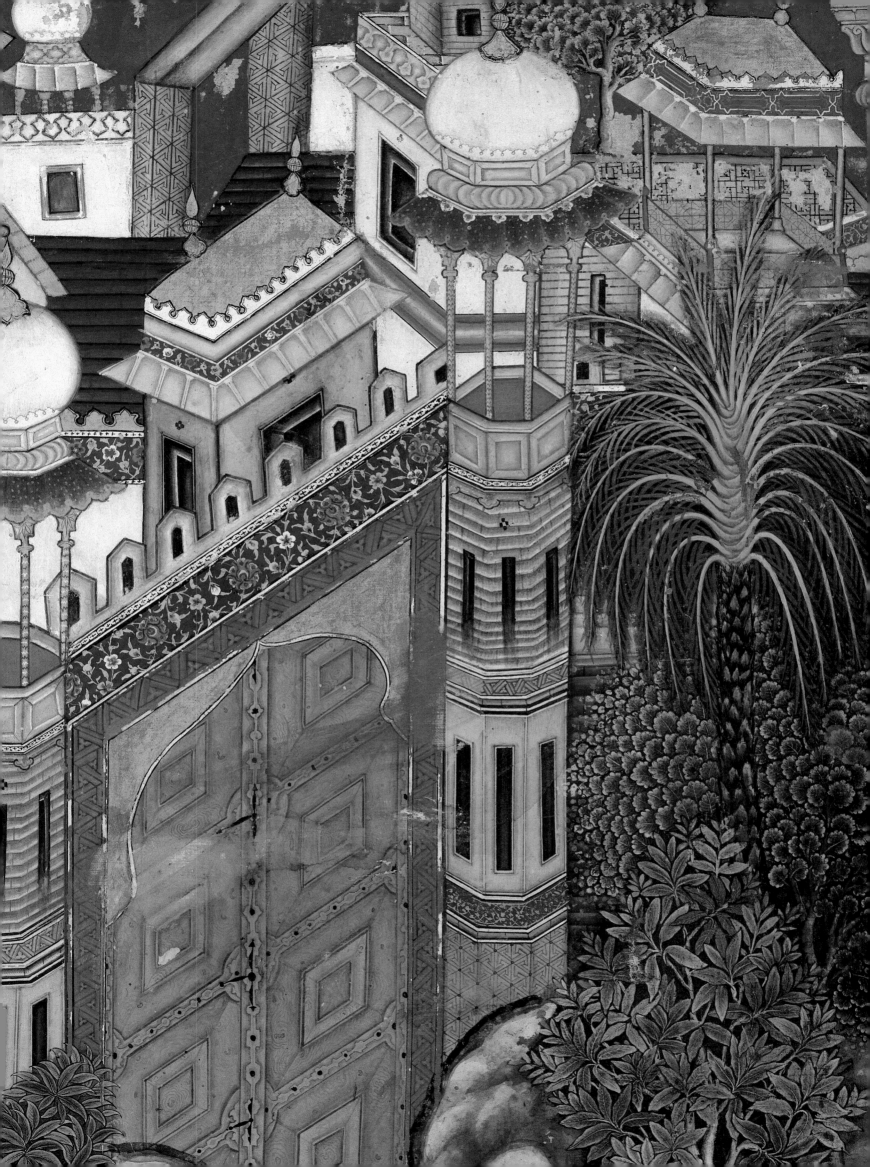

Songhur Balkhi and Lulu return to their caravanserai in hope that Malak Mah might have turned up there, but their comrades have no news of her. They decide that they will need some knock-out drugs to use in their rescue of Sa'id Farrukh-Nizhad, and reckon that they can obtain them most readily from one of the wine-sellers in town. They make their way to a pleasant-looking wineshop, and install themselves at a well-situated table. Before long, the proprietor escorts two merchants to their table and introduces them as disciples of Baba Bakhsha World-Traverser, a veteran spy living in the city. The four begin to converse, and soon the merchants disclose that they belong to a cell of spies given the mission of freeing Sa'id Farrukh-Nizhad, and they have come to procure some knock-out drugs. Delighted at this convergence of missions, Songhur and Lulu reveal that they are Iranian spies, but caution against being seen together in public for too long. At this, the four spies retire to Baba Bakhsha's establishment. It is a spy's paradise, stockpiled with weapons of all sorts and staffed by youths honing their skills in guerrilla warfare. Songhur and Lulu are brought before Baba Bakhsha, a grizzled but still vital man. Baba Bakhsha embraces them, kisses them on the forehead, and offers them food and wine.

Because this standard scene of greeting makes modest narrative demands, Dasavanta is able to concentrate his inventive powers on the colorful characters who frequent this den of spies. Songhur Balkhi leads the small delegation of Hamza's spies into Baba's lair. Baba Bakhsha remains seated, and greets Songhur by clasping both hands around his. Although Baba Bakhsha is said to have been in the business of spying for some seventy years, he is still physically imposing, with muscular arms marked with ritual burns, a hairy chest crisscrossed with heavy chains, and a full, black beard untouched by age. Other attributes – his coiled pose, the reddish fur and heavy ornaments gathered about his waist, the wicked dagger protruding from his belt, the exotic fur-trimmed cap, and, of course, his tigerskin mat – make Baba Bakhsha exude a dangerous, slightly savage quality. He also accrues power from his equally formidable coterie of spies, cloaked in furs and outfitted with similar weapons and chains, as well as from the assorted shields, swords, and skins hanging before a brilliant white wall. Dasavanta accentuates both the contours and volume of Baba's arms and legs with a pronounced but nuanced brownish outline, and models selected articles of clothing with deep, European-inspired streaky folds. He also casts the backturned figure in the foreground in the lost-profile view, a radically new view in Mughal painting.

Dasavanta brings together several other signature features. The small, scantily dressed boy in the foreground and the other preparing bhang beneath the banyan tree are closely related to several figures in one of Dasavanta's few ascribed works.[1] He introduces for no apparent reason two huge water vessels and an oversized golden vessel, the latter complete with glowering duck heads, a feature found on a prow in one of his earlier paintings (cat.36). Predictably, too, his figures usually have large pupils and feet with a splayed big toe; likewise, the unmodulated greenish black seen earlier in cat.59 recurs here as well.

Some of the secondary elements of the painting were left to Mukhlis. Among these are Hamza's four spies (save for Songhur Balkhi's head), the wavering cubic tilework pattern of the courtyard, and much of the extravagant architectural ornament. Many of these features relate to ones found in cat.58.

**Attributed to Dasavanta
and Mukhlis**

Volume 11, painting
number 74, text number 75
India, Mughal dynasty,
circa 1570
Painting 68.4 x 52.1 cm,
folio 78.4 x 62.2 cm
(detail on pp.192–93)
MAK–Austrian Museum of
Applied Arts/ Contemporary
Art, Vienna, B.I. 8770/59
Published: Welch 1978, pl.3;
Egger 1974, pl.47; Glück 1925,
pl.40.

1. *Holy Men*, Royal Library,
Windsor Castle, RCIN
1005039, f.24b. See Beach
1982, fig.10.

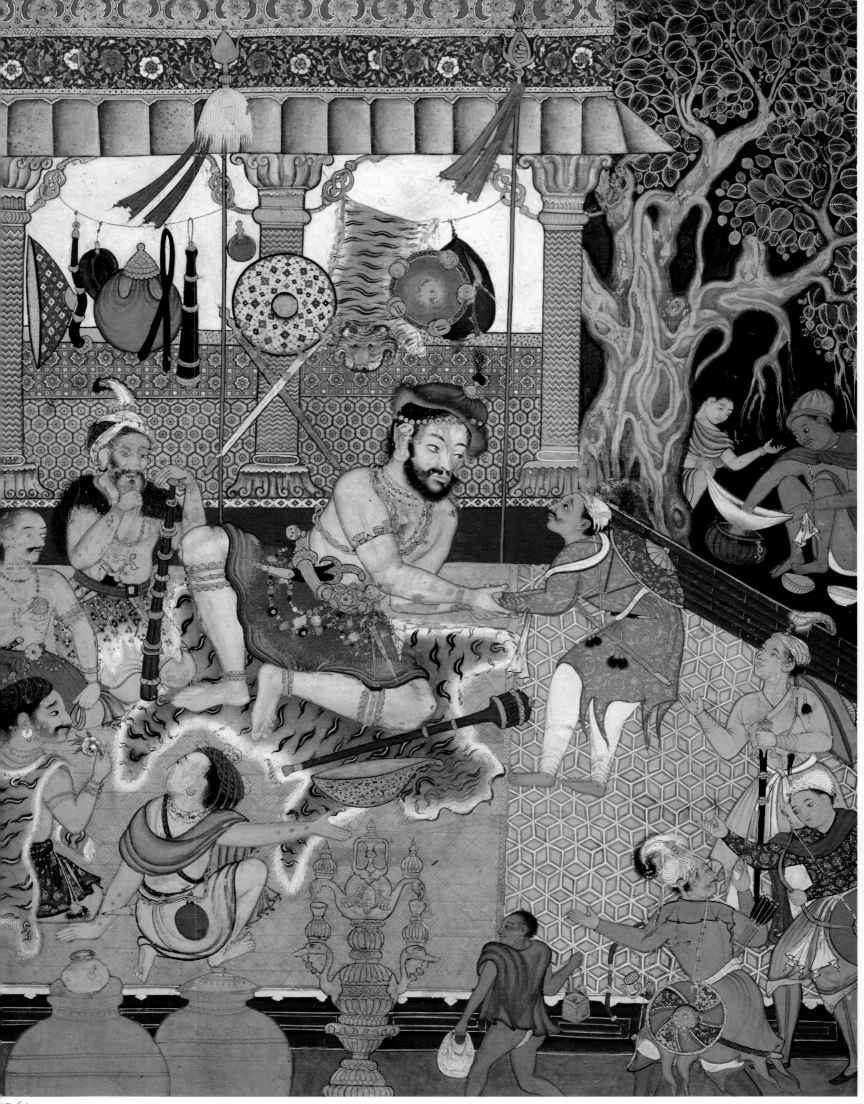

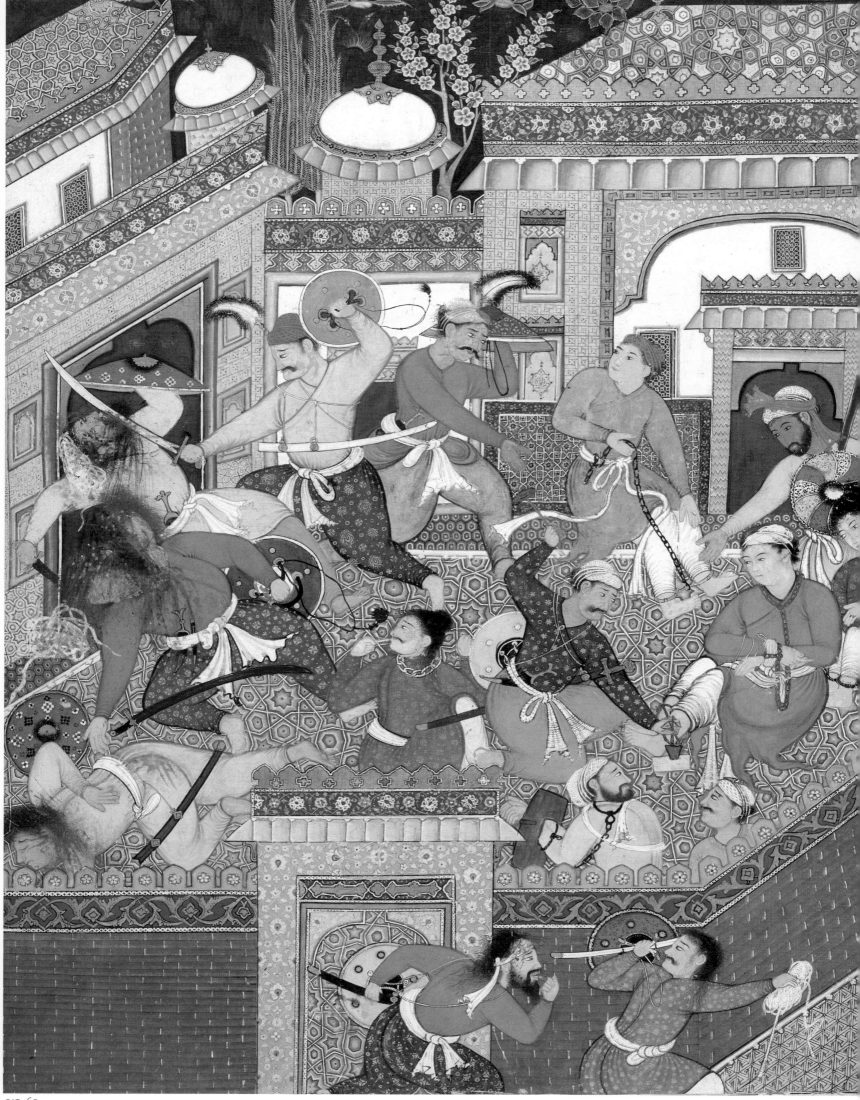

65 THE AYYARS, LED BY SONGHUR BALKHI AND LULU THE SPY, SLIT THE THROATS OF THE PRISON GUARDS AND FREE SA'ID FARRUKH-NIZHAD

Attributed to Shravana and Mahesa

Volume 11, painting number 75, text number 76
India, Mughal dynasty, *circa* 1570
68.4 × 52.1 cm
Brooklyn Museum of Art, Museum Collection Fund, 24.46
Published: Dehejia 1997, fig.195; Poster *et al.* 1994, no.24; Chandra 1989, fig.3; Welch 1963, no.2a.

The pace of the story slows now. Baba Bakhsha entertains Songhur and Lulu for a while, all the time swapping information with them about Hamza and others. That night Songhur and Parran Ayyar approach the prison where Sa'id Farrukh-Nizhad is being held. They think that they see an opening when they see the guards drinking. They are, however, soon challenged by four men dressed in black, who, it turns out, are Baba Bakhsha's operatives. Together they survey the prison, but making no inroads that night, they return to report to the Baba. Ever optimistic, Baba Bakhsha promises that once the prince is liberated, his *takiyya* will be a safehouse that no one will suspect. Now they resume their plan to poison the guards' wine.

"They came and kept Sha'ban busy until the prison guards came. Sha'ban said to Songhur, 'Go bring wine from that special vat for the men of Ahsha World-Traverser, who is now the warden of the prison.' Songhur mixed a knock-out drug into the wine and gave it to them. They fell unconscious. The *ayyar*s came to the prison gate and cut the guards' heads off, rescued Sa'id, and took him to Baba Bakhsha's *takiyya*. Baba hid the prince. The companions went to the caravanserai and informed Khosh-Khiram and Jaldak. They rejoiced."

The illustration depicts the long-awaited liberation of Farrukh-Nizhad. Although the text indicates that the guards had fallen unconscious and implies a ruthless slaughter, the artist shows a vigorous skirmish between equally balanced squads of guards and *ayyar*s. The *ayyar*s have clearly bested their foes, with three guards down and two others put to flight. Five prisoners still wear chains, but Farrukh-Nizhad, the plumpish figure in orange, is clearly the focus of both the composition and the *ayyars*' efforts. He alone is shown frontally and thoroughly manacled, and he alone is actively being freed by an *ayyar* wielding hammer and tongs.

The designer, Shravana, uses the architectural setting to establish the frenzied tempo of the scene. As in cat.47, he places the foreground wall of the courtyard flush against the lower edge of the painting, but skews the standard composition so one wall juts abruptly to the right, a feature that probably inspires – or even requires – the two fleeing guards. Accordingly, the front and rear entrances are aligned on the diagonal, along which, not coincidentally, Farrukh-Nizhad and his liberator appear. And the blackened doorway on the left provides an ideal backdrop for the most dramatic incident of the rescue, the cleaving of two guards.

Shravana also exercised his prerogative to execute the main figures in the composition. The broad and somewhat bland face of Sa'id Farrukh-Nizhad, for example, compares very closely to those of the figures at the gateway of cat.47. The two figures immediately above Farrukh-Nizhad have been repainted, but most of the other figures are by Mahesa. Mahesa's draftsmanship is sometimes weak, as it is in the lumpish backs and impossibly turned heads of one fleeing guard and the prisoner in yellow above him. When Mahesa applies yellow paint, he thins it out so much that it approaches a tinted white. Similarly, he is inclined to decorate his figures' *jama*s with a tiny gold pattern. Perhaps the subtlest trademark is his rendering of eyes, which habitually have a narrow gold rim around the black pupil. (See, for example, the four figures in the lower right.) That none of these features is visible from any distance greater than arm's length is a sure indication that the paintings were made with the expectation that they would also be scrutinized under much more intimate conditions than the nightly public recitations.

THE ESCAPADES OF PRINCE SAʿID FARRUKH-NIZHAD AND KHOSH-KHIRAM

CAT 66, 67

Malik Taysun immediately holds Baba Bakhsha responsible for Saʿid Farrukh-Nizhad's rescue and sends his spy Kajdast to confirm his suspicions. The prince is spotted moving around the *takiyya* and Malik Taysun attacks it. Eventually Farrukh-Nizhad escapes by means of a secret tunnel, but Taysun discovers his new refuge and launches yet another attack. Kajdast assures Taysun that he will kidnap Farrukh-Nizhad before the night is out. He does so, and Taysun vows to behead Farrukh-Nizhad the next day before the fortress. His vizier, however, proposes a more nefarious plan, that is, to send Saʿid to the island of Kiʾal Man-Eater, who devours anyone who strays into his territory. Kajdast is sent to accompany him. Once on the island, Kiʾal does indeed threaten to eat the prince, but he is saved by Barghal, Kiʾal's daughter, who has fallen in love with him. He promises that he will marry her as soon as he sees his parents, and to facilitate this Barghal helps him escape from the island.

Meanwhile Khosh-Khiram, a female *ayyar* who is the daughter of Princess Malak Mah's nurse, has set out to find Farrukh-Nizhad. By chance she meets the prince and Barghal, and they continue their journey together until Barghal is killed by a panther.

At last Saʿid Farrukh-Nizhad and Khosh-Khiram arrive at a palace, which they enter. Two girls are wrestling on the roof. They turn out to be Malak Mah and Sheda Banu, both confined to the palace by a sorcerer's spell. Malak Mah rejoices when she sees Saʿid Farrukh-Nizhad, and the lovers tell each other their adventures.

Detail of CAT 66

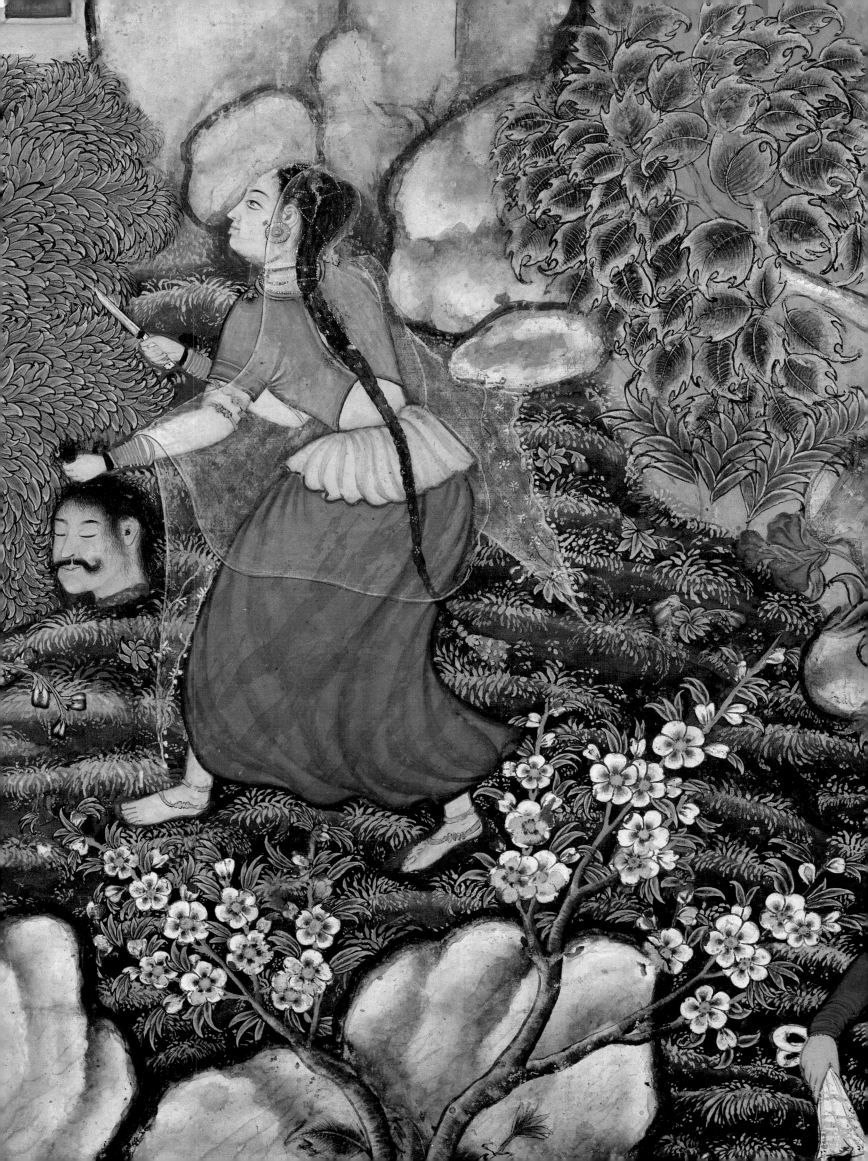

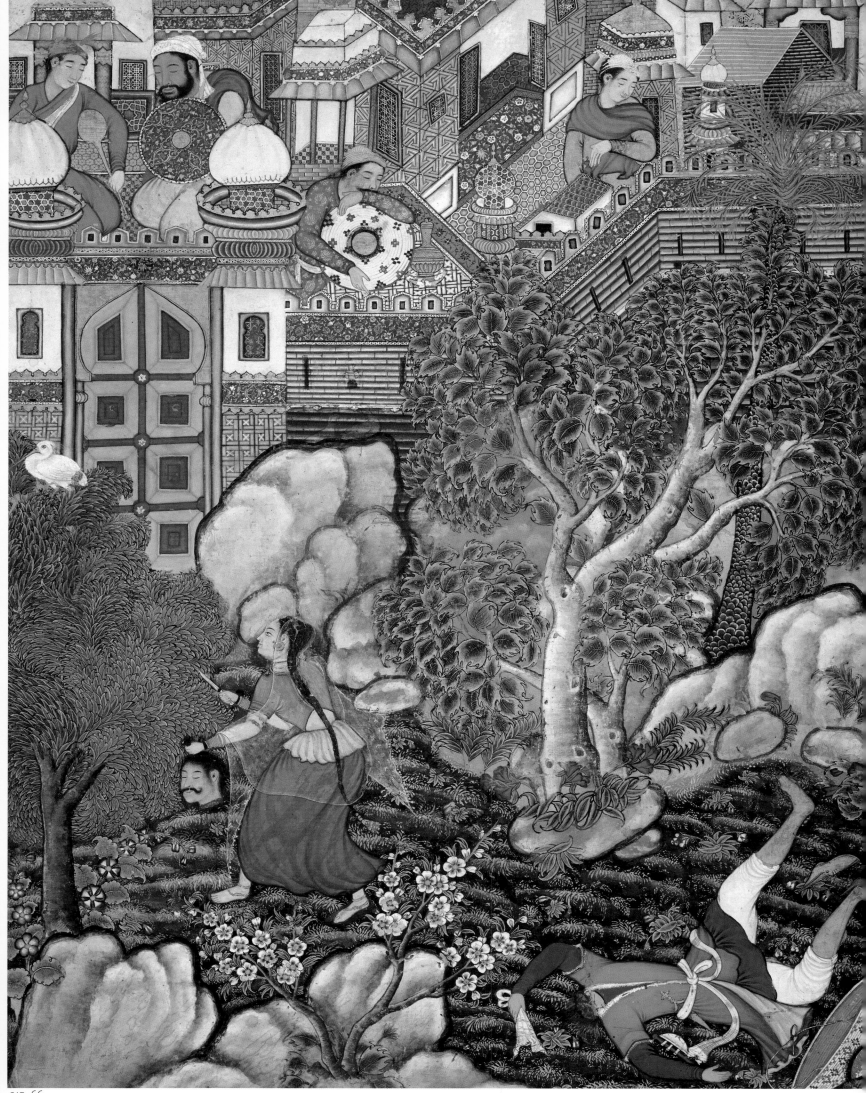

Attributed to Basavana
and Mukhlis

Volume 11, painting
number 77, text number 78
India, Mughal dynasty,
circa 1570
67.5 × 52.1 cm
(detail on pp.202–203)
Caption: 'Khosh-Khiram
beheads Kajdast Ayyar'
MAK–Austrian Museum of
Applied Arts / Contemporary
Art, Vienna, B.I. 8770/43
Published: Egger 1974, pl.48;
Egger 1969, pl.32; Glück 1925,
pl.41.

When news of Sa'id Farrukh-Nizhad's escape reaches Malik Taysun, he immediately suspects that Baba Bakhsha was involved. He dispatches one of his spies, Kajdast ('Crooked Hand') by name, to surveil Baba Bakhsha's house. He does this and soon glimpses Songhur Balkhi moving about the complex with Farrukh-Nizhad. Kajdast reports this to Taysun, who launches a heavily armed assault against that place. Fighting continues for some time, but Baba Bakhsha eventually persuades Farrukh-Nizhad to make use of a secret tunnel that will take him far from danger. Taysun, however, discovers the fortress to which Farrukh-Nizhad has retired, and leads a still larger army there. Again the battle rages. Taysun's own son defects to Sa'id's army.

"However, when Taysun entered the fortress, word came from Kajdast, saying, 'Do not grieve, for tonight I will kidnap Sa'id.' He went into the camp and kidnapped him. However, when he brought Sa'id to Taysun, he said for him to be kept under watch. They sent twenty thousand men against the camp of Islam. When they came the Muslims had gone into the fortress. They pulled back. Malik Taysun said, 'Guard Sa'id, and tomorrow we'll cut his head off in front of the fortress.' His vizier said, 'He should be sent to Ki'al Man-Eater's island, for if a stranger appears, they will eat him.' They sent a messenger and also said to Kajdast, 'You go too.' "

At this point, the story is interrupted by one missing folio. When it resumes on the reverse of this painting, Sa'id is at Ki'al's island, and is threatened with the prospect of being eaten alive, both figuratively and literally, by Ki'al's daughter, Barghal, who has amorous designs on him. Khosh-Khiram, the daughter of the nurse of Malak Mah, heads a small rescue mission. The caption of the painting summarizes the intervening narrative, and indicates that it is Kajdast, the enemy *ayyar*, who has met the ignominious fate of being beheaded outside the fortress walls.

Basavana, the designer of the painting, isolates Khosh-Khiram as she plows across an especially verdant landscape. She brandishes a bloodied knife with one hand, and clutches her grisly trophy with the other. In her wake lies the upended carcass of Kajdast, identified as an enemy agent by his discarded battle-axe and shield. She returns under cover of night to the citadel, where guards slumber blissfully unaware of her heroic but gruesome act of reprisal. Basavana constructs the luxuriant landscape around these two figures. He clears a large enough space for Kajdast's death spasms, and makes that space part of a meandering path leading back to the fortress. He elevates Khosh-Khiram within the composition by the outcrop below her, and frames her by a corresponding light rock cluster above. He uses trees to constrict the view of the citadel's gateway and to block the lower and visually uninteresting sections of its walls.

Basavana executed practically the entire lower portion of the painting. The most telling element is the central figure of Khosh-Khiram, whose softly modeled red robe recalls Zumurrud Shah's *jama* in cat.33, and whose eye differs subtly from that of Dasavanta's figure of Sanawbar Banu in cat.47. Similarly, Kajdast's orange and blue garments show the pronounced modeling favored by Basavana. Conversely, while the *ayyar*'s hair is fine and unruly, his expression is rather more blissful and ill-composed than one would normally expect from Basavana under such circumstances. Elsewhere, Basavana repeats from cat.33 the luminous and broadly conceived rocks, the animated foliage, and the paint-splashed tufts of grass.

His collaborator in this painting was Mukhlis, who rephrases from cat.58 his bastion occupied by sleeping guards. Once again, something is awry with Mukhlis's architecture: small, streaked domes rise from ill-proportioned towers, torqued windows float oddly before the walls they pierce, and tilework patterns become half-hearted gestures to geometric regularity. Basavana salvages this section by supplying the figures. This becomes apparent first from the guards' clothes, which have stronger contours, more painterly folds, and smaller patterns than Mukhlis is capable of executing. Still subtler features, such as the wispy hair and the elaborate configuration of the outer ear, also corroborate Basavana's active involvement in this section.

Ki'al's beautiful cannibalistic daughter, Barghal, continues to press Sa'id Farrukh-Nizhad to satisfy her appetite for love, but Sa'id fends her off by insisting that he will marry her as soon as he sees his parents.

"Barghal ... was beside herself with love for the prince. Smiling, she waited patiently until it was night. She went to the prison gate, killed all the guards, rescued Prince Sa'id Farrukh-Nizhad, and took him to her house, where she said, 'O prince, I have given my heart to you. Marry me.'

'My beauty,' said Sa'id, 'whenever I see my mother and father, I will grant your wish.' Barghal was patient.

The next day the guards went to Ki'al and said, 'Last night your daughter came to the prison, killed all the guards, and made away with the prisoner.'

Ki'al summoned his daughter and asked her about it. She said, 'Yes, when he was brought before you and you ordered him to be roasted, I was greatly inclined toward him. I kept you from doing it. Last night I went and took him out of prison, roasted him, and ate him.' Ki'al accepted this."

Finally, Barghal helps Sa'id escape so that they may visit his parents together. They sneak away that night and ride until dawn, when they happen to meet Khosh-Khiram, perched in a tree above their resting place. Khosh-Khiram explains that she was searching for Sa'id, but ran afoul of some Zangis, who devoured her companion but missed her because she had climbed that tree. The three journey on, but a panther enters their camp and kills Barghal.

Trusting God to guide them, Sa'id and Khosh-Khiram come upon a magnificent building with an open gate. They enter and see two girls, Malak Mah and Sheda Banu, wrestling on the roof. Malak Mah rejoices when she sees Sa'id Farrukh-Nizhad, and the two lovers excitedly recount the strange events that brought them to this place. Malak Mah tells him that she was kidnapped because a sorceress mistook her for a man, and was then placed under a spell, evidently one that prevents her from leaving. Her companion, Sheda Banu, the daughter of Malik Na'im, is under the sway of the same spell, albeit for different reasons. The text ends here, but the lines that follow this painting describe how the sorcerer responsible for the spell, Karkara Jadu, attacks Sa'id. Once Sa'id dispatches him, the girl recalls a clue to breaking the spell, and soon the quartet are on their way.

This charming painting presents something of a narrative enigma. Most of the scene is given over to a building described only as being lofty and having two entrances, one open and the other closed. The remainder shows two horses waiting in the courtyard while Sa'id Farrukh-Nizhad and Khosh-Khiram watch the two girls tussle. The text indicates this struggle as tersely as possible, and offers no explanation for how it is related to the spell cast upon the two girls, unless, of course, it is the inevitable result of cabin fever.

However the supervisor decided upon the specific moment to be illustrated, he certainly picked the right artist for the task. Shravana, whose variety of work in the *Hamzanama* establishes him as one of the most accomplished artists of the atelier, produces an absolutely scintillating architectural environment. It begins with the courtyard tiles, which form a dense and even pattern. The two-storied building runs a staggered course across the courtyard, with potentially harsh junctures softened by strategically placed horse heads. To the right lies a brilliantly colored orange wall with defensive openings, a peculiar feature for a wall enclosing a domestic compound. Still stranger is the red fence – normally used to delineate gardens – placed atop that wall, and yet accidentally passing over the corner of an eave. In the center of the building proper is a darkened entrance flanked by a series of cartouches and niches, the latter filled with decorative glass and ceramics in a manner seen earlier in cat.47. The building itself is a harmonious combination of pinkish planes, rhythmic dark openings, and delicate floral bands, all executed with a precision found in the work of few other artists. The intricate floral pattern is extended to the rooftop as a carpet, the border of which is filled with Shravana's trademark crablike foliate forms.[1]

In this luscious setting, the figures are practically an afterthought; indeed, this is literally true, for there is evidence that at least part of Sa'id was painted over the carpet border. Shravana seems to have supplied the figure of Khosh-Khiram, but another artist, Mithra, added Sa'id and the two girls.[2] Mithra, an artist heretofore known only from his work in the *Darabnama*, favors rounded, doll-like faces with doleful eyes, and smooth forms with little modeling.[3] It was apparently his decision to make the wrestling girls slighter and younger, for elsewhere in the manuscript Malak Mah is shown as a full-grown woman.

Attributed to Shravana
and Mithra

Volume 11, painting
number 78, text number 79
India, Mughal dynasty,
circa 1570
Painting 67.6 × 51.3 cm,
folio 79 × 63.5 cm
Caption: 'Sa'id arrives with
Khosh-Khiram on the roof
of a castle and sees two girls
who are wrestling'
Freer Gallery of Art,
Smithsonian Institution,
Washington, DC;
Purchase, F1960.14
Published: Beach 1981, no.5a.

1. For other occurrences of this pattern, see cat.57, n.1.
2. Khosh-Khiram is a slightly more graceful version of the central figure in f.67b of the *Tutinama* (fig.14). Essentially identical are her eye and profile, the color of her clothing, and even the form of her bangles and jewelry.
3. See, for example, his ascribed works on ff.12a, 65b, 117a (fig.19) and 117b of the *Darabnama*.

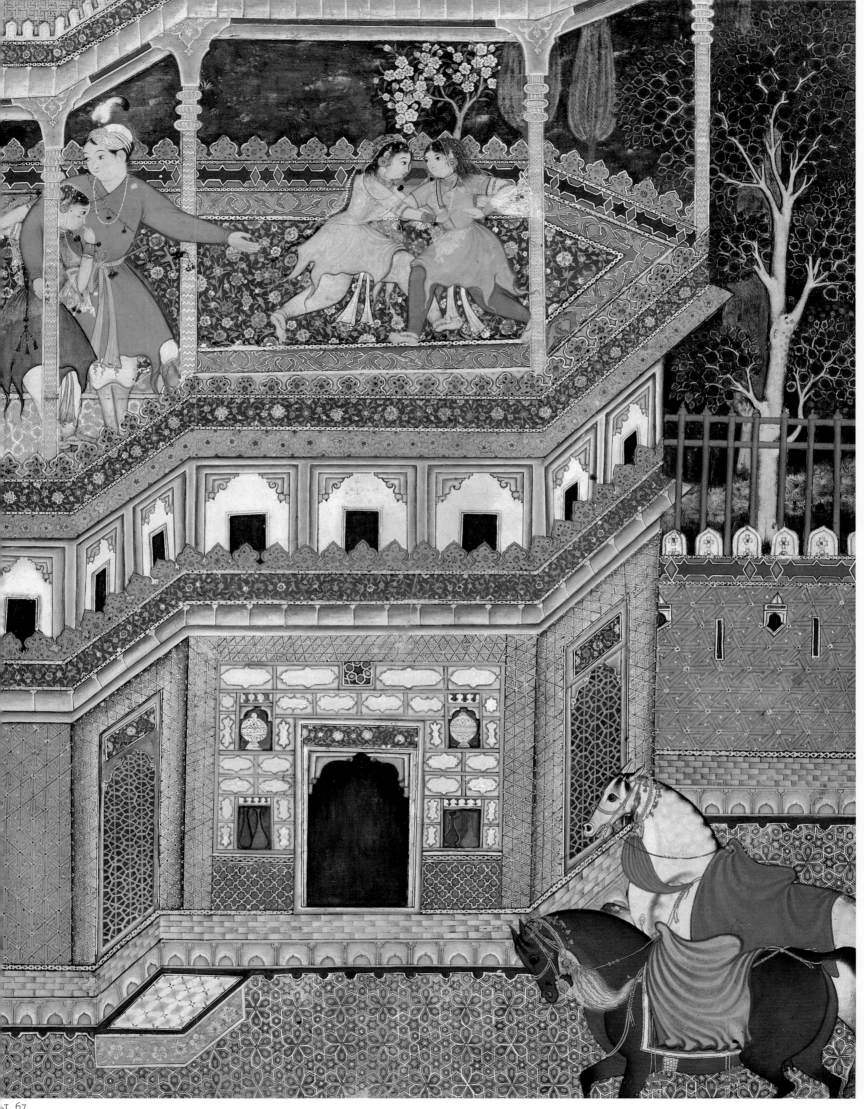

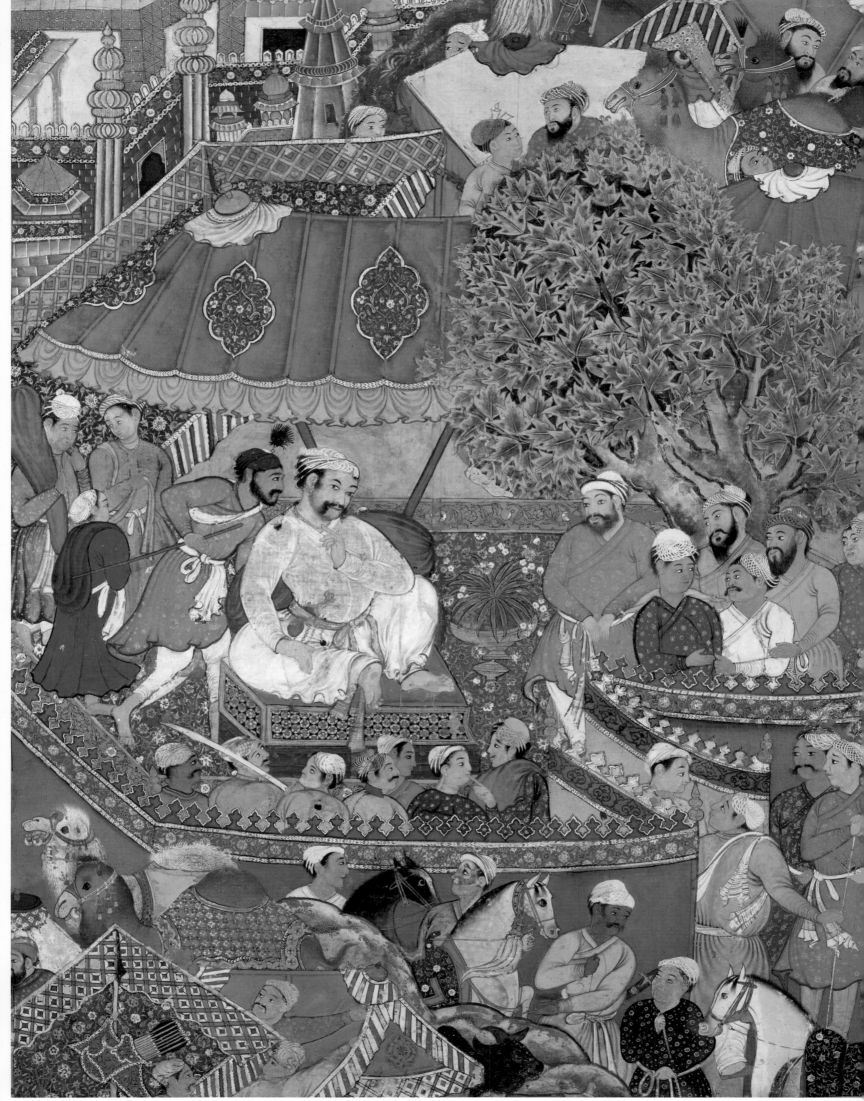

CAT 68

Attributed to Basavana, Mithra, and Mukhlis

Volume 11, painting number 80, text number 81 India, Mughal dynasty, *circa* 1570
Painting 75 × 56 cm, folio 79 × 63.2 cm
Caption: 'Mahus Ayyar whispers to Qimar'
Rare Book Department, The Free Library of Philadelphia, M2
Published: Kramrisch 1986, no.7; Comstock 1925, p. 354; Philadelphia 1924, no.77.

1. *Darabnama*, f.7b.
2. MAK, Vienna, B.I. 8770/22 and 8770/58. See Reconstruction, nos 84 and 100.

Sa'id leads the allies into battle, where he is victorious despite the enemy's much greater numbers. When Tayfur is wounded, all looks bleak for the infidels, but Malik Na'im and Qimar arrive with massive reinforcements to replenish their armies and rekindle hope. Now it is Sa'id who is threatened with defeat. The tide turns again in the allies' favor when Malik Bahman comes and throws his own huge army into the fray.

A new round of battles begins when Ki'al Man-Eater joins the infidel forces, seeking to avenge the kidnapping of his daughter, Barghal, for which he holds Sa'id culpable. Ki'al challenges Sa'id in individual combat, but is dealt a mortal wound by the prince. The enemy conclude that they should pursue a two-pronged strategy: commit all their vast legions at once and eliminate either Prince Ibrahim or Prince Sa'id Farrukh-Nizhad. They order Mahus the spy to kidnap one prince. He dispiritedly admits that this is well-nigh impossible because the God-worshippers are alerted to this sort of clandestine activity, and rues the untimely end of the last *ayyar*, Kajdast, who had been sent out on such a mission. Both strategies fail. Qimar is, in fact, taken prisoner and brought before Prince Ibrahim. He converts to Islam, but insincerely. Qimar's treacherous heart is exposed one day when Songhur Balkhi observes Qimar listening to Mahus the spy whisper in his ear. When Songhur appears, the captive leader quickly gets rid of Mahus, a tacit acknowledgement of complicity. Songhur informs Ibrahim of this suspicious behavior, and Ibrahim quickly imprisons Qimar.

Basavana, who probably designed the composition, places a relaxed and well-stuffed Qimar beneath a large canopy at the center of a busy tent compound. Mahus, the enemy operative, slinks up to the false convert. Qimar leans back and cocks his head slightly to the side as the spy whispers news of his former confederates. Songhur Balkhi, who should be lean and mustachioed if *ayyar* iconography holds true to form, does not appear among the many oblivious retainers lining both sides of the zigzagging tent walls. Those on the inside ostensibly wait in attendance, but actually pay little heed to Qimar as they converse animatedly among themselves; those on the outside are occupied with their animals and other responsibilities. Basavana fills the remainder of the composition with an assortment of decorative architectural elements and steeply pitched canopies. The result is a sense of visual hubbub raging around the duplicitous and imperturbable Qimar.

Basavana painted only a few passages in this work. He is certainly responsible for Qimar, whose face and body are the most perceptively characterized in the entire painting. It is likely, too, that he also executed the figure of Mahus, though that *ayyar*'s face has been completely repainted. And one recognizes Basavana's hand in the rough trunk and bright, oversized leaves of the plane tree, a feature seen earlier in cat.33.

One collaborator, Mithra, supplied most of the remainder of the painting. His personal style is most easily identified by his figures, whose bodies are smooth and compact, and whose faces are often marked by ungainly turbans and profiles and noticeably big, dark eyes. Mithra uses the lost-profile view for one figure, the attendant dressed in blue beside Mahus. Many other unusual facial types, notably those of the retainers in the upper right and some at the base of the tree, are modern replacements. Other details corroborate Mithra's involvement. The geometric pattern on the low throne recurs in an ascribed illustration in the *Darabnama*.[1] Mithra also favors certain colors, such as the deep mustard yellow edged in red along the central canopy, a color and modeling convention he repeats from one horse's saddle covering in cat.67. Unlike Shravana or Basavana, both of whom painted similar tent scenes earlier in the manuscript, Mithra dispenses with the vertical stays in his tent wall, which becomes a flat expanse of a red much brighter than is normally seen.[2]

The third artist, Mukhlis, seems to have done only the architecture in the upper left. The abruptly tapering tower, pronounced ribs and lobes of the domes, and exaggerated use of white in architectural detail connect this section with architectural passages in his other works, especially cat.58.

News of Qimar's imprisonment reaches Malik Na'im and Malik Taysun, the infidel commanders. Again, their distress is assuaged by a massive influx of reinforcements, this time led by Mahabat Boar-Tooth. Great clashes ensue, with Malik Taysun eventually falling before Farrukh-Nizhad, and Mahabat Boar-Tooth and Malik Na'im being captured by Prince Ibrahim. The latter convert sincerely, and Aqiqnagar, the site of so much intrigue, becomes Muslim as well. All this action transpires far from Umar, who is apparently being held at Castle Ayina. Ever resourceful, he escapes by climbing down from the castle's heights on a bit of silk fastened to a dove sent by one of his compatriots.

With this cunning descent, the story is interrupted by a missing page. When the text resumes, an altogether different story is under way. It is clear that Umar has demonstrated his wily supremacy yet again, for Khwaja Bakhtak, Anoshirvan's evil vizier, has just been dropped at Zumurrud Shah's door. Bakhtak is unknowingly made over to resemble Umar, and thus is not recognized as an ally by Yaqut Shah. But Sabukpay, Hamza's spy, who himself must be incognito, knows precisely who this figure is. To torment Bakhtak, a longtime opponent, he counsels Yaqut Shah to dismiss Bakhtak's protestations of his true identity and to order him beaten and imprisoned. Then Sabukpay departs, sweetening his revenge by indirectly letting on that this ruse was all Umar's handiwork. The vindicated Bakhtak is released from prison, and tells his story of marvels and woes to the assembled sorcerers, who concede once more that they have been outdone by Umar.

The intervening painting shows the kind of sorcery that Umar had to surpass. Although the circumstances of the battle are unknown, the participants and the resolution are among the most fantastic in all the *Hamzanama*. Soldiers thunder in from the left, magicians from the right, both threatening to overtake a slender figure trapped between them. Suddenly, and unbelievably dramatically, their quarry escapes from their clutches – not by his own doing, but by the grace of a *deus ex machina*: a disembodied hand reaching down from the clouds. As the hand grabs the disguised Bakhtak by the collar and snatches him into the air, everyone gasps with astonishment.

This miraculous ascent, which neatly complements Umar's own earlier descent, is hardly the only mind-boggling feature of the scene. The sorcerers spur on no ordinary mounts, but lions and tigers and wolves; they wear snakes as necklaces and wield them as whips and reins. Their human counterparts have more commonplace accouterments, but even their pennants, trumpets, and standards are invested with exceptional energy.

The mastermind behind this visionary scene is surely Dasavanta. His hand is evidenced most conspicuously in the heaven-bound Bakhtak. Although his face has been damaged, the heavy modeling of his cloak and sleeves and the taut reddish outlining of his legs match those of Dasavanta's figures in other illustrations, particularly cat.58 and 64. Among the other details that also typify his work are the elaborate multileveled standard finial in the left center, the gently scalloped ridge below, and the dark green area between the two groups of figures.

But most of the actual painting of the scene should be credited to Shravana. Again this artist demonstrates his ability to render highly animated faces, a quality seen most notably in the centermost sorcerer mounted on a lion. Shravana can also be distinguished from Dasavanta by some truly minute features, such as the elaborate scrolling of the outer ear, and smaller pupils of the eyes. The upper landscape strongly recalls that of cat.51, and even the colorful scrolled clouds are merely formalized versions of those permeating his other scene of an airborne journey (cat.57).

**Attributed to Dasavanta
and Shravana**

Volume 11, painting
number 82, text number 83
India, Mughal dynasty,
circa 1570
67.1 × 50.8 cm
(detail on pp.212–13)
Caption: 'A hand appears
and plucks the falsified
Umar from the earth'
MAK–Austrian Museum of
Applied Arts/ Contemporary
Art, Vienna, B.I. 8770/55
Published: Egger 1974, pl.50;
Glück 1925, pl.42.

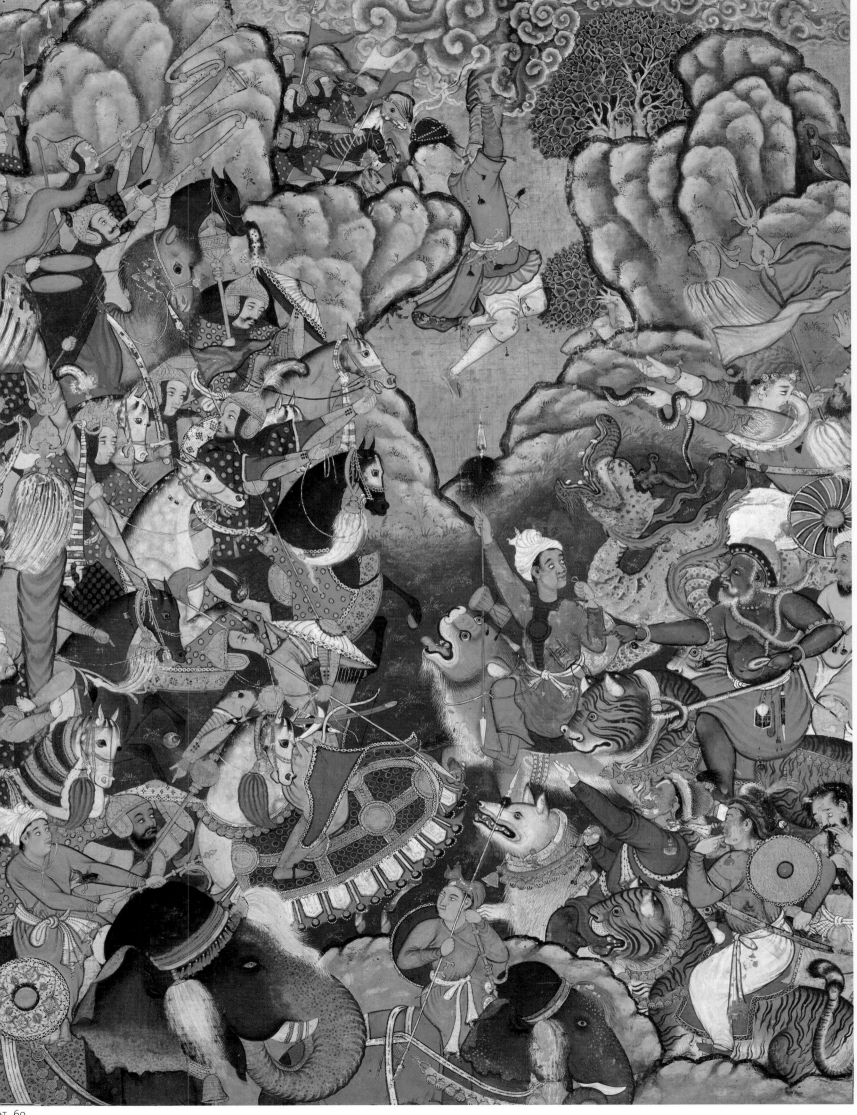

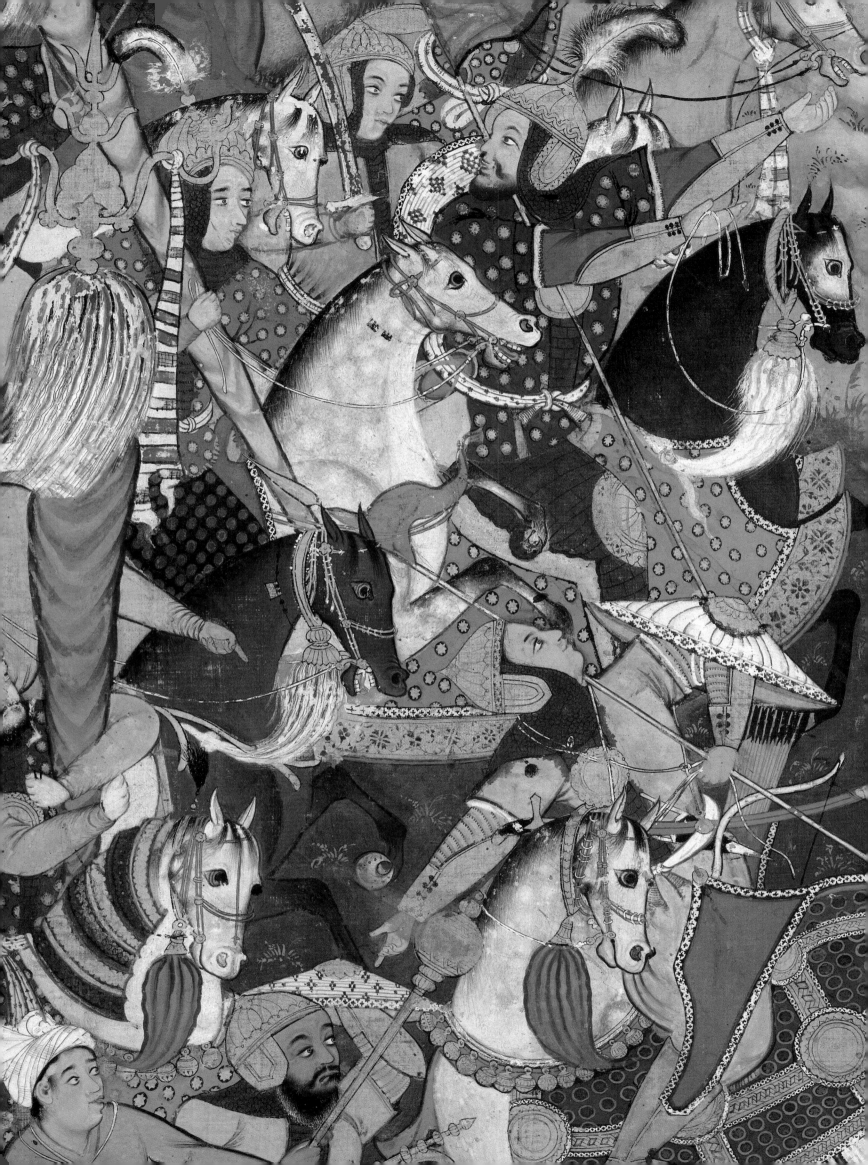

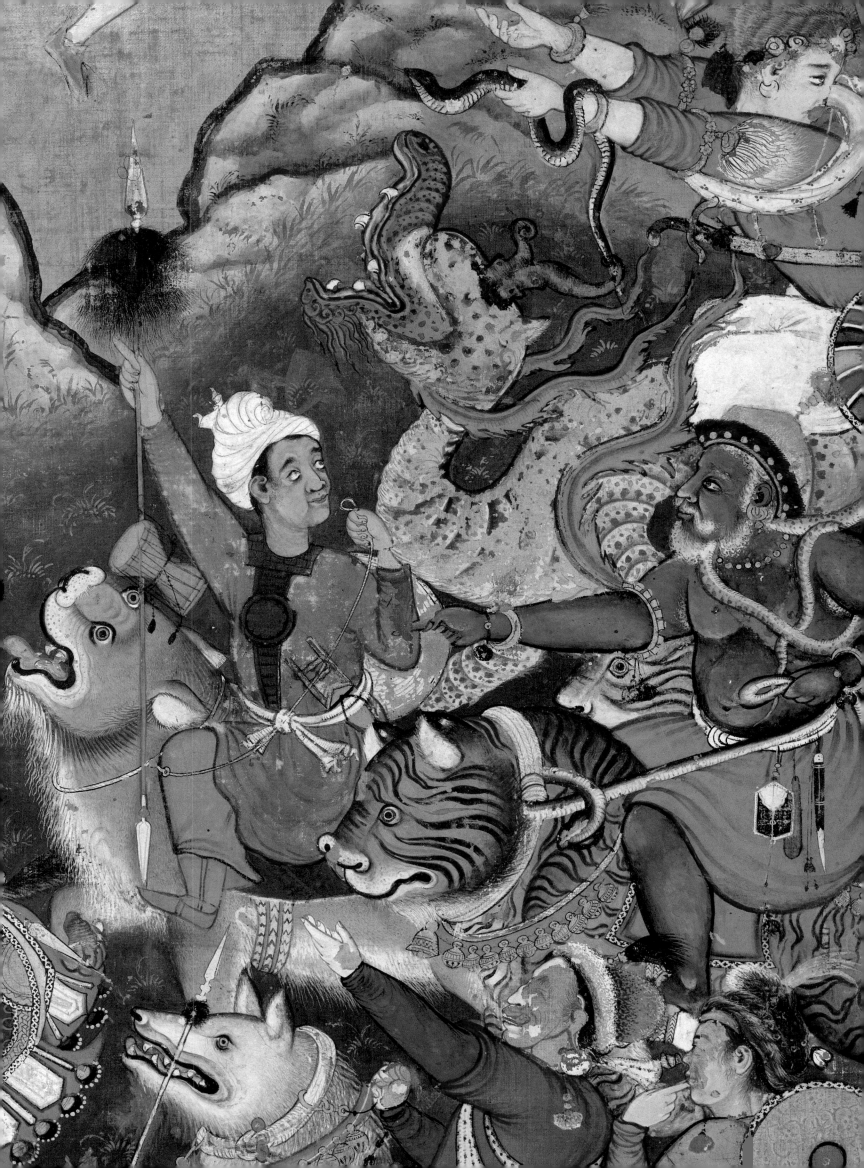

UMAR ASSUMES THE GUISE OF MAZMAHIL THE SURGEON

CAT 70, 71

After his victory over the cities of Aqiqnagar, Tawariq, and Zibarjadnagar, Hamza sends Umar on a mission to locate the whereabouts of his captured champions in the sorcerers' city, Antali. On the way there with a band of *ayyar*s, Umar meets Mazmahil the surgeon, who is returning to his home city of Antali after a long absence. Umar, who never fails to seize a fruitful opportunity, gives Mazmahil some raisins laced with a powerful drug. After Mazmahil succumbs to this poison, Umar hides his immobilized body away from the road, and dons his clothes. Then, selecting one of the *ayyar*s as his squire and sending the others on ahead, he proceeds toward Antali, where he passes himself off as Mazmahil.

Umar's disguise is so good that he is greeted warmly by Mazmahil's wife, servants and friends. First he gives the surgeon's goods to his accomplice and borrows more money from his wife and children and his friends among the city's merchants. Next, Umar resumes Mazmahil's medical practice, offering treatment for every sort of malady afflicting the many sorcerers of Antali. His medicine, however, comes from his *ayyar*'s bag of potions and poisons, and in two days his quackery exacts its deadly toll on the lot of unsuspecting patients. As the sorcerers drop like flies, Umar sneaks out of the city, awakens the still-drowsy Mazmahil, and sends him home. Imagine his reception! In a spate of anger at their relatives' deaths, the survivors assail the real Mazmahil, and haul him before Zumurrud Shah and Bakhtak. When these two hear the details of this new scam, they recognize it as another of Umar's chicaneries, and grudgingly admit that they have been outfoxed by him yet again.

Detail of CAT 71

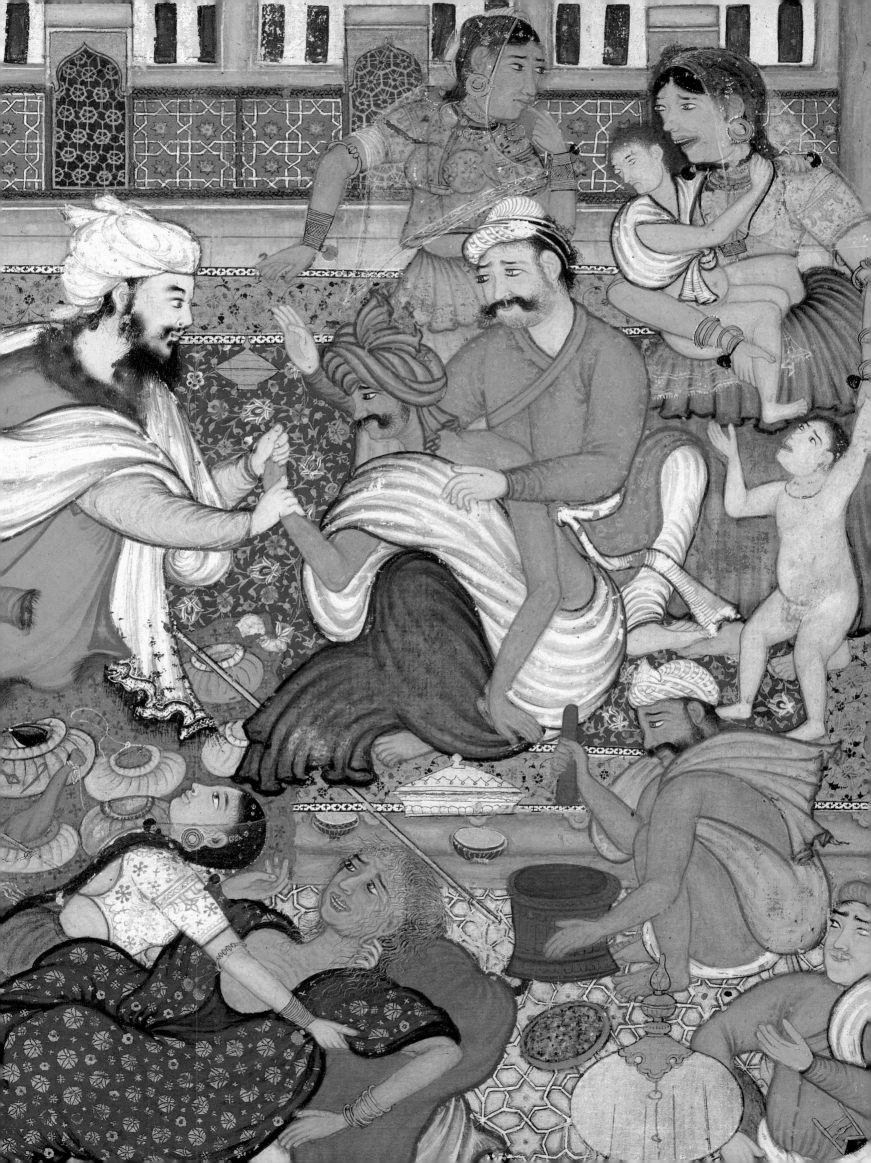

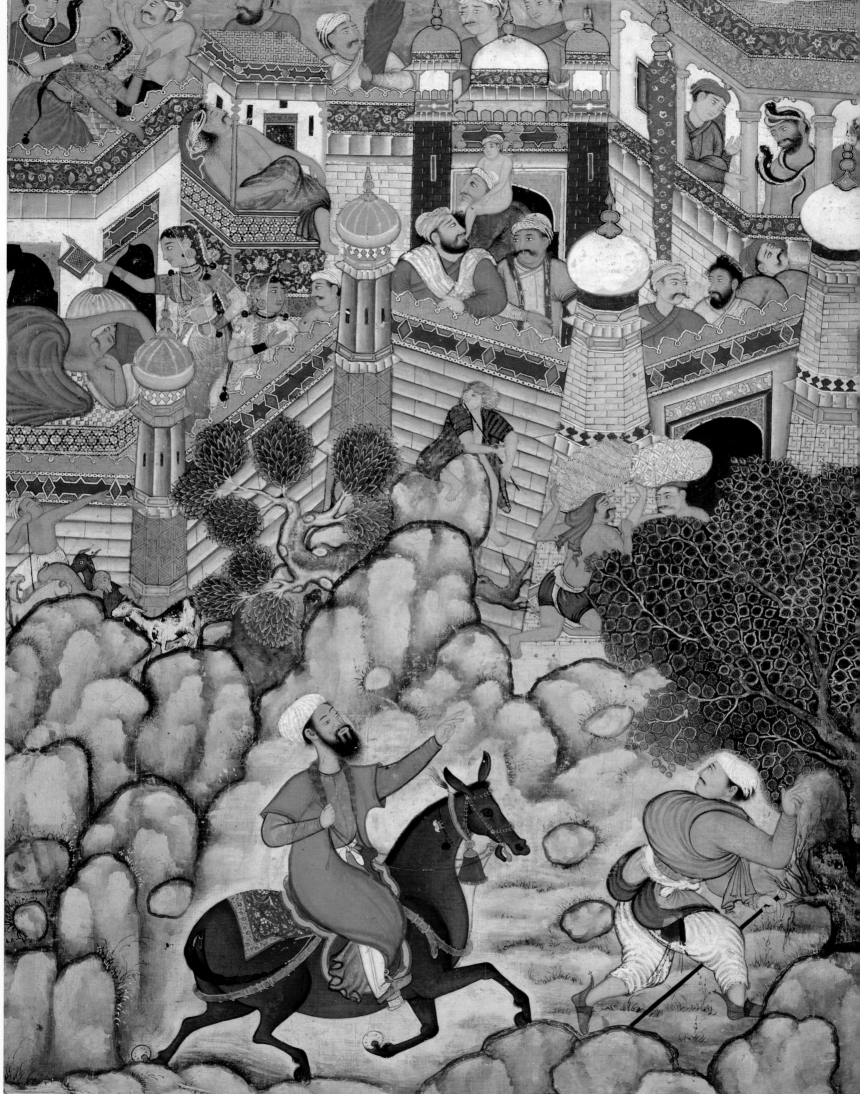

CAT 70

70 UMAR, DISGUISED AS THE SURGEON MAZMAHIL, ARRIVES BEFORE THE CASTLE OF ANTALI

Attributed to Shravana and Mahesa

Volume 11, painting
number 83, text number 84
India, Mughal dynasty,
circa 1570
Painting 67.3 × 51.2 cm,
folio 79 × 63.4 cm
Caption: 'Umar in the guise of
the surgeon Mazmahil arrives
before the castle of Antali'
Freer Gallery of Art,
Smithsonian Institution,
Washington, DC;
Purchase, F1960.15
Published: Beach 1981, no.5b.

1. Beach 1981, pp.65, 85, 87.

Hamza receives the good news that his forces have been victorious in one city after another. The joy of this moment is clouded, however, by the uncertain fate of some of his champions who are still being held prisoner by the sorcerers. Hamza orders Umar to find out what he can about them so that they can be freed. Umar dutifully sets out for Antali with a band of *ayyar*s. He meets a lonely traveler heading that way and engages him in conversation. The traveler identifies himself as Mazmahil the surgeon, and tells Umar that he has been away from his home in Antali for three years.

"Umar put his hand into his breast and gave Khwaja Mazmahil the surgeon a handkerchief full of raisins. 'I had gone to the village to buy fruit,' he said. 'I left my men there to bring [what I bought]. I myself set out for home.'

Mazmahil took the raisins, ate them, and fell unconscious. Umar hid him in a place that was not generally trafficked and where the army and servants would be safe. He took on his form, and Yakdam, one of the *ayyar*s, disguised himself as a rein-holder. Umar set out. The rest of the *ayyar*s went to the villages, bought loads of fruit, hired pack animals, loaded them up, and entered the city of Antali."

Playing upon the appeal of another ruse by Umar, that master of disguise, Shravana features Umar as the ersatz doctor, and shows him trotting toward the gates of the city of Antali preceded by a single bulky *ayyar*. There is no sign of the waylaid Mazmahil. Instead, Shravana fills the remainder of the foreground with a screen of rocks whose contours rise and fall to frame Umar's head and mount and to open a sightline to the gate. Shravana gives these rocks the same internal rectangular facets as his outcrops in cat.51, but he forgoes the heavy shading around them so that the entire area reads as thin and light, and flows readily into the pinkish ramparts of the city. By contrast, he impedes physical access to the portal with a large tree, one he makes dense enough to function as a visual obstacle by overlaying a blackened patch with dark green leaves rimmed in white, a type of tree he uses to similar effect in cat.47 and 67.

There are many indications that Shravana also designed and painted the architecture. He sets the fort's entrance at an acute angle, as he does in cat.47, and accentuates the zigzagging rhythm of the ramparts and roofs with strong decorative bands, a trait also seen in cat.67. More particularly, those bands are adorned not only with a delicate floral design, but also with one consisting of a solid blue star alternating with a triple-starred cartouche, a feature occurring only in his work (cat.67). And throughout the city, the patterns of the masonry courses and tilework exhibit all the crispness that one has come to expect in Shravana's architecture.

His collaborator is Mahesa, an artist to whom the painting had previously been attributed.[1] Mahesa was charged with peopling the city that will soon be ravaged by Umar's snake-oil remedies. He responds to this assignment with a number of figures who tower over the city they inhabit. Many are occupied with unusual activities – a goatherd surveying his world from a rock, a wife fanning her sleeping husband, an old man carrying his grandchild, and a sorcerer and sorceress wearing cobras coiled about their necks. Despite this kind of inventiveness, Mahesa never really manages to breathe life into his figures. Their gestures are invariably stiff, their faces habitually flat, and their expressions rarely more animated than a pair of knitted eyebrows. While this muted quality was becoming a conservative trait as early as 1570, it was certainly an acceptable manner for long after that, as Mahesa's prolific career attests.

When Umar, disguised as Mazmahil the surgeon, reaches Antali, he fully expects that he will have to live by his wits, for he has no idea where he is going. Luck is with him. Some merchants catch sight of 'Khwaja Mazmahil,' and quickly spread the news of his return, much to the delight of those who missed him during his long sojourn in Akhtam. His friends complain that they have suffered because the God-worshippers have broken all their spells, and now they dread the attack of Umar, who will surely try to free some of the champions imprisoned by Zumurrud Shah. 'Khwaja Mazmahil' commiserates with them, and bemusedly asks what sort of person this Umar is. He declines all food and drink, claiming that he is observing a fast. Then he is ushered to his house, where his servants, his family, and his 'wife' greet him with open arms. To the woman's alarm, 'Mazmahil' again turns down all refreshment, feigning stomach problems, but that night beds her anyway.

The next day Umar asks his *ayyar* squire, here called Kulbad Iraqi, to take to market the goods brought by the real Mazmahil's caravan, and prevails upon his family and friends for further cash advances. Kulbad plays along with all this, and absconds with a sizable sum.

"[Next, 'Khwaja Mazmahil'] had it heralded that anyone who had a pain should come to be treated. People flocked to him because in Antali all were sorcerers, and toothaches, headaches, earaches, sore eyes and feet were common. There was not a single skilled physician. When they heard that Mazmahil the surgeon had come, all gathered around him.

In short, everyone who had a pain told him about it. He gave them medicine out of his *ayyar*'s satchel, and two days later they all died. The Khwaja left Mazmahil's house in the middle of the night, woke [the real] Khwaja Mazmahil up, and gave him his horse. The man went home, but he was attacked by the people, who were shouting, 'He gave our relatives medicine and killed them!'

'Friends,' he yelled, 'I have no knowledge of this. I have just come home after an absence of three years.' But they dragged him to the house of Mâlik Zarduhusht and cried out against him. Zumurrud Shah heard their cries and said to Bakhtak, 'Summon Khwaja Mazmahil.' When he came in, he was asked about what was happening, and he explained. They realized that it was Umar. The merchants also cried out, 'He borrowed a lot of money from us.' It did no good. The news spread throughout Antali."

This painting obviously builds upon the previous illustration. The walls of Antali again trace a zigzag path across the composition, this time commencing at a much lower point so as to open up more space in the court-yard. The towers flanking the gate are battered as before, and the two smaller towers are replicated in every detail. Even the golden merlons and solid decorative cartouches are repeated. Together with the precisely rendered patterns found in the carpets, screens, and tilework of the courtyard, these features are a sure sign that Shravana has reconstructed his architectural setting.

He is joined by a pair of artists. Dasavanta probably designed all the figures, some of whom are brought by anguish and agitation to a level of expression rarely seen in Mughal painting. A pained old woman being comforted by her daughter, a screaming younger woman cradling one child and restraining another, and Umar himself, checking that the frail turbaned man before him still has a pulse – all these exceptionally inventive figures spring from Dasavanta's fervent imagination. In other cases, he draws figures from his own idiosyncratic repertoire: the round-faced onlooker – a European-inspired figure on his way to becoming a minor stock character, a dozing greybeard, a rudely clad laborer before the city gate, and a diminutive goatherd minding his flock. Surprisingly, Dasavanta actually completes few of these figures, turning that task over to an infrequent collaborator, Mahesa. Mahesa rises to the occasion, and exaggerates facial features for expressive effect. Thus, it appears that Mahesa executed at least the face of every figure in the courtyard but Umar, the two sandy-haired (and thus European-inspired) children, and the frontal onlooker. The others have the angular noses, crinkled brows, and sketchy ears that Mahesa habitually imposes on many of his figures. In this example, Mahesa renders folds in cloth with a harsh convention. The contrast between Mahesa and Dasavanta becomes evident in a comparison of the seated patient's turban with the screaming woman's two-tiered purple dress, or in one of the dirtily striped white cloths draped around the turbaned patient with the wetter, more subtly streaked white shawl of Umar. That Dasavanta would bother to add strikingly painterly garments to the three figures seated behind Umar even though he left the faces to Mahesa underscores the very *ad hoc* nature of collaboration in this manuscript.

Attributed to Dasavanta, Shravana, and Mahesa

Volume 11, painting number 84, text number 85 India, Mughal dynasty, *circa* 1570 Painting 68 × 52.4 cm, folio 78.7 × 63.5 cm (detail on pp.214–15) Caption: 'Mazmahil practices medicine on the sorcerers' Brooklyn Museum of Art, Caroline H. Polhemus Fund, 24.49 Published: Blair & Bloom 1994, fig.362; Poster *et al.* 1994, no.25; Chandra 1989, fig.4; Brand & Lowry 1985, no.12; Khandalavala 1983, fig.1; Welch 1963, no.28; Dimand n.d., pl.1; Comstock 1925, p.348.

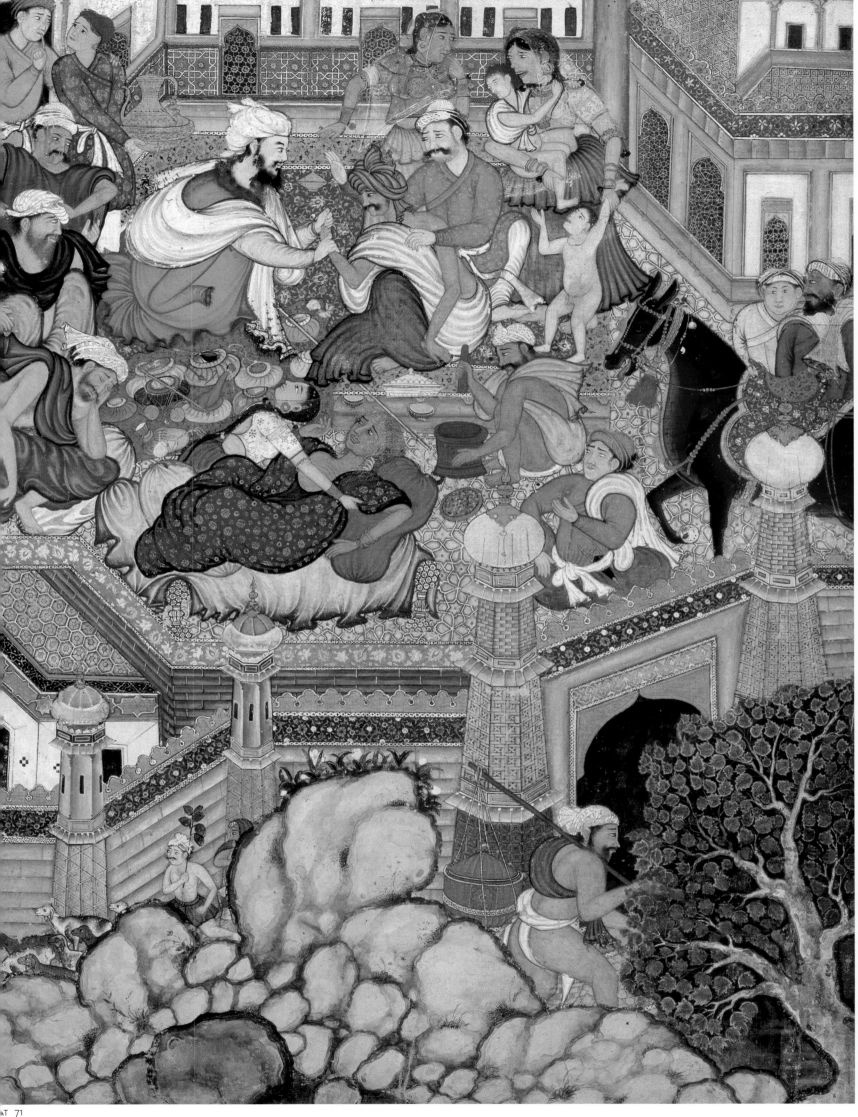

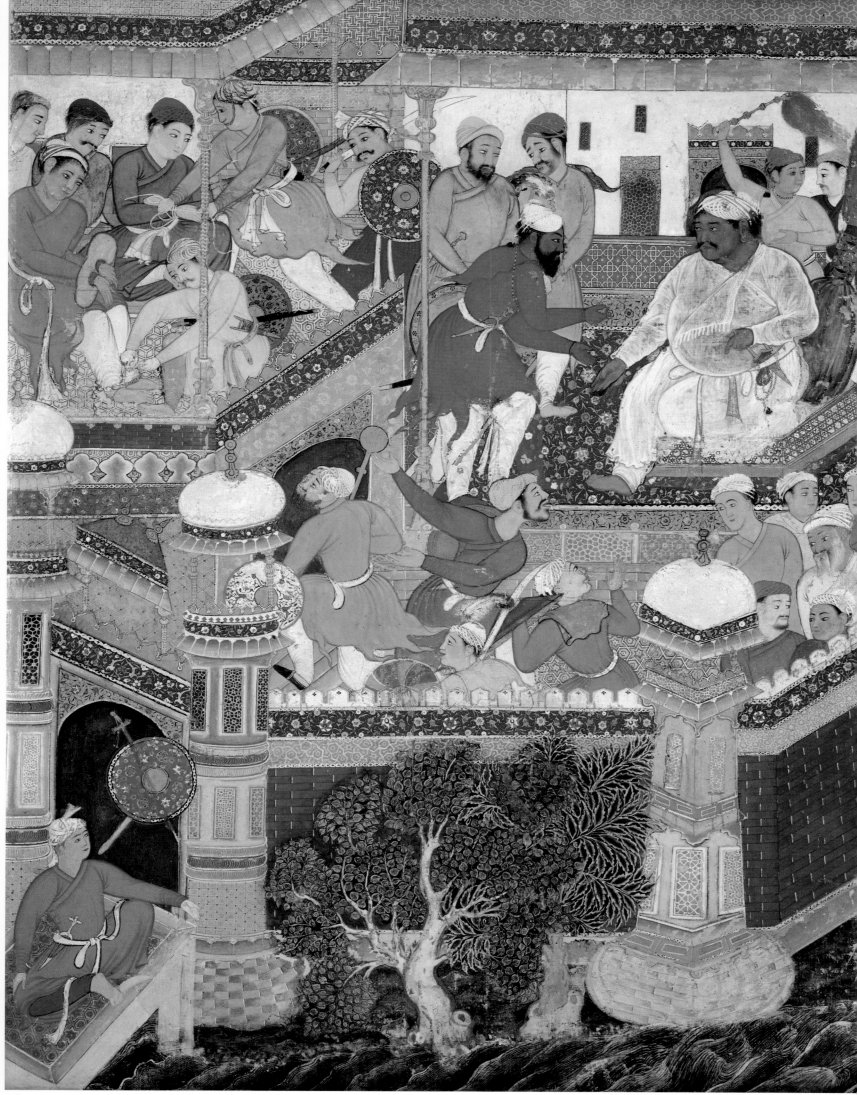

Attributed to Shravana, Mithra, and Madhava Khurd

Volume 11, painting number 86
India, Mughal dynasty,
circa 1570
67.5 × 51.6 cm
Caption: 'Zardhang Khatni
brings a ring to Maltas the
prison keeper'
Freer Gallery of Art,
Smithsonian Institution,
Washington, DC; Purchase,
F1949.18
Published: Heeramaneck 1984,
pl.139; Beach 1981, no.5c;
Ettinghausen 1961, pl.2.

1. These include Zardhang,
two of the three attendants
above the greybeard in the
lower right, the gateway sen-
tinel, and the guard dressed
in an ochre *jama*.
2. I.S. 2-1896 55/117; Sen 1984,
pl.40.

Like many modern adventure stories, the *Hamzanama* makes for many a gripping tale by repeatedly putting its heroes in harm's way. Sometimes the heroes prove their innate superiority by overcoming their formidable adversaries by sheer strength or derring-do, but many other times they are rescued from imprisonment and apparently certain death when their dull-witted captors are tricked or manipulated by a resourceful *ayyar*.

This painting has lost its accompanying text, and its caption is now obscured by a modern border. An old photograph in the possession of the Brooklyn Museum of Art, however, documents both the caption and the painting number. The caption identifies the scene as Zardhang Khatni, an *ayyar* also mentioned in cat.31 and 84, giving a ring to Maltas the prison keeper, presumably as a kind of a distraction or bribe to help secure the release of the two prisoners depicted in the upper left. The painting number (86) enables us to refine this identification. The text following a painting numbered 84 (cat.71) concludes with a passage indicating that all Hamza's champions are being locked up in Zarduhusht's black pit, from which no escape is possible. Thus, allowing for the story to develop a bit in the intervening (and now missing) folio, we can reasonably conclude that this painting belongs to volume 11 and illustrates the rescue of Hamza's champions.

The focus of this lively painting is the corpulent Maltas, complacently awaiting with open palm the tribute to which he has grown accustomed. Zardhang understands the meaning of this common gesture of desire and greed, and prepares to press a small golden ring into the prison keeper's outstretched hand. The beneficiaries of this transaction are two prisoners who are having their shackles and bindings undone by two guards. Other guards rush about in obvious agitation, a state contrasted with the placid demeanor of the courtiers huddled together below Maltas. Lounging outside the compound's gateway is one last guard, his sword and shield hanging from the doorframe, a sure sign of their infrequent use.

The overall design of the painting can be attributed to Shravana, whose penchant for dense and finely rendered architectural patterns is seen throughout the composition. This includes even the outer towers, an area where architectural details are not normally developed to such a degree. As might be expected, some specific forms and patterns are repeated from earlier works by this artist; among these are the golden merlons to the right of the prisoners, the red dado tilework depicted in cat.71, and the flattened cushion domes featured in cat.65. Shravana also enlivens the area outside the walls with a pair of vigorous trees.

Nearly all the figures were supplied by Mithra. His oval-headed, large-eyed figures are familiar from two other works not much earlier in this volume (cat.54 and 68); indeed, one guard holding a sword and shield in the upper center is identical to a courtier in the lower right of cat.68. A few figures, notably the guard behind Zardhang wearing an apprehensive expression on his stubbled face, go well beyond type. Still other faces display the flat surface, dainty features, and vacuous expressions that are the hallmark of later repainting.[1]

By far the most compelling figure is Maltas. While the primary figure of a scene often fell to the designer of the painting, in this case the indolent prison keeper was assigned to Madhava Khurd. This portrait specialist makes Maltas ample in every respect, from his thickset neck to his generously overhanging belly and lumpish feet. Rather than emphasizing mass by strengthening the contours of the body, as he usually does, Madhava accentuates Maltas's rotund form by girding the rolling expanses of dark skin on the torso and arms with tautly stretched gauzy white cloth, and then bunching that same material elsewhere so that it becomes thick and opaque. Shravana does, in fact, paint a similarly bulging dark-skinned figure in white in the *Akbarnama* manuscript in the Victoria and Albert Museum[2], but one look at the more dryly drawn clothing and less sensitively rendered face in that later painting suggests that he is merely redeploying a figure his colleague had invented in this painting.

73 HAMZA BURNS ZARDUHUSHT'S CHEST OF ARMOR AND BREAKS THE URN WITH HIS ASHES

Like many legends, the Hamza romance draws freely upon actual historical personages and events, embellishing some with fanciful details and combining others into instructive, if anachronistic tales. Thus it is that Mâlik Zarduhusht, known throughout the world as Zoroaster, a major religious leader of the sixth century BC, enters the Hamza legend, which ostensibly recounts the exploits of a figure who lived more than a thousand years later. Zarduhusht's role in the realm of myth, of course, is to personify one strain of religious resistance in Iran to Islam. In this, he finds himself allied with Zumurrud Shah, an idolater, with whom he has clashed in the past. Earlier references to Zarduhusht establish that he dwells in Antali (modern Anatolia), where he is the chief sorcerer. So potent is his own sorcery and so commanding his presence that even Zumurrud Shah defers to him, first soliciting his permission to visit the city of Antali, and then prostrating himself bareheaded before him.

Zarduhusht has two daughters. One, called Malaka, had earlier used her own powers of magic to infiltrate Hamza's camp; upon being discovered by him, she converted to Islam, and promised to use her sorcery only to ensure his conquest of Antali. Zarduhusht's other daughter, known as Saradiq the sorcerer, is neither so young nor so compliant, and dies at Hamza's hand. Although the text describing this event is now missing, Saradiq's fate is related by her daughter, Manut, when she reveals to Hamza the identity of the woman he has just slain. As always, Hamza rewards the sincere and punishes the unrepentant. Even though she is distraught at the death of her mother and the destruction of her grandfather's relics, Manut readily accepts Hamza's invitation to convert and marry one of Hamza's officers. Other sorcerers spurn this gesture of clemency, and are bound in chains and led away to be executed. One who does fare well when Hamza occupies Zarduhusht's palace is Khwaja Mazmahil, the hapless surgeon (see cat.71). In recompense for the misery visited upon him by Umar, Hamza appoints him governor of Antali.

The caption identifies the subject of this illustration as Hamza immolating the armor chest of Zarduhusht and smashing an urn, presumably containing his ashes, on the ground. Zarduhusht's spirit, depicted in the form of a faceless warrior, rises from the flames and dissipates. Thus, Hamza simultaneously desecrates a Zoroastrian fire-temple, and weakens the fervor of Zarduhusht's followers by obliterating all trace of his physical remains.

Despite this violent action, Hamza is shown typically steadfast, holding a small rectangular object – perhaps a mirror – before his face as if to shield it from the conflagration. True to form, Umar responds more actively, twisting his head about to look back toward Hamza even as he points to the shattered urn at his feet. The scene's emotional temperature peaks with Manut, who gesticulates frantically with her arms and stares in anguished disbelief at the ongoing catastrophe. But Dasavanta, the principal artist of this work, carries through the drama even in her clothing; her voluminous blouse, for example, clings to reveal her pendulous breasts and rides up to expose her stomach. These are sure signs that Manut is, after all, still a sorceress, albeit a sympathetic one who will soon be rehabilitated.

Conversely, Dasavanta makes it clear that the sorceresses manacled together opposite Manut have no redeeming virtues whatsoever. He does so by stigmatizing them as crones with misshapen profiles, snout-like noses, elephantine ears – truly some of the most hideous features of early Mughal painting. Only occasionally does he invoke such stock demonic features such as flaming eye-rims and discus-sized earrings.

Less flamboyant are Hamza's men, who, huddled together behind a ridge, are overshadowed by the snarling dragon standard above them and the writhing, heavily textured chenar tree beside them. They are the work of Mukhlis, an artist whose figures have dark features and usually animated expressions. For the splendid fire-temple, Mukhlis repeats the cubic tilework pattern of the courtyard of cat.64 and the magnificent dome from cat.58.[1]

Several faces in this painting now have quite indistinct features; this is not an original effect, but the result of the removal of previously repainted features sometime after 1937.

Attributed to Dasavanta and Mukhlis

Volume 11, painting number 88, text number 89 India, Mughal dynasty, *circa* 1570 Painting 67.9 × 51.4 cm, 79.4 × 63.3 cm Caption: 'The Amir burns the chest of Zarduhusht … and throws [his urn] to the ground' The David Collection, Copenhagen, 72/1988. Formerly in the collection of the Art Institute of Chicago. Published: von Folsach 2001, no.56; Sotheby's, London, 15 April 1985, lot 478, Glück 1925, p.152, pl.47; Culin 1924, p.142.

1. Mukhlis produces yet another version of this dome and the brightly shingled eave surrounding it in another *Hamzanama* painting (MAK, Vienna, B.I. 8770/40), published in Egger 1974, pl.37 and Reconstruction, no.86.

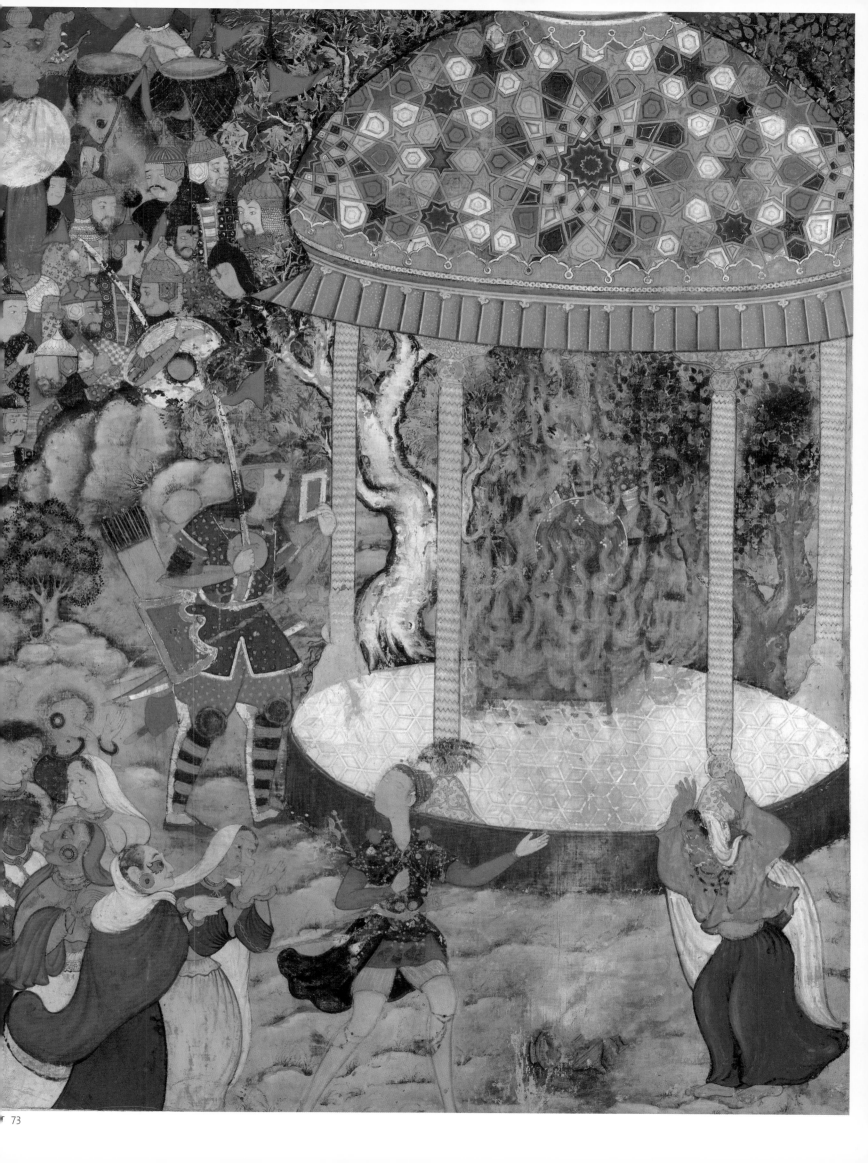

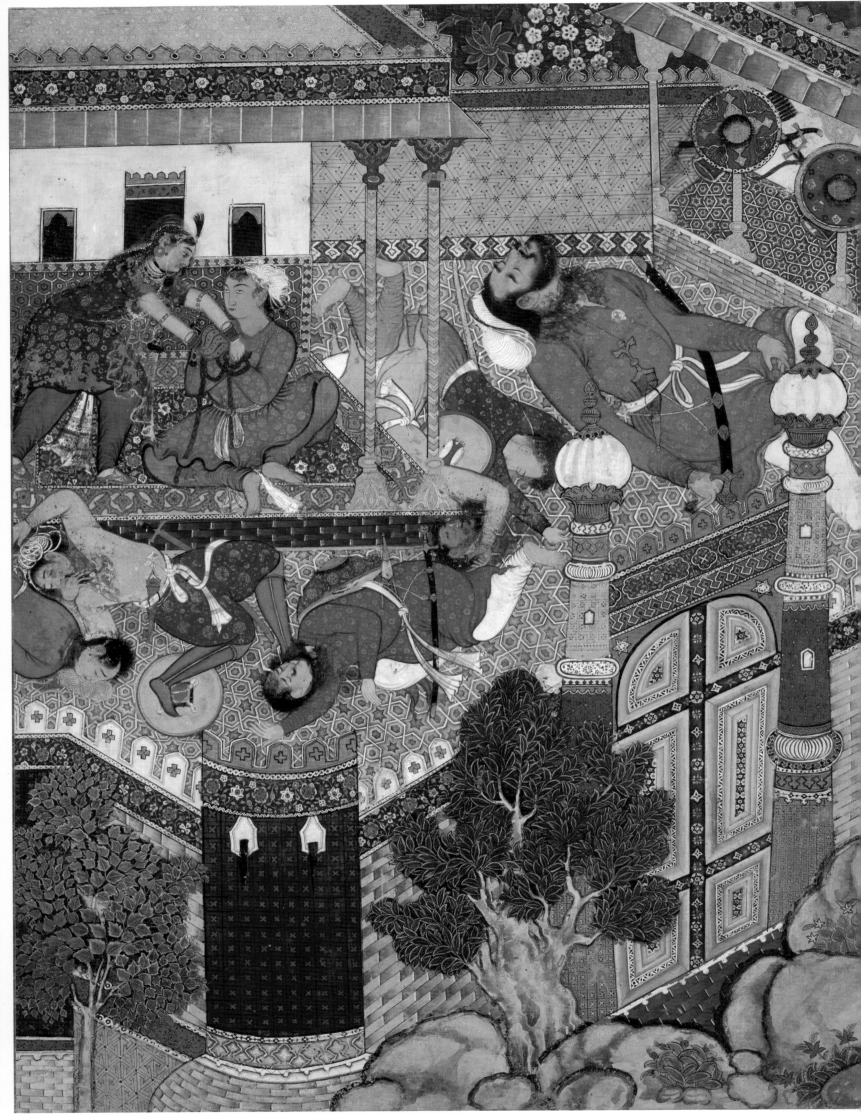

CAT 74

Attributed here to Jagana and Shravana

Volume 11, painting number 89
India, Mughal dynasty,
circa 1570
67.3 × 50.8 cm
Caption: 'Khurshedchihr knocks out the prison guards, cuts off their heads, and frees Hamid'
Arthur M. Sackler Museum, Harvard University Art Museums, Private Collection.
Published: Harle 1986, fig.299; Welch & Beach 1965, no.4; Welch 1959, fig.1.

During a hunt, Prince Hamid, the son of Malik Qasim, grapples with a veiled rider who tries to take the gazelle he has captured. The defeated rider removes her veil to reveal her resplendent beauty, and identifies herself as Khurshedchihr ('Sun Cheek'), the princess of the kingdom of Venus. The two naturally grow enamored of each other. Hamid's handsome countenance, however, also catches the attention of Khurshedchihr's mother, who, having been told by her daughter that the radiant youth was a slave, offers to buy him on the spot. Khurshedchihr declines, and begins a love affair with the youth. Meanwhile, the king notices the absence of the queen and princess, and dispatches an *ayyar* to discover their whereabouts. The *ayyar*'s report provokes the king to send two Zangis to kill Hamid. They meet an untimely end at the hand of Hamid, but another *ayyar* succeeds in kidnapping the prince. The king orders Hamid thrown into prison.

"The next day when the mother and daughter came before the king and informed him, the girl grew impatient and said, 'O queen, this Zangi they have entrusted with Hamid is in love with me. If you so order, I will go kill him and release Hamid.' With permission she set off. When she came she rendered everyone unconscious, cut the Zangi's head off, and rescued Hamid."

Jagana knows how to introduce some variety into a well-established compositional type. As usual, he isolates the protagonists, this time in a standard pavilion placed to one side of the courtyard. To avoid the potential monotony of a symmetrical composition, he places the high gateway in the opposite corner and sets it obliquely within the composition. The wall that is contiguous with the gateway now dips downward, and eventually angles upward; at this juncture Jagana inserts a massive bastion, a form that by virtue of its rounded shape and dark color simultaneously breaks up the uninteresting stretch of flat ramparts and establishes a visual axis leading back to Hamid. The artist then manipulates the sprawling bodies of the six slaughtered guards so that they fill nearly every part of the tiled courtyard; the largest guard answers the size and visual weight of Khurshedchihr and Hamid, and two other victims overlap the base of the pavilion just enough to temper the strong geometry of the setting.

Like most artists, Jagana consistently draws upon his own personal repertoire of forms. As in cat.61, his guards are simple, flattened shapes, and their clothes are either overlaid with an unobtrusive pattern in gold or are left altogether plain. Jagana reuses some poses from that same painting, casting both the large guard in orange and the figure dressed in pink and blue in positions virtually identical to those used earlier. He maintains the strong tilework pattern of the courtyard used in both cat.35 and 61, as well as the convention of shading the bricks of the outer wall. Other architectural details are more distinctive, particularly the pronounced oval ring around the necking on the gateway supports, and the black-and-white inlay around each gateway panel.

Jagana's collaborator is Shravana, who supplied the figures of Khurshedchihr and Hamid, as well as the area immediately around them. Khurshedchihr's rounded, thickset face compares closely to those of the female attendants in cat.47, and the unusual forest-green color of her clothing recurs in many of Shravana's works. Hamid's face and neck have been repainted in modern times, but his *jama* shows the same limited modeling that Shravana applies to nearly all his figures. Finally, there is Shravana's penchant for large foliate forms, found both in its customary position in the carpet border and on the capitals and bases of the slender columns.

THE TRIBULATIONS OF MIHRDUKHT
CAT 75, 76

Mihrdukht is a beautiful young woman searching for her husband, Prince Hamid. Disguised in male attire, she attracts the interest of the princess Afsar Banu. One day, while accompanying Afsar Banu on a hunt, Mihrdukht rides after a gazelle and becomes separated from the princess's retinue. Finally she finds herself lost and alone at the seashore. A boat passes by, but the captain refuses to pick her up until she offers her horse in payment. The boat sinks in a storm, and only Mihrdukht manages to make it to an island. When rescue finally does come, it is again a mixed blessing, for the rowboat that stops for her is occupied by one old man and four youths. The youths quickly see through her disguise and begin to press their affections on her. Mihrdukht, of course, wants none of this, and devises a plan to rid herself of them. She proposes that she shoot an arrow onto the shore, and declares that whichever of them retrieves the arrow will have her as the prize. Now Mihrdukht will soon have occasion to display her accuracy with the bow, but here she is more concerned with raw distance. Shoot she does, and the four youths run off after the bride-winning shaft. Mihrdukht has planned all along to use this opportunity to escape, and now appeals to the kindly old man to help her. Seeing a chance to teach the youths a lesson, he readily agrees and rows the boat away, leaving the youths forlorn and frustrated.

Many vicissitudes later, Mihrdukht finds herself besieged by suitors once more. Again she uses her skill with a bow to select the most worthy. Only one man meets her challenge – to fire an arrow through a small ring suspended at the top of a high tower – and he proves to be her missing husband, Prince Hamid.

Detail of CAT 75

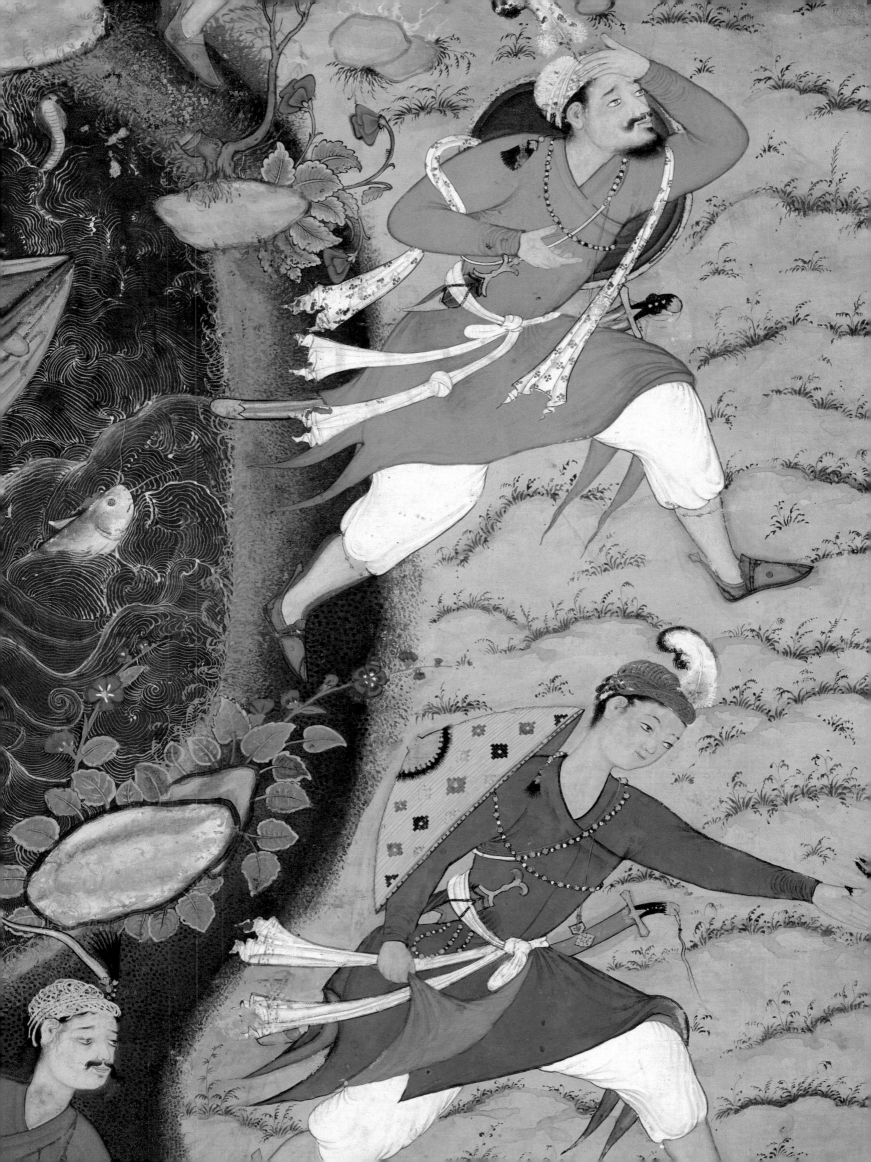

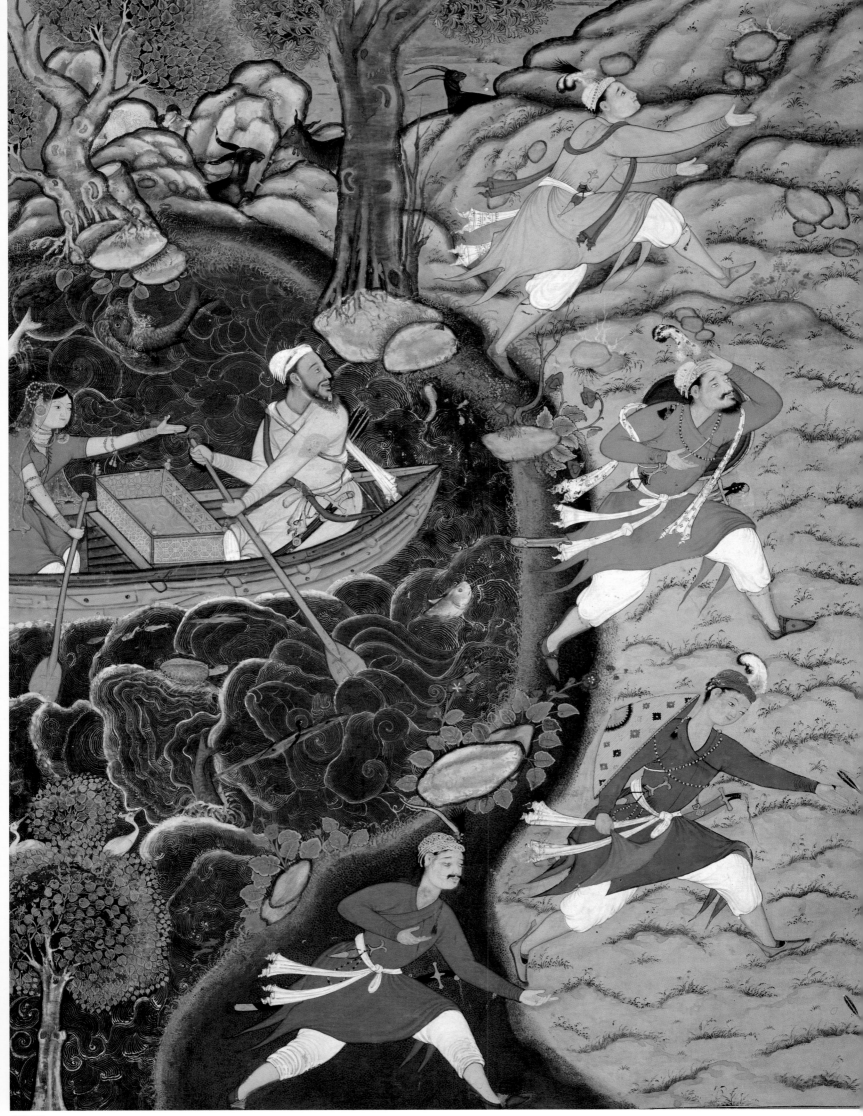

**Attributed to Banavari
and Mah Muhammad**

Volume 11, painting
number 91, text number 92
India, Mughal dynasty,
circa 1570
67.1 × 51.2 cm
(detail on pp.226–27)
Caption: 'Mihrdukht shoots
the arrow and sends the
footmen to retrieve [it]
while she gets in a boat with
an old man and escapes'
MAK–Austrian Museum of
Applied Art/ Contemporary
Art, Vienna, B.I. 8770/32
Published: Beach 1987, fig.41;
Welch 1978, pl.2; Egger 1974,
pl.54; Egger 1969, pl.33;
Comstock 1925, p.353; Betz
1965, pl.13; Glück 1925, pl.44.

Mihrdukht, on a quest to find her husband, Hamza's son Prince Hamid, is traveling disguised as a young man. A lovely princess, Afsar Banu, takes pity on the wayworn youth, and invites Mihrdukht to stay with her a while. One day the princess invites Mihrdukht to join her in hunting gazelles. Afsar Banu soon brings down her gazelle, but Mihrdukht chases hers without success.

"When Mihrdukht had gone very far in the chase, night fell on the plain. She kept on going until daylight, when she had reached the edge of the sea. There was a ship sailing by, but no matter how much she cried out, the ship would not turn back. However, when she promised her horse to the captain, he brought the ship around, and Mihrdukht gave him her horse. She got on the ship, but then the sea became turbulent.
The sea was as full of water as a crying eye, and the people were in a situation as bad as that of the pupil.
The ship struck a rock and broke apart. All were drowned, but by chance Mihrdukht clung to a piece of wood floating on the surface. After two days she reached the shore. She thanked God and went onto the island. As she looked around she spied a rowboat in the distance. There were four young men and one old man in the boat. When they got out of the sea and their eyes fell upon Mihrdukht and they realized that she was a girl, they all desired her and started fighting over her. Mihrdukht saw that the old man in their midst was saying nothing, but was attempting to stop them from fighting. 'Friends,' said Mihrdukht, 'there is no need to fight. I will shoot an arrow, and I will accept whoever brings it back first.' They agreed to this."

The narrator says that Mihrdukht was an extremely good archer. The young men turned to Mihrdukht and said, 'All right, shoot the arrow.' She shot, and the young men ran off after it. The old man turned to Mihrdukht and said, 'My beauty, what are you planning?'

'I thought I would get in the boat and escape,' she said. The old man was highly pleased by this. Mihrdukht got into the boat, and they set out."

Mihrdukht's reprieve is all too temporary, however, and she soon stumbles into yet another misadventure. But that, as the narrator says, is a story for another day.

Banavari, the designer of the painting, illustrates this fetching tale with a simple, even naive composition. Employing a very large figure scale to emphasize each of the six characters, he shows the four youths, each dressed in a different bright color, racing inland. It does not appear that they will be occupied for long. The youth in blue, who holds the end of his *jama* so that he can run unimpeded, is already within arm's reach of one arrow, and his counterpart in red has set his sights on a second. The other two youths hotfoot it in other directions. Meanwhile, Mihrdukht and the old man have already begun to head out to sea. The old man is armed with bow and arrows, but Mihrdukht, whose archery shot sets everything in motion, has dispensed with her own bow and is content to point toward her suitors' frenzied search.

Before Banavari executed the figures, he turned the painting over to Mah Muhammad, who supplied most of the landscape. Mah Muhammad, whose work to this point in this volume has been generally limited to architecture, accentuates the curving shoreline with a dark green zone that flares out at the bottom of the composition just enough to accommodate the figure of the youth in red. He overlays this area with dense stippling, an old-fashioned technique rarely seen in the *Hamzanama*. He also punctuates it with five very schematically isolated rock clusters – one for each of the youths plus another to mask the base of the greyish tree trunk at the top – and garnishes them with a ring of leaves and large red flowers. His trees are formulaic, with roots ending abruptly and knotholes placed more artificially than ever.

Banavari conceives his figures as flattened shapes, a trait most conspicuous in the youths' solidly colored *jama*s, but most memorable in the single breast protruding from Mihrdukht's. The water is truly inspired. Flotsam, fish, and snakes sporadically break up its surface, but for the most part the water forms whorls as delicate as soap bubbles. Finally, Banavari probably also strengthened the upper reaches of the landscape, and, perhaps in a sly allusion to the youths' randy disposition, included four insatiable goats.

Many a maiden's hand is won by a suitor who demonstrates his worthiness by performing a feat of great strength or skill. Mihrdukht, who earlier used her prowess in archery to throw her four youthful admirers off track, now devises a different sort of challenge for a new group of suitors. Standing on the balcony of a lofty pavilion, she takes aim at a small ring dangling from the mouth of a golden bird installed at the top of an impossingly tall tower. With incredible ease, she lets fly an arrow with such unerring aim that it passes cleanly through that ring. Only one who can match this, she declares, will ever earn my affection!

Because this painting has been shorn of its caption and text, we have no idea how many suitors tried their hand at this challenge and failed. Inevitably, however, a champion emerges from the pack and succeeds where all others have gone awry. The situation is complicated by the fact that Mihrdukht is married, though cruel fate has kept her apart from her husband, Hamid, for months on end. True enough, a handsome young man fires an arrow exactly as Mihrdukht herself had done, and comes to claim her as his prize. When he appears before her, however, Mihrdukht swoons as she recognizes him, for he is none other than Hamid!

This climactic story is told in two largely identical scenes. The first captures Mihrdukht as she draws her bow. Her immediate attendants buzz at the audaciousness of her challenge, but the three maidservants lingering outside the pavilion entrance seem oblivious to the ongoing drama. One man, almost certainly a watchman who has momentarily stepped inside the compound, looks up at the golden target; another, probably a disheartened suitor, glances over his shoulder as he flees. The second illustration repeats the setting of a garden pavilion, altering only the location of the entrance and some minor architectural details.[1] Now the dashing Hamid addresses Mihrdukht, but she has fallen in shock at his sudden appearance. Consternation spreads throughout the garden, where five unsuccessful suitors gape at the momentous reunion, and outside the compound wall, where Hamid's groom waits anxiously with the prince's stallion.

The sequential illustrations are executed by two different teams of artists. Basavana, who seems to have designed this painting, creates a spacious garden by reducing the size of its walls, and by introducing a distant side wall at an oblique angle.[2] His painterly touch is apparent in both the spreading plantain tree and the pair of palm trees, whose forms complement that of the soaring tower in different ways. Mihrdukht herself has a slightly more blockish head than Basavana's later images of women in profile, but also his distinctly narrow eye, subtle wisp of a smile, and gauzy veil; this combination strongly recalls Basavana's figure of Khosh-Khiram in cat.66. A second artist has clearly supplied the other women on the balcony, for their flattened faces and large, globular breasts are entirely unlike those features in Basavana's work.

To judge by the appearance of many familiar architectural patterns, this second artist is Jagana. He uses his favorite trilobed pattern twice on the garden fountain, and again outlines the doorway panels with a black-and-white inlaid border. Likewise, he repeats from the dado and gateway of cat.35 the intricate cubic pattern on the balcony balustrade and the interlocking arrow-headed pattern of the outer wall. The exuberantly wavy patterns on the capitals and bases of the slender sandstone columns have no precedent in Jagana's work, but are probably the most striking manifestation of his decorative interests.

Attributed to Jagana and Basavana

Volume 11, painting number 95
India, Mughal dynasty,
circa 1570
67.8 × 52 cm
Collection of Howard Hodgkin
Published: Filippi 1997, no.1;
Beach & Topsfield 1991, no.1;
Barrett & Gray 1963, p.76;
Glück 1925, fig.37.

1. MAK, Vienna, B.I. 8770/31; reproduced in the Reconstruction, no.111; Egger 1974, pl.55. It is attributed here to Mukhlis and Banavari.
2. He uses very similar compositions in the Jaipur *Ramayana* (AG 1936 and AG 1940), and fills them with comparable trees and flowers.

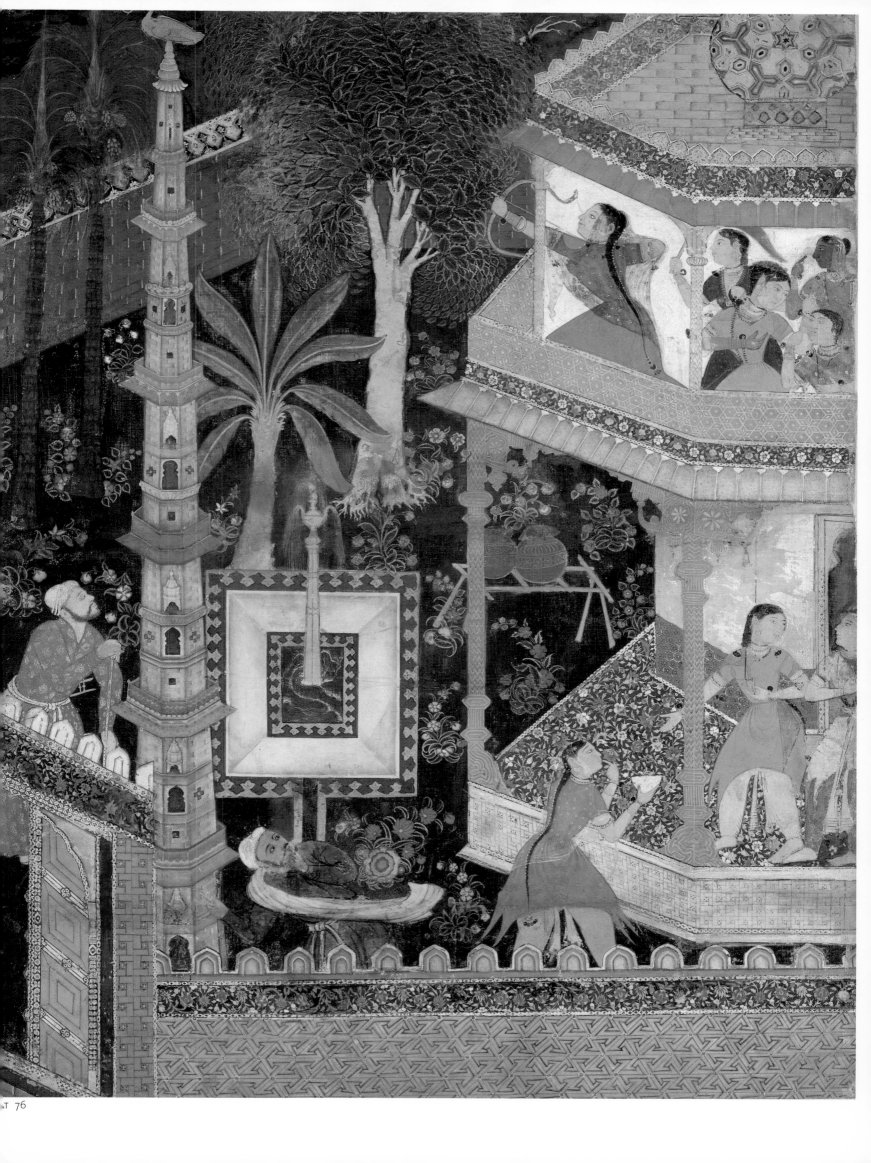

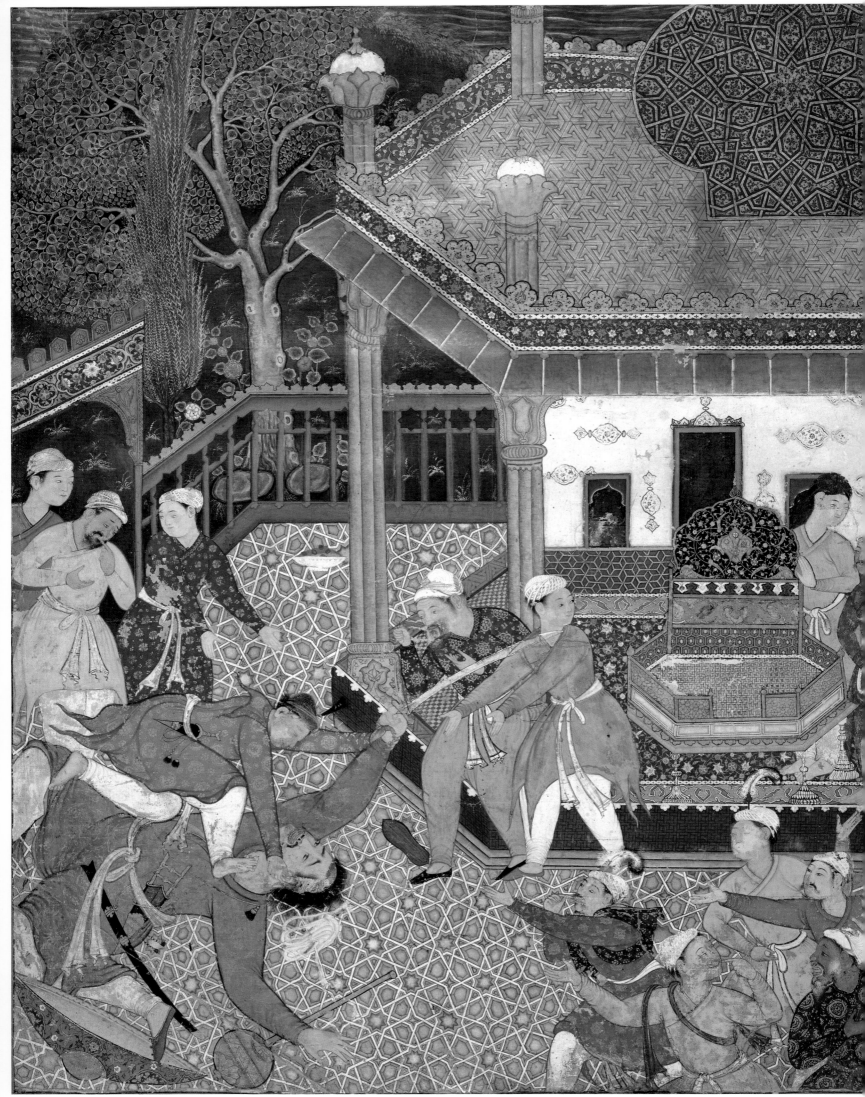

**Attributed to Shravana,
Mukhlis, and Kesava Dasa**

Volume 12, painting
number 2, text number 3
India, Mughal dynasty,
circa 1571
68 × 52 cm
Fitzwilliam Museum,
Cambridge, PD.204-1948
Published: London 1982,
no.235 (unillustrated).

Although the text and caption describing this scene have been lost, the following text and painting number provide enough clues to allow us to identify its hero and villain and to situate the illustration in the manuscript. In the opening lines, Prince Hamid vows to heap further abuse on an opponent if he does not do as he is told. That opponent seems to be Mahval, one of the henchmen of Malik Khizranshah, the ruler of Nuriya. Soon afterward, Mahval reports to Khizranshah and urges him to avenge his humiliation. Khizranshah readies two hundred thousand men to teach the insolent Iranians a lesson, and Hamid answers by amassing similarly vast legions. Before the battle is joined, however, Hamid sends an emissary to Khizranshah with an ultimatum to convert. Afsar Banu, Khizranshah's daughter, comes to court dressed as a man, and impudently rejects the emissary's demand. The armies clash the next day. On the following day, Afsar Banu takes the field wearing a veil, and finally encounters none other than Hamid himself. She removes her veil, thereby revealing her great beauty, and Hamid is hopelessly smitten.

The reintroduction of Afsar Banu relates this episode to cat.75, in which Hamid's plucky wife, Mihrdukht, is befriended by Afsar Banu. That painting, number 91 of volume 11, appears toward the beginning of a series of stories involving Mihrdukht; this one, eleven illustrations later, rounds out this sequence of events by contriving a suddenly amorous relationship between Mihrdukht's long-lost husband and her erstwhile companion.

Before he falls into his new romantic adventure, however, Hamid has other affairs to settle. Mahval has appeared at the court of Hamid, and evidently has spurned his order to submit to Hamza. A fight breaks out. The brawny Mahval draws his sword on the unarmed Hamid, but the prince leaps up and catches hold of his wrist before the brute can land a blow. Then, knocking him to the ground, Hamid plants his foot on the infidel's throat, grabs his ear, and threatens to rip it from his head. Hamid's attendants look on with astonishment as Mahval pleads for mercy.

This lively scene is the joint effort of three artists. Shravana, who probably designed the overall composition, is responsible for the courtyard and much of the splendid pavilion. He applies his trademark foliate border to the carpet and even to part of the throneback. Beyond this, he supplies the carpet, throne, fence, eaves, and unusual trefoil merlons, the last of these appearing only once in cat.67. Curiously, he allocates the remainder of the pavilion to Mukhlis, an artist with a penchant for bold and sometimes exuberant forms. From cat.58 and 64, we recognize Mukhlis's hand in the stark pavilion base, the florid capitals and bases of the clustered columns, the flaring supports of the miniature domes, the pinwheeling arrowheaded tiles of the rooftop, and the magnificent and utterly flat central dome itself.

Having delegated this much of the backdrop to Mukhlis, Shravana can concentrate on the figures. He again resorts to his favorite figure type: men with plump faces, tapering chins, broad bodies, and *jama*s with oversized patterns; all these features are found in many of his earlier works, notably cat.45 and 47. As accomplished as these figures are, Shravana yields the two key figures engaged in the rough-and-tumble scuffle to a third artist. This is Kesava Dasa, who seems to have a special affinity for subjects involved in violent confrontations. Hamid's face has flaked off, but the color and weave of his turban, the modeling and pattern of his *jama*, and the fine drawing of his feet are all unmistakable indications of Kesava's handiwork. Similarly, Mahval bears a strong resemblance to Haybat, the enemy *ayyar* in cat.55, and to Zumurrud Shah in cat.28. Kesava completed the painting with dark, brooding trees, strongly outlined rocks, and a streaky sky.

The vainglorious Zumurrud Shah, who constantly seeks to exercise his dominion over all the world, gets more than he had bargained for in the figure of Malik Iraj, a sun-worshipper who has yet to throw in his lot with the gigantic sovereign. At Faranghushia, a city near the boundaries of the Darkness, Zumurrud Shah goads the young Iraj into a fight that he knows he will surely win. Iraj answers the call, however, with unimaginable ferocity and strength. First, he savagely rips the trunk right off Zumurrud Shah's elephant, causing the beast to spew blood all over the courtyard. Then, catching hold of the massive giant, he hurls him 120 cubits into the air. Zumurrud Shah plummets to the earth, where he lands with a thunderous crash in a heap of dust. At this sight, Iraj's troops let out a tremendous roar of acclaim and his drummers strike up a frenzied beat. Even as Iraj completes his humiliation of Zumurrud Shah by binding the bewildered giant, Zumurrud Shah uncharacteristically acknowledges his worthy opponent with gestures and words of approval.

"Zumurrud Shah looked and saw that all the people of the city of Faranghushia were standing on the tops of tall buildings, on the mountains, on the walls of Alexander's garden, and on the hills, and when their gaze fell upon that adept warrior, they began to shout. Malik Iraj bowed his head."

Zumurrud Shah does not stop there. Instead, seeing Mâlik Malakut shower Iraj with gold, he extols Iraj as Hamza's equal, calls him 'son,' and awards him vast tracts of land in the east.

"Zumurrud Shah said, 'My son Iraj, I offer you my congratulations. As a reward I give you thirteen thousand leagues of the kingdom of the east.' So saying, he extended his hand, took the ring from his finger, and gave it to Mâlik Iraj. Seven times he kissed the ground, and then he put the ring on his finger."

Iraj accepts these honors graciously, and puts his city at Zumurrud Shah's disposal.

Kesava Dasa, who designed the composition, exults in the dramatic details of this episode. He shows a compact Iraj, legs widespread to increase his thrusting ability, lifting his colossal opponent high above his shoulders, a pose obviously reminiscent of the rendering of Farrukh-Nizhad's display of heroic strength (cat.52). Zumurrud Shah's huge crown falls to the ground, and parts of the balustrade, broken by his flailing limbs, shatter on the tiled courtyard. These details conflate Zumurrud Shah's precipitate ascent and descent, showing both the cause and effect of the giant's ignominious defeat.

For unknown reasons, the faces of Zumurrud Shah and Iraj have suffered an exceptionally concentrated loss of paint. Yet the underdrawing of both figures is so accomplished that the absence of pigment in these areas hardly detracts from the visual impact of the work. Exhibiting again his predilection for explicit, animated expressions, Kesava details Zumurrud Shah's gaping mouth, bushy eyebrows, deeply wrinkled eyes, and even individual strands of hair on his mustache and pate. All that remains of his normally full beard, now too thin to cover even the vertical lines of the wall behind him, is a dark fringe of black paint studded with tiny jewels. Kesava strengthens the contours and folds of Zumurrud Shah's green *jama* with rich, thoroughly blended streaks of black paint; the result is a tangible sense of volume well beyond the rudimentary modeling employed by most of his contemporaries. More schematic is his rendering of Zumurrud Shah's hands, which are flattened, glovelike shapes with a pronounced stylized curve running from the index finger to the thumb. Conversely, he achieves the same level of naturalistic mastery in this spectacularly bloodied, albeit docile elephant, as he did in cat.52, once more taking note of such features as the deep folds of skin around the eye and the speckled pink patches on the forehead and ear.

Once Kesava had established the architectural framework of the composition and sketched the figures of Zumurrud Shah, Iraj, and the elephant, he turned the painting over to Mithra, who supplied the assorted retainers and architectural detailing. Mithra likes to deploy his figures in bunches, a device used to particularly strong effect in the five attendants cowering in and gawking from a narrow doorway. His figures often have conspicuously rounded faces, an appearance exacerbated by their distinctively flattened circular turbans. Despite his preference for this idiosyncratic type, Mithra produces a convincing range of facial expressions, from the puffed-out cheeks of the trumpeters to the wary glances of the attendants below.

Attributed to Kesava Dasa and Mithra

Volume unknown, painting number 65, text number 66
India, Mughal dynasty, *circa* 1567–72
66.2 x 51.4 cm
The British Museum, London, presented by the Rev. Straton Campbell, 1925-9-29-02
Published: Rogers 1993, fig.5; Seyller 1992, fig.12; Pinder-Wilson *et al.* 1976, no.12.

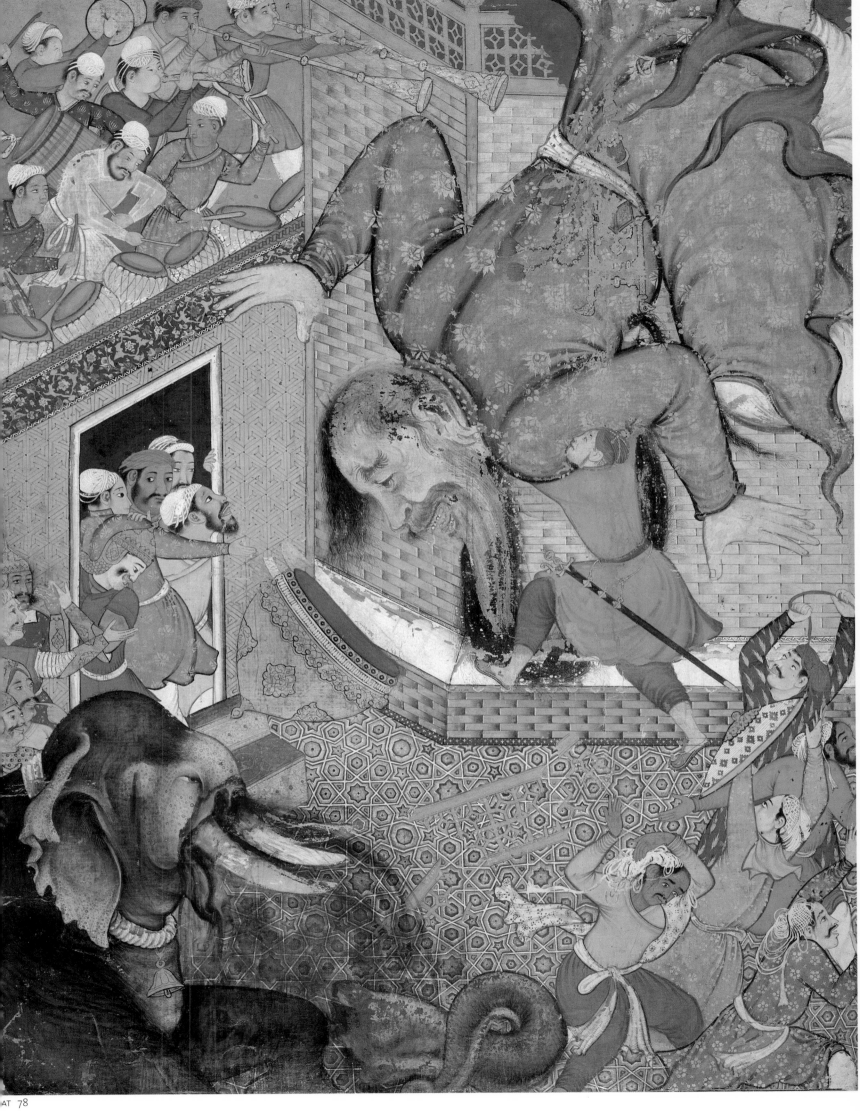

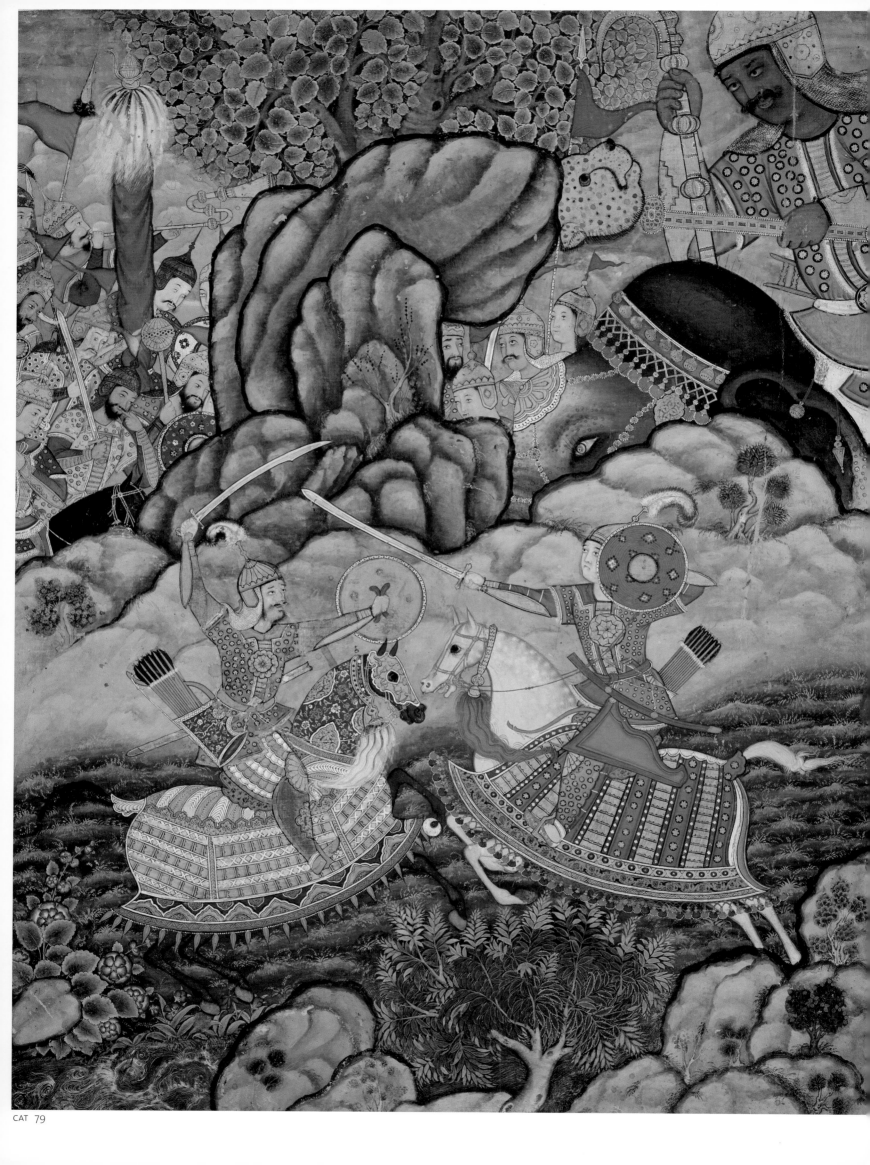

Attributed to Dasavanta,
Shravana, and Madhava
Khurd

Volume unknown, painting
number 95, text number 96
India, Mughal dynasty,
circa 1567–72
67.3 × 51.1 cm
(detail on pp.238–39)
MAK–Austrian Museum of
Applied Arts/ Contemporary
Art, Vienna, B.I. 8770/9
Published: Egger 1974, pl.59;
Egger 1969, pl.37; Staude
1955b, fig.34; Glück 1925, pl.49.

Battles in the *Hamzanama* regularly turn on individual combat. Most often, a named champion from among the God-worshippers vanquishes an infidel; occasionally, the cherished son or brother of a prominent figure is martyred at the hand of a truly formidable foe. Rarest of all is a fight to the draw, in which the two opponents are equally matched in strength if not in righteousness. Such is the case in this illustration, which comes late in one volume but has been separated from the story leading up to the encounter it depicts. Nevertheless, the text that follows the illustration provides an adequate summary of the scenario.

"When Malik Iraj Nawjavan fought with Prince Badi'uzzaman until night, he said, 'O prince, I had always heard from Landhaur b. Sa'dan praise of your bravery and courage. Now that I have seen your fist, it is clear to me that you are a hundred times more than what they said."

Iraj specifically mentions the plaudits offered in the past by Landhaur, so it is only natural that the gigantic stalwart from Ceylon makes an appearance on Badi'uzzaman's side. Iraj is no ordinary foe. He expresses his desire to battle all of Hamza's sons, not out of spite or arrogance, but apparently to test their mettle. Indeed, so well-intentioned is Iraj that he invites another of Hamza's sons, Prince Alamshah, to his tent in peace, accords him the seat of greatest honor, and professes his profound love and respect for him. Nevertheless, he bristles at Alamshah's gentle suggestion of capitulation to Hamza.

"Alamshah said, 'Iraj, the prince of the men of the world has come near, and he is the center of the circumference of the men of the world. He has been ruling and conquering for ninety, nay a hundred years now, and his life has come to its end. He has a desire for Iran also. If he is respected, it will be well.'"

Even Iraj's chivalrous affection for Alamshah has its limits when his own rule is challenged.

The painting reflects the parity between the two warriors. Badi'uzzaman advances from the right, the position of power, and thrusts his sword close to Iraj's head, but these are temporary advantages in a combat that will have no clear resolution. Although Badi'uzzaman is far younger than his bearded foe, the artist renders him his equal in size. Shravana distinguishes the combatants by using complementary colors for their tunics and trappings, and by contrasting the patterns on their caparisoned mounts. To accentuate the busily detailed figures, he sets them against dark turf splashed liberally with yellowish tufts, and fills the foreground with large-lobed rocks.

Thus far, the painting packs more charm than power. This changes in the figure of Landhaur, which, with that of his gargantuan elephant, looms ominously over the horizon like a dark storm cloud. Landhaur himself shows no inclination to intervene on the prince's behalf. Holding an elephant goad in one hand and a leopard-headed jeweled mace in the other, he watches the combat with no trace of emotion. His elephant is another matter. With its trunk, tusks, and body obscured by a ridge, the elephant initially appears as a black, inanimate form; only the large golden eye, with a menacing glare, identifies this hulking shape as an elephant of mountainous size.

Such a radical shift in scale is almost certainly the handiwork of Dasavanta. In addition to the overall design, he contributed the central outcrop, a dynamic form that seems to recoil before Landhaur's brutish elephant. Its scumbled surface, contrasting coloring, and forceful outlines recall Dasavanta's equally painterly rocks in cat.36 and 42.

The figures themselves show the facial types and expressiveness typical of Shravana's work, particularly cat.57. Other minor elements repeat forms encountered earlier in paintings by Shravana, notably the standard in cat.57 and the horse in cat.67. To judge from Landhaur's rounded eyes and hands and the strengthened outlines of his tunic, another artist, Madhava, was called upon once again to supply a single gigantic figure (as in cat.57). Madhava did this with characteristic verve, and added the two figures behind the elephant for good measure.

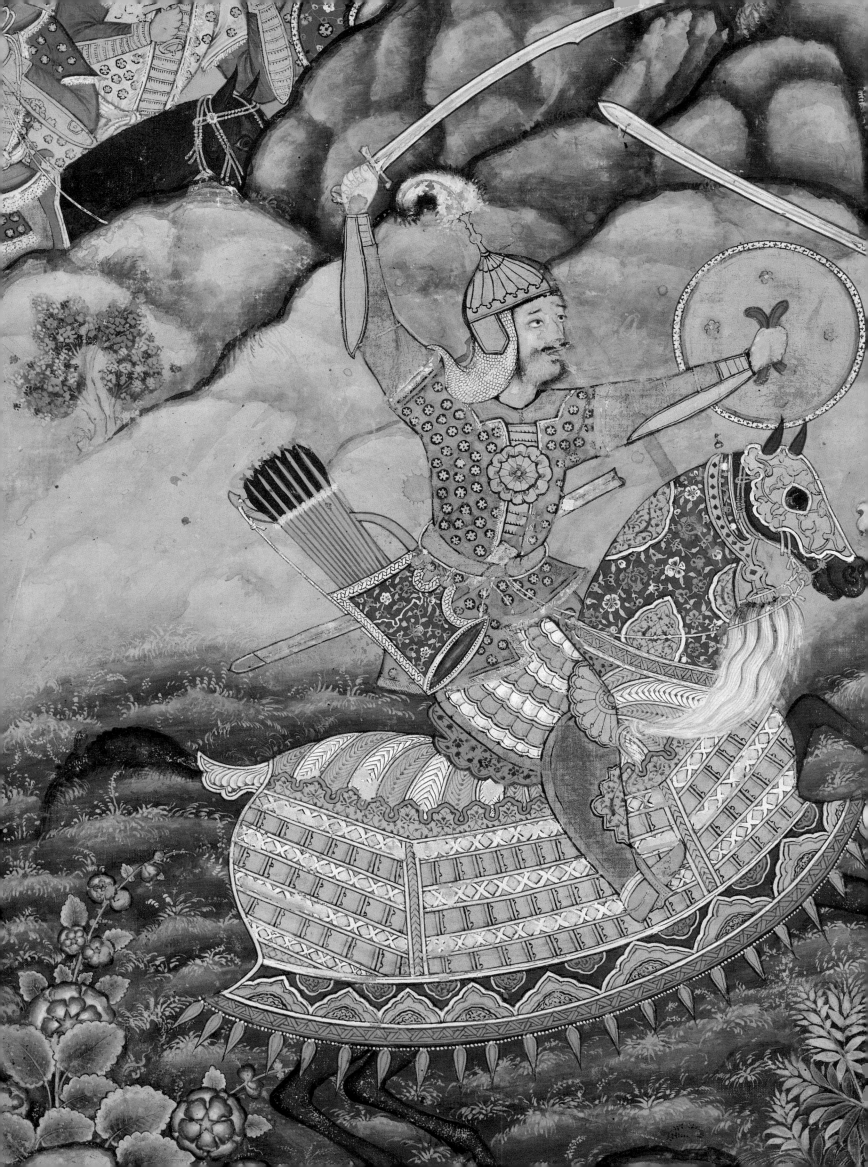

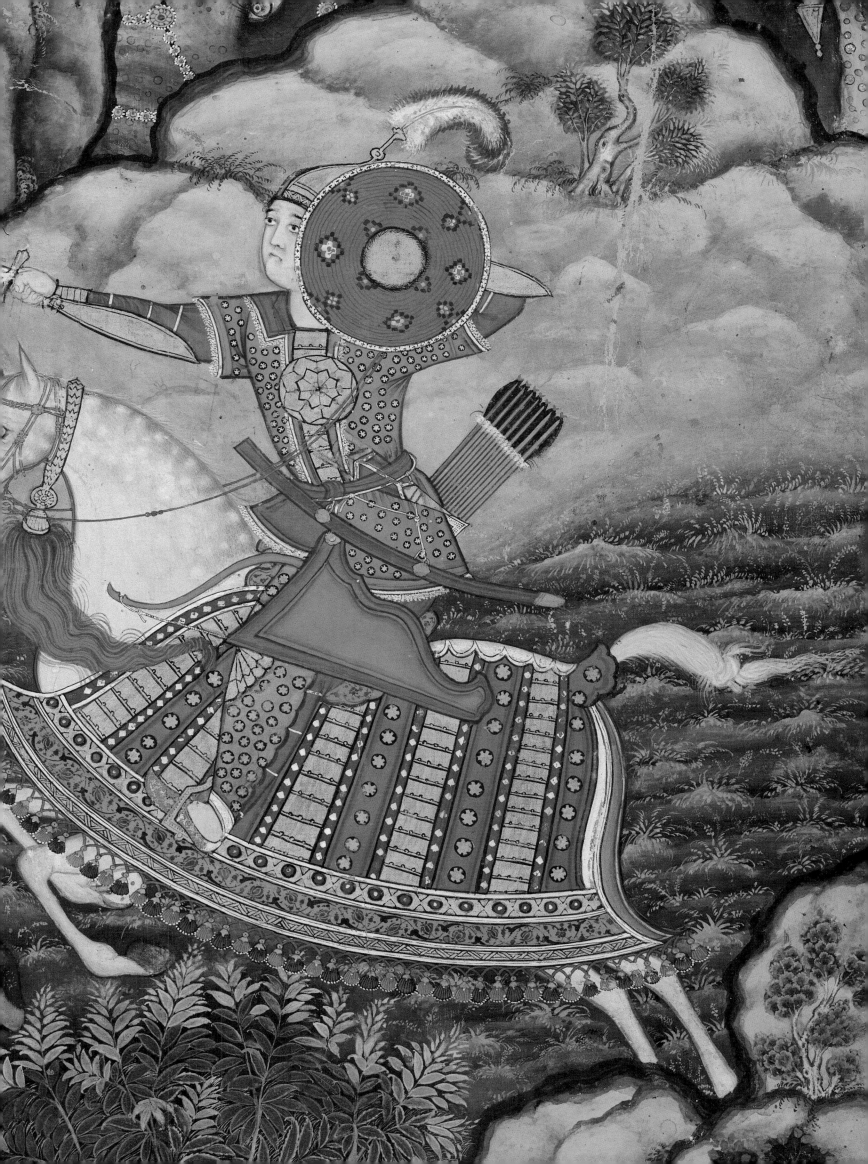

The sea imperils many a figure in the *Hamzanama*, most often when a storm overwhelms the ship in which they have taken passage. Rescue, when it comes at all, is a favorite narrative device to introduce chance encounters, sometimes with an unlikely rescuer – whether a humble fisherman or four youths – and at other times with the bewitching inhabitants of the island where the nearly drowned figure inevitably finds safety. These topoi climax in this scene depicting the rescue of Prince Nuruddahr ('Light of the Sea') by a Muslim saint, Elias.

The text that precedes this illustration is missing, but the circumstances that led up to Nuruddahr's predicament are conveniently reiterated in the passages that follow the painting. From these, we learn that Nuruddahr, who elsewhere is named as the son of Prince Badi'uzzaman, used to sit at the base of a tree where men gathered daily to behold his marvelous beauty.[1] Among these admirers was an infidel girl, the daughter of one Kayvan Buland-Rif'at. One day she is told by a demon, later identified as Andarut, that on the previous night he had kidnapped Nuruddahr and thrown him into the sea.[2] The girl in turn relays this disturbing news to Umar, who is concerned both for Nuruddahr's safety and for the recalcitrance it causes in Pahlavan Karb Dilavar, who declares that until Nuruddahr is located he is reneging on his promise to send an emissary to Hamza. For once, however, the resourceful Umar is not called upon to resolve this predicament. Instead, as the text recounts in a matter-of-fact manner:

"When the demon threw Prince Nuruddahr into the sea, St. Elias the prophet took him out of the water. Nuruddahr wound up on an island."

The painter approaches the story with remarkable narrative terseness. He forgoes an image of the abduction itself, and, omitting the demon altogether, concentrates on the miraculous appearance of Elias. This prophet, whose sanctity is indicated by his flaming aureole, glides supernaturally across the water's surface. As he does, he looks back toward Nuruddahr, extends the end of a filmy scarf toward him, and tows the tiger-skin-clad prince to shore.

To accentuate the drama of the rescue, the designer sets the interaction of prophet and prince in the midst of a large expanse of sea. As usual, the painter animates the water with a tempest-tossed surface as well as with a menacing *siyahsar* and several leaping fish. Beyond this maritime world of turbulence and danger is an exceptionally luxuriant landscape where weaver birds nest, peacocks strut, and jackals salivate.

This much-reproduced painting has been attributed to as many as four unidentified painters working together, as well as to Mir Sayyid Ali and Miskin, but many features actually point to Basavana as the artist responsible for most, if not all of the painting.[3] The face of Elias, for example, is nearly identical to that of Zumurrud Shah in cat.33. Likewise, the heavy modeling of the prophet's robes, the palpable texture of Nuruddahr's fur cap, and the prince's somewhat Europeanized facial features are all recurrent qualities in Basavana's work at a time when few other Mughal artists were sensitive to these physical effects.

The landscape also shows many signs of Basavana's hand. Some forms, such as the date palm at left, the very brushy foliage in the upper right, and the wet tufts of vegetation, are found only in paintings by Basavana and Dasavanta; others, such as the heavily painted and knotted trunks, the distinctively shaped yellow-edged leaves, and the large white flowers superimposed over the central rocks, are recognizable from Basavana's other works in the *Hamzanama*, notably cat.66. It is quite possible that another artist supplied the three peacocks, for around each of them is an area where the ground, foliage, or plumage has been altered to accommodate the superb bird.

Attributed to Basavana

Volume unknown, painting number 85, text number 86
India, Mughal dynasty, *circa* 1567–72
Painting 67.4 × 51.3 cm, folio 73.6 × 57.9 cm
(detail on pp.254–55)
The British Museum, London, presented by the Rev. Straton Campbell, 1925-9-29-01
Published: Rogers 1993, fig.15; Okada 1992, fig.71; Brend 1991, fig.150; Welch 1985, no.91; Losty 1982, no.54; Bussagli 1976, fig.11; Pinder-Wilson *et al.* 1976, no.11; Stchoukine 1929, pl.VI; Arnold 1928, frontispiece.

1. This genealogical reference appears on the text following cat.79.
2. The text following cat.81, two folios after this illustration, refers to Andarut's involvement in the disappearance of Nuruddahr.
3. Rogers 1993, p.45; Welch 1985, p.151.

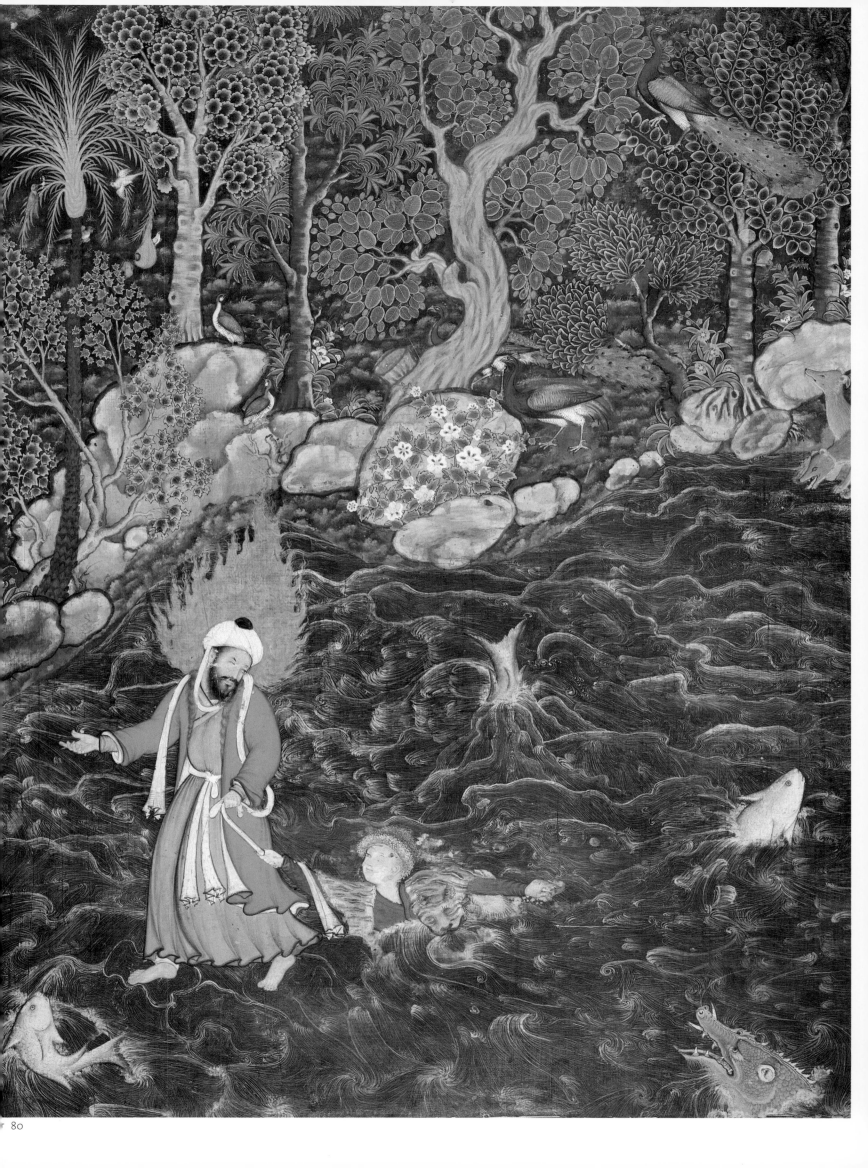

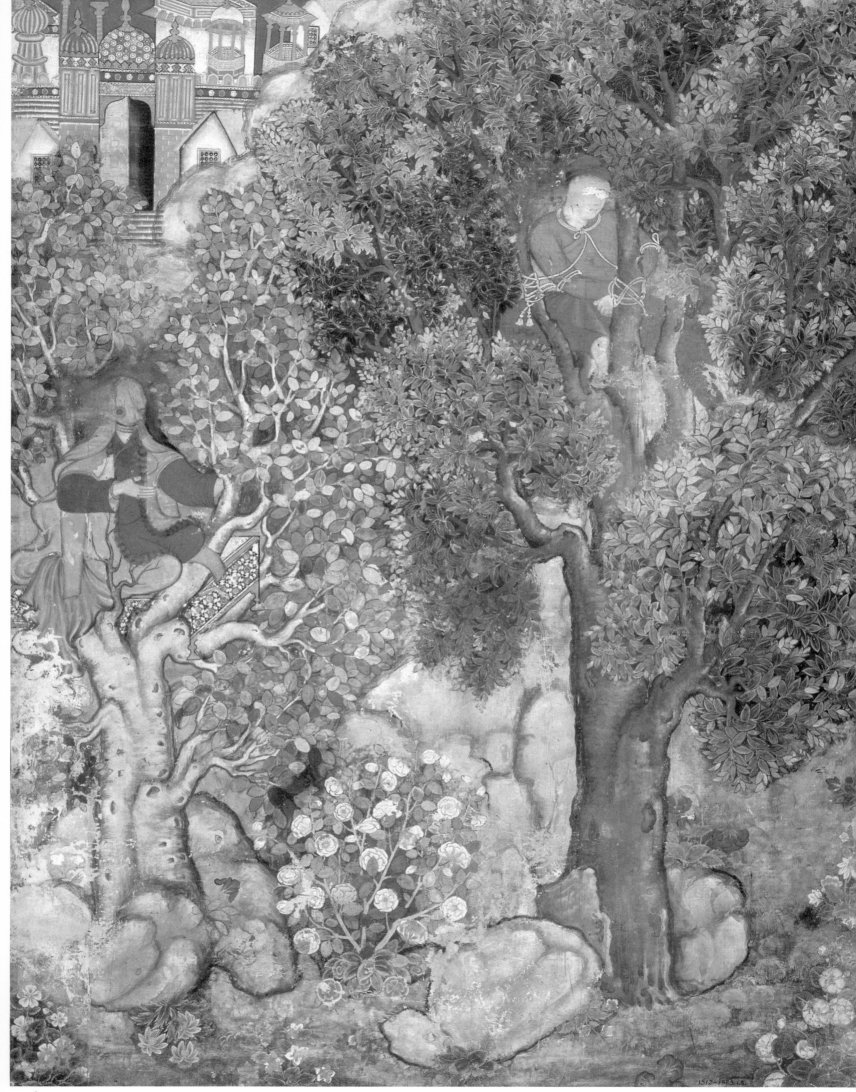

81 THE WITCH ANQARUT TIES MALIK IRAJ TO A TREE, TRANSFORMS HERSELF INTO A YOUNG MAIDEN, AND TRIES TO SEDUCE HIM

Attributed to Basavana and Mukhlis

Volume unknown, painting number 67 (a mistake for 87), text number 88
India, Mughal dynasty, *circa* 1567–72
Painting 67.4 × 51.7 cm, folio 74.7 × 58.5 cm
Caption: '... Anqarut ..'
Victoria & Albert Museum, London, I.S. 1512-1883
Published: Stronge 2002, pl.13; *Hamza-nama*, pl.10; Wilkinson 1948, pl.2; Glück 1925, fig.40; Binyon & Arnold 1921, pl.2; Clarke 1921, pl.4.

Beauty, which so often opens marvelous possibilities to those graced by it, sometimes has unforeseen negative consequences as well. Thus it is with Malik Iraj, a young king of legendary beauty who has the misfortune of being snatched up by a witch named Anqarut Jadu and deposited on an island. When she beholds this handsome creature up close, Anqarut is overcome with lust, and devises a plot to satisfy her desires. Using sorcery, she binds the fair youth to a tree, and then disappears. When she returns, it is in the guise of a beautiful fourteen-year-old maiden. She begins to sweet-talk him, floating ever more cloying blandishments in his direction. Iraj asks one simple question: 'What is your name?' Anqarut says it, and Iraj realizes that he is truly being bewitched and turns firmly away. Such spurning enrages the eager suitor, and she hurls curses at him, finally hissing that Iraj may be more receptive once he has languished in captivity for a while.

The hours go by slowly. At nightfall, Anqarut comes to make another pass at Iraj. Now it is Iraj whose ire is up. He vows to rid himself of this witch once and for all, and with a spell consisting of one unmentionable word, he does.

"When it was night she lit many candles and lamps and bedecked herself in extraordinary clothes and went to Iraj. She began to wail and said, 'Defiant one, look into my face and gaze upon me with kindliness. I am thirsty; you are the water of life. What would it cost you to sprinkle one drop on me?'

Iraj cursed. He became angry and said, 'O sun-worshipper, I will do something to you that will be spoken of ever afterward.' He spoke a name. Dust arose. When Iraj opened his eyes he found himself floating on a raft in the middle of an endless sea. He was dumbfounded."

Basavana envisions the first of these tortured exchanges occurring at treetop level. Iraj is perched high in a large almond tree, his hands and neck lashed to its spreading branches. Anqarut takes up a position in a smaller tree nearby, and makes her overtures from a luxuriously tiled platform of her own fabrication. Her heavy scarf and huge golden earring are the first danger signs, for these are normally worn only by sorceresses and witches. She also wears some unusual apparel: a very generously sized, heavily modeled, fur-lined cloak with two short sleeves and two long, the latter suspiciously unused. And, despite all her magic, she clearly has failed in her attempt to remake herself into a comely maiden. Although both figures were defiled at one point, enough of the underdrawing of Anqarut's face is clear to indicate that this witch has been unable to hide the ungainly features and behavior of her ilk – she even talks with her tongue hanging out! Iraj is rather bland by comparison. Still so young that he lacks facial hair, and dressed in rather drab clothes and a low-slung, undetailed turban, he is remarkable only for his exceptionally bulky physique. Nonetheless, he is the bright spot in the thick forest, and Anqarut cannot keep her eyes off him.

Basavana invests this isolated place with so many expressive forms that it effectively functions as a character in the scene. The two trees, for example, are set up as a complementary pair: a lightly colored, twisted trunk for her, and a rich brown, straight one for him. The silvery green foliage, too, is alternately compact and expansive, spare and dense. The rocks are irregular, mottled, and worn rather than the strong, smooth shapes preferred by Kesava Dasa. Even such an inconsequential passage as the decaying ground cover in the lower right becomes an opportunity to experiment with the effects of paint, and Basavana contrasts random daubs of the brush with the brighter and more controlled flowers nearby. In this respect, this work by Basavana surpasses even his other efforts in this vein (cat.66 and 80).

Combat sometimes occasions a special kind of frenzy, when men can no longer remember why or against whom they must fight, but are compelled by some unspeakable primal rage to lash out blindly against everyone and everything around them. Such morally ambivalent violence is relatively rare in the *Hamzanama*, in which rather clear distinctions between the righteous and the depraved are the norm.

The text that describes the circumstances of this scene of carnage is now missing, but both the caption and the text that follows mention a night raid carried out by Pahlavan Asad against Malik Iraj's camp. Asad leads the attack against Iraj, a sun-worshipper, albeit one with persistent sympathy for Hamza's cause. But the darkness that ostensibly provides cover for Asad's men also causes them to lose sight of reason, and the raid soon degenerates into a bloodbath:

"... when the benighted infidels opened their eyes and recognized each other, they saw that strangers in their midst were as rare as God's love was among them. They had killed so many of their own that it was beyond reckoning."

Asad himself leaves the scene and does not return to his fortress that night, and thus is spared Iraj's wrath the next morning.

For a scene purportedly depicting wanton violence, this illustration has a curiously placid quality. Soldiers – including two only semi-dressed to indicate that they have been roused from their beds – fight in close quarters amid clusters of tents, but their numbers are quite modest, and there is no sign whatsoever of rampant bloodletting. For the most part, the warfare seems routine, as soldiers inside and outside the fortress exchange volleys of arrows and musket fire. Indeed, some actions – a man winding his turban in the lower left or another grasping the reins of a donkey in the center of the painting – are remarkably mundane. The setting contributes to the paradoxical sense of order, counteracting hints of rough-and-tumble combat with stabilizing tents and fortress walls. And occupying the center of the composition is the mounted Asad, who, despite his raised sword and the approach of an enemy soldier, is the very picture of aloof composure.

The handsome Asad represents a youthful, princely type found throughout the *Hamzanama* manuscript; his closest counterparts are the orange-clad figure of Qasim/Hamza in cat.48 and the mounted Farrukh-Nizhad in another illustration attributed here to Basavana.[1] Like the aforementioned Farrukh-Nizhad, this figure of Asad is dressed in a sensitively modeled orange *jama*, has a long sword suspended from his belt by a golden chain, and tenders the reins of his horse at chest height. The two faces are exceedingly similar, the only difference being that Asad's features appear more delicate, an impression conveyed by his lightly rendered eyes and wispy hair, and probably accentuated by the considerable surface abrasion in the area. A better-preserved example of this same figure type, the spear-holder dressed in green at lower left, corroborates Basavana's involvement in this painting. The artist probably supplied the billowing rocks and the tree at the right, the latter graced by two superb herons.

The familiar designs of the tents and trappings of Iraj's camp are strong indications that they are the work of Shravana, an artist who collaborated with Basavana on two other camp scenes.[2] Most of the figures, however, can be attributed to a third artist, Tara, whose style at this time is documented in an ascribed painting in the *Tutinama*,[3] and who later collaborated with Basavana on two paintings in the *Akbarnama* manuscript in the Victoria and Albert Museum (fig.28).[4] Tara likes figures with ample and often unruly mustaches and beards; he also uses large, glaring eyes and bared teeth to create an impressive range of explicit and energetic expressions.

Attributed to Basavana, Shravana, and Tara

Volume unknown, painting number 11, text number 12
India, Mughal dynasty,
circa 1564–69
68.2 × 51.5 cm
Caption: 'Asad attacks Iraj at night and assails [his army] with arrows'
The Metropolitan Museum of Art, Rogers Fund, 1918. (18.44.1)
Published: Kossak 1997, pl.8; New York 1970, no.159; Grube 1966, fig.94; Lukens 1966, pp.44–45, fig.59; Comstock 1925, p.354; Glück 1925, fig.38.

1. MAK, Vienna, B.I. 8770/46, published in Egger 1974, pl.42, and the Reconstruction, no.89.
2. MAK, Vienna, B.I. 8770/22 and 8770/58. See Reconstruction, nos 84 and 100.
3. Folio 60b; Simsar 1978, pl.13, and Beach 1992, fig.9.
4. Victoria & Albert Museum, London, I.S. 2-1896, nos 17/117 and 61/117 (see fig.28 on p.53, above); Sen 1984, pls 20 and 44.

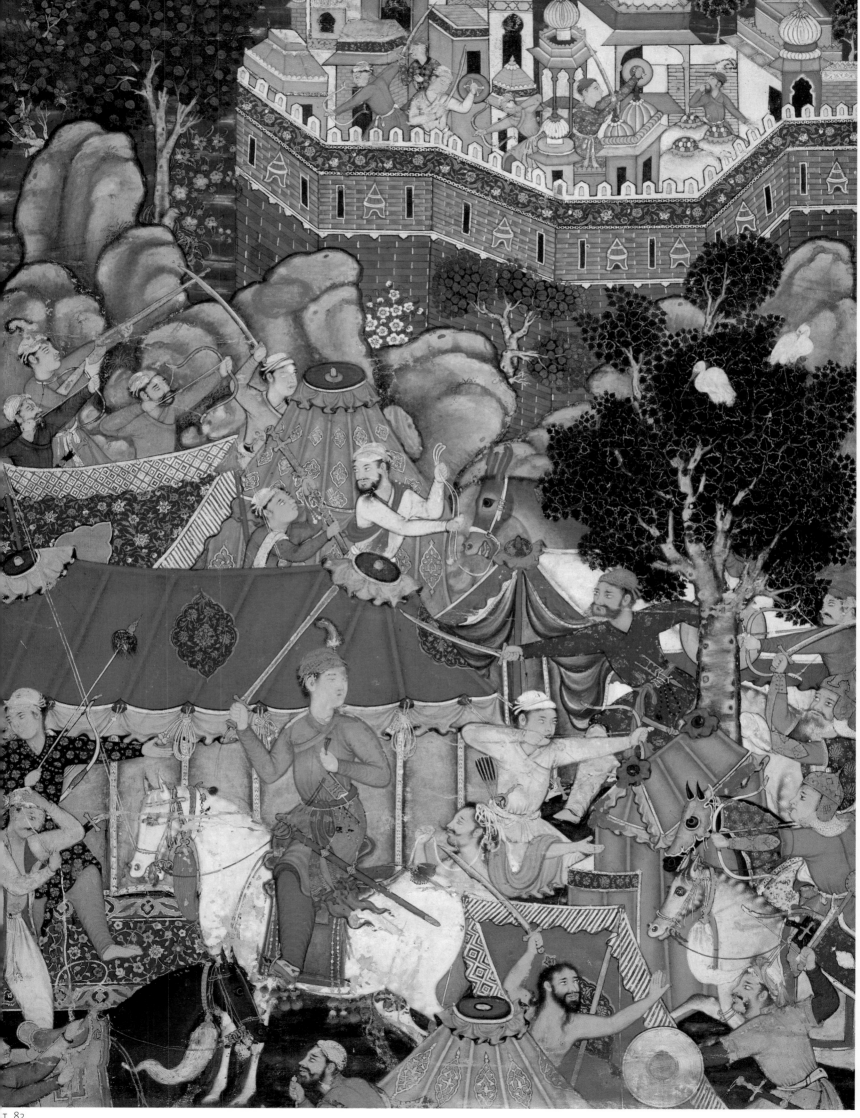

T 82

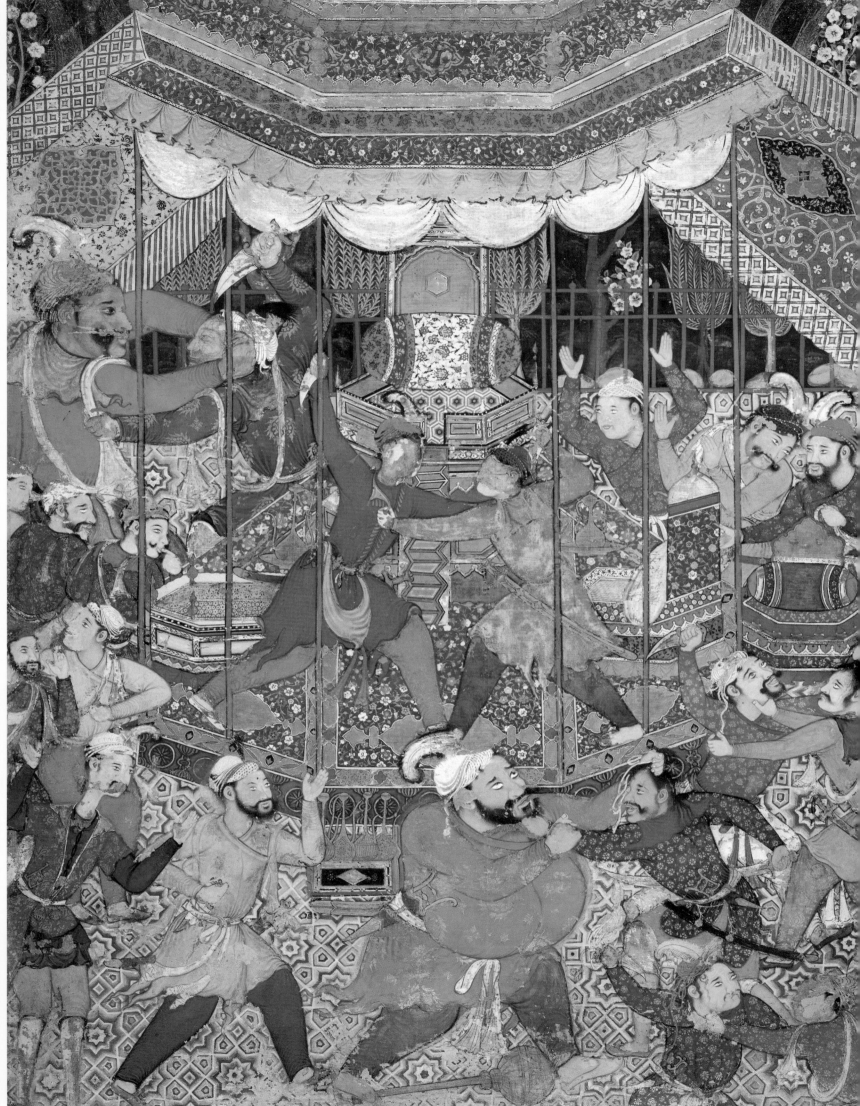

**Attributed to Shravana,
Dasavanta, and Tara**

Volume unknown,
painting number 2
India, Mughal dynasty,
circa 1564–69
68.2 × 51.5 cm
Caption: 'The heroes of
the Amir fight in support of
Qasim and Badi''
The Metropolitan Museum of
Art, Rogers Fund, 1918 (18.44.2)
Published: Schimmel & Welch
1983, p.44; New York 1982,
no.121; Comstock 1925, p.352;
Glück 1925, fig.29.

For reasons unknown, a brawl has broken out, suddenly pitting Badi'uzzaman, Hamza's son, against Malik Qasim, the king of the west. Qasim is normally a loyal ally, and elsewhere (cat.42) risks everything to rescue – or perhaps to outdo – Badi'uzzaman. But Qasim can never hold his fiery nature completely in check, and regularly succumbs to hot-headed outbursts, a habit that earns him the epithet 'the quick-tempered bloodshedder.' The text that follows refers to this episode only in the most tangential way. As Qasim emerges from this place of unexpected strife, he gazes upon a magnificent fortress; opposite it is a tree with a wondrous throne at its base. Sitting on the throne and basking in its splendor, he reflects ruefully upon the day's events, the stinging words of Hamza and Badi'uzzaman resounding in his ears, and mutters mordantly, 'You see that in the end this Arab took the part of his own son.'

In the painting, the two rivals grapple with each other in a tiled courtyard swarming with feisty participants and alarmed onlookers. The composition is organized by standard means: an elevated throne rests at the center of a hexagonal platform covered by an elaborate canopy. Six poles mark the perimeter of the platform on two sides. This arrangement has the virtue of neatly framing Badi'uzzaman and Qasim, but also causes the designer to skew the hexagonal platform quite radically. This distortion is tempered on the right by another throneback and several encroaching figures, and ultimately weighs little in a composition of such pervasive architectural symmetry and figural balance.

Unlike cat.82, this illustration really does convey a sense of fury. Badi'uzzaman and Qasim lunge at each other, each wielding a dagger with deadly intent. To their left, two equally oversized opponents carry on in the same manner, one trying to slash his assailant with a huge dagger while the other viciously grabs hold of his ears. In the lower right, three more pairs of foes attempt to throttle or impale each other. The centermost figure, identified as Umar Ma'dikarb by his sheer girth, has relinquished his mace to tear at his enemy's hair; Umar, standing at the lower left, uncharacteristically stays out of the fray.

Many decorative features of the scene, including the canopies, thrones, carpet, and tilework, can be attributed to Shravana; he even repeats elements as distinctive as the steel-grey coloring of the platform, a color also used exceptionally in the flaps of a tent in cat.82. Dasavanta's hand is evident in the dramatically posed figures, particularly the two huge combatants on the left, Umar Ma'dikarb, and Umar. Although the faces of the two princes in the center have been lost to abrasion, the color of their turbans and the modeling of the orange *jama* also point to Dasavanta. The remaining figures have equally interesting expressions and hair, but most have smaller pupils, coarser eyebrows and facial hair, and more flatly rendered clothes than Dasavanta's types. These figures thus appear again to be the work of Tara. The row of cypress trees arrayed against a flat green ground is featured so often in Dasavanta's paintings that this passage must be credited to him as well.

After all the *Hamzanama* episodes featuring admirable heroism, marvelous rescues, and clever ruses, the quotidian and outright comical quality of this scene of unabashed drunkenness comes as something of a relief. Neither caption nor preceding text has survived to identify the scene, and the illustration appears only tangentially related to the following text, whose opening lines mention three figures, Kulbad, Zardhang, and Farid. The first two are later identified as *ayyar*s, who are typically slender in build and armed with a battle-axe. One of these *ayyar*s is probably the half-naked, discreetly armed figure standing just inside the entrance to this well-appointed building; the other is still negotiating admission with the door guardian. By this reckoning, Farid, a geomancer, is the stalwart, plumed figure gesturing toward a servant filling a vat with liquid sustenance. Farid's luck in gaining an entrée to the wealthy Bibi Dilgusha's house prompts Zardhang to propose the following scheme. While Farid diverts the *dev* guards, Zardhang will steal the jewel box from the woman's house. Zardhang's goal is the wealth itself, but Farid has something longer lasting in mind. When all the local geomancers are summoned to use their powers of divination to locate the missing jewel box, Farid alone is successful. Farid asks the grateful Bibi Dilgusha for no reward, only the opportunity to serve her again.

If we do not know what initially brought the trio to this place, which may be a tavern or possibly the house of Bibi Dilgusha, we certainly cannot fail to notice the unseemly activities that go on here. Although many *Hamzanama* illustrations have touches of genre, these are normally set unobtrusively in one corner or another. Not so here. Near the very center of the painting one agitated man bowls over another, no small feat given the latter's gluttonous girth. Another reveler hunches over, facing away from these two; his stupefied expression and loosened *jama* and pants indicate that he is so inebriated that he is oblivious to everything around him, and now can muster only enough concentration to relieve himself, or, as he probably sees it, to water the flowers of the carpet underfoot. Nearby, a woman minds what must be a local still, hooked up to two medium-sized jars. The jars, flasks, and cups around her suggest that there is a ready supply of and demand for the intoxicating home-brew. Some men on the balcony set out to prove both. Turbans undone and faces buried in deep drinking cups, two figures huddle together in gleeful intimacy. One companion slakes his thirst in earnest, while another, evidently a more unconventional spirit, dances uninhibitedly as a servant delivers another round.

Such ribald goings-on must have amused contemporary audiences, which by all accounts were more abstemious than most modern ones. They clearly delighted the artist, Shravana, who indulges in buffoonery in several of his other works (cat.57 and 69). Shravana shows his hand in many other ways. Here he gives his figures the same astonishing range of expression as he did in the aforementioned works, but models their clothes with noticeable restraint, limiting darkened folds mostly to gathers at the waist or hem. Above all, he brings an unmistakable crispness to all kinds of pattern, whether on clothes, carpets, or architecture. This quality pervades most of the painting, particularly the center. It falters, however, in those peripheral portions that Shravana turned over to his collaborator, Mah Muhammad. The vertical mortar lines of the compound's front wall, for example, lapse into wavering rows, and the back wall of the balcony suddenly slips from the horizontal of the compositional grid. Walls are left a stark white, as in cat.55 and 60, an effective choice in some passages, but certainly not in others, such as the adjoining courtyard at the upper right or the plain gateway surround. Add to this the misshapen central dome and the flat blue sky, and we appreciate Shravana's inspiration and technical mastery all the more.

Attributed to Shravana and Mah Muhammad

Volume unknown, painting number 74
India, Mughal dynasty, *circa* 1567–72
67.8 × 51.4 cm
The British Museum, London, given by P. C. Manuk and Miss G. M. Coles through the National Art Collections Fund, 1948-10-9-065
Published: Titley 1983, fig.66; Pinder-Wilson *et al.* 1976, no.14.

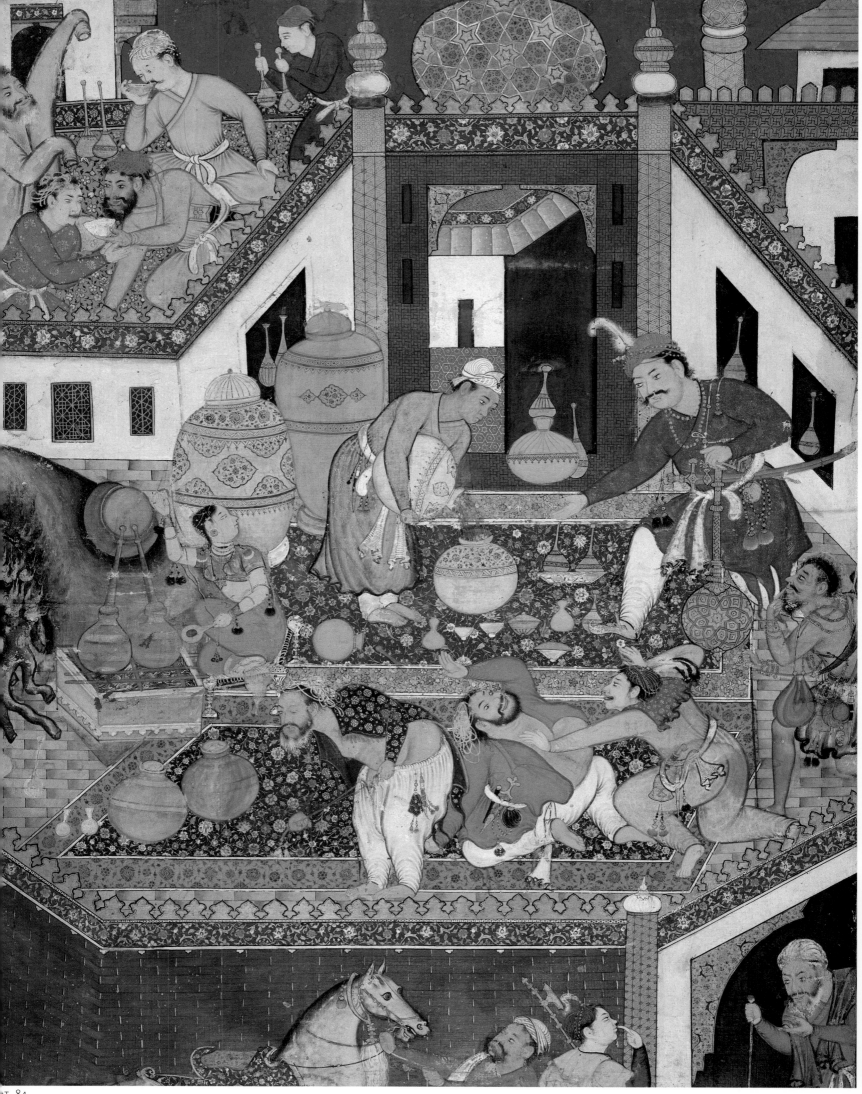

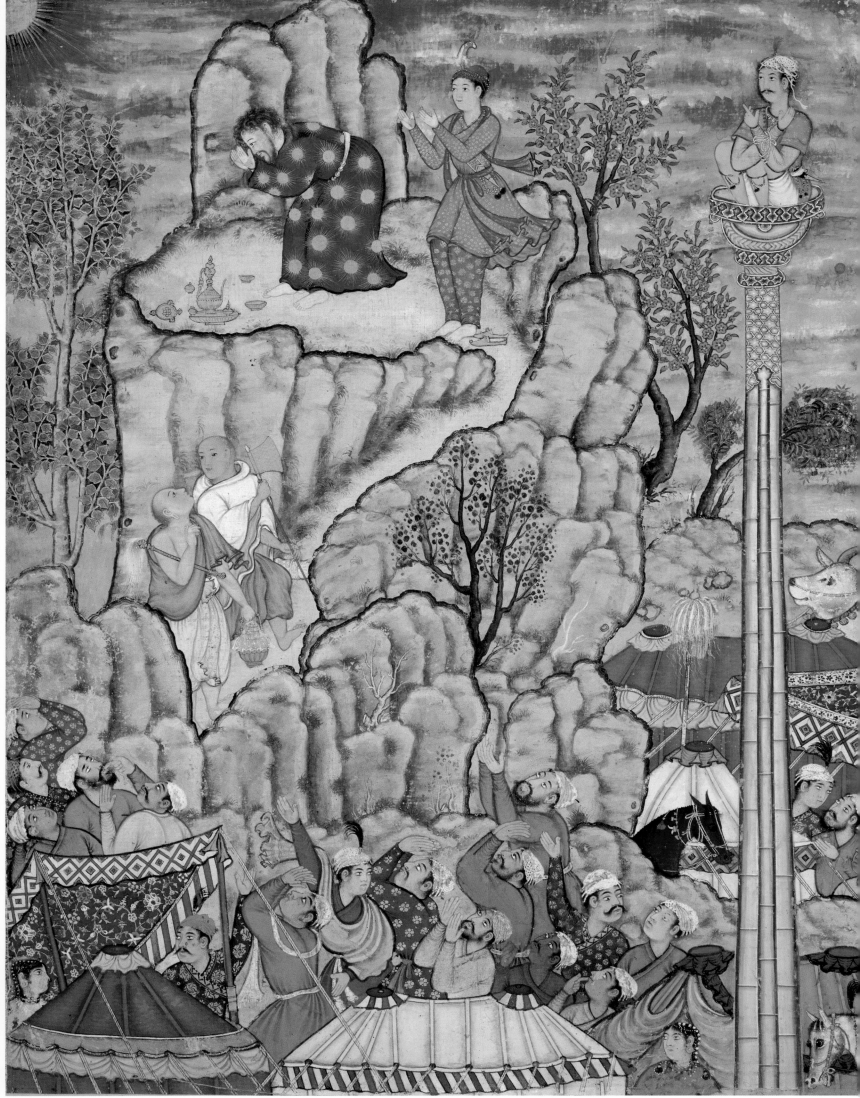

85 MALIK IRAJ CAPTURES UMAR AND PLACES HIM BOUND ON A TALL PILLAR; UMAYYA DECEIVES IRAJ, AND FREES UMAR AT NIGHT

Attributed to Kesava Dasa and Tara

Volume unknown, painting number 88, text number 89
India, Mughal dynasty,
circa 1567–72
68 × 51.1 cm
MAK–Austrian Museum of Applied Arts/ Contemporary Art, Vienna, B.I. 8770/13
Published: Egger 1974, pl.58; Egger 1969, pl.36; Staude 1955b, fig.35; Glück 1925, pl.48.

1. It is ironic that an activity disparaged here as a sign of godlessness was later practiced by Akbar himself. For an image of Akbar engaging in solar worship, see the essay by Ebba Koch (pp.21–22 and fig.4, above).
2. *Darabnama*, f.95b; Cleveland Museum of Art *Tutinama*, f.60b, published in Simsar 1978, pl.13.

As the text that follows this illustration relates, Umar has been caught sneaking around the camp of Malik Iraj. Knowing the *ayyar*'s resourcefulness and having no escape-proof dungeon at hand, Iraj orders his men to bind Umar tightly and place him on a small platform atop a tall pillar, where his every movement can be observed. Meanwhile, the allies notice that Umar is missing, and dispatch Umayya to look for him. Umayya discovers Umar's whereabouts, and passes himself off as one with only Iraj's best interests at heart:

"When Malik Iraj paid homage to the Amir, Umayya said, 'Malik Iraj, why are you heedless of the fact that the enemy are pressing you from left and right? You should be arraying your troops because it will not be long before Hamza the Arab and all his champions and sons will be upon you, and now that you have captured Umar Ayyar, take heed that you not allow him to escape, for he is the mainstay of Hamza's army. If you command me, I will go and keep watch over that thief and hold him upstairs.'"

Iraj is swayed by the ostensible prudence and generosity of this offer and agrees. Once Umayya has mounted the tower, he interrogates Umar, and the *ayyar*, recognizing a friendly face, responds with delight. Under veil of darkness, Umayya releases Umar from his bonds, and the two descend the tower by lasso, whereupon they make their way back to the court of Malik Qasim. At daybreak, the men guarding Umar realize that their prisoner has somehow vanished from his roost, and alert the dismayed Iraj.

In the absence of the caption and preceding text, it is difficult to gauge just how much imagery the artist has invented. The illustration shows the bearded Iraj, bareheaded and hands raised in prayer, venerating the sun from a mountain summit.[1] Behind this sun-worshipper stands a handsome youth – presumably Umayya – still wearing his plumed turban but having shed his shoes in deference to the sanctity of the site and ritual. Two tonsured and barefoot monks, their earlobes distended as signs of their renunciation of material life, make the long trek up the mountain, all the time sweeping the ground and air before them with a flywhisk and fan lest they trample or inhale even the tiniest of living creatures. An agitated throng of soldiers and onlookers stare at Malik Iraj, many mimicking their leader's gesture of devotion. Above and apart from all this is Umar, hands crossed and bound, perched on a minuscule platform atop a tower so tall that its base lies beyond the edge of the composition.

Kesava, who probably designed the illustration, certainly painted the three key figures, the pair of monks, and some of the landscape and sky. The most telling figure of all is Iraj, whose facial features and tousled hair appear in Kesava's other works, notably cat.55. And though the resplendent solar designs on Iraj's robe are surely its most dazzling feature, the garment's deep blue color and blackish contour modeling are unmistakable signs of Kesava's hand. Likewise, Umayya's noticeably dark eyes and hair and the rippling but weighty hem of his *jama* recall similar elements in many of this artist's figures. Other familiar effects are the painterly surface and contours of the monks' cloaks and Umar's tunic and shorts, the loosely rendered tufts lining the pathway and mountaintop clearing, the decidedly columnar treatment of three tree trunks, and the richly scumbled sky.

The figures below are clearly by a secondary artist. The lone woman in the lower right is nearly identical to one in an ascribed *Darabnama* painting, and the excited men have the same hairy faces, bulging eyes, and schematically modeled clothes as Tara's ascribed painting in the *Tutinama*.[2]

In Islamic culture, few encounters become the stuff of legend more readily than the battle of a solitary hero against a dragon. Is there a sterner test of valor than to confront the most fearsome creature to spring from the dark recesses of the human imagination? Persian literature offers rich and varied descriptions of dragons, likening them to gigantic worms, amphibians, or serpents, and attributing to them slender wings, fiery breath, noxious venom, and hair as long and deadly as lassos.[1] Persian and Mughal painters draw upon all these literary embellishments and invent yet more. They concoct dragons in nearly every color of the rainbow, scaling some, striping others, and dappling the rest. They embellish them with colorful muzzles, flaming eye-rims, antler-like horns, menacing hackles, and leonine legs and claws. Like most nightmarish creatures, dragons make their lairs in dank, foreboding places, and lurk in mountainous ravines, caves, and wells.

So it is with this magnificent beast, one of the finest dragons in all of Islamic art. He dwells in an utterly desolate place, a terrain pocked with deep circular pits, its barrenness relieved only by a few tree stumps whitened by searing blasts and poisonous vapors. Into this land stumble Umar and his men. They are on yet another mission, this time to deliver two letters, one from Qitanush Shah's own daughter, the other from Hamza to Qitanush urging him to convert to Islam and to yield to Umar. Before they can reach Qitanush's capital, however, they must pass through this hellish environment and neutralize its terrifying guardian. As usual, Umar's wiles are his greatest asset. From his *ayyar*'s furry bag of tricks Umar whips out a vial of naphtha and hurls it at the dragon, incinerating it on the spot. Then Umar presses on to Bedakdasht:

"The people took Umar inside, where Qitanush was seated on the throne, and there was an idol of gold placed on a bejeweled throne. A voice came from the idol, saying, 'Umar, where have you come from?' Umar gave Qitanush's daughter's letter, and it was read out. In it was written: 'He rescued me from the clutches of the demon Hamza the Arab. This *ayyar* has expressed his love for me. I have sent him to you that you may not leave him alive.'"

The *ayyar* is spared only when Baalbek, Qitanush's ally, convinces him to keep Umar alive long enough to lure Hamza, too, to his death. Thus Umar learns that human treachery is more dangerous than even the most formidable of creatures.

Dasavanta, the designer of this sensational painting, dramatizes the situation by giving over almost all the composition to Umar and the dragon. On the right looms the snarling dragon, its gleaming white skin studded with irregular blue spots, its wings and wattle streaming behind it, and its mouth thrown open ferociously wide. Opposite a tiny Umar stands knee-deep in a pit, armed with only a woefully small battle-axe and vial. Suddenly, the dragon is engulfed by fire. Golden flames rise from its forelegs, snout, and crest, simultaneously contrasting the creature's resplendence with the blackish gloom all about, and blurring the transition between its precise contours and the roughly painted surface of the landscape.

The confrontation is witnessed by a throng of soldiers taking cover beyond a very dark ridge. Their sheer numbers, minute scale, and joyous acclaim transform the scene from a solitary act of bravery to a righteous spectacle. They are clearly the work of another artist, Tara, who also contributed to cat.85. Tara's figures are lively enough, but their faces are noticeably awkward, an impression conveyed primarily by the very large and narrow-set whites of their eyes. Dasavanta, on the other hand, repeats his figure of Umar almost exactly from cat.36, an illustration that also features rocks painted with the same breathtaking freedom seen here in the boulders and stumps.

Attributed to Dasavanta and Tara

Volume unknown, painting number 75, text number 76 India, Mughal dynasty, *circa* 1567–72 61.9 × 51.2 cm (detail on p.11) MAK–Austrian Museum of Applied Arts/Contemporary Art, Vienna, B.I. 8770/15 Published: Beach 1992, fig.16; Egger 1974, pl.8; Egger 1969, pl.3; Glück 1925, pl.6.

1. Titley 1981, pp.3–7.

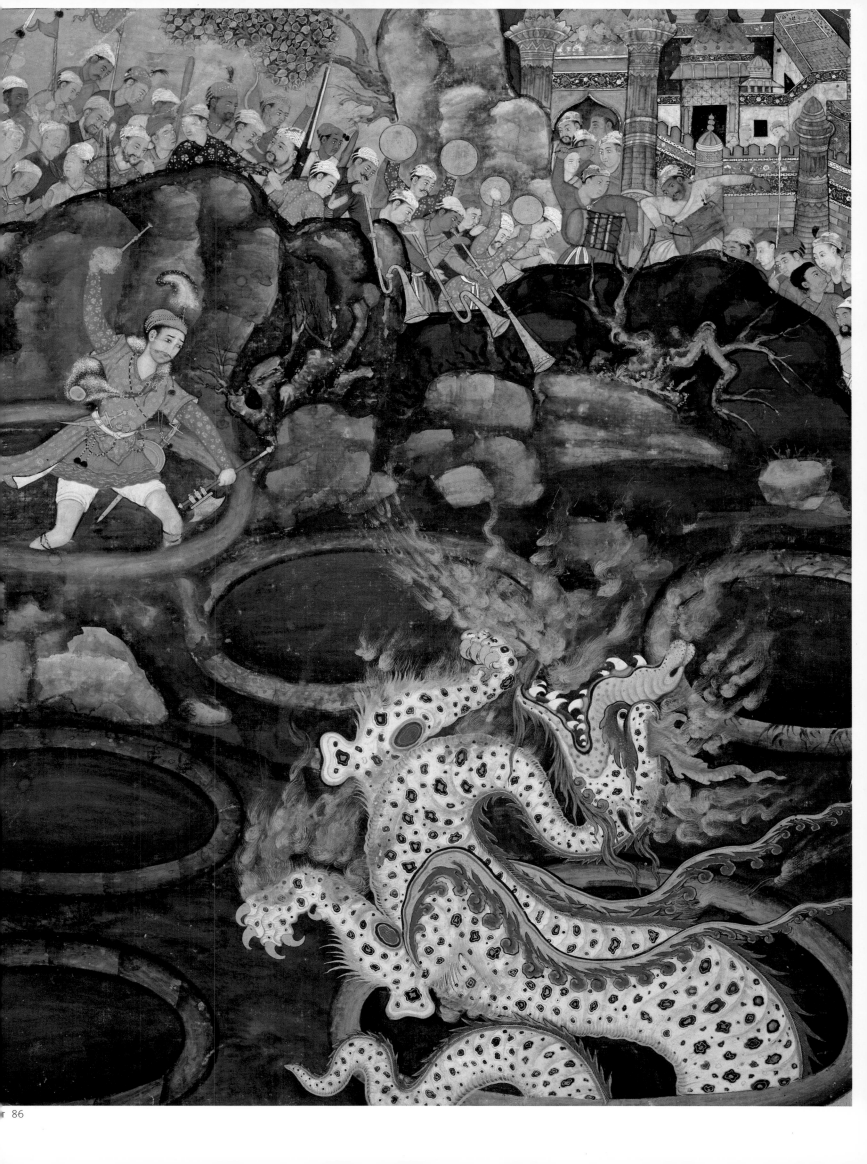

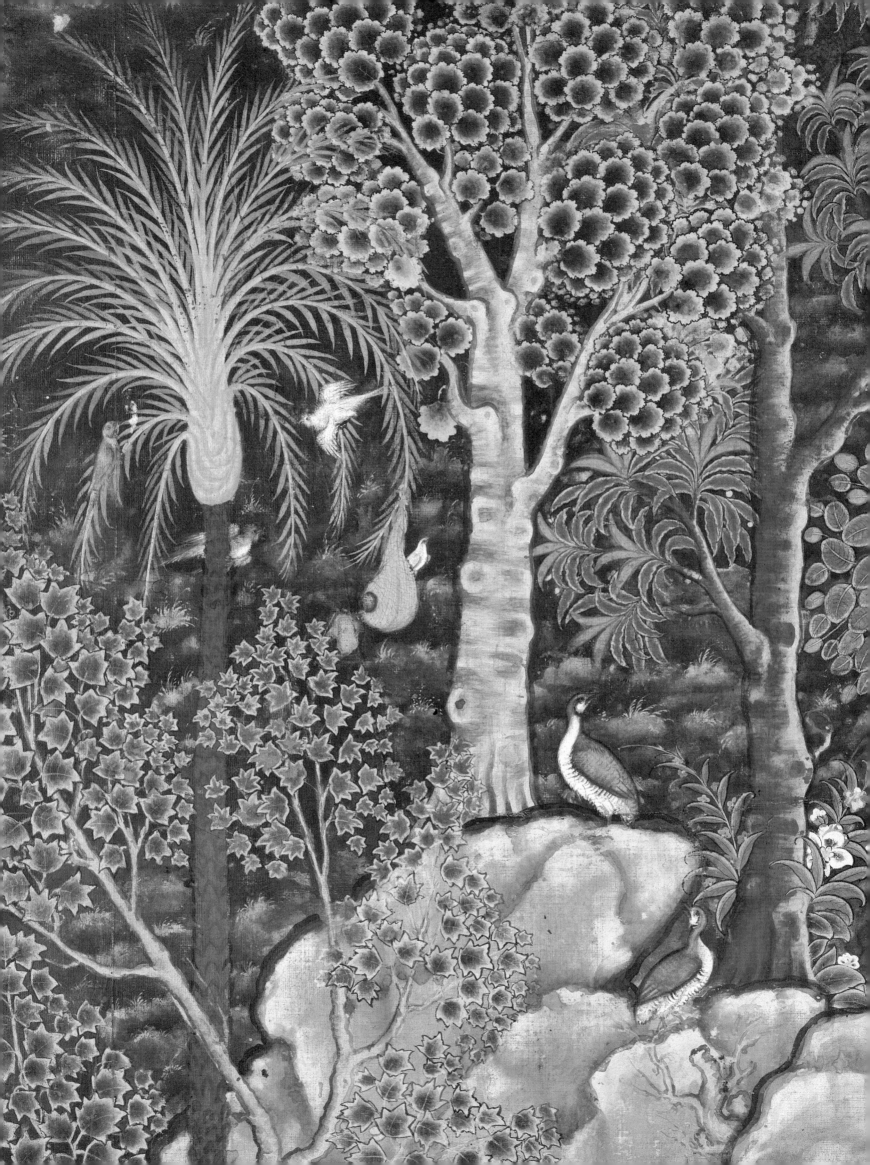

1

2

3

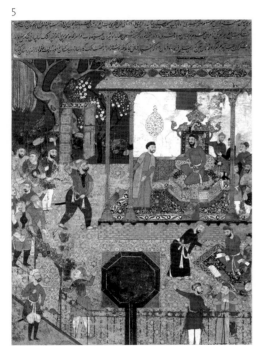

5

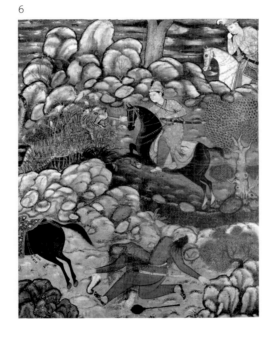

6

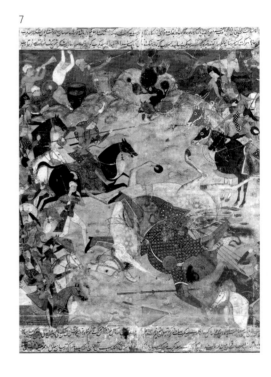

7

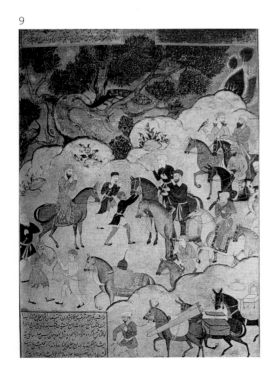

9

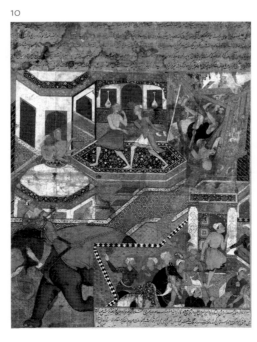

10

11

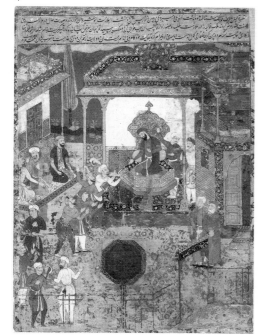

4

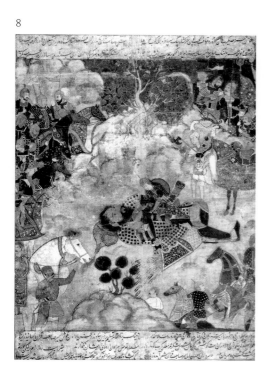

8

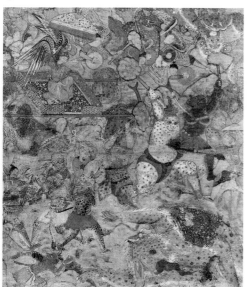

12

RECONSTRUCTION OF THE *HAMZANAMA* MANUSCRIPT
John Seyller

All known folios from the *Hamzanama* are
listed, but only those not shown in the catalogue
above are illustrated in black and white here.
An asterisk denotes an item illustrated in color
in the main catalogue.

VOLUMES 1–5

R1
*Abu Buzurjmihr Hakim finds a book
written in unusual script (Greek) and brings
it to learned men to have it deciphered.*
56.8 × 48.4 cm. The British Museum,
London, 1923-1-15-03.

R2
*Anoshirvan lays the foundation of Ctesiphon
at an auspicious hour.*
62.4 × 49.2 cm. Arthur M. Sackler Gallery,
Smithsonian Institution, Washington, DC;
Purchase – Smithsonian Unrestricted Trust Funds,
Smithsonian Collection Acquisition Program,
and Dr. Arthur M. Sackler S1986.397.
Published: Lowry, Beach, Marefat & Thackston
1988, no.38.

R3
*Khwaja Buzurjmihr takes leave of his aged
mother to go out in the world and seek redress
of his family's adversity.*
66.3 × 47 cm. Arthur M. Sackler Gallery,
Smithsonian Institution, Washington, DC;
Purchase – Smithsonian Unrestricted Trust Funds,
Smithsonian Collection Acquisition Program,
and Dr. Arthur M. Sackler S1986.398.
Published: Lowry, Beach, Marefat & Thackston
1988, no.39.

R4
*Emissaries bring tiles from the destroyed
provinces of Khaybar and Chin to Anoshirvan
as signs of their ruinous rule.*
61.4 × 47.9 cm. MAK–Austrian Museum of Applied
Arts/Contemporary Art, Vienna, B.I. 8770/2r.
Published: Egger 1974, pl.1; Glück 1925, pl.1.

R5
*Anoshirvan sends his general Purashk Sassan
against Bahram, the son of the ruler of Djinn,
into battle against the Turks.*
59 × 47.1 cm. MAK–Austrian Museum of Applied
Arts/Contemporary Art, Vienna, B.I. 8770/2v.
Published: Beach 1987, fig.45; Egger 1974, pl.2;
Glück 1925, pl.2.

R6
*Hamza kills a lion on the way to visit Anoshirvan
at Mada'. Soon after Hamza's arrival, Mihr-Nigar
falls in love with him. He then breaks in a magic*

*horse, is rescued by Buzurjmihr, and gains
honors with Anoshirvan.*
Painting number 87, text number 88.
65.2 × 51.8 cm. Victoria & Albert Museum,
London, I.M. 5-1921.
Published: Stronge 2002, pl.11, p.26; Beach 1987,
fig.65; *Hamza-nama*, pl.27; Glück 1925, fig.3.

R7
Hamza overthrows Umar Ma'dikarb in battle.
Text number 88 (?). 67 × 49.3 cm. Ashmolean
Museum, Oxford (EA 1978.2596, Reitlinger Gift).
Published: Harle & Topsfield 1987, no.82;
Glück 1925, p.26, fig.2.

R8
*Hamza sits on the defeated Umar Ma'dikarb, but
orders his men to spare Umar Ma'dikarb's forces.*
55.7 × 48.7 cm. The British Museum, London,
1923-1-15-02.

R9
The meeting of Khurshed Taban and Kaukub.
Faint number 95 in the lower text area. 68 × 48 cm.
Cowasji Jehangir Collection, Mumbai.
Published: Khandalavala & Chandra 1965, color pl.A;
Sotheby's, London, 7 February 1949, lot 43, opp. p.4.

R10
*Hamza is saved from a booby-trapped bathhouse
when Umar foils the plot by having the elephant
pull the bathhouse pillar in a different direction so
that the perpetrator, Malik Yunas, is crushed instead.*
58 × 53.6 cm. MAK–Austrian Museum of Applied
Arts/Contemporary Art, Vienna, B.I. 8770/4v.
Published: Egger 1974, pl.3; Glück 1925, fig.5.

R11
*Umar and Umar Ma'dikarb lead Hamza's
forces in battle in the Caucasus mountains.*
70 × 55 cm. Department of Museums, Museum
and Picture Gallery, Baroda, IA 338.
Published: Doshi 1995, p.57; Gangoly 1961, pl.I;
Goetz 1944–45, pl.4.

R12
Peris and demons attack Hamza.
64.5 × 56.8 cm. Fine Arts Museums of San
Francisco, Achenbach Foundation for the Graphic
Arts, Gift of Dr. William K. Ehrenfeld, 1984.2.50.
Published: Ehnbom 1987, p.45, fig.4; Ehnbom 1985, no.4.

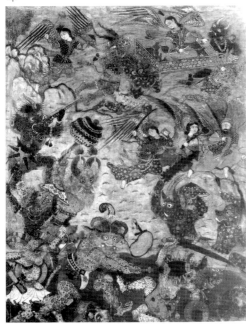

14

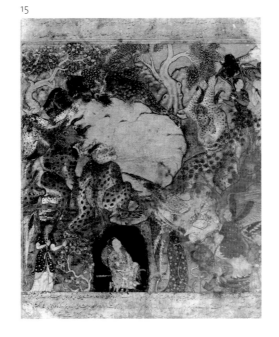

15

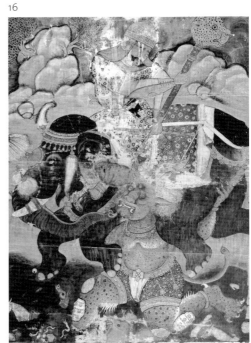

16

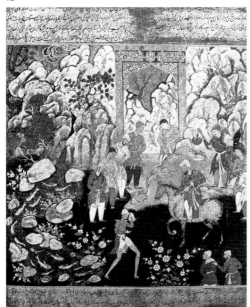

18

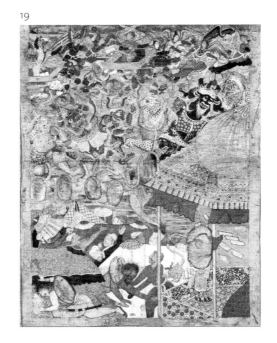

19

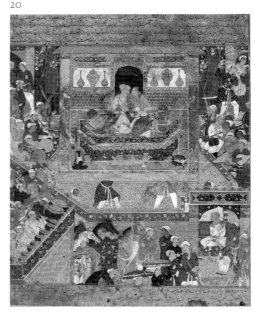

20

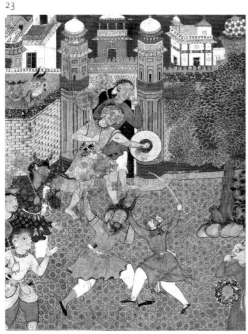

23

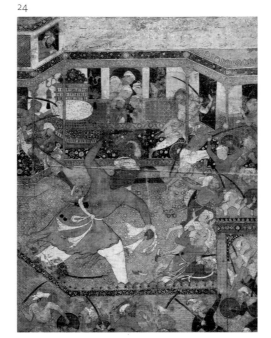

24

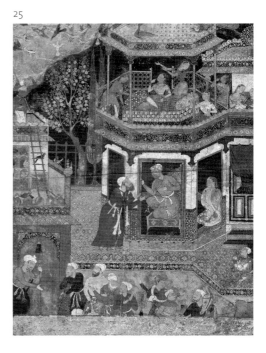

25

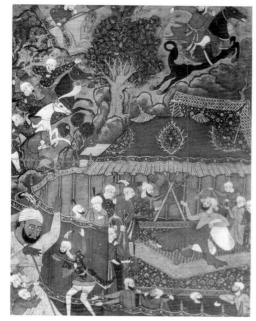

17

21

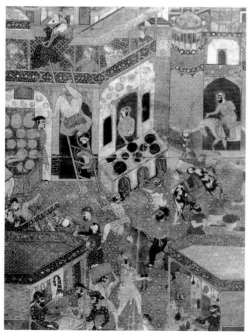

26

*R13 (cat.19)
Hamza fights three devs.
64 × 55.5 cm. Private collection.
Published: Fischer & Goswamy 1987, no.7;
Falk 1985, no.120.

R14
The Queen of the Fairies surveys the battle.
Signed 'Ali' at bottom. 69.9 × 50.6 cm.
Fondation Custodia, Paris, 1974-T.1.
Published: Bernus-Taylor 2001, no.183;
Gahlin 1991, pl.1.

R15
*The Peri Rashid orders demons to rescue
Hamza from a pit.*
71 × 55 cm. Keir Collection, London.
Published: Bernus-Taylor 2001, no.184;
Robinson, Grube, Meredith-Owens &
Skelton 1976, color pl.29.

R16
*Landhaur, Prince of Ceylon, rides on an
elephant carried by a dev.*
68.2 × 51 cm. The British Museum, London 1951-4-7-01.

R17
*Landhaur and Umar converse outside Hamza's
tent while he learns of Qaran's flight.*
Painting number 26, text number 27. 68.3 × 51 cm.
San Diego Museum of Art (Edwin Binney 3rd
Collection), 1990.274.
Published: Binney 1973, no.11.

R18
*Umar and Zubin meet after Umar had written
Zubin a letter to ask forgiveness for his faults.*
74 × 61 cm. Location unknown. Ex-Goenka Collection.
Published: Palais Galliera, Paris, 19 June 1970, lot 85.

R19
*Hamza escapes imprisonment in the Caucasus
with the Queen of the Fairies.*
Attributed to Mukhlis. 64 × 46.5 cm. The Nasser
D. Khalili Collection of Islamic Art, MSS 978.
Published: Leach 1998, no.2; Fischer & Goswamy
1987, no.95; Falk 1985, no.119; Falk & Digby 1979,
no.11; Christie's, New York, 25 May 1978, lot 102.

R20
*Hamza marries the daughter of Faridun Shah,
the King of Greece, who converts to Islam.*
56.9 × 55.5 cm. MAK–Austrian Museum of Applied
Arts/Contemporary Art, Vienna B.I. 8770/4r.

Published: Wade 1998, fig.162; Egger 1974, pl.4;
Glück 1925, fig.6.

R21
*Courtiers attend a figure seated on a throne
in a landscape; a horseman rides across the
foreground while a slender man brings refresh-
ment to a beggar beside a tree.*
54 × 47.1 cm. Bahari Collection, London.
Published: Sotheby's, London, 22 May 1986, lot 135.

*R22 (cat.25)
Landhaur is abducted in his sleep by a dev.
Attributed to Dasavanta and Shravana.
59.3 × 45.2 cm. MAK–Austrian Museum of
Applied Arts/Contemporary Art, Vienna, B.I.
8770/19. Published: Egger 1974, pl.5; Glück 1925, pl.3.

R23
*Hamza kills the leader of the Qaf, people
who have elephant ears.*
Attributed to Dasavanta. Painting number 100
in red on central *dev's* right leg; seals on blank
page on reverse. 69.3 × 51.9 cm. MAK–Austrian
Museum of Applied Arts/Contemporary Art,
Vienna, B.I. 8770/18.
Published: Egger 1974, pl.6; Glück, pl.4.

R24
*Hamza's friend Landhaur, the gigantic Moor
from Ceylon, frees his grandson from prison
in the city of Afruqiya.*
70.4 × 53.1 cm. MAK–Austrian Museum of Applied
Arts/Contemporary Art, Vienna, B.I. 8770/12v.
Published: Egger 1974, pl.11; Glück 1925, fig.19.

R25
*Hamza's son and Mihrafroz, the daughter of the
King of the Franks, are surprised and warned by
frightened birds in the king's Garden of Love.*
63 × 53.7 cm. MAK–Austrian Museum of Applied
Arts/Contemporary Art, Vienna, B.I. 8770/12r.
Published: Egger 1974, pl.12; Glück 1925, fig.20.

R26
*Khwaja Umar comes to Isfahan at the
palace of Kulbad Iraqi, meets Kulbad, and
quarrels with him over gambling.*
69.5 × 53 cm. Museum of Fine Arts, Boston,
Denman Waldo Ross Collection, 06.129
Published: Coomaraswamy 1930, pp.16–17, pl.II.

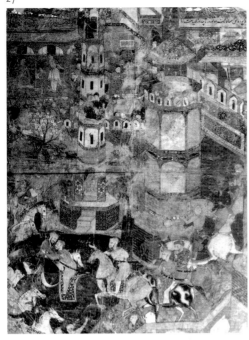

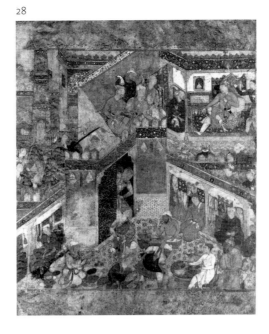

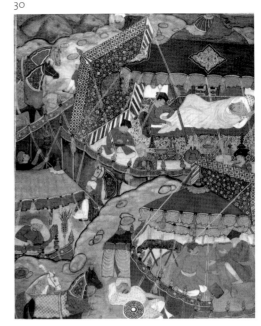

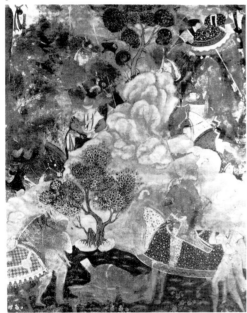

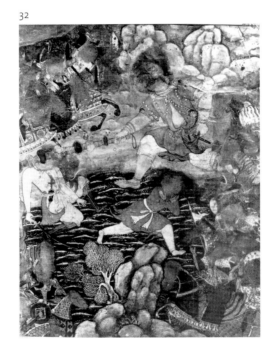

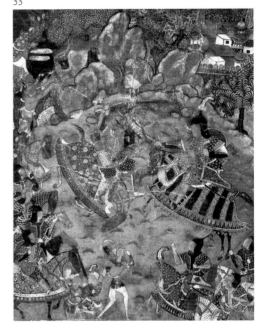

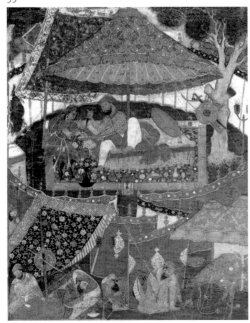

R27
Khwaja... greets Tabiq (?) Khan outside a city.
68 × 48 cm. Location unknown.

R28
*Hamza enters a city and enquires in the
bazaar to find the ruler's court.*
70 × 55.5 cm. Keir Collection, London.
Published: Robinson, Grube, Meredith-
Owens & Skelton 1976, 3, pl.108.

VOLUME 6
*R29 (cat.83)
*Hamza's heroes fight in support of
Qasim and Badi'uzzaman.*
Attributed to Shravana, Dasavanta, and Tara.
Painting number 2. 68.2 × 51.5 cm.
The Metropolitan Museum of Art, New York,
Rogers Fund, 1918. (18.44.2)
Published: Kossak 1997, no.8; Schimmel &
Welch 1983, p.44; New York 1982, no.121;
Comstock 1925, p.352; Glück 1925, fig.29.

R30
*With the aid of the traitor Zangawa,
Khwaja Umar escapes at night from the
camp of the European infidel Marzuq.*
Volume 6, painting number 2 inscribed on
the red tent wall in the foreground. 68 × 51.8 cm.
Collection of Ramesh Kapoor.
Published: Sotheby's, New York, 16 October 1996,
lot 86.

R31
*Hamza receives an envoy of Qitanush Shah,
who asks for help against the Franks.*
[Volume 6], text number 6. 67.7 × 51 cm.
Victoria & Albert Museum, London, I.S. 2516-1883.
Published: Stronge 2002, pl.5, p.19; *Hamza-nama*,
pl.26; Staude 1955a, fig.2; Glück 1925, fig.15.

R32
*Mesluq fights with the giant Sar Farangi and
is dashed to the ground. In the meantime, at the
order of Hamza, a Frank fortress is taken and
their camp is sacked.*
Attributed to Mukunda. Painting number 5
(probably a mistake for 6), text number 7.
67.8 × 51.8 cm. Victoria & Albert Museum,
London, I.S. 2511-1883.
Published: *Hamza-nama*, pl.21; Glück 1925, fig.16.

R33
*On the march to Elbrus, Hamza's son Rustam
is wounded in a duel with Malafard, one of
Marzuq Shah's subjects.*
69 × 52.1 cm. MAK–Austrian Museum of Applied
Arts/Contemporary Art, Vienna, B.I. 8770/11.
Published: Egger 1974, pl.10; Glück 1925, fig.17.

*R34 (cat.21)
*Hamza routs Marzuq and conquers the
fortress of the Franks.*
Attributed to Mah Muhammad. Volume 6,
painting number 34, text number 35. 66.5 × 55 cm.
The al-Sabah Collection, Dar al-Athar al-Islamiyyah,
Kuwait National Museum, LNS 297 MS.
Published: Grube 1971, color pl.49;
Blochet 1930, pl.xxx.

R35
Hamza disarms a Rumi (Greek) princess.
Text number 43. 67.6 × 50.8 cm. Felton Bequest,
1978, National Gallery of Victoria, Melbourne,
Australia, AS 12.1978.
Published: Galbally 1987, p.238, pl.9.1; Guy 1982,
fig.1; Sotheby's, London, 17 July 1978, lot 73.

*R36 (cat.23)
Alamshah converses with Qubad.
Attributed to Shravana and Banavari.
Volume 6, painting number 50. 67.5 × 51.2 cm.
Fitzwilliam Museum, Cambridge, PD. 203-1948.
Published: Beach 1987, pl.61.

*R37 (cat.24)
*An ayyar misunderstands Anoshirvan's
order and murders Qubad in his sleep.*
Attributed to Shravana. Dated AH 972 (July
1564–July 1565). Volume 6, painting number 74.
69.1 × 50.5 cm. Victoria & Albert Museum,
London, I.S. 1508–1883.
Published: Stronge 2002, pl.7, p.22 and
details pl.8, p.23; Walker 1997, fig.35 (detail);
Seyller 1993, figs 1–2; *Hamza-nama*, pl.6;
Glück 1925, fig.11.

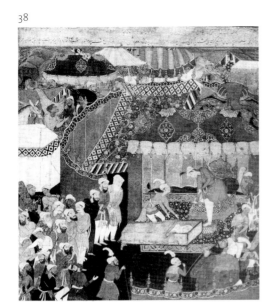

38

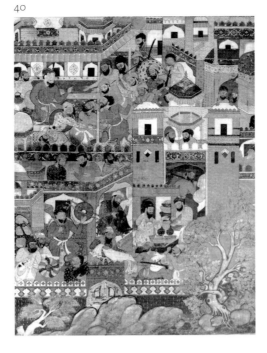

40

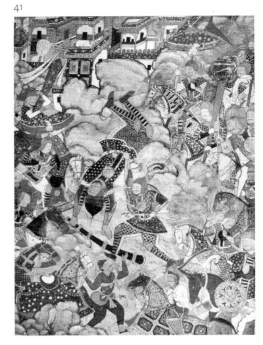

41

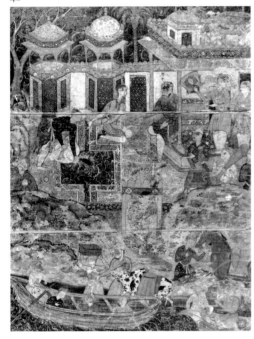

42

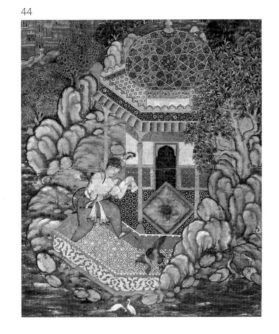

44

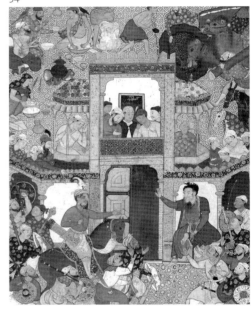

54

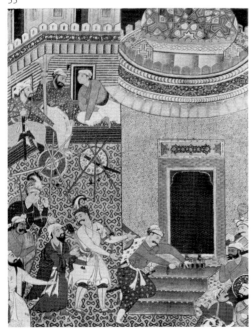

55

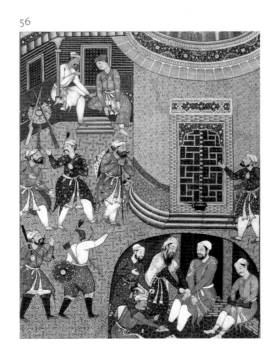

56

R38
Umar comes to look for the corpse of Mihr-Nigar.
Attributed in part to Shravana. 63.5 × 59.9 cm.
Collection of Catherine and Ralph Benkaim.
Published: Palais Galliera, Paris, 19 June 1970, lot 86.

*R39 (cat.26)
*Basu beheads Namadposh, disguises himself,
and cajoles his way into Acre Castle.*
Attributed to Mahesa and Mah Muhammad. Volume
7, painting number 10, text number 10. 66.1 × 52 cm.
Victoria & Albert Museum, London, I.S. 1520-1883.
Published: Stronge 2002, pl.12, p.27; *Hamza-nama*,
pl.18; Glück 1925, fig.30; Clarke 1921, pl.7.

VOLUME 7
R40
The King of Kalud receives a prisoner.
Volume 7, painting number 14, text number 15.
68.7 × 50.8 cm. The Art and History Trust.
Published: Grabar & Natif 2001, fig.24; Soudavar & Beach
1992, no.134; Sotheby's, London, 17 July 1978, lot 74.

R41
Battle of Mazandaran.
Volume 7; painting number 38, text number 39.
68.5 × 50.6 cm. Library of Congress, Washington, DC,
1.91.154.188.

R42
*Having been cursed, Bahram allows a retainer to
torture Khwaja Bakhtyar by plunging his head into
a fountain.*
Text number 55. 67 × 51 cm. Manuscripts Division,
Department of Rare Books and Special Collections,
Princeton University Library, Islamic Manuscripts,
3rd series, #305.

*R43 (cat.27)
A leviathan attacks Hamza and his men.
Attributed to Basavana and Shravana. Text
number 69. 71 × 55.5 cm. Private collection.
Published: Christie's, New York, 3 October 1990, lot 28.

R44
*Hamza's son Shirafgan reaches an enchanted
building and shoots a bird before it. In the bird's
feathers he finds a note containing the magic
formula to open the building, and thus is able to
free Hamza's heroes.*
Painting number 67, text number 68. 67 × 50.9 cm.
MAK–Austrian Museum of Applied Arts/
Contemporary Art, Vienna, B.I. 8770/57.
Published: Egger 1974, pl.52; Glück 1925, fig.36.

VOLUMES 9–10
*R45 (cat.28)
*Zumurrud Shah falls into a pit and is beaten
by suspicious gardeners.*
Attributed to Kesava Dasa. Possibly dated AH 975
(July 1567–June 1568). Painting number 15,
text number 16. 68.9 × 54.7 cm. Victoria & Albert
Museum, London, I.S. 1516-1883.
Published: Stronge 2002, pl.21, p.35; *Hamza-nama*,
pl.14; Stchoukine 1929, pl.v; Glück 1925, fig.42;
Clarke 1921, pl.12.

VOLUME 11
*R46 (cat.30)
*During Hamza's wedding to the daughter of
his friend Prince Unug, Hamza is abducted by
Shahrashob and stowed in a boat.*
Attributed to Basavana and Shravana. Volume 11,
painting number 3, text number 4. 67.4 × 51.8 cm.
MAK–Austrian Museum of Applied
Arts/Contemporary Art, Vienna, B.I. 8770/45.
Published: Egger 1974, pl.13; Glück, pl.7.

*R47 (cat.31)
Umar sets sail in search of Hamza.
Attributed to Dasavanta and Banavari. Volume 11,
painting number 4, text number 5. 67.1 × 52 cm.
MAK–Austrian Museum of Applied Arts/
Contemporary Art, Vienna, B.I. 8770/47.
Published: Egger 1974, pl.14; Glück 1925, pl.8.

*R48 (cat.32)
*Ayjil, Alamshah, and Tul Mast arrive at Takaw
and sell gold and jewels to Khwaja Nu'man, who
recognizes Alamshah as a former friend.*
Attributed to Basavana and Banavari. Volume 11,
painting number 5, text number 6. 67.6 × 51.8 cm.
MAK–Austrian Museum of Applied Arts/
Contemporary Art, Vienna, B.I. 8770/41.
Published: Egger 1974, pl.15; Glück 1925, pl.9.

*R49 (cat.33)
*Zumurrud Shah witnesses the prowess of
Mahlaj, who thrusts his spear through a tree.*
Attributed to Basavana and Jagana. Volume 11,
painting number 6, text number 7. 67.3 × 52.1 cm.
MAK–Austrian Museum of Applied
Arts/Contemporary Art, Vienna, B.I. 8770/42.
Published: Egger 1974, pl.16; Glück 1925, pl.10.

*R50 (cat.34)
*Shahrashob reaches Takaw with Hamza
bound in chains.*
Attributed to Mukhlis. Volume 11, painting

number 8, text number 9. 67.2 × 51.7 cm.
MAK–Austrian Museum of Applied Arts/
Contemporary Art, Vienna, B.I. 8770/48.
Published: Egger 1974, pl.17; Glück 1925, pl.11.

*R51 (cat.35)
*Shahrashob leads Hamza to prison and Tul
Mast recognizes the Amir from his room in
the caravanserai of Baba Junayd.*
Attributed to Jagana and Basavana. Volume 11,
painting number 9, text number 10. 68.1 × 51.6 cm.
MAK–Austrian Museum of Applied Arts/
Contemporary Art, Vienna, B.I. 8770/35.
Published: Egger 1974, pl.18; Glück 1925, pl.12.

*R52 (cat.36)
*Hamza's friends send Yunus the sailor for help;
he meets Umar, and directs him to Takaw.*
Attributed to Dasavanta and Shravana. Volume 11,
painting number 10, text number 11. 66.8 × 51.8 cm.
MAK–Austrian Museum of Applied Arts/
Contemporary Art, Vienna, B.I. 8770/54.
Published: Egger 1974, pl.19; Archer 1960, pl.18;
Glück 1925, pl.13.

*R53 (cat.37)
*Baba Junayd is rude to Umar and turns him away
from the caravanserai despite Nu'man's entreaties.*
Volume 11, painting number 11, text number 12.
68.5 × 53 cm. Freer Gallery of Art, Smithsonian
Institution, Washington, DC; Purchase F1981.11.

R54
*Fire-worshippers and Shahrashob come to the
caravanserai of Baba Junayd and search for Hamza's
friends, who catch sight of them from above;
Baba Junayd denies that the friends are there.*
Volume 11, painting number 12, text number 13.
67.5 × 51.8 cm. MAK–Austrian Museum of Applied
Arts/Contemporary Art, Vienna, B.I. 8770/60.
Published: Egger 1974, pl.20.

R55
*Tarut shows Umar the prison in which the
Amir is confined.*
Volume 11, painting number 13. Location unknown.
Ex-Minkenhof collection.
Published: Dimand 1948, pl.1.

R56
*After the arrival of Umar, the three friends dig
a tunnel to prison and free Hamza and Khusraw,
the son of the legitimate king of Takaw.*
Volume 11, painting number 14. 67.5 × 51.4 cm.

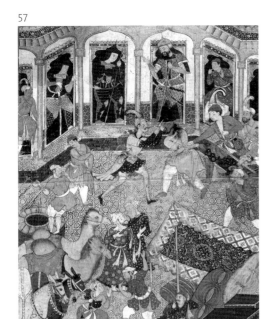

57

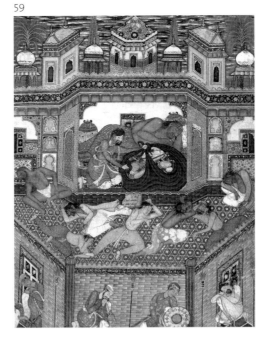

59

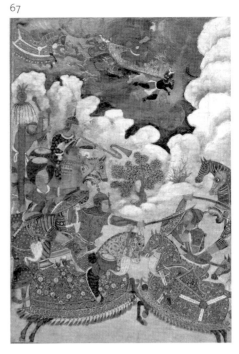

67

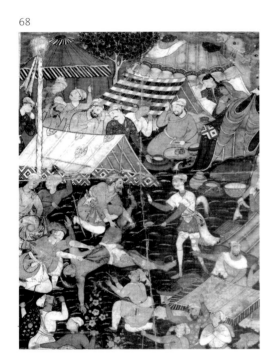

68

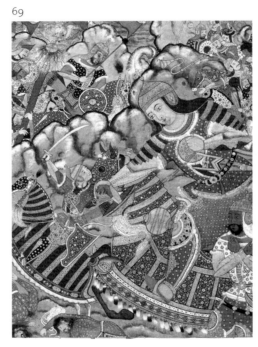

69

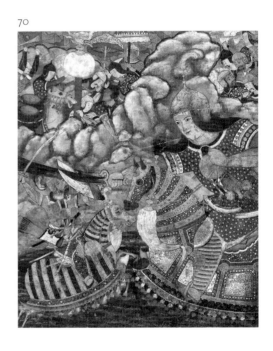

70

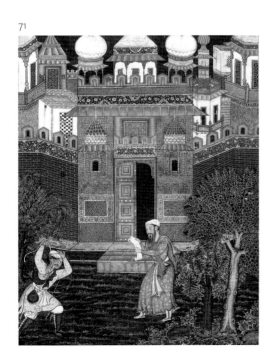

71

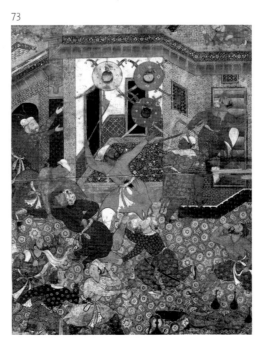

73

MAK–Austrian Museum of Applied Arts/
Contemporary Art, Vienna, B.I. 8770/29.
Published: Egger 1974, pl.21; Glück 1925, pl.15.

R57
*During a fight in the caravanserai, Umar takes
out a dagger and cuts off Shahrashob's nose
and tongue because he had insulted Hamza.*
Volume 11, painting number 15. 66.8 × 51 cm.
MAK–Austrian Museum of Applied Arts/
Contemporary Art, Vienna, B.I. 8770/53.
Published: Egger 1974, pl.22; Glück 1925, pl.16.

*R58 (cat.38)
*Hamza and Umar exchange insults with
Ghazanfar and challenge him to battle
outside the fortress of Armanus.*
Attributed to Mukhlis and Madhava Khurd.
Volume 11, painting number 19, text number 20.
71.5 × 55.3 cm. The Seattle Art Museum,
Gift of Dr. and Mrs. Richard E. Fuller, 68.160.
Published: Beach 1992, pl.C; Heeramaneck, pl.140;
Seattle 1973, no.36; Comstock 1925, p.356;
Phildadelphia 1924, no.81.

R59
*Following the fleeing Zumurrud Shah, Umar
meets the enemy ally Manzur Kamran, surprises
him in his sleep, cuts off his beard, and robs him.*
Attributed to Mukhlis. Volume 11,
painting number 20. 67.7 × 51.4 cm.
MAK–Austrian Museum of Applied Arts/
Contemporary Art, Vienna, B.I. 8770/23.
Published: Egger 1974, pl.23; Glück 1925, pl.17.

*R60 (cat.39)
*Zumurrud Shah reaches the foot of a huge
mountain and is joined by Ra'im Blood-Drinker
and Yaqut Shining-Ruby.*
Attributed to Mahesa. Volume 11, painting
number 21, text number 22. 67.9 × 51.1 cm. Brooklyn
Museum of Art, Museum Collection Fund, 24.48.
Published: Poster *et al.* 1994, no.23; Chandra
1989, fig.1.

*R61 (cat.40)
*In search of Zumurrud Shah, Hamza and his friends
reach the Noshad Pass and meet Umar Ma'dikarb.*
Attributed to Banavari, Mah Muhammad, and
Madhava Khurd. Volume 11, painting number 22.
67.8 × 51.9 cm. MAK–Austrian Museum of Applied
Arts/Contemporary Art, Vienna, B.I. 8770/39.
Published: Egger 1974, pl.24; Staude 1955b, fig.31;
Glück 1925, pl.18.

*R62 (cat.41)
*A veiled youth suddenly appears and splits
Marku' Boar-Tooth asunder.*
Attributed to Mukhlis and Lalu. Volume 11,
painting number 23. 67.5 × 51.8 cm. MAK–Austrian
Museum of Applied Arts/Contemporary Art,
Vienna, B.I. 8770/37.
Published: Egger 1974, pl.25; Glück 1925, pl.19.

*R63 (cat.42)
*Badi'uzzaman encases himself in a watertight trunk
and has it thrown into the sea around Noshad Fort;
Malik Qasim swims after it and reaches enemy territory.*
Attributed to Dasavanta and Shravana. Volume 11,
painting number 24. 67.5 × 51.5 cm. MAK–Austrian
Museum of Applied Arts/Contemporary Art,
Vienna, B.I. 8770/50.
Published: Egger 1974, pl.26; Glück 1925, pl.20.

*R64 (cat.43)
*Badi'uzzaman emerges from the trunk, slays
some opponents, and converts Zarnab.*
Attributed to Mahesa and Shravana. Volume 11,
painting number 25, text number 26. 67.2 × 51.1 cm.
Cincinnati Art Museum, Gift of John W.
Warrington, 1948.192. Published: *The Dictionary
of Art*, vol.15, fig.259; Smart & Walker 1985, no.1:
Comstock 1925, p.350; Culin 1924, frontispiece.

*R65 (cat.44)
*Malik Surkhab, the governor of the garrison
of Noshad Fort, submits to Hamza.*
Attributed to Dasavanta and Banavari. Volume 11,
painting number 26. 67.2 × 51.4 cm. MAK–Austrian
Museum of Applied Arts/Contemporary Art,
Vienna, B.I. 8770/34.
Published: Egger 1974, pl.27; Glück 1925, pl.21.

*R66 (cat.45)
*Umar slings a stone at the giant Tahmasp, and
saves one of Hamza's heroes from his clutches.*
Attributed to Dasavanta and Shravana. Volume 11,
painting number 28, text number 29. 66.3 × 51.8 cm.
MAK–Austrian Museum of Applied
Arts/Contemporary Art, Vienna, B.I. 8770/49.
Published: Egger 1974, pl.28; Glück 1925, pl.22.

R67
*Ibrahim, son of Hamza, comes to battle seated
on a throne borne through the sky by demons.*
Volume 11, painting number 29. 67.5 × 45 cm.
Chester Beatty Library, Dublin, 01.2.
Published: Leach 1995, no.1.203; Arnold &
Wilkinson 1936, 2, pl.1; Glück 1925, fig.26.

R68
*Tul Mast, the son of Salsal the Zangi, is flayed
alive at the order of Tahmasp.*
Attributed to Shravana. Volume 11, text number 31.
66.6 × 52 cm. The British Museum, London,
1966-4-16-01.
Published: Beach 1987, pl.3.

R69
*The giant Tahmasp captures Tul the Zangi
and Farrukhsawar (the knight).*
Volume 11, painting number 31, text number 32.
67.1 × 50.9 cm. MAK–Austrian Museum of Applied
Arts/Contemporary Art, Vienna, B.I. 8770/30.
Published: Egger 1974, pl.29; Glück 1925, pl.23.

R70
The giant Tahmasp battles Hamza.
Volume 11, painting number 34, text number 35.
66.2 × 51.3 cm. MAK–Austrian Museum of Applied
Arts/Contemporary Art, Vienna, B.I. 8770/8.
Published: Egger 1974, pl.30; Glück 1925, pl.24.

R71
*Before the city of Ghururiyya, the disguised
Umar meets a stranger during his search for
Hamza, fights him and discovers letters that
reveal Hamza's whereabouts.*
Volume 11, painting number 35, text number 35 (?).
67 × 49.5 cm. MAK–Austrian Museum of Applied
Arts/Contemporary Art, Vienna, B.I. 8770/24.
Published: Egger 1974, pl.31; Glück 1925, pl.25.

*R72 (cat.46)
*Qasam al-Abbas arrives from Mecca and
crushes Tahmasp with a mace.*
Attributed to Mahesa. Volume 11, painting
number 36, text number 37. 68 × 52 cm.
Philadelphia Museum of Art, Gift (by exchange)
of the Brooklyn Museum, 1937-4-1.
Published: *Orientations*, 17, no.2, February 1986,
p.57; Kramrisch 1986, no.8; Dimand 1948, p.6, fig.1.

R73
*Two of Hamza's spies, Yazak and Barkh Farangi,
push into the Noshad Fortress to free Hamza,
who had been betrayed.*
Volume 11, text number 38. 65 × 49.2 cm.
MAK–Austrian Museum of Applied
Arts/Contemporary Art, Vienna, B.I. 8770/16.
Published: Egger 1974, pl.32; Glück 1925, pl.26.

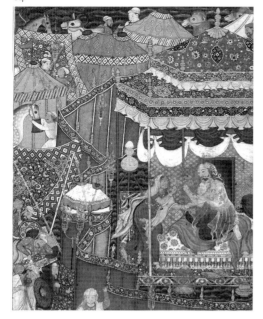

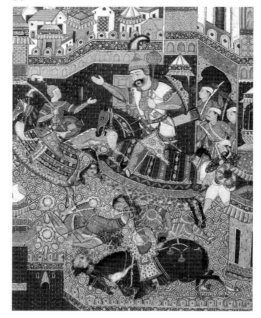

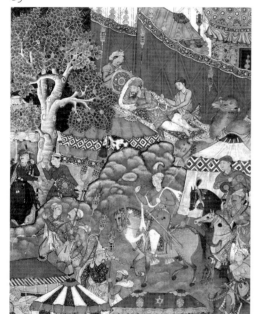

*R74 (cat.47)
Sanawbar Banu welcomes Prince Qasim and the champions of Iran and Turan.
Attributed to Shravana and Dasavanta. Volume 11, painting number 39, text number 40. 67.6 × 51.5 cm. Los Angeles County Museum of Art, From the Nasli and Alice Heeramaneck Collection, Museum Associates Purchase, M.78.9.1
Published: Pal 1993, no.46; Pal 1982, pl.1.

*R75 (cat.48)
Arghan Dev brings the chest of armor to Hamza.
Attributed to Kesava Dasa and Banavari. Volume 11, painting number 40, text number 41. 67.5 × 52.5 cm. Brooklyn Museum of Art, Museum Collection Fund, 24.47.
Published: Poster *et al.* 1994, no.22; Chandra 1989, fig.2; Pal 1983, M2; Glück 1925, fig.48.

*R76 (cat.49)
In the battle for Shisan Pass, Prince Qasim duels with the giant Kayhur, and beheads his rhinoceros.
Attributed to Mahesa. Volume 11, painting number 44, text number 45. 67.4 × 50.8 cm. MAK–Austrian Museum of Applied Arts/ Contemporary Art, Vienna, B.I. 8770/52.
Published: Egger 1974, pl.34; Glück 1925, pl.28.

*R77 (cat.50)
Turning the wheel on the Shisan Dam, Tayhur releases a torrent that floods Hamza's camp and drowns Hardam Devana.
Attributed to Jagana. Volume 11, painting number 45, text number 46. 67.9 × 51.8 cm. Chester Beatty Library, Dublin, 01.1.
Published: Leach 1995, no.1.202, color pl.11; Leach 1986, fig.10A; Arnold & Wilkinson 1936, 2, pl.2.

*R78 (cat.51)
Alamshah slays Tayhur and closes the Shisan Dam.
Attributed to Shravana. Volume 11, painting number 46. 69 × 52.2 cm.
The Cleveland Museum of Art, Gift of George P. Bickford, 1976.74.
Published: Cleveland 1998, p.171; Lee 1994, color pl.18; Leach 1986, no.10; Czuma 1975, no.45; Welch 1973, no. 53; Blochet 1928, pl.189.

*R79 (cat.52)
Lifting an elephant single-handed, Sa'id Farrukh-Nizhad so astonishes two brothers that they convert to Islam.
Attributed to Mahesa and Kesava Dasa. Volume 11, painting number 47, text number 48.

67.2 × 50.6 cm. MAK–Austrian Museum of Applied Arts/Contemporary Art, Vienna, B.I. 8770/26. Published: Egger 1974, pl.35; Glück 1925, pl.29.

***R80 (cat.53)**
Through Umar's trick, Amir Hamza, Landhaur, Umar Ma'dikarb, and Zumurrud Shah are placed bound before Lakman's throne.
Attributed to Dasavanta and Shravana.
Volume 11, painting number 50, text number 51.
67.8 × 51.1 cm. MAK–Austrian Museum of Applied Arts/ Contemporary Art, Vienna, B.I. 8770/6.
Published: Beach 1987, fig.64; Egger 1974, pl.36; Staude 1955a, fig.4; Glück 1925, fig.27.

***R81 (cat.54)**
Misbah the grocer brings the spy Parran to his house.
Attributed to Dasavanta and Mithra.
Volume 11, painting number 52, text number 53.
67.5 × 52.2 cm. The Metropolitan Museum of Art, New York, Rogers Fund, 1924. (24.48.1)
Published: Kossak 1997, no.7; Welch 1987, no.102; Bowie 1970, no.124; Dimand 1948, fig.2.

***R82 (cat.55)**
Umar walks around Fulad Castle, meets a footsoldier and kicks him to the ground.
Attributed to Kesava Dasa and Mah Muhammad.
Volume 11, painting number 55, text number 56.
67.3 × 51.3 cm. The Metropolitan Museum of Art, New York, Rogers Fund, 1923. (23.264.2)
Published: Brand & Lowry 1985, no.11; Dimand 1948, fig.3.

***R83 (cat.56)**
Iskandar finds the infant Darab in the water.
Attributed to Kesava Dasa. Volume 11, painting number 56, text number 57. 68.5 × 52 cm. Museum of Fine Arts, Boston, Horace G. Tucker Memorial Fund and Seth Augustus Fowle Fund, 24.129.
Published: Boston 1982, no.165; Coomaraswamy 1930, pl.I; Comstock 1925, p.357.

R84
During the battle against the magicians of Zarduhusht, Aswad Piyada, the Queen of Zarduhusht, comes to Hamza at night, offers her help, and is converted to Islam.
Attributed to Basavana and Shravana.
Volume 11, painting number 57, text number 58.
67.6 × 52 cm. MAK–Austrian Museum of Applied Arts/Contemporary Art, Vienna, B.I. 8770/22.
Published: Guy 1982, fig.2; Egger 1974, pl.37; Glück 1925, pl.30.

***R85 (cat.57)**
Zumurrud Shah flees with his army to Antali by flying through the air on urns sent by sorcerers.
Attributed to Shravana and Madhava Khurd.
Volume 11, painting number 58, text number 59.
67.1 × 52 cm. MAK–Austrian Museum of Applied Arts/Contemporary Art, Vienna, B.I. 8770/28.
Published: Brend 1993, pl.XXVII; Beach 1987, fig.40; Egger 1974, pl.38; Staude 1955b, fig.27; Glück 1925, pl.31.

R86
Hamza's friend King Bahman goes to the city of Qimar to seek Hamza's son Ibrahim. The king is supposed to have been poisoned fatally, but is rescued instead, and is led out of the city by Qimar.
Volume 11, painting number 64, text number 65.
66.8 × 51.2 cm. MAK–Austrian Museum of Applied Arts/Contemporary Art, Vienna, B.I. 8770/40.
Published: Egger 1974, pl.39; Glück 1925, pl.32.

***R87 (cat.58)**
Hamza's spies, sent to locate the missing Malik Bahman, sneak into the city of Qimar, where they kill the sleeping guards.
Attributed to Dasavanta and Mukhlis. Volume 11, painting number 65, text number 66. 67.6 × 51.1 cm. MAK–Austrian Museum of Applied Arts/ Contemporary Art, Vienna, B.I. 8770/25.
Published: Welch 1978, pl.1; Egger 1974, pl.40; Staude 1955b, fig.29; Glück 1925, pl.33.

***R88 (cat.59)**
Mahus the spy persuades Khwaja Bihbud to help him spirit away Qalmas and Khwarmah, Qimar's nephew and daughter.
Attributed to Dasavanta, Jagana, and Madhava Khurd. Volume 11, painting number 66, text number 67. 67.8 × 51.5 cm. MAK–Austrian Museum of Applied Arts/Contemporary Art, Vienna, B.I. 8770/33.
Published: Egger 1974, pl.41; Glück 1925, pl.34.

R89
Malak Mah, the daughter of Sarv Banu and King Na'im, goes out at night disguised as a man; she arrives at the Muslim camp at night, sees Sa'id Farrukh-Nizhad, and falls in love with him.
Attributed to Dasavanta and Mukhlis. Volume 11, painting number 67, text number 68. 67.7 × 51.6 cm. MAK–Austrian Museum of Applied Arts/Contemporary Art, Vienna, B.I. 8770/46.
Published: Egger 1974, pl.42; Glück 1925, pl.35.

R90
To free Sa'id Farrukh-Nizhad from imprisonment, Malak Mah kills Afshar Zangi, but is quickly taken away by two of Hamza's spies, Songhur Balkhi and Lulu.
Volume 11, painting number 68, text number 69.
67.6 × 51.9 cm. MAK–Austrian Museum of Applied Arts/Contemporary Art, Vienna, B.I. 8770/44.
Published: Egger 1974, pl.43; Glück 1925, pl.36.

94

100

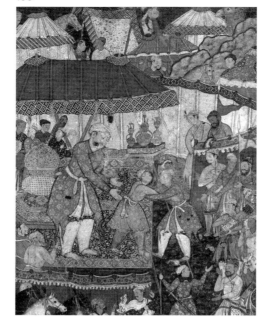

108

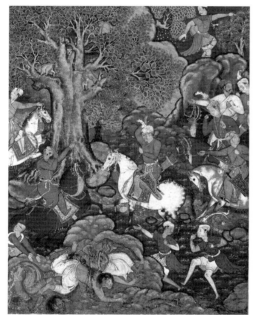

111

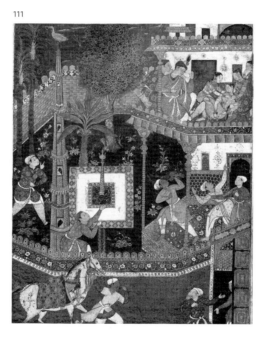

113

114

*R91 (cat.60)
*The spy Zambur brings Mahiya to
Tawariq, where they meet Ustad Khatun.*
Attributed to Kesava Dasa and Mah Muhammad.
Volume 11, painting number 69, text number 70.
68 × 51.6 cm. The Metropolitan Museum of
Art, New York, Rogers Fund, 1923. (23.264.1)
Published: Dimand 1948, fig.4.

*R92 (cat.61)
*Mahiya frees Zambur, beheads his sleeping
guards, and suspends Gharrad in his stead.*
Attributed here to Jagana and Kesava Dasa
Volume 11, painting number 70, text number 71.
67.5 × 51.8 cm. Arthur M. Sackler Museum,
Harvard University Art Museums, Francis H. Burr
Memorial Fund, 1941.292.
Published: Harvard 1996, p.143; Brand 1987, fig.7.1;
Schroeder 1941, p.110.

*R93 (cat.62)
Hamza's son Ibrahim tears an arm off As the Zangi.
Attributed to Mukhlis and Madhava Khurd.
Volume 11, painting number 71, text number 72.
67.5 × 51.7 cm. MAK–Austrian Museum of Applied
Arts/Contemporary Art, Vienna, B.I. 8770/21.
Published: Egger 1974, pl.44; Glück 1925, pl.37.

R94
*Mahiya and Ibrahim's spy Zambur enter the
fortress of Khurramabad disguised as a doctor
and a prophet to rescue Princess Khwarmah.
They drug Ghazanfar, the son of Malik Na'im,
and his people and throw them into the sea.*
Attributed in part to Bhavani. Volume 11,
painting number 72, text number 73. 68 × 51.6 cm.
MAK–Austrian Museum of Applied
Arts/Contemporary Art, Vienna, B.I. 8770/38.
Published: Egger 1974, pl.45; Betz 1965, pl.12;
Glück 1925, pl.38.

*R95 (cat.63)
*Princess Malak Mah joins Hamza's spies in
the search for Sa'id Farrukh-Nizhad, but is
ambushed by a sorceress.*
Attributed to Dasavanta and Mukhlis. Volume 11,
painting number 73, text number 74. 68 × 50.8 cm.
MAK–Austrian Museum of Applied Arts/
Contemporary Art, Vienna, B.I. 8770/36.
Published: Egger 1974, pl.46; Egger 1969, pl.31;
Glück 1925, pl.39.

*R96 (cat.64)
*Songhur Balkhi and Lulu the spy are received by
Baba Bakhsha, a former spy living in Aqiqnagar.*
Attributed to Dasavanta and Mukhlis. Volume 11,
painting number 74, text number 75. 67.5 × 51.6 cm.
MAK–Austrian Museum of Applied
Arts/Contemporary Art, Vienna, B.I. 8770/59.
Published: Welch 1978, pl.3; Egger 1974, pl.47;
Glück 1925, pl.40.

*R97 (cat.65)
*The ayyars, led by Songhur Balkhi and Lulu the
spy, slit the throats of the prison guards and
free Sa'id Farrukh-Nizhad.*
Attributed to Shravana and Mahesa. Volume 11, paint-
ing number 75, text number 76. 68.4 × 52.1 cm. Brooklyn
Museum of Art, Museum Collection Fund, 24.46.
Published: Dehejia 1997, fig.195; Poster *et al.* 1994,
no.24; Chandra 1989, fig.3; Welch 1963, no.2a.

*R98 (cat.66)
Khosh-Khiram beheads Kajdast, a spy of Malik Taysun.
Attributed to Basavana and Mukhlis. Volume 11,
painting number 77, text number 78. 67.5 × 52.1 cm.
MAK–Austrian Museum of Applied Arts/
Contemporary Art, Vienna, B.I. 8770/43.
Published: Egger 1974, pl.48; Egger 1969, pl.32;
Glück 1925, pl.41.

*R99 (cat.67)
*Sa'id and Khosh-Khiram arrive at a castle
and see two girls wrestling on the roof.*
Attributed to Shravana and Mithra. Volume 11,
painting number 78, text number 79. 67.6 × 51.3 cm.
Freer Gallery of Art, Smithsonian Institution,
Washington, DC; Purchase F1960.14.
Published: Beach 1981, no.5a.

R100
*In front of the tent of Malik Bahman, Sa'id
Farrukh-Nizhad's sons meet and embrace.*
Volume 11, painting number 79, text number 80.
67.6 × 51.7 cm. MAK–Austrian Museum of Applied
Arts/Contemporary Art, Vienna, B.I. 8770/58.
Published: Egger 1974, pl.49; Glück 1925, fig.28.

*R101 (cat.68)
Mahus the spy whispers something to Malik Qimar.
Attributed to Basavana, Mithra, and Mukhlis
Volume 11, painting number 80, text number 81.
75 × 56 cm. Rare Book Department, The Free
Library of Philadelphia, M2.
Published: Kramrisch 1986, no.7; Comstock 1925,
p.354; Philadelphia 1924, no.77.

*R102 (cat.69)
*A sorcerer reaches down from the heavens and
abducts Khwaja Bakhtak, who is disguised as Umar*
Attributed to Dasavanta and Shravana. Volume 11,
painting number 82, text number 83. 67.1 × 50.8 cm.
MAK–Austrian Museum of Applied Arts/
Contemporary Art, Vienna, B.I. 8770/55.
Published: Egger 1974, pl.50; Glück 1925, pl.42.

*R103 (cat.70)
*Umar, disguised as the surgeon Mazmahil,
arrives before the castle of Antali.*
Attributed to Shravana and Mahesa. Volume 11,
painting number 83, text number 84. 67.3 × 51.2 cm.
Freer Gallery of Art, Smithsonian Institution,
Washington, DC; Purchase F1960.15.
Published: Beach 1981, no.5b.

*R104 (cat.71)
*Umar, disguised as Mazmahil the surgeon,
practices quackery on the sorcerers of Antali.*
Attributed to Dasavanta, Shravana, and Mahesa.
Volume 11, painting number 84, text number 85.
68 × 52.4 cm. Brooklyn Museum of Art, Caroline
H. Polhemus Fund 24.49.
Published: Blair & Bloom 1994, fig.362; Poster *et al.*
1994, no.25; Chandra 1989, fig.4; Brand & Lowry
1985, no.12; Khandalavala 1983, fig.1; Welch 1963,
no.2B; Dimand n.d., pl.1; Comstock 1925, p.348.

*R105 (cat.72)
*Zardhang Khatni brings a ring to Maltas
the prison keeper.*
Attributed to Shravana, Mithra and Madhava
Khurd. Volume 11, painting number 86. 67.5 × 51.6 cm.
Freer Gallery of Art, Smithsonian Institution,
Washington, DC; Purchase F1949.18.
Published: Heeramaneck 1984, pl.139; Beach 1981,
no.5c; Ettinghausen 1961, pl.2.

*R106 (cat.73)
*Hamza burns Zarduhusht's chest of armor
and breaks the urn with his ashes.*
Attributed to Dasavanta and Mukhlis. Volume 11,
painting number 88, text number 89. 67.9 × 51.4 cm.
The David Collection, Copenhagen, 72/1998. Formerly
in the collection of the Art Institute of Chicago.
Published: von Folsach 2001, no.56; Sotheby's,
London, 15 April 1985, lot 478; Glück 1925, p.152,
pl.47; Culin 1924, p.142.

*R107 (cat.74)
Khurshedchihr frees Hamid.
Attributed here to Jagana and Shravana.

Volume 11, painting number 89. 67.3 × 50.8 cm.
Arthur M. Sackler Museum, Harvard University
Art Museums, Private Collection.
Published: Harle 1986, fig.299; Welch & Beach
1965, no.4; Welch 1959, fig.1.

R108
*A stranger named Hamraq-Tamraq orders Hamza's
son Hamid, who has just married Mihrdukht, the
daughter of the enemy Malik Tayhur, to follow
him. Hamid obeys and wanders into the wilderness,
while Mihrdukht searches for him.*
Volume 11, painting number 90, text number 91.
67.5 × 51.7 cm. MAK–Austrian Museum of Applied
Arts/Contemporary Art, Vienna, B.I. 8770/56.
Published: Egger 1974, pl.53; Glück 1925, pl.43.

*R109 (cat.75)
*To rid herself of four suitors, Mihrdukht promises
that she will have whoever is first to retrieve an
arrow, but escapes in a boat with an old man.*
Attributed to Banavari and Mah Muhammad.
Volume 11, painting number 91, text number 92.
67.1 × 51.2 cm. MAK–Austrian Museum of Applied
Arts/Contemporary Art, Vienna, B.I. 8770/32.
Published: Beach 1987, fig.41; Welch 1978, pl.2;
Egger 1974, pl.54; Glück 1925, pl.44.

*R110 (cat.76)
Mihrdukht shoots her bow at the ring.
Attributed to Jagana and Basavana. 67.8 × 52 cm.
Volume 11, painting number 95. Collection
of Howard Hodgkin.
Published: Filippi 1997, no.1; Topsfield &
Beach 1991, no.1; Barrett & Gray 1963, p.76;
Glück 1925, fig.37.

R111
Hamid arrives at Mihrdukht's palace.
Attributed to Mukhlis and Banavari. Volume 11,
painting number 96, text number 97. 68 × 52 cm.
MAK–Austrian Museum of Applied Arts/
Contemporary Art, Vienna, B.I. 8770/31.
Published: Egger 1974, pl.55; Glück 1925, pl.45.

VOLUME 12
*R112 (cat.77)
Prince Hamid thrashes Mahval.
Attributed to Shravana, Mukhlis, and Kesava Dasa.
Volume 12, painting number 2, text number 3.
68 × 52 cm. Fitzwilliam Museum, Cambridge,
PD. 204-1948.
Published: London 1982, no.235 (unillustrated).

115

116

117

122

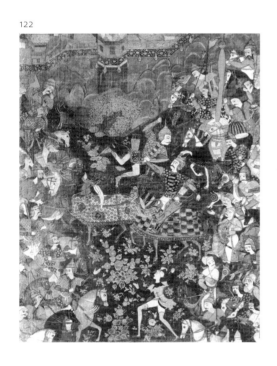

123

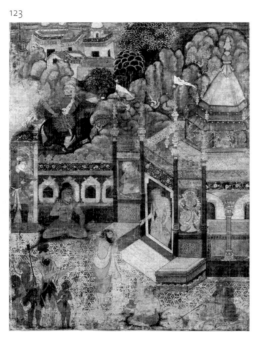

124

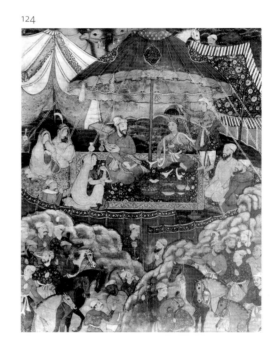

127

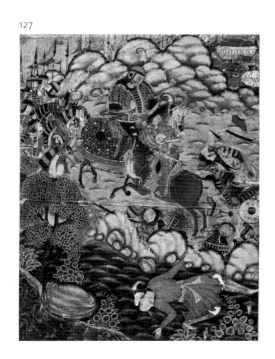

128

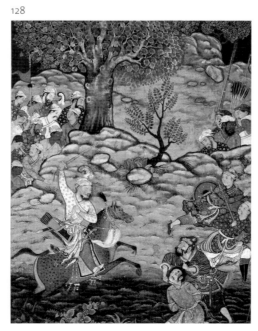

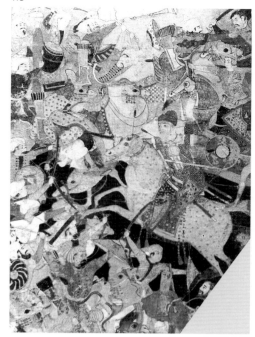

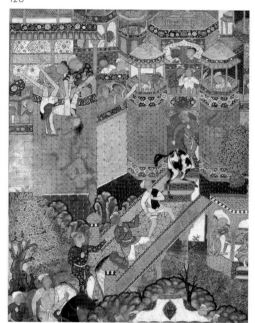

VOLUME 14

R113

Umar kills Zumurrud Shah.
Main figures attributed to Dasavanta. 70.5 × 53 cm.
Collection of Catherine and Ralph Benkaim.
Published: Palais Galliera, Paris, 5 December 1970,
lot 54; Blochet 1930, pl.xxix.

R114

*Umar brings Hamza the ring of Zumurrud Shah
as a sign of his death.*
Painting number 40, text number 41. 67.1 × 51.2 cm.
MAK–Austrian Museum of Applied
Arts/Contemporary Art, Vienna, B.I. 8770/51.
Published: Egger 1974, pl.61; Glück 1925, fig.44.

R115

*Hamza, Landhaur, Umar Ma'dikarb, and Sa'd die
in the battle at the Uhud Mountain near Medina,
and Hamza is buried properly by the Prophet himself.*
Text number 91. 68 × 52.1 cm. Victoria & Albert
Museum, London, 125-1882.
Published: *Hamza-nama*, pl.1; Glück 1925, fig.45.

PAINTINGS FROM UNIDENTIFIED VOLUMES
(Listed alphabetically by institution, then by
accession number.)

R116

*A mounted warrior is beseeched by a warrior
whose horse lies dead.*
67.5 × 51.9 cm. Curriculum Support Fund
Purchase 1999.19, Collection University of
Virginia Art Museum.
Published: Christie's, London, 15 October 1996, lot 31.

R117

An elephant attacks a fortress.
60.3 × 42.8 cm. Bharat Kala Bhavan, Varanasi 5401.
Published: *Marg*, 11, no.3, June 1958, cover.

R118

Battle scene.
66.4 × 58.5 cm. Bharat Kala Bhavan, Varanasi 54/143.
Published: Krishna 1981, color pl.4.

*R119 (cat.80)

The Prophet Elias rescues Nuruddahr from the sea.
Attributed to Basavana. Painting number 85, text
number 86. 67.4 × 51.3 cm. The British Museum,
London, presented by the Rev. Straton Campbell,
1925-9-29-01.
Published: Rogers 1993, fig.15; Okada 1992, fig.71;
Brend 1991, fig.150; Welch 1985, no.91; Losty 1982,

no.54; Bussagli 1976, fig.11; Pinder-Wilson *et al.* 1976,
no.11; Stchoukine 1929, pl.vi; Arnold 1928, frontispiece.

*R120 (cat.78)

Zumurrud Shah is hurled into the air by Malik Iraj.
Attributed to Kesava Dasa and Mithra. Painting
number 65, text number 66. 66.2 × 51.4 cm.
The British Museum, London, presented by the
Rev. Straton Campbell, 1925-9-29-02.
Published: Rogers 1993, fig.5; Seyller 1992, fig.12;
Pinder-Wilson *et al.* 1976, no.12.

*R121 (cat.84)

Farid observes a drunken scene.
Attributed to Shravana and Mah Muhammad.
Painting number 74. 67.8 × 51.4 cm.
The British Museum, London, given by P.C. Manuk
and Miss G.M. Coles through the National Art
Collections Fund, 1948-10-9-065.
Published: Titley 1983, fig.66.

R122

Battle scene.
68 × 52 cm. The State Hermitage Museum,
St. Petersburg, VP-1103.

R123

Temple scene.
70 × 53.3 cm. Collection of Howard Hodgkin.
Published: Filippi 1997, no.2; Chandra & Ehnbom
1976, no.24; McInerney 1982, no.1.

R124

*Hamza meets the three daughters of the
Byzantine emperor.*
61.5 × 46.8 cm. Keir Collection, London.
Published: Robinson, Grube, Meredith-Owens
& Skelton 1976, 4, pl.30; Glück 1925, fig.7.

*R125 (cat.82)

*Asad Karb launches a night attack on the camp
of Malik Iraj.*
Attributed to Basavana, Shravana, and Tara.
Painting number 11, text number 12. 68.2 × 51.5 cm.
The Metropolitan Museum of Art, New York,
Rogers Fund, 1918. (18.44.1)
Published: Kossak 1997, pl.8; New York 1970,
no.159; Grube 1966, fig.94; Lukens 1966, fig.59;
Comstock 1925, p.354; Glück 1925, fig.38.

R126

*Umar is taken prisoner on the march to
Abyssinia and is thrown over the wall, but is
saved miraculously with God's help.*

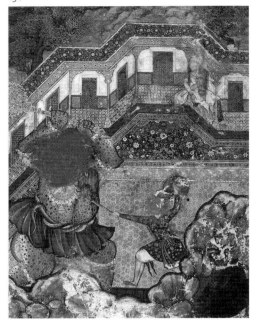

130

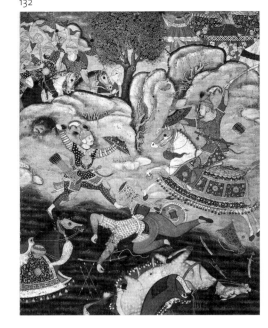

132

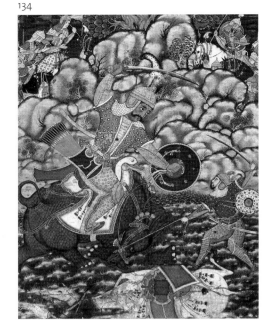

134

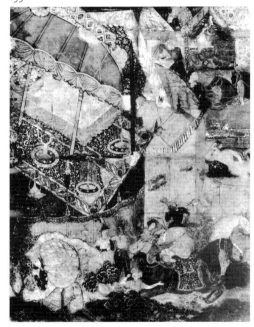

135

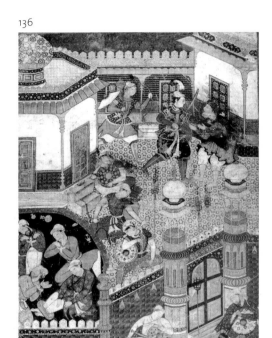

136

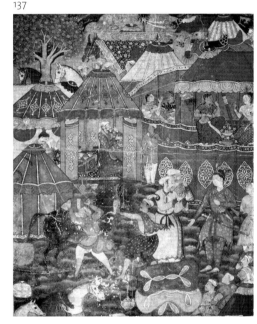

137

138

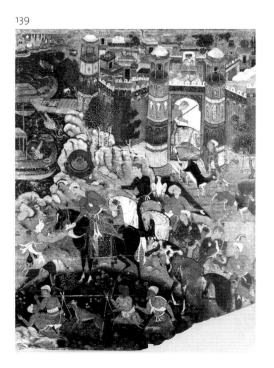

139

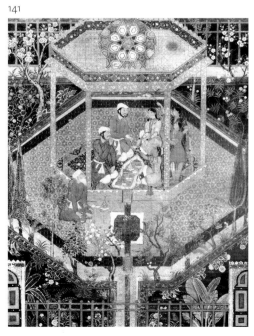

141

69.3 × 52.5 cm. MAK–Austrian Museum of Applied Arts/Contemporary Art, Vienna, B.I. 8770/3.
Published: Egger 1974, pl.7; Glück 1925, fig.27.

R127
Hamza's son Badi'uzzaman and Kharatish fight a duel in which the giant Zangi is wounded.
Text number 39. 68.5 × 51.1 cm. MAK–Austrian Museum of Applied Arts/Contemporary Art, Vienna, B.I. 8770/5.
Published: Egger 1974, pl.51; Glück 1925, fig.35.

R128
Hamza rushes in to help a man he believes to be Umar, but discovers the man is only an impostor.
Text number 98. 67.5 × 50 cm. MAK–Austrian Museum of Applied Arts/Contemporary Art, Vienna, B.I. 8770/7.
Published: Egger 1974, pl.60; Glück 1925, pl.50.

*R129 (cat.79)
Badi'uzzaman fights Iraj to a draw.
Attributed to Dasavanta, Shravana, and Madhava Khurd. Painting number 95, text number 96. 67.3 × 51.1 cm. MAK–Austrian Museum of Applied Arts/Contemporary Art, Vienna, B.I. 8770/9.
Published: Egger 1974, pl.59; Staude 1955b, fig.34; Glück 1925, pl.49.

R130
Hamza's son Alamshah Rustam frees Khurshed Khawari, the daughter of the King of the East, from a demon.
Text number 84 (?). 67 × 51.3 cm. MAK–Austrian Museum of Applied Arts/Contemporary Art, Vienna, B.I. 8770/10.
Published: Egger 1974, pl.9; Glück 1925, fig.14.

*R131 (cat.85)
Malik Iraj captures Umar and places him bound on a tall pillar; Umayya deceives Iraj, and frees Umar at night.
Attributed to Kesava Dasa and Tara. Painting number 88, text number 89. 68 × 51.1 cm. MAK–Austrian Museum of Applied Arts/Contemporary Art, Vienna, B.I. 8770/13.
Published: Egger 1974, pl.58; Egger 1969, pl.36; Staude 1955b, fig.35; Glück 1925, pl.48.

R132
Iraj fights against Hamza's friend Asad, who has beheaded Awjan and throws the head in Iraj's face.
Text number 80. 68 × 51.2 cm. MAK–Austrian Museum of Applied Arts/Contemporary Art,

Vienna, B.I. 8770/14.
Published: Egger 1974, pl.57; Glück 1925, pl.47.

*R133 (cat.86)
Umar slays a dragon with naphtha.
Attributed to Dasavanta and Tara. Painting number 75, text number 76. 61.9 × 51.2 cm. MAK–Austrian Museum of Applied Arts/Contemporary Art, Vienna, B.I. 8770/15.
Published: Beach 1992, fig.16; Egger 1974, pl.8; Egger 1969, pl.3; Glück 1925, pl.6.

R134
During the war against King Iraj, a sun-worshipper, a Muslim hero fights a duel against a gigantic black warrior astride a rhinoceros.
Text number 67. 67.7 × 51.2 cm. MAK–Austrian Museum of Applied Arts/Contemporary Art, Vienna, B.I. 8770/17.
Published: Egger 1974, pl.56; Glück 1925, pl.46.

R135
A camp is looted near the market of Zamud al-Nigar.
66.5 × 49.5 cm. National Museum, New Delhi 72.774.
Published: Daljeet 1999, p.26.

R136
A heroine forcibly enters a jail to liberate heroes.
68 × 52.6 cm. Arthur M. Sackler Gallery, Smithsonian Institution, Washington, DC; Purchase – Smithsonian Unrestricted Trust Funds, Smithsonian Collection Acquisition Program, and Dr. Arthur M. Sackler S1986.399.
Published: Lowry, Beach, Marefat & Thackston 1988, no.40.

R137
Malik Iraj flees his camp.
Text number 70. Folio 68.2 × 53 cm. The al-Sabah Collection, Dar al-Athar al-Islamiyyah, Kuwait National Museum, LNS 298 MS.
Published: Grube 1971, no.227; Blochet 1930, pl.xxx; Blochet 1928, pl.cxc.

R138
Hamza subdues some demons.
Text number 13. 68 × 52 cm. Sarabhai Foundation Museum, Ahmedabad.

R139
A prince bestows a gift outside a city gate.
Text number 16. 69.1 × 51.6 cm. Staatliches Museum für Völkerkunde, Munich, 77-11-312.

Published: Beach 1987, fig.56; von Bothmer 1982, color pl.12.

*R140 (cat.20)
Hamza converses with Hura the genie while a dragon approaches.
Attributed to Jagana and Basavana. Painting number 41, text number 42. 67.5 × 51.3 cm. Victoria & Albert Museum, London, I.S. 1505-1883.
Published: Stronge 2002, pl.3, p.16; Beach 1987, fig.43; Topsfield 1984, pl.6; *Hamza-nama*, pl.3; Pinder-Wilson *et al.* 1976, no.5; Glück 1925, fig.8.

R141
Prince Alamshah Rustam falls in love with Mihrafroz and a feast is given in a garden pavilion.
Text number 59. 67.5 × 51 cm. Victoria & Albert Museum, London, I.S. 1506-1883.
Published: Verma 1994, pl.ii; *Hamza-nama*, pl.4; Glück 1925, fig.18; Clarke 1921, pl.5.

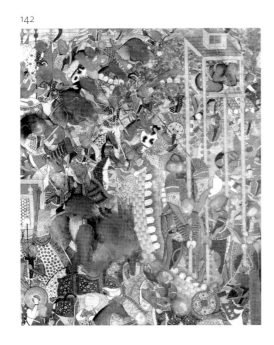

142

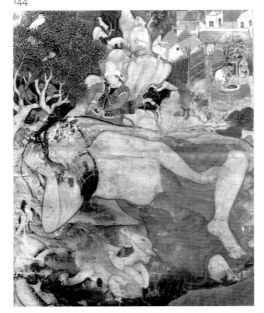

144

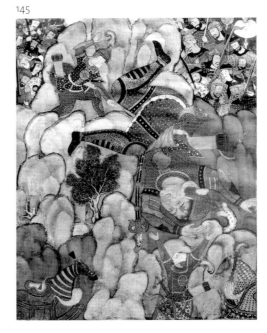

145

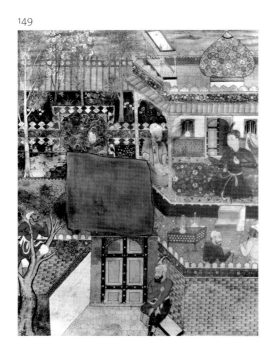

149

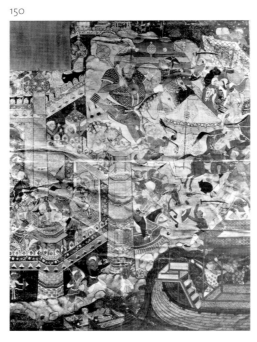

150

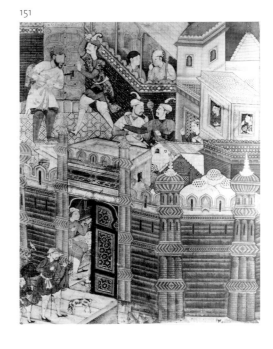

151

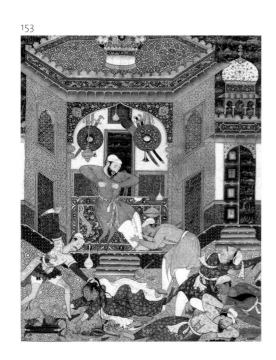

153

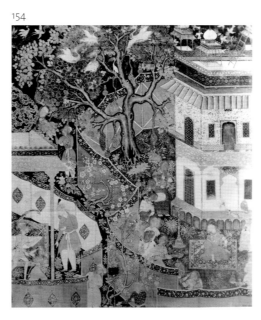

154

155

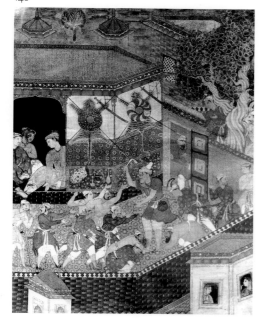

148

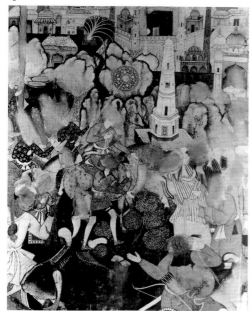

152

R142
Umar and his friends set Hamza free, but pieces of Hamza's skin are torn off with the camel's skin in which he had been hidden.
Text number 25. 68.9 × 53.7 cm. Victoria & Albert Museum, London, I.S. 1507-1883.
Published: *Hamza-nama*, pl.5; Glück 1925, fig.13.

***R143 (cat.22)**
At the birth of the Prophet, temple idols fall and the sea dries up.
Attributed to Mahesa and Mukhlis. Painting number 96, text number 97. 66.5 × 51.3 cm. Victoria & Albert Museum, London, I.S. 1509-1883.
Published: Stronge 2002, pl.15, p.31; *Hamza-nama*, pl.7; Staude 1955a, fig.1; Clarke 1921, pl.1.

R144
Hamza's scout Kawsadi searches for his lost steed, but finds it being devoured by a lion, while Zumurrud Shah sleeps nearby.
Text number 15. 68 × 52.3 cm. Victoria & Albert Museum, London, I.S. 1510-1883.
Published: *Hamza-nama*, pl.8; Glück 1925, fig.41; Clarke 1921, pl.11.

R145
Hashim and Haris, Hamza's sons, deliver Hamza's camp from unbelievers.
Text number 9. 69 × 52.2 cm. Victoria & Albert Museum, London, I.S. 1511-1883.
Published: Stronge 2002, pl.10, p.25; *Hamza-nama*, pl.9; Glück 1925, fig.23; Clarke 1921, pl.10.

***R146 (cat.81)**
The witch Anqarut ties Malik Iraj to a tree, transforms herself into a young maiden, and tries to seduce him.
Attributed to Basavana and Mukhlis. Painting number 67 (a mistake for 87), text number 88. 67.4 × 51.7 cm. Victoria & Albert Museum, London, I.S. 1512-1883.
Published: Stronge 2002, pl.13, p.27; *Hamza-nama*, pl.10; Wilkinson 1948, pl.2; Glück 1925, fig.40; Binyon & Arnold 1921, pl.2; Clarke 1921, pl.4.

***R147 (cat.29)**
A hero kills a demoness.
Attributed to Kesava Dasa. Painting number 9, text number 10. 67 × 50.5 cm. Victoria & Albert Museum, London, I.S. 1513-1883.
Published: Stronge 2002, pl.9, p.24; Guy & Swallow 1990, no.46; *Hamza-nama*, pl.11; Glück 1925, fig.9; Clarke 1921, pl.9.

R148
In search of Hamza, Umar arrives at a house where prisoners are being beaten with the foot of a donkey; Umar sets his friends free and finds Hamza.
Attributed to Shravana. Painting number 23, text number 24. 66.8 × 51.6 cm. Victoria & Albert Museum, London, I.S. 1514-1883.
Published: Stronge 2002, detail pl.16, p.32; *Hamza-nama*, pl.12; Verma 1978, pl.1; Glück 1925, fig.33; Clarke 1921, pl.8.

R149
In Khwaja Ashob's garden, Badi'uzzaman abandons himself to love and is overheard by the spy Kashdum.
Painting number 10, text number 11. 66.6 × 51.4 cm. Victoria & Albert Museum, London, I.S. 1515-1883.
Published: *Hamza-nama*, pl.13; Glück 1925, fig.31.

R150
In Hamza's absence, fire-worshippers attack his camp, but their attempt to land a fleet at night is repelled.
Attributed to Mah Muhammad.
Painting number 2. 67.5 × 50.5 cm.
Victoria & Albert Museum, London, I.S. 1517-1883.
Published: *Hamza-nama*, pl.15; Glück 1925, fig.32.

R151
The fight with the fire-worshippers continues. Disguised as a bird-seller, the spy Thayir meets the chained Fazlanshah.
Attributed to Mukhlis. Text number 30. 66.3 × 51 cm. Victoria & Albert Museum, London, I.S. 1518-1883.
Published: Stronge 2002, pl.18, p.33 and detail pl.19, p.32; *Hamza-nama*, pl.16; Glück 1925, fig.34.

R152
Hamza goes to Mecca with a great entourage and greets his father.
Painting number 43, text number 44. 66.4 × 50.5 cm. Victoria & Albert Museum, London, I.S. 2509-1883.
Published: *Hamza-nama*, pl.19; Glück 1925, fig.4; Clarke 1921, pl.2.

R153
Hamza, found in prison, rends his bindings, and Umar slays the traitorous woman responsible for Hamza's imprisonment.
Painting number 43, text number 44. 66.9 × 51.2 cm. MAK–Austrian Museum of Applied Arts/Contemporary Art, Vienna, B.I. 8770/27.
Published: Egger 1974, pl.33; Glück 1925, pl.27.

156

157

158

160

161

162

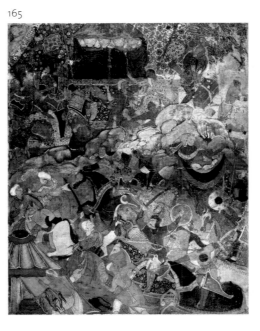

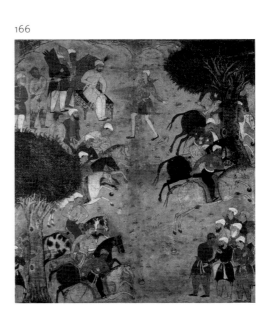

164

165

166

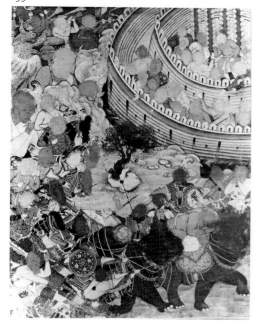

159

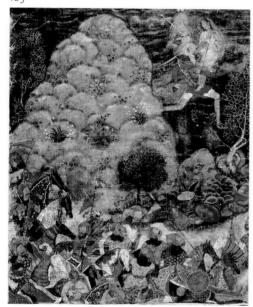

163

R154
With Hamza's support, Rustam and Mihrafroz prepare for their wedding feast.
Painting number 70, text number 71. 69.2 × 57.7 cm.
Victoria & Albert Museum, London, I.S. 1519-1883.
Published: Stronge 2002, pl.14, p.29; *Hamza-nama*, pl.17; Glück 1925, fig.21; Clarke 1921, pl.6.

R155
Sa'id, who has fallen in love with Harum's sister, sets out for Barda' in order to win her over by means of a valiant deed and fights.
Text number 75. 66.9 × 51 cm. Victoria & Albert Museum, London, I.S. 2512-1883.
Published: *Hamza-nama*, pl.22; Staude 1955a, fig.3; Glück 1925, fig.22.

R156
Sa'd, Hamza's strong-armed angel, dashes enemies to the ground and leads the army to Barda', where Hamza and the heroes recover their sight.
Painting number 23, text number 24. 66.1 × 51.9 cm.
Victoria & Albert Museum, London, I.S. 2510-1883.
Published: *Hamza-nama*, pl.20; Glück 1925, fig.24; Clarke 1921, pl.3.

R157
Umar is received by Zumurrud Shah and obtains a beautiful maiden. He also spies upon the enemy army.
Painting number 26, text number 27. 67.9 × 50.3 cm.
Victoria & Albert Museum, London, I.S. 2513-1883.
Published: *Hamza-nama*, pl.23; Glück 1925, fig.25.

R158
Hamza's army battles Girang's men and kill a giant.
Painting number 68, text number 69. 67.3 × 51 cm.
Victoria & Albert Museum, London, I.S. 2514-1883.
Published: *Hamza-nama*, pl.24.

R159
Hamza and Muqbil are captured, put into irons, and led into the fortress of Aqqa.
Attributed to Mukhlis. Text number 7. 67 × 52 cm.
Victoria & Albert Museum, London, I.S. 2515-1883.
Published: *Hamza-nama*, pl.25; Glück 1925, fig.12.

R160
Unidentified scene with figures in a tent compound.
Painting number 30, text number 31. 65.2 × 51.8 cm.
Victoria & Albert Museum, London, I.M. 4-1921.
Published: Stronge 2002, pl.6, p.20 and detail pl.17, p.32; *Hamza-nama*, pl.2; Glück, fig.43.

R161
A group of men watch two youths fight beneath a large central tree.
Attributed to Mah Muhammad. 68.7 × 52.9 cm.
Victoria & Albert Museum, London, I.S. 7-1949.

R162
Hamza wrestles with Marzban Kushtigir before Anoshirvan.
Location unknown. Formerly in the Museum für Kunsthandwerk (Kunstgewerbemuseum), Leipzig.
Published: Comstock 1925, p.351; Glück 1925, fig.10.

R163
With the help of Khwaja Umar, Gawhar Malik rescues Gulrukhsar from the clutches of the infidels.
Text number 30. 66.5 × 51.5 cm. Private collection.

R164
Landhaur battles the white dev.
Text number 51. 68.5 × 52.7 cm. Private collection.

R165
The army of Iskandar Miklan Aad takes refuge behind a mountain during a battle with Karb.
Text number 56. 67.5 × 54.3 cm. Private collection.

R166
A prince watches a horseman gallop across a hillside.
52.7 × 47.3 cm. Location unknown.
Published: Sotheby's, London, 22–23 May 1986, lot 134.

R167 (not illustrated)
Subject unknown.
Location unknown. Formerly in the State Museum, Hyderabad, P.1384.

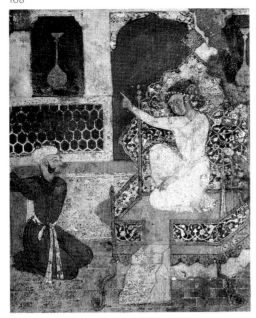

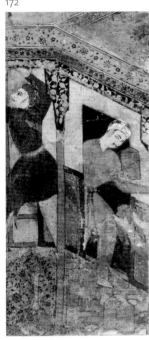

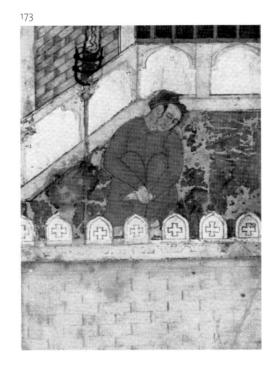

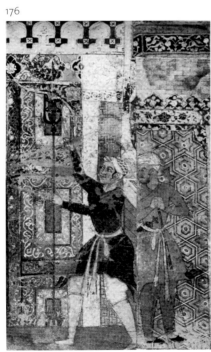

171

175

179

FRAGMENTS

R168
Fragment with an enthroned figure.
20.5 × 15.6 cm. The Art Complex Museum,
Duxbury, Massachusetts, PIM-20.

R169
Fragment of a landscape.
22.2 × 15.2 cm. The Metropolitan Museum of Art,
New York, Rogers Fund, 1918 (18.76.2).

R170
An Indian idol is enshrined beside a domed building.
31.6 × 49.3 cm. Chhatrapati Shivaji Maharaj Vastu
Sangrahalaya (formerly Prince of Wales Museum
of Western India), Mumbai, 61.1.

R171
Unidentified fragment.
21.1 × 6.3 cm. Victoria & Albert Museum, London,
I.S. 170-1949,b.

R172
Unidentified fragment.
20.4 × 9 cm. Victoria & Albert Museum, London,
I.S. 170-1949,a.

R173
A guard dozes at night in a courtyard.
16.3 × 11.5 cm. Location unknown.
Published: Sotheby's, London, 15 July 1970, lot 10.

R174
A blossoming tree grows beside a terrace.
21.9 × 12.7 cm. Location unknown.
Published: Sotheby's, London, 4 July 1975, lot 89.

R175
*A woman holds the feet of a man sleeping
in a pavilion.*
25.5 × 19.1 cm. Location unknown.
Published: Sotheby's, London, 4 July 1975, lot 88.

R176
*A torchbearer stands before a wall with scissors
in hand.*
23.6 × 14.2 cm. Location unknown.
Published: Sotheby's, London, 12 April 1976, lot 65.

R177
A youth stands behind a fence and beside a wall.
16 × 9.7 cm. Location unknown.
Published: Sotheby's, London, 2 May 1977, lot 96.

R178
Five attendants stand in a row.
20.4 × 17.1 cm. Location unknown.
Published: Christie's, London, 1 April 1982, lot 207;
Sotheby's, London, 12 April 1976, lot 64.

R179
*A musician seated on a high pole platform
plays above an encampment.*
36.2 × 50.6 cm. Location unknown.
Published: Christie's, London, 18 October 1994,
lot 6.

The production of the Mughal *Hamzanama* manuscript was an extraordinarily ambitious undertaking considering the quantity and size of the folios. An estimated 1,400 illustrations measuring approximately 68.5 centimeters by 53.5 centimeters (27 by 21 inches), excluding margins, were produced over a fifteen-year period from 1557 to 1572. The illustrations are also distinguished from the mainstream of Iranian and Mughal manuscripts in that they are painted on fabric rather than paper.

A brief technical summary of the folios in the Victoria and Albert Museum, London, was published by C.S. Clarke in 1921:

> Each painting is executed in tempera colours and gold on a page of cotton fabric, 28¼ inches long and 22 inches wide, the surface of which has been

previously treated with a slip, or plaster, of lime and gum arabic, and, when dry, polished with a smooth agate. The manuscript, which appears on the reverse side of the page, is written on coarse, thin paper of poor quality, previously pasted firmly upon the fabric.[1]

This description of the folios has been accepted and repeated numerous times since in publications and in private correspondence. A technical examination, undertaken recently, of the four folios in the Brooklyn Museum of Art,[2] and a survey of the sixty-one folios at the MAK–Austrian Museum of Applied Arts/Contemporary Art in Vienna has revealed additional information on the structure, technique and method of production of the folios. The folios examined represent only a fraction of the presumed total

of 1,400, and only about one third of those extant, and absolute conclusions are impossible. Nonetheless, this new information provides a clearer picture of folio construction and some of the materials found on the folios provide clues that suggest their provenance and past history (see below).

Only one folio from an earlier volume, which may not be representative, has been examined extensively, but it provides important evidence for a change in format during the production of the *Hamzanama*, as outlined below. Most of the folios examined are believed to be from a later volume or volumes and reveal a complexity of construction far greater than previously described by Clarke and others.[3] They consist of a main support and the remnants of a margin framework that was applied to the painted side of that support (fig.31).

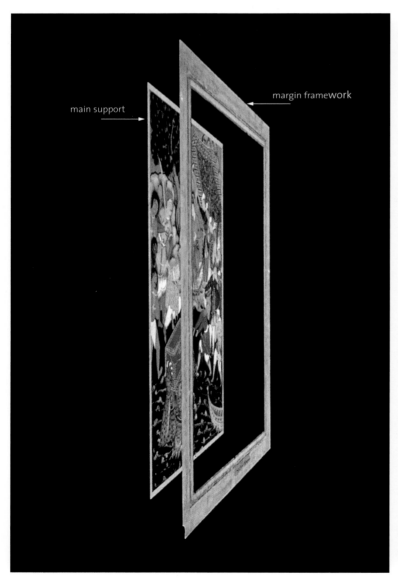

FIG 31

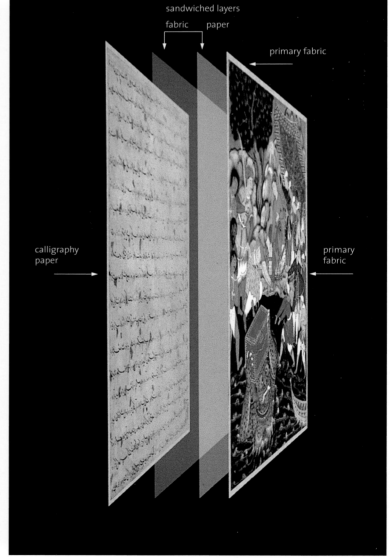

FIG 32

THE MAIN SUPPORT

The dimensions of the main support are usually 68.6 by 53.3 centimeters (27 by 21 inches), with variations in either or both directions of up to 3.8 centimeters (1½ inches). On the recto, opaque watercolors and gold paint are applied to an unpieced, plain-weave cotton fabric. The polished ground described by Clarke was not clearly detected on the folios examined. Extensive underdrawing in black and sometimes red is discernible throughout the image, in areas of paint loss as well as by examination under infrared. On the verso, nineteen lines of text in *nasta'liq* script are written in carbon ink on a sheet of paper. The calligraphy overlays decorative gold flecks applied to the paper. The paper is not pieced, but is a continuous sheet. It is difficult to determine if the paper is laid or wove due to the strong fabric weave

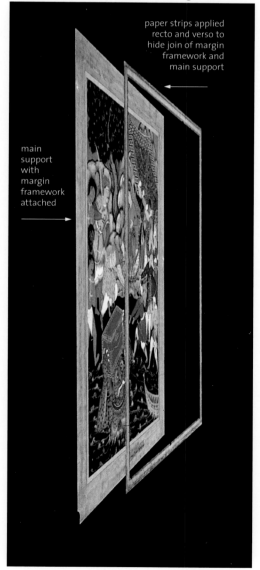

paper strips applied recto and verso to hide join of margin framework and main support

main support with margin framework attached

FIG 33

imprinted in its surface. Analysis of the paper fibers in polarized light is not conclusive, but the fibers appear to be linen or possibly hemp.[4] The paper is highly polished and micro-chemical tests indicate the presence of a starch coating.[5] Horizontal lines scored in the paper corresponding to the lines of calligraphy are faintly visible in raking light and probably served to guide the calligrapher's hand.

Examination using the microscope revealed two additional layers of paper and fabric in the main support, sandwiched between the fabric recto and paper verso (fig.32). Rather than the two layers previously described, the main support thus consists of four layers pasted together: the cotton fabric upon which the image is painted, an intermediate sheet of paper, another sheet of cotton fabric, and finally the paper upon which the calligraphy is written. There are differences in the two cotton fabrics.[6] Examination with the microscope reveals that the primary fabric on which the illustration is painted is a tight weave, without spacing between the threads, while the sandwiched fabric is a more open weave with clearly discernible spaces between the warp and weft threads. A thread count of the two fabrics was undertaken on several of the folios in the Victoria and Albert Museum. It showed the primary fabric has 29–32 horizontal threads per centimeter on the vertical axis and 27–32 vertical threads per centimeter on the horizontal axis; the sandwiched fabric has 25 horizontal threads per centimeter and 22–24 vertical threads per centimeter. This four-layer composite structure for the main support was found consistently in folios thought to be from later volumes.

THE MARGINS

The margins attached to the main support are also complex in structure. They are applied to the main support like a window frame, formed from a single piece of cotton fabric from which the center has been cut away. Both transmitted light and examination under the microscope confirm this observation. The fabric is cotton and appears to have the same tight weave as the primary fabric of the main support.

Prior to attachment to the main support, this fabric frame was originally covered recto and verso with layers of paper, the outermost being extensively decorated. Usually the paper on the recto was colorfully toned or dyed while that on the verso was decorated with intricate marbling. Gold flecks of varying size decorated either or both sides. Areas of the margin framework verso that are normally covered by attachment to the main support but have been revealed through damage are also marbled, confirming that the entire framework was decorated

Figs 31–33, 35 show *Arghan Dev brings the chest of armor to Hamza* (cat.48) Mughal, *circa* 1570. 67.5 × 52.5 cm Brooklyn Museum of Art, Museum Collection Fund, 24.47.

Fig.34 shows a detail from *Zumurrud Shah reaches the foot of a huge mountain ...* (cat.39) Mughal, *circa* 1570. 67.9 × 51.5 cm. Brooklyn Museum of Art, Museum Collection Fund, 24.48.

Figs 36, 37 show details from *The ayyars, led by Songhur Balkhi and Lulu the spy, slit the throats of the prison guards and free Sa'id Farrukh-Nizhad* (cat.65). Mughal, *circa* 1570. 68.4 × 52.1 cm. Brooklyn Museum of Art, Museum Collection Fund, 24.46.

Fig.31 A computer-generated image showing the main support and the margin framework.

Fig.32 A computer-generated cross-section of the four layers of the main support (the page of calligraphy has been turned to face inwards in the illustration for purposes of identification only).

Fig.33 A computer-generated image showing the paper strips prior to attachment to the margin framework and the main support (in reality the strips were applied not as a frame, as shown, but as individual strips which overlap at the corners).

Fig.34
Detail showing a section of the paper strip that overlays the main support and the margin framework. Note the incised lines around the caption. **A** inner edge of paper strip overlapping main support and decorated with a painted band and ruled lines.

B undecorated portion of paper strip. **C** outer edge of paper strip overlapping margin framework and decorated with a painted band and ruled lines. **D** excision of the decorative paper around the caption and at inner margin edge.

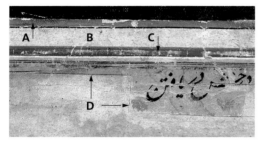

prior to attachment to the main support. With few exceptions, little is left of this original paper and gold decoration on the margins, but the residual fragments found are sufficient evidence of the once bright colors and decorative patterns. On many margins, a caption written in black ink calligraphy is found on the recto, at the bottom near the center. The caption refers to the painting immediately above.

The margins on the extant folios have all been trimmed, some extensively. The average width of most margins is approximately 5–6 centimeters (2–2³⁄₈ inches). The average dimension of the folios with margins is approximately 73.7–78.7 centimeters (29–31 inches) by 61–63.5 centimeters (24–25 inches). Two folios in the Metropolitan Museum of Art have margins of slightly greater width, approximately 7.6–8.9 centimeters (3–3½ inches), for an overall folio size of 82.2 by 64.5 centimeters (32³⁄₈ by 25³⁄₈ inches).

METHOD OF ATTACHMENT

The decorated margin framework was always attached to the painted side of the main support. The inner edge of the frame window overlaps the main support, usually by 0.64–0.95 centimeter (¼–³⁄₈ inch) on all sides. To disguise this point of attachment on the recto and verso, narrow paper strips approximately 1.4 centimeters (⁹⁄₁₆ inch) in width were applied to cover and reinforce the join between the main support and the margins (fig.33). The strips act as a bridge, one edge attached to the main support and the other edge attached to the margin. Unlike the window margin, these narrow paper

strips are pieced and usually overlap at the corners.

The strips vary in color from recto to verso and with each folio. Buff, madder, and blue-green toned papers have been found. They were decorated with painted bands and ruled lines following their application. This decoration follows a consistent pattern regardless of the colors used (fig.34). Beginning from the inner edge of the paper strip, one finds a band 0.3 centimeter (¹⁄₈ inch) wide painted red, white, light blue, dark blue or green; then an unpainted portion approximately 0.8 centimeter (⁵⁄₁₆ inch) wide; then a second painted band 0.3 centimeter (¹⁄₈ inch) wide, usually different in color from the first. Narrow, ruled lines in black, red, or white are drawn on either side of the painted bands. These extend slightly beyond the strips on to the main support and the decorated paper of the margins, confirming that the paper strips were decorated after they were applied to the folio. Additional ruled lines parallel to the outer edge of the paper strips also decorate the margins.

THE STRUCTURE OF A FOLIO FROM AN EARLIER VOLUME

As mentioned above, only one folio from an earlier volume has been extensively examined and it may not necessarily represent the structure of all folios in such volumes.[7] Nonetheless, the structure of this folio compared to that of folios in later volumes documents a format change during production.

The main support of the folio examined, MAK, Vienna, B.I. 8770/4, consists of two paintings on cotton fabric attached back-to-back. Two layers of paper are sandwiched between the paintings on fabric, and thus the main support of this folio also consists of four layers, though the order of the layers is different: painting on fabric / sheet of paper / sheet of paper / painting on fabric. Calligraphy and painting intermingle on both sides of the folio. The calligraphy consists of three or four lines of script in iron-gall ink written on sections of paper that are pasted on to the painted illustrations along the top and bottom. Faint horizontal lines are scored into these papers parallel to the baseline of the calligraphy, suggesting that they are guidelines placed for the calligrapher. Small prick holes are found on the left side at the beginning of each line. The papers are decorated with gold specks and sprinkles.[8] The calligraphy and the gold were applied after the paper was pasted to the finished painting; this order of production is confirmed by microscopic examination, which reveals bits of the gold and the ink script extending off the calligraphy paper and on to the main support.[9] The original margin framework, almost completely trimmed away, is made from a single piece of cotton fabric from which the center has been cut and removed.

CONDITION OF THE FOLIOS

All the folios examined suffer some degree of paint loss from the main support and extensive abrasion and cutting of the margins. Cockling and undulation of the folios are an inherent condition resulting from the laminate structure. In general, the condition of the folios tends to correspond with their more recent places of origin. For example, those folios acquired in the nineteenth century in India, particularly from Srinagar in Kashmir, are generally in poor condition. Most of these are in the collection of the Victoria and Albert Museum. The margins are usually almost completely trimmed and many of the human and animal faces have been obliterated and in some cases were later covered over with an opaque paint layer. There is cleavage between the laminates in some of these folios, and some are missing portions of the main support. The folios acquired from Iranian sources tend to be in better condition, although there are exceptions that include obliteration of faces, retouching, paint loss and interlayer cleavage in the support. These folios include those in the collection of the MAK that were purchased from the Persian Pavilion at the World's Fair in Vienna in 1873, and those bought from the estate of Reiza [sic] Khan Monif that were sold through Anderson Gallery auctions, New York, in November and December 1923 and February 1924.

A consistent feature found on the folios in Vienna and on the portion of folios derived from the Monif collection which were examined is the incising of the margins recto and verso with a sharp instrument in order to remove the decorative surface papers. The incisions usually run parallel to, and just beyond, the ruled lines drawn on the margins, thus eradicating all margin decoration outside the ruled lines except for the area of the caption, around which a small portion of the decorative paper has been spared (fig.34). Another consistent feature is the application of a nineteenth-century tan wove paper over the abraded margins recto and verso. In some cases the tan paper follows the incised lines, leaving the decorative paper strips and caption exposed, while in others it extends up to the main support, covering the margins and paper strips entirely. The incising of the margins, the eradication of decorative paper, and the application of the tan paper indicate that the folios, now in separate collections, were together and underwent the same treatment prior to 1873 (when the Vienna folios were acquired). It is possible that this treatment of the margins occurred in the course of binding the folios into an album. Written sources indicate that both the Vienna folios and those from the Monif estate were bound, probably in a European

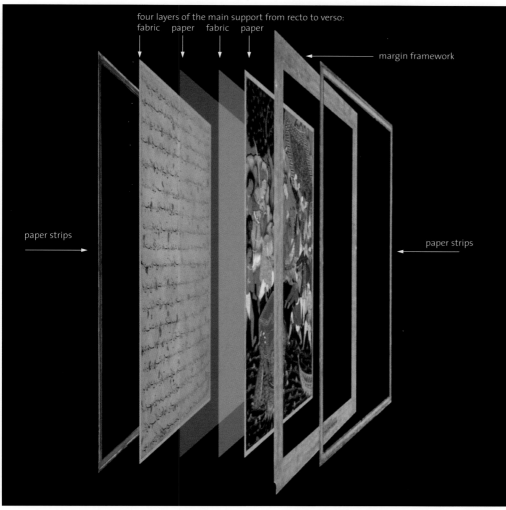

four layers of the main support from recto to verso:
fabric paper fabric paper

margin framework

paper strips

paper strips

FIG 35

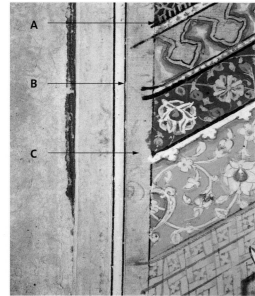

FIG 36

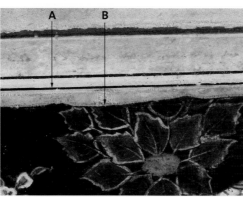

FIG 37

Fig.35
A computer-generated cross-section showing the multiple layers of the folio. Little remains of the decorative papers that once covered the recto and verso of the margin framework.

Fig.36
Detail showing the misalignment of the margin framework and of the paper strip to the painted edge of the main support.
A finished edge of painting.
B margin framework and paper strip out of alignment with the finished edge of the painting, exposing an unpainted section of the main support.
C exposed fabric of main support meant to be covered by margin framework and paper strip: note the underdrawing.

Fig.37
Detail showing the misalignment of the decorative paper strip, exposing the edge of the margin framework that is normally covered.
A inner edge of paper strip.
B inner edge of margin framework attached to main support.

style, during the early part of the nineteenth century.[10] While there is little doubt that the bindings were not original, the evidence for provenance provided by the tan paper underscores the importance of thorough documentation prior to removing any materials.

HISTORICAL DESCRIPTIONS OF STRUCTURE

It is worth comparing the multi-component structure found in the examined folios from later volumes (fig.35) with historical descriptions of the folios. Mir Ala al-Dawla's description of the *Hamzanama* written during its production suggests that the extant folios were once larger, and that they were square in shape:

> His Majesty has conceived of this wondrous book on the following lines. The amazing descriptions and the strange events of that story are being drawn on the sheets for illustrations in minuscule detail and not the subtlest requirement of the art of painting goes unfulfilled. That story will be completed in twelve volumes, each volume consisting of one hundred leaves (*waraq*); each leaf being one 'yard' (*zar'*) by one 'yard,' containing two large compositions (*majlis-i taṣwīr*).'[11]

An average extant folio would require an additional 7.6 centimeters (3 inches) on the top and bottom and 14 centimeters (5½ inches) on the sides to

achieve this square dimension. Mir Ala al-Dawla also provides insights into the production of the folios:

It is now seven years that the Mīr [Sayyid Ali] has been busy in the royal bureau of books (kitāb khāna-i ʿāli), as commanded by His Majesty (ḥaẓrat-i aʿlā), in the decoration and painting of the large compositions (taṣwīr-i majālis) of the story of Amīr Hamza (qiṣṣa-i amīr ḥamza), and strives to finish that wondrous book Although, during the aforesaid period, thirty painters, equal to Mānī and Bihzād, have constantly been devoted to the task, no more than four volumes have been completed. ... At present, the Mīr having obtained permission to go on Ḥaj, the task of preparing the afore-mentioned book has been assigned to the matchless master Khwāja ʿAbd al-Ṣamad, the painter from Shiraz; the Khwāja has greatly endeavored to bring the work to completion and has also notably reduced the expenditure.[12]

It took seven years to produce the first four volumes, but volumes 5–14 were completed in only eight years.[13] Thus the rate of production more than doubled under Abdul-Samad. One obvious explanation for the increased production rate would be the change in format from folios with paintings on both sides and only a few lines of text to those with an illustration on one side only and a full page of text on the other. It would have been quicker and cheaper to substitute calligraphy for the illustration on one side of the folio, thereby halving the number of illustrations required for the same number of folios. Whether the change in format occurred at the time that Abdul-Samad took over the project cannot be proved. The multiple layers of the main support and of the margin framework suggest, however, that a certain form of mass production was possible. By division of labor, the preparation and possibly the completion of each component (margins, illustration and calligraphy) could proceed simultaneously. Certainly the highly decorated margin framework was completed prior to its attachment to the main support. It is also likely that the components of the main support (the illustration on fabric and the calligraphy on paper) were completed separately prior to attachment. The two interior layers of paper and fabric would have provided support to either or both of these outer layers during production. A folio in the MAK, Vienna, B.I. 8770/18, provides evidence that the materials used in the main support were indeed mass-produced. It has all four laminates typical of the main support, including a paper verso prepared in the same manner as all the other calligraphy papers – that is, decorated with gold and scored with guidelines for the calligrapher – yet there is no evidence

of text and the folio falls at the end of a volume.[14]

Simultaneous work on the main support was not possible with the earlier folios, thought to have been produced under Mir Sayyid Ali and described above. Because painted illustrations and text intermingle on both recto and verso, the calligrapher had to wait until the painting was completed and the calligraphy paper applied to the surface of the painting in order to begin his writing.

Abdul-Samad 'greatly endeavored to bring the work [of the manuscript] to completion,' and assembly of the various layers of each folio was sometimes less than careful. Examples of haste found with some frequency include the misalignment of the window margin to the painted image and the misalignment of the decorative paper strips intended to cover the joint between margin framework and main support (figs 36, 37).

Muhammad Arif Qandahari, writing at a slightly later date than Mir Ala al-Dawla, also gives a brief description of the folios:

The emperor is a designer of marvels since he has ordered that of the story of Amīr Ḥamza, which has 360 tales, each tale should be illustrated with large compositions. [...] The size (qatʿ) of that book is one 'meter' and a half (yak gaz-o-nīm-i sharʿī); its paper is imbued with colours; its borders have floral designs (jul-kārī); and between two sheets of paper a sheet of chautār cloth has been placed to make it more permanent. All the pages are illustrated and gilded.[15]

Again, the shape of the page is described as a square and, since the dimensions of the main support have evidently not changed, the 'one meter and a half' may indicate the extent to which the margins of the manuscript have been trimmed. There are only two places in the structure of these folios where fabric is found between two sheets of paper. One is in the main support, where the loose-weave fabric is found sandwiched between two sheets of paper (fig.32). A 'chautār cloth' means a strong, cheap or utilitarian cloth and seems an apt description of this open-weave and probably cheaper fabric. The fabric of the margin framework that was once sandwiched between decorative papers is more tightly woven and of the same high quality as the support for the illustration. Both fabrics, in the main support and the margins, do serve to make these components more permanent.

Many unanswered questions remain regarding the folios of the Hamzanama manuscript. Why were they so many and so large, and their structure so complex? Were they ever bound? And how were they used at

Akbar's court?[16] A technical examination of all extant folios may offer more answers or clues. Certainly such an examination of the structure of all the folios from the earlier volumes, which was not possible here, might allow a comparison that would provide insight especially into changes in production methods. This brief description of only some of the folios should serve as a basis for future technical research.

A NOTE ON THE PALETTE OF THE HAMZANAMA PAINTINGS
A recent collaborative research project between the Paper Conservation department at the Victoria and Albert Museum and the Christopher Ingold Laboratories at University College London has conclusively identified the palette used in three paintings from the Hamzanama for the first time.[1]

Raman spectroscopy – a non-destructive and non-invasive method of pigment analysis in which the light scattering produced by lasers helps identify paint films – was used.[2] Between thirty and forty sites were selected from each painting in order to provide as complete a representation of the palette as possible. The speed and ease with which this number of readings could be taken compared favorably with previously employed analytical techniques such as optical microscopy, and the Raman method offered greater specificity than ultra-violet examination.

The palette was found to be extensive – including two blue pigments, indigo and lazurite (ultramarine), and two red pigments, vermilion and red lead, as well as ochre, orpiment, verdigris and white lead – and was consistent across all three folios. Both individual pigments and pigments in admixture, for shading and to expand the palette, were discovered. Areas of over-paint on the faces of some figures, for example, were found to be comprised of a mixture of red lead and orpiment. A number of the pigments found are light-sensitive or prone to degradation. Large areas of greyish-blue pigment (indigo) were found to have been overlaid originally with a thin layer of yellow orpiment (arsenic sulphide) to give a variety of shades of green. This technique was used to paint foliage in several of the Hamzanama folios in the Victoria and Albert Museum's collection, including cat.29. A small unaltered portion of pigment along the left-hand edge indicated that the grey-coloured foliage had once been a pale green, but ageing had rendering the orpiment colourless. This phenomenon has been noted previously in Dutch Old Master paintings,[3] but has not been recorded in relation to paintings in a water-based medium.

Mike Wheeler

'A TREASURE TROVE': THE *HAMZANAMA* AND THE AUSTRIAN MUSEUM OF ART AND INDUSTRY 1873–1900

Rainald Franz

On 1 January 1874, the readers of volume 100 of the *Mittheilungen des k.k. Oesterreich. Museums für Kunst und Industrie*, the monthly magazine published by the Austrian Museum of Art and Industry (today the MAK–Austrian Museum of Applied Arts) in Vienna from 1865, found an article under the title 'Purchases at the World Fair.'[1] The article enumerated the items which had been bought by the Museum and its representatives during the Vienna World Fair, which had been held in the capital of the Austro-Hungarian empire from 1 May until 1 November 1873. In his introduction, the author of the article, Bruno Bucher, who had been the editor of the *Mittheilungen* since 1870, stressed that the purchases had been made both to fill gaps in the Museum's collections and to secure objects that were of absolute importance due to their optimum technical or aesthetic quality. He also emphasized the educational motives that had lain behind various of the acquisitions. He then listed the important objects, all numbered in groups according to the materials of which they were made. Group number fourteen dealt with the purchases that had been made for the Museum's library. Bucher wrote that the library, which had the primary purpose of buying recent publications in the fields of fine and applied art and making them accessible to artists and industrialists as soon as possible, had not had many chances to buy books at the World Fair, but had been able to acquire some works of ancient art which were unique of their kind. Bucher mentioned 'above all' three volumes of old Persian miniatures, illustrations of heroic poetry, executed in the second half of the sixteenth century, calling them 'true treasure troves of costumes, architecture, devices, vessels, weapons etc, all richly and neatly ornamented.' Bucher's article was the first printed reference to the purchase of sixty miniatures from the *Hamzanama* for the Austrian Museum of Art and Industry.

THE ECONOMIC BACKGROUND TO THE PURCHASE

The history of the *Hamzanama*'s journey to Vienna and its purchase for the Museum is closely connected with the Austro-Hungarian empire's struggle to expand its trade to the Near and Far East in the second half of the nineteenth century. The Vienna World Fair was a means of illustrating the importance of these diplomatic and economic efforts:

'Thanks to the Vienna World Fair of 1873, knowledge of the Near and Far East and understanding of its importance for the empire's trade and traffic have been spread among wide circles. A new world has been opened to the eyes of the majority of visitors to the Palace of Industry within the Prater [the former imperial hunting ground and public park on the outskirts of Vienna]. They have found irresistible the view that the rich treasures that the East has sent to Vienna from the shores of Japan and China, from the heart of Africa to the Black Sea and the banks of the Danube, offer an inexhaustible source of knowledge and science, a starting-point to establish new and prosperous contacts in all directions.'[2]

The Vienna World Fair saw a wealth of pavilions dedicated to the East that no international exhibition had seen before. China and Japan had already shown their goods at the Paris World Fair of 1867, but the Vienna event involved a large number of Eastern countries for the first time. Morocco, Tunisia, Egypt, the Ottoman empire, Iran, China and Japan took the chance to build up political and economic contacts with already industrialized Western nations at Vienna.[3] Before the exhibition's opening its organizers, the Austro-Hungarian Ministry for Foreign Affairs, and important tradesmen and industrialists had made contact, and a special department and a 'Committee for the East and Far East' had been established, with offices representing the Vienna World Fair in every major town in the East. That these efforts were successful is demonstrated by the enormous subsequent impact of the East on Austrian taste, a period of 'Orientalism' in Vienna which lasted well into the 1880s. A special Museum of Trade, later renamed the Oriental Museum, was established at Vienna's stock exchange in 1874, headed by the editor of the *Österreichische Monatsschrift für den Orient*, Arthur von Scala, later to become head of the Austrian Museum of Art and Industry. Its first acquisitions were goods of Eastern provenance bought at the World Fair or during expeditions to Japan and the East.

IRAN, THE VIENNA WORLD FAIR, AND THE *HAMZANAMA*

One of the most important countries on which the efforts of Austrian diplomats and tradesmen were focused was Iran. By establishing a regular steamship route from Vienna to Trebizond (Trabzon) via Istanbul (then Constantinople), Austria had a major influence on the Iranian economy, and an Austrian school had been opened in Tehran in 1851. While the Vienna World Fair was being planned, Austria sent a special envoy to the town of Tabriz, the most impor-

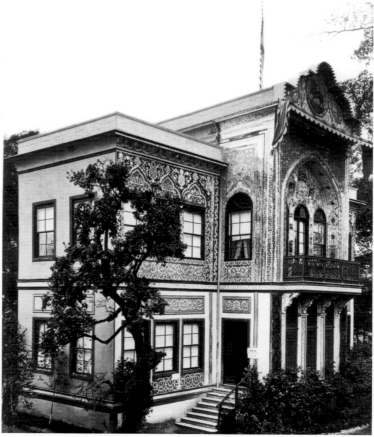

Fig.38
The 'Persian House' at the Vienna World Fair, 1873.

FIG 38

tant center of trade in Iran at that time; with the help of trading firms already established in the country, he succeeded in acquiring a wide range of Iranian products to be shown at the exhibition.

Austrian traders and industrialists strongly supported Iran's showing at the exhibition, sharing in the financing of the Iranian pavilion (fig.38) and the stand in the Great Exhibition Palace. But Iran itself, headed by Nasr al-Din Shah, realized the importance of the Vienna World Fair. In the 1870s the country had been struck by a crisis in agriculture caused by drought and a disease affecting silkworms, which meant a serious economic decline, but Iran nevertheless made strenuous efforts to take part in the exhibition. The shah himself promised to send his fabulous diamond, the 'Daria-nur,' for display as well as typical Iranian handicraft products such as carpets and silk-weaving, metalwork and stoneware. Nasr al-Din Shah visited Austria during the exhibition, causing great curiosity in Vienna about the alien Eastern empire.

The official catalogue of the 'Persian Exhibition' gave information about Iran, from its geological situation to the political and economic system, listed the objects shown within the Iranian section, and named the persons and institutions who were exhibiting their goods. This list included a few private individuals from Iran and Vienna but also members of the Imperial Persian Government and the shah's family. One of these, Prince Alikuli Mirza, Minister of Education, seems to have been personally interested in the preparations for the World Fair. The catalogue mentions him in its preface: 'We owe special thanks to Prince Alikuli Mirza *itesad essultaneh* [*sic*], a man of interest in knowledge and progress, who is especially engaged in taking up the objects of former art and cul-

ture of his country in the collections. He sent artworks and astronomic instruments to the Exhibition of high value and importance.'[4] Most of the exhibits listed in group xxvi, on education, came from the collections of Prince Alikuli Mirza, who was awarded a Fortschritts-Medaille ('medal for progress') by the exhibition's international jury.[5] It seems that the prince tried to put together a representative selection of works on mathematics, philosophy, medicine, history and poetry, combined with religious treatises and important examples of calligraphy. The catalogue text made it clear that it was 'Persia's duty to send works by its famous authors to the World Fair ... Special attention was given to the selection of manuscripts, which are outstanding due to their binding, decoration or miniatures.' All but one of seventeen objects shown in the Great Palace at the exhibition were from the collections of Prince Alikuli Mirza.[6] The penultimate item, no.458, is described as 'Hamséname, persischer Roman mit vielen Abbildungen in 3 Folio-Bänden' ('*Hamzanama*, Persian novel with many illustrations in three volumes').

THE *HAMZANAMA* AND 'ORIENTALISM' IN VIENNA

Strangely, this catalogue entry is the only evidence that the *Hamzanama* was shown on the Iranian stand in the Great Palace of Industry during the Vienna World Fair in 1873. Although curators of the Austrian Museum of Art and Industry like Bruno Bucher and Jacob von Falke acclaimed artefacts from the East in enthusiastic essays (comparable to German art theorist Gottfried Semper's writings on the purity of Indian handicrafts before the Great Exhibition in London in 1851),[7] no mention of the *Hamzanama* is to be found before Bucher's list of acquisitions quoted above.

Reports on the exhibition by curators of the Austrian Museum of Art and Industry make it clear that Eastern arts and crafts were seen as important patterns for a reform of Western, especially Austrian, art industry. Falke, who had been curator of the Museum since its foundation in 1863, wrote in 1873:

It is the Orient which is important in order to cure the degenerated feeling for colors. The Orient knows only flat ornament and color in art, but both [are] so well developed that we will hardly find a better teacher. It is the East that has gained [in] reputation from World Fair to World Fair. [From] being a curiosity at the first World Fair, today it is the East which will change our taste for color and will reform the carpets, tapestries and flatware we produce.'[8]

It was this approach which started the Orientalist movement in Austria after the World Fair. The initiative to purchase the *Hamzanama* for the Austrian Museum of Art and Industry with government funds only becomes understandable in this specific aesthetic climate.

During the period of eclecticism that dominated Europe in the second half of the nineteenth century, the Museum, and especially its first director and founder Rudolf von Eitelberger, had tried to establish the Neo-Renaissance as the typical Austrian national style. This became tangible in the Museum building, opened in 1871, where the architect Heinrich von Ferstel (1828–83) took up motifs of Italian Renaissance architecture (fig.39). The change in style after the Vienna World Fair could be seen in the important temporary exhibitions (and changes in the permanent exhibition) that took place in the Museum some years later. In 1876, the Museum organized a major exhibition, comprising 350 objects, on Islamic

FIG 39

oriental architecture and art, put together by the architect Franz Schmoranz (1845–92), who had been responsible for the Egyptian pavilions at the Vienna World Fair. Schmoranz had lived in Egypt for years, between 1869 and 1871 working for the Khedive Ismail Pasha on the construction of his palace in the newly founded city of Ismailia on the Suez Canal, and thus had a broad knowledge of Islamic culture. Lectures were given on the topic from 1875 onward by curators, including Von Falke. Austrian industrialists such as the glassmakers J. & L. Lobmeyr or the important textile manufacturers Philipp Haas & Sons reproduced in their new products the motifs presented in the exhibits and the Museum's own collections. Teachers at the Kunstgewerbeschule ('School of Applied Arts') affiliated with the Museum used Eastern objects to train their students, future designers for the art industry. In 1883 a special Arabian Room was opened in the Museum, assembled from the remaining parts of the Egyptian pavil-ion at the Vienna World Fair and supplementary items made by Austrian craftsmen in the 'Oriental Style' (fig.40).[9]

THE FATE OF THE *HAMZANAMA* IN THE AUSTRIAN MUSEUM OF ART AND INDUSTRY UP TO 1900

Given this background of an evolving 'Oriental' style in Austria, it is not surprising that the *Hamzanama*, as a 'true treasure trove of costumes, architecture, devices, vessels, weapons,' became an important object for the art industry. Official documents from the time of the Vienna World Fair show that the Austrian Museum of Art and Industry was enabled to purchase objects like the *Hamzanama* by funding from the Ministry of Education and Culture and the Ministry of Trade, although unfortunately neither of these can be related directly to the purchase of the *Hamzanama* itself and no invoice is traceable in the Museum's archive.[10] The art historian Heinrich Glück (1889–1930), who was a curator at the Austrian

Museum from 1928, published the first comprehensive study of the Viennese *Hamzanama* folios. He wrote that the '60 pages were bought for 2000 Gulden for the Austrian Museum by director Rudolf von Eitelberger in the Persian pavilion at the Vienna World Fair of 1873. The pages were bound 20 each in three volumes, made of saffian leather in the Augsburg bookbinding manner, customary in the third decade of the nineteenth century,' but he provides no sources for his story of the purchase.[11] In the inventories of the library and graphics collection, the *Hamzanama* shows up only in 1886 as part of the collection of books inventory, given the number '8770' and described as 'Roman, Persischer des 16. Jahrhunderts mit 57Bl. Illustrationen. 3Bde gr fol.' ('Persian novel of the 16th century with 57 pages of illustrations, 3 large folios'). Glück says that the volumes were taken apart in the Museum, put into large passepartouts and then into three boxes, according to the order in which they had been bound when bought at the exhibition.

The next trace of the *Hamzanama* folios was in 1897, in the Museum's magazine the *Mittheilungen*, where there was a notice that thirty-nine of the sixty miniatures were to be exhibited in room IX of the Museum's permanent exhibition, where graphic works were shown at that time.[12] This new interest in the folios may be related to a change in the directorship of the Museum: Arthur von Scala, former director of the 'Oriental Museum,' took over in the same year.

Given the interest that the purchase of the *Hamzanama* folios had raised in the Museum – as testified by Bucher's notes in 1874 – and the 'Oriental Style' that the Vienna World Fair had initiated in 1873, it remains remarkable that no major publication on the manuscript was produced before Glück's book appeared in 1925. The 'treasure trove' had become a hidden treasure again.

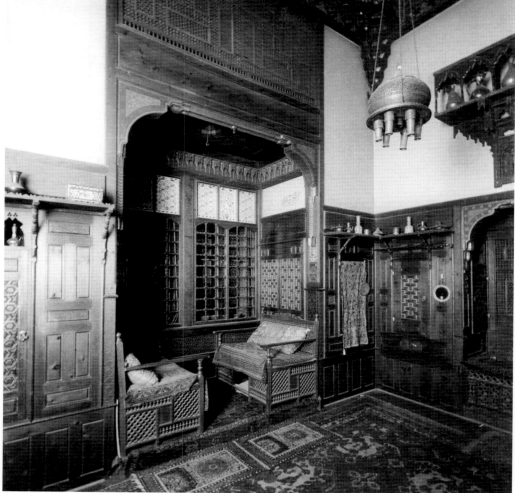

FIG 40

Fig.39. Façade of the Österreichisches Museum für Kunst und Industrie (Austrian Museum of Art and Industry, today MAK–Austrian Museum of Applied Arts) by Heinrich von Ferstel.

Fig.40. The 'Arabian Room' at the Austrian Museum of Art and Industry, 1897.

TRANSLATIONS OF TEXT ACCOMPANYING CATALOGUED *HAMZANAMA* PAINTINGS

Wheeler M. Thackston

Names occurring in the *Hamzanama* have been transliterated without resorting to macrons and dots under letters, which mean little or nothing to those who do not know how to read Persian and are superfluous for those who do. The ʿ*ayn* of Arabic script has been eliminated at the beginning of words, where it has no value in pronunciation, but it has been inserted in the middle (as in Saʿid) or at the end of words, where it either lengthens a vowel slightly or keeps two vowels from forming a diphthong.

The majority of personal names in the *Hamzanama* are ordinary names from Islamic history (Hamza, Ibrahim, Saʿid) or in the Persian storytelling tradition (like Zumurrud Shah, Mihrdukht, and Farrukh-Nizhad). Even though almost all of them have meaning (Zumurrud Shah, for instance, means 'Emerald King'), they have been left as names. The added epithets given warriors, demons, and other characters in the *Hamzanama* have been translated when they have an immediately obvious meaning ('Dog-Tooth', 'Rug-Ear', 'Gold-Belt').

The text itself is full of inconsistencies and variant spellings of names, but since we rarely have enough running text from consecutive folios to know whether or not characters with similar names are actually the same person, it is impossible to eliminate the inconsistencies.

WMT

Each of the following translations is cross-referenced to the catalogued painting to which it relates, or to the catalogue entry in which it is discussed.

TRANSLATION FOR CAT.20

Volume unknown, text number 42
Victoria & Albert Museum, London, I.S. 1505–1883

The word-weigher of this charming story thus narrates from ancient tellers of tales:

When the dragon appeared and Khwaja Umar, son of Umayya Zamiri, was carried off by the demon, the world-conquering Amir witnessed it, but since he was clement and grave, he said nothing.

When Hura the genie saw this, he turned to the Amir and said, 'How is it that you say nothing?'

'You are of a great family,' the Amir replied, 'and you were in Solomon's service. Nothing bad will be done by you.'

When Hura the genie heard this, he was embarrassed and said for Ayjil and Umar to be brought, dressed in his own men's clothes, and taken before the Amir. He also summoned his ministers of state, like Perizad the genie, Hamzad Swift-Wing, and others, along with the demon Saradiq, who was the chief of their administration along with a vizier named Azhar the genie. They all assembled, and Hura the genie ordered a great banquet given for the Amir, Ayjil, and Umar. After that he summoned the vizier and discussed the capture of Pahlavan Ayjil. Having counseled the incomparable vizier, he went to the Sahib-Qiran, kissed the ground before him, and explained the situation.

When the Amir heard this, he said, 'Whatever he thinks will be well.'

The vizier heard the reply and went before Hura the genie to report what had happened. Hura rejoiced and ordered the banquet to be held. When the implements of the banquet arrived, a lavish party was arranged, and all the genii and fairy musicians and singers there were came.

When they began to play, the Amir turned to Umar and said,

'We would like to hear a lute tune.' A master lute player was found, and he played. Umar saw that he played badly. On some pretext Khwaja Umar took the lute from his hands, cut the strings, took out some new strings from his *ayyar*'s satchel, and attached them. Then he strummed the lute and played David's tune. For words he borrowed the following two lines:

From my moon the fairies learned to show their beauty.
Were it not so, why would a fairy care to show herself?

Hura the genie praised Umar's playing and singing, saying, 'We had heard much in praise of you. Now we have seen and heard but one out of a hundred.'

'Khwaja Umar,' said the Amir, 'beware lest you speak of the learned ones of these people or of their *cadis* lest they claim we are up to something.'

When Hura heard this, he said, 'There will be no mulla better than Khwaja Umar because the marriages of all people are before him.'

Khwaja Umar stood up and changed his mien, taking on the guise of a genie *cadi*. Then he sat down in the Sahib-Qiran's view and wedded Hura's daughter to Ayjil.

After the banquet Hura the genie bade farewell to the Amir, and the Amir returned to his camp with Umar and Ayjil.

The next day a group came and cried out. The Amir asked them what was wrong. They said, 'We are the people of these foothills, and a catastrophe has struck our village.' When asked what sort of catastrophe, they said that birds the size of ostriches with wings like snakeskin had appeared, and weapons were useless against them. Each bird had a beak half a yard long, triangular in shape, that would pass through a steel shield. There were nearly six thousand of them, and they were killing and eating all the cattle, sheep, goats, and any other animal that ventured outside of the village.

The Amir went, but he could not do anything to combat them. Then Landhaur son of Saʿdan came forth and dispatched a few of them to nonexistence with his heavy mace. Finally Umar set about hatching a plan. He asked where they drank water. The pond from which they drank was shown to Khwaja Umar. He poured poison into the water of the pond when the birds all had gone to their nesting place. The birds drank from the water of the pond and died. Umar skinned them and had six thousand breast plates made.

They left that valley.

TRANSLATION FOR CAT.21

Volume 6, text number 35
The al-Sabah Collection, Dar al-Athar Islamiyyah,
Kuwait National Museum, LNS 297 MS

The narrator says:

When the ill-starred Marzuq fled the fortress, the princes of the age, the champions, and the Sahib-Qiran killed many Farangis that night. The fire of battle blazed forth. The next day the Sahib-Qiran was informed. He entered the fortress and met his sons, warriors, and champions and showed great kindness to the warriors. ...q Farangi, Marzuq's nephew, fled to the sea with his household and family.

Let us return to the story. The Sahib-Qiran asked about Marzuq. Prince Alamshah said, 'O lord [of the age, we have] searched far and wide for Marzuq, but no matter where we looked we could not find any trace of him because he got into a ship and set sail.'

The Sahib-Qiran said, 'I need someone to bring news of Marzuq.' Crocodile-Child Tayifi accepted the mission and

immediately went out. To his men he said, 'Bring me news of Marzuq, for the Sahib-Qiran is determined to find him, and we know that he has gone to the seven walls of Baʿiya. You must search all ships and investigate all roads, particularly the seven walls of Baʿiya.' So saying, he dispatched all his men to discover where Marzuq was. Then he went to the Amir and said, 'Many men have gone to find Marzuq.'

The Amir of Iran and Turan said, 'Put all the booty from the fortress on the sea shore and make a list.' Then the Sahib-Qiran [summoned] the princes Alamshah and Saʿd, who [had gone] first into the fortress. Prince Alamshah praised Barakh greatly, and the Amir rewarded Barakh and gave rewards to all the soldiers. 'I want to marry Qarasi Tajdar's daughter Mihrafroz to Prince Alamshah and Marzuq's daughter Lu'bat Farangi to Prince Saʿd,' he said, 'and to spend several days at the sea shore in celebration.' The commanders all voiced their congratulations. The Sahib-Qiran said, 'Let there be brought every rare and unusual object there is in the lands of the Franks that have been conquered.' And he ordered the commanders to bring every tent, pavilion, and canopy they had and set them up around the Solomonic court. Umar Maʿdi, Asad Asadan, Asad Lion-Catcher, Asad Fisherman, Dulkhumar Badmast and their brothers, as well as every huntsman, cook, and gatekeeper there was, were all ordered to exert themselves with no shortcoming in making preparations for the wedding and to assemble musicians, singers, and dancers from all directions, and the astrologers were ordered to select an auspicious hour.

Until that time the Sahib-Qiran had not thought about Qarasi and Darasi. That day he summoned them and said, 'What say you regarding the knowledge of God?'

'It has been proven to us that your God is the true one,' they said. They chose Islam and thus removed the rust of infidelity from their hearts by pronouncing the word of faith and becoming sincere Muslims. The Sahib-Qiran showed them great favor, and in that very assembly Qarasi approved the marriage and gave his congratulations. 'My daughter is the prince's,' he said. The Amir praised him, and [at the appropriate] hour he ordered that Prince Alamshah [and Qarasi's daughter] be adorned and sat on Solomon's throne next to Shah Qubad. Drums of rejoicing were beaten, and an order was given for the hordes and soldiers to take their places in the tents and pavilions around the Solomonic court. Everyone who had a skill and exhibited it was rewarded by the Sahib-Qiran. After drinks and rewards, the musicians and singers were summoned, and silvery-limbed *saqi*s entered as the cries of the drinkers reverberated under the dome of heaven. From the sounds of the singers' voices the birds of the spirits of the distressed flew from the strictures of their cages. Many Greek, Russian, and Circassian slaves stood on both sides, ready to serve, and the Sahib-Qiran had provided them with everything necessary.

For that marriage he had prepared thousands of Greek and Russian beauties,
... mouths and pomegranate breasts, cheeks and breasts garden after garden.

After three days of celebration and enjoyment, the *khutba* was recited, and the Amir took Alamshah by the right hand, and ... Sheroya b. Hamza [took the girl] by the left hand and led them to the bridal chamber Each one of the princes who entered the place saw a paradise filled with *houri*s and palaces. In short, the princes were married, and the next day the Sahib-Qiran, the great Amir Hamza the Arab went to the

bath with his warriors and champions ... Everyone presented the gifts he had brought, and that day the Amir showed his men much kindness and awarded them all robes of honor as he sat in enjoyment and merriment upon the throne of governance and rule.

TRANSLATION FOR CAT.22

Volume unknown, text number 97
Victoria & Albert Museum, London, I.S. 1509-1883

Mellifluous narrators and creative depictors have thus drawn the beautiful face of speech with the pen of exposition:

When the Sahib-Qiran appointed Hurmuz Nawjavan in Anoshirvan's place and sat him on the throne of Kay-Khusraw, the world-conquering Amir fell hopelessly in love with Mihr Guhartaj. He revealed his secret to Khwaja Buzurjmihr, who asked for her hand in marriage on behalf of the Amir. The mighty Sahib-Qiran went to Mecca, where he prepared all the necessities for pleasure and revelry and was married so that, eventually, from him would come Hamza's son Jamshed, who would be the Rustam of the age and unique in his time and would conquer the entire world with his shining sword.

The narrator says that when Hurmuz sat on the throne of success with all enjoyment and happiness and made justice and equity his watchwords, he so conducted himself with the people that they forgot Anoshirvan's justice. Whenever a traveler appeared in his realm he summoned him and awarded him all sorts of kindness and honor.

One day a group of merchants came to pay homage to Hurmuz and were informing him of the ends of the earth. One of them told him of the king of Ganja and Barda' and described the beauty and grace of his daughter, Mahina Banu, and of the heroism and bravery of [her father,] Hardam Devana. From afar, Hurmuz lost his heart [to Mahina Banu].

He sent Bakhtyar on an embassy with many gifts and presents. Bakhtyar went to Barda' and, offering handfuls of gold and jewels, he paid homage to Hardam. Hardam took a fistful of jewels and dumped them into his lap. He had a toothache. Thus spurned, Bakhtyar could not accomplish his mission.

When Hurmuz learned of this, he sent Khwaja Abuzurjmihr with various potions to Hardam, who was quite pleased by this. When [Khwaja Abuzurjmihr] paid homage to Mahina Banu, she said, 'I will belong to anyone who can best my brother without trying to kill him.' Khwaja Buzurjmihr sent a messenger to Hurmuz to inform him of this turn of events.

Hurmuz dispatched Abday Lamut and Taliq the Sassanian with twenty thousand horsemen. Those two champion warriors, with all their legions and army, were defeated by Hardam, and they fled in shambles, stopping nowhere, until they stood before Hurmuz. Hurmuz contemplated this affair and was quite perplexed. The commanders and nobles thought the best course of action was to send the Sahib-Qiran, other than whom no one would be able to best this foe. Khwaja Abuzurjmihr hastened to the Sahib-Qiran.

When the great Amir was informed of the imminent arrival of that wise old man, he sent his princes out to greet him. They escorted him into the Sahib-Qiran's camp and informed the Sahib-Qiran of why he had come. The world-conquering Amir accepted their plea on his behalf. He turned the camp over to Landhaur b. Sa'dan for him to proceed slowly toward Ganja and Barda', and Khwaja Abuzurjmihr fixed an hour. Bidding farewell to Landhaur b. Sa'dan, the commanders, and the nobles, the Sahib-Qiran, prince of Iran and Turan set out on foot with the fastest runner of the age, Khwaja Umar Ayyar, for Ganja and Barda'. When he arrived in Ardabil, the Amir ordered a one-day halt. Going to the bath, he rested from the travail and hardship of the road and then put up at a caravanserai. He went to the bath with Khwaja Umar, where they washed the grime of the road from their heads and bodies. When they came out of the bath, they wandered all around, touring the city of Ardabil, until they came to the square. There they saw a group of people. They asked what was happening. They were told that someone was putting on

a show. The Amir and Umar Ayyar entered the show, where they saw Badi' with his foot on top of a stack of seven ingots of red gold, claiming that anyone who could pull an ingot out from under his foot could have it. Khwaja Umar pleaded with the Amir, who took hold of the corners of the ingot and pulled so hard that the ingot flew into the air and was caught by Khwaja Umar. Badi' was astonished and said to the Amir, 'Champion, I will wrestle with you!'

TRANSLATION FOR CAT.23

Volume 6, text number 50
Fitzwilliam Museum, Cambridge, PD. 203–1948

The narrator says that when Alamshah set out for Kharishna, his attendants and soldiers followed along behind him, but when they caught up with him, he forbade them to accompany him and insisted that anyone who followed him would be put to death with horrendous torture. Of course, they all turned back. Prince Sa'd, on account of the love he bore Alamshah, when he heard that Alamshah had set out for Kharishna alone and refused all offers of accompaniment, his zeal was stirred and he turned his reins and headed off in the direction of Alamshah. When Prince Sa'd caught up with Alamshah, Alamshah refused to accept the prince's offer to accompany him. The prince begged, and finally Alamshah agreed to let him.

Luhrasp was informed that the prince was headed for Kharishna, and he too was drawn thither out of his desire to serve the prince. However, when Luhrasp came before Alamshah, Alamshah refused to accept him absolutely and finally. Sa'd said, 'Lord, someone is needed to take care of the mounts and to see to hay and grain.' Alamshah said nothing. Suddenly Zangawa appeared. Alamshah asked, 'Why have you come?'

'I have news of Luhrasp's ...,' said Zangawa.

'Seize him upon his return,' said Alamshah.

'Perhaps he will not return,' said Zangawa. Sa'd smiled. In short, all four of them set out fully armed and mounted on swift mounts. They proceeded at a gallop toward Kharishna. After several days they reached Kharishna, but there was no sign either of a city or of its inhabitants. Alamshah was pained by the loss of his friends and the destruction of his home, and several tears rained from the clouds of his eyes. After a time three people emerged from the forest. When they saw Alamshah and his comrades, they thought they were Farangis [and ran away], but Luhrasp caught them and brought them back. One of those three was Milad, Kirdaws's vizier. Alamshah recognized him and asked him about how the Farangis had come and the difficult times that their people had suffered. Milad told Alamshah everything from beginning to end. Together with Milad, Alamshah headed into the city. On the outskirts of the city ... Kirdaws was hanging by his neck. Milad took Kirdaws down, and Alamshah shrouded him and buried him in the earth. Prince Alamshah said to Milad, 'In my youth, in the company of my mother, I came across a tunnel. My mother told me that if a revolution occurs in this realm I should come to this tunnel. Now, if you know where our house was, I can find the tunnel.'

Milad took Alamshah to the top of a hill and said, 'This was your house.' The prince searched beneath it and found the tunnel. When they dug down a bit, they heard women's voices. Rabi'a also heard the sound of digging in the tunnel. It crossed her mind that it was a rebel. She had some poison and was about to drink it, but the prince had a milk-brother named Rafi'. He and some of the servants were about to flee into the ruins, but Alamshah cried out, saying, 'Do not be afraid. Have no fear' When Rafi' heard Alamshah's name, he rejoiced [and went] to Alamshah. When he opened his eyes to the prince's beauty, he began weeping. Alamshah wanted to embrace him, but Rafi' fell at Alamshah's feet and kissed them. Alamshah lifted his head and embraced him, and there was much weeping. One by one the servants came, kissed the prince's feet, and stood before him. [They all expressed their gratitude for having found one another.]

TRANSLATION FOR CAT.24

Volume 6, text number 75
Victoria & Albert Museum, London, I.S. 1508-1883

The teller of the royal tale thus ...

... Rug-Ear Ayyar ... Sahib-Qiran attacked Prince Qubad, and that majesty ... came out of the court. ... '... will raise my head to the heights of success,' but it was in a dream that the messenger of death dragged him to Anoshirvan's camp.

In short, Rug-Ear, having informed all the *ayyars*, wanted to gaze upon the world-illuminating beauty of He spied the head of a youth of tender years. A sigh arose from the depths of his being and he said, 'What hideousness ... that once again I have exterminated one of his dear sons!' Clearing his mind of his fear of ..., he picked up Qubad's head and set out for Anoshirvan's camp. When he arrived he headed for Bakhtak's quarters and placed Qubad's head on the ground in front of Bakhtak. Bakhtak Bakhtyar had Rug-Ear bound, picked up the head, got on his horse, and rode off as fast as he could to inform Shah Anoshirvan of the terrible situation. Anoshirvan wept and wailed and commanded that Qubad's head be perfumed with sandalwood and ambergris, and together with Khwaja Abuzurjmihr, Hurmuz, and the commanders and nobles, both Sassanian and Mazdakite, he set out for the Sahib-Qiran's camp.

Meanwhile, on the plain, the prince of all worldlings, the Sahib-Qiran, had a dream worse than a thousand nightmares in which he saw that the extinguished lamp of that youth was drenched in blood by the cruel machinations of the celestial spheres. Involuntarily he cried out and began to weep and wail.

From the fire in his heart came such a cry that fire fell into all people.

In short, the Sahib-Qiran's camp was like doomsday, and the leaders, commanders, and princes garbed themselves in mourning for that sapling of the garden of martyrdom, putting on clothing as black as night.

Grieving for him, the violet drooped over; rosebuds completely closed their lips to laughter.

Wailing rose to the heavens from the birds; as tears of dew rained from the eyes of the clouds.

The pine tree sat in the midst of mud as the plane tree beat itself on the head in pain.

When the terrible news reached the Sahib-Qiran, he took the crown from his head and was beset by waves of grief, saying,

Alas for that exciting beauty; alas for that enchanting lasso.

Alas for that bewitching glance; alas for that sorcerer's eye.

Alas for that realm-conquering power; alas for that mighty arm.

Alas for that country-conquering arm; alas for that champion's wing.

The next day Khwaja Abuzurjmihr's letter arrived, and from the contents it was known that Shah Anoshirvan had seized Qubad's killer and the prince's head and was headed for the camp. The Sahib-Qiran dispatched his commanders and nobles to go out and greet Anoshirvan and escort him with all honor to the Sahib-Qiran's assembly.

Shah Anoshirvan asked politely after the Amir and his dear son and observed forty days of mourning, after which Anoshirvan went to Ctesiphon.... and the commanders and princes were mightily afflicted by this tragic event, but when Shah Anoshirvan camped at Ctesiphon, Kaus's son Zubin came to inquire after the shah.... He wanted to give him leave ... every day he made arrangements and kept him. By chance one day Bakhtak and Zubin ... in Shah Anoshirvan's assembly.... The cast of the celestial dice fell in Bakhtak's favor. Zubin flared up in wrath and threw the dice on the ground, saying, 'You favor Bakhtak just as the celestial sphere does!' Shah Anoshirvan ...

... Zubin was worried by this news and contemplated ...

TRANSLATION FOR CAT.26

Volume 7, text number 10
Victoria & Albert Museum, London, I.S. 1520-1883

The narrator says that when Basu cut off Namadposh's head and buried it in the ground, a letter fell from Namadposh's

belongings. Basu read the letter, and when he learned the contents of the letter, he put on Namadposh's clothes and departed. Although Namadposh was tall, and Basu was short, nonetheless he got himself somehow to the gate of the Acre fortress in the middle of the night and cried out, 'Open the gate. I have come from Pahlavan Qaran.'

'Who are you?' asked the castellans.

'I am Namadposh the *ayyar*,' he said. When they heard that it was Namadposh, they opened the gate and let Basu in. They saw that he was not Namadposh, but he was wearing Namadposh's armor. Once again, to make certain, they asked him who he was.

'I am one of Namadposh's servants,' he said. 'Never mind who I am. Take me to Gurgana, and I'll tell him who I am.' When the castellans took Basu before Gurgana, Gurgana asked him who he was.

'I am one of Namadposh the *ayyar*'s servants,' he said. 'I was in his service when your letter came. When Pahlavan Qaran read your letter he ordered that Karb be killed, and he gave the order to Namadposh to deliver to you. When Namadposh left Qaran's court, he gave me the edict and his arms and sent me to you."You go on ahead," he said, "and I'll follow you later."'

'Where has Namadposh gotten to?' Gurgana asked.

'He had not yet come away and was still there when I set out,' said Basu. 'I don't know whether he has departed or not, but I do know that when he sent me hither, he said he would follow in two or three days.'

'You are not Namadposh,' they said. 'Why did you say you were Namadposh?'

'When he sent me,' replied Basu, 'he told me that when I came to the fortress I should say I was Namadposh so that the gate would be opened. I did as he said, and he will arrive within two or three days, and then the truth will be learned.'

When Malik Kalud heard that an edict had been issued for Karb's death, he came before Gurgana and said, 'What do you order concerning Karb?'

'He must be killed,' said Gurgana.

'In the edict it is written that Karb should be killed when Namadposh arrives,' said Malik Kalud, 'and Namadposh has not yet come. When he arrives we can kill Karb.'

This seemed reasonable to Gurgana, and he said, 'Let them bring Karb so that we can torment him a bit.' Karb was brought into the assembly hall, and Gurgana insulted and tormented him with harsh words. Karb tolerated it and did not reply. After a while it was ordered that Pahlavan Karb be taken back to prison and put back in chains. As Karb was being taken away, Basu followed behind him, saying, 'This is the one who fought with Pahlavan Qaran. He is an enemy of Lat and Malat. Torment him with insults and curses as much as you can.' He danced around Karb, speaking thus. At first Karb did not recognize Basu and kept looking at him sharply. Finally, when Basu winked at him, he recognized him and rejoiced at the sight of him. Basu also began to speak, telling him everything. Karb was extremely happy. Basu accompanied him as far as the prison. When Karb was put back in prison, Basu went back to Gurgana and said, 'Should I go or stay?'

'What did Namadposh tell you to do?' Gurgana asked.

'Namadposh didn't say anything about going or staying,' he replied. 'All he said was that he would come after me and when he came he would tell me what to do.'

'This must be a sign that you are to remain here,' said Gurgana. 'You stay and guard Karb lest some *ayyar* or trickster come and release him from prison.'

TRANSLATION FOR CAT.27

Volume unknown, text number 69
Private collection

... in his service was a wise physician named Muhandis. He was seated in attendance upon Ahras when the news was brought. He turned to Ahras and said, '... so soon ... you ..., and will be honored to convert to Islam.' Ahras got on horseback with his sons and [rode] to the edge of the sea ... an army was camped. Ahras asked, 'Who is the commander of this army?'

'Amir Hamza,' they said, 'the Sahib-Qiran.'

'Where is he coming from and where is he going?' he asked.

'From the east to the realm of darkness,' they said.

Ahras saw the Amir's court and set out in that direction. Word had been taken to the Amir that Ahras Saturn-Brow, the king of this island, would pay homage when Ahras entered. A chair was brought, and he sat down. After a time he asked if Zumurrud Shah had left there, and the story of Zumurrud Shah's getting into a boat ... was told.

The Amir asked, 'What sort of tree is it?'

'It is a thousand yards tall, and its shadow extends for four leagues. A thousand and one men can rest in its shade. ... the shadow will go away. We worship this tree, and prophets performed miracles [on account of] it. Our fathers and forefathers in the time of Solomon were tree-worshippers'

At that time ... entered through the court gate, bowed his head under the Sahib-Qiran's gaze, and said, 'O worshippers of heaven, any of your army who has gone to repel the enemy and drawn his sword, ... dagger ... will destroy utterly as easily as pouring out water As long as earth and water exist may the Sahib-Qiran and his warriors live.' The Amir listened as they told the story of Saturn-Brow and the tree.

He bowed and said, 'O prince, in the city of Sabayil there was another such tree in Zumurrud Shah's garden.'

Ahras said, 'I have heard of it, but Zarduhusht made it'

The Amir offered him the chance to convert to Islam. He said, 'I will obey the command of anyone who can defeat me in wrestling.'

In short ... they wrestled at the foot of the tree. Ahras went to his quarters.

The next day ... that morning Ahras ... champions coming to pay homage to the Sahib-Qiran arrived at the foot of the tree. They saw it was a hundred times larger than what they had heard. Ahras [wrestled] with the Sahib-Qiran ... he sincerely became a Muslim with his sons and relatives ... asked the story. Ahras ordered the base of the tree split open. Out came a chest and the ring of [Solomon?] ... and put it back in its place.

TRANSLATION FOR CAT.28

Volume unknown, text number 16
Victoria & Albert Museum, London, I.S. 1516-1883

The narrator says that when Zumurrud Shah [was attacked by the men who] leapt from ambush and beat him senseless with sticks and clubs, he cried out, 'Friends, I am just a wayfarer. I entered this garden unknowingly. I have not yet touched anything that I should suffer such a fate.'

'Fellow,' they said, 'we thought that a bear was responsible for the ruination of our garden, but you are a desert ghoul that has come and wrecked this garden every day.'

Zumurrud Shah wept and wailed, saying, 'I have never seen this place before.'

'Where are you from?' they asked.

'If you get me out of this trap,' he said, 'I'll tell you my story.' They pulled him out, and what a sight he was: an amazing stature like a cypress, a long beard, and very long to the waist. In several places his head had been broken, there was a lot of dried blood in his beard, and he was suffering much pain and discomfort.

'What is your name?' they asked.

'I am the lord of the east, Zumurrud Shah, son of Lahut Shah,' he said.

When they heard this, they shouted at him, saying, 'You [are just trying to trick us] with this [claim so] that you can escape from us.'

All at once they lit into him with whips, and no matter where Zumurrud Shah ran, they chased him and beat him so hard that he fell.

'Miserable fellow,' they said, 'don't ... again.'

He repented of making false claims. They carried that ass away and put him in chains in a barn. That evening the cows came home, and Zumurrud Shah was lying unconscious when an enraged cow stuck its horns in the ground and mooed. By divine destiny the horn went into Zumurrud Shah's nose and

tore it. Zumurrud Shah jumped up, and when he saw his condition he became upset. As he was weeping over his miserable state and wretched fate, a cow shat on him. Rubbing his broken head, he fell under the cows' legs.

The next day when the rosy-cheeked sun poked its head into bright morning,

Zaygham Blood-Drinker came near the garden and dismounted in a pleasant meadow. An uproar began in the pass, and the great ones of that place came out to Zaygham with gifts and presents. They greeted him and told him the story of the bear and the guebre. Zaygham asked that he be brought, and when he came, what an extraordinary sight he was! Despite his loyalty to Zumurrud Shah, he didn't recognize him, but he set him free. When Zumurrud Shah saw Zaygham, he was so averse to making false claims that he did not want to make himself known, so, fearing Hamza ibn Abdul-Muttalib's blade he renounced his kingship and gave in to his destruction. He headed out into the wilderness and departed.

The next day, when the beauty of the orient showed her countenance from behind the blue curtain, and the dagger of the sun put a rip in in the heart of the Hindu of the night, and the tears of the planets rolled down over the cheek of the Zangi of the night,

When at dawn the sun rose at the Omnipotent Judge's order, by its ray at once the horizon became illuminated.

The sun suddenly showed its face over the mountains.

Like the fire that emerged from the dragon's mouth you'd say Jonah fell out of the fish's belly.

Then, from the midst of the darkness, that morning Zumurrud Shah reached Bejeweled City, the glistening spires of which reached the heavens.

A marvelous city appeared that would put paradise to shame, its air as subtle as its soul.

Zumurrud Shah the Lost stepped into Bejeweled City, and Prince Murassa'posh, the king of that city, had already heard of the defeat of the disgraced Zumurrud Shah's army. He was armed for a campaign. Zumurrud Shah stepped into the market. Every direction he wandered and everyone who saw him with his strange appearance and unusual height was amazed. By chance, Zumurrud Shah the Disgraced chanced upon a tavern, in which, wherever he looked, there was revelry and pleasure. He came to a beer shop. Baba Lulu the beer-seller was sitting there with a group around him, and they were busy filling their mugs. Zumurrud Shah's gaze fell upon Baba, and he saw that he was an amazing youth. He offered him a chance to be a beer-maker and put a mug in Zumurrud Shah's hand. He quaffed it and then started making beer, in which job he continued for a time.

TRANSLATION FOR CAT.29

Volume unknown, text number 10
Victoria & Albert Museum, London, I.S. 1513-1883

The moneychangers of the market of poetry and the jewelers of the shop of cleverness say that when Zumurrud Shah the Lost took flight and clung to wretchedness, he decided that he would go to Mushtarisar with great difficulty by way of Zaranqa Valley, and so he dispatched Qahir Qahraman with his treasury and all the possessions he had – which was more than ever – together with thirty thousand brave, battle-tried horsemen, while he himself went with his miserable fate and broken heart.

Along the way he encountered Ta'us Shah, who had been held prisoner by Amir Alamgir but who had been freed by the guebres when Tahmasp wounded Prince Sa'd and the army of Islam was defeated. [Ta'us Shah] showed Zumurrud Shah great favor and kindness and gave him forty thousand vengeful, battle-ready infidel horsemen, telling him to follow the army and to be of good cheer.

The narrator says that Baba Umar Zamiri, who was the most learned of anyone in the world in the arts of *ayyar*s, had been sent by the Amir of great renown to get news of Zumurrud Shah's army. When he came near Zaranqa Valley, he saw that

nearly twenty thousand horsemen were lying in ambush. He thought to himself that since Zumurrud Shah had given his treasury and possessions to Qahir Qahraman, it was likely that these men lying in ambush to the left and right were waiting for him. He also thought that it would be a rare spectacle and a wonderful sight, so he went up on a hill and waited until Qahir and his men appeared. All at once the twenty thousand horsemen sprang at the wretched infidels. In the midst a brave young man, in whom traces of bravery were apparent, got himself to Qahir and cried out to him, saying, 'I am the person who struck Tahmasp down manfully.' So saying, he gave Qahir such a blow on the head with his sword that the blade came out between Qahir's horse's legs. That praiseworthy youth took the entire contingent prisoner and confiscated the goods and possessions.

In short, after Baba Umar witnessed this sight, he went to Zumurrud Shah's camp. When Zumurrud Shah heard the horrible news, he was too frightened to go forward and turned back to Zaranqa. The keys to the fortress were turned over to Zumurrud Shah, and the fortress was put in his charge. Zumurrud Shah entered the fortress and then set out for Mushtarisar.

The narrator says that when Khwaja Umar learned of this, he turned back. Along the way he saw Ta'us Shah coming. He was completely uninformed that Zumurrud Shah was returning by another road and that Qahir had been killed. When he reached the valley he saw that the same twenty thousand men were in ambush. Once again he went up on the hill to watch and waited until Ta'us Shah arrived. Battle with swords, arrows, and axes erupted, and acts of courage were done on both sides. Finally, however, the same youth who had put Qahir to death closed Ta'us Shah in and started battling with him. In the end Ta'us Shah was wounded and defeated, but he managed to flee. They set out after him, and when Baba Umar witnessed all this from the brave youth who had been lying in ambush, he thought that he should not go to the Amir Sahib-Qiran's court until he found out about him. Therefore he set out after the youth's camp to learn who he was and where he was going. Baba Umar had only gone a short way on their heels when he saw two masked riders. When they saw him, they drew their swords and came on like roaring lions, headed straight for Baba Umar. He fled as fast as he could and went to Amir Sahib-Qiran, to whom he explained everything that had happened. The Amir set out march by march and made Azar Koh his headquarters. The chiefs and commanders of that area hastened to bring gifts and presents to the renowned Amir.

TRANSLATION FOR CAT.30 AND 31
Volume 11, text number 4
MAK–Austrian Museum of Applied Arts/Contemporary Art, Vienna, B.I. 8770/45

The next day, when the rosy-cheeked sun poked its head out into the white dawn,

The narrator says that on that morning, when Khwaja Umar Ayyar appeared at the court of Solomon, he explained how, when the Amir went traveling, Umar also went until he came to the place where Ashqar was grazing. [Some men] had pulled the Amir onto the shore and then put him in a boat. However, as he was coming, since he passed near the place where the Amir was, he saw Mazhub. When Mazhub saw Umar, his face paled.

'Where have you been?' asked Umar.

'I have a village,' he replied. 'I went there for planting.' He left.

When Umar saw that the Amir had been taken away, his suspicions about Mazhub were aroused somewhat. Just then the Amir's generals arrived. Umar explained the situation to them. They all came to the court of Solomon. Umar summoned Mazhub. He got upset, but there was nothing he could do. Mazhub came and paid homage to Sa'd.

'Mazhub,' said Umar, 'who took the Amir away and where have they taken him?'

'How should I know?' he said.

'You know something about this affair,' said Umar. 'Tell

the truth, for it has been said

Tell the truth that you may be saved. The truth from you; victory from the Creator.

By crookedness will you fall into ruin. From all grief will you escape if you are truthful.'

'Umar,' said Mazhub, 'if you covet anything, I will give you anything you want, but do not accuse me of this, for I am no thief to commit this sort of knavery.'

'Umar,' said Sa'd, 'investigate this matter so that no one will suffer injustice.'

'If you want to hear news of the Amir,' said Umar, 'then be patient. Otherwise you will have to do as you please.'

No one spoke.

Umar said to Zardhang Khatni, 'Bring every male and female slave you have in Mazhub's house, and seal the door to his house.'

'Where is the slave who was with you?' Umar asked Mazhub.

'At the gate of the court,' he said. He was called. The slave was not there.

'Why did you lie?' asked Umar.

'Just because,' he was saying when Zamtar Red-Mustache entered holding by the hand the very slave Umar was looking for.

'How did you find this slave?' Umar asked.

'I had been given a voucher,' said Zamtar. 'In the vicinity of Sabayil is a village called Armaniya. I changed the voucher for cash and was leaving when I saw this slave running away as fast as he could. It occurred to me that he might have had a quarrel with his master and run away. I caught him and brought him to his master's house. There they told me that his master had been arrested and his house sealed. Therefore I brought him to your house.'

Umar applauded him and ordered three of Mazhub's slaves to be beheaded in the presence of the slave. The slave nearly died of fright. Khwaja Umar called the slave forward, put his hand compassionately on his head, and said, 'Come here, slave. Tell me the truth, for you were with Mazhub. Who took the Amir? And where have they taken him?' The slave fell to the ground and began weeping. Umar swore an oath, saying, 'If you tell the truth, I won't say anything to you. Rather, I'll make you rich beyond your wildest dreams. If you lie to me, however, I'll tear the skin from your head!'

In short, the slave explained, from beginning to end, about Shahrashob, Nimrod [Nimrut], Larghay Chain-Chewer, and Sharit b. Beast-Chain, how the Amir Sahib-Qiran had been seized, how Mazhub had helped, and how the Amir had been put in a boat and bound with three hundred *maund*s of chain around his hands and neck.

'Does anyone else know about all this?' Umar asked.

The slave named several of Mazhub's servants who knew about it. Umar interrogated them too. After that, Umar ordered Mazhub hanged at the market crossroads in Sabayil and his property and money given to the truthful slave.

'There is nothing for me and you to do but to get in a boat and search the east,' Umar said to Yazak. 'Perhaps we can learn some news of the Sahib-Qiran.'

In short, he took ten slaves and six months' provisions, and he charged Sa'd, saying, 'Whenever news of the Amir arrives, arm yourself and come as quickly as possible.' Saying this, and bidding farewell to the kings and champions, he and Yazak the Cathayan got in a boat. The sails were trimmed, and they set out on the sea.

Now let us see where they turn up.

TRANSLATION FOR CAT.32
Volume 11, text number 5
MAK–Austrian Museum of Applied Arts/Contemporary Art, Vienna, B.I. 8770/47

The pearl-weigher of this pleasant tale thus narrates from the old storyteller:

Two days after Ayjil, Alamshah, and Tul Mast got lost at sea, the storm subsided.

'Is Sabayil near?' they asked the sailor.

'My lords,' he said, 'we may have been carried off to a distance of two or three months.'

They sighed and said, 'We have no provisions in this boat. What's to become of us?'

'We have some slaves along,' said Tul Mast. 'We could kill them.' Ayjil refused to agree to this.

'Prince,' said Tul, 'we will all die. It would be better if even a few of us remain alive.'

When the slaves heard this, they bemoaned their fate to God's court. God had mercy on them and took the boat across the face of the water like the wind. They reached the shore by night and rejoiced. When it was daylight, Yunus the sailor got out, and it was around noon when he came back carrying something over his shoulders. He put it down in front of the comrades. It was bread and meat. They ate and said, 'Where are we?'

'This is the kingdom of Takaw,' they were told, 'the capital city of Malik Arghus. Zumurrud Shah had fled to here, and it is rumored that Tahmasp Anquil is coming, as is assistance from the city of Aaq.'

'What should be done?' they asked.

'What do you think?' asked Yunus.

'If we go into the city, Zumurrud Shah's men will recognize us.'

'My father used to come here a lot,' said Yunus. 'Come, I'll take you.'

In short, they got the boat out of the mud and dug out a sand dune in which they hid the boat, and then they set out for the city. When they were near, Yunus said, 'It is not proper for you to go into the city in these clothes. Give me some money, and I'll go to buy some clothes that are of the fashion of the people here.' They gave him money, and he left. He brought back clothes, and they put them on and went into the city. There was an uproar. They stood in a corner. Malik Kamyar appeared with a large retinue.

'Where are they going?' they asked.

'A champion from Tahmas named Mahlaj is coming with two hundred thousand men. They are going out to greet them,' they were told as the men passed by them.

Yunus took them to an inn, which the comrades entered boldly and then sat in a corner. Yunus went to the aged innkeeper. When the old man saw him he asked him how he was. Yunus asked for a room in the inn. The old man said, 'People have taken over the inn. There is no room.'

'There is a group of nobles,' Yunus said. 'It would be worth your while to let them in.' He accepted and gave them a chamber over the gate. Yunus left and brought Alamshah and his comrades. Baba Junayd came forth, and Tul Mast said, 'Put these items and carpets here until our people come.' He agreed.

The next day Yunus the sailor said to the comrades, 'Maghlub Long-Neck has come from the Aaq Desert with three hundred thousand men to help Arghus.'

'Comrades,' said Ayjil, 'we ought to think about money.'

Tul Mast gave a jewel-studded belt, and the other comrades took off what sword and dagger belts they had, as well as anything that was jewel-studded. They pounded the gold and gave it to Yunus, saying, 'Do you know anybody who can change this into money?'

Off he went to inform Baba Junayd, who went to Khwaja Nu'man.

The narrator says that this was the same Khwaja Nu'man who had given the Amir something to eat in a caravan on the road to Kharishna. The caravan men had robbed him, and the Amir had given him some jewels. In Farang he had rescued Sa'd and had been a companion of Alamshah at the foot of Marzuq's throne. By chance he had landed here and acquired untold wealth, for which he was well known in the city. Baba Junayd went to him and said, 'A group of merchants are selling gold and jewels.'

In short, he took Khwaja Nu'man to the comrades' chamber, and when Nu'man's eye lighted on Alamshah Nawjavan, he recognized him, but he said nothing, waiting for a better opportunity. He took the jewels and gold and sent them the money wrapped in a cloth. They spent a bit of the money on furnishings and to rent a house, and Khwaja Nu'man gave Baba Junayd some of the gold as a tip. Yunus made a sign, but they did not understand it until one day when Nu'man found Alamshah alone and made himself known. Alamshah rejoiced.

Thus says Wahib son of Wahab, from Mas'ud of Mecca of exalted lineage:

When Khwaja Nu'man made himself known to Alamshah Nawjavan, he rejoiced and went to Baba Junayd the caravan-serai owner and said, 'Baba, may you have your every wish. God willing, you will benefit from these youths.' And he explained about Ayjil, Alamshah, and Tul Mast. Baba rejoiced because at first the governor of the realm of Takaw had been a man named Jamshed. He had a son named Khusraw. When Jamshed died, Khusraw was made governor in his father's stead. Malik Arghus was Jamshed's sister's son, and he demanded the realm of Takaw from Khusraw. Some time after Khusraw had given the kingdom to Arghus, Arghus gave Khusraw a banquet at which he gave him a sleeping potion and threw the eighteen-year-old lad into a dungeon. This Baba Junayd was the jailer. Khusraw had a tutor named Mikal Long-Bow. He fled, and Baba Junayd accompanied him to the Zambur fortress, which was an impregnable fortification on the edge of the sea with twelve thousand men to defend it. He closed the road. Several times Malik Arghus sent his army, but they could not do anything. Finally Baba got tired of being in the fortress and sent a letter to Malik Arghus asking forgiveness for his crime. Arghus forgave him. When Baba Junayd came out, all he could do was to run a caravanserai, but Mikal Long-Bow constantly sent spies to Baba Junayd and collected whatever news there was, for he always wished that the day would come when Jamshed's son Khusraw would be released.

When he heard the names of the Iranian heroes, he rejoiced, for he had heard many good things about that nation, especially about how Zumurrud Shah had fled and come to the kingdom of Takaw and [taken refuge with] Arghus Shah.

When Khwaja Nu'man told Ayjil, Alamshah, and Tul Mast about Baba Junayd, the comrades said, 'If God grants it, we will set him free.'

One day the comrades were sitting around when an uproar broke out. Ayjil opened the little window that gave onto the market and saw that a man was heralding the following: 'Tomorrow all the men will gather at the gate of Malik Arghus's spring garden so that the champions can display their skill.'

'We would like to watch,' said Ayjil. 'Tomorrow, if God grants it, we will go, but we need a friend from the city to accompany us.' Khwaja Nu'man accepted to serve.

The next day, when the sun illuminated the world and the sound of drums and clarions came from the gate of Malik Arghus's court, all the people of the city headed out for the gate to the spring garden. Ayjil, Alamshah, and Tul Mast disguised themselves as merchants and left the caravanserai with Khwaja Nu'man, heading for the garden. Just then Malik Arghus and his son and officers appeared. When they reached them, the men stood in a corner while they passed. Then they set out for the garden. There they saw that the air, perfumed by the spring wind, was perfectly temperate, a garden to be envied.

A garden better than paradise on high, which no one could dispute.

Its redbuds were trees of coral; its rosebuds and pomegranate flowers were laughing rubies.

There was turquoise sand in its streams, and the water of life coursed across its face.

Behind the garden was a meadow of utmost beauty.

Newly sprouted greenery spread like a carpet, the subtle dew having swept the dust from the path.

The name of the garden was Fayzabad. Two arrow shots away a pavilion had been erected, and there Zumurrud Shah, Hurmuz, and all their officers sat mounted while many people were standing. Opposite the pavilion was a huge tree, and at the base of the tree was a slab of stone weighing nearly three or four thousand *maund*s.

Mahlaj mounted a horse and began to exhibit his skill in spear-throwing. A camel stuffed with sand was brought, and Mahlaj charged it and planted his spear into its side in such a way that it passed straight through. Then he picked up the camel and its load and hurled it over his head. A cheer arose from the people. Next he speared the tree so hard that it split in two.

'My Lord,' said Mahlaj, 'if anyone can pull this spear out of the tree, he will have performed a real feat.' This he said, and he dismounted.

The teller of tales of this nest of secrets thus cries out from behind the curtain:

When Mahlaj had displayed his skill, he went before Zumurrud Shah. Malik Arghus ordered gold poured over him. All applauded him, and he sat on a chair. Then Maghlub Long-Neck stretched himself to his full height and stood at the gate to the court.

Seven steel shields were brought, and he took a bow in his hand and some arrows like spears. He put an arrow as large as a shovel into his bow and shot it. It passed straight through the shields and kept on going. Everyone cheered. He sat down and said, 'I desire that my bow be passed to each and every champion, and let them all have a try.'

None of Zumurrud Shah's champions could draw the bow. Maghlub Long-Neck said, 'In all the Aaq Desert, where the men are renowned throughout the world for drawing bows and shooting arrows, no one could draw this bow or shoot this arrow.'

All the champions were amazed by the strength of this infidel's arm. Maghlub Long-Neck ordered a beautiful slave dressed in brocade to come forth and sit at the gate. Then he took an apple from the table and placed it on the slave's head. From a distance of seventy paces he shot an arrow that took the apple from the slave's head as the people cried out in glee. After that, Maghlub Long-Neck handed the bow to his servant and said, 'Go stand at the base of the tree into which Champion Mahlaj stuck his spear and from which the people tried their strength. Hold the bow and stand there. Perhaps someone among the squires or the people of the city may be found who can pull the bow.'

To Khwaja Nu'man [the comrades] said, 'Come, let's go to the tree and see whether anybody has the strength to pull the spear and the bow.' When they arrived, Ayjil said to Alamshah, 'Brother, I will try my strength against the spear. What say you?'

'If you permit me,' replied Alamshah, 'I will try my strength against the bow first.'

'Very well,' said Ayjil. Alamshah the Greek stepped forward and said to the squire who was holding the bow, 'Give me the bow so that I can have a look at it.'

He gave Alamshah the bow. That champion exerted himself and stretched it from ear to ear, snapped it three times, took some arrows, put them in the bow, and shot them so hard that they passed straight through the tree and stuck in the ground up to the feathers. Once again he exerted himself, and the bow broke at the handle. Alamshah tossed it away and said to the squire, 'Tell Maghlub not to boast any more.'

The squire picked up the broken bow and left just as Ayjil came to the tree. Mahlaj's servants were standing there. Ayjil reached out and grabbed the spear, heaved, and pulled it from the tree. Then he struck it with such force against the rock, which was lying as large as a mountain at the base of the tree, that sparks flew from the spear and the rock sank into the earth. The spear sank nearly two cubits into the rock. A shout arose from the people, and all praised the champion. One of Mahlaj's squires ran forward and grabbed Ayjil, saying, 'Come to Mahlaj to see what he says.'

'I'm not his servant,' said Ayjil, 'and I won't go to him.' The squire insisted.

'Brother,' said Ayjil, 'leave us be.'

When the people who had come from the city of Takaw and Zumurrud Shah's servants who were standing watching saw

that champion's feat, they cried out, and a group of Mahlaj's servants surrounded Ayjil. Some of the people came forward and said to Mahlaj's servants, 'Champion Mahlaj stuck his spear and Maghlub put his bow at the base of this tree as a challenge, and now this young man has performed such a feat by pulling the spear from the tree and striking the rock. If Champion Mahlaj saw this young man's strength, he should become his apprentice.'

The servant insisted, saying, 'I will take him to Mahlaj so that he can respond.'

The people parted as Khwaja Nu'man came forward, saying, 'Tell that knave who has grabbed hold of Ayjil to let go of this youth.'

The man refused, and Ayjil grew wrathful.

The narrator of this ancient tale says:

When they met Khwaja Bakhtyar, Malik Kamyar, Nimrod, Larghay Chain-Chewer, and Sharit b. Beast-Chain and explained the Amir's situation to them, Bakhtak praised Shahrashob. Then they got out of the boat, mounted, and took the news to Malik Arghus. Bakhtak said, 'Malik Arghus, good news for you: Shahrashob Ayyar has the renowned Amir Hamza in chains and has brought him by sea with Nimrod, Larghay Chain-Chewer, and Sharit b. Beast-Chain. The infidels rejoiced and ordered the drums of glad tidings to be sounded.

Khwaja Nu'man was standing at the gate, and when he heard this dreadful news he went to the caravanserai, upset and perplexed, and told Ayjil and his companions the news. They sighed and said, 'Khwaja Nu'man, you have been kind and done a courageous deed. Bring us news and let us know if the infidels make an attempt on the Sahib-Qiran's life. We will strive as long as life remains in our bodies.'

Either let us and our brothers place our feet on their necks or let us die in the attempt.

Nu'man agreed and left.

When Zumurrud Shah and Malik Arghus heard the Amir's story, they set out with Hurmuz and went to the sea shore. The guebres who were in the boat got out and joined the retinue of Zumurrud Shah, and then Shahrashob grabbed the end of the Amir's chain and pulled him out of the boat. Zumurrud Shah and all the guebres cheered and went to court, where they took their places. Then the Amir was brought in. The Sahib-Qiran frowned and sat down where he was. Khwaja Nu'man had managed somehow to get himself inside. Zumurrud Shah turned to the Amir and said, 'Come, prostrate yourself!' The Amir said, 'You dog! I have prostrated to the Almighty who created the eighteen thousand worlds.' In short, many words were exchanged between the Amir and Zumurrud Shah. In the end Zumurrud Shah ordered the Amir to be killed, but Dastur the vizier whispered in Arghus's ear, 'If Zumurrud Shah had any sense, he would not have lost his kingdom. This man is the leader of the whole army of Iran and Turan, and the champions of whom you have heard so much are in this man's service. Now, order this champion to be sent to prison so that we may see how battleworthy his men are. Whenever you want to have him killed, it will be easy enough.'

Malik Arghus went forward and said, 'O emperor of the east, to kill this man today would be simple, but I want to face his army and bring him down.'

'Arghus,' said Zumurrud Shah, 'the men who made an attack are in the city.'

'What attack?' asked Shahrashob. When he was told about it, he sighed in despair and told the story of Alamshah, Tul Mast, and Ayjil, and then he said, 'If they escape from here, we will have to rethink everything lest they rescue the Amir from our clutches.'

'Don't worry,' said Malik Arghus. 'The prison in this city is such that if a hundred thousand men were determined to break into it they would not be able to do it. Shahrashob, you

go to have a look at the prison.'

He agreed and said, 'It would be good if it were ordered that Khwaja Bakhtyar and Malik Kamyar accompany me so that we may discover the warriors.'

'So be it,' he said.

In short, the Amir was taken away to the prison. By chance the road to the prison led past the door of Baba Junayd's caravanserai, and the champions were sitting upstairs when an uproar occurred. Tul Mast opened the window and saw Shahrashob holding the Amir's chain with three or four thousand men around the Amir holding naked swords to prevent the champions from making a rescue attempt. The Amir was walking like an enraged lion and a furious elephant. The champions sighed in despair, unable to help.

In short, the Amir was taken to the prison, which was like a mountain of God's power with a dome above. The circumference of the dome was a hundred and eighty cubits, and the thickness of the walls was forty cubits. Inside a pit had been dug, and on top of that was a stone that took four hundred men to lift by handles that had been attached to it. It took forty men to move the door to the dome, and when it was closed it made such a noise that everyone in the city could hear it.

TRANSLATION FOR CAT.36
Volume 11, text number 10
MAK–Austrian Museum of Applied Arts/Contemporary Art, Vienna, B.I. 8770/35

The narrator of this ancient tale thus adorns his story:

We have described the prison. The jailer of that prison was Tamat Bear-Breast, and he had four hundred men with him. He had seven heads, and he was both night watchman and jailer. A hole had been made in the stone for passing food through.

Kamyar, Shahrashob, Bakhtak, and Zumurrud Shah's officers came. Tarut greeted them, and it took forty men to open the gate. A strange sound could be heard that startled everyone. The guebres who had come brought the prisoner, and Nimrod asked, 'Is this domed chamber the prison?'

'No,' said Tarut, 'there is a pit under the stone, and it takes four hundred men to lift it.'

'Come,' said Nimrod, 'let's try it.' No one could do it.

The Amir came forward, gave it a kick, and sent it crashing against the wall of the domed chamber. All were astonished, and they tied ropes tight around the Amir's waist and lowered him into the dungeon. Then they pulled the ropes up, and four hundred men replaced the stone over the dungeon.

Shahrashob said to Talut, 'Beware lest you let anyone into this prison.'

'Other than my own sons,' he replied, 'who could get in?' And they left the dome.

Now the Amir saw that opposite him was a naked youth whose hair had grown down to his waist. He had a loincloth around him, and his features had grown dark and drawn.

'Hello,' he said.

'Come,' said the Amir, 'and sit down.'

He sat down and asked the Amir about himself. The Sahib-Qiran recounted his story from beginning to end. Then the Amir asked him about himself.

'My name is Khusraw,' he said. 'I am the son of King Jamshed, who was the ruler of Takaw.' And he told his story.

Amir Sahib-Qiran asked, 'How many years have you been in this prison?'

'Eighteen,' he replied.

'Don't worry,' said the Amir. 'God willing, I will put you back on the throne of Takaw.'

'My lord,' he said, 'no one escapes from this prison.'

'God is generous,' said the Amir. 'Why should you be despondent?'

The narrator says that Khwaja Nu'man was in that prison when Amir Sahib-Qiran was lowered into the dungeon, and when the men left, Khwaja Nu'man told Yunus the sailor the story of the Amir and his kicking the stone. Together they went back to the inn. When they rejoined their comrades and told them the story of the Amir being put in the dungeon, the com-

rades got excited. Alamshah said, 'We must go out and do in these worthless infidels in a way that storytellers will tell of.'

Khwaja Nu'man forbade them, however, saying, 'You are only three men. There are probably six hundred thousand people in this kingdom.'

'Khwaja Nu'man,' they said, ' "A thousand of the enemy and we but one rider; vast numbers profit not an army." '

'You must be patient,' said Khwaja Nu'man. 'God is kind, and fate will play a trick so that the Sahib-Qiran may be rescued with ease.'

'We want to see the prison and check it out,' they said. 'Perhaps we can come up with a plan to rescue the Sahib-Qiran of the Age, the Warrior of Iran and Turan, Amir Hamza the Arab.'

'This too will need caution,' said Khwaja Nu'man. 'The merchants who have come with Nimrod and Shahrashob have been lodged in this inn, and every day there is communication through one of Shahrashob's men.'

They summoned Baba Junayd, who agreed to help. When it was night, they went with Nu'man to the prison gate. There was nothing they could do. 'We'll have to dig a tunnel,' they said.

'But there is a stone over the dungeon,' said Nu'man.

'So what should we do?' they asked.

'Someone will have to be sent to the Amir's army,' said he.

'Who's to go?' they asked. Yunus the sailor agreed to go. Getting the boat out of the sand, he got in the boat and set sail in the direction of Sabayil.

As for Umar, Yazak, and Sarraj the sailor, they were lost for two months. One day Sarraj climbed up to the top of the mast and saw a ship with one man in it. When it got nearer, he saw that it was his own brother. The man recognized Yunus and came to Umar. Sarraj told his story, and Yunus recounted the story of the Amir. Umar rejoiced and sent him on his way while he himself proceeded until a huge mountain and fortress came into view. Umar rejoiced.

TRANSLATION FOR CAT.37
Volume 11, text number 11
MAK–Austrian Museum of Applied Arts/Contemporary Art, Vienna, B.I. 8770/54

The master narrator, who could deceive Mani, bedecked the bride of speech in this manner.

When Khwaja Umar saw the fortress, he rejoiced and said, 'Sarraj, it is a good thing we reached an inhabited place.' Sarraj shook his head. Khwaja Umar asked him why he was dejected, saying, 'Commander, what is this confusion that has come over you?'

'This is a bad place we have come to,' he said.

'Why?' asked Umar.

'In this fortress is a champion who is a rebel against all the world. Anyone who comes here loses his possessions and his head.'

Umar sighed deeply and said, 'But you knew why you came.'

'At first I didn't know,' he replied, 'but when I saw it, I was certain.'

Just then a group came down from the fortress and said, 'Champion Mikal Long-Bow summons you.'

Umar picked up a jewel casket and set forth. He saw a strange road that by no means and by no force could be [taken]. He went until he saw a castellan at the gate. He went before Mikal. He was an old man, firm in his power and surrounded by servants. His eye fell upon Umar. He rose, bowed, and greeted him. He took Umar by the hand and indicated a place next to himself. Umar placed the casket of jewels on the floor and apologized [for having nothing more to offer].

Mikal recounted his story from beginning to end, saying, 'I want to join the Amir. Perhaps I will succeed. Recently I have heard that the Amir was in chains in Takaw, and I heard that some of the heroes of Iran had seen action. I sent someone, thinking that he might be able to find them so that together we might do battle. However, tonight I saw in a dream that someone was saying to me that tomorrow a ship would appear and the owner of the ship would grant my wish. Now I have seen you. Tell me about yourself.'

Umar rejoiced and recounted his adventures.

'I have an *ayyar* who went to Takaw to gather news,' Mikal said. 'He will return soon. You wait until he comes.'

Umar said, 'With the Amir in chains, how can I sit still?' And just then an *ayyar* was announced. He rejoiced and recounted his story. Then Mikal said, 'What news have you?'

'From the Saffron Desert comes a Zangi with two thousand men,' he said. 'He is called Lung Zangi.'

'What news have you of the Amir?' he asked.

'He is in chains with Khusraw.'

Mikal said, 'Meet this youth.' And he recounted Umar's story. [The *ayyar*] placed his forehead at Umar's feet.

'O *ayyar*, how is the road to Takaw and how long is it?' asked Umar.

'Ten days,' he replied, 'but it is a difficult road. Since you have animals you should go by sea and stay in a caravanserai where we have a friend called Baba Junayd. We have sent him there to spy. I go there and he tells me whatever news there is. However, the last time I went he told me to be courageous because our prince would soon be released. No matter how much I insisted, he would not say [more].'

Mikal said, 'Did you see the youths who made an attack?'

'No matter how much I searched for them, I could not find them,' he said.

'Which caravanserai is near the prison?' asked Umar.

'The very caravanserai where Baba Junayd is,' he replied.

'If you were to come along, it would be good,' said Umar.

'You are going by sea,' he replied, 'while I go by land.'

Umar bade Mikal farewell, got in the boat, and set forth. In five days he arrived. The customs officers stopped him and took customs duties on Umar's goods. Umar was very pleasant to them and said, 'I am a stranger. Can you show me the way to the caravanserai?' They sent one of their men, and they arrived at the door of the caravanserai. They saw Baba Junayd seated on the girthing platform. The customs man came and greeted him, saying, 'This is a good man. Give him a good place.'

'Fellow,' he cried out, 'am I a servant of the customs officer? How am I to find any room here?'

The customs servant said, 'Khwaja, we have spoken and heard. The rest is up to you.' This he said and departed.

Umar came forward and said hello. Baba replied with a frown. Umar threw a handful of gold before Baba and said, 'We have come out of love for you.'

'Am I a beautiful youth that you would come to see me?' replied Baba. 'I can do nothing for you. Pick up your gold and go in peace, for there is no room.' Umar left the caravanserai, seeing that Baba Junayd was in a bad mood.

Nu'man saw a merchant standing there with many well-laden animals, and Baba Junayd was being rough with the merchant.

'Baba, what's wrong?' asked Nu'man.

'This man is looking for a place to stay,' he said, 'and I have no room. No matter how many times I tell him, it doesn't do any good.'

Umar stood up. Nu'man saw him and bowed. [Nu'man] was ashamed and said, 'There is no reason to be rude to people. Sir, I will give you a room.' He took Khwaja Umar by the arm and gave him two rooms. Umar dressed himself as a merchant. Nu'man said apologetically, 'I am at your service.'

Umar said, 'Service should be rendered by us.' He unloaded his goods and said to Yazak, 'Summon Baba Junayd and'

TRANSLATION FOR CAT.38
Volume 11, text number 20
Seattle Art Museum, 68.160

The narrator of this ancient tale relates thus from the truthful:

One day the Amir of the Arabs and Umar Ayyar were walking around the Armanus fortress. While they were walking, they came across the Jahannuma Tower. By chance Ghazanfar was atop the tower drinking wine with a group of ill-starred infidels. When his gaze fell upon the Amir and Umar, he cursed them loudly. Umar cursed him in return, but the Amir said, 'If you are a man, come down and let us grapple to see who will win a match of courage.' This displeased Ghazanfar, and he

immediately went down from the tower, and as he approached the Sahib-Qiran he aimed a blow with his sword at the Amir's head. As the sword was coming down the Amir stretched out his champion's hand and tightened his grip on the pommel of his sword, and as he attacked he drew his sword and said, 'Take this!' Ghazanfar raised his shield over his head. The Amir reached under the shield, grabbed his collar, and pulled him down to his knees. With his other hand the Amir reached for the dagger in his belt, lifted Ghazanfar from the ground, lifted him up, and then hurled him to the ground so hard that his vile body lay flat. The Amir then tied his hands and neck. Still Ghazanfar refused to give up and cursed repeatedly.

Umar cut his tongue out and made the Amir look like Ghazanfar and Ghazanfar look like the Amir. Then he turned the Amir look-alike over to the Amir, who took him to the gate of the Armanus fortress and cried out, 'It's me, Ghazanfar. Open the gate. Hamza is my prisoner.' The infidels opened the gate and let the Amir in. When it was daylight Amir Hamza took his look-alike to Zumurrud Shah and a group of guebres. Zumurrud Shah ordered the look-alike to be killed. He was cut to pieces on the spot. Then the Sahib-Qiran revealed his blessed name and shouted out 'Allahu akbar!' so loud that the Armanus fortress trembled.

The Amir's army was lying in ambush. The drums were sounded, and Badi' and Malik Qasim were there. They destroyed the defensive wall, and Zumurrud Shah and his army fled. The Amir conquered the fortress, overthrowing the rebellious and establishing a mosque and pulpit. Muzaffar of Armanus became a sincere Muslim, and the people of the city were converted.

When Zumurrud Shah reached the place where his men had been taken and learned what had happened, he got so upset he almost went mad. He stopped there since half the night had elapsed. Manzur Kamran's sons and twenty thousand soldiers took Zumurrud Shah and all his amirs, and the next morning they set out for the city of Samaria. As the sun was rising Manzur Kamran with his thirty thousand men bowed his head before Zumurrud Shah and knelt seven times with glee. Zumurrud Shah showed him great favor, saying, 'What action was this that you performed? Were you afraid of the countenance of the king of the east?'

That guebre said, 'I was insulted because you did not count my men.' He apologized and took him to the city, where he gave them money and made preparations to do battle with the Amir. He summoned Mushak Ayyar and sent him to the Armanus fortress to get news. Mushak disguised himself as a peasant, slung a shovel over his shoulder, and set forth. The Sahib-Qiran had also dispatched Umar to get news of Zumurrud Shah. Along the way he encountered Mushak Ayyar.

'Who are you, where are you coming from, and where are you going?' he asked.

'I am called Baba Musafir the gardener,' he replied. 'Two leagues from here I have an orchard called Sarvistan. I am going to tend my orchard.' He also gave him news of Zumurrud Shah, at which Umar rejoiced and asked for water. Mushak brought some poisoned water and gave it to Umar. Umar drank it and lost consciousness. Mushak seized Umar and took him to Manzur Kamran.

'Say nothing until I bring Amir Hamza too,' he said. Off he went, but he was captured at the Amir's gate by Muqbil, who took him to the Amir. The Amir ordered him imprisoned.

As for Khwaja Umar, he pronounced prayers for the Prophet and escaped his bonds. Cutting off the beards of Manzur Kamran and all his officers and commanders, he escaped. Thereafter the fortunes of the guebres of Iran changed.

TRANSLATIONS FOR CAT.39

Volume 11, text number 21
MAK–Austrian Museum of Applied Arts/Contemporary Art, Vienna, B.I. 8770/23

The writer of this felicitous material reminds us thus from his ancient folder:

When Khwaja Umar joined the Amir, in thanks the Sahib-Qiran freed Mushak Ayyar. Mushak went to Zumurrud Shah and told him everything that had happened. Ashkhas Blood-Quaffer and A'raz Blood-Drinker and twenty thousand renowned guebres went to the wall of Samaria, made it as strong as Alexander's dam, and sat waiting.

From the other direction the Sahib-Qiran summoned Pahlavan Muzaffar of Armanus and gave him the goblet of ambassadorship. He quaffed the goblet respectfully, kissed the ground politely, and handed the goblet to the *saqi*. The Amir gave him a letter, saying, 'Hand this to Manzur Kamran and bring back his correct reply. Remember that anyone who has taken a letter of ours anywhere has brought back a correct reply.'

'I will do it willingly,' he said and departed with twenty thousand men for the wall of Samaria. When he approached the wall, he saw A'raz and Ashkhas, and he went to Zumurrud Shah accompanied by them. Zumurrud Shah ordered him seized and strung up by a rope under his arms, and his men were also imprisoned. When the Sahib-Qiran heard this, he dispatched Jumhur with thirty thousand pike-bearers to help Muzaffar. He lost his way, but the next morning he encountered Zumurrud Shah's army. Attacking, he brought down many and battled heroically. He was wounded, and all his men, together with his nineteen brothers, were captured. Aside from Jumhur, all were executed and their heads were sent to Malik Bakhtar.

Umar came during the night and made a good sneak attack to rescue Jumhur, but no matter how hard he tried he could not rescue Muzaffar. He took Jumhur before the Amir, and the Amir questioned him. Then he set off in the direction of the wall. When the sons of Manzur Kamran seized Muzaffar and went to their father the amir, they and their soldiers passed by the wall of Samaria, and when they were opposite Manzur Kamran, the sons of Adilshah came from the right wing, and everyone to whom a letter had been sent came, arriving from all directions and advancing into the field. Many were killed. Harith came out and killed him, and a pitched battle ensued. Harith was lassoed during the battle, tied up inside a coffin, and sent to the city of Anamila. Umar learned of this and brought the news to the Amir, who dispatched Malik Qasim and thirty thousand men from the rear. When the coffin arrived in the city it was buried, and they said they would kill Harith four days later.

Adilshah had a daughter named Turfa Banu. She fell in love with Harith and sent a message to her father, saying, 'Send me that God-worshipper so that I can take revenge on him for my brother.' He was sent to her, and she released Harith during the night, and the two of them mounted fleet-footed steeds and left the city, riding until they came to the fortress of Sabran. The warden of the fortress was Azim Kohpara, a relative of Adilshah's. He too was in love with the girl. She sent a messenger to him to say, 'I have come for your sake.' He opened the gate and let the girl into the fortress. Harith seized him and made the men in the fortress convert to Islam. Some of the men escaped and took the news to Adilshah. Azban Strongform and Rajman Strongform went out, but Malik Qasim killed them. Azim became a Muslim.

Adilshah came with eighty thousand men. Umar b. Rustam and Umar Ayyar came to reinforce Malik Qasim. Battle lines were drawn. Anqah Red-Mustache advanced into the field, and so did Qasim. He killed Barraq Blood-Shedder, Ashkas Blood-Quaffer, Asma High-Flyer, and Qila' Butterfly. Adilshah became a Muslim out of fear and gave his daughter to Harith. The men of the city were also converted.

Umar set out first to take the news. The next day they all arrived to pay homage to the Amir, who released Manzur Kamran, who went out in pursuit of Zumurrud Shah. He captured Zumurrud Shah's treasury and arms, and then he went before the Amir and became a Muslim. The Amir sent out spies to found out where Zumurrud Shah was.

Volume 11, text number 22
Brooklyn Museum of Art, New York, 24.48

The victorious one of this felicitous army thus narrates from the battlefield.

When Zumurrud Shah the Lost came out alone from the battlefield and traveled until it was night, he was on the road that night. The next day too he was on the road. In brief, he traveled for eight days, and on the ninth day he came to the foot of a mountain that was so high it was level with the celestial sphere. He dismounted and spent that day beside a spring hunting meat. The next day Blood-Drinker and Shining Ruby arrived and joined Zumurrud Shah. On the third day the amirs all gathered, and nearly a hundred thousand men joined him, like Darab Ocean-Eye, Asaf Lion-Eater, Qahraman Devhara, Suhayl ..., Larghay Chain-Chewer, Suhayl Star-Eye, Sabah b. Silsila, Qahr b. Sabak, Simak Dragon-Catcher, Lajja Panther-Skin, Siyah-Pil Aad, Azhar Elephant-Slinger, Mazhar Elephant-Slinger, Harz Noshirvan, Bakhtak, Gav-Lungi Cow-Rider, Malik Kayvan, Malik Kayfur High-Star, and Mihran Blood-Drinker. When these arrived, Zumurrud Shah asked them, 'What is the best course of action? We have to go somewhere.' Yaqut came forward, bowed, and said, 'You have commanded that we go to the city of Noshad, and this road leads to the city of Noshad and the foot of Anquil Demon-Nurturer's throne.' When Zumurrud Shah heard this, he was upset and said, 'He will be angry with us because his slave was killed by Marzuban.' Yaqut Shah bowed again and said, 'Our allegiance to you is not so great that if his sons are killed he will refuse to meet Bakhtar. It is also known to you that in all the realm of Bakhtar you have no supporters like Anquil Demon-Nurturer and his sons, and at present no one is as brave and courageous as he. When you come in full glory, it will not be manly for them not to face you.'

Zumurrud Shah sent him a messenger and was happy. That day the drum of good news was sounded. The next day he came out with three hundred thousand men and did obeisance to Zumurrud Shah at Gulrez Spring.

Zumurrud Shah passed by the gate, and when he decamped from Gulrez Spring and came with the king to the city of Noshad, Anquil and his ministers came and paid homage to Zumurrud Shah. The like of Ku ... Tiger-Tooth, Arabi Man-Overthrower, Muhimm Glory-Death, Ghantus Elephant-Strength, Arrad Donkey-Forehead, Misda' Cow-Skin, Afsar Cow-Skin, Afsar's son Mihlal, Sharah's son Mirrikh, and Mihlil's son Qimal came, paid homage, bowed down before that wrong-wayed one, and took him into the city of Noshad. Zumurrud Shah was afraid of the Amir. Anquil sent Qam-Hara to block the Amir's way.

The narrator now says that on the way was a river that was difficult to cross other than by a bridge, and on both sides of the river a tunnel had been dug. Water tumbled down from the top of the mountain, and it was so rocky that no one could traverse it. In olden times there had been no road through the rocks, but a road had been cut so that it was possible to go easily along the edge of the water. Facing this road a fortress had been built, and when the fortress was manned it was difficult to cross the water. Behind the fortress another gate had been constructed and another tunnel cut such that water from the moat of the fortress spilled into the tunnel and then entered a garden where buildings had been constructed. When the water left there it went to the skirt of a second fortress and then to the lands of Noshad. Anquil said, 'Be easy of mind. The road by which you have come cannot be traversed by all the armies of the world if we so choose. Let Zarnab and Surkhab go and man the city gates.' They went. The people went out and set up camp on the edge of the water.

The next day the Amir said to Umar Ma'di, 'You go.' Jasus brought news of Zumurrud Shah. He departed, and the Amir set forth. However, when Ma'di arrived there he saw no road. He dismounted and sent word to the Amir. That night Zarnab came out and made a surprise attack. Umar Ma'di was wounded ... came and Karb was near. He came and captured Zarnab, and Surkhab was greatly saddened by the capture of his companion. He sent a messenger to Anquil Shah to report everything that had happened.

TRANSLATION FOR CAT.40 AND 41

Volume 11, text number 23
MAK–Austrian Museum of Applied Arts/Contemporary Art, Vienna, B.I. 8770/39

The wise and learned scribe thus adorned camphor with ambergris:

At the time that Umar Ma'dikarb's letter arrived and the Sahib-Qiran learned of its contents, he got upset and angry and immediately placed his foot in the stirrup, accompanied by his ministers of state, and rode forth. Umar was at his side until they reached the sea shore, and there they saw a gate and wall so huge that they were astonished. Turning to Umar, the Amir said, 'Can this wall be taken? It cannot be conquered by force.' Turning back, they dismounted, and Alqama son of Jumhur and Marzang b. Marzban accepted to battle the wall with their sixty thousand men. The Amir happily dismissed them, and they dismounted on the sea shore, arrayed their lines, and beat the battle drums. No one came out, and the bridge was not opened across the moat.

The next day the sound of drums of rejoicing came from the wall. When it was investigated it was learned that when Surkhab came out and went around, when his *ayyar* came at night and he wrote a report of his condition to Anquil. He sent Marku' Boar-Tooth with seventy thousand men to reinforce the wall. That guebre arrived on the day the drums were sounded. When Marku' saw the army of God-worshippers arrayed opposite, and the defenders of the wall standing, he was perplexed. Angrily he said, 'Lower the bridge over the moat!' Immediately the bridge was rolled out, and when he was in place that guebre went out with thirty thousand men and crossed the water. Battle drums were beaten, and when he reached the field, he called for a contest. Several soldiers of Islam were unhorsed by that wretch, and then Alqama came out, but he returned wounded. Marku' went back into the fortress and spent that night in revelry. The next morning when the drums were sounded he went back out into the field and called for an opponent. Ibrahim Malik entered the arena and returned wounded. Spies brought information to the Sahib-Qiran, and he employed himself to see what the outcome would be. He sent Landhaur's son Arshivan to assist them. The next day Marku' Boar-Tooth went out. Marzang and Arshivan arrived and arrayed their ranks opposite the forces of Marku' Boar-Tooth. When his gaze fell upon that cavalier of religion, he stood in their way, and Arshivan also stood in his path. They engaged in combat with spears and then with maces, but neither one achieved a victory. Arshivan saw that he was up against a mean guebre: no matter how hard he tried he could not get anywhere. Finally he was wounded by Marku', and the guebre rode off, and when he looked at the tip of his blade he saw that it was drenched in blood and he rejoiced. Turning around, he saw that Arshivan was going toward his soldiers. 'God-worshipper,' he shouted, 'where are you going? Stay where you are. I'm coming.' All at once Marzang b. Marzban arrived with a heavy mace and said, 'You bastard, let this wounded man go!' When Marku' heard this he turned around, stood in Marzang's path, and aimed a blow with his sword at that champion. Marzang was wounded, and then, without warning, by God's command and infinite grace, a young veiled hero stepped forth. Entering the field, he stood in that infidel's path. The treacherous guebre aimed a sword blow at the veiled youth's head, but the prince raised his shield, and as the sword came down, he grabbed the guebre's wrist. Try as he might, the guebre was unable to wrest his hand and sword from the youth's grasp. With one swift motion he pulled the sword from his hand and said, 'Take that!' The guebre raised his shield over his head, but the warrior struck him so hard across his middle that, despite all his armor, he was cut in two. All the guebre's men hurled themselves into the water and ran away. The news was conveyed to the Amir, who rejoiced and sent someone after the youth. He was Kayhan b. Rustam. The next day he came and paid homage to the Amir, who assigned him a place next to himself. The prince kissed the ground politely and sat down

He accepted the task of taking the wall.

When Marku' was killed, Surkhab and Zarnab became angry and wrote a letter to Anquil. At this point Nawroz Ayyar came from Anquil and said, 'Let me across the wall. Perhaps I can achieve something.' Thus they did. By night he went to Kayhan's tent, rendered him unconscious, and stole him away.

TRANSLATION FOR CAT.42

Volume 11, text number 24
MAK–Austrian Museum of Applied Arts/Contemporary Art, Vienna, B.I. 8770/37

The embroiderer of the ancient tale thus adorned the stature of speech:

When news of Prince Kayhan b. Rustam's capture reached the Amir, he grew very angry. Immediately summoning Khwaja Umar, he sent him to the river bank at the wall, but as he rode up and down he could find no way to get across. Returning to the Amir, he explained the situation. At that time the lion of the forest of battle, the crocodile of the river of Iran, Prince Badi'uzzaman, stood up and volunteered to take the wall. The Amir gave him leave, and he departed from the Solomonic court. Qasim also went to assist Badi'uzzaman. The Amir said happily,

May your labor always be distressing to outlanders; your labor is good: may God befriend you.

When he heard this, he kissed the ground politely and departed. The two went with sixty thousand renowned warriors until they dismounted next to that river that was like a dragon's breath and contemplated how to take the wall.

The next day they ordered boats to be constructed, and several days later they were ready. Putting the warriors in the boats, they sent them around the wall. When the infidels saw the boats, they bombarded them with heavy stones and sunk them into the river. Seeing this, Qasim and Badi' were perplexed. That very day Gumyad Man-Eater came from Anquil. The next day he crossed the wall's moat with a troop of renowned infidels and, entering the field, he called for combat. The lion of the forest of Turan, the crocodile of the river of the east, the brave Malik Qasim, stood in front of the man-eater. The guebre fought mightily. In the end he was killed by Malik Qasim, and his men were driven into the river.

Badi' ordered a chest constructed, and its joints were sealed so that water would not enter it. The valiant Prince Badi' armed himself and ordered the lid of the chest to be fastened and the chest to be thrown into the river. 'The Amir should be informed,' the attendants said. 'Don't tell him,' he said, and they complied.

When Qasim heard this dreadful news he grew pained and contemplative, and after much thought he hurled himself into the river and set out in pursuit of the chest. He swam mightily, but he went under and was in fear of drowning when suddenly, by God's command, he saw a tree floating on the water. The prince got himself to the tree, grabbed hold of it, and got on it and thanked God. Then he reached the cavern from which the water of the river emerged. He struggled hard to get into the cavern with the tree, and he paddled up the cavern until he emerged the next morning into a garden that would remind one of the garden of Paradise. Making his way to the bank, he pulled himself out. After drying his clothes, he was putting them back on when he heard the sound of girlish laughter. Looking up, he saw a group of girls, and in their midst was a beauty the likes of whom he had never seen before. When the girl spied the shah of the orient, she too was smitten. The other girls became aware and asked, 'What has happened to you?' She replied,

The delight of love has gone into my fiber and veins. I call it love, and I would give my life for its pleasure.

After a while, when the girl regained consciousness, she summoned Malik Qasim to her side and asked him about himself. 'Might I inquire who you are so that I may speak with that knowledge?'

'I am the daughter of Malik Surkhab,' she said.

'I am the son of Amir Hamza, the Sahib-Qiran of the age,' said Qasim.

A robe was brought for Malik Qasim. He put it on, and they went into the palace. Wine was served, and when they had drunk several goblets, the girl asked Malik Qasim, 'Where are you headed with such magnificence?'

'I have come to take the wall,' he said.

'How will you take the wall without an army?' she asked.

'You become a Muslim and see what I will do to those people,' said Qasim.

'Accept me as your slave, and I will become Muslim,' she said.

'God willing,' replied Qasim, 'when victory will have been achieved I will marry you legally.' And she became Muslim.

TRANSLATION FOR CAT.43

Volume 11, text number 25
MAK–Austrian Museum of Applied Arts/Contemporary Art, Vienna, B.I. 8770/50

The assessor of this pleasing pattern thus held up a specimen of verbal design:

When Badi'uzzaman got into the chest and it was thrown into the water, the water carried him away until the chest was taken out of the water. When the chest was opened, he leapt out with a helmet as brilliant as the sun on his head and a sword and shield in his hands and set out toward Khizrim. Placing his feet firmly on the ground, he stood. Khizrim asked, 'O youth, who are you?'

'I am Badi'uzzaman, the son of Amir Hamza and scourge of Malik Bakhtar,' he said.

When he heard the name Badi'uzzaman, Malik Samaruq was startled and said, 'O Iranian, what are you saying?' And so saying, he aimed a sword blow at Badi'uzzaman's head, but Badi'uzzaman rushed forward, stretched forth his warrior's hand, and grabbed his wrist and the pommel of his sword. With one heroic movement he took the sword from his hand and said, 'Take that!' He raised his shield, but Badi' struck him in the head, and the sword went through his skull as though it were a ripe gourd and split him in two down to his belt. A groan came from that guebre as he fell. Just then his brother Kiaruq came and wielded his sword. The prince responded and dispatched him to hell too. There were three hundred men with him, and they all converted to Islam. One of them went to take the news to Zarnab. He set out to find Badi'uzzaman, but Badi'uzzaman and Khizrim had also set forth to Zarnab's kingdom to face him. When they met, battle lines were drawn, and Khizrim went into the field and said to his father, 'Become a Muslim, for I have become one.' The father waxed angry and wounded his son. Badi'uzzaman, brave champion of Amir Hamza Sahib-Qiran, entered the field and seized him, and he became a sincere Muslim.

When they went to the bridge, the men who had run away had informed Surkhab. They made fast the gate. The battlefield on the way to the mountain was too narrow, and the moat was a hundred cubits wide. Anyway, a messenger was sent to the Amir, and when he came next to the wall and asked about Kayhan b. Rustam, they said, 'Nawroz Ayyar Yaqut kidnapped him.' Then the Amir asked about Malik Qasim. 'There is no sign of him,' they said. The Amir was greatly saddened and fell into contemplation.

As for Malik Qasim, he spent the entire day drinking wine. That night he called for his battle gear, armed himself, and went to the wall, where there were many men standing. Malik Qasim got off his horse and stood. Behind the gate he saw a platform, so he headed for it. Malik Surkhab was seated there, and Gabr was telling Malik Surkhab the story about Badi'uzzaman's coming. Surkhab got quite upset over the news and said, 'I wonder who could have led him to the wall.' Just then Malik Qasim stepped forward and said, 'O malik, the same person who took Badi'uzzaman to the wall brought me here.'

When Surkhab heard this, he said, 'O youth, who are you to speak thus?'

'I am the crocodile of the river of the east, Malik Qasim the brave,' he replied.

Gabr Bakhtari went forward and extended his hand to grab Qasim by the collar, but that warrior knocked his arm away

and grabbed him by the collar instead. Gabr went down on both knees before the prince, who reached with his other hand and seized Gabr's belt, lifted him from the ground, and held him aloft for Surkhab to see. Then he spun him around twice and dashed him to the ground so hard that he lay flat. Then he bound him by the neck. Surkhab leapt up from his place and said, 'O brave warrior, tell me about yourself and how you came to this wall, and in return we will do whatever you say.'

The prince explained how he came there. Then Surkhab and his army of sixty thousand renowned guebres submitted to Islam. Surkhab's brother and his thirty thousand soldiers also converted.

TRANSLATION FOR CAT.44

Volume 11, text number 26
Cincinnati Art Museum, Gift of John W. Warrington, 1948.192

The embroiderer of the brocaded pattern wove a legend thus on his China silk:

Prior to this the king of the orient drank wine, and when it was night he called for his weapons. Malik Qasim got completely armed and set out for the barrier. When he got there, he saw that there was a bridge erected at the gate of the barrier and on it were seated several people. On the other side of the bridge were standing many people, but no one was paying any attention to anyone else. Qasim crossed the bridge, dismounted, and started forward. He saw that outside the gate in the barrier was erected a throne, and Malik Surkhab was sitting on the throne with a group of people. There was a famous guebre named Qamhal Dragon-Breath. First he told Malik Surkhab the story of Prince Badi''s coming to the barrier. He was astonished and asked who brought him to the barrier. Malik Qasim stepped forward and said, 'That same noble one who brought him to the barrier has also brought me.'

Qamhal Dragon-Breath stepped forward and said, 'O unlucky Iranian, what are you saying? What has come to your mind? Do you imagine that there is no one at this barrier who can stop you?' He extended his hand to take hold of Qasim's collar. The lion of the east was quicker in stretching out his lion's claw and taking hold of his collar, and he struck him such a blow that his skull was broken open and all his brains spilled out on the ground. Qamhal's brother, Qamhur Blade-Wielder, stepped in front of Malik Qasim and aimed a blow with his sword at Qasim's head, but the prince struck the back of the blade with his own sword and broke it in two. Then he struck another blow at his waist that cut him in two.

Then he faced Malik Surkhab and said, 'O guebre, what say you of that God who brought me to this barrier and of the victory I have achieved?'

Surkhab said, 'I knew that your God was right. Tell me how you came to this barrier.' Qasim explained how he had come. Surkhab sincerely became a Muslim, and his ministers joined him in converting to Islam.

For six days Malik Qasim was at the barrier, and Surkhab gave Malik Qasim many banquets, and he presented his daughter with many spoils of battle. On the seventh day they left the barrier and rejoined the Amir and showed the gifts he had brought to Umar Ma'dikarb. Together with Umar Ma'di and Khwaja Umar Ayyar he brought them before the Amir. Malik Surkhab greeted the Amir. The Amir rejoiced, summoned Malik Qasim, and embraced him, kissing him on the forehead and saying, 'Well done, my son. You have done an excellent deed.'

He summoned Malik Surkhab forth and honored him with a bestowal of royal garb. Surkhab gave the Amir the key to the barrier. The Amir gave the key to Umar Ma'dikarb. On that day Umar Ma'dikarb took the banner of generalship on his shoulder and, with his eighteen brothers of renown, thirty thousand spear-wielding Arabs, and thirty thousand swift-paced, raven-eyed two-humped camels [took] the Solomonic court with four hundred tents and four thousand canopies and crossed the barrier. On the other side of the barrier he saw a hill. He charged up the hill, and a place of bucolic loveliness

appeared. He stuck his general's spear into the ground, and at once twelve thousand strong-armed elephanteers leapt from their Bardaian camels and prostrated themselves on the ground. At once they leveled the hill. Twelve thousand *farrashes* also dismounted and at once set up the Solomonic court.

The next day the champions and heroes of the army of Islam set forth with thirty thousand of their relatives. When the overseer of the court had crossed, the next day the sultan of the western throne and Mundhir Shah of the Yemen crossed with two hundred thousand men. Behind them came Prince Nuruddahr and Malik Qasim's men. After them the kings of the east like Jamshed Golden-Quiver and Khwarshed Golden-Quiver crossed with two hundred thousand men. The next day Prince Badi'uzzaman's men and the princes of Mazandaran like Shah Shams and Shah Badr crossed with eighty thousand men. The next day Khwaja Umar's *ayyars* crossed with their treasury and camp. The next day the Amir's ministers crossed with the ladies of the harem, and the next day Alexander's drum and the instruments of the royal band all crossed. The world-conquering Amir crossed with his renowned sons and army and camped on the other side of the barrier.

TRANSLATIONS FOR CAT.45

Volume 11, text number 27
MAK–Austrian Museum of Applied Arts/Contemporary Art, Vienna, B.I. 8770/34

The narrator says:

The host of the banquet of peerlessness, Umar son of Umayya Zamiri, sought leave from the Sahib-Qiran to go to the Salija Fortress, by saying, 'Malik Kayhan b. Rustam is being held. If I have your permission to go there, perhaps through your fortune I will be able to effect something.' The Sahib-Qiran gave him leave.

Khwaja Umar set out with Yazak and Barakh Farangi, and when he reached the vicinity of the fortress of Salija, he saw an old man who had gathered a lot of firewood and was bundling it up with the help of two youths and loading it on donkeys. Khwaja Umar went up to him and greeted him. The old man replied.

'Are you a woodcutter?' Khwaja Umar asked.

'Yes,' said the old man.

Khwaja Umar reached into the *ayyar*'s satchel and took out a few dates and gave them to them. When they had eaten them, Umar asked, 'Where is your home?'

'In the Salija Fortress,' he said.

'It has been heard,' said Umar, 'that Amir Hamza's son is in there. Is it true?'

'Yes,' said the old man.

'Have they killed him,' asked Umar, 'or is he still alive?'

'He is in chains,' said he.

'Are you married?' asked Umar.

'Yes,' he replied. 'These two young men you see are my sons.'

'What is your name?' Umar asked.

'Zarmina,' he said, and he also told him the names of his sons.

After a few moments [the dates] the old man and his two sons [had eaten] rendered them unconscious. Umar took them and put them in a place no one would go. Then he disguised himself as the old woodcutter with an axe in his hand, and the other two *ayyars* disguised themselves as the two sons. After loading the donkeys, Umar drove them forward. Since the donkeys had often traveled the road they went straight to the gate of the old man's house. Umar entered. The woodcutter's old wife had prepared a meal she served him, and he ate a few morsels. When it was past midnight Umar armed himself from head to toe and went to the prison gate. There he saw that all the guards were asleep, so he put a sleeping potion in their noses and rendered them all unconscious, and thus he rescued Prince Kayhan. They attacked Mardas, and he became Muslim. The men of the fortress also converted to Islam.

After that Khwaja Umar brought Zarmina and his sons back and gave them much booty. Mardas stationed someone at the Salija Fortress and then went with five thousand men

to serve the prince and Khwaja Umar, and together they went to pay homage to the Sahib-Qiran.

The world-conquering Amir summoned Mardas forward, garbed him in princely raiment, awarded him much booty, and assigned him the governorship of the Salija Fortress. He kissed the ground politely and said,

'May your every labor be successful. May the lord of the world protect you.'

The Amir said, 'Go arm your soldiers and come tomorrow morning with Prince Kayhan, for I am mounting a campaign against Anquil Demon-Nurturer.' He kissed the ground politely and went to tend to his business.

The next day the world-conquering Amir led his army out against the benighted infidel Anquil. When they dismounted opposite each other, suddenly news came that Ta'us Shah was coming from Ta'usiya with four hundred thousand horsemen. The Sahib-Qiran, he who puts slave ings in the ears of his opponents, Amir Hamza, summoned the pride of the seven prophets of God and said, 'O rarity of the age, they say Tahmasp's men are great champions, and there are some in our camp who are hot-headed and immoderate. I hope nothing happens that would cause us concern.'

'What should be done?' asked Khwaja Umar.

'Some of these renowned warriors should be dispatched to block Ta'us Shah's way,' said the Amir of the Arabs.

'It is yours to command,' replied Umar.

Immediately the Sahib-Qiran ordered Prince Alamshah, Badi'uzzaman the brave, Hashim, and Harith to go out against him. He also assigned Asad Karb to guard the harem, which was in Qaytul, but the arms-bearers said, 'When the goods were being loaded in boats the Amir's armor chest fell into the water.' The Amir sent the hot-headed bloodshedder Malik Qasim to look for the chest and armor.

Volume 11, text number 29
MAK–Austrian Museum of Applied Arts/Contemporary Art, Vienna, B.I. 8770/49

The arrayer of this felicitous army thus spurred his steed into the arena:

The narrator says Hazabran Shadid had an *ayyar* named Ashi''a. Hazabran said, 'You can go get some of the God-worshippers' scouting party and lead them into our trap. We will be waiting in ambush in the gulch.' Ashi''a accepted the mission and set out. When he got near the scouts, he hit himself on the nose with a brick and bloodied his chest. Then, wailing and weeping, he ran to Farrukhsawar. By chance, Prince Farrukh had gone a little away from the vanguard with five hundred men looking for a good camp site, and they had just dismounted when the crafty *ayyar* arrived. When the prince saw him he asked him what had happened to him.

'We are merchants,' he said. 'Thieves set upon us and made me thus. For God's sake, help me!' Then he said,

'In justice come to my aid, for today I see no one other than you to respond to my plea.'

Since the prince was chivalrous, he and his five hundred men armed themselves and set forth as the cunning *ayyar* led them forward. When he reached the gulch he ran up on a hill and cried out the name of Zumurrud Shah the infidel. Hazabran and his thirty thousand men sprang from ambush and blocked the way against the prince of renown.

'Who are you?' he asked.

'Whoever I am, I am the slave of God,' he answered.

'You are a God-worshipper,' he said. 'To kill you would be a deed of merit.'

Just then Ashi''a Ayyar came and told Hazabran the prince's name, at which they grabbed their spears. The prince warded off their blows. With every blow Hazabran writhed like a snake, and then he reached for his cow-headed mace and struck with it. The mace came down on the prince's head. The prince stretched forth his warrior's hand and grabbed the shaft of the mace. With one swift motion he wrenched it from Hazabran's hand, but he too was quick to reach for his sharp sword. The prince threw the cow-headed mace down and

grabbed the pommel of his sword and snatched it from his hand, saying, 'Take that!' And quickly he hit him on the head with the sword and clove him in two down to his chest.

Even when the guebre was killed and night fell, his men were still unaware and kept on fighting. As dawn broke, Paykan the spy, Farrukhsawar's *ayyar*, went to inform the men of the vanguard. They came, and the guebres fled. Farrukhsawar sent Hazabran's head to the Amir, and the next day the battle drums were sounded and the armies lined up opposite each other. From the guebre army Qatil son of Zarqas came into the field; from the Amir's army came Halahum Tezjang, and he was martyred. Kayhan b. Rustam had just stepped forth when a throne descended from the sky and landed beside the battlefield, and a young man stepped down from the throne, mounted a steed, and cut the guebre in two. Pained by the loss of his son, Zarqas came into the field. The youth lifted him from the ground and then hurled him to the ground so hard that every bone in his body was broken. Turning to the army of Islam, he asked for a warrior. Imad Ghamudgardan stepped forth. He was taken captive. Mamluk Nayzadar and Isfandyar were also taken captive with some others. The drums of retreat were sounded. The young man got back on his throne, and demons lifted it and carried it off into the sky. All the soldiers were left astounded.

The next day battle drums were beaten. From the guebre army came Gumyad Man-Eater and demanded a contest. He martyred several warriors from the army of Islam. Once again the throne came from the sky. The youth mounted a horse, charged Gumyad, and cut him in two. Tahmasp wanted to go into the arena, but the young man turned toward the army of Islam and asked for a combatant. The Amir went forth and seized him. He was the Amir's own son by Surat Peri, the daughter of Nawroz the king of the fairies, and his name was Ibrahim son of Hamza. He gave the Amir's soldiers much booty, and the Amir asked him to dismiss the demons.

'His servants are all demons,' said Umar.

The Amir assigned him thirty thousand men and awarded him all the money and possessions of the commanders he had captured. He dismissed his demons.

For three days there was no fighting. On the fourth day battle drums were sounded. From the Muslims, Sahal Man-Eater came out and was killed. Then Fazlanshah came out and was wounded.

The Amir said to Umar, 'We have to rethink our strategy.'

'I have found a crooked stick for him,' said Umar, who went to the men and said, 'Curse him.' He came into the field, and with one blow of the stick Umar polished him off.

The drums of retreat were sounded, and the army set forth.

TRANSLATIONS FOR CAT.47
Volume number 11, text number 37
Philadelphia Museum of Art, 37-4-1

The narrator says that the next day the Amir sat in his court and summoned Umar.

'Brother,' he said, 'you have to go to town. Maybe you can get an idea how to help the prisoners.'

Umar bowed and departed. With him he took Yazak the Cathayan, Barakh Farangi, Zarda-Kattun Mazandarani, and Sabukpay Eki and set out for Noshad.

When they were near the city they sat down under a tree and said, 'Now, in what guise should we enter the city?'

Khwaja Umar said, 'Yazak and I will gather kindling and enter the city.'

Sabukpay Eki and Zarda-Kattun said, 'We will go as commoners carrying curds and wool.'

Barakh said, 'I will go as a dervish, and we will all meet at the crossroads.'

As for Gurdmard Ayyar, Iramzad Naqshband, and Samum World-Burner, they had already entered the city so that if the *ayyar*s of Iran came to rescue the champions, they would seize them. By chance, they caught Barakh at the crossroads and discovered his *ayyar*'s implements on him. The people attacked and took him to the square. Umar and the *ayyar*s

were there waiting for Barakh when they saw him in that state. They were perplexed. Iramzad said to him, 'Ayyar, tell me what *ayyar* came with you!'

'Commander,' he said, 'I came alone. No one else came with me.'

He was put into the stocks and not released.

Umar said, 'Bravo.' Gurdmard said, 'Bring him to me and I will make him confess.'

When it was almost night they all went home, taking Barakh with them.

Yazak said to Umar, 'I'll follow them. Maybe I can rescue him. But where will I find you?'

'In the shop of the people to whom I have sold wood,' he said.

Yazak set off with the *ayyar*s. When they reached home they entered. When it was dark Yazak got himself into the house along with his squires, and they went onto the roof. From the skylight he looked into the house. He saw four platforms on which the *ayyar*s were resting. They pulled Barakh out and said, 'Come, tell us the truth. Who else was with you?'

'I came alone,' he kept saying.

They were about to torture him when Yazak stuck his head through the skylight and said, 'Friends, I came with him.' When the *ayyar*s heard this, they all ran to the roof, but he had let himself down through the skylight and released Barakh. No matter where they looked on the roof, they could not find anybody. When they came down and could not find Barakh, they were amazed. Everyone praised Yazak for this.

When it was daylight the [guards] went to the door of Sartaq, the brother of Anquil, the ruler of the city, and explained the situation. He laughed and said, 'You had already come when we seized the *ayyar*s of Iran. You caught them and lost them for nothing. Now what do you say?'

'We are warning you to watch yourself,' they said. 'Otherwise we don't care anything about them.'

'You are telling the truth,' said Sartaq. 'We will have to do something to catch them. Otherwise we will never have any rest. I know what to do. Those who are in custody will have to be tortured. When they are killed, the *ayyar*s of Iran will cease.'

'That's a good idea,' they said.

At once they wrote a report to Zumurrud Shah and Anquil Demon-Nurturer, explaining in detail about the *ayyar*s and requesting an edict for killing the comrades. Giving the letter to a swift messenger, they sent it off.

After that, Pahlavan Balagh the night watchman was ordered to go around the city with five thousand men and to herald, saying, 'If anyone can give news of the whereabouts of the *ayyar*s of Iran who attacked tonight, he will be rewarded. If later they are discovered, the house of the one who is harboring them will be burned and the quarter reduced to rubble.'

Meanwhile, Sabukpay Eki stood up, bowed before Khwaja Umar, and said, 'O dagger-wielder of the age, rarity of the time, if you and your comrades give me permission, I will go out to have a look and bring back news.' All wished him well. He kissed the ground politely and departed. He looked everywhere and listened to everybody to hear what was being said. He saw that Balagh the night watchman and a large contingent were heralding the following: 'The *ayyar*s of Iran are in the city. Wherever they are, let it be known.'

Sabukpay brought this news back. They all grew despondent, and for three days they did not leave the city.

Volume number 11, text number 38
MAK–Austrian Museum of Applied Arts/Contemporary Art, Vienna, B.I. 8770/16

The narrators of this beautiful story say:

When Yazak the Cathayan took Barakh Farangi before the *ayyar*s of the east in that manner, they all praised him. Master Yazak and Barakh Farangi went up to the platform. Sabukpay Eki was standing there waiting for Yazak. When he saw him he grew happy and set out with them. When they reached the lane of Sarwaz, Yazak asked, 'Where are you staying?'

'The master cook has a lodging behind the gate in ..., and he has given us a place there.' When they arrived they went in, and everyone praised Yazak's deed. When it was daylight

Sabukpay went out to gather news. He saw Balagh the night watchman with four thousand men and a thousand *ayyar*s They were eating and ..., and when they had eaten their food and washed their hands, every one of them told a story of his adventures. They remained at the gate for three days. When it was the fourth night, Khwaja Umar went out disguised as a poor old man ... a sack in his hand and his head and body trembling. Shuffling, he went to the prison gate. He looked all around and became aware of what was to the left and right. He saw the guards sitting with lamps. When he went forward a few steps he spied a platform, so he went up on the platform. He saw the prison guards having a good time, sitting conversing with forty men, and they were all on the alert. When Khwaja Umar saw this, he could not go any further. He sat down where he was and thought about the comings and goings of the prisoners. When some time had passed like this, Khwaja Umar fell asleep. After a while he awoke, aware that someone had grabbed his collar tightly. When he opened his eyes he saw a man clad in black with a glove and a dagger like a snake.

'You thief,' he said,

'Upon our high roof an audacious one has come. On a love affair he has come like a lion.'

When Umar looked carefully he saw that there were four hundred other men clad in black surrounding him. Seeing this, he sighed in desperation. He imagined the padishah's *ayyar*s. As he shook his head and wiped the tears from his eyes, he said, 'O *ayyar*s, go on. What are you going to do with an old man like me?'

The man who was holding Khwaja Umar by the collar laughed and said, 'There is more to this than meets the eye.' So saying, he pulled Umar down from the platform and said, 'You thieving *ayyar*, I'll never let you go!'

'Oh,' sighed Umar, 'my poor little sons and daughters will be orphans.'

When they searched him, they found his *ayyar* paraphernalia. 'Tell the truth,' they said, 'for the great have said

The truth from you that you go free. Truth from you, victory from the creator.

By dishonesty you lose, but if you are truthful you will escape every grief

if you want to save yourself. Otherwise you will be killed.' Umar saw that there was no way around telling the truth. He explained the situation.

The person clad in black was Tahmasp's sister Sanawbar Banu. She told him all about her love for the Amir, saying, 'Umar, that night, when I was struck by the arrow of love for the Sahib-Qiran, I came to the city and converted nearly four hundred people to Islam. Then, when I heard that the *ayyar*s of Iran had come to this city, it occurred to me that they had come to rescue the prisoners. Of course there would be guards at the prison gate. I came and found you like this.'

She offered Umar a place to stay. He said, 'If you give permission, I will go inform my friends and bring them to you.'

'So be it,' she said. Umar left. When he was near the house he saw someone going with a sack on his back. Umar hid himself in a corner. He watched the person go to the very shop where his friends were and give an *ayyar*'s whistle. The door was opened, and he went in. There he saw his friends seated with the sack in front of them. When Umar went in they all jumped up and greeted him. Umar asked what it was. 'Barakh Farangi went out after you,' they said. Umar asked Barakh about it.

'I went out after you,' he said, 'but I could not find you. I saw two men talking together. One was saying to the other that the vizier was serious about finding the *ayyar*s of Iran. I went and cut his head off. Then I brought his things.' So saying, he placed the sack in front of Khwaja Umar, who said, 'All right. Pick it up and let's go. I've found a good place for us to stay.' They wanted to ... the master cook ... said to his men, 'Come and shut the door to your house.' They went and shut [the door]. They set out and traveled far. Umar led the *ayyar*s to the head of Sanawbar Banu's lane, and they entered her house.

Volume 11, text number 40
Los Angeles County Museum of Art, M.78.9.1

The narrators and tellers of this wonderful story say that in the beginning Sartaq Armil wrote a letter to Anquil asking for assistance, saying, 'The *ayyar*s of Iran and Turan have staged repeated attacks. In particular, they have killed the vizier of the city of Noshad and carried off what cash there was as booty. I have even heard that there are several of Umar Ayyar's renowned generals, and that incomparable dagger-wielder is also along. I do not know what they are up to or where they are.'

When Anquil heard this, he got very upset and sank to the bottom of the ocean of contemplation. Then Anquil summoned Kilat Camel-Neck and said, 'You and twenty thousand renowned warriors will have to go to Noshad and install yourselves in the residence where we were. From there you can send our men out to spy. After that, I will write a report to Sanawbar Banu. She too is wondering how to capture those *ayyar*s. The day you arrive send an edict to Sartaq and Umaraz the prison keeper telling them to take the God-worshippers out and execute them.' The guebre kissed the ground in servitude and departed from Anquil.

He rejoined his soldiers, took a lot of the booty, fully armed and armored twenty thousand men, and set out for Noshad. That day he was on the road, and that night he kept traveling. The next day, when the prince of the planets stole the golden cap from the green-cloaked sky and illuminated the world with the light of its face, Kilat Camel-Neck came forth and arrayed his ranks near Noshad. He saw that the people of the city were fleeing. 'What has happened to you?' he asked.

One turned to him and said, ' "O heart, when you ask an intoxicated narcissus, you ask a head that is asleep in an enchanting tale." '

When Kilat heard this, he said, 'At least tell me what is wrong.' They explained how the *ayyar*s had come, broken open the prison, and taken out the amirs and kings. Kilat Camel-Neck sighed deeply, and he turned back to Anquil. He bowed low before that guebre and told him all he had heard. Anquil was startled and sighed in desperation. Then he slapped his knee with one hand and put his other hand to his face and tore out several hairs from his beard and said,

Every day my heart is under a different burden; in my eye is a different thorn of separation ...

The people of his assembly were completely dumbfounded.

When the champions came to Sanawbar Banu's house, that moon of the heaven of beauty brought them breast plates and implements. When it was daylight they got fully armed and armored.

In the meantime an uproar had broken out, for Sartaq and ten thousand bloodthirsty guebres were going around searching house to house to find the men. They came out and killed him, scattered the guebres, and took the city. They converted the people of the city, old and young alike, to Muslims, and they confiscated Anquil Demon-Nurturer's treasury for the Sahib-Qiran and Sa'd Padishah. Khwaja Umar Zamiri, the incomparable pride of every assembly, and his friends and commanders thought it best for the champions to stay in the city while they sent word to the Amir. Whatever he thought best would be done. Khwaja Umar and the *ayyar*s set out for the Sahib-Qiran. When the courageous Prince Malik Qasim reached the edge of the sea, he summoned all the sailors in the vicinity, gathered them together, and said, 'Go into the sea and bring out the chest of armor.' They entered the sea at Prince Malik Qasim's command and swam all through the water, but they could not locate the chest. Finally, they emerged and said, 'There is a demon called Aflagh hereabouts. If you summon him, he will come and get your chest out.'

Malik Qasim went, seized the demon, and brought him back. The demon went into the sea and brought out the chest. Putting the chest on the demon's head, Malik Qasim took it back to the Amir's camp.

Ghaltan Ayyar came to Japur and brought news to the Amir, who rejoiced. After that, Umar and the *ayyar*s arrived, and the

Amir had the drums of rejoicing sounded. He sent the soldiers who had been in the city to them, and they were ordered to maintain the city. With his own hand the Amir wrote something to Sanawbar Banu, and the next day Malik Qasim came bringing the Amir's armor on the demon's head.

Volume 11, text number 41
Brooklyn Museum of Art, New York, 24.47

The narrator of this tale says thus of the story of the star surrounded by a starry host, the eye of the dawn, he of the white banner, the lion warrior of Iran and Turan, unique of the age, Amir Hamza Sahib-Qiran:

When the king of the west, Malik Qasim the quick-tempered, placed the box of the Amir's weapons on the demon's head and brought it to the Sahib-Qiran, it was afternoon when he reached the Amir, and all the warriors cheered the prince. They passed the night, but the news was that Tahmasp would again sound his battle drums. That night the braves were thinking about battle, and when dawn broke the sound of battle drums arose from Anquil's court. When the Sahib-Qiran heard it, he too ordered Alexander's drum, Jamshed's flute, and Gayomarth's cymbal sounded. When the sound of Alexander's drum reached land and sea, a great tumult arose from both armies. That day the brave soldiers were anxious to go to the battlefield, but when the hosts faced each other, such a cloud of dust arose between the two iron-clad walls that a cloud came forth from the army of the infidels and began to fight. Meanwhile, on the side of the army of Islam the breeze of victory started to blow and spread. These two warriors took the dust from the field. When the warriors' gazes fell upon each other's eyebrows, Anquil's nephew Sheran Malik came out into the field and, brandishing his weapons, called out for a warrior. Prince Alamshah the Greek lowered his head in the Sahib-Qiran's direction, asking for permission to go to the field. 'My son,' he said, 'you are always dealing with cruel strangers. May you fare well. May God protect you.' The prince kissed the ground politely and mounted. Blocking the way against that lost guebre, he captured him after a great struggle. Then came Tufan Malik, and he too was captured. Anquil's son Qirtas came out; he too was captured after much fighting. When it was night the drums of retreat were sounded, and the armies pulled back. The next day Devparast Elephant-Strength came out and was captured by Landhaur. The next day Qirmil came into the field. From the army of Islam came Maalik, who sent his spear into Qirmil's breast so hard it came out through his back. Until night twenty others were overthrown. The next day Qirtas Blood-Drinker came out into the field and killed several from Shah Qasim's army, giving them the honor of martyrdom. Malik Qasim Khavarsipah came out and cut him in two. The next day Muhimm b. Sahim came into the field, and here the title Tiger of the Age ... Amir Hamza Sahib-Qiran. Prince Badi'uzzaman took the field, and they fought until night. In the end that useless guebre fell captive to the renowned prince. The next day Mihlal b. Afsar came into the field, and from this side Prince Ibrahim the courageous came out and dispatched him to hell with a blow of his glistening sword. The next day that ill-starred guebre Tahmasp son of Anquil Demon-Nurturer came into the field as a shout arose from both armies. Khwaja Umar was saying, 'As the demon has come for blood, emerging from the vestibule of hell,' when Tahmasp brandished his weapons in such a way that cheers arose from both sides. Then he showed such skill with his battle cleaver that the Amir applauded him. After that, he called for the Amir. The Amir armed himself, went out into the field, and displayed such great expertise with the sword and spear that Tahmasp 'bit the finger of amazement' because he had never before seen such displays of prowess by any warrior. Then, after brandishing his weapons, the Amir attacked Tahmasp. They fought with spears, then with battle axes, and then Tahmasp was reaching for his 1200-*maund* cleaver when a rider arrived and gave the Sahib-Qiran Solomon's shield, which Asma the peri had sent. For three days and nights they battled. In the

end he was taken captive by the Amir and a pitched battle broke out. Prince Alamshah captured Anquil, and Zumurrud Shah fled to the pass of Shisan Dev.

Volume 11, text number 44
MAK–Austrian Museum of Applied Arts/Contemporary Art,
Vienna, B.I. 8770/27

The narrator of this ancient tale says:

Anquil Demon-Nurturer said, 'Winter is near, and the road to the dam of the city of the demons will be very difficult. If you will be patient for a while it will be good.'

The Amir asked, 'What sort of dam is it?'

'In the time of Solomon the place that is now the city of Afsariya was a desert more than a thousand leagues in length and breadth, and at the border of Noshad where Shisan's dam and Khizr's mountain are now an extremely large river flowed. When Solomon arrived there he saw the desert and the water, and it occurred to him to make the water flow into the desert. He assembled all his helpers and demons and asked, "How can we raise the water into the desert?" The demon Shisan accepted the task, and it took him and seven thousand demons five years to build a dam.'

'What sort of dam is it?' asked the Amir.

'Amir,' replied Anquil, 'unless you see it no description will avail.'

'Tell me anyway,' said the Amir.

'O prince,' he said, 'from the valley through which the water flows and the place from which the water enters the valley from the mountain to the site of the dam is fourteen leagues long. The length of the dam across the valley is half a league; and it is fourteen cubits high. It is made of a combination of lead, bronze, brass, and granite. The lake behind it is fourteen leagues long, half a league wide, and four hundred cubits deep. There are conduits installed in the mountain through which the water goes to the desert. Now, thanks to Solomon, that desert flourishes, and there is a great king, Aad Man-Eater, who rules that territory. In the dam they made a hole, and there is a round ball made of brass and chains affixed to it. On top of the dam is a crank, and the chains are attached to the crank. If they want to let the water go into the valley, it takes four hundred men to turn the crank. The ball moves from the mouth of the hole, and the water of the lake pours all at once into the valley. When they want to stop it up again, the ball covers the mouth of the hole, and the flow ceases.'

'Who is on the other side of the dam?' asked the Amir.

'O prince,' said Anquil, 'three persons of the demon Shisan's progeny are left. One is a commander named Kayhur Demon-Nurturer. It is said that the demon Shisan married a Zangi woman who was fifty cubits tall, Gahwara Zangi by name. These persons were born of her.'

In short, the Amir spent that winter in the city of Noshad. He asked for Sanawbar Banu from Anquil. He accepted and gave a feast for the people.

As for Zumurrud Shah, when he reached Shisan's dam, Tayhur and Kalut came out and greeted him. Zumurrud Shah crossed the dam, and when he approached the city of Afsariya, he sent a messenger to inform Aad, and he ordered that anyone who met Zumurrud Shah was to serve him. Thus they did. When he was near he sent a messenger. Aad Man-Eater went out to greet Zumurrud Shah with all his commanders and princes, like Hazabr b. Mahabit, Kahraq Blood-Drinker, Ham b. Kahrab, and others. They escorted him into the city and gave him a banquet.

Just then a spy arrived, saying, 'Amir Hamza the Arab has stopped for the winter in the city of Noshad and has married Anquil's daughter. Qasim has married Demon-Nurturer's niece. In the spring they intend to come here.' The color drained from Zumurrud Shah's face and he was perplexed, writhing like a snake.

When the winter was over the Amir Sahib-Qiran mounted his steed and set forth for Shisan's dam at the most auspicious hour. When he arrived at the dam he saw thirty thousand

bloodthirsty guebres arrayed against his troops. The Amir was astonished that there were so few men opposing him and wondered what it could mean. When someone was sent to investigate, he said, 'It is Kayhur Demon-Nurturer, and Bakhtak has come.'

The next day the Amir was still at his prayers when he heard the sound of battle drums. The two armies lined up opposite each other, and Kayhur entered the field riding a rhinoceros and called out for Kahraq Demon-Binder to come into the field. Kayhur knocked him from his mount and threw him to the ground so hard that his bones were crushed. Adlanishan and Fazlanshah were also wounded.

Umar said, 'Amir, he is a mean creature.'

'Yes,' replied the Amir.

Qasim came out. Both reached for their swords. Qasim took a blow from Kayhur and aimed a blow with his sword at him. Kayhur ducked, and the sword landed on the rhinoceros's neck, severing its head. Kayhur grabbed the leg of Qasim's horse, and anyone other than Qasim would have fallen from the horse. When Qasim saw this, he leapt from his horse. Kayhur tore the horse apart, put the horse's leg in his mouth, and started to chew it. The men on both sides stood still. When night fell they withdrew.

TRANSLATION FOR CAT.50
Volume 11, text number 45
MAK–Austrian Museum of Applied Arts/Contemporary Art, Vienna, B.I. 8770/52

The reporter of this account thus reveals beauty from behind the curtain:

When Malik Qasim and Tayhur Boar-Tooth separated from each other on the battlefield, they withdrew. The next day, as the sun illuminated the sky, the sound of battle drums arose from the infidels' camp. The two armies arrayed their lines opposite each other, and Tayhur was prancing on his horse on the field of battle when, from the army of Islam, Shersawar b. Sur entered the field and was martyred. Muzaffar b. Zayqam came onto the field and was wounded. Akhi Sahman Soldier-Cap entered the field, but he left wounded. Kattara Siyah posh was martyred. Bahram Lion-Eater was also martyred, and Umar Ma'di Jandi's brothers followed suit.

In short, by evening thirty men had been martyred. The armies withdrew from the field and retired to their camps. A great uproar arose from the army of Islam as the champions of Islam were buried. The Amir Sahib-Qiran retired to Solomon's tent, and all the shahs gathered. Many heroes volunteered to fight Tayhur, and each of the princes sought permission to do battle with him. That night the warriors of both sides were contemplating who would win upon the morrow.

Warriors contemplating one by one in whose favor the celestial sphere would turn tomorrow.

On whose head would fate place the crown? On whose shoulders would heaven place the robe of victory?

Who knows what will happen tomorrow and who will disappear from sight?

That night, Tayhur, however, bowed before Zumurrud Shah and requested a battle drum. That night the sound of battle drums came from both camps, as the two oceans of vengeance swelled and billowed. Finally the night was over, and the next day, when the dawn removed the pitch-black veil from the cheek of the bride of the firmament and the world once again put on its luminous garb,

Dawn broke and the sun poked its head from the dark sky. The emperor of the sky beat the drum of battle.

The two armies moved forth to do battle with each other. After performing their prayers, the Amir Sahib-Qiran turned his face toward the divine court.

He rubbed his forehead on the ground in prayer and besought assistance from God.

After that, he put on the armor of the prophets and clothed himself from head to toe in iron and steel. As he placed the foot of success in the stirrup of felicity and mounted his fleet-footed steed, all the shahs and princes tucked the hems of their chain mail into their belts of courage and set out for the Amir's retinue. At the Amir's signal the shahs in ranks mounted and rode into the field of battle. Once again the two armies drew up their ranks, and the dust of the field was stirred up.

So much dust was stirred up on the field that the warriors knew not friend from foe.

When the wind swept the field clear of the dust, the two sides looked at each other until Tayhur, mounted on his steed, entered the field. After displaying his prowess, he headed for the lines of the army of Islam and shouted, 'God-worshippers, know that the god of the east has fated your death at my hands. Fare you well!' As he said this, from the army of Islam the world-conquering Amir halted on his steed and said, 'Come into the field of combat and show me your *ayyar*'s hat, for after me no one will come into the field.'

In short, the Amir spurred his horse into the arena and came opposite Tayhur. Through the grace of the Creator he sent that infidel from the field bound hands and neck, and he returned to Solomon's tent, where he took off the garb of battle and washed the dust and blood of the field from his hands. After that, he ordered a party given during which Tayhur was brought in and offered a chance to convert to Islam. He converted. The Amir ordered that he be given a reward.

The next day he said, 'O Amir, if you permit, ... that I bring my brother.' The Amir gave him permission. When he went to the pass he began to curse. The following day the Amir went to the foot of the pass, where he saw that the pass had been blocked. He grew angry, but the princes Alamshah, Badi'uzzaman, and Qasim Ruby-Tunic ran to the pass of Shisan Dev, and the guebres threw down huge rocks, but they held up their shields. Night fell; they withdrew. Tayhur turned the crank, and the rock rolled away from the mouth of the hole, and a deluge of water poured down so that all the ground was engulfed. Many men were lost. Of those of name, Hardam Devana was drowned. Such an uproar arose in the camp that the Amir imagined that soldiers had attacked the camp. When he ascertained what had happened, it was only water. The Amir was informed of the drowning of Hardam and was very upset.

TRANSLATION FOR CAT.51
Volume 11, text number 46
Chester Beatty Library, Dublin, 1.1

When it was night and the Amir Sahib-Qiran was contemplative, an alarm broke out in the camp of the army of Islam. Kayhur got his *ayyar*'s paraphernalia together and got himself across mountain and cliff to the army of Islam. As black night fell and the sky once again became a stage for the hosts of Ethiopia, the *ayyar* of the night vengefully cut off the head of the Bahram of the day.

When the sun in the firmament garbed itself in ambergris-colored clothing made of the brocade of evening.

That night Kayhur entered the army of Islam in stealth. As his path crossed Bahram Gurd's tent as he was going in full finery of the Solomonic court to his residence, Kayhur sat in ambush until the guards went to sleep. Pulling out a stake from the rear of the tent, he went in and cut off Bahram Gurd's head. Taking the head, he departed. His path then crossed Marzang b. Marzban's tent. Finding the guards asleep, he went in and put him too to martyrdom. Taking his head, he left.

When day broke, the entire camp became aware of the situation, and all raised outcries of mourning. The Amir Sahib-Qiran was very upset by this disturbing news and, turning to Umar, he said, 'You thief, are you not alive?' Umar summoned his *ayyars* and sent them out in all directions, thinking that he might find a clue.

The next night Kayhur Boar-Tooth dressed himself as an *ayyar* and entered the camp of Islam. First he came to the tent of Prince Umar Gorzad. The dastardly one waited until the guards went to sleep, and then he went into the tent. He found the prince lying on his bed. He approached Umar Gorzad, decapitated him, picked up the head, and left the tent.

Meanwhile the Amir Sahib-Qiran had a dream that Umar Gorzad was hunting on a plain. Suddenly a boar attacked him.

Umar fell from his horse, and the boar took his head in its mouth and ran away. The Amir cried out and woke up such that all the people of the court were startled. Muqbil ran forward. The Amir said, 'Muqbil, go to my son Umar Gorzad's tent and quickly bring me news, for I have had a strange dream.' Muqbil went to Umar Gorzad's tent and found the guards asleep. Shouting at them, he went into the tent and cried out to the prince, 'The Sahib-Qiran wants you.' The servants woke up and lit the candle and lamp that the *ayyar* had extinguished. Muqbil went forward with all trepidation and beheld the scene. Crying out, he went before the Amir and began to weep. The Amir realized for certain that his dream had not been for nothing. Ascertaining the truth from Muqbil, he cried out and wailed. All the kings and princes gathered. Umar also went and came back and told the Amir what had happened, and all the kings began mourning. At once the soldiers of the army of China erupted into chaos. They cut their horses' manes and tails and put black felt around their shoulders in mourning.

Umar Ayyar was very upset and weeping. When he saw the Amir contemplative, he said, 'O Sahib-Qiran, do not allow yourself to grieve.'

'Umar,' said the Amir, 'tell someone to bring their heads so that we can put them in coffins and send them to the city of Sabayil.'

'Give me permission to cut off the perpetrator's head,' said Umar. The Amir did not agree. Umar put the point of his dagger against his breast and said, 'If you don't give me permission, I will destroy myself.' The Amir gave in, and Umar departed. No matter how much he searched, he could not find anything. Finally, when he reached the barrier, he thought, 'One can get through this way.' When he was near the barrier, he saw that nearly two hundred fully armed men were standing with torches. Umar came and got seventy renowned champions of the Amir Sahib-Qiran like Qasim, Badi', Alamshah, Landhaur, Mālik, and Tul Mast. When these came, battle broke out. Tayhur was on top of the barrier. Alamshah split him in two and ...

TRANSLATIONS FOR CAT.52
Volume 11, text number 47
Cleveland Museum of Art, 76.74

The narrator says that when they captured several of those men, they said, 'Kayhur has seized the palace of the God-worshippers and gone to Zumurrud Shah.' The army of Islam set out for the barrier. When Kayhur saw this, he took flight and went to Afsariya. The Amir Sahib-Qiran entered the barrier with an innumerable host, but the Amir sent Khwaja Umar to bring the heads back. However, when Kayhur brought the heads, Zumurrud Shah, Hurmuz, and Bakhtak Black-Face were extremely happy. He too had come with five hundred men, and two days later his brother came and reported the killing of Tayhur, the seizure of the barrier, the blocking of the water, and the [*qalam kardan*] of the [*charkh*]. A sigh went up from the guebres. Kayhur told this to Zumurrud Shah. He ordered Aad Man-Eater to go out of the city with a detachment.

Khwaja Umar arrived at the gate of Zumurrud Shah's court, and there he saw the heads displayed. He stole them by night and sent them back to the Amir with Zarhib Ayyar. In full daylight Umar Ayyar stood before the gate to Zumurrud Shah's court. He saw Kayhur appear. Umar pulled out a vial of naphtha and struck him in the face with it. He burst into flame. Umar escaped as Kayhur burned. This caused Zumurrud Shah and the guebres to flee in fright.

Zarhib brought the heads to the Amir, who sent the bodies to Sabayil to be buried on the hill of the martyrs. Then the Amir set forth. When he arrivesd, the guebres were informed. The next day they arrayed battle lines. When they dismounted the Amir sent a letter indicating that Aad should convert to Islam. He did not accept. The battle drums were sounded, and Khizr went out against Aad. He had martyred seven of Mihrab Shah's men when Hamza's son Ibrahim stepped forth and cut

him in two. The armies withdrew. Aad was very upset over his champions being killed. He sent Firoz Ayyar to kidnap Ibrahim, which he did. Zumurrud Shah assented that he should be killed, but Ibrahim the foresighted … prevented it … sent Ibrahim and ordered a blockade, but the guebres sounded the battle drums. … came forth, and … came forth and cut him in two. On the part of the guebres Salasil b. Sha'sha'a said, 'Tonight I will go to the army of Islam ….' He stationed a thousand men in ambush and went himself to the vanguard and shouted, '… come out of the vanguard so that we can do battle together.' Badi' came out and said, '… come forth.' Badi' drove him far back, and the ten thousand men emerged from ambush and started doing battle. By daybreak many of them had been killed. Then thirty thousand of the guebres' scouts arrived. Badi' prayed, and two thousand men appeared. The youth who was their leader attacked the guebres and cut Salasil b. Sha'sha'a in two. Defeat befell the guebres. The youth paid homage to Badi'. The youth was Farrukhbakht, and he was hideous. In short, he joined the Amir. The Amir gave Farrukhbakht a place on Farrukhsawar's seat, and he gave Sa'id Farrukh-Nizhad [a place] on Farrukhbakht's seat (?).

When the news reached the guebres, they were upset over Salasil. The next day the battle drums were sounded. When the armies stood in lines opposite each other, there were two brothers with Aad Man-Eater. One was named Jang-Fil, and the other was called Sarab-Fil. These two brothers came before Aad and were given permission to go into the field. Many of Aad's soldiers entered the field. One brother took an elephant by its front two legs and the other brother held it by its back legs, and they hurled it into the field. After that they set out for the Amir's army, saying, 'O God-worshippers, can any of you perform such a feat on the field of battle?' Witnessing this feat, the soldiers were astonished. Suddenly a cavalier emerged from the army of Islam.

Not a horse but an eagle he spurred forth.
Not a blade but a crocodile he wielded.

And he entered the field and faced the two brothers, saying, 'What have you done? Two people, one elephant … what say you?'

'Let us see,' they replied.

Prince Sa'id Farrukh-Nizhad grabbed the elephant by the chain around its waist. As the two armies watched what was transpiring on the field of battle, that courageous one mentioned the name of the God of the world, seized the elephant and swung it around the field …. The drums of rejoicing were sounded in the army of Islam, but Sa'id Farrukh-Nizhad slammed the elephant down on the ground so hard that its body was crushed. The two brothers came forth and sincerely became Muslims at the hand of the prince.

Volume 11, text number 48
MAK–Austrian Museum of Applied Arts/Contemporary Art, Vienna, B.I. 8770/26

The narrator says that when those two brothers sincerely became Muslim and returned, Zumurrud Shah began to curse and asked for a warrior. A man named Hizabran b. Mahabat entered and wounded him. Sa'id Farrukh-Nizhad entered and cut him in two. Battle broke out. That night they returned.

Amir Sahib-Qiran was worried about his son Ibrahim. He summoned Khwaja Umar and said, 'O champion, haven't you had any ideas about my son? Have you no news to deliver to me?'

Khwaja Umar said, 'O Sahib-Qiran, if you give permission, I will go and bring news, wherever he may be.'

'I have need of you,' the Amir said, 'but if you send some of your *ayyars*, that will be all right.' Umar agreed and immediately summoned two of his *ayyars* and sent them to obtain news of Prince Ibrahim's whereabouts. One of them was one of Ibrahim's *ayyars* named Parran Ayyar, and the other was his own, Zarda-Kattun Mazandarani by name. A third was Songhur Balkhi, and they were dismissed and departed. (We will return to them later in the story.)

When Firoz Ayyar brought Prince Ibrahim to Sadaj in the Mihratia Fortress, Sadaj Kohi was drinking wine. When Prince

Ibrahim was brought in, he asked, 'O handsome young man, who captured you?'

'No one captured me through manliness,' he answered. 'I was stolen away from my bed.'

'Wasn't there anyone in Aad Man-Eater's army who could take you in combat?' Sadaj asked. Then he cried out at his men, 'Untie this God-worshipper's hands so that I can take him in combat!'

Firoz would not allow it and said, 'Sadaj, you don't know this God-worshipper. He is the son of Amir Hamza Sahib-Qiran.' And he related all the feats he had performed.

Sadaj turned to the prince and said, 'If you swear that, if you win, you will allow yourself to be bound again, I will wrestle with you.'

Ibrahim swore he would, and his hands were untied. Sadaj ran toward the prince, and they grappled. Sadaj was thrown. Firoz began to be worried. Ibrahim gave his hands to be bound, and heavy chains were placed on his hands and feet. All the men were astonished. In short, Prince Ibrahim was imprisoned in a well-fortified place.

The narrator says that Sadaj had a son named Mihrat. He set out to fish in the sea. After two days a boat appeared with a group of girls, all with musical instruments and singing. When the boats came near each other they inquired after one another.

'It is Malik Sadaj's son Mihrat,' the girls were told. 'He has come out to see the sea. Who are you? Have you come to see the sea? Tell us your names.'

'It is the daughter of Malik Kisar from the kingdom of Samaria,' they said, 'and her name is Khoshkhoy.'

In short, the two left the sea together and went to the girl's garden, where they reveled. One day the girl's brother, Devran son of Kisar, came in. The girl hid Mihrat under the throne. However, Mihrat sneezed, and the brother realized he was there. The girl ran away. Mihrat was seized, brought forward, and condemned to death. The vizier Malyan did not allow it and ordered him imprisoned instead. When Mihrat's men saw this, they got in their boat and escaped, taking the news to Sadaj Kohi. He was extremely worried by this sad news. He imme-diately summoned his vizier. When the vizier came he explained the situation to him and said, 'Think up a plan.' The vizier was also troubled by this worrisome news and sank into contemplation. After much thought, he saw the best plan of action was, as he told Sadaj, to go before Farid the God-worshipper and see what he thought was best. He set forth at once.

The narrator says that there was a mountain in that vicinity called Fil Koh. There was a cave in that mountain, and a God-worshipping dervish five hundred years old lived there. They went to him, and Sadaj fell in the dust at his feet. When Farid the God-worshipper realized that he was crying bitterly, he turned to him and said, 'Become Muslim and release the son of Amir Hamza the Arab so that you may have your wish.' And he did so.

They got into battle armor when Ibrahim went hunting, and along the way he saw a dervish (?).

TRANSLATION FOR CAT.53
Volume 11, text number 51
MAK–Austrian Museum of Applied Arts/Contemporary Art, Vienna, B.I. 8770/6

The adorners of speech in the assemblies of eloquence have made their ambergris-scented pens flow thus in expressing this sweet, ancient story:

When Khwaja Umar bowed down at the Amir's feet and opened his mouth in apology, the Amir showed him great favor and then proclaimed a banquet in his Solomonic tent and had the drums sounded in rejoicing. Khwaja Umar brought Lakman and Tahamtan's Zangis to pay homage to the Amir, and he was given a place in the Solomonic tent. The Amir showed him great favor. Khwaja Umar received from the Amir the island of Nardan and its dependencies along with

several other provinces for Lakman. They were given robes of honor and given permission to depart.

Zumurrud Shah the Lost and the black-faced infidels were summoned to be given advice, but no matter how much he stressed his points, it was of no use.

What profits advice to the black-hearted? An iron nail will not go into stone.

'If they had bound me by force of manliness and chivalry,' said Zumurrud Shah, 'the advice would have had an affect on my heart. But you, *ayyar*, bound me through trickery. All this talk is of no use.'

'Actually,' the Amir said, 'what Zumurrud Shah says is not untrue. Take the bonds from Zumurrud Shah's and the other infidels' hands and feet.' As ordered, the men rushed to release them, and the infidels were released and went to their homes.

The narrator says that the shahs and princes praised and extolled Khwaja Umar. The Amir gave a sumptuous banquet for him. During the conversation the Amir asked Khwaja Umar what marvels and strange things he had witnessed.

'The best of what I have seen in the world,' said Khwaja Umar, 'was when I saw Iraj and [the?] sun-worshipper. The Amir must know that he drove Aas Bronze-Body like canvas [?] and wounded Prince Nuruddahr. Is there now such a champion that nobody except the Amir could oppose?'

At this time Nuruddahr said, 'I gave him a wound he won't forget as long as he lives.'

Khwaja Umar said, 'The one thing he doesn't think about is that wound.'

Nuruddin [Nuruddahr] did not like this talk at all. When night fell he mounted alone and rode toward the city of Faranghushia in search of Iraj. When he arrived at the city, all the people there were astonished by his beauty. He asked the people, 'Is there anything marvelous or strange in this city?'

'There is Iraj's exercise house,' they said, 'which one can see.'

Immediately he went there and found a marvelous exercise house. When he asked the people about Iraj, they said, 'Iraj has gone hunting, but his deputy Ud Kayli is here. Just now he is exercising.'

Nuruddahr saw that Ud Kayli and his followers, each according to his ability, were exercising by lifting images of rhinoceros, elephants, oxen, camels, and other things made of brass. When Ud Kayli had finished his exercises he began to boast and brag, saying, 'Where is Rustam son of Saam and Amir Hamza Sahib-Qiran and the champions who lay claim to manliness? Let them come and witness the real men of the world!'

Just then Prince Nuruddahr's zeal was stirred, and he stepped into the field, saying, 'All this boasting and bragging is not appropriate.'

Just then Iqbal Shah stood up and said, 'Young man, there is no objection. If you have any strength, it will be found out.'

When Nuruddahr saw that Iqbal Shah was there, he paid more attention than before, and he displayed all the things Iraj had done. The people of the city were astonished and rushed upon the prince. Iraj's supporters attacked. When Iqbal Shah saw that many people had gathered around the prince, he forbade them and said, 'Let them bring a horse for the prince.'

TRANSLATION FOR CAT.54
Volume 11, text number 1/53
Metropolitan Museum of Art, New York, 24.48.1

The narrator says that when Mahus realized that Parran had gone, he thought long and hard. Finally he decided that Parran Ayyar had come to the city in order to rescue Ibrahim. 'I must go and lay an ambush around the prison,' he thought. 'Maybe I can catch him.'

Having decided thus, he went out and sat in ambush. When it was night, he saw someone clothed in black using a lasso to get up over the roof. He too went up. He looked and saw Mihrdukht with her nurse Sharifa. He left and went to Qimar, to whom he explained the situation.

The next night Qimar came with a group of men and sat in ambush. He saw no one. The next day Qimar ordered Ibrahim

to be taken to Jamshed's Dome, which had no windows and into which no tunnel could be made because it was made of solid granite. Its doors were of iron, and it was as impregnable as Ujan. In short, it was ordered that Hamza's son Prince Ibrahim be taken and put in chains. Kharas Zangi and forty bloodthirsty Zangis kept constant watch at the gate. When Prince Ibrahim was taken away and Parran Ayyar found out about it, he was worried.

Qimar entered the harem and summoned Mihrdukht, saying, 'Aren't you ashamed to have gone to a God-worshipper and dishonored me before all the world?' Sharifa managed to escape, but he had Mihrdukht put in chains....

Parran and his companions thought about how to rescue Hamza's son Ibrahim.

When the Sahib-Qiran returned from battle and his sons had performed valiant deeds, Zumurrud Shah the Wayward had not done battle for seven days, and the eighth day the battle drums were sounded. Siqlun Aad came onto the field and defeated twenty men. Hashim entered, and he cut him in two and threw thirty of the Aadites into the dust. The armies retired.

The next day the battle drums were sounded. Ahraq Zangi came onto the field and martyred forty from the army of Islam. Sa'id Farrukh-Nizhad entered the field, cut him in two, and felled thirty more men. The armies retired.

The next day, when the sun illuminated the world—
Morning came, and the sun stuck its head out from the indigo celestial sphere; the emperor of the sky beat the drum of battle—
the sounds of battle drums came from the field, and the hosts of morning appeared. When the battle lines were formed opposite each other, from the infidels' army came Tarid son of Sharih. Sa'id Farrukh-Nizhad entered the field and wounded him. Aad Man-Eater entered, wounded Sa'id, captured twenty of Amir Sahib-Qiran's champions, and retreated. When he entered the court, Zumurrud Shah ordered them killed, but his vizier, Pesh-Andesh, would not allow it lest Filhud Aad take him to the city of Afsariya and destroy him. He entrusted them to prison to remain in chains in Hubal's prison. Every night four hundred men kept guard.

In short, when they were brought into the city, a litter appeared in front of them. 'It is Aad Man-Eater's daughter,' they said.

'Who are those people?' asked Sharifa Banu.

'They are from Amir Hamza's army,' they said, 'and one of them is Amir Hamza's son, Isfandyar by name.'

No sooner had the girl's gaze fallen upon Isfandyar than she fell hopelessly in love with him. In vain – for they took them to prison and turned them over to Tarak the warden, whom they charged to take care of the God-worshippers' *ayyars*. He agreed and put them in chains. We will return to their story later.

Meanwhile, when Amir Sahib-Qiran returned from battle [he?] settled down at the Court of Solomon. When the shahs and princes assembled, the Amir of the Arabs removed his battle dress and put on banquet clothes. He summoned Khwaja Umar and said, 'We have not had any news of our sons and friends for a long time. Send out a few *ayyars*.' Umar dispatched Kulbad Iraqi and Sabukpay Eki.

Meanwhile, the infidels were beating their battle drums, but the next day they did not stir from their places in the field, and both sides drew up ranks. Didfar Khan Man-Ripper entered the field, and from Harith's troop came Abr Khan Dilavar, who was martyred. Qamar Khan Jangi came onto the field; he too was martyred. [Didfar Khan] felled many when Harith Dilavar came onto the field and cut him in two.

TRANSLATION FOR CAT.55 AND 56
Volume 11, text number 56
Metropolitan Museum of Art, New York, 23.264.2

The nurse of the welcome babe strives to raise such an infant.
When Khwaja Umar overthrew this footsoldier and sat on his chest, he looked. It was one of Fulad's *ayyars* named Haybat. Umar started to kill him, but he said, 'Khwaja Umar, don't kill me, for I will render you good service. I will show you the way into the castle.'

Khwaja Umar rejoiced and took the *ayyar* to the Amir. When the Sahib-Qiran asked him about himself, he said, 'O prince, if you mount I will show you the way.' The Amir Sahib-Qiran mounted with a group of champions with that *ayyar* in front. He led them to the foot of a mountain and showed them a tunnel. Umar went in. The Amir Sahib-Qiran asked for his weapons. He got himself fully armed. Choosing a group of champions and stationing another group at the gate of the castle, he then went into the tunnel himself. When he came up in the midst of the castle, outcries arose from the people of the castle. Fulad Aad was informed and became worried. He summoned his vizier, Pesh-Andesh, and said, 'Vizier, make a plan!'

'O prince,' said the vizier, 'he who is chosen by fortune is mighty.

The stars and heaven are his friends; his market is brisk with good fortune.

He accomplishes easily every difficult task to which he turns his mind.

No one like him has ever put his foot in a stirrup; the sun has never seen another like him.

And now his religion is right and Zumurrud Shah is in error. If you become Muslim, you will be saved from all tribulation.' He agreed and sent Pesh-Andesh the vizier to the Amir to sue for amnesty. The Amir granted it. He came and paid homage, and he became Muslim in all sincerity. All the people of Afsariya also became Muslim. The Amir sent Pesh-Andesh the vizier to Aad Man-Eater.

In short, he too converted to Islam and became a servant of God. The Amir Sahib-Qiran ordered the city decorated and wedded Sharifa Banu to Prince Isfandyar. After that he entered the army and sent someone to bring news of Zumurrud Shah's whereabouts and movements. Someone was sent to Noshad to bring Sanawbar Banu by sea, for she was pregnant. She started out in a boat, but the heavens rumbled and an adverse wind arose. The whole sea became so stormy that the boat crashed against a cliff and sank. Sanawbar Banu got onto a raft, and her labor pains began. She brought forth a son on the raft. She had a jewel from the Amir on which his name was engraved. She bound the jewel to the infant's arm, wrapped him up in a piece of cloth, and died three days later. The child remained on the raft for two more days. The raft floated until it reached the island of Siquliya, where all the people were worshippers of water. Siqulshah was the king, and he possessed three thousand leagues of land. There were several wise men in attendance upon the throne, and he was a worshipper of water and did not obey Zumurrud Shah.

However, there was a fisherman in that city named Iskandar. It was his habit to go to the edge of the sea to fish from morning till evening, and thus he lived and passed his time. By chance, one day he was busy fishing when from a distance his gaze fell upon a raft. When he looked carefully he saw the raft coming into view, and there was something wrapped in cloth on it. At once he stripped, bound his loins, pronounced the name of the One God, jumped into the sea, and swam out. When he reached the raft, he took hold of the raft and swam back to the shore. When he opened the bundle, he saw that it was a crying babe. His heart melted. He kissed the child with love and affection, took it into his arms, and adopted it as his own child, giving it the name of his own father, Darab. Then he took it home and entrusted it to his wife. She was childless, but she was very desirous of having children, so she took the child in her arms, and at once milk flowed into her breasts. Thus she began to raise the child.

Now let us return to our story.

TRANSLATIONS FOR CAT.57
Volume 11, text number 57
Museum of Fine Arts, Boston, 24.129

The narrator relates that when the heathen Zumurrud Shah went with his defeated army to Antali and A'zam the astrologer was appointed in Kihray the astrologer's place, Zumurrud Shah summoned him and said, 'O prophet, I have been ordered to spare the people of Antali and to have mercy on them.'

A'zam prostrated himself and said, 'O lord, whatever you command will be done.'

Zumurrud Shah said, 'I have ordered that you go before Malik Zarduhusht and inform him of the coming of the lord of the east.' Once again A'zam prostrated himself.

Yaqut Shah said, 'O lord, when Malik Zarduhusht is informed of your coming he will come out to greet you, but you should take precaution against impudent slaves.'

'I have been taking precaution against them for three hundred years,' said Zumurrud Shah.

Bakhtak said to Hurmuz, 'Prior to this I ordered him exiled miserably from the city of Sabayil.'

In short, A'zam the astrologer was sent to Antali, but Malik Zarduhusht had already heard that Zumurrud Shah had fled Hamza the Arab's followers and was headed in that direction. He let his thoughts range far and wide and summoned his sorcerers. The renowned among them were Malaka Zarduhusht, Aghur Brackish-Earth, Qamis Wind-Stirrer, Minqar Fire-Scatterer, Sharih Gut-Neck, Sula Jadu, Kula Jadu, Rasum Jadu, Kayd Jadu, Qabih Jadu, Dog-Tit Jadu, Thong-Tit Jadu, Qumquma Jadu, Marzban Jadu, Lafa Jadu, Mukahhal Jadu, Lamtas Jadu, Sammar Jadu, Jammar Jadu, Kalb Jadu, Kilab Jadu, Bozina Jadu, Kashif Jadu, Fahwa Jadu, Makkar Jadu, Samma' Sihrdan, Batil Drum-Holder, Sammaq Demon-Brow, and others. In short, seven hundred sorcerers gathered, and they all bowed their heads before Malik Zarduhusht, who recounted the story of Zumurrud Shah's coming. They all accepted, but Malik ordered them to write letters. One of those letters he sent to Lahat Jadu on the island of Khandaq, and another letter he sent to Farubia to Damaya Jadu. In short, he sent a letter summoning every sorcerer who was capable of wielding a bow and telling them that A'zam the astrologer had come. The sorcerers went out to greet him, but Malik Zarduhusht turned to the sorcerers, saying, 'What plan have you thought up?' They all replied, 'Whatever you think.'

'O sorcerers,' said Malik, 'even though our religion is contrary to Zumurrud Shah's religion, and aforetime he tried to impose his religion on us, nonetheless this Hamza Sahib-Qiran says that all religions other than the worship of God are false and that he will put to a miserable death all who are not worshippers of God. Therefore we must help Zumurrud Shah and put into action some spells to repel these people from the realm of the east.' All agreed with this.

They greeted A'zam the astrologer and treated him as an honored guest. Then they asked about Zumurrud Shah. A'zam the astrologer told them what there was to tell, and he described the Amir Sahib-Qiran in detail. All the sorcerers were astonished. Three days later they gave A'zam leave to depart, and they summoned Zumurrud Shah. When A'zam came before Zumurrud Shah, he told him about the sorcerers. He rejoiced, and the next day he set out for where Malik Zarduhusht had arrived. There he paid homage to the sorcerers and Zumurrud Shah, and they camped in a lovely, green meadow and held deliberations with him. However, when it was spring, the Amir set out from Afsariya. A spy brought news that Zumurrud Shah had gone to Antali. The Amir set out after him in the direction of Antali. However, Malik Zarduhusht had a daughter named Malaka. She thought to herself, 'I have heard much praise of these God-worshippers. Let me go to their camp. Perhaps I will be able to accomplish something.'

In short, she came to the Amir Sahib-Qiran's camp, and when the Solomonic court came into view, she dismounted on a hill overlooking it. Most of the night had passed, and the Amir Sahib-Qiran had lain down to sleep when a girl came down from the roof of his tent. The Amir realized that she was a sorcerer. He recited a spell against magic. She came forward and stretched forth her hand to lift the sheet from the Amir, but the Sahib-Qiran seized her arm and leapt up.

Zarduhusht's daughter Malaka was amazed. The Amir asked, 'Who are you?'

'They call me Zarduhusht's Malaka,' she replied.

'Come,' said the Amir, 'and become a Muslim.' She converted with all sincerity. The Amir said, 'Forswear sorcery!'

'You will have need of me,' she said. 'I will forswear it after the conquest of Antali.' And she obtained permission from the Amir and departed.

Volume 11, text number 58
MAK–Austrian Museum of Applied Arts/Contemporary Art, Vienna, B.I. 8770/22

The narrator says that when Zumurrud Shah held a discussion with the sorcerers, he turned to Mâlik Zarduhusht and said, 'Amir Hamza knows how to cast magic spells and how to break magic spells. Something must be done to keep him from doing this.' Mâlik Zarduhusht sent Iblis Wahaldar, Mashruh Rudagardan, and Lahat the sorcerer to take care of the Amir, but Iblis said to Lahat, 'We ought to work a spell so that Amir Hamza will not remember either how to break a spell or cast one.' Thus they did. Then they went to the Amir. Umar Ma'di was in charge of the vanguard. They cast a spell and dispersed him and his thirty thousand men, and they turned Umar Ma'di into a lion and chained him at the gate to Zarduhusht's palace. The rest of the soldiers they turned into animals and let loose in the plains. The Amir Sahib-Qiran learned of this event, and he was on the march when the sorcerers arrived and arrayed their ranks opposite the Amir. Every sorcerer appeared to be sixty cubits tall, riding on dragons, and with serpents for whips. Iblis lashed his whip, and fire leapt from his whip, curled around both sides of the army, and was coming forward in the direction of the soldiers. Shaban-Bachcha Tayifi threw himself on the fire in a rage and burned up. For two days no one went out onto the field. No matter what the Amir did, he could not remember how to break a spell. All the Muslims were perplexed and at a loss, when a person emerged on foot from the midst of the fire and came into the Amir's view. That person bowed and handed the Amir a letter. The letter was from Zarduhusht's Malaka, and it said, 'I am called Aswad Piyada. When anything needs doing, they refer to me.'

The Amir said, 'Piyada, I have forgotten how to break a spell and cannot remember.'

'Unless Iblis is killed,' he said, 'you will not remember.' Aswad recited a name, and the fire went away. Iblis went onto the field, and so did the Amir. Whatever magic spell Iblis cast, Aswad broke it. The Amir killed Iblis, and he remembered how to break a spell.

Mashruh Rudagardan entered the field, and he was killed. Lahat had the drums of retreat beaten, and he fled by night to Antali. When he reached Antali, Shaban-Bachcha Tayifi had been kept opposite Umar Ma'di. They had built a tower all around him such that his eyes and mouth showed, but all the rest was encased in mortar and bricks. Bozina Jadu had put a goat at the tower cage, and the goat would call the name of anyone who appeared.

When Zumurrud Shah camped in a meadow he received the news of the sorcerers' defeat. He set out for Antali. The sorcerers had received permission from Zumurrud Shah to think up a plan against Hamza. Marzban was with Zumurrud Shah. They decamped. One station down the road [Zumurrud Shah] saw a pole and asked [Marzban] about it. 'The sorcerers have set up seven talismans to block the road so that the God-worshippers cannot pass,' Marzban said.

'How are we going to get past the talismans?' asked Zumurrud Shah.

'I will send someone and inform them of your approach,' he said. He made a bird of clay, wrote a letter, tied it to the bird's wing, worked his magic, and made it fly to Antali.

Two days later they saw that several jars had appeared. Zumurrud Shah and all his commanders, horsemen, and soldiers were sat on the jars, and off they flew into the sky toward Antali. The next day when the sun in the orient lit up the ancient world, several thousand jars appeared in the sky, and all of Zumurrud Shah the Wayward's horsemen and soldiers were sitting on the jars. The whole city of Antali was festively decorated, strange and fabulous shapes were made, and fine carpets were laid. Then, when Zumurrud Shah stopped at the

gate to Mâlik Zarduhusht's house, sorcerers gathered all around Zumurrud Shah to welcome him and escort him into the palace, where a banquet was given in his honor. Each of Zumurrud Shah's commanders was lodged in the house of a sorcerer. Zumurrud Shah set off barefooted to have an audience with Zarduhusht, and when he arrived he rubbed his forehead on the ground and lamented greatly. A voice came from a closed chest, saying, 'Your visit has been accepted.'

Volume 11, text number 1/59
MAK–Austrian Museum of Applied Arts/Contemporary Art, Vienna, B.I. 8770/28

The narrator says that one day Qubad, son of Sa'd Padishah, went out intending to hunt. He was bringing down prey in every direction when he saw a red deer. Taking a lasso from his saddle ring, he looped it and set out after the deer. No matter how hard he galloped, he could not catch up with it. Suddenly a dark shape appeared. Prince Qubad saw from the midst of the darkness a hand appearing that snatched both him and his mount away.

Ghaltan Ayyar went out in search of the prince but could not find him. Despondent, he returned to the Amir and related his story. The Amir was extremely worried.

The next day Amir Sahib-Qiran decamped. Landhaur was riding beside him when a whirlwind appeared on one side. Landhaur looked to his right: he saw a dome. He rode toward it, but the closer he got to the dome the stronger the wind became. When he approached he got down from his horse. He saw a river of water in front of the dome. No matter how much he walked up and down the water, he could not see a way to cross. He returned to the Amir and related the situation. The Amir ordered several men to go throughout the region; perhaps they might find some locals. The ayyars went off in all directions. After much searching they found two men they brought to the Amir. The Amir questioned them. They said, 'We, father and son, are boatmen. This son of mine is named Laku.'

'There is a certain dome around here,' said the Amir.

'Yes,' they replied. 'We have heard that in the vicinity is a dome called Jamshed's Dome. The Zahhak put a treasure in it and bound it with a spell called the wind spell.'

The Amir mounted with his officers. When they were near [the dome], the wind carried off both man and mount. Amir Sahib-Qiran returned and busied himself with his religious duties and then went to sleep. He saw in a dream that someone said to him, 'O Hamza Arab, you must go five leagues toward the qibla of the dome. A magnificent mountain will appear. Ride close to the skirt of the mountain. Take the road and approach toward the dome of the wind. When you reach the dome there will be a brass step attached to the dome. If anyone tries to place his foot on that step to go up, the step will turn, catch the person in the middle, and cut him in two. At the foot of the brass step is a very long pole of iron with a platform attached to the foot of the pole. You must go up on the platform. Take a heavy mace in your hand and strike the pole with it as hard as you can so that the pole goes into the earth and renders the brass step null. A road will appear up the mountain. Enter, and then on the slope of the mountain will appear a pool with brass pipes arranged along the slope of the mountain so that the water is brought through the pipes up the slope. On the pole of the dome is a bird. The water enters into the bird and pours down from its beak. On the bird's head is bound a talismanic seal. When the water reaches that seal it goes fast. When you reach the pool, you must shoot an arrow from the edge of the pool so that it goes straight and knocks off the bird's head. When the bird's head has been separated from its body, the wind will cease. However, a demon will come out of the dome, holding a mace. He will hurl the mace at you. Repel it. After you attack him, he will take a lasso from his waist and throw it at you. Grab the lasso and split the demon with one blow of your sword. Go up on the dome, and there you will find a round stone as white as milk. Pick it up. A wheel of diamond will appear with chains attached to it. The water has been so arranged that it flows

down the side of the dome and reaches the handle of the wheel and flows around its base. You must smash the wheel with one blow of your heavy mace. A door into the dome will appear. Go in. There will be a deep pit in the dome, and the Zahhak's treasure is in that pit. However, you must be careful for the pit is not devoid of black-faced sorcerers.'

In short, Amir Sahib-Qiran came out of his heavy sleep, summoned the shahs, and told them the story of his dream. They mounted and headed off for the dome. When they arrived, they did as [they had been told]. Amir Sahib-Qiran came to the edge of the pit.

The depth of the pit was a league, as dark and narrow as a Jew's grave.

The stricture of nonexistence a foot of it; ...

Not a pit was it, but a catastrophe: a dragon going into the earth it was.

When Amir Sahib-Qiran stood at the edge of the pit, a dragon came out and sprayed him with fire. The Amir recited a spell against magic, and the dragon began to weep and wail. The Amir killed it. There was Shamsa the sorcerer with a tablet in his arms. The Amir brought it out, picked up the treasure, left, and hastened back to his soldiers.

TRANSLATION FOR CAT.59
Volume 11, text number 66
MAK–Austrian Museum of Applied Arts/Contemporary Art, Vienna, B.I. 8770/25

The narrator says that when Songhur Balkhi entered that prison, he saw that it was very dark. Hiding himself in a corner, he waited until they had all left and shut the door. When night fell he went to the edge of the pit, took his ayyar's shirt, and let himself down into the pit. In short, he took the bonds from Ibrahim b. Hamza's and Sabukpay Eki's hands and feet. They got out of the pit, tore the door of the prison from its hinges, and departed.

Just then Chiras arrived and blocked the way. Ibrahim threw him out of the way and hit the other one so hard that both of them were squashed. Grabbing his sword, he fell upon the guebres. The night watchmen got wind of this and appeared from all directions. They sent someone to Qimar, and battle broke out. When Parran Ayyar learned of the alarm he arrived to help with forty braves. They got themselves to the door of the Victory Gate, opened the gate, and sent Songhur Balkhi to Sa'id.

When Qimar learned of this, he ordered Qatas Elephant-Ear to go quickly. He went. Malik Bahman got news and left his station. The guebres attacked. Qatas was slain by Ibrahim, and Sital the night watchman and Malikyar the night watchman were killed by Malik Bahman.

Next the guebres attacked just as Sa'id Farrukh-Nizhad arrived with cavalry and troops and sounded the drums and clarions. Qimar saw no alternative to fleeing and took flight to Tawariq.

When Bihbud the vizier saw this, he ordered the men to summon Ama ... 's men. When it was day Sa'id came into the tent. The friends greeted each other and were happy. Parran Ayyar, Misbah the greengrocer, and Dost the butcher were brought with those forty ayyars. The prince was very kind to them. Qimar's cousin had been captured. He was imprisoned in the very place Ibrahim had been. Bihbud the vizier became Muslim. Qimar's son, Qubad by name, was captured. He became Muslim. They gave him his father's place, and they made Misbah the greengrocer the police chief of the city and Dost the butcher the overseer of the market, and they gave their friends much gold. They wrote a proclamation of victory and sent it to the Amir with Sabukpay Eki.

When Qimar set out for Tawariq with a group, along the way Mahus Ayyar had been sent to Na'imshah. He arrived. They asked, 'What have you done?'

'They have brought Na'imshah with four hundred thousand men and forty commanders,' he said.

The next day they met. They greeted him and his commanders, like Hamvat Man-Thrower, Asamir Man-Thrower, Qartam

b. Tamtahir, Tamil Blood-Drinker, Mahas Man-Eater, Damir b. Aad, Khalis Ramli, Sharat Dilavar, and Fil-Kas Elephant-Strength.

In short they paid homage to Qimar and entered the city of Tawariq. Mahus was sent to the army of Islam.

Ibrahim was reveling with Khwarmah. Mahus came to the city of Zibarjadnagar. He saw Khwaja Bihbud mounted on a horse. He chased him until he entered his castle. Mahus went up on the roof of the house. He looked through a window. He saw that someone was seated before Bihbud, saying, 'O khwaja, something must be done so that we may reach Qimar quickly.'

'To go empty-handed is not good,' said Bihbud. 'One of the sultans of Iran must be taken.'

Mahus came down, entered, and told his story. All rejoiced and said, 'Qalmas is in bondage.'

'I know of a tunnel,' said Mamud.

In short, he went to the entrance to the tunnel and entered it along with Bihbud the vizier. Fifty men were languishing in prison waiting for someone to arrive. After several days he arrived and released Qalmas, took him to Bihbud, and said, 'I'm going to bring Khwarmah.' He went. Khwarmah was in a garden asleep on a throne, so he went over the wall into the garden, rendered her unconscious and took her to Bihbud.

'O ayyar,' he said, 'in one night you have done something no one has ever done.'

'O khwaja,' he said, 'now one must go.'

'How should we go?' he asked.

'I will put you in a chest, the wife in another chest, Khwarmah in another chest, the cousin in another. Then I'll load the four chests and put those who are loyal to you in a certain caravanserai.'

Bihbud said, 'That's a good idea.' And they set out to execute that plan.

TRANSLATION FOR CAT.60

Volume 11, text number 69
MAK–Austrian Museum of Applied Arts/Contemporary Art, Vienna, B.I. 8770/44

The narrator says that when it was daylight the distressed Zangis went to Malik Mu'in's gate and explained the situation to him.

'I hope the ayyars of Iran don't rescue him,' he said. 'He had better not get away! Just as Zibarjad Shah said, he should be sent to Malik Taysun in Aqiqnagar.' Malik Taysun was Malik Mu'in's father-in-law. It was ordered that Mashrut Jangi and two thousand men should take him.

The next day the battle drums were sounded. The infidels lined up, and when the ranks were arrayed, Prince Ibrahim came into the field with his army and performed valiantly. When he returned, Ibrahim son of Hamza summoned Zambur Ayyar and said, 'Go get news of Songhur.' He entered the city, and one of Mahus's soldiers collared Zambur. All of a sudden a man appeared and killed the soldier. He was Songhur Balkhi. Then he came up to Zambur, and the two of them rejoiced in the sight of each other. After that, he told Zambur everything that had happened to him from beginning to end. They bid each other farewell, and he left to take the news to Ibrahim. Songhur took the news to Malak Mah. Word came that Ghazanfar, who was the brother of the girl [Malak Mah], came, and when he entered he was drunk. After he calmed down, he said, 'Sister, can't you do something to make Khwarmah meet with me?'

'Brother,' replied Malak Mah, 'she is smitten with that Iranian, and as long as he is alive it won't be possible.'

'Sister,' he said, 'We sent Sa'id Farrukh-Nizhad, who was held captive by us, to Malik Taysun in Aqiqnagar, and we will fix him!'

'We'll tell Mahus and Mahlal to bring him,' the girl said, 'but you will have to do something to plant love for me in his heart.'

Then someone came from Malik Mu'in to say, 'This is no time to be drinking wine.' He bade farewell to his sister. She summoned Songhur and told him about Sa'id Farrukh-Nizhad and how he had gone to Aqiqnagar.

Songhur said, 'In any case I have to go.'

'I will accompany you,' said the girl. Nothing he could say would prevent her from going with him, so she set off on a fast horse together with Songhur, Jaldak Ayyar, and a maid-servant named Khosh-Khiram.

The next day when the battle drums were sounded Zambur went before Prince Ibrahim and informed him of the ayyars. He rejoiced. Bayram Taq came onto the field, and he killed fourteen of Malik Kaysar's men. Sarut came onto the field and was wounded. Prince Ibrahim came onto the field. When he and [Bayram Taq] were near each other, the prince extended his hero's arm and seized him. The armies retreated. Bayram Taq became Muslim. Mahlal took the news to Malik Mu'in, and just then a chamberlain came in and whispered in the ear of Muhandis the vizier, saying, 'For two nights now Malika Bedarbakht [?] has been suffering.' When they were in private he told this to Malik Mu'in, who flew into a rage, but no matter how hard he searched he could not find [...?].

Ibrahim summoned Zambur, Parran Ayyar, and Lulu the spy and said, 'All my trouble is for the sake of Khwarmah.'

They said, 'The two bastards Mahus and Mahlal may know [where she is]. If we go into their camp they may try to do her in. We have sent someone to bring news.'

'Let one person go,' said Ibrahim, 'and ask Sher Banu. She may have news of Khwarmah.'

She said to the person who had been sent, 'I don't know, but I have a woman in my service who has no equal in trickery and sneakiness. She says that if someone goes with her she will go into the city and get word of Khwarmah.'

Zambur said, 'I will go.'

'Then go,' said Ibrahim.

He went to Sher Banu saying that he was going. She said to summon Mahiya. 'Get two donkeys,' she said. 'Load one with fruit and the other with supplies.' Mahiya put her veil over her head and got on a donkey and set off with Zambur to Tawariq. When they got there Zambur asked where to go. 'Take me around the city lane by lane,' she said. Suddenly a man appeared with a donkey on which sat a woman. The woman was wailing.

Mahiya said to Zambur, 'Ask what is wrong with her and where she is going.' He asked.

'I am Ustad Khatun,' she said, 'and I am a medicine woman.' Mahiya went with her.

TRANSLATION FOR CAT.61

Volume 11, text number 70
Metropolitan Museum of Art, New York, 23.264.1

The narrator says:

When Mahiya said, 'I am looking for Ustad Khatun's house,' [the woman] joined her. They went together to the gate of Ustad Khatun's house. Mahiya got off the donkey and sat in a hallway. Zambur took the saddlebag from the donkey and placed it in front of Mahiya, and he also took down the baskets of fruit. After that, Mahiya went inside Ustad Khatun's house. She greeted her profusely and said, 'You will forgive me, for I have brought you only a little fruit.' Ustad Khatun embraced her and complimented her. Mahiya gave her the baskets of fruit and said, 'I have brought my husband too.' So saying, she put her hand in her pocket, took out ten *tanga*s, and placed them before Ustad Khatun.

'What is this?' asked Ustad Khatun.

'Should I really tell you what's wrong with me?' Mahiya asked.

'Yes, tell me,' said Ustad Khatun.

'I have been feeling blue for several days,' she said. 'I wanted to come to town for a few days to get the sadness out of my heart. When we arrived in town my husband said, "The place for us to stay is Ustad Khatun's house." So we came here.'

'And you are welcome here,' said Ustad Khatun.

To Zambur she said, 'Your wife has much pain. You stay here for a few days. You can tour the town and market.' Zambur agreed to this. She emptied a wooden room for them. When night came Mahiya went to Zambur and said, 'We have taken lodgings here. Now one must look for news. Be off with you.'

Zambur went out and set forth.

On the night that Mahus's pupil was killed by Songhur, Malik Mu'in said to Gharrad, 'You must be watchful and constantly patrol the city. Maybe one of the ayyars of Iran will fall captive to us.' He agreed, and that night he was drinking wine with his friends in the marketplace. When half the night had passed and the men were resting here and there, he and his friends got up and looked all over the marketplace. Just then Zambur came into view from afar. They lay in ambush, and when Zambur reached that place they seized him, tied him up, and took him roughly before the guebres who were drinking wine. He took him forward, sat down, and started drinking wine. Then he said to Zambur, 'Tell the truth! Who are you, where do you come from, and what do you think you're doing?'

'I am a stranger,' he replied. 'I came to this city today. I sold fruit to someone. She detained me and entertained me. Just now I set out from there to go to bed when you encountered me.'

Gharrad laughed and said, 'You don't know much about the city.' When he was drunk he ordered his men to hang Zambur upside down. No matter how much Zambur cried and pleaded, the guebre was unmoved and kept drinking his wine. All the ayyars went to sleep.

As for Mahiya, she saw that it was late and she was waiting for Zambur to return. When a long time had passed she got upset. She put on her veil and boots and went outside the house, looking all through the marketplace until she came to that place. There she saw that someone was suspended upside down and a group of men had been drinking wine. The utensils of the party were scattered, and the participants were lying all over the place. She went forward and, recognizing Zambur, she set him free. Then she drew a knife from her belt and cut off the heads of all Gharrad's companions. She hung Gharrad up in Zambur's place and went back home with Zambur.

The next day the people of the city came and saw what had happened. Everyone gathered, perplexed by the sight.

When this distressing news reached Malik Na'im, he and his men got very upset. A servant went to Ustad Khatun and said, 'Malaka summons you.'

Mahiya said, 'Which Malaka summons me?'

Ustad Khatun said, 'The daughter of the king ... has a pain. Sometimes she summons us. We go and treat her.'

'Ustad Khatun,' said Mahiya, 'how would it be if you did me a favor and took me with you so that I could see the daughter of a king? After all, I came from my village to see the city in order to get the grief out of my heart. Now that we are staying in your house, I am at your disposal.'

TRANSLATIONS FOR CAT.62

Volume 11, text number 71
Arthur M. Sackler Gallery, Harvard University Art Museums, 1941.292

The narrators say that when Mahiya flattered Ustad Khatun and said, 'Kind lady, I want to see the beauty of Malik Qimar's daughter,' Ustad Khatun acted very kind and said, 'Mahiya, you are like my own daughter. Come with me. I'll take you there and show you things you have never seen before. I will take you into the harem of Malik Na'im, the king of the city of Tawariq. Come now, and we'll go together to Khwarmah.'

'Ustad Khatun,' said Mahiya, 'consider me as one of your maidservants.'

In short, Mahiya and Ustad Khatun put on their veils and boots and went outside.

'Let me tell my husband not to go anywhere until I get back,' said Mahiya to Ustad Khatun. So saying, she went to Zambur and said, 'Ayyar, I have good news for you. Khwarmah has summoned Ustad Khatun, and I am going with her. Let us see what happens.' Zambur rejoiced.

Mahiya then went with Ustad Khatun to the door to Khwarmah's house. Mahiya was astonished by every article of royal luxury she saw until they reached the door to the harem. The eunuchs asked Ustad Khatun who the other woman was. 'She is my sister,' she told them. 'She too has a hand in my business.' So saying, she went in, taking Mahiya with her. When they entered, Khwarmah's mother said to Ustad

Khatun, 'Khwarmah is in that room, complaining of a pain in her side.' Ustad Khatun went into the room with Mahiya. When Khwarmah spied Mahiya, she recognized her and smiled. Mahiya winked and bit her lip.

'What is the reason for this smiling?' asked Ustad Khatun.

'Lady,' said Khwarmah, 'I have a pain for which no one knows the remedy and which no one can treat save that person whom I know.'

Ustad Khatun went forward, put her hand on Khwarmah's side, and rubbed it. Just then the queen asked Ustad Khatun who the other woman was. 'She is a druggist,' she said, 'and she comes from the city of Aqiqnagar. She is a relative of mine.'

In short, they were there until evening. Khwarmah said, 'Khatun, when a bit of the night has passed, the pain in my side grows worse. If there is somebody who can give me a massage at that time, I can calm down.'

'My queen,' said Ustad Khatun, 'I have a house full of things, and I also have guests. I cannot remain here at night.'

'I will stay here,' said Mahiya. This, of course, was Khwarmah's object. In short, she kept Mahiya there, and Ustad Khatun left. When it was night Mahiya remained until they were alone together. Khwarmah said, 'Sister, how were you separated from Sher Banu?'

'My queen,' said Mahiya, 'when they kept you here, Hamza's son Prince Ibrahim heard that they had put you in chains. He sent someone to Sher Banu, thinking she might have news of you, but she didn't. Ibrahim was very worried and ordered the ayyars to come and find out about you. No one agreed to come. Sher Banu summoned me and told me. I accepted and have come to you.'

'Are you alone, or do you have someone with you?' she asked.

'Zambur Ayyar is with me,' said Mahiya. 'Now tell me your news, and I will tell Zambur Ayyar, and he will send it to Ibrahim.'

'It was true that they put me in prison,' said the queen. 'But I sweet-talked them into letting me go.'

Now the narrator says that when Malik Na'im had not done battle for several days, one day Muhandis the vizier came before him and said, 'As the Zangi's son Shahan has been in your prison for some time now. If you release him, maybe he will be a match for the God-worshippers.'

The narrator says that As was Malik Na'im's slave, and he was extremely domineering. He was always making trouble in the city and killing people. When he ate them, they put him in prison. Now they summoned him and told him to repel the God-worshippers. He accepted.

The next day the battle drums were sounded and ranks were formed. The Zangi entered the field and killed several from the army of Islam. Then Ibrahim entered the arena and cut him to ribbons. The armies retired from the field.

Now, there was Malik Na'im's son Ghazanfar. He was hopelessly in love with Khwarmah. One day he said to Muhandis the vizier, 'I will soon die from love of this girl. After I am dead, of what use will the girl be? Tell this secret to the malik.'

Muhandis told the father, who grew angry and said, 'Now is no time for talk of brides and grooms!' And he was much disturbed to hear this news.

He grew more emaciated from love every moment – pale, ill, and miserable.

Volume 11, text number 72
MAK–Austrian Museum of Applied Arts/Contemporary Art, Vienna, B.I. 8770/21

The narrator says that when Ghazanfar despaired of his father, he was unable to say anything. There was a fortress, Khurramabad by name, and Ghazanfar's mother was in the citadel, and Ghazanfar and Qalmas's mother was [?] not there. When he despaired of his father, he went to his mother and wept and cried until she had pity on him. She had an *ayyar* named Tarmas, who was very clever and powerful. Ghazanfar's mother summoned him, and when he came she said, 'Ayyar, you must get yourself somehow to the city of Tawariq in order

to capture Khwarmah and bring her here. This son of mine is going to die of grief and pain. I will ennoble you in return. However, you must not bring her by land. Get into a boat and come here lest something happen on land.' He accepted. Ghazanfar's mother had a eunuch she sent along with him, and she gave them much gold.

The two set forth and traveled until they reached Tawariq. Tarmas had an *ayyar* of his own who was Khwarmah's mother's cook. In short, he went to him/her [?] and put a knock-out drug in the food and gave it to Khwarmah and her mother. That night he got into the castle, stole Khwarmah away, and took her to the eunuch. He put her in a chest, got into a boat, and set out by sea. However, the next day the men learned of the event. Mahiya was very upset. She thought that the *ayyars* of Iran might have stolen her, but one of the kitchen workers said, 'An *ayyar* named Tarmas came. In the middle of the night he went into the king's harem, and there was a [*gulabari*]. I didn't know what it was since if the men had recognized him they would have known that it was Tarmas's work.'

Qalmas's mother said to Malik Na'im, 'Your son has done such a thing.' When they ascertained for certain that it wasn't he, he had gone to the citadel at Khurramabad, and Malik Na'im also recognized this Tarmas Ayyar, got angry, and wanted to send someone to the citadel to bring them all and punish them.

Muhandis the vizier said, 'One son of yours turned out ill-starred over this girl. Do you want to lose this one too?'

Malik Qimar agreed and said nothing.

When Mahiya ascertained [?], she went to Zambur, bade the [Ustad Khatun] farewell, and set out for the fortress.

When they brought the girl, Ghazanfar's mother showed her respect. Khwarmah was perplexed that she should be acting like that. 'You are not a stranger,' she said. 'When Malik Qimar gives permission, as usual' She accepted and told her son. He rejoiced, and immediately she sent Ihraq Gavmal to Malik Na'im with a letter, saying, 'Since my son almost died, we brought her here. Get permission for us to marry him here.'

Mahiya arrived at the gate of the fortress with Zambur Ayyar. 'We will be a doctor,' he said, 'and you be a geomancer.' Mahiya put a feed bag around her neck and said, 'We will treat anyone who is in pain,' as they went around the neighborhoods. Zambur opened a shop at the crossroads. Someone took the news to Ghazanfar that a geomancer had come to the neighborhood. Since he was in love he always wanted to ascertain news. He summoned Zambur. He came and told him a few tales. He was pleased and asked him about himself. 'O prince,' he said, 'I have a sister who is so knowledgeable about magic that she can turn the earth into the sky.' She was summoned. Mahiya said, 'If I am acquainted with her, within three days I can make it so that she will come to you.' Ghazanfar rejoiced and sent someone to Khwarmah, saying, 'A woman doctor has come.'

'I don't need a doctor,' said the queen. 'Mahiya had told me that I should see her.' They sent Yaknazar. When she saw her, she was happy. She asked about her. She said, 'I am a woman doctor.'

'A doctor like you is of no use to me,' she said.

In short, they spoke for a while. Khwarmah was happy and said, 'Previously one of Ghazanfar's people came and took the news to me.' He was happy, but Khwarmah summoned Mahiya and said, 'Think of something.' She said, 'O queen, don't worry. Tonight we will make him unconscious and take you away.' She was happy. Mahiya came and said to Ghazanfar, 'Good news! Tonight you will have your wish.' To Ghazanfar's mother they said, 'Until someone comes, let us converse together.'

In short, when the conversation grew warm, they applied the knock-out drug. Ghazanfar was thrown into the sea by his people, and Khwarmah was outfitted. The three let themselves down with a lasso and set forth, traveling until dawn. Khwarmah's feet were blistered. Zambur said, 'You stay here while I go. Maybe I can find a remedy.'

TRANSLATION FOR CAT.65
Volume 11, text number 75
MAK–Austrian Museum of Applied Arts/Contemporary Art, Vienna, B.I. 8770/59

The narrator says that when Baba Bakhsha World-Traverser embraced Songhur and Lulu the spy and kissed them on the forehead, he said, 'Your countenances are blessed.' He sat them in a good place and brought them food and drink.

In short, they spent that day in each other's company, and [Baba Bakhsha] asked about the Amir, Umar, and the Amir's officers. The disciples had gathered on that day. When night fell they received permission to depart and went to their chambers in the caravanserai, where they said to each other, 'Both of these appear to be in league with us.'

When they came before Jaldak Ayyar and Khosh-Khiram and explained the situation, they were uneasy on account of Malak Mah. However, when the companions emerged from Baba Bakhsha World-Traverser's *takiyya*, since Baba Bakhsha was a far-sighted man, he said to his faithful disciples, 'Comrades, these two young men are, of course, among the *ayyars* of Iran who have come to rescue Sa'id Farrukh-Nizhad.' To all the disciples he said, 'Wherever you see that young man, seize him and bring him to me.'

However, when it was night, Songhur Balkhi and Parran Ayyar decided together that they would go to the prison gate in disguise so that, perhaps, they might accomplish something. They set forth. Both went to the prison. When the men ceased their comings and goings, and half the night had passed, they began to circle around the prison. The prison guards, however, were drinking. When the *ayyars* came to the rear of the prison, they saw four men dressed in black. They went forward and asked who they were. One of the four stepped out and said, 'What persons are you?' Lulu the spy recognized them as pupils of Baba Bakhsha World-Traverser. He acknowledged them and said to the other youths, 'These two youths are merchants who had come to Baba's *takiyya*. Baba Bakhsha showed them great respect. They too went forward with great humility and met Songhur and Lulu. 'O youths,' they said, 'you are merchants? What are you doing at such a time in such a city?'

Lulu replied, 'Comrades, know that they call me Lulu the spy, and I am among Khwaja Umar's pupils. This one is called Songhur Balkhi, and he is one of Khwaja Umar's commanders. When we went to Baba's *takiyya* and heard familiar talk from Baba, we wanted to acknowledge our acquaintance and show ourselves to him, but it wasn't possible. Now we have come to the prison in hopes of accomplishing something.'

They rejoiced, but no matter how much the six of them circled around the prison that night, they could not do anything. They turned away and went to Baba Bakhsha World-Traverser's *takiyya*.

The next morning they went before Baba and met him. After that, they told him what had happened to them. Baba arose and kissed their hands, saying, 'O commanders, I had a dream in which I was told to do something to rescue Sa'id Farrukh-Nizhad from his chains, and now I am trying to accomplish that. Now that you have come, praise God, we can do something together and, with the help of the Creator, get that young man released from the bondage of these woe-begotten infidels.'

'We need a place in which we can hide him after rescuing him,' said Lulu.

'Have no worry on that score,' said Baba Bakhsha, 'for it has occurred to us to hide Sa'id Farrukh-Nizhad in our own *takiyya* in such a way that no one will have the slightest suspicion that he is there.'

They rejoiced. Baba Bakhsha said, 'O youths, what thought have you had concerning the rescue of Sa'id Farrukh-Nizhad?'

'It occurs to us,' they said, 'that we will go to the shop of Sha'ban the wine-seller and lie in wait until the prison guards come to buy wine. We will use a knock-out drug. Perhaps we will be able to accomplish something.'

'Let several of my disciples go along,' said Baba Bakhsha.

They came and kept Sha'ban busy until the prison guards came. Sha'ban said to Songhur, 'Go bring wine from that special vat for the men of Ahsha World-Traverser, who is now the warden of the prison.' Songhur mixed a knock-out drug into the wine and gave it to them. They fell unconscious. The *ayyars* came to the prison gate and cut the guards' heads off, rescued Sa'id, and took him to Baba Bakhsha's *takiyya*. Baba hid the prince. The companions went to the caravanserai and informed Khosh-Khiram and Jaldak. They rejoiced.

The next day they took the news to Taysun, who ordered two hundred men to keep guard at the gate. He had an *ayyar* who was called Kajdast Khunrez (Crooked-Hand Blood-Shedder). He summoned him and said, 'Such a thing has happened, and the perpetrator must be discovered.'

'It seems to me,' he said, 'that this is the work of Pahlavan Bakhsha World-Traverser.'

TRANSLATION FOR CAT.66
Volume 11, text number 76
Brooklyn Museum of Art, New York, 24.46

The narrator relates that when Malik Taysun's son heard that Kajdast ... he said, 'I believe this is the work of Baba Bakhsha World-Traverser.' He said, 'It is not his doing.' Malik Taysun accepted and said, 'You lie in ambush and see whether he has done such a thing.' Kajdast said, 'I'm going to make an ambush.' This he said and departed. At midnight he crept over the wall of Baba Bakhsha's garden. This building was under the ground and located to the right of the garden, and just then Songhur Balkhi son of Dalv-Avar the spy came out of the underground with a candle in his hand. Sa'id also came out with them. Seeing them, Kajdast said, 'Good.' He brought the news to Malik Taysun, and he sent a thousand fully-armed men to bring them all in bound hand to neck. The spy brought the news to Baba Bakhsha. Baba and forty braves armed themselves. Sa'id Farrukh-Nizhad and his companions got armed. Battle broke out. At first many warriors of Islam were killed by the guebres. Kajdast Ayyar came before Malik Taysun, and he sent forty long-stirruped [steeds] with Marku' Dilavar with two thousand men. They fought until day broke. Both guebres were killed by Prince Sa'id Farrukh-Nizhad, and from the rest of the soldiers came pleas for quarter. When it was night Baba Bakhsha came to Sa'id Farrukh-Nizhad, saying, 'I have dug a tunnel that comes out seven leagues from the foot of Mount La'l.' Sa'id did not approve and said to Baba Bakhsha, 'All these Muslims will be killed. It is not right.' In the end Prince Sa'id and his companions came out. Baba Bakhsha World-Traverser had dug two pits in the road so that anyone who came would fall in. They closed the gate and went inside. The guebres had turned back and gone in front of that house. No matter how hard they searched, they were too afraid to be able to get in. Finally the infidels used all their strength and broke the door in. There was no one there. They realized they had gone into the tunnel. Malik Taysun's son came and ordered some of them to go into the tunnel. They went forward and fell into a pit. They pulled them out and proceeded. Finally they sent men all around to make the news known. ... but Sa'id Farrukh-Nizhad and his companions came out from the skirt of Mount La'l. Baba Bakhsha said, 'There is a fortress here, and my squire is in it. If someone informs him, it will be good.' Shahbaz Ayyar went and returned, saying, 'Malik Taysun's envoy was in this mountain when Prince Sa'id went and killed the guebres and drove the envoy away.' Shahbaz came and spoke to Ra'un. He was happy and said, 'I renounce Zumurrud Shah.' He went and called his companions, and they started reveling. However, Malik Taysun was thinking about the envoy when the envoy came and told him what had happened. Afterwards news of them arrived that they had gone to Ra'un Elephant-Neck's fortress. He got angry and sent his army to destroy the fortress. Sa'id came out and killed them, and the guebres sent news. Eighty thousand men came. Sa'id came back. Battle lines were drawn. Kunas Cat-Eye came out. Shahbaz Ayyar stepped forth and planted a knife in his side, bringing him down. Several other champions were

also killed. The next day Abraq came out into the field. Sa'id came out and took him. He became a Muslim and received permission to go convert his soldiers and bring them over. He went and told Taysun, 'I have given them [my word].' As'ad, who was Taysun's son and Baba Bakhsha's squire, got his weapons, and together they attacked Taysun's camp. News was taken to that guebre. He almost went mad, but As'ad and Andaq plundered Taysun's camp and went to Sa'id. However, when Taysun entered the fortress, word came from Kajdast, saying, 'Do not grieve, for tonight I will kidnap Sa'id.' He went into the camp and kidnapped him. However, when he brought Sa'id to Taysun, he said for him to be kept under watch. They sent twenty thousand men against the camp of Islam. When they came the Muslims had gone into the fortress. They pulled back. Malik Taysun said, 'Guard Sa'id, and tomorrow we'll cut his head off in front of the fortress.' His vizier said, 'He should be sent to Ki'al Man-Eater's island, for if a stranger appears, they will eat him.' They sent a messenger and also said to Kajdast, 'You go too.' They accepted and went into the sea. Kajdast came bringing news. The next day they started fighting and battling.

TRANSLATIONS FOR CAT.67
Volume 11, text number 78
MAK–Austrian Museum of Applied Arts/Contemporary Art, Vienna, B.I. 8770/43

The narrator says that As'ad, Malik Taysun's son, said, 'Comrades, no one can be sent to Ki'al's island to send reinforcements.'

Khosh-Khiram said, 'Let Songhur go and inform Prince Ibrahim son of Hamza of this. What a pity that there is no one who can guide me to Ki'al's island.'

Just then one of Baba Bakhsha World-Traverser's *ayyars*, who was called Kajrah Ayyar, said, 'If what you want is to be guided, I will undertake this service.'

Khosh-Khiram rejoiced, and she took those *ayyars* along, bade her comrades farewell, and set off in the direction of Ki'al's island. Songhur Balkhi was given leave and departed to the city of Tawariq.

The narrator says that Prince Sa'id was brought before Ki'al, who had a daughter named Barghal. When she saw Sa'id, she fell in love with him. However, when Ki'al saw Sa'id, he said, 'Bring a skewer and roast this human!'

'Malik Taysun has sent this one for safe-keeping,' said Barghal.

'Then what should be done?' asked Ki'al.

'He should be put in chains in the prison,' she replied.

Ki'al said to Silaq Man-Eater, 'I entrust him to you. Keep him in chains.' And he took the prince away and put him in chains in the prison.

Barghal, however, was beside herself with love for the prince. Smiling, she waited patiently until it was night. She went to the prison gate, killed all the guards, rescued Prince Sa'id Farrukh-Nizhad, and took him to her house, where she said, 'O prince, I have given my heart to you. Marry me.'

'My beauty,' said Sa'id, 'whenever I see my mother and father, I will grant your wish.' Barghal was patient.

The next day the guards went to Ki'al and said, 'Last night your daughter came to the prison, killed all the guards, and made away with the prisoner.'

Ki'al summoned his daughter and asked her about it. She said, 'Yes, when he was brought before you and you ordered him to be roasted, I was greatly inclined toward him. I kept you from doing it. Last night I went and took him out of prison, roasted him, and ate him.' Ki'al accepted this.

Nonetheless, every night she came to Sa'id and repeated her demand. Sa'id gave her the same answer until the girl got fed up. The fire of her love enflamed, she said, 'O prince, when will you go to your mother and father?'

'My mother and father will not come here,' he said, 'but if you get horses and arms, you and I will escape and get ourselves to them so that you may have your desire.'

The girl immediately brought horses and arms. The two mounted and set out, traveling all night. The next day they

dismounted beneath a tree. A voice came to Prince Sa'id's ears. It was someone saying, 'Thank God.' Sa'id looked up and saw Khosh-Khiram climbing down from the tree.

'Woman,' he said, 'what are you doing here?'

'I went out in search of you,' she said, 'and one of Baba Bakhsha World-Traverser's *ayyars*, Kajrah by name, was with me. He was showing me the way. When we arrived here, a group of Zangis appeared. I climbed up this tree and they didn't see me, but they ate Kajrah Ayyar.'

'Yes,' replied Sa'id, 'it has been said
*By crookedness you fall lower and lower.
From all grief you are free if you are true.'*

In short, they set out together until they reached the edge of a river. They got into a boat and crossed the water. They dismounted at the foot of a mountain and camped there for the night. However, a panther came down from the mountain and tore Barghal to bits. Sa'id killed the panther and, the next morning, laid Barghal to rest in the earth.

Khosh-Khiram and Sa'id both got on horses and set out, but they did not know where they were going.

'Don't you know the way by which you came?' Sa'id asked Khosh-Khiram.

'No, I don't,' she answered.

Then, trusting in divine goodness, they proceeded until they came to a gate, one door of which was open and the other closed. Sa'id and Khosh-Khiram entered and saw lofty buildings and a kiosk. Both entered. They saw two girls wrestling with each other. One was Malak Mah and the other was Malik Na'im's daughter. When Malak Mah saw Sa'id, she almost fainted from happiness. They all greeted each other.

'Prince,' she asked, 'what are you doing here?'

Sa'id explained his situation and asked her about hers.

'I was going to the city of Tawariq to the *ayyars*,' she said. 'A hag came from behind a tree and worked magic. Grabbing me by the hair, she took me to her house. Since I was wearing man's clothes she thought I was a man. When she realized that I was a girl she put me under this spell. This girl's name is Sheda Banu. The daughter of the king of the birds, Zagh-Chashm, was in love with her brother. The brother died, and the sorcerer brought his coffin and suspended it from the ceiling of his house. Her brother's hair has held me. He is called Karkara Jadu.'

Volume 11, text number 79
Freer Gallery of Art, Smithsonian Institution, Washington, DC; Purchase 1960.14

The narrator says that when Sa'id Farrukh-Nizhad learned about Karkara Jadu from Malak Mah, he stayed there that night. Khosh-Khiram placed her head to Malak Mah's feet and told her the story of Kajdast the *ayyar*. She was happy. When it was day, Karkara Jadu learned of the situation. Disguising himself as a lion, he attacked Sa'id, but the prince overthrew him, to the delight of Malak Mah and Sheda Banu. However, they did not know how to get out. Prince Sa'id said, 'All this time you have been under his spell were you never able to learn from the sorcerer how to get out?'

'One day I asked the sorcerer by what means a person who wanted to get out of his spell could do it,' said Sheda Banu. 'He said, "There is a rod with a bird on it. You have to move the bird's head the distance of a barleycorn. The rod will turn and a way will appear."'

The prince did as she said, and a way opened. They escaped.

Two days later they came to a mountain that was extremely high, and atop the mountain they saw a fortress, and at the foot of the fortress were camped around ten thousand soldiers. The prince asked and was told, 'The fortress is called Dar al-Hisar, and the warden of the fortress is called Sherzad Shergir, and this is his army.'

The prince put the girls in a safe place and then went into the guebres' camp, advancing straight to the gate of the court. A guebre chieftain was stationed over everyone. Sa'id went to him and said, 'Get up so that I may sit on this chair.' He got up and sat down in a lower place. Sa'id took his place.

The guebre who got up from the chair was called Mikal Mushtzan. Sa'id glanced at Sherzad, who asked Sa'id, 'Young man, where have you come from and where are you going? What is your name, and what do you do in this world?' Prince Sa'id told him about himself from beginning to end and then offered him conversion.

'Young man,' he replied, 'until now I have eaten my bread by soldiery. When you defeat me at wrestling and can master an exercise stone I have, I will do whatever you say.'

The prince stood up, started wrestling with him, and defeated him. Then he went into the fortress and mastered the exercise stone. He saw a spring there, and when he asked about it, he was told, 'This spring has the peculiar characteristic that if anyone is sick and about to die, if he washes in the spring he will not die for a long time. If anyone has an illness and washes in the spring, the illness will quickly vanish. However, if anyone tries to take water from the spring elsewhere, it turns to blood.' The prince converted Sherzad to Islam. Then he went down from the fortress and took the girls inside, where they remained for a few days in celebration and revelry.

Then they got several mounts from Sherzad. Each one got on a horse and set out for Ruby Mountain and Raghun Elephant-Neck's fortress.

The narrator says that when Malik Taysun dispatched Sa'id to Ki'al Man-Eater's island, they realized that soldiers would have to be stationed around the fortification. He went into the city of Aqiqnagar. Tayfur's twenty thousand soldiers and Sherzad joined him. He stationed the vizier and went to the city. Since there were no provisions left in the fortress, As'ad said, 'We have to get out of this fortress. Maybe we can make the soldiers go away.' He went out with five thousand men, leaving Bakhsha World-Traverser inside. When Tayfur surrounded them with his twenty thousand men, battle broke out. Tayfur brought down the five thousand in a cloud of dust. Sa'id appeared with Sherzad Shergir and ten thousand men, and they defeated the infidels. Tayfur was wounded and fled. However, when Tayfur entered the city he received word that Malik Na'im and Qimar had arrived. He went out to greet them, escorted them inside with honor, and gave them a banquet. Just then Tayfur arrived to report the situation. 'Thought must be given to Sa'id before Ibrahim comes,' they said. Four commanders were dispatched. Sa'id's army had almost been defeated when Malik Bahman arrived with a large army and attacked the infidels' camp. The drums of retreat were sounded.

The next day Ibrahim arrived with his entire army and they met each other. The guebres beat the battle drums. Mahavan Elephant-Neck went into the field and martyred three men. Then Malik Bahman went out and overthrew him. Mahavan's son Mihr went out and was killed. When he had killed thirty-one men, the armies retreated.

TRANSLATION FOR CAT.68
Volume 11, text number 80
MAK–Austrian Museum of Applied Arts/Contemporary Art, Vienna, B.I. 8770/58

The narrator says:
The army withdrew, and the next day Mihr Gold-Belt entered [the field]. Prince Ibrahim went out and seized him. Mihr Gold-Hat went out and ... him. Malik Taysun withdrew. The prince offered the captives a chance to convert. They became sincere Muslims. The guebres, however, thought it would be best to launch a surprise attack on the army of Islam. Zambur Ayyar brought word of this. Sa'id Farrukh-Nizhad, Malik Bahman, and all the soldiers departed from the camp. The guebres came. There was battle until day. In the end defeat befell the guebres, who fled to Aqiqnagar. The men of Islam got a lot of booty. When Malik Na'im and Malik Taysun arrived at Aqiqnagar, Ki'al Man-Eater's emissary came bringing a letter. The contents were as follows: 'O Malik, the Iranian you sent seized our daughter and fled with her. Now I am here with the entire army to destroy him.' Malik Taysun rejoiced and honored the emissary greatly. The next day an emissary from Malik

Sharif came from Sharafiya in search of Khwarmah.
'Khwarmah is in the hands of the God-worshippers,' he said. 'Send an army and get her from them.'

Just then Mahus Ayyar arrived and bowed his head before Malik Taysun, saying, 'When the sun rises, the army of the God-worshippers will come.' Malik Qimar lowered his head and sank into contemplation.

Malik Na'im said, 'Malik Qimar, do not worry, for whatever is fated will come to be.'

Malik Taysun replied, 'Malik Na'im, be assured that I have summoned so many soldiers that after a few days there will be no trace of the army of God-worshippers.'

The next day when the bright sun illuminated the dark lamp, the army of Islam had arrived and the two forces had lined up opposite each other when Ki'al Man-Eater's emissary, Shahim Mihrang, came before Malik Taysun and said, 'If I am commanded to go into the field, I will teach them a lesson that will be retold as long as the world remains.' Mihrang went out. Prince Sa'id went out and killed him. By the time he had brought down seven men and stirred up a lot of dust, Ki'al Man-Eater arrived with sixty thousand men. When he saw Prince Sa'id in the field he went out and strove until nightfall, when he withdrew and the armies dismounted. Malik Taysun gave a banquet for Ki'al.

The next day the battle drums were sounded. Once again the armies drew up their ranks opposite each other. Ki'al Man-Eater went out and called for Sa'id Farrukh-Nizhad. He fought hard until he wounded Ki'al. The armies withdrew. Malik Na'im, Malik Qimar, and Malik Taysun went to visit Malik Ki'al. It was midnight when he died of the wound he had received. The guebres mourned him. Ki'al's men took his coffin and set out for their island.

Malik Taysun said, 'Malik Qimar, is there no *ayyar* who can kidnap Ibrahim?'

'That is a job for Mahus,' said Qimar. They summoned him and explained the situation to him.

'My lord,' Mahus said, 'I would have been able to kidnap him, but now their *ayyar*s are lying in ambush. I can do nothing.'

Taysun said, 'Malik Qimar, I had an *ayyar* called Kajdast. He would have been able to kidnap Sa'id and bring him in. I sent him to Ki'al's island.'

'What happened to him?' asked Qimar.

'The God-worshippers' *ayyar*s killed him,' Malik Taysun said.

'Something has to be done to remove them,' said Na'im. 'What?' they asked.

'All the soldiers should be ordered to move,' Qimar said. 'Maybe we can remove them.'

The next day the battle drums were sounded and the armies began to move in vengeance. Fully armed, they lined up opposite each other. A guebre stepped into the field, and Ibrahim went out and killed him. The guebres attacked all at once and battle broke out. Malik Qimar was taken captive. The armies withdrew. Malik Na'im was very worried, but the prince pulled back and entered the court. Summoning Malik Qimar, he offered him a chance to convert. He became Muslim out of fear. Songhur Balkhi lay in ambush until the next day, when Mahus Ayyar entered Qimar's court and whispered something into Qimar's ear. When Songhur appeared, Malik Qimar put Mahus to flight. Songhur withdrew and reported it to Prince Ibrahim. The prince had Qimar arrested. The news of Qimar's arrest was reported to Na'im by Mahus Ayyar.

TRANSLATION FOR CAT.69
Volume 11, text number 81
Rare Book Department, John Frederick Lewis Collection, Free Library of Philadelphia, M2

The narrator says that when the news of the imprisonment arrived, Malik Timar, Malik Taysun, and Malik Na'im became very concerned and began to wonder how their entanglement with the God-worshippers would turn out.

Namos Ayyar entered and said, 'Malik Taysun, you must know that Malik Sharif's son Mahabat Boar-Tooth [has come] from Sharif with fifty thousand mighty, battle-scarred guebres.

We must go out to greet them.'

Taysun rejoiced, and the next morning when the world-illuminating sun brightened the sky with the light of its countenance, the infidels went to greet Mahabat. When Malik reached Mahabat he wept bitterly.

'Malik Taysun,' said Mahabat, 'do not be upset, for as soon as I get there I will trounce the God-worshippers. If any more forces are needed, I'll send a messenger to my father to dispatch as many soldiers as are needed to crush the God-worshippers.'

In short, they camped at Malik Taysun's gate, and when they were settled in, Taysun gave a banquet for Mahabat. At that banquet the *ayyar*s of Islam were present when Mahabat asked Malik Taysun to sound the battle drums.

Malik Na'im said, 'Since you have just arrived and are still covered with the dust of the road, it would be best for you to rest a moment.'

He did not agree and said, 'Malik Na'im, you have heard it said that

A man who is short-sighted, addicted to luxury, and a worshipper of wine will give his religion over to plunder and lose everything in the world.

When a merchant sits with his beloved and wine, his profit vanishes and his capital disappears.

Inasmuch as the God-worshippers are guilty of aggression, how can I sit here at ease?'

In short, he ordered the battle drums sounded. The *ayyar*s of Islam brought the news to Prince Ibrahim and Sa'id and told them much about Mahabat. The next day just as the sun of the east put forth its head from the blue curtain and brightened the dark world—

When the sun quaffed a goblet at dawn, it became red in the face from that cup of vermilion wine —

the two armies reared up in vengeance against each other, and the battle-scarred warriors and mighty champions, clad in iron and steel, set out for the field of battle and stood opposite each other. Ranks were drawn up, and dust covered the face of the earth. Cloud and wind began to rain down and sweep clean the field. When the arena was as bright as the hearts of the pure, a guebre from the ranks of the infidels named Sarad son of Elephant-Neck came forth into the field by Mahabat's leave and demanded a contest. Prince Ibrahim son of Hamza went forth and took him down. After dispatching another nine men to hell, Mahabat Boar-Tooth went into the field and stood opposite Ibrahim. He fought hard, but in the end he was captured, and Malik Taysun ordered all the soldiers to move in and surround the prince. Prince Sa'id Farrukh-Nizhad attacked with his troops. A pitched battle ensued. The two sides attacked each other like two oceans of arrows and axes, and the sound of battle rose to the sky. Malik Tahamtan entered with his troops from behind the guebres and began to fight, with warriors pulling each other down from their mounts. Just then Malik Taysun stood against Sa'id Farrukh-Nizhad and was killed. The infidel army, unaware of what had happened, kept endeavoring, and Malik Na'im blocked Prince Ibrahim's path. He was captured, and the infidel army took flight.

Unfaithful warriors in retreat; pillagers occupied with plunder. Captive-takers all taken captive; archers killed in a rain of arrows.

The Muslims took much booty, and when they returned, the captives were offered a chance to accept Islam. Malik Na'im and Mahabat both became sincere Muslims and sent a messenger to Sharafiya to Malik Sharif, who also came with much tribute and became Muslim. The city of Aqiqnagar was also made Muslim, and a noble ... Baba Bakhsha World-Traverser ... someone to the Amir. ... the champion who was taken captive was put in Zarduhusht's pit.' The armies retreated. The Amir summoned the *ayyar* and said, 'Who will go and find out about Umar?' The Amir accepted and left. That night he tied a piece of silk to a dove's leg and sent it off. The dove alighted at the foot of Castle Ayina. Umar came and grabbed the dove, taking the piece of silk from its leg and unfolding it. Umayya made a lasso. Umar came down and went to the Amir.

Volume 11, text number 83
MAK–Austrian Museum of Applied Arts/Contemporary Art,
Vienna, B.I. 8770/55

The narrator says that when the sorcerers left Bakhtak at the gate to Zumurrud Shah's court, a chamberlain entered and told Yaqut Shah that Khwaja Bakhtak had come.

'It is Umar Ayyar,' said Hurmuz.

Sabukpay arose and said, 'Send for him.'

When Bakhtak came in and he saw Bakhtak, he became confused because Shah Anoshirvan had ordered Hurmuz to drag [?] him into Cuttock. He arose in anger, picked up a mace, and hit Bakhtak on the head with it. He cried out, 'I am Khwaja Bakhtak!'

Sabukpay said, 'He is lying.' Just then a *charqab* fell from Hurmuz's shoulders. He leapt, picked it up, threw it over his own shoulders, and left the court.

Yaqut Shah said, 'It is Umar's crime. Put him in chains.' Bakhtak was taken away and put in chains in prison.

When Hurmuz was finished binding Bakhtak, he asked for his *charqab*.

'Khwaja Bakhtak took it away,' he was told.

'Bring him in,' he said. When they went for him they saw that Bakhtak was leaving mounted on a camel. They cried out, 'Hurmuz is summoning you.'

Sabukpay said, 'What will Hurmuz do with me?'

'We don't know,' they answered.

Sabukpay said, 'Go say that it was Umar Ayyar who took the *charqab*.'

When the men heard this, they turned around and reported it to Hurmuz. He realized that it was Bakhtak. They summoned him and gave him a horse and robe and asked him about himself. He related his adventures from beginning to end.

Zumurrud Shah said, 'Do you have any idea why we have put you in Cuttock?'

Yaqut Shah prostrated himself and said, 'O lord, speak.'

'Sometimes he creates a doubt in the heart,' he said. 'That is why we are punishing him.'

Bakhtak lowered his head in prostration, and all the sorcerers were astonished by this act of Umar's, but Sabukpay came before the prince and explained. The prince laughed, but when the sorcerers became aware of what he had done they said, 'This is a bad person to have as an opponent. Let us hope he doesn't release the champions who are in chains in the city.'

Mâlik Zarduhusht said, 'Maltas Man-Eater is in the city. Who would dare to enter?'

'A group of *ayyar*s should be sent,' they said, 'in order that they may be aware.'

Iramzad Naqshband, Samum World-Burner, and Waswas the spy were sent to the city, but the prince was very concerned over the champions who were in chains. Just then there was a commotion at the gate.

'What is happening?' asked the prince.

'Songhur Balkhi has come from Prince Ibrahim b. Hamza,' he was told.

'Let him come in,' he said. He came in. He lowered his head in the prince's sight and said, 'O king, into whatever head there comes an image of your stature, from every direction *peri*s come to kiss your feet.'

After that he handed the prince a letter. The Sahib-Qiran ordered gold strewn over his head. The contents were well wishes from Prince Ibrahim, Sa'id Farrukh-Nizhad, Farhad Yakzarbi, and Malik Bahman Arjast Quhistani. The rest was a proclamation of victory of the cities of Aqiqnagar, Tawariq, and Zibarjad. The prince was elated and ordered a letter written saying to come quickly. However, the Sahib-Qiran turned to Umar and said, 'O brother, we have no news of the champions. Some thought must be given, and they must be released from the sorcerers' bondage.'

Umar accepted to go to the city and find out what was happening. He set off with a group of *ayyar*s toward the city, and along the way he saw a man riding a pack horse. Khwaja Umar said to his companions, 'You proceed very slowly while

I go and get news from Antali. This he said and went before the man and greeted him. Then set off next to him. The man asked, 'Where are you from?'

'From Antali,' answered Umar. Then he asked him about himself.

'I am called Mazmahil the surgeon,' he said. 'My house is also in Antali. Jamshed Akhtaran summoned me in Akhtam. I went and joined his service. It has been three years since I left my home, but no matter how I tried to get Jamshed to let me go, he wouldn't do it. Now, when the God-worshippers' cry went up, he gave me leave to depart. When the caravan drew near I longed to converse. For that reason they went on earlier, but I have sent someone forward.'

Umar put his hand into his breast and gave Khwaja Mazmahil the surgeon a handkerchief full of raisins. 'I had gone to the village to buy fruit,' he said. 'I left my men there to bring [what I bought]. I myself set out for home.'

Mazmahil took the raisins, ate them, and fell unconscious. Umar hid him in a place that was not generally trafficked and where the army and servants would be safe. He took on his form, and Yakdam, one of the *ayyar*s, disguised himself as a rein-holder. Umar set out. The rest of the *ayyar*s went to the villages, bought loads of fruit, hired pack animals, loaded them up, and entered the city of Antali.

Ustad Rindaq Tawwaf bought the fruit and became acquainted, and Aq-Temür rented a house.

Volume 11, text number 84
Freer Gallery of Art, Smithsonian Institution, Washington, DC;
Purchase 1960.15

The narrator continues thus:

When Khwaja Umar [b.] Umayya took on the guise of Mazmahil the surgeon, he headed for the city of Antali, but he did not know in the slightest where his house was. On he went, riding his horse with that *ayyar* holding the reins, until he reached the city and Khwaja Mazmahil's men appeared. As soon as the news of Khwaja Mazmahil's arrival was delivered by the merchants, his friends, children, and relatives went out to greet him. When they saw the *khwaja* from afar, they rejoiced, got off their mounts, and threw themselves on the ground. Khwaja Umar also got off his horse and ran forward, embracing his friends eagerly. All the food, drink, and fruit they had brought they placed before Umar.

Khwaja Umar said, 'I am observing Zoroaster's fast.' They picked up the things and asked 'Khwaja Mazmahil' how he was.

'Yes,' said Umar, 'Jamshed Akhtaran had a serious illness. When he summoned me from Mâlik Zarduhusht, Mâlik sent me. When I went before Jamshed, he was in a bad state. I treated him. He kept me for three years, but now that the renown of the God-worshippers has spread, he gave me leave to depart and sent much booty along with me. When the caravan got near here I headed for my house.'

'Khwaja,' his friends said, 'welcome, for the God-worshippers are mightily victorious, and all the talismans that have been used have been broken by the God-worshippers' magicians. In every battle and every encounter they have emerged victorious. The sorcerers have seized several of their renowned champions and imprisoned them in Zarduhusht's dungeon. They have stationed Maltas Man-Eater in the city, and now Zumurrud Shah has sent Iramzad Naqshband and a group of *ayyar*s to guard the champions lest Umar Ayyar attack.'

'Khwaja Mazmahil' said, 'What sort of person is Umar?' The men told him what they knew of him. Umar shook his head, mounted with his friends, and went into the city. When they reached the gate of his house, the men said, 'Khwaja, we will be at your service. Go home now and rest.' With this, the servants raced out of the house and fell at Mazmahil's feet. Umar realized that this was Mazmahil's house. He dismounted. The neighbors came, and there was a huge uproar in the quarter because Khwaja Mazmahil the surgeon had come from Akhtam after three years.

However, when Umar went into the house, and the people

of the household surrounded him left and right, Khwaja Umar saw that the house was decorated. He rejoiced.

In short, food was brought, but he didn't eat anything. That night he slept in his wife's embrace. When it was day the wife asked him the reason. 'The water of Akhtam does not agree with strangers,' he said as he showed her his feet. She was astonished and sank into thought. 'Don't worry,' said Umar, 'for I will think up something for myself.'

The next day all the goods and items he had brought from Akhtam arrived. Umar said to Kulbad Iraqi, who was disguised as his squire, 'Soldier, the goods have arrived. Be easy of mind. Take these things to Zumurrud Shah's camp, and tell the merchants that Khwaja Mazmahil has arrived and gives these things to repay your loans.'

Then, to his 'wife' he said, 'During these three years that I was in Akhtam I had to borrow a lot. Now I will sell these goods.'

In short, Kulbad took them, and Khwaja Umar borrowed much from the wife and children and from the merchants and gave it to Kulbad, whom he sent off. He had it heralded that anyone who had a pain should come to be treated. People flocked to him because in Antali all were sorcerers, and toothaches, headaches, earaches, sore eyes and feet were common. There was not a single skilled physician. When they heard that Mazmahil the surgeon had come, all gathered around him.

In short, everyone who had a pain told him about it. He gave them medicine out of his *ayyar*'s satchel, and two days later they all died. The Khwaja left Mazmahil's house in the middle of the night, woke [the real] Khwaja Mazmahil up, and gave him his horse. The man went home, but he was attacked by the people, who were shouting, 'He gave our relatives medicine and killed them!'

'Friends,' he yelled, 'I have no knowledge of this. I have just come home after an absence of three years.' But they dragged him to the house of Mâlik Zarduhusht and cried out against him. Zumurrud Shah heard their cries and said to Bakhtak, 'Summon Khwaja Mazmahil.' When he came in, he was asked about what was happening, and he explained. They realized that it was Umar. The merchants also cried out, 'He borrowed a lot of money from us.' It did no good. The news spread throughout Antali.

Volume 11, text number 85
Brooklyn Museum of Art, New York, 24.49

The narrator says that when Zumurrud Shah was sorely pressed by Umar, he said to the sorcerers, 'Can't you think of some way of dealing with Umar?'

'Of course, lord,' they said. Mâlik Zarduhusht the magician sent many sorcerers into the Amir's camp to work their magic. They took away most of the renowned champions like Landhaur b. Sa'dan, Sa'd Padishah, Shah Sulayman Farsi, Badi', and Qasim. When Amir Sahib-Qiran was informed of this situation he was very disturbed. He summoned Khwaja Umar and said, 'Ayyar, find out what they have done to the champions the sorcerers have taken away.'

Umar said, 'My *ayyar*s are in the city. They will bring whatever news there is.'

The Amir said, 'You go!' Umar headed for the city of Antali. He gathered a pile of brush and disguised himself as a brush-gatherer. When he entered the city of Antali he saw that Shah Sulayman was cooking. Umar smiled and said, 'O master, will you buy some kindling?' Shah Sulayman shouted at Umar.

Umar went on and saw a blacksmith's shop, and there he saw Landhaur working as a blacksmith. He was astonished and went on. He saw Malik Azhdar roasting liver, in which task he was completely absorbed. The Khwaja was even more astounded. He went on. In short, he saw every one of the Amir's champions doing something totally out of character. Perplexed, he proceeded. He saw a caravanserai, and on either side of the caravanserai was a high raised platform. On one platform Prince Badi'uzzaman and Malik Qasim Ruby-Robe were seated, sewing caps. On the other platform was seated Sa'd Padishah, who was sewing saddle cloths. Khwaja Umar said to himself, 'Let me play a trick on Sa'd.' He put his pile

of brush down, went forward, and whispered into Sa'd Padishah's ear, 'If you knew how to ply such a trade, why were you a king?' Sa'd Padishah jumped up and grabbed Umar, crying out, 'I have captured Umar!' Just then Qasim and Badi' jumped up to help, and together they tied him up. Sa'd took Umar to Mâlik, who ordered him to be put in chains into Zarduhusht's black pit. Bakhtak was happy, but the magicians said to Zumurrud Shah, 'We have captured all of Amir Hamza's champions. If you so order, we will have the drums sounded and go out into the field to capture him too.' Zumurrud Shah rejoiced and ordered the battle drums sounded. From the army of Islam also the sound of drums arose.

The next day the two armies stood opposite one another. From the host of sorcerers nearly a hundred came out, each in a fantastic form. Laqda Jadu had a [?] black felt around his neck. He had overthrown several from Muqbil the Faithful's troop when Muqbil came out, and, seeing him from afar, killed him with an arrow. Saqa Jadu came out and was killed. When seven of the sorcerers had been killed, Mâlik Zarduhusht cried out at the sorcerers, and Mukahhal Jadu came out with a rope in his hand. Muqbil saw that he would lose. He tried to pull back when Mukahhal threw the rope around his neck. Muqbil fell, pulling him from his mount. A cry went up from the Muslims.

Then Muqbil Qadir-Andaz came out. He shot an arrow, but it did no good. In short, they pulled him down and carried off twenty of the Muslims when Sarbirahna Talabi came out and killed him. Qima brought down eighteen of the sorcerers, and then Marzuban came out with a cup in one hand and a lasso in the other. He threw the cup to the ground, and all was darkness. He threw the lasso around Sarbirahna's neck, but he stood his ground and cried out. The Amir charged in and cut the lasso with his sword. [The sorcerer] turned himself into a lion and attacked the Amir. The Amir lopped off one of his hands with his sword. He withdrew, and then ... came opposite the Amir riding on a rhinoceros. The Amir recited a charm against sorcery so that his magic would not work on the army of Islam. All at once the Amir saw that the rhinoceros had fallen and was rolling around on the ground. Qaran appeared riding a rhinoceros. That sorcerer rushed off, wanting to flee to his own troops, but Qaran ran in, grabbed him by the hair, and dragged him off to the Muslims' lines. The Amir's men sounded the drums of rejoicing. The armies retreated.

Zumurrud Shah turned to Mâlik Zarduhusht and said, 'Mâlik, why did you lose?'

Mâlik said, 'Zumurrud Shah, don't you know that I have imprisoned all his sons and champions in Zarduhusht's black pit? We know what will happen to Qaran. Don't worry.'

TRANSLATION FOR CAT.73 AND 74

Volume 11, text number 89
David Collection, Copenhagen, 72/1988.

The narrator says:

When the Amir asked the girl what her name was and whose daughter she was she said, 'I am the daughter of that old woman you killed.'

'What was her name?' the Amir asked.

'She was called Saradiq the sorcerer,' she said, 'and she was the daughter of Zarduhusht. She named me Manut.'

The Amir offered her a chance to convert to Islam. She became a sincere Muslim.

'You can have any of our commanders you want,' the Amir said. She chose Qubad b. Sa'd Padishah. The Amir ordered her taken to the harem.

When the Amir settled in Zarduhusht's palace, he ordered the sorcerers who were in chains to be brought. He gave them a chance to convert. Malik Marzban was young. He became a Muslim, but the Marzban the Amir had once overthrown did not become Muslim. The Amir had him and all the other sorcerers killed. Then he ordered the girl to make a celebration, and they converted all the people of the city. Some have said that the queen became the wife of Marzban Khurasan, although others say she did not accept to have a husband.

The Amir gave her a province, and he gave the city of Antali to Malik Marzban, and he made Khwaja Mazmahil the surgeon military governor of the city because he had suffered much loss on account of Khwaja Umar. The Amir sent Umar to Qubad b. Sa'd Padishah, telling him to find out whether he wanted to marry the girl who was Zarduhusht's granddaughter or not. Umar went and asked. He did not accept. Azada Nushindokht came and stole Qubad away by magic. The next day the world-conquering Amir, who was worried over Hamid, grew even more worried on this account. Umar said, 'It is the work of Azada Banu ...

... when the daughter of ... and Hamid escaped that night, they traveled for seven days. Then, one night, they let their horses graze. When the girl awoke she could not find her horse. She went after it. Hamid wondered if it was her sorcery. He mounted his horse and rose until sunrise. A gazelle appeared. He caught it with his lasso. A rider appeared. They grappled, and Hamid pulled the rider from his horse. As he was about to overthrow him, the rider said, 'Anyone you pull up from the dust you must throw down.' Hamid put him back on his mount, and the rider's veil fell away. It was a girl as radiant as the sun. In search of the girl came nearly five hundred men who bowed to her. 'O youth,' she said, 'our home is nearby. Be welcome.' Hamid set out. He spied several tents. The girl went into one of them. After a time she summoned Hamid and asked about him. 'I am a merchant,' he said, 'but I have been separated from my companions.'

'Stay with me,' she said, 'until you find news of your friends.'

'Tell me about yourself,' Hamid said.

'This is our kingdom of Venus,' she said, 'and my father is the king of this realm. My name is Sun-Cheek.' The girl had a garden into which they settled. One day a messenger came to say, 'Your mother is coming.'

'Stand for a time among my servants,' the girl pleaded with Hamid.

When the mother came she spied Hamid. 'A group of merchants came,' the girl explained, 'and I bought this slave from them.'

'He is not suitable for you,' the mother said. 'I'll buy him from you for double the price you paid.' The girl said nothing. Since the mother had fallen in love with Hamid, she stayed there and gave a party. However, when the king went into his harem and could not find his wife, he asked about her. He was told that she had gone to see her daughter. The king had an *ayyar* he sent to find out where his wife was and to summon her. When the *ayyar* got to the garden gate he found the gate locked. He went over the wall and saw the mother and daughter giving a party, and in the midst of the assembly was a handsome youth. The *ayyar* waited patiently until it was time for sleep. He saw that the youth's place was outside. At midnight the girl left her mother and went to the youth's embrace. The *ayyar* waited until it was day, and then he informed the mother. She asked her daughter, who became worried. The woman had the *ayyar* beaten two hundred lashes. The *ayyar* went and informed the king, who had two man-eating Zangis he sent. Hamid killed them both. The king was informed. He sent Chaplus, who kidnapped Hamid. When he was brought before the king he was made to swear. 'I am called Hamid Ruby-Cloak,' he said. 'I am the son of Malik Qasim. What has that girl done to me?' He was thrown into chains. The next day when the mother and daughter came before the king and informed him, the girl grew impatient and said, 'O queen, this Zangi they have entrusted with Hamid is in love with me. If you so order, I will go kill him and release Hamid.' With permission she set off. When she came she rendered everyone unconscious, cut the Zangi's head off, and rescued Hamid. When the king found out about it, he said to Chaplus, 'Go get news.' He found Hamid in a garden. The guebre informed on him. Two commanders were sent with two thousand men. When they arrived, Hamid killed one of the commanders, and the other became a Muslim.

Volume 11, text number 91
MAK–Austrian Museum of Applied Arts/Contemporary Art, Vienna, B.I. 8770/56

The narrator says that Mihrdukht kept traveling, and after two days she saw several tents. When she went forward she saw a group of girls of the utmost beauty. They summoned her. She went forward. She saw a girl who was served by the others.

A stature like a cypress glowing like a candle in the midst; the others like moths circling around her.

Mihrdukht bowed. The girl asked her about herself. 'I am the son of a merchant,' she said. She asked her name. 'My name is Mihrzad,' she said. 'One night the others decamped. I fell asleep while riding, and my horse carried me off the road and far from my friends. I was looking for them when I came across you.'

The narrator says that this girl was the daughter of Malik Khizranshah Giti-Nishan, the ruler of the realm of Nuriya. He possessed nearly three hundred thousand warriors of renown. The daughter's name was Afsar Banu. When she had been informed of Mihrdukht's situation, she said, 'Young man, don't worry. Stay with us until your friends are found.'

Afsar Banu was the fiancée of Kayhur Shah. She refused to set eyes upon any man, and Kayhur Shah did not have the courage to say anything about it. Khizranshah had only this one daughter, and he loved her very much. One day she was i n her garden and Khizranshah Giti-Nishan was seated in his court when a messenger entered and said, 'Long live the king!' He delivered a letter to Khizranshah, and when he read it he realized that Kayhur Shah's father had written, saying, 'Khizranshah, be it known to you that my dear son Kayhur is gravely ill. If you could send Afsar Banu to his sick bed, it would be good for him to gaze upon her beauty in his last moments.' Khizranshah became very upset and sent the letter to Afsar Banu. When she was apprised of the contents of the letter she rejoiced, although she showed herself to the people as very concerned and upset. Several days later Afsar Banu received news that Kayhur Shah had died, and she went into mourning. When the sad news spread throughout the realm, Khizranshah also went into mourning. Mihrdukht saw that Afsar Banu was really happy that Kayhur Shah had died. After a while the girl's mother came and took her out of mourning.

Afsar Banu summoned Mihrdukht and said, 'I would like to go hunting. If you come too, it would be good.' The next day Afsar Banu set out to hunt with a group of her elite companions, and she took down prey in all directions. Finally two gazelles appeared. Afsar Banu galloped after the gazelles, and Mihrdukht accompanied her as the two of them went far from their people. Afsar Banu shot one of the gazelles and dismounted to cut its head off. Mihrdukht went after the other gazelle, which had escaped, but as hard as she galloped she could not catch it. Night fell on the plain. Afsar Banu returned to her people and asked what had happened to Mihrdukht. 'He hasn't come,' they said. Very worried, she went into the garden.

When Mihrdukht had gone very far in the chase, night fell on the plain. She kept on going until daylight, when she had reached the edge of the sea. There was a ship sailing by, but no matter how much she cried out, the ship would not turn back. However, when she promised her horse to the captain, he brought the ship around, and Mihrdukht gave him her horse. She got on the ship, but then the sea became turbulent.

The sea was as full of water as a crying eye, and the people were in a situation as bad as that of the pupil.

The ship struck a rock and broke apart. All were drowned, but by chance Mihrdukht clung to a piece of wood floating on the surface. After two days she reached the shore. She thanked God and went onto the island. As she looked around she spied a rowboat in the distance. There were four young men and one old man in the boat. When they got out of the sea and their eyes fell upon Mihrdukht and they realized that she was a girl, they all desired her and started fighting over her. Mihrdukht saw that the old man in their midst was saying

nothing, but was attempting to stop them from fighting. 'Friends,' said Mihrdukht, 'there is no need to fight. I will shoot an arrow, and I will accept whoever brings it back first.' They agreed to this.

The narrator says that Mihrdukht was an extremely good archer. The young men turned to Mihrdukht and said, 'All right, shoot the arrow.' She shot, and the young men ran off after it. The old man turned to Mihrdukht and said, 'My beauty, what are you planning?'

'I thought I would get in the boat and escape,' she said. The old man was highly pleased by this. Mihrdukht got into the boat, and they set out.

One of the young men was a better runner than the others, and when he brought the arrow he found no trace of the old man or the girl, so he went out in search of the others. When they returned and could not find him, they searched the sea shore.

However, Mihrdukht and the old man, whose name was Baharan, went to the island where his home was. When he took Mihrdukht home, his ill-tempered wife disliked her. She rendered her unconscious and put her in a chest. Then she gave the chest to a slave to sell. The slave put it on his back and went through the market, saying, 'Who will take a chance and buy this chest? Whoever buys it will get his wish, and whoever does not buy will not.'

Volume 11, text number 92
MAK–Austrian Museum of Applied Arts/Contemporary Art, Vienna, B.I. 8770/32

The narrators have expressed this charming tale as follows:

That slave tied the chest to his back and wandered through the market, crying out, 'Whoever buys it will rejoice, and whoever does not buy it will regret.'

The people were astonished, but there was a rich merchant in that city with slaves with rings in their ears in his service. Among them were four beautiful maids who were without equals in beauty and comeliness. When the merchant heard the story of the slave, he went out and agreed to pay a thousand dinars. He took the chest and counted the gold out for the slave. After that, he took the chest into a chamber and opened the lid.

A girl he saw unrivaled in beauty, renowned across the horizons like the sun.

Whoever saw her was stricken and made acquainted with grief and pain.

Fascinated, restless, and stricken by her, and with one glance he was charmed.

When the merchant asked her what had happened to her, Mihrdukht said nothing.

'I bought you for a thousand dinars,' said the merchant. Mihrdukht asked for a few days' respite. There was a room upstairs where Mihrdukht lived, and the four maids lived downstars. When they came before Mihrdukht they were astonished by her beauty and were too ashamed to remain in her presence. Mihrdukht also said nothing to them and always watched them and was on her guard against them.

One day the four maids had a thought together. 'If this girl is going to be in the master's service,' they said, 'we will have no honor or respect. If we do away with her as soon as possible it would be in our best interests.' Since the women were feeble-minded, they decided to put poison in her food. One day when Mihrdukht was seated upstairs, they cooked some food, poured poison on Mihrdukht's plate, and took it to her. She raised an outcry, saying, 'My sisters, I have neither done anything inimical to you nor had anything to do with you, good or ill. Why have you put poison in my food? Do you imagine that I will be your mistress? I am only Afsar Banu's maid. I got separated from her on a hunt. I reached the edge of the sea and gave my horse to a ship's captain. By chance, the ship foundered, and I clung to a piece of wood. After two days I reached an island. There I saw four young men and an old man. There was an argument over me. I shot an arrow, and the young men went running off after the arrow. I got into a boat with

the old man and came to this island. An old woman did such a thing to me and sold me. Why do you put poison in my food?'

The maids were very ashamed and apologized profusely.

'Bring me a horse and arms,' she said, 'so that I can be on my way.'

'Lady,' they replied, 'you be our queen and let us serve you.'

'I have lost a jewel,' said Mihrdukht, 'and I am in search of it but I cannot find it.'

In short, they brought her a horse and arms. Mihrdukht put on a man's armor, mounted the horse, bade the maids farewell, and set out in a ship. Two days later she left the sea, mounted, and set out in search of a road. Her path lay across an endless, waterless wasteland.

A wasteland, a plain filled with terror. At every step a hundred different afflictions.

The air was like the air of hell; the ground was rocky, nay magnetic.

Instead of red tulips in that expanse was ... stained with blood.

Mihrdukht had grown very weak, and her horse was exhausted, but she went on that day. The next day she emerged from the desert and came to a spring. She let her mount have its fill of water, and she too rested a bit and thanked God. However, she was thinking of Hamid and saying, 'O Lord, what can have happened to Prince Hamid Ruby-Cloak?' She let her horse graze in the fields, and after a time she mounted and headed into the wilderness.

From afar a tall tree came into view, and she headed toward it. As she drew near, she saw two horses standing at the base of the tree. She went forward and heard a cry. When she galloped, she saw a young man who had thrown an old man to the ground and was sitting on his chest and holding a diamond-colored dagger ready to cut his head off and end his life. Mihrdukht let out a yell, saying, 'Tyrant! What are you doing to this wretch?'

The young man looked back, and his gaze fell upon Mihrdukht. He beheld a young woman of the utmost beauty, mounted on a horse, dressed in man's clothing, and bearing down on him, sword unsheathed. The young man got up in a hurry and ran toward Mihrdukht. That beauty mentioned the God of the world and brought her sword down across his chest. He let out a moan and crumpled. The old man got up, kissed Mihrdukht's stirrup, and apologized profusely.

TRANSLATION FOR CAT.77
Volume 12, text number 3
Fitzwilliam Museum, Cambridge, PD. 204–1948

The versifier of this nest of secrets speaks thus from behind the curtain:

When Prince Hamid Ruby-Tunic ... '...[if] you do not appear at the court and exalted threshold, I will rip your ears from your head!' He left.

Kaus said, 'Prince, an amazing hornets' nest ...,

'... but since you are afraid of him I'll deal with him first.' Kaus rejoiced, and they reveled. However, when Mahval came to Khizranshah and told about He had a brother named Thamud. He summoned him and said, 'Take two hundred thousand men, and bring that Iranian and Kaus in, hands and neck bound.' ... Mahlal Man-Eater, Mahlal's son Qaran, Fanaksawar Mashriqi, Tarib son of Samsama, and As Dragon-Capturer got busy tending to their arms. Khizranshah entered the harem and ... had not happened for the Iranians are an evil group, and this one and that one have broken Solomon's seal.'

'I have dispatched two hundred thousand men,' he said.

Afsar Banu was extremely clever. 'Father,' she said, 'I want to go too.'

'There is no need for you to go,' he said, but she insisted and her father finally let her.

Meanwhile, Hamid was out hunting when Sh...iz Qabar, whom Kaus had made Muslim, arrived and told of the army. Hamid entered the city, armed himself, and came out with the whole army. The leader, Samun Lion-Heart, rode out near them. The next day their army arrived, and behind Samun was Malik Tayhur with twenty thousand men, and behind him

was Malik Barsam with twenty thousand men, behind him was Kaus son of Sa'sa'a, Sa'sa'a son of Kaus, Mahamun, and Shama Barq with thirty thousand horsemen. Behind them was Ghantus the Mad in the fore. Both sides camped. Hamid said, 'Someone must be sent on an embassy.' Samun bowed and accepted to go. When the news reached the guebres that an ambassador was coming, they all gathered at the court. Afsar also dressed herself as a man and took a seat next to her uncle. When Samun came in, he greeted them and was seated in an honorable place. After drinks and food, they asked him on what mission he had come. He took out a letter that said: 'Become Muslims, or else I will destroy you!'

'This Iranian is filled with vain pride,' said Afsar, 'because he has not yet met anyone who could chastise him properly. We will show him a thing or two with our blade in combat!'

'Many a person has made such a claim,' said Samun, 'but they all failed.'

'Go,' said Afsar, 'and cease speaking nonsense!'

In short, they gave him leave to withdraw. When he came back to Hamid ... and said that next to Thamud Cat-Eye was seated a boy in whose chin was a dimple that would put the sun to shame. He spoke roughly. Kaus said, 'It is not unlikely that he is Khizranshah's son.'

In short, the next day both armies drew up their ranks on the battlefield. From the army of the guebres came Shersawar Bakhtari, and he had felled five of Kaus's soldiers when Ghantus the Mad, a member of Hamid's retinue, entered the field and squashed him with a blow of his club. He bested twenty-eight men. Malik Thamud Cat-Eye cried out, 'Men, what has happened to us?' All were standing watching when Thamud's son, Safam Elephant-Dragger, entered the arena and stood in front of Ghantus. Ghantus killed that guebre's horse, and they began to wrestle. Thamud feared. Sounding the drums of retreat, both armies retired from the field. Hamid rewarded Ghantus greatly.

The next day battle lines were formed again. From the guebres Samsama's son Tarit entered the field and had bested several of Hamid's men when Hamid took the field and cut him in two. Just then Afsar came onto the field veiled. They fought until noon and were still standing against each other. Afsar Banu When they brought her forward, she threw off her veil, and Hamid saw

A beauty far beyond the borders of humanity, the like of which no one had seen among peris or houris.

Losing his mind, he fell miserably in love.

TRANSLATION FOR CAT.78
Volume unknown, text number 66
British Museum, London, 1925-9-29-02

The teller of this exalted tale draws onto the string pearls of rubies:

When that battled-tried warrior, that lion of strength, that all-defeating fighter, Malik Iraj Nawjavan the sun-worshipper, with the strength of his arm gloriously and valiantly threw Zumurrud Shah the Wayward a hundred and twenty cubits into the air, a cheer arose from the entire army, and all praised the strength of that champion of the age. The sun-worshippers beat their drums, and the sound of their solar battle-cry reached the celestial sphere: 'Malik Iraj has thrown Zumurrud Shah into the dust!'

With the breath knocked out of him, Zumurrud Shah was bound. Then he put his hand on Malik Iraj's head and face and praised him, as all of Zumurrud Shah's champions and Mâlik Malakut assembled. Zumurrud Shah looked and saw that all the people of the city of Faranghushia were standing on the tops of tall buildings, on the mountains, on the walls of Alexander's garden, and on the hills, and when their gaze fell upon that adept warrior, they began to shout. Malik Iraj bowed his head. When Khwaja Bakhtak saw such strength in Malik Iraj's hand, he was confused and set out for Hurmuz, to whom he said, 'Prince, it occurs to me that this warrior must be from the family of Amir Hamza Sahib-Qiran; otherwise in the realm of the east such strength did not exist in Tahmasp

or Alqas or Zu'l-Qarnayn, and it is not known who outside of that family has such strength.'

'Bakhtak,' said Hurmuz, 'the world is a vast place.' Just then Mâlik Malakut ordered four hundred platters of gold and jewels to be poured over Malik Iraj's head while Zumurrud Shah watched – which left Bakhtak dumbfounded. When Zumurrud Shah saw this thing, he said, 'My slaves, I am completely astonished that I have created one like Hamza and that I have allowed wrath to dominate the people of the east, for I set him over them to destroy those people. Now I think I'll call this young man "son." ' All the champions prostrated themselves. Mâlik ordered him to kiss the ground in servitude. Zumurrud Shah said, 'My son Iraj, I offer you my congratulations. As a reward I give you thirteen thousand leagues of the kingdom of the east.' So saying, he extended his hand, took the ring from his finger, and gave it to Malik Iraj. Seven times he kissed the ground, and then he put the ring on his finger. Zumurrud Shah said, 'My son, know that I have set my countenance, which lights up the world, against him in wrath, and I have made him a prisoner in the hands of his enemy, whose name is Malik Qasim. However, I grew angry at that enemy and threw him into the maw of a dragon. Now that he is out, I give you the lord of the orient too.'

When Malik Iraj heard this good news, he kissed the ground in servitude. All the commanders of the sun-worshippers also kissed the ground and offered their congratulations.

Mâlik Malakut was extremely happy, and Malik Iraj offered the city to Zumurrud Shah. Zumurrud Shah entered the city, which was decorated for a celebration. Since it was near the boundaries of the Darkness, they had used many extraordinary things. Zumurrud Shah passed through the city and settled in Mâlik's belvedere palace.

Mâlik Malakut ordered food brought. After that he had fruit brought in. Then he ordered the chamberlains to make the place ready for revelry, and singers and musicians were summoned from everywhere there were any. Banquet tables were laid, and beautiful wine-bearers appeared holding pure wine in china bottles laced with gold. A fine assembly with beautiful wine-bearers and all the implements of revelry were prepared, and the singers and musicians began to play and sing as the banquet began.

From the time Zumurrud Shah the Wayward had left Qitul Bartul and come out of Sabayil he had never seen such a banquet. He grew very happy, and when he was completely drunk he shouted out, 'My slaves, I think I will not remain in the kingdom of the east, for I am going to the Darkness to ennoble those slaves with the light of my countenance, for I have given the entire orient to Malik Iraj.'

TRANSLATION FOR CAT.79
Volume unknown, text number 96
MAK–Austrian Museum of Applied Arts/Contemporary Art, Vienna, B.I. 8770/09

He who tuned the harp of meaning began his words thus:
When Malik Iraj Nawjavan fought with Prince Badi'uzzaman until night, he said, 'O prince, I had always heard from Landhaur b. Sa'dan praise of your bravery and courage. Now that I have seen your fist, it is clear to me that you are a hundred times more than what they said.

I heard you were a man of the battlefield;
When I saw, you were a thousand times more.

Bravo, tomorrow I will do combat with you.' Accepting the challenge, the prince withdrew.

Landhaur b. Sa'dan met the prince and asked about the Sahib-Qiran.

'The prince has drawn near,' he said.

The kings all met Badi'. They passed the night. In the morning the drums of battle were sounded, and they headed for the field.

When Amir Sahib-Qiran came near, he said, 'If anyone has a desire to fight Iraj, there is no impediment.'

No sooner had Karb, Alamshah, Farrukhbakht, and Iskandar Farrukhliqa turned to face Iraj's army than Prince Nuruddahr

son of Badi'uzzaman and Asad son of Karb arrived with Iskandar's drum, Azhdaha-Paykar's standard, Solomon's tent, Gayomarth's cymbal, Jamshed's clarion, and Hatam's white seal. The kings greeted them. The prince paid homage to Amir Sahib-Qiran, and Asad also filled Solomon's tent with supplies. The Amir praised Asad. Prince Nuruddahr did not see [his] father. He inquired about him. The Amir said, 'Bakhtak Iraj left.' He wanted to go, but the Amir would not allow it.

Asad set out in his father's retinue. He came to a place where the combat with Iraj was to be. Badi''s hand sprang from his shoulder when Karb entered the field, and he tore away a piece of chain mail along with the skin from Iraj's body. Iraj grabbed both of Karb's shoulders and ran backwards. Karb's foot went into a hole and he was badly injured. He turned around just as Iskandar Farrukhliqa arrived and received a blow from Iraj. No sooner had Iraj turned around than Alamshah appeared. Iraj asked Landhaur who it was. When Landhaur spoke the name of Alamshah, Iraj said, 'I have a yen to do combat with all of the Amir's sons. I want Alamshah's opinion, but I see him gone, and I will go forward to him in truce.'

Landhaur said, 'Very well.' Just then Devchihr came saying that Alamshah was coming.

Thus it was that Alamshah said, 'Comrades, I am going to advise Iraj because Iraj said that anyone who loves him should come to meet him.'

In short, he met Alamshah, took him into his tent, and gave him a place above himself. He asked the reason for his coming. Alamshah said, 'Iraj, the prince of the men of the world has come near, and he is the center of the circumference of the men of the world. He has been ruling and conquering for ninety, nay a hundred years now, and his life has come to its end. He has a desire for Iran also. If he is respected, it will be well.'

Iraj got angry and said, 'Much sincerity and respect have I shown you, and involuntarily a relationship of love for you has developed in me. If anyone other than you had said these words, I would have done him in. However, I have a desire to be a champion. If I do thus, what will the men of the world say?

When they see me less than him in manliness,
What will the men of the world say of me?

In short, he showed such cultivation of the courtly arts, such signs of greatness and rule, that Alamshah was astonished. He presented Alamshah with a costly robe of honor and much else besides and escorted him to the edge of the camp. The next day the Amir Sahib-Qiran's army A day and a night the army came. On the fourth day Zumurrud Shah's chariot appeared.

TRANSLATION FOR CAT.80
Volume unknown, text number 86
British Museum, London, 1925-9-29-01

The narrator of this beautiful tale thus wove his design into the brocade:
When the demon threw Prince Nuruddahr into the sea, St. Elias the prophet took him out of the water. Nuruddahr wound up on an island.

Meanwhile, the morning after the demon kidnapped the prince, the men who came every day to gaze upon Prince Nuruddahr's beauty arrived. Seeing no trace of the prince, they grew anxious. When Khwaja Umar did not see Prince Nuruddahr at the base of the tree, he too grew anxious. The demon came and said to the girl, 'I took the youth away and threw him into the sea.' The girl grew extremely upset. When the demon went out after some food, the girl went to Umar and said, 'Play something, for I am very upset today.' Umar asked her the reason.

'The youth you told me about,' the girl said, 'was thrown into the sea last night by the accursed demon.'

A sigh arose from Umar's heart, and he too was most upset.

The next day, when the shining sun put forth its head from the window of the east and illuminated the dark world with the light of its world-adorning countenance, Pahlavan Karb Dilavar arrived. When he came to the base of the tree, he did

not see Prince Nuruddahr. He asked the residents of the area where the prince was. They said, 'The demon carried him away and threw him into the sea.'

When Pahlavan Karb heard this, he grew quite contemplative and said, 'Until Nuruddahr is found, I shall not stir from the foot of this tree.' Umar was watching from above, and he saw Karb. He too became upset. When Karb did not see the prince, he said, 'As long as he is not found I will not send anyone to the Amir.'

Meanwhile, since Prince Nuruddahr had set out with a caravan, he soon came to an island, where he stopped in a caravanserai. The ruler of Nay-Rod was Iklil Yellow-Cloak. The brother of Daylam Simat Zangi waged war, and Iklil was defeated. The Zangis attacked the gates of the city. Nuruddahr came out and killed Daylam Simat Zangi's brother. When Iklil realized this, he became a Muslim. The prince asked the way to Seven Mile, came back, and saw Karb. He rejoiced and told his story. Karb advised the prince. He would not agree and wept so bitterly that Karb felt sorry for him. He too became a wandering dervish and sent someone to the Amir.

Meanwhile, when he saw that Nuruddin [Nuruddhar] had been found again, he set out for Nuruddahr. He was taken captive. He was about to kill him. The demon agreed to go and bring the girl. Nuruddahr let him go. He went and did not come back. Karb's messenger brought news to the Amir. The Amir sent Badi'. Badi' came with the army, and the girl's father who was named Kayvan Buland-Rif'at fought a battle with Badi' and was captured. When offered the chance to become Muslim, he said, 'I shall become a Muslim when you kill the demon and rescue my daughter.' Badi' came and advised Nuruddahr. He would not agree. They sent the news to the Amir Sahib-Qiran. The Amir set out with Muqbil. The sun-worshippers got wind of it. They beat their battle drums. Arrad Elephant-Strength came into the field and wounded several of the Amir's soldiers. Hashim killed him. Defeat befell the sun-worshippers' army when Iraj arrived and wounded Hashim. A pitched battle ensued. Ta'us Shah and Qamhur were released from captivity. Landhaur had a fever. The army of Islam (?) Sa'd Padishah sent Umayya to the Amir Sahib-Qiran, but the Amir and Muqbil came to do battle. Haft Paykar joined the Amir Sahib-Qiran's retinue. The Amir ... Badi', Karb, and Nuruddahr ... One day Umar said to the girl, '... give the demon a lemon.' She did it, and the demon fell unconscious. The girl released Umar. Umar threw the demon down and ... The Amir Sahib-Qiran with the lasso ... did not reach Fars ...

TRANSLATION FOR CAT.81
Volume unknown, text number 88
Victoria & Albert Museum, London, I.S. 1512-1883

The master poet thus opens the lid of this treasure:
When Anqarut Jadu carried Malik Iraj off to the island and attacked him, when her eyes fell upon Iraj's beauty, she said to herself, 'Khwaja Muzaffar's daughter was right!' With her knowledge of magic she bound Iraj to a tree. After a time she appeared to Iraj in the guise of a fourteen-year-old girl and said, 'O youth,

How wonderful would it be that my wish be granted to end my life under your feet.

No matter how beautiful you are, however, I do not want so much as a hair of your head. Place your arm and imagination around my neck so that my head will be exalted to the skies. Any service that you cannot perform for him entrust to me, for I will do it with ease.'

Iraj asked her name. 'I am Jawahir Ankut Jadu,' she said. Iraj averted his face. No matter how much she screamed and yelled and cursed, Iraj said not a word to her.

Anqarut said, 'Now he is angry. Let him suffer for a while, and then he will be more cooperative.' And she left Iraj.

When it was morning the servants came to the gate of the court. They saw a head hung on the gate. They were perplexed and shouted out so much that Mâlik Malakut and Zumurrud Shah became aware. They asked for the head. They put it in a golden brick and took it to Zumurrud Shah. Iraj's [...?] saw that

a cry was coming from Iraj's house that Khwaja Farah had torn the clothing from his body and came wailing to the court. He saw the head before Zumurrud Shah. He cried out, and the people of the assembly began crying, and the army of the sun-worshippers sat in mourning, and Zumurrud Shah became very despondent.

He beat his head and cried. What is the result of injustice save weeping?

When Zumurrud Shah's amirs saw their lord like this, they got upset. Zumurrud Shah thought long. Nothing occurred to him to remedy the plight of the God-worshippers. When Mâlik Malakut saw Zumurrud Shah and his amirs broken-hearted, he said, 'O lord, be easy of mind, for I will battle the God-worshippers again to see who will succeed. Moreover, Malik Mismar is a mighty padishah who is coming with three hundred thousand men across the sea.'

Zumurrud Shah, who had his head lowered, did not raise it, but when this news was conveyed to Susan Amir he went to the camp of Islam to the Sahib-Qiran. The Amir of the Arabs was very saddened by this devastating news.

'O Arab,' said Khwaja Umar, 'what a pity, this young Nuruddahr,' and he began to weep involuntarily. Each of the kings who had seen Iraj was distraught by his early death. Mourning clouded the Sahib-Qiran's camp. The infidel *ayyar*s carried the news. Andarut told the story to a neighbor woman. That woman told her husband that Iraj had been killed by the daughter of Andarut Maqarut. That man went to Khwaja Farah and recounted this story. The Khwaja ordered Andarut seized and brought, and he was questioned. [He said,] '...threw into the sea, and he was lost.' Mâlik Malakut ordered Andarut to be killed along with many of his relatives. They went into mourning.

Anqarut left Iraj that day. When it was night she lit many candles and lamps and bedecked herself in extraordinary clothes and went to Iraj. She began to wail and said,

Defiant one, look into my face and gaze upon me with kindliness.

I am thirsty; you are the water of life. What would it cost you to sprinkle one drop on me?

Iraj cursed. He got angry and said, 'O sun-worshiper, I will do something to you that will be spoken of ever afterward.' He spoke a name. Dust arose. When Iraj opened his eyes he found himself floating on a raft in the middle of an endless sea. He was dumbfounded.

TRANSLATION FOR CAT.82
Volume unknown, text number 12
Metropolitan Museum of Art, New York, 18.44.1

The moneychanger of poetry with words like gold draws pearls onto the string thus:

When Pahlavan Asad Karb ... and left, the infidels kept falling upon one another and ... came out: they killed, bound, and wounded friend and foe alike and had no mercy on each other.

The next morning when the bright sun put its head out through the window of the east and lit up the dark world with its countenance—

At the moment of dawn as this merciless killer came out of the east with kettle and blade—

when the benighted infidels opened their eyes and recognized each other, they saw that strangers in their midst were as rare as God's love was among them. They had killed so many of their own that it was beyond reckoning. Landhaur b. Sa'dan said, 'Malik Iraj, beware lest you pit yourself against that madman.' But Pahlavan Asad did not get himself into the fortress and took off in some direction.

The next day Malik Iraj mounted his horse and provoked battle. He was not able to capture anyone. Faris the keeper of the castle came out and shouted, 'Malik Iraj, if you have laid siege to this castle on account of Asad, he is not here. If you're a man, go after him! Why are you bothering with us cowards?'

'Malik Iraj,' said Landhaur, '...

...b Devsar set out and arrived. The shahs who had come out to greet him got Malik Iraj down from his horse. Iraj asked

about Akhtam and set out in that direction. Khwarshed and Jamshed of Akhtam heard that Malik Iraj was on his way to Akhtam. They sat thinking. Their champions, like As Elephant-Foot, As Bronze-Body, and As son of Shimsham went to Jamshed and Khwarshed and sought to do battle with Malik Iraj. They were given leave. The champions with three hundred thousand men got into ships, went across the water, and pitched camp on the shore of the sea. The next day when the prince of the stars appeared in the azure field of the sky and the world was once again illuminated—

At dawn when the Turk who dwells in a tent came out of his fiery home,

he overturned the tent of night and nailed shut the demon's lip with iron—

that morning Malik Iraj the sun-worshiper's soldiers got up, and the next day Malik Iraj arrived. Battle lines were arrayed, but that day it rained and they stayed in their places. That night the braves of both armies were concerned over what the morrow would bring. *Who knows what will arrive tomorrow? who will disappear from view? on whose head will the crown of luck be placed? whose bundle of hopes will be placed outside the door?* That night was spent by the warriors in worry. The next day when dawn illuminated the world from the horizon—

When the king of Byzantium emerged from his emerald throne, he overthrew the hosts of evening during black night—

that morning the two armies set out, fully armed, to do battle and headed for the field. When they stood opposite each other, lines were drawn. As Bronze-Body came onto the field, blocking Iraj's troops and asking for a combatant. Iraj came forth and As struck Iraj's mount with his sword. Iraj grew wrathful, pulled him down along with his rhinoceros, and threw him onto the ground so hard that both man and mount were wounded. When As Elephant-Foot and As son of Shimsham saw this act of valor, they roared at each other and, recognizing that it was a good time to retreat, got into their boat and entered Akhtam. Iraj plundered their camp and stopped at the edge of the sea.

The next day Iraj got in a skiff, but Shimsham's son As blocked his way. Iraj leapt from the skiff and cut As in two. Then he knocked over the castle with blows of his mace. Soldiers came out of the water and entered Akhtam. Chaos broke out in the fortress. Jamshed Akhtami escaped by another road and went to Mushtarisar, but Khwarshed, who had crushed Iraj's letter under foot, was captured. Iraj threw him down and rubbed his foot into his stomach so hard that he died. Ujan captured Jamshed on the sea and brought him in. He capitulated.

TRANSLATION FOR CAT.83
Volume unknown, text number 2
Metropolitan Museum of Art, New York, 18.44.2

The teller of this sweet tale thus brought forth his speech.

When Prince Malik Qasim came out ... and went to the barrier at Jalandariya, he came to the foot of the barrier. ... and he saw a river, thanks to the effulgence of which the entire plain was green and verdant, and a meadow with wonderful air appeared. The prince of the realm of courage, Malik Qasim, he of the ruby tunic, the bloodshedder of the east, looked up at the top of the fortress.

If one looked to the top of it, the viewer's hat would fall off.

Opposite the fortress he saw a marvelous tree. Under the tree a throne of rare workmanship had been placed. ... The prince, the lion of the battlefield, Malik Qasim the courageous dismounted from his horse, took the reins from the head of that demonic steed, and let it graze. He sat on top of the throne and viewed the fortress, marveling at the handicraft of the creator. However, from time to time the harsh words of the Amir Sahib-Qiran and the words of the world-conquering Prince Badi'uzzaman rang in his ears. His complexion changed, and he said, 'You see that in the end this Arab took the part of his own son.' ...

He was saying this when suddenly a ... emerged from the

fortress, and following it were six ... with four Negroes on their backs. Behind them came a group of eunuchs 'who gave the world a different splendor.'

While this was going on, people gathered. Some of the eunuchs spurred their horses and yelled at Prince Malik Qasim, saying, 'Get up! Go to the side!' Prince Malik Qasim asked them what was happening. 'The daughter of Jahan Pahlavan is going to the garden,' they said.

Prince Malik Qasim was speaking with them when a litter came like a rose before the prince. From behind the curtain the girl saw that her eunuchs were speaking with a youth, a prince who was so handsome that anyone who looked at the arch of his eyebrow would place the new moon on the shelf of forgotten things and open his mouth in praise, and anyone who gazed upon his erect and harmonious stature would chastize the cypress.

All who saw him were stricken with grief and grew accustomed to pain.

With one glance all were smitten by him, mad with love, without consolation.

All it took was one glance on the part of the girl, and she fell helplessly in love with him. Turning to her eunuchs, she said, 'Bring that young man to the garden,' but she raised the bottom of the curtain slightly, and by chance the prince's eye fell upon her loveliness. He spied a beauty whose cheeks would put the sun to shame.

The hyacinth would be ashamed before her two tresses.

From her mouth, when she smiled, flowers could be plucked by the basketful.

In short, an arrow flew from the arch of her brow and struck Malik Qasim in his rancorless breast. A sigh arose from the depths of his being, but just then a eunuch named Ambar came and said, 'Young man, the queen of beauties, Sim-Andam, summons you.'

The prince said, 'Whatever you say, I shall obey.'

In short, he got on his steed and, together with the eunuch, went to the garden. Sim-Andam summoned the prince into the garden. The prince entered. The beauty greeted him, falling at his feet and begging and pleading with him. She took the prince by the hand and led him up on to a dais in the garden, and there they sat on a carpet like two new roses embracing each other in the meadow of beauty, or like the moon and Jupiter in conjunction in the constellation of loveliness.

So much was each desirous of the other, they sat opposite each other.

The prince bowed his head at this ..., and the girl, having learned the prince's story, the prince left the garden intending to take the fortress. When he reached the bottom of the mountain the prince said to the girl, 'How can this fortress be taken?'

'O Malik,' she said, 'I will lead you, for I have been in love with you for a long time.' And she showed him the picture she had taken from Gurdmard. The prince rejoiced and took her inside the fortress.

TRANSLATION FOR CAT.84
Volume unknown, text number 74
British Museum, London, 1948-10-9-065

Narrators of tales have thus expressed themselves:

When Kulbad and Zardhang sat rejoicing over Farid's luck, they said, 'If we can find a way, great wealth will appear, and the doors of many triumphs will open to us. We will see comely youths and rare beauties, and with the polish of the eyebrows of beauties we will eliminate the rust from our hearts, as little by little we become acquainted with everybody.'

'Well you say,' said Zardhang, 'but let us think. A stratagem has occurred to my mind.'

'Say it!' they said.

'Master Farid is acquainted somewhat with the art of geomancy. It would be appropriate for him to take a stroll in Bibi Dilgusha's lane and ... begin to speak with the genii. I will go and steal all Bibi Dilgusha's ornaments, gold, and jewels and put them in a place where we can find them at our leisure, and then we can enjoy our wealth.'

All approved heartily of his plan. One night Zardhang, on the pretext of a stroll, passed through Bibi Dilgusha's lane. Throwing his *ayyar*'s lasso up onto the roof, he got himself up. No matter what direction he went to go around the house ... they had the treasury in the middle and patrolled it. Spying the treasury, he turned back to the house, where he fell into contemplation of how to rob it. Another night he went, got hold of Bibi Dilgusha's jewel box, and ran out. At the base of a mountain he dug the earth and hid the things there. Then he turned his attention to Farid ... was in ambush and guarding it lest some fellow steal it and deprive them.

When the world-illuminating sun put its head out, the treasurer's maid became aware of what had happened and, pulling her hair and scratching her cheeks, she hastened to Bibi Dilgusha and informed her of her situation. Bibi Dilgusha exploded with anger. She ordered the maids and servants to be beaten. No trace of the jewels was found. She sent a messenger to Shabahang and ... he inspected every corner of the house. Many men were put to torture, and up to five hundred persons were killed under torture. Bibi Dilgusha said, 'Let someone go and summon Mulla Mathun the geomancer.' An order was given for every geomancer and astrologer that could be found to be brought. When their minds were put at ease, they were brought. In this manner Farid was also brought in.

As the geomancers gathered, the first to throw the die was Mulla Mathun the geomancer, but no matter how he thought and contemplated, he could not succeed in doing anything. Each of the geomancers in turn threw the die and spoke. Finally it was Farid's turn. He knelt politely and said to Shabahang, 'First, if these geomancers can find anything, let them find it and relieve all our minds of anxiety. If not, I will try.'

Shabahang asked them all to try, but they all failed to find anything. With self-assurance Farid knelt, threw the die, and put some of his opponents to sleep. After a time, he said, 'I have found it!' And he gave the particulars. Shabahang and Bibi Dilgusha headed for the place he had described, and there they found the gold and jewels. Rejoicing and relieved, the people of the city let out a cry of joy. Everyone praised Farid, but no matter how many things they offered him, he refused and said, 'I am a stranger. Why should I keep these things? Now I have become acquainted with you. If you would be so kind, you might occasionally ask after me. I may be able to render you services to show my gratitude. I wish only your well-being.'

TRANSLATION FOR CAT.85

Volume unknown, text number 89
MAK–Austrian Museum of Applied Arts/Contemporary Art, Vienna, B.I. 8770/13

Narrators unique in storytelling ability explain the tale thus:

When Malik Iraj paid homage to the Amir, Umayya said, 'Malik Iraj, why are you heedless of the fact that the enemy are pressing you from left and right? You should be arraying your troops because it will not be long before Hamza the Arab and all his champions and sons will be upon you, and now that you have captured Umar Ayyar, take heed that you not allow him to escape, for he is the mainstay of Hamza's army. If you command me, I will go and keep watch over that thief and hold him upstairs.'

'Very well,' said Iraj, who asked that gold and jewels be brought and offered them, but they were refused. Iraj ordered him to go up. Umayya went up and kept watch over Umar. Finding him to be an extraordinary man, he asked, 'Who are you?'

'The caliph of the sun, Umar,' he said. 'Are you Umayya or Qasim son of Umayya?' he asked. When he told him about himself, Umar rejoiced. Umayya undid the bonds from Umar's arms and legs, and when it was darkest night Umayya and Umar let themselves down by lassos and set out for the Hirman Gate.

When they entered Shah Sulayman saw Umar and rejoiced. News was taken to Malik Qasim. He received Umar and asked about the Amir. Umar said, 'He is near, but the ascendant of this sun-worshipper is very powerful.'

The next morning, when the men surrounding the tower looked, they found no one. Withdrawing, they took the news to Iraj, who realized that it was an *ayyar*'s trick.

When the men of Islam heard of Umar's escape they rejoiced. However, the next day, when the prince of the orient displayed his beautiful countenance from behind a dark veil and rent the heart of the Hindu of the night with the dagger of his disc, and tears poured over the black face of night,

The crocodile of dawn reared its head from the indigo river; the hand of morn tore the robe from the panther of night.

There was no more market for the musky goods of dark night, and the world was recompensed with the camphor of dawn.

That morning the sound of battle drums arose from the army of Ganjab son of Ganjur. In Iraj's camp too the drums were sounded. The armies faced one another, and when the field was completely cleared Qahqaha son of Kayahar emerged from Ganjab's camp fully armed, strode up and down the field, and demanded a combatant. Thawr son of Hamal came into the field from the army of the sun-worshippers and headed off Qahqaha. He was wounded. Sut the archer came into the field and was killed. Aqrab Blood-Sifter came out and was wounded. When it was evening, after wounding around seven men and killing three, he retired. The armies made camp. The next day the battle drums were sounded, and when the armies stood opposite each other, Qahqaha entered the field, blocking the army of Islam. Just then a cavalier rode on to the field and stood in Qahqaha's way. He was wounded. Sa'dan Iron-Helmet entered, and when he was wounded, a rider from the right wing of the army of Islam came on to the field and received a blow on his arm from Qahqaha. In return he struck Qahqaha on the head and split him in two. It was the champion Asad son of Karb. The armies retired. The shahs of Islam applauded him. Ayjil and Shah Sulayman bragged about Asad to Umar more than can be described. Umar asked about Nuruddahr. They said that he was held captive by Kaysarang Shah. This upset Umar, but the next day Ganjur ordered the battle drums sounded. When the battle lines were formed Saffdar son of Nur came onto the field and asked for a combatant from the *ayyar*'s troops. Dev Jahr came out and was wounded. Shabrang Ayyar came out. He was killed.

The next day too he demanded a combatant from the army of Islam. Bathu came out and was wounded. Jahansoz came out and was killed. Then Umar came out and killed Saffdar with a rock. The armies retired.

Khwaja Umar Ayyar went to Malik Iraj's gate in the guise of a water-carrier while everyone was talking about Umar Ayyar's exploits in the battlefield.

Mālik Malakut said, 'I have heard that he steals kings' crowns.' Landhaur son of Sa'dan was talking about him when the banquet was served. After they finished eating, Umar stood up and asked for Mālik. As Umar handed Mālik the water, he slapped him on the face, snatched the crown from his head, and ran from the court. The men ran after him, but he left them in the dust.

TRANSLATION FOR CAT.86

Volume unknown, text number 76
MAK–Austrian Museum of Applied Arts/Contemporary Art, Vienna, B.I. 8770/15

The narrator relates that when Umar, with strategy and tactics, burned the dragon, Sa'id presented Umar with their thousand horses. Umar branded them and then asked how far it was to Qitanush Shah's capital. They said it was three hundred leagues. Umar started out on the road and galloped day and night. In Bedakdasht, where ghouls and demons were guardians, Umar came to that king's capital. When he reached Qitanush's court, a voice came from inside the court, saying, 'Umar the *ayyar* has come.' Umar was perplexed. The people took Umar inside, where Qitanush was seated on the throne, and there was an idol of gold placed on a bejeweled throne. A voice came from the idol, saying, 'Umar, where have you come from?' Umar gave Qitanush's daughter's letter, and it was read out. In it was written: 'He rescued me from the clutches of the demon Hamza the Arab. This *ayyar* has expressed his love for me. I have sent him to you that you may not leave him alive.'

Qitanush rejoiced and ordered Umar seized and killed, but Baalbek would not allow it, saying, 'Hamza will come here. Then we will kill him.'

In short, Umar was imprisoned beneath Baalbek's throne. When Qitanush read Amir Sahib-Qiran's letter, in it was written: 'After praising God and extoling the Prophet, O Qitanush, become Muslim and accept Umar as your son. Do not regard him as an *ayyar*, for he reigns supreme over Bakhtar, Iran, and Turan. End of letter. Peace.'

The narrator says that Amir Sahib-Qiran waited long for Umar. After two months, he set out for Qitanush's capital. When he reached the city of Sa'dnasur, he gave Umar's possessions to the soldiers, and they camped there. The Amir drew a line around the camp and went himself around the vanguard until he went up on a hill and dismounted from Ashqar and went to sleep. Muqbil was with him. He too went to sleep, but Ashqar neighed. The Amir woke up and saw a black thing. He was about to mount when the blackness threw a rock that hit Ashqar on the ... If the Amir's hand ..., it would have been smashed. The Amir grew angry. Bidding farewell to Muqbil, he mounted, forgetting his spear, and set out after the blackness. All night he traveled. Three hundred leagues he traversed. He came to the mouth of a cave, from which the sound of glorification came. There was a curtain of leaves hung [over the mouth of the cave]. A voice came, saying

The arch of my sight is your nest. Be kind and alight, for the house is yours.

The Amir got down from his horse and proceeded. A voice came, saying, 'O Sahib-Qiran, we have waited long for you. Take down your things, for in the end all will be well.'

An inscription from the Messiah on this ancient monastery: Despair not, for the end is good.

As long as you are without the door, you see everything as strange:

Come in, come in, for this house is devoid of strangers.

The Amir entered. He saw a wise man dressed in sackcloth. 'O Amir,' he said, 'Baalbek has confounded you, but your difficulty will be solved at the foot of Qitanush's throne. I was promised I would see you, and that you would bury me.' So saying, he gave up the ghost. The Amir buried him and then went to Qitanush's capital. At the gate he spied a bow and arrow. He asked [about them], but no one replied. The Amir took the bow and arrow and went into the city. At the market crossroads he spied a platform on top of which was a statue with a bucket hung around its neck and a bejeweled crown on its head. The Amir asked about it and was told that a prince had come to ask for a girl's hand. He would have to take the crown from the statue's head, a deed no one was able to accomplish because a hand would appear and cut off the attempter's head.

The Amir went to a caravanserai and dismounted.

The narrator says that Baalbek went to the Amir's army. The next day Qitanush came. That youth arose. They prevented him. He did not accept and said,

I will not cease my quest until I succeed:

Either body from soul or soul from body will be separated.

In short, [the suitor] wanted to take the crown from the statue's head when a hand appeared and struck his head and neck so hard that he died on the spot. A great shout went up from the crowd. Malik Nush wanted to arise. He would not let him and said, 'I will take it off.' Calling on the Great Name, he went forward. A hand appeared [on the statue] but it was unable to do anything. The Amir had just taken the crown when a demon came. The Amir called for bow and arrow. He shot an arrow into the demon's chest so hard that it fell to the ground and gave up the ghost. The Amir offered Qitanush Shah a chance to convert to Islam. He converted sincerely.

A NOTE ON ARTISTS' NAMES

Names of Hindu artists written in Arabic script pose a particular challenge of transliteration. Some consonants in Indian languages do not occur in Persian, and short vowels, which are normally written in Indian names, are omitted when they are transcribed into Persian. The transliteration of all names thus involves some adjustment to their standard forms. Krishna, for example, is written in Persian as K-SH-N, which yields Kishan, a common vernacular form of Krishna. Bhīshma, on the other hand, is written as B-H-Ī-K-M, which is unrecognizable to most readers. To maintain a sense of the underlying Indian names and to standardize their appearance, I have transliterated them as though they were written in Devanagari script, the base script for north Indian languages. Because consonants in Devanagari are almost automatically followed by a vowel, the result habitually ends in a final 'a,' which is typically silent when the name is spoken. The letter 'w,' which does not exist in Devanagari, has been rendered consistently as 'v'. Thus, readers will find here Basavana rather than the more commonly rendered Basawan, Madhava Khurd rather than Madhu Khurd, and Shravana rather than the unintelligible Sarwan.

GLOSSARY

AH	abbreviation for *anno hegira*, the year reckoned according to the Islamic calendar, which starts from the date of the Prophet Muhammad's emigration from Mecca to Medina in AD 622
Allahu akbar	'God is great'
amal(-i)	'work (of)', a term used in Mughal ascriptions to individual artists
Amir	a prince, lord, military officer; when used alone, refers to Hamza
ayyar	*a* spy, a cunning operative
Baba	a term of respect used for an elder
b.	an abbreviation of *ibn*, 'son of'
burqaʿ	a woman's veil through which only the eyes are visible
cadi	a judge
Cathay	northern China
charqab	a robe of gold embroidery
colophon	an inscription at the end of a manuscript providing information about its scribe, date, and place of production
dev	a demon
Farangi	'Frank', a European
farrashes	officers who superintend the pitching of tents
genie	a supernatural creature
guebre	the name given to Zoroastrians in the *Hamzanama*
houri	a virgin of Paradise
jama	an article of male clothing; a knee-length tunic or overgarment
Khwaja	doctor
Malik	King, a title of honor
-nama	a body of writing, e.g., *Akbarnama*
maund	a unit of measurement equivalent to 82.286 pounds
padshah	a king
Pahlavan	Champion
peri	a celestial creature or angel
qibla	the direction of Mecca, to which prayer is directed
Rum	Greece, the Roman empire, or Europe in general
rupee	a unit of Indian currency
saqi	a cup-bearer
shah	a king
siyahsar	a type of Indian crocodile
Solomon	the biblical king who commanded all creatures on the earth
takiyya	a place of repose, sanctuary
vizier	a minister
Zangi	an Ethiopian, a dark-skinned person

NOTES

FOREWORD
1. Semsar 2000, p.309.
2. Clarke 1921, p.3.

INTRODUCTION
1. Hanaway 1970, pp.196–201.
2. Meredith-Owens 1960, pp.153–54.
3. Meredith-Owens 1960, p.153.
4. Meredith-Owens 1960, p.153.
5. The following remarks are indebted to Hanaway 1970, pp.240, 243–45.
6. This feature is discussed in Hanaway 1970, pp.240–41.
7. The following narrative summary is based largely upon Hanaway 1970, pp.337–49.
8. Hanaway 1970, pp.212–13.
9. Staatsbibliothek Preussischer Kulturbesitz, Berlin, Orientabteilung Ms. or. fol.4181. The manuscript is published in Stchoukine, Flemming, Luft & Sohrweide 1971, no.61.
10. The outline of the *Darabnama*, which focuses on Darius and Alexander the Great, is given in Hanaway 1970, pp.291–305. The Mughal *Darabnama* manuscript is discussed in Losty 1982, no.59. Representative illustrations are reproduced here as figs 18 and 19.

THE INTELLECTUAL AND ARTISTIC CLIMATE AT AKBAR'S COURT
1. Habib 1999, in particular pp.xi and xvi.
2. *Akbar's India: Art from the Mughal City of Victory*, at the Asia Society Galleries, New York during the Festival of India in 1985–86, was dedicated solely to Akbar's patronage.
3. Subrahmanyam 1999, p.135.
4. Reported by, among others, Antonio Monserrate in his *Mongolicae Legationis Commentarius*; see Monserrate 1922, Appendix, p.xvi.
5. Vambery 1899, p.52.
6. See, for example, *Rajatarangini*, p.411 *et passim*.
7. *Baburnama*, pp.112–13, 334–48, *et passim*.
8. For Bengal see Eaton 1993, pp.66–69 *et passim*. For Kashmir, see bottom of page and p.27.
9. *Muntakhabut-t-Tawarikh*, 1, p.573.
10. Minorsky 1940–42, pp.150–51.
11. *Qanun-i Humayuni*, pp.80–81; cf. Necipoğlu 1993, pp.313–14.
12. *Muntakhabut-t-Tawarikh*, 2, p.336; cf. Monserrate 1992, p.184. On Mughal solar symbolism see also Skelton 1988. On the painting and related examples, see Das 1982.
13. Eaton 1993, pp.66–69 *et passim*.
14. *Rajatarangini*, pp.134, 139, 148.
15. Chattopadhyaya 1998, p.53.
16. *Muntakhabut-t-Tawarikh*, 2, p.336; cf. Rizvi 1999, pp.19–20.
17. Rizvi 1999, pp.19–20.
18. Rehatsek 1887. For a discussion of the addressee and the different editions see Maclagan 1932, p.44, n.57.
19. *Akbar Nama*, 3, p.1011.
20. Nizami 1989, pp.120–22 *et passim*; Khan 1997; Rizvi 1999.
21. *Muntakhabut-t-Tawarikh*, 2, p.378; cf. M. Athar Ali 1999, p.176.
22. *Muntakhabut-t-Tawarikh*, 2, p.296; *Akbar Nama*, 3, pp.581–82.

23. At the beginning of the second book of his *Histories*, Herodotus reported that the Egyptian king Psammetichus (Psamtik I, d. 610 BC) had children raised in isolation to find out which race and language was older, Egyptian or Phrygian; and the Hohenstaufen Frederick II (1194–1250), Holy Roman Emperor, King of Sicily and Jerusalem, and in many ways a kindred spirit of Akbar, is credited with having undertaken a similar venture (with similar results) to establish which was the first language of mankind, Hebrew, Greek, Latin, or Arabic; Kantorowicz 1963, p.325. In the supplementary volume (annotations to p.325) Kantorowicz suggests both Herodotus and Ibn Tufayl's famous philosophical novel *Risalat Hayy bin Yaqzan*, written in the last third of the twelfth century, as sources of inspiration for Frederick. I thank Joachim Deppert for helping me with these references.
24. Maclagan 1932, pp.24, 191, *et passim*; Koch 1982.
25. Rehatsek 1887. Similar words of Akbar's are recorded by Monserrate 1922, p.182.
26. For the Family of Love see Rooses 1882, in particular pp.55–67; cf. Clair 1960.
27. Rizvi 1999, p.18.
28. In the biography of Abu'l-Fazl preceding his translation of the *A'in-i Akbari*, H. Blochmann (pp.liv–lvi) gives the Persian text (with some misprints) and a translation. For the Persian text see also Nizami 1989, pp.381–82. The translation presented here is my own and closer to the Persian text than Blochmann's; it was undertaken with the help of Dr. Yunus Jaffery.
29. Vanina 1996, pp.120–33.
30. Moosvi 1999; M. Athar Ali 1999, p.177.
31. Alam 1998. I thank Sunil Kumar for drawing my attention to this publication and for providing me with a copy of it, and also for helpful comments on an earlier version of the present essay.
32. *Rajatarangini*, pp.147, 166.
33. Alam 1998, p.329.
34. Monserrate 1922, p.201.
35. Brand & Lowry 1985b, pp.36, 290–91, 294.
36. This phrase is borrowed from Giles Tillotson (1989, p.15), who argues, however, against such a political agenda in architecture.
37. *A'in-i Akbari*, translation, 2, p.191.
38. Koch 1987; Koch 1991, p.38; for Akbar's architecture see pp.43–69.
39. Brand & Lowry 1985a, pp.23–32; Adle 2000.
40. Brand & Lowry 1985a, p.23.
41. *A'in-i Akbari*, Persian text, 1, p.111; my translation, undertaken with the help of Dr. Yunus Jaffery, follows the Persian text more closely than Blochmann's translation, 1, pp.102–3.
42. *Dhakhirat al-Khawanin*, 1, p.87; *Dhakhirat ul-Khawanin*, pp.60, 63.
43. A useful overview of the production of Akbar's painting studio is given by Brend 1993; for the history of the Panchatantra see M. Athar Ali 1999, p.178.
44. *Baburnama*, p.220.
45. Rizvi 1999, p.15.
46. *Muntakhabu-t-Tawarikh*, 2, p.347.
47. *Akbar Nama*, 3, p.1015.

THE ORGANIZATION AND USE OF THE *HAMZANAMA*
1. Chandra 1976, p.178.

2. Bayerische Staatsbibliothek, Munich, Pers. Codex 3. A thorough discussion of the contents and date of this manuscript appears in Chandra 1976, pp.174–78.
3. Chandra 1976, p.175, and pl.120.
4. Chandra 1976, p.177.
5. Translation by C.M. Naim in Chandra 1976, p.180.
6. Ibid., p.181.
7. A full account of this author and text appears in Chandra 1976, pp.185–87.
8. Translation by C.M. Naim in Chandra 1976, p.187.
9. Chandra 1976, p.187, n.9.
10. For valuations of individual Mughal paintings, see Seyller 2001. For Mughal valuations of unillustrated and illustrated manuscripts, which range from as low as one rupee to as high as 20,000, see Seyller 1997, pp.255–79.
11. *Akbar Nama*, 2, pp.343–44.
12. *A'in-i Akbari*, Persian text, 1, pp.116–18, as translated by C.M. Naim in Chandra 1976, p.184.
13. *Muntakhabut-t-Tawarikh*, 2, p.329.
14. *Muntakhabut-t-Tawarikh*, 3, p.292.
15. Dickson & Welch (1981, p.179) understand the discrepancy between the two numbers as the result of Badauni including a one-volume copy of the *Shahnama* in his total.
16. Mir Husayn al-Husayni worked for a time in the Shaybanid court at Bukhara before joining Akbar's service. He must have been in Bukhara as late as AH 975 (AD 1567–68), for both the city and date are included in the colophon of the *Gulistan* of Sa'di in the British Library, London, Or. 5302.
17. Schimmel 1984, pp. 183–84, citing the *Majma' al-shu'ara Jahangirshahi*, p.50.
18. *Maasir al-Umara*, 1, pp.454–55.
19. Chandra 1976, p.180, n.20.
20. Chandra 1976, p.63, n.40.
21. Dickson & Welch 1981, p.179.
22. The following folios have blue paper in the text area: Keir Collection, nos V.2 and V.3; MAK, Vienna, B.I. 8770/2 recto, 8770/4 verso, 8770/4 recto, and 8770/19 (cat.25). Two paintings, British Museum, London, 1923 1-15-03, and one in a private collection (*Khwaja ... Greets Tabiq (?) Khan Outside a City*), have pale-green paper panels. In some cases, these strips of colored paper are used in conjunction with regular cream-colored paper. This sporadic use of dyed paper is also characteristic of some contemporary manuscripts and albums.
23. MAK, Vienna, B.I. 8770/4 verso and recto (Reconstruction, nos 10 and 20).
24. For summaries of these positions, see Chandra 1976, pp.63–68; Leach 1986, pp.38–39. Dickson & Welch (1981, p.254, n.16) use Persian sources to support an argument for a third set of dates, 1566–80.
25. Seyller 1993; Glück 1925, p.155.
26. Melikian-Chirvani 1998, p.50, n.7. He subsequently dismisses the number as 'apocryphal.' But not all royal objects included the word *sana* in their inscriptions. Two spinels recently sold at Sotheby's, London (3 May 2001, lots 140–41), lack the word below their respective dates of AH 1016 (AD 1607–8) and AH 1070 (AD 1659–60) and AH 1022 (AD 1613–14). (One spinel has two dates: these precious stones were akin

to family heirlooms and were often inscribed by successive emperors.) Even so fine a painting as cat.17 has a date (996) written without the word *sana* below it.
27. For example, to my knowledge, illustrations in Persian manuscripts are not even given painting numbers, as they normally are in Mughal ones. For a variety of informally written dates, ascriptions, and painter's directions, see Seyller 1987.
28. Two other paintings are inscribed as belonging to volume 6: one in the collection of Ramesh Kapoor (Reconstruction, no.30), painting number 2; and another in the al-Sabah Collection (cat.21), painting number 34. Three paintings are inscribed as belonging to volume 7: one in the Victoria and Albert Museum (cat.26), painting number 10; another in the collection of the Art and History Trust (Reconstruction, no.40), painting number 14; and a third in the Library of Congress (Reconstruction, no.41), painting number 38.
29. Leach 1998, p.17, calculates that each volume after volume 4 took approximately nine and a half months, and thus advocates a commencement date just after Akbar's accession.
30. The first digit (9) has a disturbed loop; the last digit is a solid heart-shape, a rare form of the number 5.
31. See Introduction, note 9, above.
32. See Reconstruction, no.113.
33. See the reference to the modern binding on the folios in the MAK, Vienna, in Antoinette Owen's essay, p.283, n.10.
34. For a comprehensive study of these inspection notes, see Seyller 1997.
35. The remaining notes and seals, not transcribed in the captions to figs 11 and 12, are as follows. MAK, Vienna, B.I. 8770/1 (fig.11): 'God is almighty. Inspected on the date of the 17th of the month of Jumada I year 18 of the august reign [11 July 1645]. On the date of the first of Shahriwar Ilahi year one [13 August 1606] transferred to Mulla Abdul-Ghaffur the courtier.' Seals of Inayat Khan Shah Jahani year 31 [1658]; Sayyid Ali Khan, disciple of Alamgir Padshah 1089 [1678–79]. MAK, Vienna, B.I. 8770/20 (fig.12): 'God is almighty. Thirteenth volume. Volume 13. On the date of the first of Shahriwar Ilahi year one [13 August 1606] transferred to Mulla Abdul-Ghaffur the courtier. God is almighty. Inspected on the 17th of the month of Jumada I year 18 [11 July 1645] of the august reign. Inspected on the date of 14 Zi'l-Hijja year 30 [7 October 1656]. Inspected on 22 Shawwal year 5 [28 December 1610].' Seals of Inayat Khan Shah Jahani year 31 [1658]; Sayyid Ali Khan, disciple of Alamgir Padshah 1089 [1678–79]; Kifayatullah Khan year 7.

THE *HAMZANAMA* MANUSCRIPT AND EARLY MUGHAL PAINTING
1. In addition to Mir Sayyid Ali and Abdul-Samad, they were Mir Musawwir, Dust Muhammad, Muhammad Darvish, and Mawlana Yusuf. For a discussion of these artists, see Skelton 1994 and Adle 2000.
2. *A'in-i Akbari*, Persian text, 1, pp.116–18;

translation by C.M. Naim in Chandra 1976,
pp.182–83.
3. Ibid., translated by C.M. Naim in Chandra
1976, pp.183–84.
4. For an overview of the workings of
the Safavid studio, see Simpson 1993. For a
similar discussion of the Mughal workshop,
see Seyller 1987.
5. For an example of such a supervisory
note, see cat.40. A *Hamzanama* painting in
the Nour Collection also has some enigmatic
notes, some in Devanagari script, written in
the unpainted cloth margins. The painting
is published in Leach 1998, no.2.
6. In Mughal manuscript painting, these
respective functions are indicated by the
words *tarh* and *amal* in the ascription
below the illustration.
7. Basavana, Jagana, Mahesa, and Shravana
are all documented as being active in the
mid- to late 1590s.
8. See the Reconstruction, no.14; the
painting is reproduced in color in Gahlin
1991, no.1.
9. For a thorough discussion of this
aspect of the manuscript, see Seyller 1992.
10. The Chandayana style refers to an
Islamicized Indian painting style embodied
in the *Chandayana* manuscript of *circa* 1540
in the Prince of Wales Museum, Mumbai,
and another *Chandayana* manuscript in
the John Rylands Library, Manchester. For a
detailed discussion of this style, see Seyller
in Mason *et al.* 2001, pp.50–51.
11. For Dasavanta's career, see Beach 1982
and Das 1998b.
12. The manuscript is discussed in Losty
1982, no.59; a list of subjects and artists
appears in Titley 1977, no.18. See also figs 18,
19, 22, 25, 27, 29, and 30.

TECHNICAL ASPECTS OF THE *HAMZANAMA*
1. Clarke 1921, p.3.
2. Brooklyn Museum of Art, New York,
24.46, 24.47, 24.48 and 24.49.
3. Faridany-Akhavan 1989, p.55.
4. Samples examined by Janet Douglas,
Department of Conservation and Scientific
Research, Freer Gallery of Art, Washington, DC.
5. Iodine/potassium iodide staining test as
described in Browning 1977, pp.90–91.
6. Hillcoat-Imanishi 1998, p.36.
7. Schäning 1999.
8. See also above, p.37, n.22.
9. Schäning 1999, p.52.
10. 'The folios were bound twenty at a
time in Saffian leather bindings typical
of Augsburg practice during the thirties
[1830s]. They were then removed from their
European bindings for the sake of better
preservation'; Glück 1925, p.11. 'They were
like a book, with a leather cover, 5 of them
were sold before to different Museums and
collectors and 20 of them were left for auc-
tion. [Of these] four selected are left with
the cover which has the seals of the Persian
government'; H. Khan Monif in a letter to
Stewart Culin, 24 December 1923, Brooklyn
Museum of Art Archives.
11. Mir Ala al-Dawla, *Nafais al-Maasir*,
Bayerische Staatsbibliothek, Munich, Pers.
Codex 3, quoted in Chandra 1976, p.180.
12. Ibid., pp.180–81.

13. For the dates and rate of production,
see above, pp.38–40.
14. Faridany-Akhavan 1989, p.53.
15. *Tarikh-i Qandahari*, pp.45–46.
16. Some of these questions are addressed
above, pp.41–42.

A NOTE ON THE PALETTE OF THE *HAMZANAMA*
1. Victoria & Albert Museum, I.S.1505-1883
(cat.20), 1508-1883 (cat.24) and 1513-1883
(cat.29). For the identification of pigments
on other *Hamzanama* pages, see Purinton
& Newman 1985; Fitzhugh 1988.
2. A. Derbyshire and M. Wheeler, 'Further Uses
of Raman microscopy in Paper Conservation,'
V&A Conservation Journal, vol.40, 2002.
3. M. Watters, 'Arsenic and old paint',
New Scientist, 29 May 1999, p.20.

'A TREASURE TROVE': THE *HAMZANAMA* AND THE
AUSTRIAN MUSEUM OF ART AND INDUSTRY
1873–1900
1. Bucher 1874a (translation by the author).
2. Scala 1875 (translation by the author).
3. Pemsel 1989, pp.44, 49.
4. Vienna 1873a, pp.3–4 (translation by
the author).
5. Vienna 1873b, p.454.
6. Vienna 1873a, pp.144–46.
7. Bucher 1874b; Falke 1873, p.165; Semper
1852.
8. Falke 1873, p.25 (translation by the author).
9. Schmoranz 1876; Falke 1876; Sekler 2000.
10. The Ministry of Education and Culture
placed a sum of 2000 Austrian Gulden
at the Museum's disposal, the Ministry of
Trade 3000 and 5000 Gulden; Austrian
State Archive in Vienna, Index of Austrian
Ministry of Education and Culture 1873,
doc. nr. 5519/12596 and Index of the Austrian
Ministry of Trade 1873, doc. nr. 33532/A.
11. Glück 1925, p.11.
12. Vienna 1897.

BIBLIOGRAPHY

Primary Sources

A'in-i Akbari
 The *Ā'īn-i Akbarī by Abū'l-Faẓl 'Allāmī*,
 Persian text edited by H. Blochmann in
 2 volumes, Calcutta, 1867–77; translated
 in 3 volumes by (1) H. Blochmann, revised
 and edited by D.C. Philott, 1927, (2, 3)
 H.S. Jarrett, edited by Jadunath Sarkar,
 1948–49; reprinted New Dehli: Oriental
 Books Reprint Corporation, 1977.
Akbar Nama
 The *Akbar Nama of Abu-l-Fazl*,
 translated by H. Beveridge, 3 volumes,
 1939; 2nd reprint New Dehli: Ess Ess
 Publications, 1979.
Baburnama
 The *Baburnama – Memoirs of Babur,
 Prince and Emperor*, translated, edited
 and annotated by W.M. Thackston,
 Washington, DC: Freer Gallery of Art and
 Arthur M. Sackler Gallery, Smithsonian
 Institution, and New York: Oxford
 University Press, 1996.
Dhakhirat al-Khawanin
 Shaikh Farid Bhakkari, *Dhakhirat
 al-Khawanin*, edited by Syed Moinul Haq,
 Karachi: Pakistan Historical Society, 1961.
Dhakhirat ul-Khawanin
 The *Dhakhirat ul-Khawanin of Shaikh
 Farid Bhakkari*, translated by Ziyaud-Din
 Desai, Delhi: Idarah-I-Adabiyat-i Delli, 1993.
Hamza-nama
 *Hamza-Nama: Vollständige wiedergabe
 der bekannten Blätter der Handschrift
 aus dem Bestänsen aller erreichbaren
 Sammlungen. 2. Band. Die Blätter aus
 dem Victoria & Albert Museum London.*
 Graz: Akademische Druck-u.
 Verlaganstalt, 1982.
Maāthir ul-Umarā
 Shah Nawaz Khan, *Maāthir ul-Umarā*,
 translated by H. Beveridge and Baini
 Prashad, 1911–41; reprinted Patna: Janaki
 Prakashan, 1979.
Majma' al-shu'ara Jahangirshahi
 Qati'i-i Haravi, *The Majma' al-shu'ara
 Jahangirshahi*, edited by Muhammad
 Saleem Akhtar, Karachi: University of
 Karachi, 1979.
Muntakhabut-t-Tawarikh
 *Muntakhabut-t-Tawārikh by Abdu-l-
 Qadir ibn-i-Muluk Shah known as
 al-Badaoni*, translated in three volumes
 by (1) G.S.A. Ranking, 1898, (2) W.H. Lowe,
 1924; reprinted Delhi: Idarah-i-Adabiyat-
 i-Delli, 1973.
Qanun-i Humayuni
 *Qanun-i Humayuni (Also Known as
 Humayun Nama) of Khwandamir (Died
 A.H. 942, A.D.1535)*, translated and anno-
 tated by Baini Prashad, Calcutta: Royal
 Asiatic Society of Bengal, 1940.
Rajatarangini
 The *Rajatarangini of Jonaraja*, translated
 by Jogesh Chunder Dutt, 1898; reprinted
 Delhi: Gian Publishing House, 1986.
Tarikh-i Qandahari
 Muhammad Arif Qandahari, *Tarikh-i
 Qandahari*, edited by Mu'inu'd-Din
 Nadwi, Azhar Ali Dihlawi and Imtiyaz
 'Ali 'Arshi, Rampur, 1962.

Secondary sources
Adle 1993
 Chahryar Adle, 'Les Artists Nommés

Dust-Moḥammad au XVIᵉ Siècle,' *Studia
 Iranica*, 22, no.2, 1993, pp.216–96.
Adle 2000
 —, 'New Data on the Dawn of
 Mughal Painting and Calligraphy' in *The
 Making of Indo-Persian Culture*, edited
 by Muzaffar Alam, Françoise Delvoye
 and Marc Gaborieau, New Delhi:
 Manohar, 2000, pp.167–222.
Alam 1998
 Muzaffar Alam, 'The Pursuit of Persian:
 Language in Mughal Politics,' *Modern
 Asian Studies*, 32, 2 (1998), pp.317–49.
Arnold 1928
 Thomas W. Arnold, *Painting in
 Islam. A Study of the Place of Pictorial
 Art in Muslim Culture*, Oxford: Oxford
 University Press, 1928.
Arnold & Wilkinson 1936
 Thomas W. Arnold and J. V. S. Wilkinson,
 *The Library of A. Chester Beatty.
 A Catalogue of the Indian Miniatures*,
 3 volumes, London: private printing at
 Oxford University Press, 1936.
Archer 1960
 William George Archer, *Indian
 Miniatures*, Greenwich, CT: New York
 Graphic Society, 1960.
M. Athar Ali 1999
 M. Athar Ali, 'Translations of Sanskrit
 Works at Akbar's Court' in Khan 1999,
 pp.171–80.
Bahari 1997
 Ebadollah Bahari, *Bihzad. Master of
 Persian Painting*, London and New York:
 I.B. Tauris Publishers, 1997.
Banerjee 1978
 Priyatosh Banerjee, *The Life of Krishna
 in Indian Art*, New Delhi: National
 Museum, 1978.
Barrett & Gray 1963
 Douglas Barrett and Basil Gray, *Painting
 of India*, Geneva: Skira, 1963.
Beach 1976
 Milo Beach, 'A European Source for Early
 Mughal Painting,' *Oriental Art*, 22, no.2,
 1976, pp.180–88.
Beach 1981
 —, *The Imperial Image: Paintings for
 the Mughal Court*, Washington, DC,
 Freer Gallery of Art, 1981.
Beach 1982
 —, 'The Mughal Painter Daswanth,'
 Ars Orientalis, 13, 1982, pp.121–33.
Beach 1987
 —, *Early Mughal Painting*, Cambridge,
 MA: Harvard University Press, 1987.
Beach 1992
 —, *Mughal and Rajput Painting*, *The New
 Cambridge History of India 1: 3*, Cambridge:
 Cambridge University Press, 1992.
Beach 1994
 —, ''Abd al-Samad,' *Dictionary of Art*,
 London: Macmillan, 1994, 1, pp.25–27.
Bernus-Taylor, 2001
 Marthe Bernus-Taylor, *L'etrange et le
 merveilleux en terres d'Islam*, Paris:
 Réunion des musées nationaux, 2001.
Betz 1965
 Gerd Betz, *Orientalische Miniaturen*,
 2 volumes, Braunschweig: Georg
 Westermann Verlag, 1965.
Binney 1973
 Edwin Binney, 3rd, *Indian Miniature
 Painting from the Collection of Edwin
 Binney, 3rd. The Mughal and Deccani
 Schools*, Portland Art Museum, 1973.

Binyon, Wilkinson & Gray 1933
Laurence Binyon, J.V.S. Wilkinson and Basil Gray, *Persian Miniature Painting*, London: Oxford University Press, 1933.

Blair & Bloom 1994
Sheila S. Blair and Jonathan M. Bloom, *The Art and Architecture of Islam 1250–1800*, New Haven and London: Yale University Press, 1994.

Blochet 1928
Edgar Blochet, *Musulman Painting*, London: Methuen, 1928.

Blochet 1930
Edgar Blochet, *Collection Jean Pozzi: Miniatures Persanes et Indo-Persanes*, Paris, 1930.

Boston 1982
Asiatic Art in the Museum of Fine Arts, Boston, Boston: Museum of Fine Arts, 1982.

von Bothmer 1982
Hans-Caspar Graf von Bothmer, *Die islamischen Miniaturen der Sammlung Preetorius*, Munich: Staatliches Museum für Völkerkunde, 1982.

Bowie 1970
Theodore Bowie, ed., *Islamic Art Across the World*, Bloomington, IN: Indiana University Art Museum, 1970.

Brand 1987
Michael Brand, 'The City as an Artistic Center,' *Fatehpur-Sikri*, edited by Michael Brand and Glenn. D. Lowry, Bombay: Marg Publications, 1987, pp.93–120.

Brand & Lowry 1985a
Michael Brand and Glenn D. Lowry, *Akbar's India. Art from the Mughal City of Victory*, New York: The Asia Society Galleries, 1985.

Brand & Lowry 1985b
—, eds, *Fatehpur-Sikri. A Source Book*, Cambridge, MA: The Aga Khan Program for Islamic Architecture at Harvard University and the Massachusetts Institute of Technology, 1985.

Brend 1991
—, *Islamic Art*, London: British Museum Press, 1991.

Brend 1993
Barbara Brend, '[Mughals]. Painting and the Applied Arts,' *Encyclopaedia of Islam*, second edition, 7, Leiden, 1993, pp.337–40.

Brend 1995
—, *The Emperor Akbar's Khamsa of Niẓāmī*, London: British Library Board, 1995.

Brend 1999
—, 'A European Influence in Early Mughal Painting,' *Bamberger Symposium: Rezeption in der Islamischen Kunst*, Beirut: in association with F. Steiner, Stuttgart, 1999.

Browning 1977
B.L. Browning, *Analysis of Paper*, New York and Basel: Marcel Dekker, Inc., 1977.

Bucher 1874a
Bruno Bucher, 'Die Erwerbungen auf der Weltausstellung,' *Mittheilungen des k.k. Oesterreich. Museums für Kunst und Industrie (Monatsschrift für Kunstgewerbe)*, no.100, Vienna, 1 January 1874, IX. Jahrgang, pp.23–24.

Bucher 1874b
—, *Über ornamentale Kunst auf der Wiener Weltausstellung*, Berlin: C.O. Lüderitz'sche Verlagsbuchhandlung. Carl Habel, 1874.

Bussagli 1976
Mario Bussagli, *Indian Miniatures*, New Delhi: The Macmillan Company of India Limited, 1976.

Canby 1994
Sheila Canby, ed., *Humayun's Garden Party. Princes of the House of Timur and Early Mughal Painting*. Bombay: Marg Publications, 1994.

Canby 1998
—, 'The Horses of 'Abd us-Samad' in Das 1998a, pp.14–29.

Chandra 1976
Pramod Chandra, *The Tūtī-nāma of the Cleveland Museum of Art and the Origins of Mughal Painting*, 2 volumes, Graz: Akademische Druck-u. Verlaganstalt, 1976.

Chandra & Ehnbom 1976
Pramod Chandra and Daniel J. Ehnbom, *The Cleveland Tuti-nama Manuscript and the Origins of Mughal Painting*, Cleveland Museum of Art and The David and Alfred Smart Gallery, The University of Chicago, 1976.

Chandra 1989
—, 'The Brooklyn Museum Folios of the Hamza-nama,' *Orientations*, 20, no.7, July 1989, pp.39–45.

Chandra 1994
—, 'The Brooklyn Museum Folios of the Qissa-i Amir Hamza (Hamza-nama)' in Poster 1994, pp.61–69.

Chattopadhyaya 1998
Brajadulal Chattopadhyaya, *Representing the Other? Sanskrit Sources and the Muslims*, New Delhi: Manohar, 1998.

Clair 1960
Colin Clair, *Christopher Plantin*, London, 1960.

Clarke 1921
C. Stanley Clarke, *Indian Drawings. Twelve Mogul Paintings of the School of Humāyūn (16th century) Illustrating the Romance of Amir Hamzah*. London: His Majesty's Stationery Office, 1921.

Cleveland 1998
Masterworks of Asian Art, Cleveland Museum of Art, 1998.

Comstock 1925
Helen Comstock, 'The Romance of Amir Hamza,' *International Studio*, 80, February 1925, pp.348–57.

Coomaraswamy 1930
Ananda K. Coomaraswamy, *Catalogue of the Indian Collections in the Museum of Fine Arts, Boston*, VI, *Mughal Painting*, Cambridge, Massachusetts, 1930.

Culin 1924
Stewart Culin, 'Illustrations of the Romance of Amir Hamza,' *Brooklyn Museum Quarterly*, 11, no.3, July 1924, pp.139–43.

Czuma 1975
Stanislaw Czuma, *Indian Art from the George P. Bickford Collection*, Cleveland: Cleveland Museum of Art, 1975.

Daljeet 1999
Daljeet, *Mughal and Deccani Paintings in the Collection of the National Museum*, New Delhi: Prakash Book Depot, 1999.

Das 1982
Asok Kumar Das, 'Notes on a Portrait of Akbar Worshipping the Sun,' *Indian Museum Bulletin*, 17 (1982), pp.15–18.

Das 1994
—, 'Persian Masterworks and their Transformations in Jahangir's Taswirkhana' in Canby 1994, pp.135–52.

Das 1998a
Asok Kumar Das, ed., *Mughal Masters. Further Studies*, Mumbai: Marg Publications, 1998.

Das 1998b
—, 'Daswant: His Last Drawings in the Razmnama' in Das 1998a, pp.52–67.

Dehejia 1997
Vidya Dehejia, *Indian Art*, London: Phaidon Press Limited, 1997.

Dickson & Welch 1981
Martin Dickson and Stuart Cary Welch, *The Houghton Shahnameh*, 2 volumes, Cambridge, MA, and London: Harvard University Press, 1981.

Dimand n.d.
Maurice S. Dimand, *Indian Miniatures*, New York, no date.

Dimand 1948
—, 'Several Illustrations from the Dastan-i Amir Hamza in American Collections,' *Artibus Asiae*, 11, nos 1–2, 1948, pp.5–13.

Doshi 1995
Saryu Doshi, ed., *The Royal Bequest. Art Treasures of the Baroda Museum and Picture Gallery*, Bombay: India Book House Ltd., 1995.

Eaton 1993
Richard M. Eaton, *The Rise of Islam and the Bengal Frontier, 1204–1760*, 1993; reprinted New Delhi: Oxford University Press, 1997.

Egger 1969
Gerhart Egger, *Der Hamza Roman. Eine Moghul-Handschrift aus der Zeit Akbar des Grossen*. Vienna: Österreichisches Museum für angewandte Kunst, 1969.

Egger 1974
—, *Hamza-nama: Vollständige wiedergabe der bekannten Blätter der Handschrift aus dem Bestänten aller erreichbaren Sammlungen*. Graz: Akademische Druck-u. Verlaganstalt, 1974.

Ehnbom 1985
Daniel Ehnbom, *Indian Miniatures. The Ehrenfeld Collection*, New York, 1985.

Ehnbom 1987
—, 'The Ehrenfeld Collection of Indian Miniatures,' *Orientations*, 18, no.7, July 1987, pp.43–55.

Elgood 1994
Heather Elgood, 'Who Painted Princes of the House of Timur?' in Canby 1994, pp.9–32.

Ettinghausen 1961
Richard Ettinghausen, *Paintings of the Sultans and Emperors of India in American Collections*, New Delhi: Lalit Kalā Akademi, 1961.

Falk 1985
Toby Falk, ed., *Treasures of Islam*, Sotheby's/Philip Wilson Publishers in association with Musée d'art et d'histoire, Geneva, 1985.

Falk & Digby 1979
Toby Falk and Simon Digby, *Paintings from Mughal India*, London: Colnaghi, 1979.

Falke 1873
Jacob von Falke, *Die Kunstindustrie auf der Wiener Weltausstellung*, Vienna: Carl Herold, 1873.

Falke 1876
—, in *Mittheilungen des k.k. Oesterreich.*

Museums für Kunst und Industrie (Monatsschrift für Kunstgewerbe), no.128, Vienna, 1 January 1876, XI. Jahrgang, pp.16–17.

Faridany-Akhavan 1989
Zahra Faridany-Akhavan, 'The problems of the Mughal manuscript of the "Hamza-Nama": 1562–77. A reconstruction,' Ph.D. thesis, Harvard University, Cambridge, MA, June 1989.

Farooqi 1970
Anis Farooqi, 'Reassessment of the Commencement of the Dastan-i Amir Hamza,' *Roopa Lekha*, 42, nos 1–2, 1970, pp.35–37.

Filippi 1997
Giuseppe Filippi, ed., *Indian Miniatures and Paintings from the 16th to the 19th Century. The Collection of Howard Hodgkin*, Milan: Electa, 1997.

Fischer & Goswamy 1987
Eberhard Fischer and B.N. Goswamy, *Wonders of a Golden Age. Painting at the Court of the Great Mughals*, Zürich: Rietberg Museum, 1987.

Fitzhugh 1988
E. Fitzhugh, 'A Study of Pigments on Selected Paintings' in Lowry, Beach, Marefat & Thackston 1988, Appendix 9, pp.425–32.

von Folsach 2001
Kjeld von Folsach, *Art from the World of Islam in the David Collection*, Copenhagen: F. Hendriksens Eftf., 2001.

Gahlin 1991
Sven Gahlin, *The Courts of India. Indian Miniatures from the Collection of the Fondation Custodia, Paris*, Zwolle: Waanders Publishers, 1991.

Galbally 1987
Ann Galbally, *The Collections of the National Gallery of Victoria*, Melbourne: Oxford University Press, 1987.

Gangoly 1961
O.C. Gangoly, *Critical Catalogue of Miniature Paintings in the Baroda Museum*, Baroda: Museum and Picture Gallery, 1961.

Glück 1925
Heinrich Glück, *Die indischen Miniaturen des Haemzae-Romanes im Österreichischen Museum für Kunst und Industrie in Wien und in anderen Sammlungen*, Leipzig, Zürich, and Vienna: Amalthea-Verlag, 1925.

Goetz 1944–45
Hermann Goetz, 'An Illustration from the Hamza-nāma, the Earliest Mughal Manuscript,' *Baroda State Museum Bulletin*, 2, pt.1, 1944–45, pp.31–34.

Grabar & Natif 2001
Oleg Grabar and Mika Natif, 'Two Safavid Paintings. An Essay in Interpretation,' *Muqarnas*, 18, 2001, pp.173–202.

Grube 1966
Ernst Grube, *The World of Islam*, New York and Toronto: McGraw-Hill Book Company, 1966.

Grube 1968
—, *The Classical Style in Islamic Painting. The Early School of Herat and Its Impact on Islamic Painting of the Later 15th, the 16th, and 17th Centuries, Some Examples in American Collections*, Venice: Edizioni Oriens, 1968.

Grube 1971
—, *Islamic Paintings from the Eleventh to*

the Eighteenth Century in the Collection of Hans P. Kraus, New York: H.P. Kraus, 1971.

Guy 1982
John Guy, 'The Melbourne "Hamza-nama" and "Akbar-nama" Paintings,' Art Bulletin of Victoria, 22, 1982, pp.25–41.

Guy & Swallow 1990
John Guy and Deborah Swallow, eds., Arts of India 1550–1900, London: Victoria and Albert Museum, 1990.

Habib 1997
Irfan Habib, ed., Akbar and His India, Delhi: Oxford University Press, 1997.

Habib 1999
—, 'Introduction' in Khan 1999, pp.xi–xvi.

Hanaway 1970
William Hanaway, 'Persian Popular Romances Before the Safavid Era,' Ph.D. dissertation, Columbia University, 1970.

Hanaway 1971
—, 'Formal Elements in the Persian Popular Romances,' Review of National Literatures, 2, no.1, Spring 1971, pp.139–60.

Harle 1986
James Harle, The Art and Architecture of the Indian Subcontinent, New York: Viking Penguin, 1986.

Harle & Topsfield 1987
J.C. Harle and Andrew Topsfield, Indian Art in the Ashmolean Museum, Oxford: Ashmolean Museum, 1987.

Harvard 1996
Harvard's Art Museums, Cambridge, MA: Harvard University Press, 1996.

Heeramaneck 1984
Masterpieces of Indian Painting from the Heeramaneck Collection, Verona: Alice N. Heeramaneck, 1984.

Hendley 1884
Thomas Holbein Hendley, Memorials of the Jeypore Exhibition, 1883, 4 volumes, Jaipur: W. Griggs, 1884.

Hillcoat-Imanishi 1998
A. Hillcoat-Imanishi, thesis presented for a Master's Degree in Conservation at the Royal College of Art and Victoria & Albert Museum Joint Course in Conservation, London, June 1998.

Kantorowicz 1963
Ernst Kantorowicz, Kaiser Friedrich der Zweite, Düsseldorf and Munich: Helmut Küpper vormals Georg Bondi, 1963.

Khan 1997
Iqtidar Alam Khan, 'Akbar's Personality Traits and World Outlook – A Critical Appraisal' in Habib 1997, pp.79–96.

Khan 1999
—, ed., Akbar and His Age, Indian Council of Historical Research Monograph Series, 5, New Delhi: Northern Book Centre, 1999.

Khandalavala 1983
Karl Khandalavala, 'The Heritage of Islamic Art in India' in An Age of Splendour. Islamic Art in India, Bombay: Marg Publications, 1983, pp.2–31.

Khandalavala & Chandra 1965
Karl Khandalavala and Moti Chandra, Miniatures and Sculptures from the Collection of the Late Sir Cowasji Jehangir, Bart., Bombay: The Prince of Wales Museum, 1965.

Khandalavala & Mittal 1969
Karl Khandavala and Jagdish Mittal, 'An Early Akbari Illustrated Manuscript

of Tilasm and Zodiac,' Lalit Kalā, 14, 1969, pp.9–20.

Koch 1982
Ebba Koch, 'The Influence of the Jesuit Missions on Symbolic Representations of the Mughal Emperors' in Islam in India. Studies and Commentaries, 1, The Akbar Mission & Miscellaneous Studies, edited by C.W. Troll, New Delhi: Vikas Publishing House Pvt Ltd 1982, pp.14–29; reprinted in Ebba Koch, Mughal Art and Imperial Ideology: Collected Studies, New Delhi: Oxford University Press, 2001, pp.1–11.

Koch 1987
—, 'The Architectural Forms' in Fatehpur-Sikri. Selected Papers from the International Symposium on Fatehpur Sikri Held on October 17–19, 1985, at Harvard University, Cambridge, Massachusetts and Sponsored by theAga Khan Program for Islamic Architecture at Harvard University and the Massachusetts Institute of Technology and the Department of Fine Arts at Harvard University, edited by M. Brand and G.D. Lowry, Bombay: Marg Publications, 1987, pp.121–48.

Koch 1991
—, Mughal Architecture: An Outline of Its History and Development (1526–1858), Munich: Prestel, 1991; reprinted 1998; second edition, New Delhi: Oxford University Press, 2001.

Kossak 1997
Steven Kossak, Indian Court Painting, 16th–19th Century, New York: The Metropolitan Museum of Art, 1997.

Kramrisch 1986
Stella Kramrisch, Painted Delight. Indian Paintings from Philadelphia Collections, Philadelphia: Philadelphia Museum of Art, 1986.

Krishna 1973
Anand Krishna, 'A Reassessment of the Tuti-Nama Illustrations in the Cleveland Museum of Art (and Related Problems on Earliest Mughal Paintings and Painters),' Artibus Asiae, 35, no.3, 1973, pp.241–68.

Krishna 1981
—, ed., Chhavi-2: Rai Krishnadasa Felicitation Volume, Banares: Bharat Kala Bhavan, 1981.

Leach 1986
Linda York Leach, Indian Miniature Paintings and Drawings, Cleveland: Cleveland Museum of Art, 1986.

Leach 1995
—, Mughal and Other Indian Paintings from the Chester Beatty Library, London: Scorpion Cavendish Ltd, 1995.

Leach 1998
—, Paintings from India, The Nasser D. Khalili Collection of Islamic Art, VIII, London: The Nour Foundation in associ-ation with Azimuth Editions and Oxford University Press, 1998.

Lee 1994
Sherman E. Lee, A History of Far Eastern Art, New York: Harry N. Abrams, 1994.

Lee & Chandra 1963
Sherman Lee and Pramod Chandra, A Newly Discovered Tūtī-Nāma and the Continuity of the Indian Tradition of Manuscript Painting,' Burlington Magazine, 105, December 1963, pp.547–54.

Leidy 1994
Denise Patry Leidy, Treasures of Asian Art. The Asia Society's Mr. and Mrs. John D. Rockefeller 3rd Collection, New York: The Asia Society Galleries in association with Abbeville Press, 1994.

Lentz & Lowry 1989
Thomas W. Lentz and Glenn D. Lowry, Timur and the Princely Vision, Los Angeles: Los Angeles County Museum of Art, 1989.

London 1982
In the Image of Man, London: Arts Council of Great Britain, 1982.

Losty 1982
Jeremiah P. Losty, The Art of the Book in India, London: British Library Board, 1982.

Lowry 1987
Glenn D. Lowry, 'Persian Miniatures from the Vever Collection,' Orientations, 18, no.9, September 1987, p.50.

Lowry, Beach, Marefat, & Thackston 1988
Glenn D. Lowry, Milo Beach, Roya Marefat and Wheeler M. Thackston, An Annotated and Illustrated Checklist of the Vever Collection, Arthur M. Sackler Gallery, Smithsonian Institution, Washington, DC, in association with University of Washington Press, 1988.

Lowry & Nemazee 1988
Glenn D. Lowry and Susan Nemazee, A Jeweler's Eye. Islamic Arts of the Book from the Vever Collection, Arthur M. Sackler Gallery, Smithsonian Institution, Washington, DC, in association with University of Washington Press, 1988.

Lukens 1966
Marie G. Lukens, Guide to the Collections. Islamic Art, New York: The Metropolitan Museum of Art, 1966.

McInerney 1982
Terence McInerney, Indian Painting 1525–1825, London: Artemis Group, 1982.

Maclagan 1932
Edward Maclagan, The Jesuits and the Great Mogul, 1932; reprinted New Delhi: Vintage Books, 1990.

Mason 2001
Darielle Mason, with contributions by B.N. Goswamy, Terence McInerney, John Seyller, and Ellen Smart, Intimate Worlds. Indian Paintings from the Alvin O. Bellak Collection, Philadelphia: Philadelphia Museum of Art, 2001.

Mehta 1926
N.C. Mehta, Studies in Indian Painting, Bombay: D B Taraporevala Sons and Co., 1926.

Melikian-Chirvani 1998
A.S. Melikian-Chirvani, 'Mir Sayyed 'Ali: Painter of the Past and Pioneer of the Future' in Das 1998a, pp.30–51.

Meredith-Owens 1960
G.M. Meredith-Owens, 'Ḥamza b. 'Abd al-Muṭṭalib,' Encyclopedia of Islam, III, Leiden: Brill, and London: Luzac, 1960–, pp.152–54.

Michell 2000
George Michell, Hindu Art and Architecture, New York: Thames and Hudson, 2000.

Milstein, Rührdanz & Schmitz 1999
Rachel Milstein, Karin Rührdanz and Barbara Schmitz, Stories of the Prophets. Illustrated Manuscripts of Qiṣaṣ al-Anbiyā', Costa Mesa, CA: Mazda Publishers, 1999.

Minorsky 1940–42
V. Minorsky, 'A Civil and Military Review in Fars in 881/1476,' Bulletin of the School

of Oriental and African Studies (University of London), 10 (1940–42), pp.141–78.

Mohammad Sheikh 1995
Gulam Mohammad Sheikh, 'Tradition in a Moment of Change: Paintings of the Hamzanama' in Indian Painting: Essays in Honour of Karl J. Khandalavala, edited by B.N. Goswamy in association with Usha Bhatia, New Delhi: Lalit Kala Akademi, 1995, pp.387–408.

Monserrate 1922
The Commentary of Father Monserrate, translated by J.S. Hoyland and anno-tated by S.N. Banerjee, 1922; reprinted Jalandhar: Asian Publishers, 1993.

Moosvi 1999
Shireen Moosvi, 'Making and Recording History. Akbar and the Akbar-nama' in Khan 1999, pp.181–87.

Necipoğlu 1993
Gülru Necipoğlu, 'Framing the Gaze in Ottoman, Safavid, and Mughal Palaces' in Pre-Modern Islamic Palaces, edited by Gülru Necipoğlu, Ars Orientalis, 23, 1993, pp.303–42.

New York 1970
Masterpieces of Fifty Centuries, New York: Metropolitan Museum of Art, 1970.

New York 1982
Arts of Islam: Masterpieces of Islamic Art from the Metropolitan Museum of Art, New York: The Metropolitan Museum of Art, 1982.

Nizami 1989
Khaliq Ahmad Nizami, Akbar and Religion, Delhi: Idarah-i-Adabiyat-i Delli, 1989.

Okada 1989
Amina Okada, Miniatures de l'Inde impériale. Les peintres de la cour d'Akbar (1556–1605), Paris: Editions de la Réunion des musées nationaux, 1989.

Okada 1991
Amina Okada, 'Basawan' in Pratapaditya Pal, ed., Master Artists of the Imperial Mughal Court, Bombay: Marg, 1991.

Okada 1992
—, Indian Miniatures of the Mughal Court, New York: Harry N. Abrams, 1992.

Okada 1998
—, 'Kesu Das: The Impact of Western Art on Mughal Painting' in Das 1998a, pp.84–95.

Pal 1982
Pratapaditya Pal, Indian Paintings in the Los Angeles County Museum of Art, New Delhi: Lalit Kalā Akademi, 1982.

Pal 1983
—, Court Paintings of India, 16th–19th Centuries, New York: Navin Kumar, 1983.

Pal 1991
—, 'Introduction' in Pal, ed., Master Artists of the Imperial Mughal Court, Bombay: Marg Publications, 1991.

Pal 1993
—, Indian Painting. A Catalogue of the Los Angeles County Museum of Art, 1. 1000–1700, Los Angeles: Los Angeles County Museum of Art, 1993.

Pemsel 1989
Jutta Pemsel, Die Wiener Weltausstellung von 1873: das grün-derzeitliche Wien am Wendepunkt, Vienna: Böhlau Verlag, 1989.

Philadelphia 1924
Paintings and drawings of Persia and India (with some others) exhibited at the

Pennsylvania Academy of Fine Arts ... from the collection of John Frederick Lewis ... from December 17 to January 10, 1923–1924, Philadelphia: Pennsylvania Academy of Fine Arts, 1924.

Pinder-Wilson *et al.* 1976
Ralph Pinder-Wilson *et al.*, *Paintings from the Muslim Courts of India*, London: World of Islam Publishing Company Ltd, 1976.

Plotinus 1927
Plotinus, 'The Illustrations of the Romance of Amir Hamza,' *Rupam*, 29, January 1927, pp.22–26.

Poster *et al.* 1994
Amy Poster *et al.*, *Realms of Heroism. Indian Paintings at the Brooklyn Museum*, New York: Brooklyn Museum of Art in association with Hudson Hills Press, 1994.

Pritchett 1991
Frances Pritchett, *The Romance Tradition in Urdu. Adventures from the Dastan of Amir Hamzah*, New York: Columbia University Press, 1991.

Purinton & Newman 1985
N. Purinton and R Newman, *A Technical Analysis of Indian Painting Materials* in Smart & Walker 1985, Appendix 1, p.107–13.

Rehatsek 1887
E. Rehatsek, 'A Letter of the Emperor Akbar Asking for the Christian Scriptures,' *The Indian Antiquary*, 16, 1887, pp.135–39.

Richard 1994
Francis Richard, 'An Unpublished Manuscript from the Atelier of the Emperor Humāyūn, the K̲h̲amsa Smith-Lesouëf 216 of the Bibliothèque Nationale' in *Confluence of Cultures. French Contributions to Indo-Persian Studies*, edited by Françoise Delvoye, New Delhi: Manohar, 1994, pp.37–53.

Richard 1997
—, *Splendeurs persanes. Manuscrits du XIIe au XVIIIe siècle*, Paris: Bibliothèque nationale de France, 1997.

Rizvi 1999
Syed Athar Abbas Rizvi, 'Dimensions of *Sulh-i Kul* (Universal Peace) in Akbar's Reign and the *Sufi* Theory of Perfect Man' in Khan 1999, pp.3–22.

Robinson, Grube, Meredith-Owens & Skelton 1976
B.W. Robinson, Ernst Grube, G.M. Meredith-Owens, and Robert Skelton, *Islamic Painting and the Arts of the Book*, London: Faber and Faber Limited, 1976.

Rogers 1993
J. Michael Rogers, *Mughal Miniatures*, London: The British Museum, 1993.

Rooses 1882
Max Rooses, *Christophe Plantin: Imprimeur Anversois*, Antwerp: J. Maes, 1882.

Scala 1875
Arthur von Scala, in *Oesterreichische Monatsschrift für den Orient, herausgegeben vom Orientalischen Museum in Wien*, no.1, 15 January 1875, pp.1–2.

Schäning 1999
Anka Schäning, *A Contribution to the Examination of Painting Technique and Object History of the Indo-Persian Miniature Paintings of the Hamza-nama Manuscript: Conservation and Restoration of a Leaf with Both Sides Painted*, Master's thesis for Diploma in Restoration and Conservation presented to the Academie of Fine Arts, Vienna, June, 1999.

Schimmel 1984
Annemarie Schimmel, *Calligraphy and Islamic Culture*, New York: New York University Press, 1984.

Schimmel & Welch 1983
Annemarie Schimmel and Stuart Cary Welch, *Anvari's Divan: A Pocket Book for Akbar*, New York: The Metropolitan Museum of Art, 1983.

Schmoranz 1876
Franz Schmoranz, 'Katalog der historischen Ausstellung des islamitischen Orients, umfassend Darstellungen von Kult- und Profanbauten,' *Mittheilungen des k.k. Oesterreich. Museums für Kunst und Industrie (Monatsschrift für Kunstgewerbe)*, no.126, Vienna, 1 March 1876, XI. Jahrgang, pp.1–10.

Schroeder 1941
Eric Schroeder, 'A Painting from the Hamza Romance,' *Bulletin of the Fogg Art Museum*, 9, 1941, p.110.

Schulz 1914
Ph. Walter Schulz, *Die persisch-islamische Miniaturmalerei*, Leipzig: Karl W. Hiersemann, 1914.

Seattle 1973
Asiatic Art in the Seattle Art Museum, Seattle: Seattle Art Museum, 1973.

Sekler 2000
Mary Patrica Sekler, 'Le Corbusier und das Museum als eine Stätte des Lernens' in *Kunst und Industrie, die Anfänge des Museums für angewandte Kunst in Wien*, edited by Peter Noever, Ostfildern, Germany: Verlag Hatje Cantz, 2000, pp.261–70.

Semper 1852
Gottfried Semper, *Wissenschaft, Industrie und Kunst. Vorschläge zur Anregung nationalen Kunstgefühles bei dem Schlusse der Londoner Industrie–Ausstellung von Gottfried Semper ehemaligem Director der Bauschule zu Dresden. London den 11. October 1851*, Braunschweig: Druck und Verlag von Friedrich Vieweg und Sohn, 1852.

Semsar 2000
Mohammad-Hasan Semsar, *Golestan Palace Library. Portfolio of Miniature Paintings and Calligraphies*, Tehran: Zarrin and Simin Books, 2000.

Sen 1984
Geeti Sen, *Paintings from the Akbar Nama*, Varanasi: Lustre Press, 1984.

Seyller 1986
John Seyller, 'The School of Oriental and African Studies *Anvār-i Suhaylī*: The Illustration of a *De Luxe* Mughal Manuscript,' *Ars Orientalis*, 16, 1986, pp.119–51.

Seyller 1987
—, 'Scribal Notes on Mughal Manuscript Illustrations,' *Artibus Asiae*, 48, nos 3/4, 1987, pp.247–77.

Seyller 1992
—, 'Overpainting in the Cleveland *Tūṭīnāma*,' *Artibus Asiae*, 52, nos 3/4, 1992, pp.283–318.

Seyller 1993
—, 'A Dated *Ḥāmzanama* Illustration,' *Artibus Asiae*, 53, nos 3/4, 1993, pp.502–5.

Seyller 1994
—, 'Recycled Images: Overpainting in Early Mughal Art' in Canby 1994, pp.49–80.

Seyller 1997
—, 'The Inspection and Valuation of Manuscripts in the Imperial Mughal Library,' *Artibus Asiae*, 57, nos 3/4, pp.243–349.

Seyller 1999
—, *Workshop and Patron in Mughal India: The Freer Rāmāyaṇa and Other Manuscripts Illustrated for ʿAbd al-Raḥīm*, Zürich: Artibus Asiae in association with the Freer Gallery of Art, 1999.

Seyller 2000
—, 'A Mughal Code of Connoisseurship,' *Muqarnas*, 17, 2000, pp.177–202.

Seyller 2001
—, 'For Love or Money: The Shaping of Historical Painting Collections in India' in Mason 2001, pp.12–21.

Simpson 1993
Marianna Shreve Simpson, 'The Makings of Manuscripts and the Workings of the *Kitab-khana* in Safavid Iran' in Peter M. Lukehart, ed., *The Artist's Workshop*, National Gallery of Art, Washington, DC, 1993, pp.104–21.

Simsar 1978
Muhammed A. Simsar, trans. and ed. *The Cleveland Museum of Art's Ṭūṭī-Nāma, Tales of a Parrot by Ziya' u'd-Din Nakhshabi*, Graz: Akademische Druck u. Verlagsanstalt, 1978.

Skelton 1988
Robert Skelton, 'Imperial Symbolism in Mughal Painting' in *Content and Context of Visual Arts in the Islamic World*, edited by Priscilla P. Soucek, University Park and London: Published for the College Art Association of America by the Pennsylvania State University Press, 1988, pp.177–87.

Skelton 1994
—, 'Iranian Artists in the Service of Humayn' in Canby 1994, pp.33–48.

Smart & Walker 1985
Ellen S. Smart and Daniel S.Walker, *Pride of the Princes. Indian Art of the Mughal Era in the Cincinnati Art Museum*, Cincinnati: Cincinnati Art Museum, 1985.

Soucek 1985
Priscilla Soucek, "ʿAbd al-Ṣamad Šīrāzī" *Encyclopedia Iranica*, Boston: Routledge, and London: Kegan Paul, 1985, I, pp.162–67.

Soudavar & Beach 1992
Abolala Soudavar with Milo Cleveland Beach, *Art of the Persian Courts. Selections from the Art and History Trust Collection*, New York: Rizzoli International Publications, 1992.

Soudavar 1999
Abolala Soudavar, 'Between the Safavids and the Mughals: Art and Artists in Transition,' *Iran*, 37, 1999, pp.49–66.

Staude 1955a
Wilhelm Staude, 'Les artistes de la cour d'Akbar et les illustrations du Dastân I-Amîr Hamzah,' *Revue des Arts Asiatiques*, 2, 1955, pp.47–65.

Staude 1955b
—, 'Les artistes de la cour d'Akbar et les illustrations du Dastân I-Amîr Hamzah,' *Revue des Arts Asiatiques*, 2, 1955, pp.83–111.

Stchoukine 1929
Ivan Stchoukine, *Les miniatures indiennes de l'époque des grands moghols au Musée du Louvre*, Paris: Libraire Ernst Leroux, 1929.

Stchoukine, Flemming, Luft & Sohrweide 1971
Ivan Stchoukine, Barbara Flemming, Paul Luft, and Hanna Sohrweide, *Illuminierte Islamische Handscriften*, Wiesbaden: F. Steiner, 1971.

Stronge 2002
Susan Stronge, *Painting for the Mughal Emperor. The Art of the Book 1560–1660*, London: V&A Publications, 2002.

Subrahmanyam 1999
S. Subrahmanyam, 'Further Notes on the "Foreign Hand". The Mughals, the Portuguese and Deccan Politics, c. 1600' in Khan 1999, pp.132–59.

Suleiman 1970
Hamid Suleiman, *Miniatures of Babur-Nama*, Tashkent: 'Fan' Publishing House of the Uzbek SSR, 1970.

Tillotson 1989
G.H.R. Tillotson, *The Tradition of Indian Architecture. Continuity, Controversy and Change since 1850*, New Haven and London: Yale University Press, 1989.

Titley 1977
Norah M. Titley, *Miniatures from Persian Manuscripts*, London: The British Library Board, 1977.

Titley 1981
—, *Dragons in Persian, Mughal and Turkish Art*, London: British Library Board, 1981.

Titley 1983
—, *Persian Miniature Painting and Its Influence on the Art of Turkey and India*. Austin: University of Texas Press, 1983.

Topsfield 1984
Andrew Topsfield, *An Introduction to Indian Court Painting*, London: Victoria and Albert Museum, 1984.

Topsfield & Beach 1991
Andrew Topsfield and Milo Cleveland Beach, *Indian Paintings and Drawings from the collection of Howard Hodgkin*, London: Thames and Hudson, 1991.

Vambery 1899
A. Vambery, trans., *The Travels and Adventures of the Turkish Admiral Sidi Ali Reïs in India, Afghanistan, Central Asia, and Persia, during the Years 1553–1556*, 1899; reprinted Lahore: Al-Biruni, 1975.

Vanina 1996
Eugenia Vanina, *Ideas and Societies in India from the Sixteenth to the Eighteenth Centuries*, New Delhi: Oxford University Press, 1996.

Verma 1978
Som Prakash Verma, *Art and Material Culture in the Paintings of Akbar's Court*, New Delhi: Vikas Publishing House, 1978.

Verma 1994
Som Prakash Verma, *Mughal Painters and Their Work*, Oxford: Oxford University Press, 1994.

Verma 1998
Som Prakash Verma, 'La'l: The Forgotten Master' in Das 1998a, pp.68–83.

Vienna 1873a
Special-Catalog der Ausstellung des Persischen Reiches, Wien 1873, Selbstverlag der Persischen Ausstellungs-Commission, Vienna,1873.

Vienna 1873b
Weltausstellung 1873 in Wien, Amtliches Verzeichnis der Aussteller, welchen von der Jury Ehrenpresie zuerkannt worden sind, Staatsdruckerei Wien, 1873.

Vienna 1897
Mittheilungen des k.k. Oesterreich.

Museums für Kunst und Industrie
(Monatsschrift für Kunstgewerbe),
no.139, Vienna, 15 July 1897, N.F. XII.
Jahrgang, p.420.
Wade 1998
Bonnie Wade, *Imaging Sound. An
Ethnomusicological Study of Music, Art,
and Culture in Mughal India*, Chicago:
University of Chicago Press, 1998.
Walker 1997
Daniel Walker, *Flowers Underfoot.
Indian Carpets of the Mughal Era*,
New York: The Metropolitan Museum
of Art, 1997.
Welch 1990
Anthony Welch, 'The Wordly Vision of
Mir Sayyid 'Ali' in *Persian Masters. Five
Centuries of Painting*, edite

d by Sheila
R. Canby, pp.85–98. Bombay: Marg
Publications, 1990.
Welch 1959
Stuart Cary Welch, 'Early Mughal
Miniature Paintings from Two Private
Collections Shown at the Fogg Art
Museum,' *Ars Orientalis*, 3, 1959, pp.133–46.
Welch 1963
Stuart Cary Welch, *The Art of Mughal
India*, New York: Asia Society, 1963.
Welch 1972
—, *A King's Book of Kings. The Shah-
Nameh of Shah Tahmasp*, New York:
The Metropolitan Museum of Art, 1972.
Welch 1973
—, *A Flower from Every Meadow. Indian
Paintings from American Collections*,

New York: Asia Society, 1973.
Welch 1978
—, *Imperial Mughal Painting*, New York:
George Braziller, Inc., 1978.
Welch 1979
—, *Wonders of the Age. Masterpieces of
Early Safavid Painting, 1501–1576*, Cambridge,
MA: Harvard University Press, 1979.
Welch 1985
—, *India: Art and Culture 1300–1900*,
New York: The Metropolitan Museum
of Art, 1985.
Welch 1987
—, *The Islamic World*, New York:
The Metropolitan Museum of Art, 1987.
Welch & Beach 1965
Stuart Cary Welch and Milo Beach,
Gods, Thrones, and Peacocks, New York:

Asia Society, 1965.
Wickens 1974
G.M. Wickens, trans., *Morals Pointed
and Tales Adorned: The Būstān of Sa'dī*,
Toronto, Buffalo: University of Toronto
Press, 1974.
Wilkinson 1948
J.V.S. Wilkinson, *Mughal Painting*,
London: Faber and Faber, 1948.
Zebrowski 1983
Mark Zebrowski, *Deccani Painting*,
London: Philip Wilson Publishers Ltd,
1983.

INDEX

LENDERS TO THE EXHIBITION

MAK–Austrian Museum of Applied Arts/Contemporary Art, Vienna
principal lender to the exhibition

Arthur M. Sackler Gallery, Smithsonian Institution, Washington, DC
Arthur M. Sackler Museum, Harvard University Art Museums
The British Museum, London
Brooklyn Museum of Art, New York
Chester Beatty Library, Dublin
Cincinnati Art Museum
The Cleveland Museum of Art
The David Collection, Copenhagen
Fitzwilliam Museum, Cambridge
The Free Library of Philadelphia
Freer Gallery of Art, Smithsonian Institution, Washington, DC
Howard Hodgkin Collection
Los Angeles County Museum of Art
The Metropolitan Museum of Art, New York
Musée des arts antiques asiatiques–Guimet, Paris
Museum of Fine Arts, Boston
Philadelphia Museum of Art
The al-Sabah Collection, Dar al-Athar al-Islamiyyah, Kuwait National Museum
The Seattle Art Museum
Victoria and Albert Museum, London
Stuart Cary Welch, Jr.

PHOTOGRAPHIC ACKNOWLEDGMENTS

The publishers wish to thank all those individuals and institutions who kindly supplied photographs and gave permission for their reproduction in this book. They are named in the captions to each illustration and in the list below, where further copyright and photographic information is given.

The al-Sabah Collection, Dar al-Athar al-Islamiyyah, Kuwait National Museum cat.21; R137 / The Art and History Trust R40 / The Art Complex Museum, Duxbury, MA R168 / Arthur M. Sackler Gallery, Smithsonian Institution, Washington, DC cat.3, 4; fig.13; R2, R3, R136 / Courtesy of the Arthur M. Sackler Museum, Harvard University Art Museums. © Harvard University. Photos: Allan Macintyre cat.61, 74 / Ashmolean Museum, University of Oxford R7 / Bahari Collection, London R21 / Courtesy of the Department of Museums, Museum & Picture Gallery, Baroda. Not to be reproduced without prior permission of the Director of Museums R11 (photo after Saryu Doshi, ed., *The Royal Bequest. Art Treasures of the Baroda Museum and Picture Gallery*, Bombay: India Book House Limited, 1995, p.57) / Collection of Catherine and Ralph Benkaim R38, R113 / Bharat Kala Bhavan, Varanasi R117 (photo after *Marg*, vol.11, no.3, June 1958, cover), R118 / Bibliothèque nationale de France, Paris cat.5 / The British Library, London figs 3, 5, 18, 19, 22, 25, 27, 29, 30 / © The Trustees of the British Museum, London (2002) cat.15, 16, 78, 80 (detail on pp.254–55), 84; R1, R8, R16, R68 / Brooklyn Museum of Art cat.39 (detail on p.81, bottom row, right), 48, 65, 71 (detail on pp.214–15); figs 31–37 / Courtesy the Trustees of the Chhatrapati Shivaji Maharaj Vastu Sangrahalaya (formerly Prince of Wales Museum of Western India), Mumbai R170 / Reproduced by kind permission of the Trustees of the Chester Beatty Library, Dublin cat.50; figs 1, 6; R67 / Cincinnati Art Museum cat.43 (detail on p.81, bottom row, middle) / © The Cleveland Museum of Art 2001 figs 14, 15, 15a, 23, 24; cat.10–13, 51 / Cowasji Jehangir Collection, Mumbai R9 / The David Collection, Copenhagen. Photograph © Ole Woldbye and Pernille Klemp cat.73 / Fine Arts Museums of San Francisco R12 / Trustees of the Fitzwilliam Museum, Cambridge cat.23, 77 (detail on p.81, third row) / Fondation Custodia, Paris R14 / Free Library of Philadelphia, Rare Book Department. Photo Will Brown cat.68 / Freer Gallery of Art, Smithsonian Institution, Washington, DC cat.1, 17, 37, 67, 70, 72 / Collection of Howard Hodgkin cat.76 (detail on p.80, top right); R123 / Collection of Ramesh Kapoor R30 / Keir Collection, London figs 4, 21; R15, R28, R124 / Photos Ebba Koch figs 7, 8, 9 / Khuda Bakhsh Oriental Public Library, Patna. Photo courtesy Milo Cleveland Beach fig.16 / Library of Congress, Washington, DC R41 / Los Angeles County Museum of Art. Photography © 2001 Museum Associates/LACMA cat.7, 47 / Maharaja Sawai Man Singh III Museum, Jaipur fig.20 (photo after Banerjee 1978, fig.244) / MAK–Austrian Museum of Applied Arts/Contemporary Art, Vienna figs 11, 11a, 11b, 12, 12a, 12b, 38–40; cat.25, 30 (details on pp.106–107 and p.80, bottom right), 31–33, 34 (detail on p.81, second row, middle), 35, 36 (detail on pp.116–17), 40 (detail on p.81, top row, left), 41, 42 (details on p.81, top row, middle, and pp.140, 141), 44 (detail on pp.132–33), 45 (detail on pp.146–47), 49 (detail on pp.156–57), 52, 53 (details on pp.15–16 and p.80, left), 57 (details on pp.6–7, 176–77), 58 (details on pp.78–79, 180–81), 59, 62, 63 (detail on pp.196–97), 64 (detail on pp.192–93), 66 (details on p.81, second row, left, and pp.202–203), 69 (detail on pp.212–13), 75 (detail on pp.226–27), 79 (detail on pp.238–39), 85 (detail on p.81, bottom row, left), 86 (detail on p.11); R4, R5, R10, R20, R23–25, R33, R44, R54, R56, R57, R59, R69, R70, R71, R73, R84, R86, R89, R90, R94, R100, R108, R109, R111, R114, R126–28, R130, R132, R134, R153 / Photographs © 2001 The Metropolitan Museum of Art cat.2, 14, 54, 55 (detail on p.81, top row, right), 60 (detail on pp.182–83), 82, 83; R169 / Musée des arts asiatiques-Guimet, Paris. Photos RMN–Richard Lambert cat.6a, 6b, 8a, 8b / Courtesy of Museum of Fine Arts, Boston. Reproduced with permission. © 2000 Museum of Fine Arts, Boston. All Rights Reserved cat.56; R26 / The Nasser D. Khalili Collection of Islamic Art. Photo © The Nour Foun-dation R19 / National Gallery of Victoria, Melbourne, Australia R35 / National Museum, New Delhi R135 / Philadelphia Museum of Art cat.46 / Princeton University Library R42 / Rijksmuseum, Amsterdam fig.26 / Seattle Art Museum cat.38 / San Diego Museum of Art R17 / Sarabhai Foundation Museum, Ahmedabad R138 / School of Oriental and African Studies, University of London fig.17 / Staatliches Museum für Völkerkunde, Munich R139 / The State Hermitage Museum, St Petersburg R122 / Victoria & Albert Museum, London. © V&A Picture Library cat.20, 24, 28 (detail on pp.102–103); 29; cat.22, 26, 81 after Stronge 2002, pls 15, 12, 13 respectively; figs 2, 10, 28; R6, R31, R32, R115, R141, R142, R144, R145, R148–52, R154–61, R171, R172 / Collection University of Virginia Art Museum R116.

Private collections: cat.9, 18, 19, 27 (detail on pp.2–3); R163–65.

Paintings whose current whereabouts are unknown were reproduced from the following sources: R18 Photo after Palais Galliera, Paris, 19 June 1970, lot 85 / R27 Photo courtesy A.M. Kevorkian, Paris / R55 Photo after *Artibus Asiae*, vol.XI, 1948, pl.1 / R162 Photo after Glück 1925, abb.10 / R166 Photo after Sotheby's, London, 22–23 May 1986, lot 134 / R173 Photo after Sotheby's, London, 15 July 1970, lot 10 / R174 Photo after Sotheby's, London, 4 July 1975, lot 89 / R175 Photo after Sotheby's, London, 4 July 1975, lot 88 / R176 Photo after Sotheby's, London, 12 April 1976, lot 65 / R177 Photo after Sotheby's, London, 2 May 1977, lot 96 / R178 Photo after Sotheby's, London, 12 April 1976, lot 64 / R179 Photo after Christie's, London, 18 October 1994, lot 6.